An Auteurist History of Film

T0317789

Charles Silver

An **Auteurist History** of **Film**

The Museum of Modern Art

New York

Produced by the Department of
Publications, The Museum of Modern
Art, New York

Christopher Hudson, Publisher
Chul R. Kim, Associate Publisher
David Frankel, Editorial Director
Marc Sapir, Production Director

Edited by Jessica Loudis
Designed by Beverly Joel, pulp, ink.
Production by Matthew Pimm
Printed and bound by Pristone Pte.
Ltd., Singapore

This book is typeset in Stag and
GT Cinertype. The paper is 130gsm
Magno matt.

Library of Congress Control Number:
2016933312
ISBN: 978-0-87070-977-7

Published by The Museum of
Modern Art
11 West 53 Street
New York, New York 10019
www.moma.org

Distributed in the United States
and Canada by
ARTBOOK | D.A.P., New York
155 Sixth Avenue, 2nd floor,
New York, NY 10013
www.artbook.com

Distributed outside the
United States and Canada by
Thames & Hudson Ltd.
181A High Holborn, London WC1V 7QX
www.thamesandhudson.com

Cover: *Modern Times*. Directed by
Charlie Chaplin. 1936. USA. Black
and white, 87 minutes. See pp.
79–80

Back cover: *On the Waterfront*.
Directed by Elia Kazan. 1954. USA.
Black and white, 108 minutes. See
pp. 154–55

Printed in Singapore

Table of Contents

Director's Foreword

For over forty years, until his retirement at the end of 2015, the late Charles Silver nurtured generations of film scholars and artists through his exhibition programs and dedicated shepherding of the Film Study Center at The Museum of Modern Art. Countless publications have benefited from his guidance but none has projected his voice and critical insights as fully as *An Auteurist History of Film*. For five years, from 2009 to 2014, the Museum offered a weekly series of films under that title, curated by Charles. The series was accompanied by a blog, which featured a short essay on each week's film that Charles posted on the Museum's website, at www.moma.org. This book is a revised and enhanced collection of those posts, and offers an inspired, idiosyncratic perspective on cinema by one its most avowed fans.

The series was dedicated to the critic Andrew Sarris, whose *American Cinema: Directors and Directions 1929–1968* (1968), which many consider the most influential work of film criticism written in the English language, was its initial inspiration. Charles's book expands the scope of Sarris's to include works of "precinema," movies made before 1915, and films made from 1968 to 1980. The prevailing concept, however, remains the same: that a film, despite its collaborative nature, is ultimately the work of a single artist, the director. However indebted to Sarris's auteur theory Charles may have been, his writing is nonacademic and informal and is based on more than six decades of viewing films. His book is not intended as a final say on cinema history but as an individual take on the subject.

Passion is as critical to the work of a curator as are intellectual curiosity and serious scholarship. Charles always brought an urgent intensity to his work in the Department of Film. His passion over the many years of his career was nurtured by two successive Chief Curators, Mary Lea Bandy and Rajendra Roy. Colleagues within the department, curators outside it, and most of all legions of cinephiles are indebted to his commitment to the Museum, and to the mission of advancing film history that it has pursued since 1935. I hope this book inspires new passions for film, and the ideas for new histories to be written.

—Glenn D. Lowry
DIRECTOR, THE MUSEUM OF MODERN ART

Acknowledgments

As my late friend Vito Russo wrote regarding his seminal *The Celluloid Closet*, "This book put a lot of decent people through hell." No one suffered more over the five years of my writing the blog posts mostly reproduced here than my supremely patient editor, Jason Persse. I wish to thank him and members of MoMA's Publications Department: Christopher Hudson, Chul R. Kim, David Frankel, Marc Sapir, and Matthew Pimm; and outside the Museum, this book's designer, Beverly Joel, and especially its editor, Jessica Loudis. I also, of course, wish to thank my colleagues in the MoMA Department of Film.

I am grateful for the contributions and friendship of Charles and Mirella Affron, Gary Bandy, Richard Barsam, Cari Beauchamp, Alejandro Branger, Bryan Cash, Nicole Crunden, Nathaniel Epstein, Scott Eyman, Philip Fuhr, Cullen Gallagher, David Gerstner, Laurie Goldbas and Dave Knoebel, Mark Griffin, William P. Gruendler, Kyoko Harano, Hanna Hartowicz, Molly Haskell, Emily Hubley, Ray Hubley, Laurence Kardish, Judith M. Kass, Matthew Kennedy, Michael Kerbel, Maria Kornatawska, Stuart Klawans, Elspeth and Nicholas Macdonald, Daisuke Miyao, Ben Model, Linda Moroney, Hisashi Okajima, Vika Paranyuk, David Phelps, Carl Prince, Justin Rigby, Laura Rugarber, Anthony Stanhope, Kevin Stoehr, and Catherine Surowiec. Also, I fondly remember Steven Bach, Stephen Harvey, Faith Hubley, Jytte Jensen, Donald Richie, Vito Russo, and Charles Smith.

This book is dedicated to Karen and to the memory of two mentors, Mary Lea Bandy and Andrew Sarris.

— Charles Silver

Introduction Charles Silver

I've been going to the movies, mostly on my own, for nearly seventy years. In general, I was a pretty solitary little kid, and there was a theater within easy walking distance in our un-menacing and polluted New Jersey suburb. (Going alone was usually better, since I once took my little sister Karen to see the seltzer bottle-squirting Clarabelle the Clown from the Howdy Doody TV show, and she freaked out.) The weekly program was divided into two double-bills, so if you went to both Saturday and Sunday matinees, you could see four of Hollywood's latest products for, as I recall, fifty cents total. These ranged from Westerns to musicals to what I disparaged as "love stories." I've never been very good at remembering plot details, but I still have a vivid memory of the climactic battle in John Ford's *Fort Apache* (1948). I've also never ridden a horse, but I remain a sucker for Westerns.

This was also the period when television began to spread to the masses. Channel 13, now the highly respectable Public Broadcasting System channel, managed to show around half a dozen 1930s B-grade Westerns each day to fill up its schedule. Somewhat forgotten cowboys like Ken Maynard, Hoot Gibson, Colonel Tim McCoy, Bob Steele, Buster Crabbe, and many others became heroes to a new generation, to which I belonged. Channel 13 also offered two shows hosted by "Uncle" Fred Sayles: *Junior Frolics* (mostly featuring low-rent 1930s animation) and Friday night wrestling

from Laurel Gardens in Newark, which was also low-rent, but that's another story.

I guess it's fair to say I was hooked early by a medium I didn't recognize at the time as art. I think the only film my school owned was a ratty 16mm print of Ronald Colman in *A Tale of Two Cities* (1935), which was trotted out from time to time. Gradually, however, I became aware that there were several decades' worth of movies in the world, some of which were not even American. As a teenager, I found myself occasionally taking the bus into New York, sometimes to see the Rangers skate rather futilely in the old Madison Square Garden, and sometimes to visit a place called the Museum of Modern Art, where one could see old movies, including silent ones. MoMA collected films, tried to preserve them — and even took them seriously! As an undergraduate, I took advantage of a service offered by the Museum that allowed scholars to view films for research, a service I would be administering in less than a decade. Films have been a central love of my life, struggle as I might to shake off the addiction. When I became bored studying political science in graduate school, I found myself being drawn back to film. When I finally moved to New York in 1968, in the back of my mind my intention was to somehow wind up in the Film Department of the Museum of Modern Art. Eventually, I lucked out.

I confess to being, in spite of everything, an unabashed Romantic. No less an authority than

Wikipedia describes the Romantic movement as having "emphasized intense emotion as an authentic source of aesthetic experience." For me, film is the most potent medium for generating such emotion.

There is an artificiality to theatre. Literature is too prone to interruption and distraction. Music and dance have a flow, but their emotional content seems abstract, and I find opera mostly boring. Great painting, sculpture, and photography can be arresting, but there is no follow-up or engagement with the vibrant moving creatures depicted. With apologies to some of my curatorial colleagues, I find new media unworthy of serious consideration in this context. Film has a special capacity to overwhelm, to envelope, to suck the viewer into a fluid experience, which, if done properly, can tap into the most primal feelings. This does not mean that all films have to contain this kind of magic, but most of the very best films do. I can appreciate different kinds of film, but abstract animation, avant-garde or experimental films and most non-narrative works fail to meet my highest standards, whereas works by emotionally gripping auteurs like John Ford, Charlie Chaplin, Jean Renoir, D. W. Griffith, and several others do. The operative word here, I think, is "primal."

At their core, movies innovate on one of mankind's oldest pastimes — storytelling. Film meant that storytellers could suddenly create a credible alternative world for their audiences. D. W. Griffith, for all his ignorance and flaws, was the first to understand this. Although his dream of a universal cinematic language was shattered by Al Jolson in *The Jazz Singer* (1927) less than a generation later, Griffith perfected a new art that enabled us "to see" as we never had before, and to be moved by art more viscerally than ever.

Before I arrived at the Museum, I had come under the influence of Andrew Sarris through his weekly column in *The Village Voice* and his monumental book *The American Cinema: Directors and Directions 1929–1968*. Sarris was introducing what later became known as "auteur theory" to the Anglophone world, and was personalizing and expanding on it. The theory had first been promulgated by a handful of young critics at the Parisian magazine *Cahiers du Cinema* in the 1950s, and though its intricacies can be convoluted, permit me to elucidate it just a little. The *Cahiers* folks (André Bazin, François Truffaut, Jean-Luc Godard, Éric Rohmer, and others) were ostensibly reacting to the French cinema's "tradition of quality," which since just before World War II had been churning out craftsman-like but impersonal films. In the service of attacks against these

films, Hollywood was invoked as a model system in which "auteurs" such as John Ford, Howard Hawks, and Raoul Walsh could produce films that were not only commercially viable, but also expressed the distinctive personality of the director. Little attention was paid to the behind-the-scenes workers who did much of the heavy lifting on these Hollywood films, but the theory attained legitimacy by focusing broadly on certain directors whose work contained discernible patterns, themes, values, and a clear visual style, similar to that of a writer or painter. Although I am not disposed towards theory or abstraction, this has always struck me as the most intelligent approach to taking film seriously as art. It is also why the Museum of Modern Art was able to include film in its holdings. I was gratified to recently come across this statement made in 1925 by the founder of our department, Iris Barry: "If a film, of no matter what type, is to be worth while, it must be entirely dominated by the will of one man and one man only — the director." Barry, ahead of her time as usual, was an auteurist long before the word existed.

Regarding Sarris, although I met him a few times socially, Andy and I were never buddies. In some ways, I think it might have been a burden for him to have inspired a coterie of young cineastes. During his time as film editor for the *Voice*, he published several pieces I wrote. These moments, of course, put me in a kind of ecstasy, though one was mitigated when a bird pooped on my head as I was walking home after picking up a copy of the paper. Many years later, I was gratified to be able to dedicate the series on which this book is based to Andy, and also pleased to hold a memorial screening for him after his death. His lovely wife, Molly Haskell, spoke at the event, and we showed *Letter from an Unknown Woman* (1948) by his favorite director, Max Ophüls.

I am indebted to Rajendra Roy, the Celeste Bartos Chief Curator of the Department of Film at the Museum for proposing the film history screening series and its accompanying blog, and for accepting its basis in auteur theory. The exhibition, originally intended to last two years, ran from September 2009 until September 2014. Though influenced by Sarris's *The American Cinema*, it differed in that we met auteurs at various stages of their careers, and our series was more inclusive in terms of years covered and geographical scope. All films were drawn from MoMA's archive, highlighting the collection's strengths and weaknesses. This was a mixed blessing: We found that many of the greatest films of directors such as, for example, Alfred Hitchcock and Josef von Sternberg were not in our holdings, and that many of the

films we did have were in poor shape. Via the series, we discovered significant gaps that we hope to rectify, including that our collection contained few holdings from the non-Western world. In spite of this, we included nearly all of the major auteurs in film history, and represented many of them through their best films. It should also be pointed out that MoMA's collection goes beyond the films themselves, and contains many documents, a vast archive of stills, and unique items such as D. W. Griffith's personal papers and business records.

Finally, I want to acknowledge what a rare privilege it was to choose the films and have my writing (mostly reproduced here) posted on the Museum's website, projected onscreen before each film, and eventually gathered into a book. The result, which you have in your hands, is idiosyncratic and occasionally even autobiographical. In my undisciplined way, I have shied away from writing an academic book, and tried to write the kind of book I would want to read. I hope my passion for film compensates for what some might perceive as a lack of seriousness in my approach. Sixty-eight years of watching movies has left me with a lot of material to work with, and it hasn't been easy to encompass all of it, or be consistent in my evaluations. However, I believe I have remained true to certain basic values when considering a large number of auteurs and their work. Whether a director excels in visual innovation, narrative development, or direction of actors, I have tried to give each his — or occasionally her — due. Writing so idiosyncratically, I sometimes allow my personal values as a humanist and social democrat to come into play. But narrative films, after all, are about something, and politics, history, and values do matter. Leni Riefenstahl's Nazi-financed images may have been more grandiose than those in the films of auteurs such as Chaplin, Renoir, or Ford, but the latter were far greater artists. And film, like all other art forms, could never have attained greatness without transcendent artists.

Early
Cinema

Eadweard Muybridge and Pre-Cinema

A handful of documentary films in the Museum's collection deal with the long pre-history of cinema. I am not sure what prompted the Naval Photographic Center to undertake *Origins of the Motion Picture* (1956) in the lull between Korea and Vietnam. Whatever the reason, this little film, based on Martin Quigley Jr.'s book *Magic Shadows*, is surprisingly informative in sketching out eight centuries of cinematic invention before cinema in a mere twenty-one minutes. Merritt Crawford was an early twentieth-century scholar who corresponded with many significant nineteenth-century innovators, including Eadweard Muybridge (1830–1904), a key crossover figure between photography and film. A still photographer, Muybridge discovered that it was possible to create the illusion of motion by shooting a sequence of photos of a horse or man at regular intervals and then projecting them in rapid succession. He lived for nearly a decade into the era of cinema, and although he never technically made a motion picture, he was well aware of what his experiments had facilitated. For serious scholars, the MoMA library holds the Merritt Crawford papers on microfilm, and for those interested in Muybridge, Thom Andersen's 1975 documentary, *Eadweard Muybridge, Zoopraxographer*, admirably explores his subject's contributions.

Early Auteurs The Lumière Brothers / Thomas Alva Edison / Max Skladanowsky / Robert William Paul / Cecil Hepworth

The Lumière brothers, Louis (1864–1948) and Auguste (1862–1954), are the closest we have to the first auteurs. Their role as "directors" largely consisted of finding a subject that interested them, plunking down their camera (or "cinématographe"), and turning it on. Eventually, virtually all directors dismissed this ultra-simple method as antiquated, but seventy years later, Andy Warhol brought it back to considerable acclaim in some circles. The Lumières' earliest films included depictions of workers leaving a factory at the end of the day, and a notorious film of a speeding train heading directly at the camera — which apparently terrified its unsuspecting audience. By sending film crews around the world to photograph the commonplace and the exotic, the Lumières effectively shrank the globe in ways never before thought possible.

One hundred and twenty years later, one of the things that intrigues me about the Lumière films is the people in them. Some of the middle-aged ones may have shaken Abraham Lincoln's hand; some of the elderly may have seen Napoleon marching through Paris. And yet on film they look and move much as we do, denizens of a world as strange to us as ours would be to them. They

have achieved some level of immortality, and they embody one of the best arguments for film preservation: keeping our past alive.

The role played by Thomas Alva Edison (1847–1931) in the development of early cinema is more in the realm of mystery than romance, more about profit and litigation than art. Edison's focus on film was peripheral compared to many of his other endeavors, and he mostly left the field to associates like the wealthy independent entrepreneur George Eastman, who invented the 35mm perforated celluloid film still used to this day, and William Kennedy Laurie Dickson, who built Edison's Black Maria studio and "directed" the first films Edison showed in his Kinetoscope peepshow parlors. Edison's actual contributions are disputable, but he claimed the movies as his invention. Eastman, meanwhile, went on to become a major philanthropist and the namesake of The International Museum of Film and Photography in Rochester, and Dickson left Edison to work for the American Mutoscope and Biograph Company, which was the Edison Studio's main rival at the time. The Wizard of Menlo Park went on to sue everybody not under his control, and he finally left the film industry when antitrust action and the artistic inclinations of others made it no longer lucrative. For those who have never been, the Edison Laboratory in West Orange, New Jersey is well worth a visit, and the Edison Tower now stands atop his original Menlo Park location, also in New Jersey.

Max Skladanowsky (1863-1939) was the German contender for the Lumières' throne. This graduate of Magic Lantern shows (a pre-cinema device for projecting images) went on to invent a cumbersome and unreliable projection system that provided Berliners with their first taste of the movies. These short films were once classified as "Skladanowsky Primitives," and they live up to that moniker.

Robert William Paul (1869-1943) and Cecil Hepworth (1874-1953), key figures in the early days of British cinema, both exemplify how inventors could become directors and eventually auteurs. There were no rules or training for making movies at the time, and so engineers or technicians were able to stumble into the "creative" process. After a flurry of innovative experiments involving refining cameras and inventing various tricks, Paul gave up making movies in 1910. Hepworth, on the other hand, survived until the advent of talkies, making thirty features along the way. His film *Rescued by Rover* (1905) contained plot elements that inspired many subsequent animal-loving directors, and

served D. W. Griffith three years later in his debut film, *The Adventures of Dollie*, about saving a kidnapped baby.

Edwin S. Porter, America's First Director

As Charles Musser explains in his documentary about Edwin S. Porter (1870-1941), Porter was a jack-of-all-trades who accidentally stumbled into being the first director of note in American film. A failed businessman, he began working for Edison in 1900, when "directing" movies was hardly considered a profession. His career lasted until 1916 and included twenty features, mostly co-directed with others. Among these were the now-infamous *The Count of Monte Cristo* (1913) starring James O'Neill (the film adaptation of the play that figured so prominently in the great *Long Day's Journey into Night* by O'Neill's son, Eugene) and the Mary Pickford vehicle *Tess of the Storm Country* (1922). It is doubtful that Porter ever regarded himself as an artist, but his role in the early days of film makes it impossible to totally dismiss him from cinema history.

Much of Porter's output for Edison was derivative of the immensely popular trick films made by Georges Méliès and other directors working in France. These films used primitive special effects to showcase cinema's ability to create alternate realities. What remains of genuine consequence are Porter's "actualities," or simple documentaries, whose subjects ranged from McKinley's assassination to priceless documentation of turn-of-the-century Coney Island, and two films Musser singles out: *The Life of an American Fireman* (1903) and *The Great Train Robbery* (1903), which were acquired by Iris Barry for MoMA's fledgling "film library" in the mid-1930s. The former was ahead of its time in its editing techniques, and the latter anticipated the spectacular Westerns to come, even though Porter and his crew got no further west than the Hudson River. The well-paced narrative flow of *The Great Train Robbery* was atypical for its time, and the film established a model that D. W. Griffith would improve upon five years later.

Griffith himself appears in Porter's *Rescued from an Eagle's Nest* (1908), though he was soon to be rescued from such thankless roles by moving behind the camera at Biograph. A stage actor, writer and poet, Griffith did not think much of the primitive movies of the period until he later became a director. As Porter descended into

obscurity, Griffith climbed to the top. There is no record of whether the two had any further relationship, and the index of the D. W. Griffith Papers at MoMA contains no entry for Edwin Stanton Porter.

Georges Méliès and His Rivals
Ferdinand Zecca / Segundo de Chomón / Gaston Velle

I see Georges Méliès (1861–1938) as a link in a continuum that runs from Jules Verne to filmmakers like Walt Disney and Tim Burton. Méliès had been a stage magician, and just as Disney and Burton would later make use of cinema's technical ability to transcend reality, Méliès's films highlighted the new and magical possibilities of the medium. Many of Méliès's films such as *A Trip to the Moon* (1902) were directly adapted from Verne, and his influence can be found in Méliès's *The Impossible Voyage* (1904), *Tunnelling the Channel* (1907), and *The Conquest of the Pole* (1912), among others. The author made fantasy respectable, and Méliès, more than other early auteurs, benefited from and catered to this audience. Verne lived until 1905, meaning he was very likely aware of Méliès during his heyday. I hope that the younger filmmaker found a way of expressing his gratitude to the older novelist for inspiring some of his best work. Méliès died just a few weeks after Walt Disney released the first of his epic fairy tales, *Snow White and the Seven Dwarfs* (1937).

Before he went on to influence future generations of filmmakers, the Beaux Arts student-turned-magician-turned-director was so successful that he inspired several contemporary imitators. *Excursion to the Moon* (1908), by Ferdinand Zecca (1864–1947) and Segundo de Chomón (1871–1929), is clearly a rip-off of Méliès's immensely popular *A Trip to the Moon*. Chomón, an innovator in the fields of special effects and animation, also photographed Giovanni Pastrone's 1914 epic *Cabiria*, which is famous for its fluid camerawork. Gaston Velle (1872–1948) is another significant but nearly forgotten figure in the early history of the cinema. Also a former magician, he labored in the shadows of Méliès and others, making many accomplished films that are often not easy to distinguish from those of his colleagues. As a result, there have been disputes over the attribution of several of his works. (For those with a serious interest in early French cinema, the definitive work in English is Richard Abel's *The Cine Goes to Town*.) In any event, Velle's films

speak silently for themselves, evoking an innocence that would soon be buried in the mud of the Great War. Finally, though he came later, Czech animator/director Karel Zeman was influenced by Méliès, and his feature films *The Fabulous World of Jules Verne* (1957) and *Baron Munchhausen* (1962) explicitly evoke the earlier director's style and subject matter.

Méliès's fantastical films also share a sensibility with some American literature of his period, namely L. Frank Baum's *The Wonderful Wizard of Oz*, and Garrett P. Serviss's *Edison's Conquest of Mars*, a guilty pleasure in which the Wizard of Menlo Park kicks Martian butt. He was a man of his time, a director in full command of the cinematic resources available to him. In spite of their energy and imagination, however, Méliès's films eventually wore out his audience's goodwill, and his speculative visions were overtaken by a demand for greater reality. He earned an honorable place in film history, even receiving the Legion of Honor, but ultimately faded away. At the end of his life, Méliès was hawking toys in the Montparnasse train station, a turn memorialized in Martin Scorsese's adaptation of Brian Selznick's illustrated novel *Hugo* (2011). Ever the magician, it's easy to envision Méliès adding a bit of performance and prestidigitation to his routine in order to delight young customers.

Forgotten Pioneers
Ferdinand Zecca / Alice Guy-Blaché / J. Stuart Blackton / Wallace McCutcheon

A great number of films were made in the early twentieth century, and a great number of these have been lost. Though a handful survive, the puzzle of this early period is always going to be incomplete.

Ferdinand Zecca (1864–1947) was a rival of Georges Méliès who made similar films. He was a commercially oriented Parisian café performer, and much of his work was "derivative" — which is to say, stolen. Eventually, he found his true calling as head of Pathé, a major French studio.

Alice Guy (1873–1968), or Alice Guy-Blaché, went from being a secretary at Gaumont to becoming the world's first female director in a matter of months. At one point she was, in effect, the production head of that

venerable studio. Founded in 1895, it is the only one from the period that still exists today. Guy emigrated to America with her husband, Herbert Blaché, in 1910, and the couple established their Solax studio in Flushing, Queens soon after. After Solax failed, Guy continued to make films for various studios in the U.S. Following her divorce in 1922, she returned to France only to discover that she had been forgotten. Failing to get work, she spent the rest of her life in relative obscurity, and little is known of her films. She received the Legion of Honor in 1953, and died in Mahwah, New Jersey at age ninety-five.

In terms of subject matter, religious films were popular with early twentieth-century audiences, who perhaps had to rationalize their patronage of this lowly art form with higher aspirations. Two Christ films, Zecca's *The Life and Passion of Jesus Christ* (1903) and Guy's *The Life of Christ* (1906), are more reflective of the demands of the period than of either director's talent. Both engage in respectful tableaux that emphasize the static nature of the camerawork and the overly grand gestures of the actors. The use of exteriors helps create a sense of authenticity, and elaborate sets contribute to efforts to create depth of field. (For delicate sensibilities, the scourging of Jesus is a walk in the park compared to Mel Gibson's interpretation.) Méliès-esque special effects such as superimpositions — the process of running film through the camera twice — here become means of expressing the sacred and holy. Audiences probably found both films ambitious and spectacular, and one assumes that many a pastor went to considerable trouble to show them in their churches whenever attendance flagged. A similar phenomenon occurred decades later when non-theatrical distributors like Brandon Films made a mint facilitating screenings of Pier Paolo Pasolini's *Gospel According to Saint Matthew* (1966) for God-fearing audiences — in spite of the director's homosexuality and Marxist beliefs.

J. Stuart Blackton (1875–1941) was born in Britain, but as a young man in New York he had a fortuitous meeting with Thomas Edison that encouraged him to go into film. With two other men Blackton formed Vitagraph, a production company headquartered in a glass-enclosed studio in Brooklyn. Vitagraph's output was eclectic, ranging from pseudo-newsreels to animation and even comedy films, which Blackton pioneered a decade before Mack Sennett became known as the king of slapstick comedy. As film historian Ephraim Katz suggests, "Next to Griffith, Blackton was probably the most innovative and creative force in the development of the motion picture art." His experiments with sound and color film were influential, and he brought culture and respectability to film through literary projects, including a range of Shakespeare adaptations. His *The Life of Moses* (1909) is generally considered the first feature film, though it was released as a five-part serial. As with many filmmakers of the time, Blackton's status as an auteur is hard to evaluate, in part because he had a diverse portfolio that included directing, producing, acting, animating, editing, and serving as an entrepreneur. Albert E. Smith, Blackton's business partner, observed that while some filmmakers worked like artists, "Vitagraph was like a magazine or a newspaper, [which] has a clientele that it must furnish a supply to regularly." Blackton's career ended in 1926, after he sold Vitagraph to Warner Brothers and was forced to retire. To learn more about him, I highly recommend Anthony Slide's book, *The Big V: A History of the Vitagraph Company*.

Vitagraph movies like *Francesca di Rimini* (1910), a lavishly produced thirteenth-century melodrama, and *The Automobile Thieves*, aka *The Bold Bank Robbery* (1910), should be seen as markers of Blackton's place in history rather than as measures of his cinematic talent. *Francesca*, one of Vitagaph's popularized "classics," has all the earmarks of a low-budget Victorian stage production. *The Automobile Thieves*, released seven years after Porter's *The Great Train Robbery*, reflects the popularity of crime films at the time with its excessive gunplay and moving-camera chase scene. (It also suggests that the automobile was as novel as movies themselves.) Yet these were minor short films. Griffith's *The Lonely Villa* was already more advanced despite coming out a year earlier, and he would bring more sophistication, credibility, and close-ups to the crime genre — not to mention fewer histrionics — with *The Lonedale Operator* (1911) and *An Unseen Enemy* (1912).

Wallace McCutcheon Jr. (1880–1928) was a stage musical comedy actor and house director of the Biograph production company from 1897 until Griffith took over in 1908. According to former MoMA curator Eileen Bowser, McCutcheon's film *At the Crossroads of Life* (1908) "is of interest chiefly because it shows the primitive state of most filmmaking at the time." The film starred Griffith as a stage-door seducer, and it is likely he drew on his experience as an actor in writing the scenario and (over) playing his role. The film comes alive for a single exterior shot and clearly anticipates how quickly Griffith would transform the medium in the months ahead. Only weeks after acting in *At the Crossroads of Life*, Griffith would cross his personal Rubicon and move behind the camera.

One of Griffith's first films, *Old Isaacs, the Pawnbroker* (1908) was shot on the Lower East Side of Manhattan and featured local Jewish residents. It was unabashed in its use of caricature, and the kinds of stereotypes it depicted would unfortunately remain a staple of cinematic melodrama into the sound era. Though the mise-en-scène certainly reflects life's ugliness, there is nevertheless something redemptive about its plot, in which a kindly old Jew comes to the rescue of a little girl.

D. W. Griffith at Biograph 1908–1914

Henri Matisse said: "My purpose is to render my emotion... I think only of rendering my emotion."

Many film history textbooks have cataloged the elements of cinematic grammar and expressiveness that D. W. Griffith (1874-1948) invented or refined during his five years at Biograph while collaborating with cinematographer G. W. "Billy" Bitzer. This seemingly endless list includes close-ups, fades, masking, parallel editing, the moving camera or dolly shot, backlighting, changing camera angles, restraining histrionics through the cultivation of professional film actors, the development of "spectacle," and so on. All of these essentially manipulative techniques, however, served a larger purpose. Griffith's great genius was his intuitive understanding of the inherent power of the movies to render emotion and evoke feeling. No medium, before or since, has so thoroughly facilitated art's capacity to touch that raw nerve, the primal human essence, and Griffith was the first filmmaker to fully grasp and exploit this fact. Fashions and conventions come and go, but, at their best, Griffith's films – like all great art – are deeply felt expressions of what it is like to be human.

The Museum's film collection has preserved several hundred of Griffith's Biograph films, but most are not presently viewable due to lack of funding. (Inroads have been made, however, thanks to a generous bequest from Lillian Gish). MoMA is fortunate to have nearly all of Griffith's films, and so it's possible to study the refinement of his art as almost a daily progression. Griffith essentially revolutionized a medium as no artist has done before. We may with some justification compare his films to prehistoric cave paintings; as historian Richard Brookhiser wrote, "Cro-Magnon man painted magical images on cave walls that seem to move. Now people head into caves to watch images that actually do move; some of them are magical." Griffith was the first filmmaker to capture the true magic of the moving image, a conjuration that has moved us for more than a century.

The Scandinavian Connection
Urban Gad and Victor Sjöström

Urban Gad (1879-1947) made a few films in Germany in the 1920s during the golden age of Expressionism, but by 1927 his career had petered out. Though he did anticipate certain trends and was ahead of his time in his use of eroticism onscreen, he was clearly not playing in the same league as F. W. Murnau, Fritz Lang, G. W. Pabst, Leni Riefenstahl, or Robert Wiene. Gad's most significant contribution to film was the discovery of Asta Nielsen, who he married in 1912. Working in Germany mostly with Gad, "Die Asta" developed a restrained style of film acting comparable to her American counterparts like Lillian Gish and Mae Marsh. (To fully appreciate the achievements of these women, one should check out Sarah Bernhardt's stagey film appearances from this period.) Nielsen performed Strindberg, Ibsen, Wedekind, and a cross-dressing Hamlet, but her most familiar role to museum audiences was in Pabst's *The Joyless Street* (1925), the film that precipitated Greta Garbo's move to America. After appearing in one talkie, *Unmöchlige Liebe* in 1932, Asta Nielsen began a retirement that would last forty years (later to be topped by Garbo's half-century "reclusion"). At the age of seventy, however, she undertook a second career as a gifted collagist.

Victor Sjöström (1879-1960) started his career while D. W. Griffith was still at Biograph, and in certain ways, his films seem more sophisticated and adult than those of his American rival. In many of his best works (*A Man There Was*, 1917; *The Outlaw and His Wife*, 1918; and *The Phantom Carriage*, 1922), Sjöström relied on a very talented actor: himself. This established a precedent for the likes of Charlie Chaplin, Erich von Stroheim, Orson Welles and others to star in their own movies. It also led to Sjöström's marvelous performance in Ingmar Bergman's *Wild Strawberries* (1957). Like his fellow Swede, Sjöström's vision of the world was less than cheerful, although his films do have comic moments. (The great Danish director Carl Theodor Dreyer surpasses both Bergman and Sjöström in the Scandinavian somberness department.) Sjöström spent his childhood in America,

leading one to wonder: What might his career have been like if he hadn't returned to Sweden in the 1890s, just as films were beginning to take off?

In *Ingeborg Holm* (1913), Sjöström's second film, a widow is sent to the poor house and her children are given to foster families. When the widow's youngest child fails to recognize her, she breaks down and is committed to an insane asylum, where she stays until her oldest son presents her with a photo of herself as a young woman and she regains her wits. Based on a play by Nils Krok, a member of the poverty relief board in the Swedish city of Helsingborg, the film became an unexpected sensation and was deemed an example of "unwholesome cinematography." Sjöström's company tried to get off the hook by saying that the film depicted conditions in rural areas, not Stockholm, and also argued that it was film's social responsibility to "arouse sympathy for the less fortunate members of society." Here Sjöström again anticipated Griffith, who would make similar claims about cinema's potential to change the world. The debate ignited by the film (which proved to be a commercial success) did, indeed, lead to the modernization of poverty relief laws in Sweden.

Two Danish Innovators
Stellan Rye and Benjamin Christensen

Though *The Student of Prague* (1913) has been called "the first real auteur film," it appears to have been a collaborative effort between director Stellan Rye (1880–1914), cameraman Guido Seeber, and star Paul Wegener, whom the same critic, Klaus Kreimeir, dubbed "the first modern German film actor." After Rye, a Dane, died fighting for Germany early in World War I, Seeber went on to photograph the 1914 version of *The Golem*, G. W. Pabst's *The Joyless Street* (1925) and *Secrets of a Soul* (1926). Wegener, a Max Reinhardt protégé, acted in, directed, or did both in films including *The Golem*, its more famous 1920 remake, several Ernst Lubitsch films, Rex Ingram's *The Magician* (1926), and numerous films for the Nazis. In 1926, Henrik Galeen also adapted Hanns Heinz Ewers' story *The Student of Prague*, this time casting the great Conrad Veidt as "Der Student." Ewers later became the chronicler of Nazi icon Horst Wessel, and Wegener starred in the 1933 adaptation of Wessel's biography, *One of Many*.

Rye's film was a clear forerunner of German Expressionism, making it all the more sad that he died so young, a tragedy perhaps rivaling Jean Vigo's death at twenty-nine. Although *The Student of Prague* was shot naturalistically in locations throughout the city, Rye's imaginative facility with the camera evoked the legend of Faust, E. T. A. Hoffmann, and Edgar Allan Poe. If Rye had lived longer, one wonders whether he might have been forced to choose between his native Denmark and his proto-Nazi compatriots and collaborators.

The Mysterious X (1913) was the first film by fellow Dane Benjamin Christensen (1879–1959). Although it wasn't as ingenious as Sergei Eisenstein's *Strike* (1925) or Orson Welles's *Citizen Kane* (1941), it had a huge impact on 1913 audiences. Upon its release in America under the title *Sealed Orders*, one critic hailed it as "a revelation in dramatic motion pictures. It sets a new and hitherto but hoped for standard of quality. It emphasizes… the absolute superiority of the screen over the stage and opens up a vista of coming triumphs for the motion picture." None other than fellow Dane Carl Theodor Dreyer called Christensen "a man who knew exactly what he wanted and pursued his goal with unyielding stubbornness… People shrugged him off as a madman. The way things have turned out [as of 1922], it is clear that he was the one in touch with the future."

Before he became a director and starred in *The Mysterious X* and Dreyer's *Mikael* (1924), that "madman" had studied medicine and been an opera singer. In many ways, Christensen can be seen as the Danish counterpart to D. W. Griffith and Victor Sjöström in the early years of the twentieth century. He was a master innovator in the realm of lighting and devised techniques that would be highly influential for German Expressionism. Film historian Ron Mottram admires Christensen's superb editing skills and cites a scene from *The Mysterious X* set in an old mill as "one of the earliest, genuinely sophisticated examples of a scene built from the juxtaposition of its constituent elements." Christensen's better-known masterpiece *Haxan (Witchcraft Through the Ages)*, which he made in Sweden in 1922, is a must-see, and one of the great Expressionist films.

Filmmaking opportunities in Europe were disappointingly scarce for a director as independently minded as Christensen, and like Sjöström and Mauritz Stiller, he was lured to MGM. This was hardly a director's paradise, but Christensen managed to make six films there in three years. *Mockery*, a 1927 Lon Chaney vehicle, showcases many of the lighting effects he had first used in *The Mysterious X*. In 1929 he returned to Denmark after

a decade of inactivity, made four talkies, and spent his remaining years managing a suburban Copenhagen cinema. One wonders if he read *Cahiers du Cinéma* in the 1950s, when the magazine was propounding the auteur theory he espoused decades earlier. The year of his death, 1959, was also the year that two of most famous auteurs, François Truffaut and Jean-Luc Godard, began work on their first features.

D. W. Griffith Leaves Biograph

1914

1915 marked the publication of poet Vachel Lindsay's *The Art of the Moving Picture*, the first serious attempt in English to come to grips with a medium that had out-grown penny arcades and nickelodeons and was now threatening to appear in venues that could rival cathedrals. Like so many early commentators on the movies, Lindsay struggled to find the language that would do justice to his thoughts. In an indication of the heady atmosphere of the times, Lindsay waxed positively Biblical in his enthusiasm for film, addressing filmmakers directly:

All of you who are taking the work as a sacred trust, I bid you God-speed… You will be God's thoroughbreds… It has come then, this new weapon of men, and the face of the whole earth changes. In after centuries its beginning will be indeed remembered. It has come, this new weapon of men, and by faith and a study of the signs we proclaim that it will go on and on in immemorial wonder.

The previous year, as extraordinary European films like Benjamin Christensen's *The Mysterious X* and Giovanni Pastrone's *Cabiria* were arriving on American shores, D. W. Griffith had been tearing at the seams of his constraining Biograph contract. Feature-length films were essentially a new phenomenon, and Griffith, influenced by European imports, wanted to pursue them. Before he did, his early Westerns reached a zenith with the twenty-six minute film *The Battle of Elderbush Gulch* (1914). Griffith had used the plot of the U.S. Cavalry saving settlers from Indians before, but in *Elderbush Gulch* the scale is grander, the photography more brilliant, the execution and editing of the action precise. Lillian Gish and Mae Marsh gave performances that can be seen as rehearsals for the genius they displayed in *The Birth of a Nation* the following year. Griffith, God's thoroughbred *du jour*, had now pushed short film to its farthest limits, and

something had to give. But he still had one more Biograph film to make, and he wanted to make it special.

I was privileged to have known Blanche Sweet, star of *The Avenging Conscience* (1914) and Griffith's final film for Biograph, *Judith of Bethulia* (1914). Blanche was feisty and opinionated. She claimed to have frightened Cecil B. De Mille; she delighted in talking about how wonderful it was to have lived through the 1906 San Francisco earthquake; she worked as a shop girl after her career mostly ended in 1930; she was politically progressive, unlike her successor to Griffith's affections, Lillian Gish. Lindsay was an admirer, composing a poem after seeing her in the 1913 Biograph short, *Oil and Water*: "Solemn are her motions / Stately are her wiles / Filling oafs with wisdom / Saving souls with smiles." In later life, Blanche worked with the Department of Film at MoMA to restore her movies, including the silent version of Eugene O'Neill's *Anna Christie* (1923), an adaptation the playwright greatly admired. Though she was set to do the talkie remake, Greta Garbo got the part instead. When Sweet died, her dear friend Martin Sopocy arranged for the Brooklyn Botanical Gardens to cultivate the Blanche Sweet lilac. Her ashes were quietly sprinkled over the gardens, and lilacs bloom there every spring.

Judith of Bethulia was an adventure for all involved since Griffith's company of actors and technicians (nearly all of whom would follow him after he left Biograph) had never made a film nearly as long or spectacular. Griffith assured Blanche, then seventeen, that her great (but short) costar, Henry B. Walthall, would "measure up" as General Holofernes. "Don't worry," Griffith said, "Wally will play him tall." Walthall lived up to this promise – at least, until Blanche decapitated him. The story is from *The Apocrypha*, but Griffith would soon move on to more authentic Biblical sources in *Home Sweet Home* (1914) and *Intolerance* (1916), which fully realized the ambitions laid out in *Judith*. The film was lavish by Griffith's earlier standards, but aside from the restrained intensity of the performances, it still paled in comparison to the Italian imports of the era.

The Avenging Conscience reflects Griffith's reverence for Edgar Allan Poe and literature in general. (One of his first shorts was an adaptation of Poe's "The Raven.") Pretentious enough to earn the support of Lindsay and others arguing for film's acceptance as "art," Griffith's fourth independent production – and the immediate predecessor to *The Birth of a Nation* (1915) – anticipated the psychological leanings of German Expressionism, which would become all the rage five years later. Griffith and cameraman Billy Bitzer

(who later worked at the MoMA Film Library) used all the technical resources at their command, as though beefing up for challenges ahead. In the context of Griffith's career as the quintessential romantic naturalist director, *The Avenging Conscience* remains a commendable oddity, in part because of how it anticipates non-naturalistic lighting effects.

Giovanni Pastrone's
Cabiria 1914

H. G. Wells published *The Time Machine* in 1895, a date that roughly coincided with the birth of cinema. That same year, the Lumière brothers sent out their cadre of globetrotting cameramen, exposing film audiences to the world, with all its exoticism and regional oddities. Film offered new possibilities for capturing reality, and though Wells mastered the speculative, future-oriented tradition of Jules Verne, filmgoers were perhaps even more intrigued by the possibility of traveling back in time and viewing the distant past.

D. W. Griffith had dabbled with history in films such as *In Prehistoric Days* (1913), but the real heavy historical lifting was done by the Italians. In 1912, Enrico Guazzoni stunned the film world with his spectacular adaptation of Henry Sienkiewicz's novel *Quo Vadis?* Although the film lacks Griffith's and Sjöström's sophisticated use of close-ups and restrained performances, the sheer wonder it inspired with its depictions of Rome burning, chariot races, massive scenes of extras, and lions eating Christians cannot be overestimated. It was staged entirely on lavish, authentic-looking sets, and it lasted for two hours at a time when thirty-minute movies were the norm. Guazzoni remained active throughout the fascist period, and excerpts from some of his other works are included in *Anthology of Italian Cinema*, a compilation film held in the MoMA collection.

Giovanni Pastrone, aka Piero Fosco (1883–1959), was the most important filmmaker during Italy's dominance of the European film scene in the period prior to World War I, and *Cabiria* marked the high point of his career. As Griffith was later to do with the Babylonian sequence in *Intolerance* (1916), Pastrone painstakingly researched and recreated the look of the Second Punic War. "Compared to the other colossal Italian spectacles of its time," film historian Liam O'Leary said of *Cabiria*, "it had an integrity and sense of purpose." Cinematographer

Segundo de Chomón's use of moving camera was revolutionary, and *Cabiria* achieved a level of prestige and recognition for its artistry that other filmmakers craved. It opened with an eighty-piece orchestra and a seventy-person choir in Turin in April 1914 — barely four months before Europe went up in flames, seemingly intent on following Carthage down the road to oblivion. Aside from the excesses of its performers, *Cabiria* felt like a real glimpse into the past, and led to a deeper understanding of cinema as a virtual time machine. Though Italy would reclaim some of its former glory during the Mussolini era in the spectacles of Carmine Gallone, Alessandro Blasetti, and Mario Camerini, the country did not return to center stage in terms of cinema until after the Second World War. Then, it was the antithesis of sword-and-sandal epics — the nitty-gritty Neorealist masterpieces of Luchino Visconti, Roberto Rossellini, and Vittorio De Sica — that commanded attention.

D. W. Griffith's The Birth of a Nation 1915

I have been struggling with the *Birth of a Nation* for nearly half a century, since the first time I saw it as a teenager. On the one hand, it reaches the highest artistic plateau that film attained in its time, and it is probably, on balance, the most influential movie, in terms of technique, ever. On the other hand, it reeks of the conjugal evils of slavery and lethal white supremacy. How does one reconcile D. W. Griffith's Leonardo-like genius with his sleazy acceptance of a worldview so shameful and repulsive? Can we ever accept the excuse that his adaptation slightly tempered the racism of Thomas Dixon's novel *The Clansman*, or that the film nostalgically reflected a Confederate-soaked childhood? How tolerable is this "blind spot" — as Atticus Finch termed racism in *To Kill a Mockingbird* — when it condoned the nineteenth-century Ku Klux Klan and helped start a new one in the twentieth century? And finally, does the film still matter as a social document? I would like to approach these questions by begging your indulgence and recounting my personal journey as it relates to the film. Much of this will lie outside the scope of standard film history and criticism, but this is no ordinary film.

As a kid my first hero was Jackie Robinson (along with several obscure cowboy stars from B-grade Westerns). As a teenager, I went to Washington, D.C. as

part of an integration march. In high school, I traveled with the basketball team as a statistician, and I always wondered why the two black stars got off the bus on the side of town that none of us would otherwise visit. At Rutgers, I wrote a paper on the school's All American football player-turned-activist, Paul Robeson, who was at that time unmentionable on campus. As one of the first American Civilization majors, to the delight of my professors, I decided to write my senior honors thesis on *The Birth of a Nation*. (I think the paper is still moldering in the MoMA library.) I was present when Dr. King had his dream. Sick of graduate school in 1964, I signed up for "Freedom Summer," and prepared to register black voters in Mississippi. When three guys were murdered upon arrival, I chickened out. In retrospect, I consider this decision cowardly but wise.

Forty-five years later, in September 2009, I finally got to Mississippi. I took a weeklong bus tour, visiting numerous sites of the Vicksburg Campaign. For those of you who are not Civil War buffs (an addiction I owe in part to Griffith's film), Vicksburg was known as the "Gibraltar of the Confederacy." From its bluffs, the rebels controlled traffic on the Mississippi. When Vicksburg finally fell to Grant on July 4, 1863, simultaneous with Lee's retreat from Gettysburg, the South was doomed — although it took another twenty-one months of blood and agony to get to Appomattox.

While I accept that impressions gleaned from stops at strip malls and overnights at industrial-park motels are suspect, I did form impressions that I want to share. What I found disturbing was that my fellow buffs on the bus, all of whom were white, never seemed to broach the subject of what the war had been about. I don't blame this on our guide, the estimable historian Edwin Bearss. The author of a three-thousand-page study of the battle, Bearss had an encyclopedic memory of Vicksburg (especially extraordinary given that he was eighty-six) and could tell you who did what to whom at what time of which day on any given spot on the battlefield. He did point out when the bus passed the town where Emmett Till was murdered, and told us that the black church where we made a pit stop had replaced a structure burned by "night riders" in the 1960s.

We met two descendants of former plantation owners who happily talked about what their ancestors did in the war (one proudly showed off family weaponry), but nobody, myself included, had the effrontery to ask how many slaves they had owned. Mentioning slavery was politically incorrect, and one wonders what our black bus driver made of the whole thing. The final stop on the tour was the courthouse in Vicksburg, where the victors finally raised the U.S. flag. It turns out that Jefferson Davis, who owned a nearby plantation, began his political career with a speech in the courthouse square. Behind the building was a tiny restful garden overseen by busts of Davis and his wife. In front of the courthouse there was a plaque calling Davis "the best equipped, most thoroughly trained, most perfectly poised man who had ever entered the arena of politics in America." This encomium was put forth by Thomas Dixon, author of *The Clansman*, co-author of *The Birth of a Nation*, and mentor to D. W. Griffith. What I found most disturbing was that this plaque had not been installed in the 1910s or 1920s (the heyday of Dixon and the Klan) but was dated 1997. As recently as two decades ago it was deemed acceptable to venerate Davis and regard Dixon as more authoritative than vile.

So how relevant is the content of *The Birth of a Nation* today? When a congressman screamed out "you lie!" to President Obama (Maureen Dowd of *The New York Times* suggested that his tone implied he meant "you lie, boy!") it struck me that he was from the same South Carolina where Dixon enshrined his Klan and Griffith depicted members of the Reconstruction-era legislature as shiftless barefoot blacks. In *The Birth of a Nation*, the villain, played by George Siegmann, is, like President Obama, of mixed race. In the minds of Griffith and Dixon, this makes him preternaturally dangerous, combining alleged white intelligence with assumed black bestiality. There are many reasons why the film should have been dismissed as a racist relic, yet because of Griffith's unprecedentedly skillful artistry, it cannot be ignored. *The Birth of a Nation* remains the pachyderm in the movie palace.

D. W. Griffith's Intolerance 1916

The humdrum life of a film archivist can occasionally be punctuated by privileged moments. For me, one of these relates to *Intolerance*. Joseph Henabery played Abraham Lincoln in *The Birth of a Nation* in 1915 and had a small part in the French storyline of *Intolerance*. The year after that film came out, under D. W. Griffith's tutelage, Henabery began a career as a director. Unlike Griffith protégés John Ford, Erich von Stroheim, Raoul Walsh, Allan Dwan, and Marshall Neilan, Henabery never rose above the status of journeyman, although he did get to work with Douglas Fairbanks, Dorothy Gish, and Rudolph Valentino, and made training films for the U.S.

Army Signal Corps. His real legacy, however, lay elsewhere. When Griffith set out to recreate Babylon for *Intolerance*, he took a leaf from the book of *Cabiria* director Giovanni Pastrone and began doing serious research to ensure the authenticity of his recreation. Henabery was assigned to gather photos and drawings of Babylonian buildings and art and to compile them in a scrapbook for Griffith. When Iris Barry acquired Griffith's papers for MoMA, that scrapbook was included. Henabery visited the Museum shortly before his death, and my colleagues and I had the pleasure of looking through his work with him. The Babylonian set and the introductory crane shot that Griffith and cinematographer "Billy" Bitzer devised (with obvious help from Dwan) remain stunning. The movies had offered nothing like it before and seldom have since.

Critic Stuart Klawans designated *Intolerance* as a prime example of what he termed a "film folly" — a movie that goes beyond acceptable limits for either its producers or intended audience. *Intolerance*, indeed, was a box office disaster, a fate attributed to its fugue-like structure, which interweaves four apparently unrelated stories. Even its unprecedented level of spectacle seems to work against the viewer's ability to take it all in. It was surely ahead of its time. Yet without its ambitions to push the envelope, we might never have had the great films of the Soviet montage directors, or *Citizen Kane* (1941) with its violations of temporal unity, or Cecil B. De Mille, the Fairbanks spectacles of the 1920s, Ford's Cavalry Trilogy, David Lean, Stanley Kubrick, or James Cameron.

To recoup some of his losses, Griffith split *Intolerance* into two shorter films: the Babylonian section

was adapted as *The Fall of Babylon* in 1919, and the modern story became *The Mother and the Law*. The latter film, released that same year, stands on its own as one of the director's major achievements, largely due to the exquisite performance of Mae Marsh. Her greatness in *The Birth of a Nation*, *Intolerance*, and in Griffith's 1923 film *The White Rose* cannot be overly praised. Marsh remained active in cinema throughout her lifetime, and can be found gracefully stealing scenes in several late Ford films.

Griffith insisted that *Intolerance* was a direct response to progressives' hostility towards *The Birth of a Nation*. He issued a pamphlet, *The Rise and Fall of Free Speech in America* after the film's failure, which argued that motion pictures were entitled to the same protections against censorship as the printed word. While this issue remains unresolved, it's difficult to sympathize with Griffith's plea for tolerance after making a film as fundamentally intolerant and libelous as *The Birth of a Nation*. Though he was an artistic genius, one finds his argument about as convincing as Leni Riefenstahl's insistence that she acted as a neutral observer while making *Triumph of the Will* (1935).

Although he would soon concentrate mostly on smaller films, Griffith was not yet through with spectacle. *Hearts of the World* (1918), shot during World War I, and *Orphans of the Storm* (1921) about the French Revolution, are two of his best works. The latter was filmed at his briefly owned Mamaroneck studio, and in many ways strikes his most satisfactory balance between sweeping epic and emotionally gratifying human drama. This was mostly thanks to the superb Lillian and Dorothy Gish, who star in both films. The sisters were uniquely talented, but Lillian in particular was the greatest actress of the silent screen. His 1924 film *America*, about the American Revolution, was something of a disappointment, but Griffith redeemed himself six years later with his first talkie, *Abraham Lincoln*.

Griffith's Heirs Thomas Ince and Cecil B. De Mille

By the end of first decade of the twentieth century there was a general awareness among film people that D. W. Griffith had brought something new to the discipline and broadened the playing field. Rather than be intimidated, many ambitious young men who aspired to be directors followed Griffith's lead as they forged their own paths toward success. Thomas Ince (1882-1924) was one of them. He shared Griffith's background as an unsuccessful stage actor who had accidentally stumbled into the medium that would enable him to make his fortune. Unlike Griffith, however, Ince was highly organized and had a strong sense of business. He had twice constructed his own studios, and gradually fudged the lines between directing and producing, as he was seemingly adept at both. The early French critic Louis Delluc made the following distinction between Ince and his hero: "Griffith is cinema's first director. Ince is its first prophet."

Like the Ford brothers, who starred in a number of his films in the 1910s, Ince was from New England. This, however, did not prevent him from having a natural affinity for Westerns, film's most authentically American genre. To solidify his connection to the West, he even bought 20,000 acres of California real estate surrounding his Inceville studio. I find it interesting that all the great silent movie cowboys — Harry Carey, William S. Hart, and Tom Mix — were also born in the Northeast. (Carey and Hart now reside in New York City cemeteries.) It was almost as if the American vision of the West had been waiting for the invention of film.

Custer's Last Fight (1912) was made only thirty-six years after the actual event, and in this film Ince strove for an epic quality and almost documentary authenticity. As I wrote in my book, *The Western Film*: "Although Custer is not as heroically dashing as Errol Flynn in *They Died With Their Boots On* (1941), Sitting Bull is portrayed as cowardly. The photography and the use of space clearly anticipate [John] Ford's cavalry films… Sitting Bull's career is followed until his death in 1890 with a considerable degree of historical accuracy. We see the monument to Custer at the Little Big Horn, and in a flashback (not unlike the closing shots of Ford's *Fort Apache*), we see Custer alive again, fighting to his glorious death."

On the very next page, I refer to Cecil B. De Mille (1881-1959) as the "Buffalo Bill of movie directors." This is a reference to the broad popular appeal that De Mille sought — and generally achieved — through showmanship and hoopla. Although he started his career with Westerns and intermittently returned to the genre, he had no genuine commitment to them or to their authenticity. He instead was invested in exploiting subjects as divergent as the circus, ancient history, and the Bible, and in mining his material for sensationalism and sex. With rare exceptions such as *King of Kings* (1927), De Mille was a master at creating superficial entertainment with little artistic pretension. A few of his

early films, such as *The Cheat* (1915) and *The Whispering Chorus* (1918), do have an interesting look about them, but De Mille seemed to realize that his gift lay more in spectacle and high production value than in cinematic innovation. *The Cheat* was spectacular in its own way, and helped launch Sessue Hayakawa's ascent to stardom, but it also exploited the taboo sensationalism of racial mixing by presenting a portrait of perversity and corruption. For all his self-proclaimed righteousness and religiosity, nobody ever accused De Mille of having much of a social conscience, especially if there was a buck to be made.

Marshall Neilan and King Vidor

Marshall "Mickey" Neilan (1891–1958) is an archetypal example of squandered talent. He managed to cling to a twenty-plus-year directorial career before giving in to the allure of alcohol. (Several of the most talented directors suffered from this problem, but some, such as John Ford, seemed to control it by generally restricting benders to between-film breaks.) Blanche Sweet, who had the "honor" of being married to Neilan, and who acted under him in *The Sporting Venus* (1925), told me a horror story of coming home to her brand-new house and finding Mickey, John Barrymore, and other pals competing to see who could spit the most tobacco onto the ceiling. The "boy wonder" was essentially unemployable for the last twenty years of his life.

Amarilly of Clothes-line Alley (1918) is one of several films Neilan made with Mary Pickford, the Canadian who became "America's Sweetheart." Both actress and director began their careers under the tutelage of D. W. Griffith, and Neilan and Pickford's best collaborations resemble some of Griffith's more charming but less ambitious work. Mary may not have been able to plumb the depths of emotion that Lillian Gish or Greta Garbo could, but she was enormously popular with silent-movie audiences, and her fabled marriage to Douglas Fairbanks set a precedent for Hollywood royal couplings that has continued through Elizabeth Taylor and Richard Burton and Angelina Jolie and Brad Pitt. Sadly, Mickey Neilan got left in the dust. His last film appearance was a minor role in Elia Kazan's *A Face in the Crowd* (1957), and by then he was little more than that.

King Vidor (1894–1982) began his film career as a young boy, photographing hurricanes in his native Galveston, Texas. He went to Hollywood in 1919 to direct cheap independent films, of which *The Jackknife Man* (1919) is the most notable. From 1925 on, Vidor was one of America's leading directors. As early as *The Jackknife Man*, it is evident that Vidor had a special empathy that he was able to convey through images. He also had an experimental streak that makes films like *The Big Parade* (1925), *Hallelujah* (1929), *Street Scene* (1931), *Our Daily Bread* (1934), and several of his later quasi-Gothic romances seem almost avant-garde.

The Jackknife Man provided me with one of those rare moments that a film archivist hopes for but almost never experiences. The film is about a young waif, played by Bobby Kelso, who is adopted by an old "primitive" artist, played by Fred Turner. I had been impressed and deeply moved by the film when MoMA acquired it around 1972 for our King Vidor retrospective, my first full-scale curatorial venture. One day, I got a phone call from a gentleman who inquired as to whether we had *The Jackknife Man* and if he could see it. His name was Bobby Kelso. So, some sixty years later, I was able to show him the film he had made as a boy. Vidor and Charlie Chaplin eventually became close friends. I don't know whether Chaplin saw Vidor's film before he made *The Kid* (1921) with Jackie Coogan, but I like to think it possible.

Raoul Walsh and Maurice Tourneur

The career of Raoul Walsh (1887–1980) represents the flip side of that of Mickey Neilan. Both were rakish protégés of D. W. Griffith, but Walsh had the self-discipline and instinctive artfulness to manage a fifty-year directorial career. Although he worked in various genres, *Regeneration* (his first important film, made in 1915) speaks to his special facility with "gangster" films and the tragic destinies of their heroes. Three of his best films, *The Roaring Twenties* (1939), *High Sierra* (1941), and *White Heat* (1949), also fall into this category. His auteurist personality was not always universally appealing. He had a penchant for sophomoric humor, as exemplified in his two sequels to *What Price Glory?* (1926), his fine adaptation of Laurence Stallings's Broadway hit, which paired Victor McLaglen and Edmund Lowe.

AMARILLY OF CLOTHES-LINE ALLEY. DIRECTED BY MARSHALL NEILAN. 1918. USA. BLACK AND WHITE, SILENT, 67 MINUTES.

Although not as important as John Ford or Howard Hawks, Walsh has an honored place in the history of Westerns. *In Old Arizona* (1928) is the first talkie shot largely on location, and *The Big Trail* (1930) is spectacularly inventive in its use of an experimental widescreen process. Walsh worked productively with everyone from Humphrey Bogart to Mae West, and, of course, he discovered John Wayne. Happy endings were not requisite for Walsh, and he even waxed lyrical over the massacre of Custer in *They Died with Their Boots On* (1941). Walsh was an archetypal example of a studio director who took all kinds of assignments and managed to mold them into personal statements. Hollywood filmmaking would have been much poorer without him.

In the 1970s, MoMA held a Walsh retrospective. While I was not its curator, I did have the opportunity to shepherd him around a bit while he was visiting. This was kind of poignant, as he was unwilling to acknowledge that he had gone blind. Walsh was extraordinarily dapper and concerned with his appearance, sporting a trim moustache, a cowboy hat, and riding boots. There was an in-house luncheon attended by, among others, his former star and sometime paramour Gloria Swanson, who came equipped with a parasol and a bag of nuts and berries, determined to avoid the poisonous fare being served to other guests. Ever gallant, Walsh made a point of complimenting Gloria on her appearance. Lest one be inclined to feel sorry for him at his advanced age, his behavior at the Warwick Hotel (once owned by another of his stars, Marion Davies, a gift from William Randolph Hearst) Walsh left no doubt that he hadn't fully succumbed to geriatric manners. His nurse reported that he had tried to pull her into the tub as she was giving him a bath. "Regeneration" has many meanings.

Maurice Tourneur (1876–1961) had what amounted to several careers. After apprenticing to Auguste Rodin, he became an actor, and then entered film in 1911 at an advanced age. He spent World War I working for the Éclair Company and eventually went on to moonlight for a number of other film studios in New Jersey. Many of his early directorial works (such as *The Blue Bird*, 1918) were highly stylized fantasies that were pictorially ahead of their time and indebted to Georges Méliès. Tourneur was also indebted to his gifted designer, Ben Carré, and his editor, Clarence Brown, who became a leading director at MGM. Following a falling-out over his adaptation of Jules Verne's *The Mysterious Island*, Tourneur returned to France in 1926. The films he made in Europe were a bit more conventional. His last silent work was *The Ship of Lost Men* (1929), which starred Marlene Dietrich, although she always insisted she made no films before *The Blue Angel* (1930). He continued to make films under the Vichy government and was active in administering the film industry during that period. His *Volpone*, made in 1941 on the eve of World War II and starring Harry Baur (who would soon die mysteriously after interrogation by the Gestapo), is the only sound film of Tourneur's in the MoMA collection. His son Jacques came to America in the mid-1930s and became a prominent director in the 1940s, having inherited some of his father's flare for visual expressiveness.

Send in the Clowns
Mack Sennett / Mabel Normand / Roscoe "Fatty" Arbuckle

First, I should acknowledge my personal prejudice against slapstick. I believe that Charlie Chaplin and Buster Keaton rose to the heights of screen comedy by distancing themselves from Mack Sennett, Mabel Normand, and Roscoe "Fatty" Arbuckle. The philosophy of "anything for a laugh" — evident in most of Mel Brooks's films and the early works of Woody Allen — seems incongruous to me if we are talking about "Art." I won't even dignify the Three Stooges or Abbott and Costello with a mention. (So, kindly disregard that mention.) Seriously, though, I have always sought out some kind of logical structure, character development, or visual invention when determining the worthiness of a film. This doesn't mean that I am incapable of laughing at silly antics, and I fully acknowledge that some of the greatest moments of Keaton and Chaplin can be painfully unfunny. There is an imaginary line in what's left of my brain that makes me distinguish between entertainment for its own sake and art.

Mack Sennett (1880–1960), another D. W. Griffith disciple, established the Keystone Studio in 1912, and the great clowns flocked to him. It is legitimate to consider him an auteur, although I would not want to risk a custard pie in the face or a sudden de-pantsing by getting too close to him in character. Even when he was only nominally the director, Sennett's films reflect his managerial personality. He remained active through 1935, but I challenge anyone to cite a near-great film that he made. His gift was in providing a haven for ambitious young talent.

Among these talents was Mabel Normand (1894–1930), one of the first women to perch behind the camera, and the cinema's greatest comedienne prior to the rise of the equally lovely Marion Davies. I think it's probably pointless to argue that she had a directorial style or a feminist bent that differed from Sennett, although I know of scholars trying to do just that. As with her compatriot, Roscoe "Fatty" Arbuckle, Hollywood's overreaction to scandal ruined her career and hastened her death. All of Hollywood was on trial at the time, and in spite of gallant efforts, Normand could not avoid the perception that she was a drug addict.

"Fatty" Arbuckle (1887–1933), had the distinction of mentoring both Chaplin and Keaton in addition to making his own films. As I suggested in 2006 during the Museum's Arbuckle retrospective, Fatty's persona as the "jolly fat man" constrained him from being something more than that, but it also made him lovable to a loyal following during the 1910s. By contrast, the conventionally good-looking Chaplin and Keaton aspired to roles that were more promising, and were ultimately able to transcend slapstick.

Send in the Cowboys
John Ford and William S. Hart

At the start of his career, twenty-three-year-old John Ford (1894–1973) embarked on a series of Westerns starring Harry Carey as Cheyenne Harry. Of these, *Straight Shooting* (1917) was the first. Carey was a more natural actor than his rivals, fellow Western stars William S. Hart and Tom Mix, and Cheyenne Harry was a gallant but unglamorous saddle tramp, not unlike the character John Wayne would play four decades later in Ford's *The Searchers* (1956). The films salvaged Carey's waning career (he had worked for D. W. Griffith and appeared in *The Battle at Elderbush Gulch* in 1913), and Ford became the most promising director on the Universal lot.

In technique, acting, and content, *Straight Shooting* shows a strong Griffith influence. Yet many of the compositions are sui generis in their exquisite symmetry and lighting, and compare favorably to Ford's much later work. He was a natural. Reviews of Ford's Universal films frequently commented on their extraordinary photography and use of locations. The plots seemed to resemble Hart's simplistic Westerns, but they lacked his oppressive moralizing and concentrated more on vigorous action.

"Gentlemen: I am enclosing a list of films which I own. In your search for pictures for your library, would they interest you?" With this brief hand-written note, dated January 22, 1936, William S. Hart (1865–1946) offered the fledgling Museum of Modern Art Film Library its first major donation, which included all the actor's surviving film material. (Douglas Fairbanks and Griffith would follow suit.) Six years later, writing to curator Iris Barry from his Horseshoe Ranch, the seventy-two-year-old Hart waxed poetic over the prospect that his films would be preserved for future generations:

"Oh! What a thrill it gives me… Oh! dear lady how high my heart leaps (?) to know that these pictures will always be seen in their simplicity and bigness of nature. Just as they were and just as they are – Those pictures that I gave my very being to breathe the breath of life into, will still live!"

And so, the Museum has *White Oak* (1921) and several dozen other films by Hart, all pieces cut from a tapestry, the likes of which no longer exist. In spite of his romantic sensibility, Hart's films strove for authenticity. His passion for realism gives these films credibility, no matter how unlikely their plots or how theatrical the acting. *White Oak* was nominally directed by the journeyman Lambert Hillyer and was photographed by Joseph August, who would begin a fruitful collaborative relationship with Ford four years later, culminating in the great World War II epic *They Were Expendable* (1945). August began working with Hart in 1917. In those days, Hart accepted credit as director, although there was never any doubt even in his later career that he, like Douglas Fairbanks or Buster Keaton, was an auteur. In some instances "nominal" directors were credited in his films, but it was always clear who the real author was. Both Hart and August deserve credit for the extraordinary photography in such films as *Shark Monroe* (which the Museum has beautifully restored) and *The Tiger Man*. The expressionist lighting in these 1918 Westerns clearly anticipates the German experiments of the 1920s.

In his autobiography, *My Life East and West*, Hart writes, "To those who claim superiority of race – the white over the red – I can only say, 'Arrant drivel.' " Yet his films, and in particular *White Oak*, do have racist overtones. A *New York Times* reviewer found it absurd that Hart singlehandedly defeats the Indians, a moment referred to in a title-card as "brown death." Hart's early success, *The Aryan* (1916), climaxed with a renegade white man remaining true to his racial heritage. It is, of course, unfair to ask major film artists of other eras to live up to contemporary standards. (Ford, who killed off a multitude of Indians in his films, lived long enough to try to belatedly compensate with *Sergeant Rutledge*, 1960, and *Cheyenne Autumn*, 1964). Hart's films have an ineffable beauty to them that links us to our past. Not all of our past is attractive, but it is inescapably ours. Perhaps it is best to think of Bill Hart as a medieval chevalier with an archetypal face and a grand stage manner – D. W. Griffith on a horse – who, true to his own beliefs, rode to the rescue of Westerns and Western civilization.

Abel Gance's J'Accuse 1919

Over the course of film history, there have been directors who chafed at the restrictions the medium seemed bound to. D. W. Griffith established a revolutionary but enduring film grammar and enjoyed enormous success (although his legacy is tainted by the subject matter of films such as *The Birth of a Nation*). This encouraged him to envision the film fugue, and he went on to make *Intolerance* (1916), which was too advanced for its time, too far outside the envelope for audiences to comfortably comprehend. Griffith, however, was wily enough to get over his bitterness and he returned to the kind of narrative that had worked for him before, making most of his best films in the ensuing decade. Similarly, men like Sergei Eisenstein and Orson Welles started their careers in their mid-twenties with a flourish of innovation but became tamer, although no less creative, as time went on. Josef von Sternberg's flame largely burned out after a decade of highly personal filmmaking, and Erich von Stroheim never quite got the hang of balancing commercial realities with big ideas. Stanley Kubrick's planet-shaking *2001: A Space Odyssey* (1968) remains a sort of anomaly in an otherwise creditable but mixed career. A more recent maverick is, of course, James Cameron, whose enormous box office successes with *Titanic* (1997) and *Avatar* (2009) have made him somewhat immune from restraints.

Perhaps the leading exemplar of thwarted ambition is Abel Gance (1889–1981), an actor-turned-director who began making films in 1911. Some of his early work was in the fantastical tradition of Georges Méliès. After some two dozen films he made *J'Accuse*. This strange but forceful indictment of the folly that led to World War I made Gance into France's most serious director and emboldened him to consider the limitations and untapped possibilities of the medium. After shooting *La Roue* (1923), Gance visited Griffith in America and then spent the next year re-cutting his film with Griffith's techniques. The final film ran a reputed eight hours and anticipated the debut of Eisenstein and Soviet montage by two years. Understandably, Gance began to develop the reputation of being part genius, part madman.

His next project, *Napoleon* (1927), was perhaps a peculiar subject for an ardent pacifist. What survives of Gance's masterpiece is a film that would surely make Griffith or Cameron envious. The director seems to have had unlimited resources. It is a colossal movie, embroidered with startling effects: the frame splits into

BROKEN BLOSSOMS. DIRECTED BY D. W. GRIFFITH. 1919. USA.
BLACK AND WHITE, 90 MINUTES.

multiple facets, it made use of mobile aerial cameras
not unlike those now used for television coverage of
sporting events, and there is a famous three-screen climax.
Intended as the first of a six-part series, the surviving
film is a monument to both Gance's vision and its
overextension. The original premiere was at the Paris
Opera House, and I had the privilege of being present at the
Radio City Music Hall screening in 1981 when the aged
and ailing Gance called in from Paris.

At the helm of *Napoleon* Gance had been like a
general directing a splendid army on the battlefield. By the
1930s, and with the coming of sound, the director struggled
to retain his stature. His 1935 film *Lucrece Borgia* was a
success in France, but it seldom rises above being a
commercial confection, an Alexander Korda-like spectacle
spiced with Cecil B. De Mille salaciousness. The scenes
involving Antonin Artaud's Savanrola and a burning at the
stake are evocative of Carl Theodor Dreyer or Eisenstein,
and there also seems to be explicit borrowing from
Rouben Mamoulian's *Queen Christina* (1933). Gance went
on to make a dozen films, including a remake of his silent
J'Accuse, but none approached his early greatness. Like
Griffith, he found that the times and the cinema had grown
too small for his particular genius.

D. W. Griffith on a Smaller Canvas 1919

Although D. W. Griffith's racism was unforgivable,
nothing can ever take away the fact that he was the most
gifted and creative director of the first thirty years of
cinema. Writing about Louis Armstrong in *The New
Yorker*, John McWhorter observed that Armstrong's early

78-rpm recordings "were as crucial in creating our modern musical sensibility as D. W. Griffith's films were in creating the grammar of cinematic narrative." McWhorter goes on to say that "while performers around [Armstrong] assimilated his innovations, he never really grew." One might argue that this was also true of Griffith, and not simply because he lost his independence in the final decade of his career due to changing public tastes and his lack of business sense. Griffith never quite developed beyond the nineteenth-century stage melodramas on which he had been weaned. America had changed in ways he had not. However, his greatest gift never failed him, and that was his skill with actors.

Broken Blossoms (1919) is Griffith's great and somber tragedy, his Limehouse *Romeo and Juliet*. The short story it is based on, Thomas Burke's "The Chink and the Child," is about a young Chinese man who falls in love with a white girl. The film is narrated primarily from the point of view of the "Yellow Man," played by Richard Barthelmess, who Griffith romanticizes. With Griffith's assistance, Lillian Gish fleshed out the fragile, waifish character of Lucy with a myriad of human touches, and the resulting child-goddess is an exquisite creature who shatters all barriers between artifice and reality. As Burke put it, "she was a poem." We believe in Lucy – and in *Broken Blossoms* – simply because they exist before our eyes. It is all the more extraordinary given that there was little in Griffith's career (or in anyone else's) that had laid the groundwork for such soulful poetry. *Broken Blossoms* stands alone as a work of lyric genius in which technique is virtually invisible.

Both Richard Barthelmess and Gish bring to their roles sensitivity commensurate with the style and subject of the film. The brutish excesses of Donald Crisp, who plays Lucy's father, lend even more grace to the actors' portrayals. Lucy is such a forlorn creature that she must manipulate her mouth with her fingers to force a smile. The poetic intertitles, largely borrowed from Burke's text, do not approach the eloquence of her disbelief or her twittering delight at the man's kindness. Because the film features only three main characters, Gish is allowed to perform with far greater subtlety than in any of her previous roles.

The film's pace is leisurely, and the midsection is a plotless study of two of the most gifted faces that cinema has given us – and of each studying the other. This cloistered interlude of love will soon be horribly destroyed, but only after we have had the privilege of seeing how two people alone in a small space can communicate expressively without a single word. This is the essence of silent art, and it is seldom presented more gloriously than in *Broken Blossoms*.

In 1919 Griffith also released a trilogy of small films that, taken as a whole, provide a celluloid record of the imprint that a Kentucky childhood left on his soul. These three works are built around a Gish character that was richly unsophisticated and ornately simple. Never was she more endearing or more sublimely suited to her roles than in these films.

In *A Romance of Happy Valley*, *True Heart Susie*, and *The Greatest Question*, Gish's little girl manages to be more worldly and wise than Bobby Harron's young man by adhering to the old-fashioned values in which Griffith believed – but which conflicted with the director's ambition and lifestyle. Living in Hollywood as the most honored master of the most popular art form in human history was not in harmony with Griffith's idealization of life back on the farm. These films signify his gnawing realization that he would never be truly comfortable amongst the city slickers who kept the accounts and who gradually came to own slices of his soul. These rural romances represent a yearning after the lost illusions of his youth; they were the secret stories he told himself in the private moments of the night. They are art of a different kind than his epics, more personal testaments to what might have been.

Gish's acting in these films depends more on gestures than facial expressions, and there is a tender delicacy in her scenes with Harron. Coy kisses mask the ferocity of patient commitment. Humor conceals vulnerability, and love is a lifelong statement that precludes all else. Because it is uncontaminated by plot complexities, *True Heart Susie* is the best of the trio. It is a lyrical ode to simplicity and plainness, and Gish, having the least plain of female faces, persuades us out of our senses. Like all screen magic, it is inimitable and indescribable. I can only suggest that part of the secret may lie in Gish's ability to play the character simultaneously tongue-in-cheek and with supreme naturalistic precision, something akin to what Marlene Dietrich would later achieve for Josef von Sternberg. *Susie* allows Gish to be comedienne and tragedienne, incorporating both skills into one of the sweetest and most moving performances ever committed to film.

1920-1929

Erich von Stroheim's Foolish Wives 1922

The name Erich von Stroheim (1885–1957) generally provokes one of two reactions: he is either a great genius done in by imbecilic studio executives, or a self-immolating martyr who succumbed to his own inflated ego. Although the truth obviously lies somewhere in between, I'm not sure exactly where. Stroheim's life and career are wrapped in several overlapping enigmas that further confuse matters. The first is, indeed, the self-created myth of his identity.

Not content to be descended from Jewish merchants, Erich declared himself Austrian nobility and gave the name Erich Oswald Hans Carl Maria von Stroheim upon disembarking from the *Prince Friedrich Wilhelm* at Ellis Island in 1909. Certainly, a professional storyteller can be forgiven a certain degree of fabrication, and his "nobility" became an asset in lending authenticity to his celluloid exposes of European nobles — characters he sometimes played himself, such as in *Foolish Wives*, in which he plays a malevolent seducer and count. "Chutzpah" is, after all, not a four-letter word, even in Yiddish. Yet pseudo-authenticity became a mania, and at one point Erich even insisted that the undergarments of his actors conform to standard-issue Hapsburg attire. What was a studio executive to do? Reading Cari Beauchamp's account of Stroheim's antics on the set of the unfinished *Queen Kelly*, one wonders how he shot any film before the producers stepped in and figuratively ripped it to shreds. *Queen Kelly* was never finished, but what survived was later released essentially for scholarly purposes.

I find it hard to understand how Stroheim developed his reputation for realism when so many of his characters are, to borrow Andrew Sarris's phrase, "grotesque gargoyles." In *Greed* (1924), for example, many of his hideous men and women seem as if they would be more at home in a *Star Wars* saloon tossing one down with Han Solo and a Wookie than in pre-earthquake San Francisco. I am also puzzled by arch-humanist Jean Renoir's early enthrallment with the director, and particularly with *Foolish Wives*. Renoir made his 1926 version of Zola's *Nana* to honor Stroheim, and, of course, made him the star of *Grand Illusion* (1937). Whatever his virtues (and we'll come to those) Stroheim seems to be operating in a universe parallel to Renoir's.

As Richard Koszarski points out in his excellent *The Man You Loved to Hate: Erich von Stroheim and Hollywood*, the director's debut *Blind Husbands* (1918) burst on the scene like no other first film before *Citizen Kane*. (Stroheim's original title was *The Pinnacle*, and an apocryphal story holds that Universal boss Carl Laemmle changed the name because "there ain't no pinochle in it.") Set in Europe and focused on seduction and the specter of infidelity, the film opened up the screen to more explicit "debauchery" than had been permissible in the pre-war era, and led to a more Europeanized American cinema. Koszarski cogently suggests that "in the work of no other great director are autobiographical elements so crucial, and such elements are stronger than usual in *Blind Husbands*." I'd hold out for Charlie Chaplin, and I question whether Stroheim

tried to be as wicked as the characters he played, even as they shared his penchant for seduction. Scholar Cullen Gallagher has suggested that after all the critical attacks on Stroheim's films, "what remains is a coherent work unified by its global immorality and ritualistically debased virtue, all centered around von Stroheim's strong, nefarious presence that is unmistakable and immutable."

Stroheim never seemed to learn that filmmaking was a medium financed by people much more concerned about making a profit than making art, and time and time again he seemed to flagrantly violate whatever trust was put in him. Eventually, he lost all support, and he spent his last quarter-century acting and sometimes forced to parody his own image.

(We owe thanks to Arthur Lennig for the painstaking work of salvaging as much as could be salvaged of *Foolish Wives*. Art, now a retired professor living in Albany, used to visit the Museum on a regular basis. One of his signature stories is about how a derelict Bela Lugosi, broke and ravaged by addiction, showed up on his doorstep one day in belated response to fan letters he had written the actor decades earlier. Be careful who you admire.)

Nothing written here should be interpreted as an outright dismissal of Stroheim. He may have been the best of those who were tutored directly by D. W. Griffith. He was certainly an auteur: he was innovative, his films betrayed a beauty beneath their frequent squalor; and, as Sarris has suggested, his style anticipated the coming of sound. One wishes he had had more opportunities to make films and could have finished and preserved the films he was able to make. Yet one also wishes he had been a little more shrewd and pragmatic. Greater artists than Stroheim — such as John Ford, Alfred Hitchcock, Howard Hawks, Ernst Lubitsch, and Fritz Lang — were able to play the studio game and emerge triumphant. For whatever reason, Erich von Stroheim was not.

The Chaplin Revue
A Dog's Life 1918 / Shoulder Arms 1918 / The Pilgrim 1923

I've written more about Charlie Chaplin (1889–1977) than about any other filmmaker (including in my book *Charles Chaplin: An Appreciation*) and I'm not exactly sure where to begin now. Certainly, he is the auteur's auteur, having had incredible freedom to visualize on celluloid whatever he dreamed or imagined. This was the lucky consequence of being the most famous artist in the world, which allowed him to purchase his own studio, rehearse endlessly, and show his audience only that which he considered to be up to his standards. The great Jean Renoir said: "the master of masters, the film-maker of film-makers, for me is still Charlie Chaplin." Given the opportunity to meet Chaplin, Renoir rhapsodized, "it was like inviting a devout Christian to meet God in person." René Clair said that even though Chaplin had little direct influence on the cinema, he was so "profoundly original" that without him, "*we* would not have been altogether the same people we are today." I share many of these feelings.

"Feelings," is, of course, the key word in evaluating Chaplin's art. Clearly, he was a skilled director, always knowing where exactly to place his camera, as cinematographer Néstor Almendros told me. And clearly no other director tackled the great issues of the time — war, mechanization, poverty, fascism, nuclear weapons, McCarthyism, old age — more directly or with greater passion. When all is said, however, the heart of Chaplin's genius was his acting, and he had no genuine rival when it came to intensity or depth of performance. As Andrew Sarris said, Chaplin's face was his mise-en-scène. D. W. Griffith could extract superlative performances from actors, and he fully understood film's power to engage its audience emotionally, but not even he could match Chaplin's ability to move us, to involve us completely with experiences and thoughts, and as Clair put it, to be "our friend." As much as Griffith empathized with his actors, that was nothing compared to Chaplin's ability to both direct and star in a film at the same time. He was helped enormously by the fact that he appeared as essentially the same character in all but his last four films. Of those, *Monsieur Verdoux* (1947), *Limelight* (1952), and *A King in New York* (1957) are as autobiographical as any works by a major director. By the time he stepped out of the Tramp character for good at the end of *The Great Dictator* (1940), our "friend" had become our lifelong companion.

In order to grasp Chaplin's importance, one must see the films. His methodology, technique, theories, whatever, cannot be taught. He was inimitable, and we will never see anyone like him again. His growing command of film can be seen in the shorts that he made in his late twenties for the Keystone, Essanay, and Mutual studios, but it is only in his longer works that we

see him surpassing the stamp of genius. *Shoulder Arms* and *A Dog's Life* mark a turning point. The former is a film as funny as any comedy about that least funny subject: war. In the latter, Charlie mistakes a man's crying for laughter, which seems fitting, as his whole life and career are a commentary on the frail membrane that separates the two.

In *The Pilgrim*, the Tramp is an escaped convict masquerading as a preacher. There is something almost self-deprecating in an extraordinary tracking shot in which a naughty boy knowingly looks at the camera and then throws a banana peel in the path of Charlie and the fat deacon, played by Mack Swain. Of course, both obligingly slip and fall, and it is even funnier for our having anticipated it. However, by making the boy acknowledge the camera and, hence, our presence, Chaplin seems to be telling us that pratfalls are now too easy for him — he must move on to bigger things.

Chaplin famously defied the coming of the talking picture by continuing to make silents a decade into the sound era. However, *City Lights* (1931) and *Modern Times* (1936) did have musical soundtracks that Chaplin composed. While his scores might not be up to classical standards, they have become an integral part of these films. They are totally idiosyncratic and, yes, Chaplinesque. Later, he added his music to his earlier work, including his 1959 compilation of three films, *The Chaplin Revue*.

Chaplin withheld his films after his exile to Switzerland in 1953, and their re-release in the early 1960s was a life-changing experience for me.

Buster's Planet
Our Hospitality 1923 and Sherlock, Jr. 1924

Joseph Francis "Buster" Keaton (1895–1966) began appearing in his family's vaudeville act at the age of three. Charlie Chaplin made his first stage appearance at five. Psychologists have had a field day tracing all kinds of problems in two of the cinema's greatest comedy stars back to their unusual childhoods. The fact may be, however, that they simply loved to perform and make people laugh. Buster, whose nickname has been attributed to Harry Houdini, followed in Chaplin's footsteps and started making films in 1917 under the tutelage of Roscoe "Fatty" Arbuckle.

Keaton produced his own shorts between 1920 and 1923, resulting in gems like *One Week* (1920), *The Playhouse*, *The Boat* (both 1921), *Cops*, *The Electric House* (both 1922), and *The Balloonatic* (1923). In these films, he would play the role of the "Great Stone Face," unperturbedly triumphing over a universe in which inanimate objects and natural elements were stacked against him. Keaton's acting fit his roles, yet he never soared to the emotional levels of Chaplin. While Chaplin worshipped his heroines, Keaton comes across as borderline misogynistic. While Chaplin's world is rooted in naturalism, Keaton's has a sense of wonder and magic to it. In these early shorts, his fascination with machines is evident, and particularly with what he considered the most important machine, cinema. Chaplin's films were rarely experimental — the dream sequence in *The Kid* (1921) being an aberration — but Keaton pushed the cinematic envelope from the moment he stepped behind the camera. Defenders of the avant-garde rarely look toward Hollywood, but if they did, they might find him ruling over their pantheon.

Although Keaton made two features before *Our Hospitality* (1923), that was his first sustained masterpiece. A charming evocation of rural antebellum life, the film reveals the twenty-seven-year-old Keaton to already be a mature and gifted director. Up until that point, no other American filmmaker in his twenties had shown the promise displayed by *Our Hospitality* (and *Sherlock, Jr.*, which came out the following year). *The General*, released three years later, is as precise and perfectly made a film as any I can think of. If it were not for the extraordinary athleticism he shows in the film, one might easily forget how young Keaton was.

Orson Welles was later to call movies "ribbons of dreams," and depictions of dreams in film date back to Alice Guy-Blaché, Georges Méliès, and Edwin S. Porter. Dream sequences would play key roles in innumerable Hollywood films, including Hitchcock's 1945 thriller *Spellbound*, which was designed by Salvador Dalí. Keaton's *Sherlock, Jr.* not only anticipated this, but also laid the groundwork for films as divergent as Harry Hurwitz's *The Projectionist* (1971) and Woody Allen's *The Purple Rose of Cairo* (1985). In *Sherlock, Jr.*, Keaton is a conscientious projectionist who falls asleep on the job. As the film progresses, he steps into the screen in a spectacular metaphor for entering the alternate reality of cinema itself. The film poses the question: does art imitate life, or does life imitate art? And what prompted a young unschooled clown from Kansas to raise such questions?

SHERLOCK JR. DIRECTED BY BUSTER KEATON. 1924. USA.
BLACK AND WHITE, SILENT, 45 MINUTES.

The Lubitsch Touch

Ernst Lubitsch (1892–1947) was more responsible than any other filmmaker for bringing a continental flavor to the largely Anglo-Saxon world of American cinema. Although Erich von Stroheim preceded him, the Austrian's obsessions were too outré to be fully integrated into the Hollywood sensibility. Lubitsch was also fixated on European subjects and locales, but his broad humanism and sense of comedy resonated with Americans in ways that Stroheim's esoteric naughtiness did not. Stroheim returned to Europe after World War II; Lubitsch died a Hollywood insider.

Lubitsch's journey from his hometown of Berlin took a few atypical turns. Beginning in 1914 he directed himself in several crude comedies that emphasized Jewish stereotypes. Some of his more sophisticated satires (*The Oyster Princess, The Doll*, both from 1919; *Romeo and Juliet in the Snow*, 1920) hold up well and reflect Lubitsch's stage training with Max Reinhardt. His ersatz D. W. Griffith spectacles like *Madame DuBarry* (1919) and *Anna Boleyn* (1920) first gained him notice in America, and Mary Pickford brought him to Hollywood to do the costume drama *Rosita* (1923), which she subsequently tried to destroy. Fortunately, Warner Brothers signed him to a contract that resulted in a series of adult comedy/dramas, of which *The Marriage Circle* (1924) and *So This Is Paris* (1926) are representative.

Charlie Chaplin, during the height of his fame as the Tramp, decided to make a film in which he gave himself only a brief cameo. *A Woman of Paris* (1923) was a serious melodrama about an innocent country girl caught up in romantic intrigues in Paris, and it was praised for its subtlety and sophistication. The film made an enormous impact on Lubitsch. American audiences had seldom experienced stories of marriage and adultery in which women were allowed to operate on a more-or-less level playing field. Prior to this, heroines had been

largely represented as wily yet vulnerable childwomen portrayed by actresses such as Lillian Gish and Mary Pickford, or as unscrupulous vamps. Lubitsch presented the possibility that women were just women, with needs and intellects that corresponded to those of men. Although *The Marriage Circle* (1924) handles its subject matter with deftness and delicacy, scholar Greg S. Faller has pointed out that there is a superficiality (endemic to the period) in Lubitsch's threat to the status quo. He summarizes it as follows: "An essentially solid relationship is temporarily threatened by a sexual rival. The possibility of infidelity serves as the occasion for the original partners to reassess their relationship... The lovers are left more intimately bound than before." Yet all this is presented with a visual panache that came to be called the "Lubitsch touch."

Of all the great directors, Lubitsch is perhaps the least remembered for imagery. Although he drew upon master studio set-designers to create palatial environments for his human dramas, he had practically no concern for visual effects, landscape, spectacle, or many of the other qualities we often describe as "cinematic." His gifts lay elsewhere. Lubitsch, in league with Maurice Chevalier, rescued the musical from the vulgarities of Al Jolson and the studio-promoting vaudeville reviews that proliferated in the early days of sound. In the 1930s, he was responsible for some of the most enduring romances ever produced, including *Trouble in Paradise* (1932), *Desire* (a 1936 film produced by Lubitsch and directed with luxuriance by Frank Borzage), *Angel* (1937), *Ninotchka* (1939), and *The Shop Around the Corner* (1940).

F. W. Murnau's The Last Laugh 1924

Friedrich Wilhelm Murnau (1888-1931) had already made over a dozen films before *The Last Laugh*, but only *Nosferatu* (1929) made any blip on the international scene. *Nosferatu* was released in America seven years after it was came out in Germany, and when it finally opened in the wake of *The Last Laugh*, *Tartuffe* (1925), *Faust* (1926), and *Sunrise* (1927), it received a condescending review in *The New York Times*. But before that, few were prepared for what may be the best film ever made by a German in Germany.

The style of *The Last Laugh* is derived from the *Kammerspiele*, an intimate approach to theater

introduced by the great stage impresario Max Reinhardt, of whom Murnau was a disciple. Reinhardt's theater, which featured chamber dramas about lower middle class life, was dimly lit and the audience was placed close to the stage so actors could perform with greater subtlety. Lotte Eisner, the doyenne of film scholarship of the Weimar era, makes the point that Murnau's achievement lay outside developing the Expressionist techniques that had come to dominate German cinema by 1924. She contends that Murnau's moving camera "is never used decoratively or symbolically," and that each movement "has a precise, clearly-defined aim." (Whatever his rationale, Murnau's long takes and mobile cameras set a standard for future masters such as Kenji Mizoguchi and Max Ophüls, and these techniques were also developed into a counter-theory to the montage theory postulated by Sergei Eisenstein and the Soviets. One of Orson Welles' great achievements was to synthesize these two approaches.) According to Eisner, Murnau's use of "opalescent surfaces streaming with reflections, rain, or light... is an almost impressionistic way of evoking atmosphere." She also suggests that the supposed ponderousness of *The Last Laugh* is a way of lending gravitas and significance to what is, ultimately, a trivial event: the demotion of a doorman to a men's room attendant.

It is all thoroughly German. Although *The Last Laugh* has a tacked on "happy ending," the dominant feeling — as in so much of Murnau's work and in Weimar cinema in general — is one of foreboding. I won't go so far as to credit Siegfried Kracauer's idea, put forth in *From Caligari to Hitler*, that German films of the 1920s and early 1930s show the inevitability of the Nazis, but there was certainly a pervasive pessimism underlying all the frolic that made Berlin the fun capital of Europe during those years. One can find it in the paranoia of Fritz Lang and in the cynicism of G. W. Pabst, and one can certainly find it in the perversity and bestiality of *Nosferatu*. Murnau was also a closeted homosexual, and although the bohemian Berlin art scene was a relatively safe place at the time, this must have been a psychic burden to anyone born eighty years before the international gay rights movement which arose from the Stonewall revolt.

Due credit must be given to Emil Jannings, who gives (for once) a restrained and moving performance. Jannings later enjoyed a brief Oscar-winning turn in Hollywood, and dragged the Jewish Josef von Sternberg to Berlin to direct him in *The Blue Angel* in 1930. Jannings showed his true colors during the Third Reich, winning high honors from the Nazis for acting in party

propaganda films, becoming a studio head, and ultimately accepting a post as a high-ranking cultural official for the Reich. Banished from the film industry after the war, Jannings experienced some of the humiliation he portrayed so well in *The Last Laugh*. After following *The Last Laugh* with two classical adaptations that also starred Jannings (*Tartuffe* and *Faust*), Murnau went to Hollywood and staged something of a revolution in film style and production.

Fritz Lang's Die Nibelungen

1923–24

In a sense, there are two Fritz Langs (1890-1976), for his life, career, and sensibility were split in half by the rise of the Nazis. The German Lang is monumental, existing in the realm of the fantastic, the superhuman, the surreal. The American Lang is naturalistic, existing in a real world inhabited by ordinary earthlings, people with feelings, folks with whom we can identify. The crossover film was Lang's first talkie, *M* (1931), in which a child murderer played by Peter Lorre is accorded a sympathetic hearing. *M* underscored how much Lang's work over the preceding twelve years had been lacking in genuine emotion. This is not to suggest that he ever became a conventional naturalistic director over the course of his honorable and mostly successful American career. He was as much a progenitor of film noir as he was of the expressionism that produced it, and in his later years he adapted Zola, collaborated with Bertolt Brecht in Hollywood, and appeared in Jean-Luc Godard's *Contempt* (1963) — all of which highlight an exceptional career.

Peter Cohen's documentary *The Architecture of Doom* (1989) cites Richard Wagner's opera *Rienzi* as a key influence on Hitler during his formative years, and suggests that the dictator welcomed the destruction of his Reich as a fitting reenactment of the *Götterdämerung* at the end of Wagner's Ring Cycle. There is no question that the spirit of German nationalism hangs very heavily over Lang's *Die Nibelungen*, a 1924 film composed of *Siegfried's Tod* and *Kriemhild's Rache*, Lang's adaptation of the Ring Cycle. How much the film foreshadowed the rise to power of the Nazis nine years later is debatable. (Thea von Harbou, Lang's writer, wife, and the former wife of Dr. Mabuse actor Rudolf Klein-Rogge, eventually became a full-fledged Nazi after Lang divorced her and went west.) In approaching *Die Nibelungen*, historian

Lotte Eisner focuses primarily on the film's artificial landscapes and stylized architecture. "The veil separating Nordic man from Nature cannot be torn down; so the Germans… construct an artificial Nature," she writes. "The massive architecture in *Die Nibelungen* constitutes an ideal setting for the stature of its epic heroes. Aiming for spectacular effects, Lang brought life to the grandiose rigidity of the architecture with a skillful use of lighting."

Eisner does comment on certain racial implications in the film's depiction of the Huns, but she attributes this more to Harbou than to Lang. The critic Siegfried Kracauer, on the other hand, points out the differences between Wagner's operas and the film, but states that Lang "defined this film as a national document fit to publicize German culture all over the world. His whole statement somewhat anticipated the Goebbels propaganda." Kracauer speaks of "the complete triumph of the ornamental over the human" in *Die Nibelungen*, and makes the claim that the Nazis drew inspiration from Lang's film for the mass rallies in Nuremberg in 1934 that were immortalized in Leni Riefenstahl's *Triumph of the Will* (1935).

Ideology aside, *Die Nibelungen* was the most expensive and emblematic film ever to come out of Universum-Film AG (UFA), the leading German studio between the wars. It was shot entirely indoors at UFA's Neubabelsberg studio — the same wonder of the early film world where a young Alfred Hitchcock visited F. W. Murnau on the set of *The Last Laugh* (1924) and where Josef von Sternberg filmed *The Blue Angel* (1930). Lang went on to film *Metropolis* (1927) and *Woman in the Moon* (1929) there as well. At Neubabelsberg, a multitude of craftsmen seemed to perform miracles, oblivious to the petty realities of budgets. Lang's grandiose film was justification enough for the studio's existence.

King Vidor's The Big Parade 1925

In his autobiography *A Tree Is a Tree*, King Vidor recounts the origins of *The Big Parade*. Having made some good but ephemeral films for the fledgling MGM, Vidor told Irving Thalberg, "If I were to work on something that had a chance at long runs… I would put much more effort, and love, into its creation."

If there is anything wrong with *The Big Parade*, it is that Vidor put too much into it. The film is at once a grand epic, an intimate romance, a comedy of camaraderie, and a savage polemic against war. Somehow, Vidor managed

THE BIG PARADE. DIRECTED BY KING KIDOR. 1925. USA. BLACK AND WHITE, SILENT, 151 MINUTES.

to hold all this together and seemingly overnight became the leading "serious" director in America, assuming at thirty-one the mantle that had fallen from D. W. Griffith's shoulders when the Master was forced to sign a contract with Paramount in 1925. *The Big Parade* still dwarfs virtually every film made about World War I, and it is arguably Vidor's finest achievement.

For Marxist critics *The Big Parade* was anathema, since as one reviewer wrote, Vidor "centered his comment upon the war in an absurd love affair between a French peasant girl and an American doughboy while men were being blown to bits." What this writer for *Experimental Cinema* didn't seem to realize was that for Vidor, as for most people, the impossibility of love under conditions of combat was precisely the point. The tragedy of war is not the interruption of dialectic, but of love and of life.

The greatness of *The Big Parade* lies in its manic romanticism, its total commitment to absurd peasant girls and doughboys, and to individual happiness above all else. As Vidor once said, "war has always been a very human thing." He reduces war to its human level, to the trivialities that constitute life, such as smoking cigarettes and chewing gum. Only through the director's painstaking efforts towards verisimilitude are we able to fully appreciate the broader implications of his magnificently painted canvas. He shows us grotesquely tiny men caught in surreal bombardment in night battle scenes; a funereal march through Belleau Wood with bodies falling in cadence; and the Big Parade itself, which climaxes with Melisande's refusal to let go of Jim's left leg, as if she knew he was soon to lose it for a cause neither of them understood. *The Big Parade* does not have the ideological simplemindedness of classic Soviet films, or even the philosophical consistency of Ernst Lubitsch's *Broken Lullaby (The Man I Killed)* released seven years later, but Jim does cry out with a question as relevant today as it was in 1918: "What the hell do we get out of this war anyway?"

Vidor said of the film: "I wanted it to be the story of a young American who was neither overpatriotic or a pacifist, but who went to war and reacted normally to all the things that happened to him. It would be the story of the average guy... He simply goes along for the ride and tries to make the most of each situation as it happens." It was Thalberg's idea to have Vidor collaborate with Laurence Stallings, who was then enjoying the great success of *What Price Glory?* on Broadway. Certainly some of the sardonic dynamics from that play were applied to the trio of compatriots in *The Big Parade*. Most of the scenario was written by Stallings (who had lost a leg at Belleau Wood), with Vidor and Harry Behn while they traveled across the U.S. in a Pullman car. Vidor's book provides a rich account of his efforts to choreograph the Belleau Wood march as a "ballet of death," and his experiments with "silent music" to do so. The move toward the front was shot with equal care. Each army unit was set to an different tempo in an attempt to create a "total symphonic effect." The result is like nothing else in American silent film, save perhaps the rhythmic climaxes of *The Birth of a Nation* (1915) and *Intolerance* (1916).

In the midst of Vidor's superbly orchestrated panorama, the images one retains are those of tender

moments between actors John Gilbert and Renée Adorée, whose star-crossed careers and lives peaked in this film. In the penultimate sequence, when Jim tells his mother that he loves a girl in France, she replies, "Then you must find her... nothing else matters." One can't quite help but feel that in *The Big Parade*, nothing mattered quite so much for King Vidor as these two little people and their absurd love affair. His mind may have been on his metronome, but Vidor's heart was surely with Jim and Melisande.

The Trials of Sergei Eisenstein

Sergei Eisenstein (1898-1948) is in many ways a special case. He was undeniably one of the geniuses of early cinema. As a theoretician, he wrote voluminously, and posited a theory of montage (editing), derived from the work of D. W. Griffith, notably *Intolerance* (1916). Eisenstein's theory of montage, which was centered on juxtaposing short shots to make a point, directly contradicted the German Expressionist approach most successfully promulgated by F. W. Murnau. It was enormously influential to many directors, though it did not always produce satisfying results.

Eisenstein was an early believer in the Bolshevik Revolution and was the great chronicler of the revolution and its antecedents. His *Strike, Battleship Potemkin* (both 1925), and *October (Ten Days That Shook the World)* (1928) shook the film world in Europe and elsewhere. There was room in the 1920s for a kind of simpleminded political optimism, and nobody captured this spirit more famously than Eisenstein. Even in America, the exploits of the Red Army, Lenin, and Trotsky seemed far more appealing than the smarminess of Warren Harding and the smugness of Calvin Coolidge. Many of the people I most admire (Charlie Chaplin, Paul Robeson, Upton Sinclair) were supportive of the Russian experiment— though mostly from a safe distance.

Auteur theory posits that the genuinely great directors can, in addition to expressing virtues and highlighting talents, use their films to showcase their personalities, their obsessions, and their visions of the world. Sergei Eisenstein was a highly educated cosmopolite, a student of languages (he spoke English, among others) and literature, a sophisticated and intrinsically bourgeois Jew. (He reminds me of his near contemporary, the highly acclaimed writer Isaac Babel, whose firsthand accounts of the glories of the revolution – and the civil war that followed – did not save him from Stalin's purges, or from dying in obscurity in a Siberian prison in 1941.)

One cannot imagine Eisenstein spending his life driving a plow or milking a cow as good Soviets do in his ode to the collective farm, *The General Line (Old and New)* (1929). He was far more comfortable on the tennis courts of Hollywood with Charlie Chaplin or Ernst Lubitsch or in Mexico with the available boys. Regarding the former, he had been invited to California by Paramount to work on an adaptation of Theodore Dreiser's *An American Tragedy*. (The film would eventually be made by Josef von Sternberg, and MoMA has Eisenstein's script among his papers in our library). Regarding the latter, Upton Sinclair sent Eisenstein south of the border to make the epic *Que Viva Mexico!*, an intended multipart epic on Mexican culture and history, but eventually the puritanical Sinclair's patience – and his wife's money – ran out, and Eisenstein succumbed to Stalin's demand that he return to Moscow. Although he was married, Eisenstein, like Murnau, was homosexual, and reportedly spent much of his time in Mexico pursuing young men. (The Museum has preserved around 120 miles of Eisenstein's spectacular footage, some of which can be viewed by the public.)

His first venture back in Russia, *Bezhin Meadow* (1937), was suppressed. His next film was a beautiful medieval epic, *Alexander Nevsky* (1938), which was intended as a warning to the Nazis that the Russians had dominated Germany before and were quite willing to do it again. (As we know, the warning went unheeded.) His multipart, cryptically anti-Stalinist *Ivan the Terrible* (1944) is a wonderful film, but it totally violates the director's earlier insistence on montage as the basis of film.

Remarkable as his films are, Eisenstein never had the opportunity for genuine self-expression. As oppressive as Hollywood studios may have been at times, men like John Ford, Alfred Hitchcock, and Howard Hawks were able to game the system. Even George Cukor and Vincente Minnelli used the resources of MGM for their own purposes. Louis B. Mayer didn't play in the same league as Stalin. Eisenstein must have been under constant stress in Russia for being a thinker, for being gay, and for being an artist, but after his Hollywood experiences, he still thought his career opportunities were better in his homeland. It is a tragedy that Eisenstein's genius was never applied to more personal and less party-friendly projects. There is little doubt that all this contributed significantly to his fatal heart attack shortly after his fiftieth birthday.

Documentary Expands
Merian C. Cooper and Ernest B. Schoedsack / Robert Flaherty / Joris Ivens

Calling Merian C. Cooper (1893-1973) and Ernest B. Schoedsack (1893-1979) auteurs might seem like fudging things little bit, but I don't think it is. There might not be a single dominant creator, but the bond between them seems so natural in their films as to be almost unique. Furthermore, although they made their collaborative mark in documentary, immediately after *Grass* (1926), the pair began to move away from actualities and towards narrative features.

Both had notable careers before they began working together closely. Schoedsack photographed the Keystone Cops for Mack Sennett, codirected *The Most Dangerous Game* (1932) with Irving Pichel, and directed *The Last Days of Pompeii* (1935) on his own. (Cooper produced the latter two films.) Cooper partnered with John Ford to produce many of the greatest Westerns ever made, from *Fort Apache* (1948) to *The Searchers* (1956), as well as Ford's Oscar-winning comedy *The Quiet Man* (1952). Together, Cooper and Schoesdsack moved from making ersatz documentaries such as *Chang* (1927) to fiction films such as the silent version of *Four Feathers* in 1929, and, most notably, *King Kong* in 1933.

Although documentaries had existed since the very beginning of cinema in the actualities of that other famous pair, the Lumière brothers, there was little creative talent in the genre until Robert Flaherty (1884-1951) came along. Flaherty's first two features (*Nanook of the North* in 1922 and *Moana* in 1926) documented the frozen North and the South Seas, but they were also the narrative products of a romantic sensibility, replete with heroes and a semblance of plot. *Grass* (which preceded *Moana* by several months) was different. It offered a spectacular canvas with a multitude of "performers," a throwback to Griffith and De Mille extravaganzas – except this time it was real. These were not Hollywood extras pulling their sheep and goats out of an imaginary Egypt, but authentic Persian tribesman undertaking their treacherous annual migration to find grass for their livestock. The result, in the estimation of Dennis Doros, the head of Milestone Films and the current distributor of *Grass*, is the greatest documentary ever made.

I would be remiss not to mention the contribution of journalist and one-time spy, Marguerite Harrison, who traveled with Cooper and Schoedsack and raised substantial funding for the project. The trio's extraordinary adventures are recounted in *Grass: Untold Stories* by Bahman Maghsoudlou, and Cooper's life is recounted in detail in *Living Dangerously* by Mark Vaz. Most filmmakers aspire to (and sometimes achieve) a pretty bourgeois existence, but not these two.

Joris Ivens (1898-1989) rivals Flaherty in importance in the development of documentary. *The Bridge* (1928) and *Rain* (1929) were early attempts to capture the poetic beauty of his native Netherlands. After making a series of similar but longer films, Ivens became political, and following several pro-Bolshevik films in Russia, he returned to the West for his most famous work, *The Spanish Earth* (1937). In spite of his leftist credentials he was employed under the New Deal to make *Power and the Land* (1940). All his life, Ivens was a committed humanitarian, traveling the globe many times over. One of his major works later in life was the six-part *How Yukong Moved the Mountains* (1976), a detailed study of post-revolutionary China. It is hard to think of any filmmaker more devoted to both the potential of documentary and the power of cinema to improve the world.

Buster's Best

The career of Buster Keaton is one of cinema's glories and one of its greatest tragedies. If auteurism is measured by a director's ability to portray an alternate personal universe on film, then Keaton ranks as among the best. His vision of a world wherein nature and machinery perpetually challenge human ingenuity and survival is made credible by his precise mastery of the mechanics of his art form and the musculature of his own body — and his ability to establish a link between the two.

As with all works of true genius, there is some-thing ineffable about Keaton's films. While his greatest moments lend themselves to anthologizing as much as those of Sergei Eisenstein or Alfred Hitchcock, Keaton's onscreen presence defies prospective imitators. Thankfully, I've never seen Donald O'Connor in *The Buster Keaton Story* (1957), but I assume Sidney Sheldon's film makes at least a minimal effort to recreate some of Buster's "stunts." No matter how successful those attempts might be, what can't be recreated is his expression (or lack thereof) at key moments. In addition to his other gifts, Keaton was a great actor.

THE GENERAL. DIRECTED BY CLYDE BRUCKMAN AND BUSTER KEATON.
1926. USA. BLACK AND WHITE, SILENT, 67 MINUTES.

While both *The General* (1927) and the cyclone sequence in *Steamboat Bill, Jr.* (1928) are, on one level, hysterically funny, the humor is derived from some very dark material — the most grisly war in American history and a world gone meteorologically mad, respectively. It is amusing to see a train plunging off a bridge into a ravine, but it's also a different level of calamity than slipping on a banana peel. What dark ghosts enabled Buster to find amusement in these events, and why do they bring us delight in addition to awe? I believe the answer lies somewhere in Keaton's pursuit of perfection, his desire to put forth a unique vision, his alcoholism, and his surreal view of the world. His great rival, Charlie Chaplin, would find somber humor in the antics of a misogynistic serial killer in *Monsieur Verdoux* (1947), and Stan Laurel and Oliver Hardy seemed to thrive on the expert application of pain and humiliation.

Keaton's ghosts eventually did him in. Though his marriage to Natalie Talmadge was failing, he still followed her advice and gave up his independence to Nicholas Schenk and MGM in 1928. His decline began with the silent *Spite Marriage* (1929), in which Keaton's ambition and creativity were inhibited by the studio. The advent of talkies and his descent deeper into alcoholism proved a fatal double-whammy, and Keaton became what amounted to a supporting player to Jimmy Durante. Keaton was essentially destroyed by thirty-three. By that age, Chaplin had made nothing more formidable than *The Kid* (1921). What Keaton might have accomplished had he been permitted to make his own films as a mature artist we will never know, and I mourn those lost films.

There were, however, wonderful glimmerings that appeared occasionally throughout the last forty years of Keaton's career as his stoically handsome face wrinkled and crumbled. These include his haunting, weird musical duet with Chaplin in *Limelight* (1952); a touching evocation of his past glory in an episode of *The Twilight Zone* (1961's

"Once Upon a Time"); his role in Samuel Beckett's *Film* (1965); and *The Railrodder* and *Buster Keaton Rides Again*, both made that same year — all of which can be seen as sad hints at what might have been.

F. W. Murnau's Sunrise: A Song of Two Humans 1927

After the international success of *The Last Laugh* (1924), the film cognoscenti could legitimately argue that F. W. Murnau should be recognized as the most important filmmaker in the world. D. W. Griffith was then coming off several interesting but unprofitable films and was about to lose some of his independence. Erich von Stroheim was fighting to salvage *Greed* (1924), and Charlie Chaplin had yet to make *The Gold Rush* (1925). Sergei Eisenstein and Josef von Sternberg were still on the horizon. Murnau followed *The Last Laugh* with two more Emil Jannings vehicles, adaptations of Molière's *Tartuffe* and Goethe's *Faust*. Both films continued to utilize the vast resources of the UFA studio, and the latter was especially spectacular. Eminent film historian Lotte Eisner wrote that no director had ever "succeeded in conjuring up the supernatural as masterfully" as Murnau did with *Faust*. Hollywood took note.

One studio executive was particularly interested. William Fox, a product of Eastern European Jewry, immigrated with his parents to a Lower East Side tenement when he was nine months old. In 1915, he formed the Fox Film Corporation. Although modestly successful by the mid-1920s — thanks largely to the popularity of cowboy star Tom Mix and a stable of extremely promising young directors like John Ford, Frank Borzage, and Raoul Walsh — Fox still yearned for prestige. UFA and Murnau had buckets of that.

Although shot in California, *Sunrise: A Song of Two Humans*, is to a significant extent a UFA production. Carl Mayer, who had written *The Cabinet of Dr. Caligari* (1920) in addition to Murnau's *The Last Laugh* and *Tartuffe* (1925), wrote the screenplay in Germany, and most of the planning for the film took place there as well. Murnau brought UFA's pioneering technological innovations to *Sunrise*, and he gave the film a look that revolutionized much of American cinema. His presence on the Fox lot certainly inspired the cadre of in-house directors. John Ford actually shot some of *Four Sons* (1928) on leftover *Sunrise* sets, and by the time his

Oscar-winning *The Informer* (1935) had been released, Ford had assimilated German Expressionism into his own naturalism and was well on his way to becoming perhaps the single greatest American filmmaker. Raoul Walsh was similarly influenced, and Murnau's mark is apparent in Frank Borzage's masterful 1928 film *Street Angel*.

Fox charged audiences an absurdly high two dollars to see *Sunrise*, which won an Oscar for its "Artistic Quality of Production." Janet Gaynor also won the first Oscar for best actress for her role in it and two other films: Borzage's *Seventh Heaven* (1927) and *Street Angel* (1928). George O'Brien, one of Ford's favorite leading men, was a limited actor, but he gives an intense and more-than-adequate performance in *Sunrise*, and would remain a loyal friend to Murnau until the director's untimely death.

With its specially constructed city sets — which were ingeniously built to perspective, and fantastically stylized yet still believable — *Sunrise* looks a lot like *The Last Laugh*. Murnau's moving camera and sensual lighting were unprecedented in American film. Instead of using Karl Freund, his preferred German cameraman, the director relied on Charles Rosher (who specialized in Technicolor musicals and making Mary Pickford look good) and Karl Struss, a distinguished still photographer who later worked for D. W. Griffith, Charlie Chaplin, and Orson Welles. Rosher went on to win an Oscar for his work on *Sunrise*. Hugo Riesenfeld produced the film's synchronized score, which is so much a part of *Sunrise* that it is hard to imagine the film without it.

Scholar Rodney Farnsworth has suggested that the "human characters in *Sunrise* are secondary to the true protagonist — the camera." Indeed, the film's plot is deceptively simple, and its characters, "the Man," "the Woman," and "the Vamp" — drawn from Hermann Sudermann's novel, *The Journey to Tilsit* — are dangerously close to schematic. However, Murnau's conviction and stylistic mastery reduce this concern to a quibble. Relax and let *Sunrise* take you on a ride through the director's imagination. Welles called movies "ribbons of dreams." *Sunrise* is one of the purest ribbons, made by one of the greatest ribbon-makers. Grab hold.

Early Animation 1907–1928

The art of film animation developed out of a long tradition of newspaper and magazine cartoons in both Europe and the United States. Émile Cohl (1857-1938), a

Frenchman, and Winsor McCay (1871-1934), an American, were politically tinged newspapermen who took advantage of the newly invented concept of stop-motion photography and made early animated films by shooting slightly varied drawings on successive film frames. Although their work now appears primitive beside the technological wizardry of Pixar and others, they must have inspired a sense of wonder and awe in early audiences who had never before seen drawn figures seemingly come to life. In a sense, animation can be seen as an even purer art form than actualities or narrative films, both of which depend on photographed reality rather than images that spring completely from an artist's imagination. McCay's *Gertie the Dinosaur* (1914) set a standard for anthropomorphic movies to come, and his *The Sinking of the Lusuitania* (1918) was incredibly complex and sophisticated for its time.

Comic strips like *Mutt and Jeff* and *Felix the Cat* provided an audience for movie cartoonists such as Richard Huemer (1898-1979), who would later join both the Fleischer brothers and Walt Disney, and Otto Messmer (1894-1971) who summed up the period nicely: "Nowadays, kids don't dream about the moon — they know. Then, all was magic. All we had was a pencil and paper. We didn't want to duplicate life; a photo would've done that. Felix was always a cat, but with a boy's wonder about the world. That, and visual tricks, and we had it." Messmer's Felix preceded Mickey Mouse as a thoughtful and sophisticated cartoon character with human tendencies.

Then, there was Disney (1901-1966). Rising from obscure Kansas City beginnings to become a colossus, "Uncle Walt" branded the American century more indelibly than any other artist in any other medium. Largely dependent on animator Ub Iwerks (1901-1971) and a host of other resident geniuses, Disney parlayed Mickey Mouse, the series *Silly Symphonies*, and his early great features into an unrivalled empire. Disney's reputation as dictatorial tycoon raises many questions about his status as an auteur, but love him or hate him, he clearly dominated — and, in a sense, still dominates — the field of animation.

Lotte Reiniger (1899-1981), working in Germany and later in Britain, was a pioneer in developing silhouette animation and stood out as a woman in a male-dominated field. Her *The Adventures of Prince Achmed* (1926) is credited as the first full-length animated feature. Around the same time, Ladislas Starevich (1892-1965), working first in Russia and then in France, established the field of puppet animation, which inspired the work of Willis O'Brien, George Pal, and Ray Harryhausen, and anticipated the contemporary craze for computer animation.

If Disney's commercial supremacy was ever threatened, it was by Viennese-born Max Fleischer (1883-1972) and his brother, Dave (1894 1979). Continuing in the tradition of McCay, Huemer, and Messmer, the Fleischers were based in New York, though they later moved to Miami because of labor problems. The Fleischer Studio was truly the anti-Disney: it created subversive and often raunchy characters like Betty Boop, and questioned the wholesome middle-American values Walt was fond of espousing.

To learn more about early animation, I highly recommend *Remembering Windsor McCay* (1974) and *Osso Messmer and Felix the Cat* (1977), two excellent documentaries by the distinguished scholar, teacher, and animator John Canemaker. The birth of animation resulted in many rich achievements by artists who labored in obscurity and deserve to be remembered. This brief essay only scratches at the surface of their accomplishments, and at the marvel that is the creation of a totally new medium.

Frank Borzage's Street Angel

1928

From the opening shot of *Street Angel*, it is evident that Frank Borzage (1893-1962) had been enraptured watching F. W. Murnau shoot *Sunrise* the preceding year at the Fox Studio. With an attention to atmospheric light and shadow, the camera prowls elaborate Neapolitan sets in long complicated takes. Borzage had won the first best director Oscar for *Seventh Heaven* in 1927, but he evidently realized that Murnau and his team brought something new to Hollywood, and he never cast off the German director's spell over the next thirty years of his career.

Though less explicitly, later films such as *Moonrise* (1948) also contained many lessons in lighting and camera movement learned at Murnau's knee. Borzage developed his own team of technicians, but many wound up working for Murnau. Cinematographer Ernest Palmer collaborated on several Borzage films, including *Seventh Heaven* and a handful of talkies, but he also photographed Murnau's *Four Devils* (1928) and *City Girl* (1930). Set designer Harry Oliver, similarly, was a Borzage man, but he also designed *City Girl*. It was almost as though these men were Borzage's gifts to his mentor, who had left his UFA support staff back in Germany.

Although *Street Angel*'s canvas is smaller than that of *Sunrise*, it is also a tale of a fractured relationship made whole by the redemptive power of love. Borzage's lovers seem obsessed with the purity of their spiritual relationship within a world of apparent depravity. The film's soundtrack contains many variations on "O Sole Mio," which became a huge pop hit in America in 1950, and was rendered in English as "There's No Tomorrow" by Tony Martin, who performed it for over six decades. ("There's no tomorrow, when love is new / There's no tomorrow, when love is true / So kiss me, and hold me tight / There's no tomorrow, there's just tonight.") The song gives *Street Angel* an emotional impetus that would become far more difficult to achieve with the arrival of the spoken word in film. It was left to Josef von Sternberg to find a way to restore "feeling" to American talking cinema, which he did in *Morocco* (1930) by shooting many scenes that relied more on gesture than dialogue. Murnau never made a sound film, and Charlie Chaplin avoided the new technology for over a decade.

Janet Gaynor and Charles Farrell worked together on several more Borzage films after *Seventh Heaven*, and also on ones by other directors. She won the first Oscar for best actress for her combined efforts on *Seventh Heaven*, *Sunrise*, and *Street Angel*. Farrell, surely one of the best-looking actors of the period, remained popular in talkies even after *Sunnyside Up* (1929) betrayed his high, squeaky voice. Borzage, a former actor himself, set great store in naturalism and "simplicity" in his actors.

In a sense, *Street Angel* raises interesting questions about the integrity of art itself. Does the virginal portrait Farrell paints of Gaynor become less authentic when he temporarily sees her as less than virginal? Does art lie, and does that matter? When Gaynor asks Farrell at the end of the film to look into her eyes in the hope of reestablishing the ethereal bond of faith between them, the moment highlights one of cinema's transcendent gifts. The great Danish director Carl Theodor Dreyer believed that "the eyes are the mirrors of the soul." In his *The Passion of Joan of Arc* (1928), Dreyer established the sincerity and conviction of Joan's faith through the exquisite luminosity of Maria Falconetti's eyes. While Joan burned, in *Street Angel* Farrell begs for forgiveness, recalling George O'Brien in *Sunrise*.

Frank Borzage was Hollywood's most unabashed romantic. The opening titles of *Street Angel* make reference to "souls made great by love." Borzage seemed to believe in this. His whole career can be summed up in the lyrics sung by a crooner in *Moonrise*: "Let's give love a chance."

Carl Theodor Dreyer's
The Passion of Joan of Arc 1928

Carl Theodor Dreyer (1889-1968) made eight good but unspectacular features between 1919 and 1926. In the ensuing four decades, he made only six more films — one of which he disowned. Even so, he is always near the top of any informed list of the greatest filmmakers

Dreyer spent much of his life as a journalist, film critic, and manager of a cinema in Denmark. He was not adept at raising funds for his projects or lending them commercial appeal; he appears to have been as somber and uncompromising as his characters. (I once upset one of my curatorial colleagues by suggesting that there might be a tiny bit of tongue-in-cheek humor in his 1932 horror film, *Vampyr*.) *The Passion of Joan of Arc* has been acclaimed for generations, but it was a financial flop, and even I recognize that it is entirely humorless.

First, a disclaimer: while I consider myself spiritually inclined, my inclination is more toward some vague form of pantheism or Romanticism than to formal religion. Frankly, the idea of hearing voices "from God" seems to me like some sort of wacky delusion. To look to a deity as a kind of military adviser, as Joan does, seems no more sensible than following the strategic advice of Groucho Marx as Rufus T. Firefly in Leo McCarey's *Duck Soup* (1933).

Yet despite my reservations and prejudices, *Joan of Arc* is intensely moving and powerful. The reliance on close-ups, the film's most dominant stylistic feature, makes Dreyer's Joan unique and ineffable. Though this was Corsican stage actress Maria Falconetti's only film appearance, she had few rivals in the complexity and depth of her performance. The only performers who come to mind as equals are Lillian Gish and Greta Garbo, both of whom had many years to hone their craft. So we must credit Dreyer (and maybe the Big Guy upstairs) for her inspiration. Truly, this is the kind of magic of which cinema alone is capable. No painting, no statue, no stage performance can generate the kind of pulsating intensity that Falconetti achieves. Her eyes, as Dreyer suggests, do mirror a soul, and they can make an unbeliever quaver. We are given no choice but to believe.

Dreyer subsequently went on to examine vampires and witches before performing the ultimate miracle of bringing the dead back to life in *Ordet* (1955). These were all remarkable films, as was his last, *Gertrud* (1964). However, *Joan of Arc* possessed a special kind of

enchantment (or "realized mysticism," as Dreyer once called it) that could not be replicated in sound films. Be it simplicity or innocence, something was irrevocably lost in the audio revolution of the late 1920s.

The French Avant-Garde in the 1920s

Charles Sheeler was one of the few American artists who dabbled in film in the 1920s. In Europe, there was much more overlap between film and other visual arts. In Germany, mainstream Expressionist cinema was considered avant-garde, and a handful of artists in Italy embraced surrealism after Mussolini's rise to power in 1922. Filmmakers in France interacted freely with other visual artists, a dynamic that was particularly unique and clearly benefited the culture. Movie production in France was not dominated either by commerce or by the state,

ENTR'ACTE. DIRECTED BY RENÉ CLAIR. 1924. FRANCE. BLACK AND WHITE, SILENT, 22 MINUTES.

which promoted a greater atmosphere of independence and individuality. This state of affairs had positive effects on this side of the Atlantic: it certainly helped Iris Barry, founder of MoMA's Film Library, to be able to cite dabblers like Man Ray, Marcel Duchamp, and Fernand Léger when appealing to patrons who might not have recognized the high aspirations or legitimacy of film in the works of directors such as Douglas Fairbanks, Charlie Chaplin, or Walt Disney. (It was left to future generations of curators to make cogent arguments for Otto Preminger, Clint Eastwood, and John Waters.)

Paris, the avant-garde capital of Europe, was particularly full of crossover artists. Man Ray (1890–1976) was an expatriate American photographer who made several films, the first and briefest of which being *Le Retour à la Raison* (1923). His films are determinedly non-narrative and poetic, and pointed the way to the

later experimental cinema of Stan Brakhage and a host of others who often worked on the fringes of the Hollywood behemoth. Fernand Léger (1881-1955) made his *Ballet Mecanique* (1924) with Dudley Murphy, an intriguingly enigmatic American who wandered in and out of film history, directing people like Bessie Smith and Paul Robeson along the way. Although Léger shared Buster Keaton's obsession with modern machinery, perhaps the most enduring image in his *Ballet Mecanique* is an homage to Charlie Chaplin. And even though Duchamp (1887-1968) directed only the short *Anemic Cinema* (1926), he made frequent appearances in other films, including René Clair's *Entr'acte* (1924). All three of these men used film to expand their artistic practices, but, as far as I'm concerned, they did little or nothing to alter the course of the medium itself.

Paris played the role of hospitable host to refugees and expatriates from all over, including many filmmakers uprooted by the Bolshevik Revolution. This group included Ladislas Starevich (1882-1965), Dimitri Kirsanov (1899-1957), and Eugene Deslaw (1898-1966). (Starevich was, for a time, affiliated with Albatros Films, a Paris-based company run by Russian émigrés that specialized mostly in narrative features, including several starring Ivan Mozzhukhin.) Deslaw shared Léger's fascination with the movement and textures of machines, and his first film, *La Marche des Machines* (1928), is an exercise in rhythmic choreography, similar in some ways to Joris Ivens's *The Bridge* from that same year. Deslaw gradually moved toward more conventional documentaries but never became a major figure in the field.

Germaine Dulac (1882-1942) was part of a feminist movement in French cinema that stretches from Alice Guy-Blaché to Agnès Varda. Her film *The Seashell and the Clergyman* (1928) was written by Antonin Artaud and explored sexuality in a manner far removed from Hollywood, even though Dulac was influenced by American films and was for a short time a pupil of D. W. Griffith. Like Griffith, she sought purity in images, and her work was inhibited by the introduction of sound. Dulac wound up her career as Guy-Blaché had started hers four decades earlier — working in the offices of the Gaumont studio. Considered to be the inspiration and "heart" of the French avant-garde in the 1920s, she occupies a status similar to that of Maya Deren in the U.S.

Three directors from this period moved from the avant-garde into mainstream cinema: Jean Renoir (1894-1979), René Clair (1898-1981), and Luis Buñuel (1900-1983). *Charleston* (1927), one of Renoir's more experimental films, starred the director's then-wife Catherine Hessling, who had modeled for Jean's father, Pierre-Auguste Renoir, as a teenager. Though the film feels like a home movie, for Jean, who would become possibly the greatest of all filmmakers, it seemed to be his way of saying, "I can do avant-garde, too." Clair had been immersed in the Dadaist art scene, and *Entr'acte* was initially made to be shown at intermission during a ballet by Francis Picabia featuring music by Erik Satie. Both men appear in the film, as do Man Ray and Duchamp. Clair made several absurdist, charming, and genuinely experimental films before becoming the most successful director of the early sound period in France.

Buñuel and his Spanish compadre Salvador Dalí (1904-1989) were both men of destiny, although they took very different paths after their sojourns in Paris. Through their collaboration on *Un Chien Andalou* (1929) and the feature-length *L'Age d'Or* (1930), the pair brought the shock-value of Surrealism to the screen. *L'Age d'Or* ultimately led to a falling out between them. Even though Dalí became dismissive of cinema, it didn't prevent him from wandering back to the movies later in his career, most notably for the dream sequence of Alfred Hitchcock's *Spellbound* (1945). Buñuel followed a brief tenure at the Museum of Modern Art in the 1940s with a failed attempt to direct in Hollywood. He later enjoyed a distinguished directorial career in Mexico before making a triumphant return to Europe in the 1960s where, ever loyal to his roots, he released half a dozen Surrealist masterpieces.

Vsevolod I. Pudovkin's
Storm Over Asia 1928

Vsevolod Illarionovich Pudovkin (1893-1953) was, like Sergei Eisenstein, a pupil of Lev Kuleshov, and all three were heavily influenced by D. W. Griffith's work and masterful approach to editing. All three also wrote copiously on film theory, finding intellectual justification for the choices they made in their movies. Few early American filmmakers made much effort to convey their thought processes, and most seemed happy to create the impression that they worked on the basis of intuition. When Peter Bogdanovich asked John Ford how he made a particular shot, Ford replied soberly, "with a camera."

Of course, Alfred Hitchcock did submit to François Truffaut's book-length interview, and King Vidor wrote a book, *King Vidor on Filmmaking*, to try to explain

his methods. Neither of these, however, quite matched the portentous tomes that Pudovkin and Eisenstein published. I do think, however, that their montage theories were more amenable to intellectual codification than certain subtleties in Ford's work are. For instance, Ford was a master at creating poignancy by using the same actor in multiple films, which helped the audience recall the actor's appearances in previous movies. There is some discussion of technique and style in Josef von Sternberg's charming autobiography, *Fun in a Chinese Laundry*, but the greatness of films such as *Morocco* (1930), *Shanghai Express* (1932), *The Scarlet Empress* (1934), and *The Devil Is a Woman* (1935) have as much to do with the unique alchemy of Sternberg and Marlene Dietrich and the "baggage" they carried as anything else. Such things are inimitable, and hardly grist for Film Directing 101 textbooks.

But back to Pudovkin: His first released film was the short comedy *Chess Fever* (1925), and by the time it came out he was already hard at work on his documentary, *The Mechanics of the Brain* (1926). His real breakthrough came the following year with his adaptation of Maxim Gorky's novel *Mother*, a story of a mother-son relationship caught up in the sweep of Russia's abortive 1905 revolution. Here, he established his fundamental differences from Eisenstein, whose revolutionary zeal would not permit him to traffic in much sentimentality or emotion. Pudovkin was no less a supporter of the Revolution, but he was aware that a collective was made up of individuals, and that audiences who were attracted to a Charlie Chaplin or Lillian Gish might want to identify with a character or personality instead of just a cause. In this observation, he seemed particularly astute about the ultimate power of the movies.

If Eisenstein was the pre-eminent Soviet propagandist, Pudovkin and his Ukrainian contemporary Alexander Dovzhenko were the epic visual poets of the regime. Pudovkin's *Storm Over Asia* is a spectacle that was more or less unprecedented in world cinema. Scenes in which masses are filmed with a moving camera and subjected to his theories of editing certainly rival similar moments in Griffith's *Intolerance* (1916), yet they possess a contemporaneity that Griffith's faux-Babylonians could not match. Pudovkin was recreating the recent history of Russia and its fringe republics, and he believed in the cause of the revolution as Ford believed in America's destiny. Whether Pudovkin had seen *Napoleon*, a film made two years earlier by another Griffith disciple, Abel Gance, both works share a soaring epic quality, and both focus on an unlikely hero who grows to

greatness before our eyes. With the coming of sound and Stalinism, Pudovkin never again rose to quite the same heights, but he retains an honorable place in the history of film and film literature.

Charlie Chaplin's The Circus
1928

With the possible exception of his 1952 film *Limelight*, Charlie Chaplin's *The Circus* is the most personal and self-revelatory film ever made by a major director. Chaplin made more than seventy shorts between 1914 and 1923, passing through several studios before establishing his own. *A Woman of Paris* (1923) won him great admiration from critics, even though he only had a fleeting onscreen appearance. *The Kid* (1921) and *The Gold Rush* (1925) earned him worldwide adulation and lots of money. By 1925, he had become the most recognizable and beloved living person in the history of the world. The cult of celebrity that has so dominated most of the past century, as my friend Jonathan Goldman argues in his writings on Chaplin, largely started with the Tramp. Chaplin, through a combination of courage and solipsism, used his celebrity to explore in his work his innermost feelings, and he used his genius to compel his audience to share them.

Since Chaplin was in total control of his films, and since he was the most gifted of actors, he came as close as one could with a camera to the solitary act of scratching a pen on a blank page. What he did, in essence, was use the whole mechanical apparatus of his movie studio to say, in the manner of a diarist: "This is my life; these are my feelings; this is me." He offered up that most intimate of gifts: himself.

Lest this all sound a bit too serious, it should be pointed out that *The Circus* is one of the funniest comedies ever made. The tightrope-walking sequence is maybe the most riotous scene in any movie. Several primal fears are confronted simultaneously as Charlie struggles to maintain his balance at a great height, with his pants falling down, and furry beasts biting his nose and sticking their tails in his mouth. Chaplin makes us laugh hysterically at the extremes of human desperation and fear, and by extension, at our own endless scramble for survival.

As he was to do again in *Limelight*, in *The Circus* Chaplin explicitly explores the nature of comedy itself.

Playing the part of a clown in a circus, the Tramp is unable to be anything but inadvertently funny, unlike Chaplin, who achieved his unparalleled results only through conscious and painstaking efforts. The circus, the music hall, and the tradition of clowning produced Chaplin, but the naturalistic possibilities of cinema allowed him to develop the comedy of a character through audience familiarity and love. Ultimately, his achievements led to an enduring legacy of "reality"-based movie comedies and (mostly debased) television situation comedies. Chaplin rejected being compartmentalized as a clown in favor of being seen as a fully rounded person who happened to be funny. He also acknowledged that, through the movies, he had almost single-handedly wrought a great change in probably the oldest and most-valued means of communication: making people laugh.

The unfortunate fact about *The Circus* is that Chaplin's failed romantic life had made him sad. Robert Florey, a director and later an assistant to Chaplin, wrote about a chance encounter at the time: "I cannot express what melancholy overwhelmed me in recognizing the total solitude of the most popular man in the world." Chaplin's artful declaration of this solitude in *The Circus* was to become an existential landmark in the history of the movies. When the bareback rider the Tramp is in love with (Merna Kennedy) runs away from her evil circus-owner father, the Tramp makes the supreme romantic gesture of engineering her hasty marriage to the tightrope walker, personally providing a ring and showering them with rice at the wedding. Two years later, in Josef von Sternberg's *Morocco*, Adolphe Menjou would similarly sacrifice himself to facilitate the reunion of Marlene Dietrich and Gary Cooper, explaining to embarrassed friends, "You see, I love her. I'd do anything to make her happy." In *The Circus*, Chaplin is publicly recognizing his own failed attempts at union and conceding his apparent inability to provide anyone with what will "make her happy."

The devastating ending of the film finds the Tramp sitting on a box in the center of what had been the ring. The wagons carrying Merna and her new husband have pulled out, leaving him entirely alone. Charlie picks up the tattered paper star through which Merna had ridden, crumbles this symbolic remnant of his hopes and fame, and kicks it backward. Then the solitary figure, the movies' most famous silhouette, inimitably walks away from the camera into a dawn-lit desolate landscape. It is the most forlorn and hopeless image in all Chaplin's work – indeed, in all of cinema.

Josef von Sternberg's
The Docks of New York 1928

Josef von Sternberg (1894-1969) divided his childhood between his native Vienna and Queens, New York. Before going to Hollywood in the mid-1920s, he learned the rudiments of filmmaking at studios in Ft. Lee, and in the Army Signal Corps during the Great War. His first film, *The Salvation Hunters* (1925), was amazingly accomplished, especially considering its miniscule budget. It was, in essence, an independent film, an almost unique specimen for its time. Only the good fortune of capturing the eyes of Douglas Fairbanks and Charlie Chaplin brought Sternberg out of obscurity and to the attention of the studios. Of his nine silent films, only four survive. Apart from *Salvation Hunters*, these other works – *Underworld*, *The Last Command* (both 1928), and *The Docks of New York* – are so good that one must conclude that Sternberg's career, perhaps more than that of any other director, suffers from the blight on film history I have come to think of as lost-film syndrome.

In a pattern set by *The Salvation Hunters*, his films deal with complex and painful romantic relationships shot in a stylized manner. While Erich von Stroheim made a false claim to realism, Sternberg was often apologetic for too closely approximating reality. By the end of his first decade as a director (far and away his most productive period), Sternberg could certainly be considered cinema's greatest romantic artist, rivaled only later by Max Ophüls.

As a studio director, he had to pay some lip service to genre. *Underworld* was the first gangster movie, and it was an enormous commercial success – even without the audible machine guns and police sirens that Warner Brothers would soon bring to the genre. *The Last Command* was an inside-Hollywood film, depicting a former Czarist Russian general turned Hollywood extra who is brought out of obscurity to command a faux-army before the cameras, with fatal consequences. (It was partially for this film that Emil Jannings won the first Oscar for best actor, while Sternberg's film shared the best picture award with William Wellman's 1927 film *Wings*.)

The Docks of New York is Sternberg's first surviving full-scale collaboration with screenwriter Jules Furthman. (Furthman adapted *Underworld* and co-wrote the now lost *The Dragnet* with his brother Charles.) The writer went on to collaborate on six more of Sternberg's (mostly) finest films, while also beginning another

symbiotic relationship with Howard Hawks. Although I would certainly argue for the primacy of the director over the writer, there are instances in which the writer is so intrinsically in synch with the director's vision that individual contributions cannot be easily distinguished. It should be said, too, that Furthman's work with other directors did not measure up to his films with these two giants.

The Docks of New York is probably the last genuinely great silent film made in Hollywood, save for Chaplin's against-the-grain masterpieces of the 1930s. It largely established the themes and style (camera movement, lyrical lighting effects, etc.) that I believe helped make Sternberg the most important American director of the early-sound period. Betty Compson's performance anticipates in manner and gesture that of Marlene Dietrich in her films under Sternberg's direction. The sound films, of course, are better able to showcase Dietrich's emotional equipoise and sophisticated mastery of ironic ambiguity as she deals with her gentlemen, despite their relatively sparse and often clipped dialogue. The result is a combination of deeply felt emotional maturity and raw passion not previously seen on the American screen.

Victor Sjöström's The Wind 1928

Victor Sjöström (Seastrom in his MGM years) was instrumental in demonstrating cinema's potential, both through his Swedish films and during his Hollywood period. Ingeborg Holm (1913) introduced a sustained psychological intensity not previously seen in the movies. His work from 1917 until his departure for Hollywood in 1923 (which included A Man There Was in 1917, The Outlaw and his Wife in 1918, The Phantom Carriage in 1921, and numerous adaptations of Selma Lagerlof novels) place him in the first rank of silent directors, and he pioneered the pitfalls of directing himself as an actor before Charlie Chaplin, Erich von Stroheim, or Buster Keaton did. Several of his nine Hollywood films no longer survive, although the two Lillian Gish vehicles, The Scarlet Letter (1926) and The Wind (1928) remain, and luckily appear to be the best of the lot. He returned to Europe in 1928, directed only two talkies, and continued to act in Swedish films until delivering his final bravura performance for Ingmar Bergman in Wild Strawberries (1957) at the age of seventy-eight.

During his brief time in Hollywood, he presided over a small MGM-based expatriate Swedish colony that included Mauritz Stiller (Sjöström's Finnish-born erstwhile compatriot at Stockholm's Svenska-Bio Studio), Greta Garbo (a Stiller discovery who Sjöström directed in the mostly lost 1928 film The Divine Woman), Lars Hanson, and a girl from Springfield, Ohio named Lillian Gish. Gish allegedly chose Sjöström to direct The Scarlet Letter since his Scandinavian background seemed to parallel that of the austere New Englander Nathaniel Hawthorne. Garbo was drawn to Gish by the way she tenderly commiserated over the death of Greta's sister back in Sweden. (Gish was close professionally and personally to her younger sister, Dorothy.) I find it pleasing to think of these two — the greatest of silent actresses — as friends and ultimately neighbors for several decades in the vicinity of Sutton Place in New York City.

In my book, The Western Film, I wrote:

The silent film form itself was about to become extinct, and perhaps its greatest "Western" came just before the end. The quotes are necessary because… The Wind *is more a psychological study that just happened to be set in the West. Yet it contains elements central to so many Westerns… human isolation in a vast landscape, the alienation of the woman in Western society, and the brutal indifference of nature.* The Wind *is perhaps the purest expression of a rare form, a woman's fantasy of life in the West, in a genre dominated almost exclusively by male fantasies.*

There have been many great sound films since Al Jolson killed the silents. Yet, as Norma Desmond says in Sunset Boulevard (1950), they had faces then. Gish's pouting mouth, her perfect little nose, and the eyes that could see into eternity were modeling clay that could be wrought into a myriad of voiceless women who had lived and loved and endured since the beginning of time. After scarcely three decades this priceless art was no longer wanted. By the time she made The Wind, Gish had achieved precision in her expressions and gestures. Her disgust at Lars Hanson's forced kiss, her consuming fear of the wind, her horror when Montagu Love appears to rise from the dead, her tender acceptance of Hanson's love following her ordeal — all are achieved with apparently effortless grace. It is as though she is crying out in her most ladylike manner: "Look at this! How can you forsake something this sublime?"

G. W. Pabst's Pandora's Box 1928

What counts is the image. So I would still claim that the creator of the film is much more the director than the author of the scenario or the actors. — G. W. Pabst

Georg Wilhelm Pabst (1885–1967) was the third member of the great Weimar directorial triumvirate, along with F. W. Murnau and Fritz Lang. In some ways he was the most elusive and mysterious of the three. Murnau was haunted by whatever demons went along with being homosexual in an uncongenial era. Pabst's fellow Austrian, Lang, seemed to flirt with fascism – his intellectual instincts were Teutonic, his wife was a Nazi, and he was offered control of the Reich's film industry – but he ultimately went west and wound up in Hollywood where he became a practicing democrat. (Reports of his tyrannical relations with coworkers, however, would probably disqualify him from canonization.) Pabst was a horse of a different color altogether, or, perhaps more correctly, several different colors. While Lang could only imagine New York for *Metropolis* (1927), Pabst spent a few youthful years in the city. He came to film directing rather late in 1923, but he had made several successful movies – *The Treasure* in 1923, *The Joyless Street* in 1925, *Secrets of a Soul* in 1926, *The Love of Jeanne Ney* in 1927 – before *Pandora's Box* in 1928.

Then, a kind of intellectual wanderlust set in. He made *The White Hell of Pitz Palu* (1929), starring Leni Riefenstahl. He seemed to tack to the left with the anti-war *Westfront 1918* (1930), an adaptation of Bertolt Brecht's *Threepenny Opera*, and the pro-proletariat *Kameradschaft* (1931). When the Nazis came to power, Pabst, like Lang, went to France and then briefly to America, where he made *A Modern Hero* (1934). After that, he returned to France and traveled to Germany at the outbreak of World War II, where he made two films under the Nazis. Following the war, he seemed to atone with several anti-Nazi films. As critic Lotte Eisner said, "he is full of contradictions." Will the real G. W. Pabst please stand up? At least we know he seems to have been a much nicer guy and more gracious colleague than Lang.

Pandora's Box was adapted from two plays by Frank Wedekind, and it made the American Louise Brooks briefly into an international star. The film is one of exceptional and hypnotic strangeness. Pabst captures much of the erotic zeitgeist of Weimar Germany through the various relationships of a showgirl before her murder at the hands of Jack the Ripper in London. The director had been on the brink of signing the little-known but more knowing Marlene Dietrich to play Lulu, but opted at the last moment for the more innocent looking and younger Brooks. (Dietrich would have sweet revenge a year later when she landed the part of Lola in Josef von Sternberg's *The Blue Angel* and signed a long-term contract with Paramount, the very studio Brooks had ditched for Pabst.) The film is less conventionally expressionistic and melodramatic and is more fluid than Pabst's earlier work. Where Murnau is a poet and Lang a mythologist, Pabst is mostly concerned with contemporary slants on psychology and sexuality. Taken in this sense, the film was extremely modern and remains so, but the audiences of 1928 were not ready for its boldness and frankness, even in few-holds-barred Weimar Berlin. Interestingly, the film's production coincided with Erich von Stroheim's madly unsuccessful attempt to complete a similarly erotic story with Gloria Swanson, *Queen Kelly* (1929).

In her wonderful and intelligent book, *Lulu in Hollywood*, Brooks praises Pabst for his willingness to confront reality, "his truthful picture of this world of pleasure." (She was to make one additional picture with him, *Diary of a Lost Girl*, in 1929.) He seems to have recognized a unique vitality in her, or as she once said, "It was clever of Pabst to know... that I possessed the tramp essence of Lulu." The great Jean Renoir wrote that Pabst "knows how, better than anyone else, to direct actors. His characters emerge like his own children, created from fragments of his own heart and mind." If scholar Russell Merritt is correct in calling Brooks's Lulu a "narcissistic chameleon," this may help us understand Pabst's own chameleon-like qualities.

Dziga Vertov's The Man with a Movie Camera 1929

Dziga Vertov (1896–1954) presents some unusual problems for inclusion in this book. If we define an auteur as a filmmaker who places the stamp of personality and vision on all their work, the presumption is that the filmmaker has a distinctive way of looking at the world. While no one could possibly disagree with the fact that from a technical standpoint, Vertov was a great innovator and expander of the medium – a rival to D. W. Griffith, F. W. Murnau, Sergei Eisenstein, and Alfred Hitchcock –

we don't know much about who he really was. What we do know is that he was born Denis Arkadievitch Kaufman in what is now Poland (then part of the Czarist empire) and was the elder brother of two other distinguished filmmakers, Mikhail, a cameraman on several Vertov films and later a director, and Boris Kaufman, who was a cinematographer for Jean Vigo, Abel Gance, Elia Kazan, and Sidney Lumet.

Vertov was essentially a crusader against the idea of filmmaker as artist, and he believed that the filmmaker was more like a machine — a conduit for capturing and shaping reality. This appealed to Lenin, and so Vertov produced a series of *Kino-Pravda* (Cinema-Truth) "newsreels" in the early 1920s. But however sincere he may have been, Vertov still relied on the manipulative tricks of the movies. While Georges Méliès sought magical entertainment and Griffith authentic human emotion, Vertov applied his skills to the service of the Bolshevik Revolution.

According to historian Erik Barnouw, 'Denis Kaufman' suggests in Russian a kind of perpetually spinning top, or in human terms, a whirling dervish. This seems quite appropriate for the energy level of Vertov's most famous film. *The Man with a Movie Camera* is generally considered his masterpiece, and to some it is a high-water mark of cinematic imagination and purity. Although Eisenstein called the film "unmotivated camera mischief," it is unquestionably dazzling. Even so, I find it as much of a dead-end as some of Eugene O'Neill's most ambitious experiments from that same period, such as *Strange Interlude*, which features spoken thoughts. I am left impressed but wondering, Where does all this innovation lead? Is it eye-candy or spinach? One thing it does not seem to be is emotionally affecting. Who is this man with a camera whose shadow we see and who tells us, "I, a machine, am showing you a world, the likes of which only I can see." Critic Sharon Lee put her finger on Vertov's limitations when she claimed, "he has shown us reality; he has expanded our vision of life, but it is a reality that only exists on film."

With the advent of sound, Vertov became more political, making *Enthusiasm* in 1933 and *Three Songs of Lenin* in 1934. His apprentice, the American scholar Jay Leyda (later on staff at the MoMA film library, and then a film professor at NYU) saw these as Vertov's most personal and successful films. Leyda believed that sound allowed Vertov to realize his childhood dream of marrying cinema with poetry, and "of making an art of the sights and sounds of the world around him, arranging harmonies and dissonances out of these realities."

MAN WITH A MOVIE CAMERA. DIRECTED BY DZIGA VERTOV. 1929. SOVIET UNION. BLACK AND WHITE, SILENT, 68 MINUTES.

As was the case with so many of his contemporaries, Vertov gradually ran afoul of Stalin, and his career dissipated. However, for good or ill, he had an enormous influence on documentary and on other filmmakers both in the Soviet Union and abroad. Thanks to him we can celebrate the rationality of Jean Rouch and Frederick Wiseman, and perhaps we can also lament the inanity of television news.

Alexander Dovzhenko's Rural Trilogy 1929–1932

The third member of the triumvirate of great silent Soviet narrative directors is Alexander Dovzhenko (1894–1956). Unlike Sergei Eisenstein and V.I. Pudovkin,

Dovzhenko was Ukrainian and worked mostly in Odessa and Kiev, which allowed him slightly more freedom as he wasn't constantly under Stalin's nose in Moscow. Like his esteemed contemporaries, he left behind extensive writings on cinema. His concern for peasants, a group that included his illiterate father, led him away from urban settings and towards promoting a lyrical and poetic depiction of nature. His great rural trilogy, made up of *Zvenigora* in 1928, *Arsenal* in 1929, and *Zemlya* in 1930, move beyond immediate political concerns and into a personal and emotional realm. In these films, feeling triumphs over agitprop.

Arsenal is, first and foremost, a war picture dealing with the civil strife that followed the overthrow of the czar. In keeping with his conception of cinema as a form of poetry, Dovzhenko developed a unique style replete with symbols, metaphors, and poetic intertitles that was somewhat removed from the conventions of cinematic narrative — even those pioneered by other Soviet filmmakers. The screenwriter John Howard Lawson, a member of the Hollywood Ten, said that "no film artist has ever surpassed Dovzhenko in establishing an intimate human connection between images that have no plot relationship." (Lawson went to prison in 1948 for refusing to cooperate with the House Committee on Un-American Activities during its Hollywood witchhunt. He made several films before and during World War II that would later be viewed as pro-Communist propaganda, even though one of them had previously earned him an Oscar nomination.)

Dovzhenko was no stranger to persevering against a rising tide of bitter disappointment, a condition familiar to those who carried the Soviet banner. He was only able to make a few sound films before finally succumbing to the heart ailment that had kept him out of World War I. Of those, *Ivan* (1932), *Aerograd* (1935) and *Shchors* (1939) can certainly be viewed as major achievements, even if they were not up to the standards of *Arsenal* and *Zemlya*. The beauty of his films belies his lament: "I often think of how my life has been wasted." When my friend Sonia Volochova died in 1980, I included a Dovzhenko clip among the films shown at her private memorial at the Museum. Sonia, a refugee from the Revolution, was neither a peasant nor a Bolshevik, but she had a great passion for and encyclopedic knowledge of Soviet film. We never discussed it specifically, but I suspect that Dovzhenko would have been her ideal, someone for whom politics was secondary to art and life.

King Vidor's Hallelujah 1929

1894 was a uniquely auspicious year for the movies. Not only is that when film history as we have come to know it began, but it was the year in which three of the medium's greatest directors were born: Jean Renoir, John Ford, and Josef von Sternberg. King Vidor was also born in 1894, and while he may not have achieved quite the unity of vision of the other three, he came close. After his *The Big Parade* (1925) put MGM on the map, he made five more silent films including *La Bohème* in 1926 (Lillian Gish's best vehicle apart from her performances for D. W. Griffith and Victor Sjöström), two brilliant comedies starring the scintillating Marion Davies (*The Patsy* and *Show People*, both in 1928), and *The Crowd* (1928), one of the crown jewels of the period. The ever-ambitious Vidor was then ready for sound.

Hallelujah was shot in Tennessee and Arkansas, far from the prying eyes of studio executives and the interference of newly venerated sound engineers. Thanks to the distance, Vidor was relatively free to experiment with what was essentially a new medium. (Judging by the limitations of the next several films that Vidor made while back on the lot at MGM, it is likely that much of the adventuresome quality of *Hallelujah* would have been lost if it had been made under the nose of Irving Thalberg.) Visually, *Hallelujah* is as striking as any of Vidor's silent films. Since many sequences were shot silent with sound added afterward, the director was able to retain the fluidity of camera movement so evident in *The Crowd*. Vidor's lovely soft-focus images of life in the cotton fields, his spectacular staging of a mass baptism, the brilliant expressionism of a church meeting and a climactic chase through a swamp are unparalleled in early sound film. His imaginative use of sound, ranging from off-screen voices to moving musical numbers, is equally unique. It could be argued that *Hallelujah* is in its way as important to the development of talkies as *The Birth of a Nation* was to silent film fourteen years earlier. Unfortunately, the parallels between the two films don't stop there.

Vidor, a proud Texan, carried much of the baggage of his Southern upbringing. On one level, *Hallelujah* clearly reinforces the stereotype of blacks as childishly simple, lecherously promiscuous, fanatically superstitious, and shiftless. This was, of course, not unusual in American films; even the great Paul Robeson had to shuffle a bit in James Whale's *Showboat* (1936). Chick, the mulatto temptress in *Hallelujah* (or "yellow

HALLELUJAH. DIRECTED BY KING VIDOR. 1929. USA. BLACK AND WHITE, 109 MINUTES.

hussy," as Zeke's mother calls her) would later reappear as the Lena Horne character in Vincente Minnelli's "sophisticated" debut, *Cabin in the Sky* (1943). Though Vidor could never be accused of displaying the overt racial venom exhibited by Griffith in *The Birth of a Nation*, it's still hard to give *Hallelujah* the benefit of the doubt after seeing his 1935 film *So Red the Rose*.

The director himself links the two films by opening *So Red the Rose* with cotton field footage of the Johnson family from *Hallelujah*. Daniel Haynes, who played the sharecropper Zeke in *Hallelujah*, reappears as a loyal slave who puts down a slave rebellion after the Emancipation Proclamation. In this role, he converts blacks back into the happy singers they were before they became uppity and began to think of themselves as men rather than chattel.

Is there, then, a defense for *Hallelujah* beyond its aesthetic importance? I think there is, and I think it lies in Vidor's personality as we know it from his films. (Full

disclosure: In the few hours I was privileged to spend with him in 1972, I found Vidor modest and utterly charming.) Remembering that Vidor made *Hallelujah* in 1929 may provide grounds for understanding, if not approval. He did grow up in the South and he did, indeed, have preconceptions about blacks. He tried to render these lovingly in what he sincerely deemed to be an honest and affectionate film. Given his naiveté, his lack of malice, and his trust in his own fairness — as well as his almost mystical fervor — *Hallelujah* can and should be accepted as the remarkable achievement it is. Perhaps we can best gauge Vidor's purity of intent through the words of Zeke's song: "I can't go wrong, I must go right / I'll find my way 'cause a guiding light / will be shining at the end of the road."

Frank Borzage's They Had to See Paris 1929

Will Rogers made a number of silent films, mostly in the early 1920s. *They Had to See Paris* was the first sound film he starred in. In it, we see a performer with the rare gifts of spontaneity and presence whose persona is already fully developed and almost perfectly suited to the new medium. Through the sheer force of his personality, Rogers transcends the staginess of this early talkie. Something is always happening on his face and behind it, and in the infrequent moments when Rogers's impromptu wit fails, his absolute charm succeeds.

This kind of naturalistic "acting" was to reach its zenith a third of a century later in the famous long take of James Stewart sitting beside a river in John Ford's *Two Rode Together* (1961). Will Rogers in *They Had to See Paris* is the prototypical American character of the sound era, soon to be followed by such outstanding personalities as Stewart, Gary Cooper, and John Wayne. In the film, Rogers, playing an uncouth Oklahoman who struck it rich in oil, is dragged to Paris by his social-climbing wife, and finally embarrasses her sufficiently to permit their return to Oklahoma. The assertion of provincial, pragmatic American values in *They Had to See Paris* was to be echoed throughout the films of Ford, Howard Hawks, King Vidor, Frank Capra, and other major American directors.

Frank Borzage was more at home in the realm of near-manic romance, and his Paris lacks the sparkle he captured in such masterpieces as *Seventh Heaven* (1927) and *History Is Made at Night* (1937). Given Borzage's inclinations, it is not surprising that the film's most pricelessly charming scenes feature Rogers and Fifi D'Orsay, as the comedian innocently yet knowingly indulges in the smalltown American fantasy of, as Edgar Kennedy puts it, "*parlez-vousing*" the French. Their duet "I Could Do It for You" is almost good enough to redeem all the bad 1929 musicals that survived. Miss D'Orsay was to reappear in a similar role in the other Borzage/Rogers film, *Young As You Feel*, in 1932.

Though *They Had to See Paris* may seem peripheral to Borzage's overall career, his work with Rogers contributed to the development of the screen personality that Rogers would use in his following seventeen films, and should not be ignored. Will Rogers is one of the American cinema's great treasures, and we should be especially grateful that this seminal film was preserved just before nitrate deterioration took its irreversible toll.

Rouben Mamoulian's Applause 1929

Rouben Mamoulian (1898-1987) showed potential as a film director for five years before he limped into a disappointing second act and then virtually disappeared. Born in then-Soviet Georgia to Armenian parents, he emigrated to the U.S. in 1923. He was a promising newcomer like George Cukor — another of the many imports from the Broadway stage around the advent of sound technology — but unlike Cukor, whose career lasted more than a half-century, Mamoulian never quite figured out how to survive and thrive within the Hollywood system. The great success of his 1927 Broadway production of *Porgy* in New York made him and everyone else think he was notably inventive, but his cinematic gifts proved limited and transitory.

Applause was filmed mostly in Paramount's Astoria studio (now the home of the American Museum of the Moving Image) and having Manhattan just across the river afforded Mamoulian the opportunity to exploit the sights and especially the sounds of the city as nobody had done before. Much of his innovation came from capturing the ambient noise of New York streets and subways — banal to us residents who tend to disregard them, but no doubt fascinating to folks outside the city. There is a genuine fluidity to Mamoulian's camerawork, but unlike F. W. Murnau or later practitioners Kenji Mizoguchi and Max Ophüls, the camera movement often seems to serve no artistic purpose other than to assert the supremacy of the image over the tyrannical sound engineers of the era. Mamoulian also, like many directors of the time, pays lip service to Eisensteinian montage in an early scene in which Helen Morgan steps off the chorus line and has a baby. Ultimately, *Applause* was probably the best of the countless backstage musicals made in the era that Al Jolson wrought, which is to say it was tawdry but tongue-in-cheek. It would not have been too surprising if all the women in the chorus line had also been pregnant.

At the heart of *Applause* is a deeply felt performance by the great Helen Morgan, then only twenty-eight. Mostly a cabaret singer, Morgan would go on to play the mixed-race Julie in James Whale's *Show Boat* (1936) before succumbing to youthful alcoholism. Her performance in *Applause* may seem a little overwrought, but there were no introductory courses on how to play this kind of role in a talking picture. She is torn

between the demands of sexual vulnerability and motherhood in a no woman's land, turf later trod by Greta Garbo in *Anna Karenina* (1935) and Barbara Stanwyck in *Stella Dallas* (1937).

Mamoulian was a hot commodity for a while, releasing a run of successful films that culminated in *Queen Christina* (1933) with its iconic Garbo performance. He tried to do something similar that same year with Marlene Dietrich (then on a break from Josef von Sternberg) with *Song of Songs*, but that fell flat, as did most of the rest of Mamoulian's career. He completed only one film after turning fifty in 1948, but his star rose again on Broadway, where he directed original productions of *Porgy and Bess, Oklahoma, Carousel,* and *Lost in the Stars*. Despite his changing fortunes, no one survived the Hollywood wars with more success.

Ernst Lubitsch's The Love Parade 1929

Ernst Lubitsch followed up *The Marriage Circle* (1924) with eight more silent films, only five of which survived. Because of his ability to draw out subtle performances from actors, by 1929 he was likely seen as one of the then-prominent directors who could succeed with sound. With *The Love Parade*, Lubitsch did not disappoint.

The Hollywood musical, which originated with Al Jolson in *The Jazz Singer* (1927) quickly led to two genres: backstage melodramas (of which Rouben Mamoulian's 1929 *Applause* was one of the best) and studio reviews (filmed vaudeville showcases highlighting some of the talent — and "talent" — then under contract to a given studio). Lubitsch went in a different direction. With his roots in Europe and operetta, he made five films in five years — *The Love Parade* (1929), *Monte Carlo* (1930), *The Smiling Lieutenant* (1931), *One Hour With You* (1932), and *The Merry Widow* (1934) — that together were the greatest sustained effort in the genre, at least until producer Arthur Freed's tenure at MGM a generation later.

Most of Lubitsch's films starred an itinerant French actor/singer/charmer named Maurice Chevalier. Chevalier had dabbled in film since 1908, but he was primarily known for his work on the musical stage in France, and was the partner of Folies-Bergère star Mistinguett, both on stage and in bed. Paired with Chevalier in *The Love Parade* was an American chorus

girl turned operetta star, Jeanette MacDonald. The two would go on to make two other Lubitsch musicals together as well as Mamoulian's *Love Me Tonight* in 1932, and they were to the early musical what James Cagney and Edward G. Robinson were to the embryonic gangster genre. The Lubitschean musical represented a new form unto itself, owing something to stage operettas, but with the director's unique flavor. Supplementing the cast of *The Love Parade* were character actors Lillian Roth (of *I'll Cry Tomorrow* fame), Eugene Pallette (whose girth and booming voice would grace many great comedies to come) and Lupino Lane (erstwhile silent clown and uncle of Ida Lupino).

Despite having few cinematic reference points at his command, Lubitsch developed a penchant for finding obscure vehicles to adapt. Most Americans were unfamiliar with stageworks, which opened up a whole field for Lubitsch to draw on. For *The Love Parade* he turned to the book *Le Prince Consort*, a decade-old fantasy by Léon Xanrof and Jules Chancel. Thanks to Lubitsch's wit and Chevalier's charm, Xanrof and Chancel's silly Sylvanian plot was elevated into something that was scintillating and entirely new to movie audiences. The director quickly learned how to integrate musical numbers into his plots to keep the magic moving seamlessly. Films like *The Love Parade* would soon provide fodder for parodies like Leo McCarey's 1933 Marx Brothers vehicle *Duck Soup*, but Lubitsch was canny enough to know that his schmaltz was understood and accepted by audiences for what it was. Sound would continue to push films toward naturalism, but in 1929 there was still room for flights of fancy.

The Love Parade was nominated for the Best Picture Oscar but lost to *All Quiet on the Western Front*, and Lubitsch lost to the Best Director statuette to Lewis Milestone. He was not nominated again until 1943 for *Heaven Can Wait* — another fantasy, this time without songs. Apparently, his interests were deemed lacking in gravitas. To counter this perception, and out of genuine conviction, Lubitsch made the antiwar film *The Man I Killed (Broken Lullaby)* in 1932.

The New York Times recently published a colloquy with the young writer Sam Wasson in which he praised the director for his unique humor and sense of timing. Reflecting on Lubitsch, Wasson remarked, "there will never, ever, ever be another. Ever. A guy like that comes around once in a universe."

Alfred Hitchcock's
Blackmail 1929

Alfred Hitchcock (1899-1980) is the leading example of a commercially successful film director who never lost his taste for innovation and experimentation. During the transition to sound, Hitchcock took the opportunity, mid-production, to convert his thriller *Blackmail* into a talkie. Still, Sir Alfred must have been anathema to those on the avant-garde fringes of film who over the course of their entire careers were never able to attract the audiences that *Psycho* (1960) or *The Birds* (1963) could in a single day. His body of work remains extremely personal and unified in its vision of a precarious universe.

No other major director so relished sharing his methodology and insights. Hitchcock's book-length colloquy with François Truffaut and his frequent television interviews are testaments to how seriously he took his profession and how conscious he was of his own artistry. A John Ford shoot was like an extended family vacation that frequently — and seemingly on accident — would produce a golden masterpiece. An Orson Welles shoot was like a rollercoaster ride; he would earn a few bucks acting in an inferior film and then summon his far-flung cast and crew to some obscure location to shoot scenes while the money lasted. With Hitchcock, virtually everything was planned and storyboarded in advance. Hitchcock considered this the real creative process; the actual filming bordered on boring routine, and he disliked contending with actors (or "cattle," as he once called them). One of the most amazing things about Sir Alfred was that he got some of the best performances out of many of the cinema's greatest actors, including Cary Grant, Ingrid Bergman, James Stewart, and Anthony Perkins, even though he must have found the process distasteful.

Hitchcock's several youthful years in Germany appear crucial to his development. He was exposed to the working methods of F. W. Murnau (then filming *The Last Laugh*, which would be released in 1924) and savored the sophisticated technical facilities at the UFA Studio. Much of Hitchcock's mature work is stylistically in synch with the lighting, camera movement, and overall style of the films that were being produced in Germany during his tenure there. Since the release of Robin Wood's book-length study of Hitchcock in 1965, there has been little doubt that Hitchcock's American films are far superior to his pre–1940 British ones. However, Hitch's basic themes and obsessions were already present in the latter, ready to be fleshed out by his growing maturity and the greater technical capabilities of American studios. Of his ten silent films, *The Lodger* (1926) remains the most interesting, and thematically and stylistically anticipates much of his later work. When sound finally came to Britain in 1929, Hitchcock was primed to test and be tested by the new medium.

As he explained to Truffaut, the wily Hitchcock expected that the producers would eventually want to release *Blackmail* as a talkie even though it was shot silent. "We utilized the techniques of talkies, but without sound. Then, when the picture was completed, I raised objections... and they gave me carte blanche to shoot some of the scenes over." Hitchcock incorporated a number of sound experiments in the film — though really, it was all still experimental then — and toyed with other innovative methods as well. Because star Anny Ondra was German and dubbing had not yet been invented, an English actress had to read her lines from just out of camera range. For a sequence set in the British Museum, he used Eugen Schüfftan's mirror effect, which he had observed at UFA when Schüfftan was doing special effects for Fritz Lang's *Die Nibelungen* (1924). This process entailed having actors perform in front of miniature backgrounds that were later enlarged.

Though *Blackmail* only touches on key Hitchcockian themes such as moral ambiguity and transference of guilt, it does mark the first time that the director uses an iconic monument (in this case, the British Museum) as a playing field for indulging his fantasies. (In *The Wrong House: The Architecture of Alfred Hitchcock*, Steven Jacobs has some interesting things to say about how the director liked to use the civilized setting of museums to heighten the sense of chaos experienced by his protagonists.) Ultimately, both silent and sound versions of *Blackmail* were released, and the latter revolutionized the British film industry during this transitional period.

Following the success of *Blackmail*, Hitchcock's immediate output was mostly an uneasy mixture of musicals, filmed stage plays, and absurdities. *Murder* (1930) is particularly interesting in how it hints at the Hitchcockian perversity to come, while *Number 17* (1932) strikes one as a dose of James Whale on a bad day. By the mid-1930s, however, Hitchcock had found the path he would tread to fame, fortune, and artistic triumph over the next four decades.

1930-1939

Lewis Milestone's All Quiet on the Western Front 1930

Lewis Milestone (1895-1980) was born Lev Milstein near Odessa, Ukraine. He immigrated to America in 1913 and served in the photographic unit of the Army Signal Corps during World War I. In 1919 he began working in Hollywood and he directed his first film six years later. Even before Milestone earned his Oscar for *All Quiet on the Western Front* (1930), he had won a "best comedy direction" statuette for *Two Arabian Knights* in 1927, beating out Charlie Chaplin's *The Circus*.

Like fellow Soviet émigré Rouben Mamoulian, however, Milestone's early promise was never truly fulfilled. After *All Quiet*, his early talkies leaned heavily on writers such as Ben Hecht and Charles MacArthur. A stage play by the pair became *The Front Page* (1931), a Somerset Maugham story was turned into *Rain* (1932), and Al Jolson was more bearable than usual in Milestone's comedy *Hallelujah, I'm a Bum* (1933). Milestone's 1936 film *The General Died at Dawn* was ersatz, but inferior, Josef von Sternberg (comparable to Mamoulian's *Song of Songs* three years earlier) and Milestone made two watchable Steinbeck adaptations, *Of Mice and Men* (1939) and *The Red Pony* (1949). Many of his later films are forgettable.

Though World War II provided an opportunity for Milestone to rejuvenate the reputation he had established with *All Quiet*, his output during this period — *Edge of Darkness*, *The North Star* (both 1943), *The Purple Heart* (1944), *A Walk in the Sun* (1945), *Arch of Triumph* (1948), an adaptation of another novel by *All Quiet* author Erich Maria Remarque, and *Halls of Montezuma* (1950) — only intermittently tipped the scales in his favor. Similarly, the Korean War resulted in just another war film, *Pork Chop Hill* (1959). The fact that his career climaxed with the Rat Pack's version of *Ocean's 11* (1960) and *Mutiny on the Bounty* (1962) starring Marlon Brando as Fletcher Christian, doesn't lend much to the argument that Milestone had a coherent worldview. Andrew Sarris got it right when he described Milestone as "almost the classic example of the uncommitted director."

Hollywood could hardly have been more jingoistic in the period surrounding the First World War. On the screen, spies of various nationalities seemed to be swarming everywhere, and it is a wonder that Erich von Stroheim, the archetypal celluloid Hun, ever had time to sleep. But by the time King Vidor's enormously popular *The Big Parade* (1925) was released, the film industry found it safe to question whether war was such a good idea after all. America was returning to its isolationist roots, a process hurried along by the Great Depression and a growing number of disillusioned veterans. *All Quiet on the Western Front* caught the wave of pacifism sweeping both America and Europe at the end of the 1920s. The arrival of the novel in 1929 and the release of the film starring Lew Ayres the following year could not have been timelier. Remarque's book was a worldwide success, and the film made lots of money. In addition to Milestone's Oscar for directing, the movie won an Academy Award for Best Picture and was nominated for screenplay and cinematography awards. Some of the credit for the film should probably go to dialogue director George Cukor, a recent recruit from Broadway who began directing his own films that same year.

It was recently reported that a remake of *All Quiet* is in the works with *Harry Potter's* Daniel Radcliffe. (Radcliffe already died once in the World War I trenches, playing Rudyard Kipling's son in the 2007 television drama *My Boy Jack*.) Presumably the remake will remain faithful to the original film and novel, and attempt to cast a cold eye on warfare. This, however, was a problem for Milestone many years ago, and it remains a problem in film today. There is an inevitable pageantry in cinematic warfare that can work against whatever pacifist intentions a filmmaker might have. Milestone and his trio of top cameramen (Arthur Edeson, Karl Freund, and Tony Gaudio) had such facility for capturing the intrinsic spectacle of battle that, in Sarris's words, "the orgasmic violence of war is celebrated as much as it is condemned." For me, the most accomplished pacifist film set during World War I is Joseph Losey's *King and Country* (1964). It is bleak, laid back, and almost nonchalant in its acceptance of the grim reality of war. Tom Courtenay's character in that film is a clear descendant of Ayres — a nobody and an everyman, a young man tragically caught up in the mindless irrationality of nationalism and patriotism.

G. W. Pabst's Westfront 1918 1930

After he directed *Pandora's Box* in 1928, G. W. Pabst made two more silent films: a Louise Brooks vehicle, *Diary of a Lost Girl* (1929), and in collaboration with Arnold Fanck, *The White Hell of Pitz Palu* (1929), a mountain film starring Leni Riefenstahl. His first sound film, *Westfront 1918*, was based on Ernest Johannsen's anti-war novel *Vier von der Infanterie*. Unfortunately, both the book and film were buried under the international wave of acclaim for Erich Maria Remarque's *All Quiet on the Western Front* and Lewis Milestone's 1930 adaptation.

This is too bad, because Pabst's film is arguably better than Milestone's. Both are revisionist and unbridled in their pacifist propaganda, but as critic Siegfried Kracauer suggested in a 1930 review, Pabst's film goes beyond conventionally slick cinematic exposition to take an almost a documentary look at the horrors and claustrophobic tedium of World War I. In this effort, Pabst was aided immeasurably by the fluid camerawork of veteran cinematographer Fritz Arno Wagner, who had shot Fritz's Lang's *Destiny* (1921) and *Spies* (1928), several F. W. Murnau films including *Nosferatu* (1922), and Pabst's *The Love of Jeanne Ney* (1927). Though *Westfront 1918* is in some ways a mirror image of *All Quiet on the Western*

Front in its portrayal of the horrors and tedium of war, there are key differences. When Pabst's protagonist goes home on leave, he discovers poverty and his wife in bed with another man. Ultimately, he returns to the front to take on a suicidal mission.

The late 1920s and early 1930s were, indeed, dark days in Germany. In commenting on *Pandora's Box*, I pointed to the confusing patterns of Pabst's life and career during and after this period. The left-wing tendencies evident in *Westfront 1918*, *The Threepenny Opera* (1931), and *Kameradschaft* (1931) — the three major sound films he made before briefly departing Germany — seem totally out of synch with his later return to the Third Reich, even if his Nazi-era films were not overtly political. Charles Shibuk, writing in *The New York Film Bulletin*, praised the first half of *Westfront 1918* as "easily recognizable Pabst — if one can indeed call anything typical from this illusive figure who is unquestionably the most baffling and half understood major talent in the history of the cinema." In contrast to Milestone, who Andrew Sarris designated an "uncommitted director," Pabst, if anything, seemed overcommitted but confused by the troubled times in which he lived and worked.

Pabst's films in Hollywood, France, and back in Germany show little of what Lotte Eisner called his "great visual gifts": his talent for sophisticated Expressionism. Eisner, however, also found him to be "full of contra-dictions" and refers to Harry Alan Potamkin's view that "Pabst never got to the root of the problems inherent in his art, but merely skimmed over the surface of his subjects." I share in the view that the director was something of an elusive enigma. Pabst left us with several early master-pieces and a very clear statement of auteurist principles: "I remain certain that in the cinema the text counts for very little. What counts is the image. So I would still claim that the creator of a film is much more the director than the author of the scenario or the actors."

Howard Hawks's The Dawn Patrol 1930

Like his friendly rival John Ford, Howard Hawks (1896–1977) began his career as a Hollywood property man, moving furniture and performing other menial tasks. Hawks did this while in school, and he went on to get a degree in mechanical engineering from Cornell. This explains why his films reflect the precision of an engineer

and the erudition of a college boy. (Ford, by contrast, spent about two minutes in college.) After a stint in the Army Air Corps and a job designing airplanes, Hawks wound up directing his first film at the Fox studio – where Ford was also under contract – in 1926. The two worked on parallel tracks for decades, proving themselves better than most directors at balancing personal expression with the demands of the studio system.

According to scholar Gerald Mast, "Hawks was perhaps the greatest director of American genre films" regardless of which genre he was working in. Hawks tackled gangster films (*Scarface*, 1932), film noir (*The Big Sleep*, 1946), screwball comedies (*Bringing Up Baby*, 1938; *His Girl Friday*, 1940), musicals (*Gentlemen Prefer Blondes*, 1953), science fiction and horror (*The Thing*, 1951), and war films (*Sergeant York*, 1941). With regard to Westerns (*Red River*, 1948; *Rio Bravo*, 1959; *El Dorado*, 1966), he was Ford's only genuine competitor. And, of course, he had great affection for airplanes, as demonstrated by *The Dawn Patrol* (1930), *Ceiling Zero* (1936), *Only Angels Have Wings* (1939), and *Air Force* (1943). Then there was what amounted to his own genre, which we could call "Hawksian." These films, which include *A Girl in Every Port* (1928), *Tiger Shark* (1932), *To Have and Have Not* (1944), and *Hatari!* (1962), generally focus on a group of professionals living and working in an exotic milieu, and revolve around their interactions and the limits of their professionalism. (Speaking of *Tiger Shark*, would you believe that I once advised a young, little-known filmmaker to see it before making a movie about a shark? That director's name was Steven Spielberg.) All these films and many more contain threads of Hawks's personality, obsessions, and his view of the world. In short, he was an authentic auteur.

Richard Barthelmess was easily the most accomplished actor among the silent screen heartthrobs – a group that included Douglas Fairbanks, John Gilbert, Rudolf Valentino, George O'Brien, and Charles Farrell, among others. His performances for D. W. Griffith in *Broken Blossoms* (1919) and *Way Down East* (1920) and for Henry King in *Tol'able David* (1921) were outstanding, and he was nominated for the first Oscar for acting in 1928. Barthelmess lost to Emil Jannings, although he should have lost to Charlie Chaplin. Barthelmess provided Hawks with the exact level of intensity needed in *The Dawn Patrol*, giving a very different performance from the one a laid back Errol Flynn would in Edmund Goulding's 1938 remake. Opportunities for Barthelmess began to disappear by the mid-1930s as his boyishness faded, but Hawks gave him one last great supporting role in *Only Angels Have Wings* (1939), and the actor held his own opposite Cary Grant and Thomas Mitchell.

An aviation genre had grown out of William Wellman's Oscar-winning silent *Wings* (1927), which was released the same year as Charles Lindborgh's solo flight across the Atlantic. Frank Capra and Ford put out aviation movies, and Hawks released *The Dawn Patrol* even though two of his brothers had been killed in a crash eight months earlier. The film reflects the fatalism of professional men following their calling in spite of serious danger. "Each character becomes trapped between the inevitability of his situation... and his own personal feelings," distinguished film historian John Belton suggests. "They give themselves willingly over to their mission and resolve their tensions through cathartic action." Hawks's representation of this kind of commitment established a standard that would be taken up by Paul Muni (*Scarface*, 1932); Edward G. Robinson (*Tiger Shark*, 1932); James Cagney (*The Crowd Roars*, 1932); Cary Grant (*Only Angels Have Wings*, 1939); Gary Cooper (*Sergeant York*, 1941); Humphrey Bogart (*To Have and Have Not*, 1944); John Wayne (*Rio Bravo*, 1959); and so many others.

It should be pointed out that although *The Dawn Patrol* doesn't feature any Hawksian women such as Louise Brooks, Ann Dvorak, Carol Lombard, Katharine Hepburn, Jean Arthur, Rita Hayworth, Barbara Stanwyck, Lauren Bacall, or Angie Dickinson, in Hawks's movies women are as strong, independent, and well-defined as their male counterparts.

These lists of some of the greatest names in cinema attest to Hawks's mastery of the medium and of the Hollywood studio system. Across a host of genres, the director managed to make films that were a testament to both his genius and personal vision.

D. W. Griffith's
Abraham Lincoln 1930

D. W. Griffith came to the end of his career in 1931. It is now time to bury and praise him. He remained an enigma until his final film. *The Struggle* (1931) was a passionate plea against alcohol made by a committed, unredeemable, and self-destructive drunk. If *Abraham Lincoln* (1930) was intended as some sort of apologia for *The Birth of a Nation* (1915), the director seems to have missed the point of the outrage he inspired. Although the latter film deified his

fellow Kentuckian, Abe Lincoln, and showed tolerance toward that butcher of Confederates, Ulysses S. Grant, Griffith barely acknowledged the existence of blacks, much less their centrality to the Civil War.

Both of these last films, Griffith's only talkies, now appear old-fashioned. There is an awkwardness about them, and not just due to the director's struggles with unfamiliar and primitive sound equipment. Much of *Abraham Lincoln* looks like vintage Griffith: it contains historical tableaux, recreations of highlights from *The Birth of a Nation* such as the departure of Confederate soldiers and the assassination of Lincoln, and Henry B. Walthall doing a reprise of his "Little Colonel." Yet the simple fact is that much of Griffith's best, from the Biograph films on, look old-fashioned to modern audiences. One must see these films in the context of their times. As a wise man once said, "masters have no age."

(Actually, there is a bit of prescience in a scene featuring a cowardly young soldier who is pardoned by Lincoln, played by Walter Huston, for desertion during the heat of battle. Twenty-one years later, Huston's son John would direct a Griffith-esque adaptation of Stephen Crane's *The Red Badge of Courage* starring Audie Murphy in a similar role. Both Griffith and Walter Huston had just recently died, but were they able to see movies wherever they wound up, one might imagine a telling wink passing between them.)

There are also some fine battle scenes in *Abraham Lincoln*. The post-Bull Run montage and *The Battle Cry of Freedom* sequence are rousing, and they suggest Griffith's growing command of the new medium. Huston, consistently one of the best actors in early American talkies, is fully up to the iconographic task at hand. We have become cynical about politics and politicians, but when the film was made audiences were closer to the Civil War than they were to our era, and the Lincoln Memorial had just been recently erected. There was a level of feeling about Lincoln and his saving of the union — even among defenders of slavery like Griffith — that today we simply can't grasp.

There's that word again: "feeling." When I first introduced Griffith's Biograph films, I quoted Henri Matisse: "My purpose is to render my emotion. I think only of rendering my emotion." In suggesting a kinship between Griffith and Matisse, I pointed out that "Griffith's great genius was an intuitive understanding of the inherent power of the movies to render emotion, to evoke feeling." So, we have come full cycle. Griffith, whatever his innovations and faults, made us care about Blanche Sweet, Mae Marsh, Lillian Gish, Richard Barthelmess, and,

shockingly and for a foolish moment, about the KKK. He certainly had his highs and lows. The country boy who returned from the big city — first in triumph and later in tragedy — now lies in a rural Kentucky churchyard, far from the madding crowd. One can imagine Gish's True Heart Susie stopping by to put flowers on his grave. (Gish had, in fact, helped arrange the funeral.) Like Thomas Hardy, whose novels anticipated many of the director's films, Griffith left an indelible mark on his chosen medium.

Raoul Walsh's *The Big Trail* 1930

Raoul Walsh, like Howard Hawks, made films across a range of genres and carried an aura of robust masculinity. Unlike Hawks, however, Walsh's films often lacked the gravitas and profundity of great art. In saying this, I don't intend to be dismissive. Walsh was certainly a cut above the good jack-of-all-trades directors of his generation, such as Allan Dwan, Tay Garnett, Henry Hathaway, and Michael Curtiz, but, as Andrew Sarris suggests, Walsh's perspective is often that of "the lost child in the big world." For Walsh, it seems making movies was more fun than ever fully growing up. Fortunately for him and for us, fun sold tickets in his day, just as pomposity, pretension, and tedious digital effects seem to fill seats in our age of matrices and inceptions.

The Big Trail was one of a handful of Hollywood features made using the Grandeur widescreen process in 1930 — an approach that proved commercially untenable for an industry still in the midst of the conversion to sound. Walsh tried to take full advantage of the new technology by capturing as many spectacular Western locations as possible in the film, which depicts the opening of the Oregon Trail via a wagon train traveling west from the Mississippi. (In the 1980s, Peter Williamson, MoMA's film preservation officer, went to great lengths and considerable expense to restore *The Big Trail* to its widescreen majesty, and that was still less expensive than the original production.) Of the film, critic Fred Camper wrote: "Walsh has given us a rare vision of nature, one that is not man-centered; his film is permeated with a powerful, mysterious sense of an always-looming, weighty, abstracted empty space... a true metaphor for trackless wilderness." Camper concluded that "the presence and meaning that [Walsh] gives to empty space in *The Big Trail* make it about as close as Hollywood has ever come to creating a genuinely abstract film."

But there are actors in *The Big Trail*, and they are a decidedly mixed bag. El Brendel, playing the pseudo-Swedish "comedian" Gussie, was actually Elmer Goodfellow Brendle, a Philadelphia-born actor who affected a phony German accent until the sinking of the Lusitania. (I've been after Peter for years to find a surreptitious way to excise Brendel's laboriously unfunny presence from numerous early Fox talkies. If he ever succeeds, well, to quote the actor, "yumpin' yimminy.") Tyrone Power, Sr. was once some kind of matinee idol, but by the time he was cast as Red Flack in *The Big Trail* he was a burly, grizzly grotesque – the total antithesis of Tyrone, Jr., a somewhat callow and effete leading man whose film career began two years later. Tully Marshall, who played Zeke, spent thirty years playing mostly leering villains. (Walsh commented in his autobiography that Marshall's false teeth "made him look like an amiable horse.") Ward Bond, who would later star in John Ford's *Wagon Master* (1950) and the television series *Wagon Train*, was presciently assigned by Walsh to manage the wagons in *The Big Trail*. Marguerite Churchill plays the pretty heroine, and off-screen wound up marrying George O'Brien, one of Ford's favorite leading men.

Then there was Marion Michael Morrison, the guy Walsh and Fox rechristened "John Wayne." He had moved props for Ford while in college, and been cast in a few minor speaking parts in the director's early talkies. It's clear Walsh saw something in Wayne that Ford had missed – as he put it, "a winner." Wayne was to become the archetypal Western hero in the films of Ford and Howard Hawks, the best ever made in that most American of genres. No actor personified the dominance of American cinema – and film's ability to create lasting mythologies – more than "Duke" Wayne.

However, this legacy was almost lost. Wayne spent the decade after *The Big Trail* in B-grade Westerns. (Unlike the more lavish and expensive A-Westerns, B-grade Westerns were quickly made potboilers with almost identical plots and lots of horses. They first appeared in the silent years but were mass-produced in the 1930s and 1940s. I spent much of my pre-adolescence watching many of them every day on New York's Channel 13 before the advent of "educational television" deprived me of this guilty pleasure.) Wayne was one of my early heroes, and as a more mature actor he became an icon. Ford finally got it in 1939 and "rediscovered" Wayne in *Stagecoach*. The pair went on to collaborate for a quarter-century, and Ford, helped in no small measure by Wayne, became one of the best American filmmakers.

(There is much irony in the fact that George O'Brien became a B-Western regular after a falling out with Ford and only returned from purgatory when the director brought him back to support Wayne in a few late films.) Although there is a certain awkwardness in Wayne's performance in *The Big Trail* (one typical of almost all actors in early talkies), there is also a naturalness and genuineness that presages his later work in some of our greatest films. If Raoul Walsh never made any movies after *The Big Trail* – and fortunately for us, he made several dozen – we would still be in his debt for discovering "a winner."

Josef von Sternberg's
Morocco 1930

On March 31, 1930, Marlene Dietrich appeared on the stage of Berlin's Gloria Palast for the premiere of *The Blue Angel*. Later that very night, she set sail for America and *Morocco*. *The Blue Angel's* director, Josef von Sternberg, had long ago departed for Hollywood and expected never to see the actress again. Yet Dietrich had placed a copy of Benno Vigny's play *Amy Jolly* in a bon voyage basket to the director, deeming it "weak lemonade." In this Sternberg found *Morocco*, and he arranged for Paramount to sign Dietrich and have her star in what would become his warmest and best film.

The early talkie was a slave to the microphone and its bulky soundproof booth. Most filmmakers succumbed to the public fixation on dialogue, and few paid any heed to the once all-important visual quality of their films. A few directors did however dabble in sound experimentation, and several developed eccentric effects that relieved at least some of the tedium and suggested new avenues for the creative use of sound. Among his other contributions, Sternberg was the first director to attain mastery and control over this new medium by restoring the fluidity and beauty of the late silent period. One of the key elements of his innovation was that he understood the value of silence. *Morocco* contains long sections sustained only by stunning visual beauty, and others augmented with appropriate music and aural effects. Sternberg was the first artist to demonstrate how sound could be an authentic cinematic virtue.

Furthermore, the exotic nature of the film's locale liberated Sternberg's romantic tendencies. From the first shots of the Foreign Legion marching past

bare-breasted natives and arrogant camels, it is evident that what is to follow will be at the very least a spectacular display of stylistic imagination. Sternberg's style relies on dazzling camera movements, delicately textured effects of light and shadow, expressive décor, and the precise gestures of a high-powered cast consisting of Dietrich, Gary Cooper, and Adolphe Menjou. All of these elements come together brilliantly to create a sultry, crackling ambience in which actors obsess over their sexual desires.

The triangulated relationship between Cooper, Dietrich, and Menjou provides *Morocco* with a unique level of tension that persists up until the very last shot. Dramatic tension, like other intangible commodities, is almost impossible to adequately discuss, yet it is the stuff of Sternberg's narrative genius. He is able to visualize emotionally obsessive sexual relationships, embellish them through milieu, and express it all through subtle movements of eyes, mouths, and hands.

In 2001, I lectured on the film in Rabat, Morocco. I fear that many of the local Moroccans couldn't quite figure it out. Of course, Sternberg's depiction of Morocco is not exactly sensitive or sympathetic. It is, however, picturesque, and since he has never been accused of an interest in social commentary, the director's respectful visualization of Morocco's otherness may vindicate its shortcomings. Sternberg's ravishing, ersatz Morocco compensates for superficiality with beauty. (The director would bare his artistic soul in a similar manner two years later with a sumptuous take on the Chinese Revolution in *Shanghai Express*.) And the Moroccan government seems to have recognized the film's merits. It advertised in *The New York Times*: "Representatives of Morocco's tourist industry hope that visitors will be seduced, just as Gary Cooper was, and will want to return again and again to this country filled with unforgettable landscapes and engaging people."

The film's unforgettable ending works dramatically because it comes at a moment of panic after Dietrich has already been brought to the brink. Sternberg said, "the average human being lives behind an impenetrable veil and will disclose his deep emotions only in a crisis which robs him of control." Dietrich's character, Amy Jolly, had hidden behind her veil for many years and many men, and her emergence, her decision to sublimate fear and pride to desire, is one of the most supremely romantic gestures in film. It is a measure of today's cynicism that no contemporary artist today would dare attempt what Sternberg accomplished in 1930.

René Clair's Under the Roofs of Paris 1930

René Clair (1898–1981), a disappointed poet, novelist, and actor, lived and worked on the fringes of the French Surrealist movement in the 1920s. In total, he made eight silent films of varying lengths – most notably, *The Italian Straw Hat* (1927) – and established a reputation for humor and fanciful imagination.

In spite of his reservations about sound film, no French director (and very few others) got off to a better start in the new medium than Clair. *Under the Roofs of Paris* relies little on spoken dialogue and plot complications. A lyrical homage to a rapidly disappearing Paris, the film now seems like a gift to unreconstructed romantics – a lilting time capsule that floats buoyantly, like Clair's crane shots, above the fray of life.

Much of the film's beauty can be credited to Clair's choice of collaborators. Cinematographer Georges Périnal worked with Marcel L'Herbier and Jean Cocteau before filming Clair's early talkies. Then, like Clair, he went to Britain in the 1930s to work for Alexander Korda's London Films, making several gorgeous movies in Technicolor. Périnal's late work included Charlie Chaplin's *A King in New York* (1957) and Otto Preminger's *Bonjour Tristesse* (1958). Credit is also due to Armand Bernard for arranging the music, and to Raoul Moretti and René Nazelles for the still-unforgettable title song.

However, no one deserves more credit apart from Clair than Lazare Meerson, the brilliant Russian-born art director who began designing for L'Herbier at age twenty-five. He worked with nearly all the significant French directors of the period and collaborated with Clair on seven films before making the seemingly requisite trip to Kordaland and dying at the shockingly young age of thirty-eight. Meerson's allegiance to the concept of "poetic realism" seemed a perfect fit for Clair, and his sets for *Under the Roofs of Paris* are probably Meerson's most memorable, although he made nearly sixty pictures in only thirteen years.

Clair made two more masterpieces the following year, *Le Million* and *À nous la liberté*, before his gift for invention began to run out. If he had died young (like Jean Vigo), we would probably venerate him more for the films he would never make. The reality was that, like Rouben Mamoulian in America, Clair's inspiration began to flag after a few glorious years. He made two more films in France after *Under the Roofs of Paris*, two for

Korda in Britain, and then spent World War II in Hollywood where he released four features before returning to France in 1946. None of his pre- or postwar work was all that bad, but the promise of his early years did not materialize in these intermittently interesting but seemingly unengaged works, some of which could be deemed highly honorable failures. Clair seems to have been an honorable, literary, and decent man, who, like Julien Duvivier, was unfairly targeted by the *Cahiers du Cinéma* crowd in the 1950s for perhaps being too literary. Yet Jean Renoir, "godfather" of the New Wave, had been close to both men during their shared Hollywood exile, and his judgment is generally good enough for me.

Julien Duvivier's David Golder

1931

Whatever reputation Julien Duvivier (1896-1967) once possessed has been largely eclipsed in recent years. Major films like *La belle équipe* (1936) and *Un carnet de bal* (1937) are rarely shown, and *Pépé le moko* (1937) does not live up to its legend. Even as *David Golder* was being filmed, Duvivier was laboring in the massive shadows of Jean Renoir and René Clair, a condition that continued through the 1930s and in the wilds of Hollywood among wartime exiles.

Unlike his compatriots, Duvivier generally lacked a strongly defined personality and distinct visual style. *David Golder*, a film about the moral dimemma of a Jewish tycoon as he faces a kind of retribution for his sins, is an eclectic compendium of the aesthetic trends of the time. It makes use of Murnau's probing subjective camera style (often with extraordinary fluidity and grace for 1931); Eisensteinian montage; expressionistic lighting and spatial arrangement; and even the occasional "abstract" image, such as an overhead shot of the deserted stock exchange. Eclecticism, of course, is hardly a vice in itself – *vide Citizen Kane* (1941), a film that *David Golder* curiously anticipates.

The film opens with a prologue telling us we are about to learn the previously obscured truth about the public life of a great mogul. Golder's possessions are, of course, stamped with the monogram "G" rather than "K", but the themes of loneliness and loss of innocence amidst worldly success are the same in *David Golder* as they are in *Citizen Kane*. Duvivier's use of Kaddish is

just as ingenious and evocative of Golder's tragedy as a score by Bernard Herrmann might have been.

It is difficult to think of a place or period in cinematic history as rich in variety and abundance of acting genius as France was in the 1930s. Duvivier's greatest strength, fortunately, was his direction of actors. At the heart of *David Golder* is a tour de force performance by Harry Baur, who was as subtle and moving in it as he would be excessively overblown in Maurice Tourneur's *Volpone* (1939).

It is inconceivable but true that Mordaunt Hall reviewed the film for *The New York Times* without mentioning that the protagonist was Jewish. Although Duvivier presents Golder very sympathetically in the context of his roots (he is the product of a Polish ghetto and a "Jew peddler of New York"), some other characters must be viewed as mere stereotypes. Duvivier has total compassion for Golder as he is betrayed by family and friends and gradually gains self-awareness. However, one might suggest that there is almost as much leer in the director's perspective on the Jewish experience as there is Lear in Baur's depiction of the central role. As Renoir was to later prophesize, the rules of the game for Jews were as different in "civilized" France as they were in the rest of Europe. Marcel Ophüls also painfully documented this decades later in *The Sorrow and the Pity* (1969). Harry Baur's death at the hands of the Nazis was a very personal testament to the precariousness of tolerance and civility in a world where decency is paid far greater service with words than deeds.

Charlie Chaplin's City Lights 1931

City Lights **is Charlie Chaplin's most perfectly** accomplished and balanced work. It is certainly on the shortlist of films I would care to be stranded with on a desert island.

By 1931 the silent cinema was effectively dead. It took considerable courage to lavish two years of rather expensive production on a silent film (and it took even more courage to make *Modern Times* five years later), but Chaplin felt he had very little choice. He correctly perceived that the Tramp would lose his poetry and grace if he were coerced into the leveling mundanity of human speech. He foresaw that sound would force him to sacrifice the "pace and tempo" he had so laboriously perfected.

Chaplin, like most intellectuals of the period, saw no real advance in the replacement of silent films by ones

that talked, or, even more commonly at the time, squawked. A few directors such as Josef von Sternberg, Ernst Lubitsch, René Clair, Howard Hawks, and King Vidor did admirable work distilling the better qualities of both sound and picture during the early years of talking movies. Ninety-nine percent of the films that were released while *City Lights* was in production, however, were ghastly and far below the standards of 1928, the last year silent cinema dominated in America.

City Lights uses sound in the form of a synchronized track for Chaplin's own purposes, poking fun at the talkies and establishing moods through a musical score composed by the director. Chaplin was adamantly eloquent in his wordlessness, and achieves the ever-essential goals of conveying feelings and asserting the primacy of the heart. As *Monsieur Verdoux* (1947) and *Limelight* (1952) were later to prove, he was not at a loss for words; rather, he believed words themselves were a loss. They were intrinsically cheaper and less emotionally exalting than what Jean Cocteau called "the language of the heart" — the language of mime.

Eventually, the realities of commerce and age prompted him to make five sound films without the Tramp, but he held out against "progress" for more than a decade, making perhaps his two greatest films while sailing against the prevailing winds.

Although the Tramp never changed, Chaplin inevitably did. By the time of *City Lights*, he was in his forties and his hair had turned white during the course of legal disputes with his ex-wife, Lita Grey. He also perceived that the world was getting uglier around him. The threat posed by sound films and his increasing loneliness must only have added to his perplexed views of modernity. Yet somehow, in spite of this — or because of it — *City Lights* contained a lyrical romanticism that was far more intense than in Chaplin's earlier work. Like all romantic works, the film depended on the denial of the present, a retreat from reality.

Virginia Cherrill's blindness, which keeps her from realizing that Chaplin is a tramp, provides *City Lights* with some of its funniest moments. In his interactions with her, the Tramp is reminded of how precarious the romantic ideal is in the modern world even as he demonstrates his chivalry and stoic gallantry. When the two first meet, Chaplin slips back to watch her get fresh water from a fountain, which she then unwittingly throws in his face. He brings her a bag of groceries, has her feel each item, and is confounded by the problem of which end of a duck is appropriate for her to touch. He holds a skein of wool for her to ball, but she mistakenly grabs a loose thread from his long johns, and he writhes in noble discomfort while she unravels his underwear.

The film reaches its climax when the Tramp is given the opportunity to restore the girl's sight, which he does, destroying the illusion upon which their relationship is based. Revealing himself as the Tramp is a risk he must take, and it's a decision made monumental by Chaplin's experiences with unreliable women in earlier films (and previous real-life marriages). Chaplin knew that one of the consequences of blindness was the inability to experience that which was the center of his life, the medium through which he felt most fully alive: the motion picture. By providing the girl with the ability to see, he metaphorically gave her the most precious gift he had to offer — himself. Perhaps he sensed it was safer to relate through celluloid; that however unstable and combustible it might be, it is still more dependable than acting on the unreliable passions of the flesh.

So the risk is taken, and the girl sees that her chevalier is a bum. Their reunion is profoundly austere and awesomely moving in its ambivalence. We will never know if the girl can see beyond her sight and beyond Charlie's wrinkled smile, timidly hidden behind a rose. What I think we do know is that final scene of *City Lights* is, in James Agee's words, "the highest moment in the movies."

F. W. Murnau's Tabu 1931

F. W. Murnau made six or seven great or near-great films during his all-too-brief career. All save his last film were tightly controlled, studio-stylized works that, despite being beautiful and often moving, were thoroughly planned artifice. His final film is almost the complete antithesis. *Tabu* is one of the simplest, most lyrical, and most masterful expressions of a despairing romanticism forced to succumb to the realities of a world from which none of us can escape.

The original idea was that Murnau would collaborate on the film with the great ethnographic documentarian Robert Flaherty, who had already enjoyed critical success for another Polynesian project, *Moana* (1926). Although Flaherty was a romantic in his own fashion, the two did not mesh, and Flaherty somewhat bitterly sailed home. Murnau, after his relative imprisonment in Weimar Berlin and mad Hollywood, loved Tahiti, Bora Bora, and the smaller islands. Their informality and laxity towards behavioral strictures

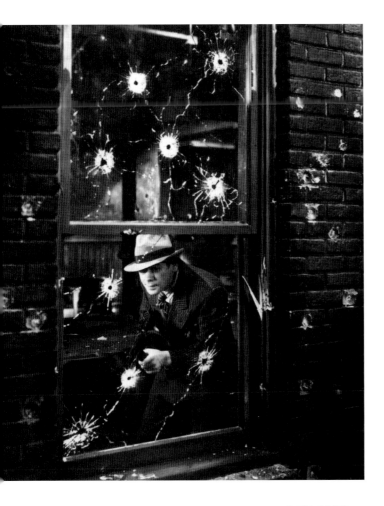

SCARFACE: THE SHAME OF A NATION. DIRECTED BY HOWARD HAWKS.
1932. USA. BLACK AND WHITE, 93 MINUTES.

(including sexual ones) offered him a kind of rebirth.

Murnau had very little money and relatively primitive equipment to work with. He was freed, however, from studio-imposed shooting schedules and all the annoyances of film capitals. In the islands he was mostly his own man, left to entertain visitors such as Henri Matisse. Working with cinematographer Floyd Crosby in the lush wilds of Polynesia must have been totally different from the claustrophobia of studio sets with their vast numbers of production people and hangers-on. Crosby went on to win an Oscar for *Tabu*, and launched a career that ranged from making documentaries for Pare Lorentz and Joris Ivens to exploitation films for Roger Corman.

In his book *The Age of Wonder*, Richard Holmes traces Charles Darwin's inspiration to set sail on his voyages of discovery back to Joseph Banks, a naturalist who had accompanied Captain James Cook to Tahiti in 1769. Banks spent three months on the island before returning home and becoming the leading figure in British science during the Enlightenment. Reviewing *The Age of Wonder* in *The Nation*, Paula Findlen observed that in Tahiti, "Banks had temporarily become a different man. Freed from the trappings of his own society, he had allowed himself to be seduced by Tahitian customs, the seeming ease of social relations and the rhythm of rituals. Banks... did not conceal its effect on his psyche."

Murnau seemed to have experienced a similar change. Film historian Tom Waugh suggests that only in *Tabu* did Murnau "seem to have peace and a little happiness in surroundings which abolish the guilt-feelings inherent in European morality." Murnau was homosexual, and Waugh believes that he attained a degree of spiritual liberation by observing the guiltless behavior of the natives during his extended sojourn in the islands, where Murnau lingered as long as possible before returning to California.

Regardless of whether *Tabu*'s success can be attributed to Murnau finally finding a truer path to genius, or, more mundanely, because it forced him to work without money, the film is a great treasure to lovers of cinema. Its haunting imagery is intrinsically lovely, its rhythms unique, its denouement overwhelming. Part of the legend of *Tabu* is that Murnau moved a sacred rock to better place a camera. Some believe what happened next was related: Back in California, returning from a trip to collect money for the film's soundtrack, Murnau's car went off the road and he was killed. Whatever one thinks of this story, the potential for more great cinema died with him.

Howard Hawks's Scarface: The Shame of a Nation 1932

Over his forty-four-year career, Howard Hawks was arguably the most consistently successful of all directors in satisfying the commercial demands of the Hollywood studio system while simultaneously maintaining a high level of personal expression in his films. One might say he was the "auteur's auteur." It helped a great deal that he was proficient in so many different genres.

The modern gangster film essentially began with Josef von Sternberg's *Underworld* (1927) starring George Bancroft, but the advent of sound solidified the genre's

popularity. Warner Brothers specialized in treating viewers to screeching sirens and rhythmic tommy-guns, and the studio scored big hits with Edward G. Robinson in Mervyn LeRoy's *Little Caesar* (1930) and James Cagney in William Wellman's *Public Enemy* (1931). Much of the flak that Hawks took for *Scarface* had to do with how likable his brutal and bloody underworld characters were. Hawks very much admired professionalism and dedication to one's work, and since the occupation in this instance was crime, Hawks was accused of glamorizing unlawfulness and mythologizing its subject matter. Similar criticism can be directed at the movies mentioned above, and one might argue that sympathy for the bad guy became even more pronounced in films such as Ridley Scott's *American Gangster* (2007) and Michael Mann's *Public Enemies* (2009). (When I lived in Chicago, the former headquarters of Al Capone, the real Scarface, was just down the block, and I think the neighborhood took a certain perverse pride in this notoriety.)

It's ironic, disconcerting, and in today's parlance, politically incorrect that the non-ethnic LeRoy and Wellman and the ultra-WASP from Indiana, Hawks, made signature films on Italian and Irish hoodlums. But then, it is probably more ironic and offensive that Italian mobsters were played by Jews born in the Austro-Hungarian Empire. Paul Muni was, in fact, a veteran of the Yiddish Art Theater in New York. His first trip to Hollywood had been unsuccessful, and *Scarface* marked a kind of triumphant return to the movies. Muni quickly became *the* serious movie actor — at the expense of perhaps more gifted compatriots — winning Oscars for *The Story of Louis Pasteur* (1936) and *The Life of Emile Zola* (1937). Muni was not a bad actor. He was highly effective in those roles, as well as in *Scarface* and *I Am a Fugitive from a Chain Gang* (1932). However, the 1930s also brought us James Stewart, Cary Grant, Henry Fonda, James Cagney, Ronald Colman, Charles Boyer, Spencer Tracy, Humphrey Bogart, and others who had, I think, a wider range than Muni.

As he almost always did during his prime, Hawks assembled a superb cast. This included George Raft (for whom this was a breakthrough role), Karen Morley, and Ann Dvorak. Ben Hecht, who wrote the original story for *Underworld* and who knew his gangsters, brought his special brand of humor to the script. He later worked with Hawks on adapting *The Front Page*, a play he cowrote with Charles MacArthur, into *His Girl Friday* (1940). Lee Garmes, Josef von Sternberg's great cinematographer, lent *Scarface* a stylish and striking visual quality that is rare in Hawks's films. The director would go virtually unrecognized by the Hollywood establishment for nearly another decade before being nominated for an Oscar for the relatively minor *Sergeant York* (1941).

Ernst Lubitsch's
Trouble in Paradise 1932

Ernst Lubitsch somehow remained true to his own idiosyncratic style of filmmaking even though he had what amounted to about a half-dozen separate but overlapping careers. Over the course of his thirty-some years behind the camera, he developed a sophistication and assurance that marked him as one of the great directors. He started off with a certain pioneering crudity, and between 1914 and 1918 often appeared onscreen in his native Germany as a Jewish caricature. Later comedies like *The Oyster Princess* and *Die Puppe* (both 1919) were far more mature. The historical spectacles he made between 1919 and 1923 were heavily influenced by D. W. Griffith, and were good enough to win him an invitation from Mary Pickford to come to Hollywood.

In California, as the first of many major European directors to venture to our shores, he introduced new levels of visual wit and ripeness (the "Lubitsch touch") though a series of romantic comedies made between 1924 and 1926. Of all the great silent comedy directors — including Charlie Chaplin, Buster Keaton, and Mack Sennett — only Lubitsch made an immediate and prosperous transition to sound. Lubitsch's musicals, such as *The Love Parade* (1929), helped compensate for the mostly dreadful films of the early talkie period. Finally, beginning with *Trouble in Paradise* and lasting almost until his untimely death, he developed what was essentially his own genre. These films, mostly set in Europe, were one of the most distinctive brands of the pre-World War II decade. They eschewed spectacle for scintillation, and cast aside Depression-era reality for exuberant performances and unlikely plots made credible by the romanticized photography of flesh on celluloid.

With the exception of Greta Garbo's 1939 tour de force *Ninotchka*, these masterpieces — *Trouble in Paradise*, *Angel* (1937) and *The Shop Around the Corner* (1940) — were all written by Samson Raphaelson, who had on his conscience the original play from which Al Jolson's *The Jazz Singer* (1927) had been adapted. Together, Lubitsch and Raphaelson fashioned a kind of "magical realism"

tinged with subdued and poignant melancholy. Writing of *Trouble in Paradise*, the critic Dwight Macdonald said, "Within the admittedly drastic limitations of its genre, it comes as close to perfection as anything I have seen in the movies." Possibly part of the truth of Lubitsch's genius was that by limiting himself to a canvas of a particular size and texture, he was able to polish his work to a jewel-like quality and come "close to perfection."

There is a marvelous anecdote in Scott Eyman's brilliant biography of Cecil B. De Mille, *Empire of Dreams*. For a brief period in the mid-1930s Lubitsch took over as head of production at Paramount, the studio that De Mille had helped found a generation earlier. One day, while De Mille was shooting his medieval epic, *The Crusades* (1935), Lubitsch wandered over and became transfixed with the set. Cecil remarked that *Trouble in Paradise* was "like a present from Cartier's with the tissue paper just removed." Then he asked Lubitsch what he found so fascinating about the set for *The Crusades*. Ernst replied, "I'm hypnotized. There isn't a cocktail shaker or tuxedo in sight."

Leo McCarey's Duck Soup 1932

Leo McCarey (1898-1969) has long been one of the most unheralded major directors in film history. I made my own small effort to resurrect his status in a 1973 article in *Film Comment*. At that time, I reminded readers of a quote from critic and screenwriter Frank Nugent: "McCarey directs so well it is almost antisocial of him not to direct more often." Unfortunately, McCarey remains all too obscure to this day.

McCarey entered the film industry at the tender age of twenty, and was a full-time director and writer of Hal Roach shorts by 1924. He made or supervised hundreds of them, and was the man most responsible for bringing together Stan Laurel and Oliver Hardy, whose comedy is one of my guilty pleasures. (Historian William K. Everson claimed that Stan and Ollie's *Wrong Again*, 1929, had been inspired by Luis Buñuel and Salvador Dalí's *Un Chien Andalou*, and McCarey's education makes this plausible.) The Roach films helped McCarey develop a unique sense of comic timing and provided bits that served him well in his features. After making a half-dozen features, McCarey was ready for the challenge of the Marx brothers, who were apparently zanier off screen than on it. In spite of its infernally brilliant use of language, some of the best moments in *Duck Soup* are

silent, such as a scene in which three of the brothers (Groucho, Harpo, and Chico in identical costumes and makeup) mime each other on opposite sides of a glassless "mirror." This scene was derived from Stan and Ollie's 1930 short *Brats*, which McCarey wrote.

The Marx brothers were, of course, beloved by the Surrealists, and much of the anarchism of *Duck Soup* seems antithetical to McCarey's personality and sensibility, as he was politically conservative and devoutly Catholic. If auteur theory posits that a film reflects a director's personality, then when it comes to the contradictory McCarey, the question inevitably arises: "Will the real Leo McCarey stand up?" Critic Robin Wood tried to grapple with "problem" of McCarey as an auteur:

It might be argued that McCarey's work validates a more sophisticated and circumspect auteur approach: not the author as divinely inspired individual creative genius, but the author as the animating presence in a project within which multiple determinants — collaborative, generic, ideological — complexly interact. The only adequate approach to a McCarey film would involve the systematic analysis of that interaction.

Maybe, but *Duck Soup* is ultimately a Marx brothers movie, and Groucho's character is still Rufus T. Firefly. (I would love to hear Firefly's comments on "multiple determinants" and "systematic analysis.") McCarey's main contributions are his comic genius, and his decision to dispense with Harpo's harp, Chico's piano numbers and the callow romantic subplots that infest most of the brothers' other films. In *Duck Soup*, we have the Marx brothers and Margaret Dumont raw and unrelieved, leaving no time for tedium and stagnation. It's McCarey who makes this soup effervesce; his tureen runneth over.

Merian C. Cooper and Ernest B. Schoedsack's King Kong 1933

In the eight intervening years between their classic documentary *Grass* (1925) and *King Kong*, Merian C. Cooper and Ernest B. Schoedsack seemed, at least superficially, to move in a very different direction. Their 1927 film *Chang* retained the trappings of actuality, but was far more manipulative. It took on a commercial cuteness in its intertitles, and in the words of scholar Erik Barnouw, much of the film "must have been part of Hollywood pre-planning, along with pretentious subtitled

KING KONG. DIRECTED BY MERIAN C. COOPER AND ERNEST B.
SCHOEDSACK. 1933. USA. BLACK AND WHITE. 100 MINUTES.

dialogue." Cooper and Schoedsack's three fiction features prior to *Kong* were not without merit, but the big guy brought something entirely new to cinema.

Willis O'Brien was a San Francisco newspaper cartoonist and sculptor who helped develop the art of stop motion animation. As early as 1914 he was playing with dinosaurs, and he finally made his mark with an adaptation of Arthur Conan Doyle's *The Lost World* (1925). Without his special effects genius, *King Kong* would not have been possible. (Ray Harryhausen became O'Brien's assistant later on, and he, George Pal, and many others are part of O'Brien's legacy.)

It is hard to imagine what it must have been like to see Kong straddle the recently built Empire State Building while sitting in a sold-out crowd in the even newer Radio City Music Hall. There is perhaps no image

more iconic in the history of the movies. Audiences in 1933 were probably more prone to accept something as wildly imaginative as King Kong, but even today's "sophisticated" viewers find something real and touchingly human in O'Brien's magic.

Cooper and Schoedsack tried to cash in on their great success with *Son of Kong* (1933) and *Mighty Joe Young* (1949). Descendants of the two filmmakers have done inferior remakes and all manner of imitations. In Japan, Godzilla has laid claim (and lots of eggs) to miles of celluloid, and even confronted Kong himself. During the "Atomic Age," films like *The Beast From 20,000 Fathoms* (1953, dinosaur) and *Them!* (1954, giant ants) wreaked havoc on civilization, reinforcing the Kongian theory that size matters. All of this was made possible by the big guy.

Getting back to the question of how far Cooper and Schoedsack strayed from their origins with *Kong*, their earlier film, *Grass*, was a documentary about the epic annual migration of Persian nomads and their

perennial struggles with the perils of the natural world. Kong, fictional puppet though he was, portrayed a natural creature who survived on an isolated island until he was brought to New York by the Barnumesque Carl Denham (Robert Armstrong) — who, at Cooper's insistence, was modeled on the director. Cooper, whatever his early ethnographic pretensions, came to recognize his essentially commercial instincts and settled comfortably into a Hollywood career, eventually partnering with John Ford and dabbling in the widescreen Cinerama process.

Universal's horror film cycle (*Frankenstein*; *Dracula*, both 1931; *The Mummy*, 1932) were immensely popular at the time, but none of those films had the currency of *King Kong*. For Cooper, Schoedsack, and their audience, World War I was a recent memory. France and other population centers had been devastated by new forms of warfare such as aerial bombardment. Then as now, people had good reason to be fearful of the future. The foolish release of Kong in New York, the development of nuclear weapons, and the "bring 'em on" bravado with regard to terrorists are all cut from the same hubristic cloth. Would that all we had to worry about now was a miniature model ape. Well, actually there is something else looming on the horizon that we have to fear — word has come from Australia that a musical version of *King Kong* is being planned for Broadway. We can only hope that there are still a few Curtiss O2C-2 biplanes able to fly.

Jean Renoir's Boudu Saved from Drowning 1932

I am hard pressed to name a twentieth-century artist in any medium whose work reflects a richer diversity of feelings and ideas than Jean Renoir (1894–1979). His broad and serious concern with the social state of mankind is combined with a warmly romantic sense of humor, and all this is given expression through an almost effortless command of the complex tools of his métier. He was a self-proclaimed realist, an improviser, and an infinitely loving apostle of egalitarian humanism.

Renoir was, of course, the son of the great Impressionist artist Pierre-Auguste Renoir. The director once said, "I have spent my whole life trying to determine the extent of my father's influence on me." Following a nearly fatal crash as a World War I aviator (a moment memorialized in his 1937 film *Grand Illusion*), Renoir tried

his hand at ceramics before entering the movies. Of his eight silent films, *The Little Match Girl* (1928), adapted from the Hans Christian Andersen fairytale, is one of his earliest and simplest, and in it we perhaps see the purest expression of the director's childlike soul. However, it would be a mistake to confuse this innocence with a lack of sophistication and worldly awareness. His lavish homage to Emile Zola (*Nana*, 1926) was followed by a series of eclectic choices. In 1931 he made *La Chienne* with Michel Simon (remade fourteen years later by Fritz Lang as *Scarlet Street* with Edward G. Robinson), and followed that with a Georges Simenon adaptation, *Night at the Crossroads* (1932), which starred his brother Pierre as Inspector Maigret.

Simon was not exactly a matinee idol, but he managed to star in films for nearly all of the best French directors of the period — Jean Vigo, Marcel Carné, Julien Duvivier, René Clair — and he made three films with his lifelong friend Renoir. Simon remained active until his death, often specializing in gross characters that projected a kind of primordial rakishness. In *Boudu Saved from Drowning* he played a tramp who is rescued from the Seine and taken in by a respectable family. In their home, he violates all rules of bourgeois order, from sexuality to cleanliness. I remember seeing Simon in the early 1970s on the arm of a young woman in Central Park, looking appropriately like he had just stepped out of the Duck Pond (or the Seine forty years earlier).

Renoir said, "I cannot conceive of cinema without water. There is an inescapable quality in the movement of a film which relates to the ripple of streams and the flow of rivers." Andrew Sarris brought an auteurist twist to the metaphor: "Renoir's career is a river of personal expression. The waters may vary here and there in turbulence and depth, but the flow of personality is consistently directed to its final outlet in the sea of life."

Jean Renoir was humanism incarnate, and had an outlook broad enough to include the very dregs of the species. As André Bazin, the father of auteurism, suggests, "*Boudu*'s charm lies in its glorification of vulgarity. It portrays the most blatant lubricity in a civilized and nonchalant manner. *Boudu* is a magnificently obscene film." It is also very funny.

The Films of Jean Vigo

October 5, 1934, the day Jean Vigo succumbed to tuberculosis and leukemia at twenty-nine years and six

months of age, may have been the most tragic day in film history. (March 11, 1931, the day F. W. Murnau died in an auto accident, is perhaps the only rival.) Vigo was the son of a fugitive anarchist and the father of one child, three short films, and one feature.

A propos de Nice (1930) was made after Vigo moved to the Riviera following an early bout with tuberculosis. His cinematographer on that film (as on all of his films) was Boris Kaufman, brother of the Soviet documentarian/propagandist Dziga Vertov. (Kaufman later had a highly successful career working for Abel Gance, Elia Kazan, and Sidney Lumet, and *A propos de Nice* is very much in keeping with the pattern Vertov established with *Man with a Movie Camera* the previous year – scathing social commentary paired with striking imagery.) As critic Eric Smoodin has suggested, *A propos de Nice* "attempts nothing less than the restructuring of the world by presenting it to us not so much by a seamless, logical narrative, but rather through a fast-paced collection of only tangentially related shots." Vigo's next short, *Taris* (1931) is a playful eleven-minute homage to Jean Taris, France's leading swimmer.

Zéro de conduite (1933) runs a mere forty-three minutes. Its depiction of a repressive boarding school outraged the French bourgeoisie – something a great many of the best films of the 1930s managed to do – and the film was banned until after World War II. It had an enormous influence on François Truffaut's *The 400 Blows* (1959) and the New Wave in general. Vigo proved himself decades ahead of his time in liberating his camera and breaking all the rules; the true scion of an anarchist father.

L'Atalante (1934), Vigo's only feature, sacrifices some of the visual poetry of his short films for greater depth in character development and a more coherent narrative. The film challenges the bourgeoisie in the particularly vulnerable realm of sexuality. Both Michel Simon and Jean Daste (who also appears in *Zéro*) had been in Jean Renoir's *Boudu Saved from Drowning* (1932) and Daste went on to act in two more of Renoir's films. He also provided a direct link with Truffaut, appearing in three of that director's films in the 1970s. The German-born Dita Parlo is unforgettable in Renoir's *Grand Illusion* (1937) as the German farm widow with whom Jean Gabin falls in love. In *L'Atalante*, Simon, Daste, and Parlo form a ménage-à-trois that is among cinema's oddest and most memorable. Vigo's health was already deteriorating by that point and the film was beset by production problems, all of which were exacerbated by Vigo's overall unhappiness with the story

presented to him by the producers. Miraculously, the film was completed and is more or less a masterpiece, though the director did not live long enough to attend its premiere.

I have always had difficulty in evaluating Vigo as an auteur because of the brevity of his career. At least Murnau, who also died an early death, left a legacy of masterpieces – *The Last Laugh* (1924), *Sunrise* (1927), *Tabu* (1931), and other major works such as *Nosferatu* (1922) and *Faust* (1926). It's impossible to know how Vigo's personality might have changed over succeeding decades. Jean Renoir, more than a decade Vigo's senior, was still directing into the 1970s. Might Vigo have become more conventional or inspired? Sadly, we will never know.

Alessandro Blasetti's
1860 1934

Alessandro Blasetti (1900–1987), a law school graduate and failed movie extra, started out as a film critic and participant in what might be viewed as an Italian forerunner to the French New Wave, the Augustus Cooperative. Blasetti and his circle were rebelling against an Italian cinema dominated by costume epics and melodramas, the kinds of films that made Rome one of the premiere movie capitals of the world before World War I. Although his first film *Sole* (1929) was experimental, it was ironically not long before Blasetti undertook his own epic rendering of Italian history with *1860* (1934). In it, he argued that viewing Garibaldi's campaign to unite Italy through the eyes of peasants had a social relevance that biblical and imperial epics did not. However, several of his early works seemed to betray this crusade, as they lacked the social relevance he was fond of espousing. One critic labeled him "the Don Quixote of the Italian cinema."

1860, like other Blasetti films of the period, is often cited as a precursor to Italian Neorealism, the post-World War II movement led by Luchino Visconti, Roberto Rossellini, Vittorio DeSica, and others. It was shot mostly on location with nonprofessional actors, and it offered a visual starkness that was in keeping with its socially conscious message. Blasetti was also influenced by the graphic imagery of Sergei Eisenstein and other Soviet directors who brought their own brand of "realism" to their films.

Part of the problem in dealing with Blasetti is that, whatever his deeply held beliefs may have been, he is forever linked with Benito Mussolini and the Fascist regime. He never even came close to the glorification of fascism that Leni Riefenstahl achieved in *Triumph of the Will* (1935), but many of his views on Italian society seemed to coincide with those of Il Duce. It can be argued, however, that there are veiled criticisms of the regime between the lines (frames) of several of his 1930s films. *The Old Guard* (1934), for instance, recounts Mussolini's 1922 March on Rome, which led to his ascent to power. The film was criticized by the Fascists as being insufficiently enthusiastic, and ultimately I think Blasetti was too sophisticated be a true believer in Il Duce.

In 1952, Blasetti appeared as a cynical movie director named Blasetti in Visconti's *Bellisima*, portraying himself as a purveyor of "amusement of idiots." His half-century-long career was too influential and successful for either Blasetti or Visconti to really believe that, but an enigmatic quality is still associated with this director who thrived and became a dominant figure in cinema under a totalitarian regime. Blasetti was perhaps the canniest Don Quixote of them all, appearing in photos like the genially obese proprietor of a spaghetti joint while still exercising his intelligence and talent wherever and whenever he could. Ted Perry, former Director of the Department of Film at MoMA, has made the point that Blasetti's contributions went well beyond his own films. He was an influential theorist and founder of the school that was to become the Centro Sperimentale, Rome's noted film archive. So, we owe him not just for the gift of his own films, but also for the preservation of so much of early Italian cinema — even the films he vehemently attacked as a young critic.

Documentary Develops
Robert Flaherty and John Grierson

Although Robert Flaherty is credited with being the father of the documentary, there had been "actuality" films since the very beginning of cinema. The Lumière brothers sent film crews around the world to bring audiences the wonders of the planet long before jets made it possible to travel to exotic or remote locales. The great photographer of Native Americans, Edward Curtis, released his only motion picture, *In the Land of the*

War Canoes (In the Land of the Headhunters: A Drama of Primitive Life on the Shores of the North Pacific) in 1914. Flaherty had previously tried and failed to capture the lives of the Baffin Island Eskimos, and was inspired by Curtis's film to try again. The resulting work was *Nanook of the North* (1922). Although both men shared a romantic desire to preserve native cultures on film before the incursion of "civilization," I think Flaherty was more adept at co-opting the zeitgeist of Hollywood. Such a judgment would be anathema to the Flaherty cult that flourished for a long time, but it's indisputable that Flaherty's pure, authentic vision was tempered by an irrepressible artistry that caused him to shape and manipulate his material while remaining true to his basic principles. *Nanook* made a lot of money and was critically acclaimed, as was his later South Seas film, *Moana* (1926).

After his falling out with F. W. Murnau over *Tabu* in 1931, Flaherty made a few short films in Britain. *Man of Aran* (1934) was his first sound feature, and while it fits his established anthropological pattern, it tends toward greater narrative coherence. The poetry is supplied by the enormity of the natural forces with which the Aran islanders must contend, and by the fathomless, unforgiving beauty of the shark-infested sea. The film was criticized by his friend John Grierson, among others, for ignoring the contemporary reality of the Depression and the economic exploitation of the islanders. Grierson wrote: "I imagine they shine as bravely in pursuit of Irish landlords as in the pursuit of Irish sharks." In Flaherty's (and auteurism's) defense, historian Jack Ellis said: "In some respects his films are as much about him... as about the people he was filming."

After one more frustrating attempt to participate in the commercial film industry with Zoltan Korda's *Elephant Boy* (1937), Flaherty returned to documentaries. His *The Land* (1942), produced by the U.S. government, dealt with contemporary social issues he had previously avoided, and was cited by the critic Stuart Byron as the greatest documentary ever made. Flaherty's final feature, *Louisiana Story* (1948), is beautifully photographed but its message about the harmlessness of oil drilling has been somewhat undermined by, among other disasters, the BP spill in the Gulf of Mexico. The film was produced by Standard Oil of New Jersey.

John Grierson (1898-1972) was a disciple of Flaherty's, and was critical of his mentor's detachment from the real world. Grierson's films, such as *The Drifters* (1929), *Granton Trawler* (1934), *Song of Ceylon* (1934), and *Night Mail* (1936), were authentic but generally didn't

aspire to poetry. They were mostly directed by others, and Grierson was usually listed as the supervising producer. Grierson was the central figure in the establishment of the National Film Board of Canada during the Second World War, and he not only invented the term "documentary" but also developed a coherent theory of its meaning. Because he was involved in so many films seen by so many people, Grierson was in many ways a more influential figure than Flaherty. We are in his debt every time we turn on our television to watch a nonfiction program or tune in to one of the numerous cable channels that specialize in the genre. He was an able teacher, if not an artist.

King Vidor and Pare Lorentz Confront the Great Depression

1934–1937

When I wrote about *Our Daily Bread* (1934) in 1972 as part MoMA's massive King Vidor retrospective, I described the film as naïve, simplistic, and awkward, but nonetheless extremely lovely in its innocence. I stand by this assessment. Intended as a sequel to Vidor's silent masterpiece *The Crowd* (1928), its message is not so much a plea for agrarian communism as it is for humanity. The film has much in common with the work of Vidor's acknowledged master, D. W. Griffith, and had he remained active, one could easily imagine Griffith making a film similar to *Our Daily Bread* at some point during the 1930s.

John and Mary Sims, having failed in the city like millions of other victims of the Great Depression, are given the opportunity to start a new life by returning to the soil. They are joined on the farm by a group of people who probably lived just around the corner from the set Richard Day designed for Vidor's adaptation of Elmer Rice's *Street Scene* (1931). (In fact, John Qualen reprises his role in *Street Scene* in *Our Daily Bread*, and would revive it again in many brilliant performances for John Ford, who would soon be Vidor's rival for Griffith's mantle.) There are echoes of other Vidor films in *Our Daily Bread*: A scene in which farmers go into the cornfield singing "You're in the Army Now" gestures to *The Big Parade* (1925), and John's abortive flight with a seductress, delightfully played by Barbara Pepper, recalls Zeke's weakness in *Hallelujah* (1929).

With his wide-open face, very American charm, and "Vidorian" hat, star Tom Keene looks just too much

like Vidor for the resemblance to be dismissed as coincidental. Keene's freewheeling performance, however, is one of the film's problems. He is a bit too toothy, loud, and ingratiating for sound. His character has not changed much since *The Crowd* (he still has "big ideas"), but Vidor could get away with things in his silent films that are just too grating and abrasive in a talkie, and the problem is accentuated by Karen Morley's subtle performance and Alfred Newman's beautifully lilting score.

The climactic ditch-digging sequence, however derivative of Soviet films it might be, remains one of the greatest of all experiments in cinematic rhythm. Vidor dusted off the metronome he used previously in *Three Wise Fools* (1923) and *The Big Parade*, and enhanced the power of his cadenced cutting and action through the creative use of sound effects and music. The result, from the first pick breaking ground to the moment where Vidor appears on screen and shouts, "O. K. to go," is arguably the most exciting final reel in any American movie since Griffith's *Intolerance* (1916).

It is a measure of the ardor that Vidor felt for *Our Daily Bread* that he managed to make it outside the studio system and in spite of American cinema's traditional aversion to controversial subjects. The film sprang from the director's deeply held conviction that it needed to be made, and became a passionate obsession. This is, after all, what art — and certainly the best of Vidor's films — is all about.

Pare Lorentz (1905–1992) was for a short time a pivotal figure in documentary films, largely through his association with President Franklin D. Roosevelt. Like an American John Grierson, but on a smaller scale, he made two classic propaganda films for the U.S. government: *The Plow That Broke the Plains* (1936) and *The River* (1937), which one critic has suggested may be "the finest American documentary to date." He also directed a longer but less focused film about a Chicago maternity center, *The Fight for Life* (1940). His agency produced Joris Ivens's *Power and the Land* (1940) and Robert Flaherty's *The Land* (1942), and Lorentz's efforts led to the extensive use of film by the government during World War II. (His *The Nuremberg Trials*, which was released in 1946, sadly, was never quite finished).

Lorentz was friendly with King Vidor, who acted somewhat as his mentor. Vidor brought Lorentz to Britain in 1938 as an adviser, and through the intervention of Iris Barry (first curator of MoMA's Film Library, as the Department of Film was then known), a special screening of *The River* was arranged for Grierson, Flaherty, and

Charles Laughton. (Laughton would later prepare for his 1955 film *The Night of the Hunter* by spending lots of time at the Museum watching D. W. Griffith's films.) This led to a wide release of *The River* in the United Kingdom, including an early telecast. The film also beat out Leni Riefenstahl's *Olympiad* in the best documentary category at the 1938 Venice Film Festival. Even Mussolini's stooges recognized the film's value, though Hollywood wouldn't: it had been denied an Oscar because of the Motion Picture Academy's unwillingness to accept a government-produced film in competition.

The cameramen on *The River* were Floyd Crosby (who had won an Oscar for his cinematography on *Tabu* seven years earlier), Stacy Woodward, and Willard Van Dyke. In 1939 Lorentz wrote a treatment for *The City*, a plea for the virtues of suburbia over urban life that was heavily influenced by the ideas of critic Lewis Mumford. The film was directed by Van Dyke and Ralph Steiner, one of Lorentz's cameramen on *The Plow That Broke the Plains*. Somehow Van Dyke and Lorentz had a falling out, and a permanent vendetta developed. Van Dyke went on to become the Director of the Department of Film here at MoMA, and was my first boss. He spoke of Lorentz with some animosity, but when Lorentz came in to do some research, he seemed like a perfectly nice guy to me.

Josef von Sternberg's
The Devil Is a Woman 1935

After *The Blue Angel* and *Morocco* (both 1930), Josef von Sternberg went on to make five more semi-autobiographical films with his "discovery" and lover, Marlene Dietrich. In my judgment, the best of these are *Shanghai Express* (1932), *The Scarlet Empress* (1934), and the confessional *The Devil Is a Woman*. His films with Dietrich are the centerpiece of Sternberg's career and represent perhaps the highest point achieved in cinema in the early sound era.

The Devil Is a Woman is something of a transla-tion of the relationship between Sternberg and Dietrich into visual poetry and metaphor. Dietrich steadfastly maintained that it was her favorite of the films they made together, and many observers have commented on the obvious physical similarity between Sternberg and his two male protagonists, Lionel Atwill and Cesar Romero. The film is neither as warm as *Morocco* nor as accessible as *The Blue Angel*. Though perhaps the most perfect film ever made in some ways, its very precision conveys a coldness, a diamond-like hardness; the romanticism of *Morocco* has transformed into cynical introspection and fatalism. If Sternberg is any closer to understanding Dietrich, he is unwilling to solve the puzzle for the audience. The film remains one of the most beautifully realized enigmas in the history of cinema.

If, as Ernest Hemingway said, Dietrich knew more about love than anyone, let us not forget her insistence that Sternberg taught her everything she knew. Indeed, in his marvelously entertaining autobiography, *Fun in a Chinese Laundry*, Sternberg comments: "No puppet in the history of the world has been submitted to as much manipulation as a leading lady of mine who, in seven films, not only had hinges and voice under a control other than her own but the expression of her eyes and the nature of her thoughts." Elsewhere he says, "Miss Dietrich is me – I am Miss Dietrich."

The complexity of their relationship may be reflected in the ornate style of *The Devil Is a Woman*, but it is not apparent in its plot. Much is conveyed by glance and gesture, and not articulated by dialogue. One of the great virtues of the film, and one of the problems audiences have with it, is its compactness. Unlike in *Shanghai Express*, there are no melodramatic subplots to cushion the blows or sugarcoat the pill. The film is as raw as the emotions it portrays, as raw as the wounds Dietrich blithely inflicts.

Dietrich went on to work for other world-class directors such as Frank Borzage, Ernst Lubitsch, Alfred Hitchcock, Fritz Lang, Billy Wilder, and Orson Welles, but she would occasionally call out for Jo in moments of desperation. She survived a period of "box office poison," performed heroics at the front during the struggle to destroy her former countrymen, and did her extraordinary cabaret act in clubs and as "the Queen of Broadway. " In spite of everything, she always acknowledged her debt to Sternberg. The two even appeared together at MoMA in the late 1950s. One afternoon in the 1970s, I returned from lunch to be told that Marlene Dietrich was calling me from Paris. In disbelief, I heard a slightly woozy voice (it was cocktail hour there) requesting any documentation we might have from their earlier appearance. (She was becoming involved in the production of Maximilian Schell's 1984 documentary, *Marlene*, and was looking for the script of the evening's festivities.) In the course of humble and awed compliance, I mentioned that I had written a small book about her and her films that I would also send.

THE DEVIL IS A WOMAN. DIRECTED BY JOSEF VON STERNBERG. 1935.
USA. BLACK AND WHITE, 79 MINUTES.

A short time later, I received a handwritten letter thanking me and telling me "not to worry about all the mistakes. You probably copied them from somebody else's book." I was thrilled.

After breaking with Dietrich, Sternberg's career plummeted, only recovering spasmodically until his retirement in the 1950s. The Depression and World War II left the world with little inclination toward romantic mythology, and television would mostly sweep visual grandeur off the screen. Even though several of his silent films are missing, for less than a decade Sternberg was one of the kings of Hollywood, and we can be grateful that most of his best work has been saved.

Leo McCarey's Ruggles of Red Gap 1935

Marmaduke Ruggles, Charles Laughton's character in *Ruggles of Red Gap*, is something of a visual homage to Mark Twain, and much of his innocent naughtiness harkens back to Laurel and Hardy, the team created by Leo McCarey. The film depicts Ruggles, an English butler, being taken to the "wild" west by his nouveaux riche American employers. It's an appropriate throwback to McCarey's buttock-abusing slapstick origins that Laughton's first assertion of independence takes the form of a kick to stuffy Lucien Littlefield's derriere.

The dramatic high point of *Ruggles of Red Gap* is Laughton's barroom recitation of the Gettysburg Address and its assertion of "a new birth of freedom," which prompts this gentleman's gentleman to unknot his traditional ties and become the independent proprietor of an establishment called the Anglo-American Grill. And yet, from what we know of McCarey's closet authoritarianism (which comes out screaming in *My Son John* in 1952 and *Satan Never Sleeps* a decade later) it is evident that he is only dabbling in democracy — just as, in the Marx brothers' *Duck Soup* (1932), he dabbled in anarchy.

Yet, the film works, thanks almost entirely to McCarey's genius for directing actors and his exquisite sense of timing — both of which are far more evident here than ever before. Laughton's previous performances ranged from the bizarre to the grotesque, but as Marmaduke Ruggles he became more endearing and accessible than he had ever been — or ever would be, for that matter. The Laughton of *Ruggles* is a near cousin to

Michel Simon in Jean Renoir's *Boudu Saved from Drowning*, made four years earlier. Laughton physically resembled the great French actor, and his drunk scenes have a Boudu-like roguishness ("the brute in me"). Mary Boland and Roland Young are superb in supporting roles, and ZaSu Pitts performs with great charm as the widow whose fondness for the Englishman cannot quite withstand his mild criticism of her meat sauce. The relationship between Prunella and her Marmaduke is our first real glimpse at that lovely, delicate romanticism that flowed from McCarey at the peak of his powers. We would see it again in the grace of Beulah Bondi and Victor Moore in *Make Way for Tomorrow* (1937), betweeen Irene Dunne and Charles Boyer in *Love Affair* (1939), and perhaps most moving of all, in Maria Ouspenskaya and her memories in that same film.

Jean Renoir's A Day in the Country 1936

A Day in the Country, **although attenuated by a lack of** funds, is a great film — one of the cinema's purest delights. The film strays very little from the Guy de Maupassant story on which it is based. It is too simple to see *A Day in the Country* as Renoir's homage to his father's paintings, but there is certain a validity to that view. Such lovely, lyrical passages as Henriette's (Sylvia Bataille) ride on a swing evoke specific images captured by the painter. The lighting of the film appears entirely natural and recalls the Impressionists — within the limits, of course, of black and white cinematography. The film's fluid and lovingly created imagery elicits a feeling of tenderness, of vague desire, one that recalls Henriette's response to the country: "It almost makes you want to cry."

Within this setting, Renoir enacts his most sensual and hedonistic drama. While Henriette's giggling mother is chased through the woods by Rodolphe, an itinerant fishermen who is transformed into Pan, Henriette is taken by Rodolphe's pal Henri into a shaded cove which he calls his private den. Here the beauty of a nightingale's song does, indeed, make her cry. Although Henri is at first timid (he believes in "love eternal"), and Henriette properly virginal, the perfect natural setting combines with the effects of too much Bordeaux. It seems to me unclear whether she submits to seduction, but the scene culminates in an exquisite close-up of her tear-moistened face, followed by years of poignant

memories. As the weather then changes to wind and rain, Renoir's camera skims gracefully back up the river and Joseph Kosma's turbulent romantic music becomes more ethereal until it finally drifts away. Nature weeps as Henriette returns to her betrothed, to a future that holds no romance, and a relationship that has no room for feelings.

A title then informs us that years have passed and Henriette's Sundays are now as sad as her Mondays. She returns to Henri's den, and while her husband sleeps, the two lovers tell each other how much the memory of their one afternoon together has meant. The feckless husband then wakes up and takes his possession back to Paris. We see them row out of the frame, and Henri is left alone beside the river — alone, that is, except for his treasured memory. It is perhaps consoling to recall Renoir's view, expressed in his marvelous 1966 novel, *The Notebooks of Captain Georges*, that "the only things that matter are the ones we remember."

Marcel Pagnol's César 1936

Although Marcel Pagnol (1895-1974) directed eighteen films, his identity as an auteur is a little hard to pin down. Some of his best work is captured in film adaptations of his stage plays, several of which were directed by others. He had a hand in writing all of the movies he directed, but he also wrote screenplays for others. To top it off, he was a producer with his own studio. (I also find it intriguing that he married a woman named Jacqueline Bouvier at age fifty, eight years before Jack Kennedy married a different woman by that same name.)

There has always been an element of tension between film and its theatrical roots. Early film directors often sprang from the melodramatic Victorian stage. D. W. Griffith, although well versed in the literary canon of Charles Dickens, Edgar Allan Poe, and others, had essentially been a transient stage actor who stumbled into his seminal role as a film director at Biograph in 1908. Until the very end of his career, Griffith's films oscillated between nineteenth-century theatrical conventions (refined and made more subtle by his peerless stable of actors) and the spectacle made accessible by the virtually limitless possibilities of cinema. Similarly, Cecil B. De Mille appeared in and wrote plays for the same stages, although he was more successful than Griffith in his theatrical ambitions thanks to his association

with producer David Belasco. When De Mille caught the film bug, his first impulse was to travel to the wide-open spaces of the West, where he filmed *The Squaw Man* (1914).

Laurence Olivier, however worshipful he may have been of William Shakespeare's words, made the dichotomy between cinema and theater explicit and earned himself a special Oscar with the first film he directed, *Henry V* (1945). He faithfully recreated the Globe Theater's painted flats and limited space, and then opened up the production to the glories of cinematic spectacle, transporting his audience to the battlefields of France, where huge armies replaced a few stage extras. No matter how artfully contrived, it was an implicit acknowledgement of the limitations of theater. While I believe there is plenty of room for all kinds of films, I must confess to a certain prejudice in favor of spectacle. I am moved more viscerally and emotionally by the cavalry troop passing through Monument Valley during a thunderstorm in John Ford's *She Wore a Yellow Ribbon* (1949) than by the brilliant cocktail banter of Miriam Hopkins and Herbert Marshall in Ernst Lubitsch's *Trouble in Paradise* (1932).

Pagnol welcomed the arrival of sound film thusly: "The art of the theatre is reborn under another form and will realize unprecedented prosperity. A new field is open to the dramatist enabling him to produce works that neither Sophocles, Racine, nor Molière had the means to attempt." From the very beginning of his career in film, he asserted his intention to work as a dramatist on celluloid, largely dismissing what cinema had achieved in the silent era. His Marius Trilogy consists of *Marius* (directed by Alexander Korda in 1931), *Fanny* (directed by Marc Allegret in 1932), and *César* (which Pagnol directed himself in 1936). In addition to showcasing brilliant performances by major actors such as Raimu, Orane Demazis, and Pierre Fresnay, these works strike me as authentic depictions of a certain Marseilles subculture. Along with his several versions of *Topaze*, these films preserve Pagnol's work as a playwright and contribute to the art of cinema, even if that was far from his intention. It is not unfair to say that he anticipated Italian Neorealism, which emerged a decade later. In fact, Pagnol's Marseilles studio was used to film Jean Renoir's *Toni* (1934), which is often also cited as a precursor to Neorealism. Renoir's assistant at that time was a young man named Luchino Visconti, who went on to direct *The Postman Always Rings Twice* (1942) and *The Earth Trembles* (1947), two of the cornerstones of that movement.

Charlie Chaplin's Modern Times 1936

If *City Lights* (1931) represents Charlie Chaplin at his romantic zenith, *Modern Times* most admirably displays his satirical gifts. In the early 1930s, he began a relationship with Paulette Goddard that began to relieve his obsessive loneliness and self-absorption and culminated in a secret marriage in China. Along with extensive travels in Europe and Asia, this caused Chaplin to turn outward and consider problems beyond the personal. America and the world were in the midst of the Great Depression, and he felt a need to speak out about it, on screen and off. To some in that pre-Reagan era, an actor's involvement in politics seemed highly pretentious. Chaplin biographer David Robinson has cogently pointed out, however, that "no one before or since had ever had such a burden of

idolatry thrust upon him. It was not he or his critics, but the crowd that mobbed him everywhere... that cast him in the role of symbol of all the little men in the world." These throngs sensed that Chaplin, the man who made them laugh and cry, was one of their own, and he willingly accepted a leading part in, as the subtitle to *Modern Times* says, "humanity crusading in the pursuit of happiness."

The appellation "Tramp" was, of course, misleading. Chaplin's character had had dozens of jobs since 1914, though his pluckiness never added up to a career. Typically, Charlie does not resent dehumanizing work itself, but rather the little indignities imposed on him: The boss spies on him in the toilet, there is no time to scratch an itch. In his films, Chaplin risks crudeness by reminding us that we are bodies as well as souls. Even

MODERN TIMES. DIRECTED BY CHARLIE CHAPLIN. 1936. USA. BLACK AND WHITE, 87 MINUTES.

eating, the most fundamental of physical functions, is threatened when Charlie is used as a guinea pig to demonstrate a maniacal feeding machine. For Chaplin, a hallmark of modernity is the role-reversal of normality and insanity, and society's passive acceptance of values that were considered barbaric under previous standards. He lays a strong claim to prophesy in suggesting that man's ultimate self-destruction will come from his obeisance to tools. By the late 1930s, Chaplin was already conscious of being "red-baited" for such views, and it is with delicious irony that in *City Lights* he had the Tramp innocently pick up a red flag just as a labor protest rounds the corner behind him. Eventually, he solicits arrest as shelter from a world gone berserk. It is only his accidental collision with Goddard's gamine — "the only two live spirits in a world of automatons... two joyous spirits living by their wits" — that allows him to proclaim at the end of the film: "Buck up — never say die. We'll get along."

Modern Times has been criticized for its loose construction, but it compensates for this with persistent inventiveness. Chaplin was quite aware by then that he stood alone as a maker of silent films. Regardless of its success or failure, *City Lights* was almost assuredly going to be the Tramp's last hurrah, and Chaplin's farewell to the form. The complexity and ingenuity of the comic set pieces reflect an obvious desire to go out in style. In scenes like the roller-skating department store inspection and one in which Keystone-buddy Chester Conklin is gobbled up by machines, Chaplin insists one last time on the superior fluency of the visual over the verbal. Words could do nothing to enhance the grace of his movement; nor could they say more than his facial expressions as he dutifully attempts to feed Conklin's disembodied head, protruding perilously from the machinery. Aside from music, sound in *Modern Times* comes essentially from technology: the factory boss on the two-way television, the recorded sales message for the feeding machine, a gastritis commercial on the radio. Sound thus becomes identified with dehumanization — mechanical sound denatures life as Chaplin believed it did to cinema.

Finally, the dire straits of poverty force the Tramp to become a singing waiter, and Chaplin's voice is heard for the first time. His physical animation causes him to lose the words written on his cuffs, which go flying off into the far reaches of the cabaret. Charlie is left to sing in gibberish, a final defiant comment on language's lack of salience. In spite of his incoherence — or because of it — Charlie the singing waiter is a great hit. The audience responds to the elegance of his movement, the effulgence of his face, the sublimity of his mime.

Charlie and Paulette ultimately run from the machines and the city and escape to the open road. We last see them walking toward the distant mountains, their flight a symbolic nod to the struggling "little people" of the world. The film's soundtrack includes the wistful, Chaplin-composed "Smile." ("Smile, though your heart is aching... You'll find that life is still worthwhile, if you'll just smile.") Chaplin's life must have seemed to him more worthwhile than ever at that moment, even though he certainly knew that the métier that had sustained him for a quarter-century was irrevocably an artifact of the past. In his maturity — he was by this time approaching fifty — he was ready to face new challenges, such as making talkies and saving the world.

William Cameron Menzies's
Things to Come 1936

I can't deny that there may be a slight element of guilty pleasure in my inclusion of *Things to Come* in this series. William Cameron Menzies (1896–1957) was a towering figure in the history of film, if not as a director, than as an art director. I would argue he crossed the line into auteurism, even while working for major directors such as Raoul Walsh, Allan Dwan, Ernst Lubitsch, Frank Borzage, D. W. Griffith, Howard Hawks, and Alfred Hitchcock. With his Douglas Fairbanks epics such as *The Thief of Bagdad* (1924) and *The Iron Mask* (1929), Menzies was responsible for some of silent cinema's most enduring imagery. His work on *Gone with the Wind* (1939) is legendary, and Hitchcock delighted in describing how he and Menzies devised the ingenious plane-crash-at-sea moment in *Foreign Correspondent* (1940). As a director, however, Menzies's contributions were slight — with the exception of the dystopian sci-fi film *Things to Come*. In it, an apocalyptic world war breaks out (three years before the real one) and a fascist tyrant emerges from the ruins. The dictator, played by Ralph Richardson, is ultimately defeated by the forces of good, civilization is rebuilt, and later generations attempt a moonshot.

The movies of the early-to-mid 1930s offered much to furtive devotees of science fiction. On Saturday afternoons, viewers could see Gene Autry riding the range in *The Phantom Empire* (1935), or stare in wonder as he disappeared into the bowels of the Earth, where a futuristic civilization flourished. 1936 brought the first of Buster Crabbe's three Flash Gordon serials featuring

Emperor Ming the Merciless of the planet Mongo – Hollywood's dark alternative to the earthbound and merciful Charlie Chan of the fortune cookie bon mots. H. G. Wells had mostly left the future far behind by then, but his 1890s novels *The Island of Dr. Moreau* and *The Invisible Man* were made into successful films. (*The Time Machine* and *The War of the Worlds*, of course, would be filmed again and again in later years.) Wells was a very respected prognosticator by the thirties, and his book *Things to Come*, which served as the basis for Menzies's film, was treated with due seriousness by an anxious interwar public.

Wells's book and screenplay, written with Lajos Biro, the erstwhile collaborator of Lubitsch and Josef von Sternberg, provided Menzies with the unprecedented opportunity to let his imagination soar. Vincent Korda, Alexander's brother, was the nominal art director, but it is most likely that Menzies's vision was the one that prevailed. *Things to Come* can be criticized for keeping a certain distance from its characters – which perhaps reflects Menzies's inexperience with actors and his preoccupation with the spaces surrounding them – but even so, Ralph Richardson and Raymond Massey are extremely memorable. Richardson's tyrant, "The Boss," reflects the crudity of Benito Mussolini and anticipates Mel Gibson's "Mad Max." Richardson was much underrated as a screen actor: His Korda films, especially *Four Feathers* (1939), are excellent, and his classic roles in *The Fallen Idol* (1948), *The Heiress* (1949), and *Long Day's Journey into Night* (1962), deserve far greater attention than they have gotten.

With war looming, Wells and Menzies created a credible contemporary world and then destroyed it. That the destruction depicted in the film did not come to pass in real life can mostly be attributed to Nazi laxity in developing a nuclear weapon. With contemporary hindsight, the film's leap into the space age seems quite abrupt. In spite of developments such as Robert Goddard's rocket experiments and Fritz Lang's *Woman in the Moon* (1929), with its rocket designed by Herman Oberth and Willy Ley, Wells still relied on a space gun for interplanetary travel – just as Jules Verne and Georges Méliès had a few generations earlier. Only a few years after *Things to Come* was made, Nazi rocket scientist Werner von Braun would "aim at the stars" – and all too frequently hit London. In any case, Menzies's vision of the future features spectacular sets tempered with throwbacks such Roman Empire-style tunics. This seems to have anticipated Michael Anderson's *Logan's Run* (1976) and George Lucas's *Star Wars* series. On the whole,

Menzies's "world of tomorrow" seems a lot less silly than Lang's much-celebrated *Metropolis* (1927) made a decade earlier. Why Menzies directed so few films over the next twenty years remains a bit of an enigma.

Fascism on the March
Leni Riefenstahl v. Joris Ivens 1935–1937

It was inevitable that film, as the most popular and influential medium of propaganda in history, would respond on many levels as the relative calm produced by the Treaty of Versailles gave way to the madness of a worldwide depression. Being somewhat dependent on the European market, Hollywood studios approached political and economic issues very gingerly. Even *Confessions of a Nazi Spy* (1939), released only four months before the invasion of Poland, tiptoed around anti-Semitism. The writing on the wall should have been evident to everyone by that point, but eighteen months later, Charlie Chaplin was still under pressure not to release *The Great Dictator* (1940).

Europe did not have the luxury of such timidity. The Nazis took over the German film industry in 1933, and Joseph Goebbels immediately established that it was at the service of the Reich, by which he clearly meant the Party. Although he probably fancied himself the creative force behind all German films made over the next twelve years – a kind of über-auteur – he was still dependent on "artists" and technicians to do the nuts-and-bolts work of fashioning alternative realities to be projected on to screens. Nobody was more successful in this regard, at least in the eyes of der Führer, than Leni Riefenstahl (1902–2003), a reasonably attractive dancer turned actress turned director. Her film performances, beginning in 1926, were mostly in mountain films directed by the ex-geologist Arnold Fanck. In 1932, Riefenstahl directed and starred in one herself, *The Blue Light*, a film of striking imagery, and in 1933, she performed in what would be her last of such films, *S. O. S. Eisberg*, codirected by the American Tay Garnett. That same year, Hitler appointed her "film expert to the National Socialist Party."

In 1934, Riefenstahl was assigned to make *Triumph of the Will*, which would ostensibly be a documentary about the Nazi Party Congress at Nuremberg. Despite her later protestations that she was a naïve and apolitical documentarian, it must have been obvious to

her that the whole event was staged for the benefit of her and her immense crew. (Morris Dickstein recently pointed this out in his excellent survey of Depression-era culture, *Dancing in the Dark*.) All of the resources of the Reich and vast sums of money were put at her disposal, and unprecedented masses of people were summoned to perform the rituals that she and her collaborators devised. Nothing like it had ever been seen before, and we are fortunate that the event did not create a lasting genre, although choreographers of annual military parades in Beijing and Pyongyang probably owe Riefenstahl something. (While I was sojourning just off the coast of Venezuela roughly a decade ago, I glimpsed on TV a failed attempt by Hugo Chávez to evoke a similar ethos.)

There is an undeniable brilliance to Riefenstahl's imagery, even though it builds on what German Expressionist directors had accomplished in the preceding fifteen years. Still, for any thoughtful person, the spectacle of Hitler and his henchman being glorified can evoke nothing but deep repulsion and horror. Although Riefenstahl managed to avoid the amorous attention of Goebbels and probably remained on platonic terms with Hitler, her soul was in bed with the Nazis. When Paris fell, Leni telegraphed Hitler: "You exceed anything human imagination has the power to conceive, achieving deeds without parallel in the history of mankind." Innocent neutral observer, indeed. I recommend *Leni*, the book by my late friend Steven Bach, as a balanced and authoritative study of Riefenstahl.

After his early poetic documentaries, Dutchman Joris Ivens (1898-1989), became politicized during his 1930 visit to Moscow and began a worldwide odyssey unparalleled by any other filmmaker. This even included a period in Hollywood and making a U.S. government-commissioned film, *Power and the Land*, in 1940. As a committed leftist, much of Ivens's late career was devoted to documentaries extolling the Cuban, Vietnamese, and Chinese Revolutions, and he somewhat sacrificed personal artistry for the causes to which he devoted his life.

The Spanish Earth (1937) was made at a time when issues were more clearly drawn than today. Although it took President Franklin Roosevelt several years to drag America kicking and screaming into the war against fascism, there is a sense of nostalgic comfort in knowing that Ivens was on the side of the good guys before public opinion swung in that direction. The film shares with the then vastly popular *March of Time* series the use of both actualities and staged or reconstructed scenes. When Ivens was criticized for not being objective, he replied, "a documentary filmmaker has to have an opinion on such vital issues as fascism… if his work is to have any dramatic, emotional or art value." Riefenstahl could have taken some lessons on candor from him, but then, her cause was less noble and she was not called upon for explanation until after it had been defeated. Ernest Hemingway's script for *The Spanish Earth* — and his narration of it — is utilitarian and undogmatic, which allows the viewer to decide on their own which side they support. Although Ivens's quiet craftsmanship pales beside Hitler's regimented multitudes, it is worth thinking about which film is genuine art and which is, to use a popular Nazi term, degenerate.

Animation in the 1930s
Walt Disney / Ub Iwerks / Max Fleischer

With the emergence of figures like Walter Ruttmann and Oskar Fischinger in Germany, and with the coming of sound, Len Lye in Britain, abstraction became the dominant form of animation in 1930s Europe. Lotte Reiniger continued work on her silhouettes, and eventually landed in Britain. In France, Ladislas Starevitch spent the first decade of the sound era working on the puppet feature, *The Tale of the Fox* (1930).

America, as always, was different. This was in part because almost all animation came out of studios inextricably linked to the commercial film industry and its exhibition venues. The studios created by Walt Disney (1901-1966) and Max Fleischer (1889-1972) continued to grow and flourish, but in their own ways. Disney was based in Los Angeles and reflected the "wholesome" middle American values of Uncle Walt's Kansas City roots. Fleischer's New York-based outlook was more sophisticated and cosmopolitan, as Max was a transplanted Viennese Jew. Disney's characters tended to be anthropomorphic creatures gifted with human speech and dress. Fleischer's tended to more-or-less human, although I must confess I would cross to the other side of the street if I ever saw Betty Boop or Popeye coming toward me.

I have another confession: I tend to be ambivalent about animation, even though some of my best friends are animators. (I had a close friend who was so compulsive about the genre that he was addicted to everything from the homoerotic *Johnny Quest* to the post-pornographic *Family Guy*.) I do believe, however, that no other form of film is so intrinsically creative.

Animation enables artists to bring images into being without intervening props like actors. At the same time, however, this seems to limit the medium's power to emotionally engage with the spectator, a crucial measure of a work's success. No animated Charlie Chaplin, Lillian Gish, or John Wayne could ever reach the level of feeling attained – under proper direction – by flesh and blood figures. I admire more recent works like *Wall-E* (2008) and *Avatar* (2009), but the feelings they undeniably evoke are somehow of a lesser order as a result of their artificiality.

Although I have defined auteurs as directors, the level of control exercised by Disney and Fleischer as studio heads supervising animation dominated and personalized the studio products in ways that Louis B. Mayer or Darryl F. Zanuck must have envied. Of course, a nod must be given to the creators of individual cartoons, but Disney or Fleischer films are consistent in style and philosophy and ultimately belong to them. Broadly speaking, there was an innocence to Disney's view of the world, while Fleischer projected an underlying kinkiness. Although the films were shown to all audiences, one can't escape the feeling that Disney saw his audience as children while Fleischer's target was more knowing adults, attuned to Betty Boop's seductiveness and Popeye's *sub voce* murmurings.

Disney's most famous and enduring star was, of course, Mickey Mouse. The squeaky little rodent, originally voiced by Walt, was essentially the brainchild of animator Ub Iwerks (1901–1971). Iwerks and Disney met as teenagers in Kansas City and partnered, off and on, for the rest of their lives. Disney summoned Iwerks to Hollywood shortly after his own arrival. They worked together briefly in 1930, not totally without recriminations, and this encounter enabled Iwerks to work independently on a number of films, including his own Flip the Frog series. Iwerks's sensibility was less restrained than Disney's, though it didn't quite reach Fleischer's level of subversiveness. He and Walt reconciled, and Iwerks became a special effects innovator on Disney films, and ultimately on Alfred Hitchcock's *The Birds* (1963).

Walt Disney's Snow White and the Seven Dwarfs 1937

After *Snow White*, no comparable challenge to the existing order in American narrative cinema would come along again until the advent of *Star Wars* some forty years

later. (I consider Stanley Kubrick's *2001: A Space Odyssey* from 1968 to be more experimental than narrative.) The concept of a feature-length movie without human representation and in Technicolor, to boot must have riled many traditionalists who had endured the innovation of sound only a decade earlier. *Snow White and the Seven Dwarfs*, which premiered during Christmas week in 1937, was the inevitable culmination of Walt Disney's financial and artistic success. The film ultimately cost around ten times the originally budgeted amount. It required five years of work and hundreds of people, and could not have been made by anyone else. There are six directors and an army of technicians listed in the credits, but Disney is the sole auteur — with a little help from the Brothers Grimm.

John Canemaker and Neil Gabler, among others, have written extensively about Disney and the film. *Snow White* broke all records at Radio City Music Hall and elsewhere. Ticket scalpers got as much $7.70 — imagine paying that much for a movie! The film was even shown at Buckingham Palace to Princesses Elizabeth and Margaret (in spite of the British censors warning that the witch was too scary), and Walt got a special Oscar. Disney went on to make a string of masterpieces, including *Pinocchio*, *Fantasia* (both 1940), *Dumbo* (1941), and *Bambi* (1942), and his studio made a Herculean effort to help the Allied cause during World War II. Perhaps now that dragons are back in fashion, *The Reluctant Dragon* (1941) will finally get its due.

Things changed after the war. Disney began to make live-action films, and his animated films were generally not as innovative. He expanded his empire beyond film by building his theme parks, becoming a lovable TV star, and marketing his merchandise. It would be unfair to blame Disney too severely for the current Fantasyland of American society, but Neil Gabler inadvertently touches on something in his praise of Uncle Walt. Gabler subtitled his Disney biography, "The Triumph of the American Imagination." At the end of the book, summing up Disney's contributions, Gabler topped them off by noting, "he demonstrated how one could assert one's will on the world... He had been a master of order." Certainly Gabler did not intend to compare Disney with Hitler (as filtered through the lens of Leni Riefenstahl) but Disney's record as an authoritarian employer contrasted with the sweet gentleness of the whistle-while-you-work dwarfs. (In 1938, while the rest of Hollywood was shunning her, Disney invited Riefenstahl to tour his studio.) There is a case to be made that animation director Vladimir Tytla was parodying Disney in the character of Stromboli, the entertainment

entrepreneur who kidnaps and enslaves Pinocchio. Yet Disney's life and excursions outside cinema seem somehow out of step with the films he signed. Since auteurism is ultimately about a body of films reflecting the personality and values of a single creative artist, Disney is perplexing.

George Cukor's Camille 1937

Of all the major film directors of the classical Hollywood period, only two were New York City boys. And although one of them, Raoul Walsh, romanticized the city in several of his films, he was a cowboy at heart. George Cukor (1899–1983), on the other hand, seemed to bring the city's cosmopolitan culture to his career. Growing up close to Broadway and becoming a theater stage manager at twenty made an impact on him. (I was born on the wrong side of the Hudson and I can attest to the early lure of the city, even though my Lincoln Tunnel travels were mostly limited to seeing the hapless New York Rangers at the old Madison Square Garden, and only once did I visit the Metropolitan Opera in its pre-Lincoln Center digs.) After a decade in the theater, one of Cukor's earliest films following the advent of talkies was *The Royal Family of Broadway* (1930), which satirized John Barrymore, who Cukor was to direct two years later.

In the 1920s and 1930s, Louis B. Mayer's MGM was long on production values but short on patience with maverick talent. Even King Vidor, who put the studio on the map with *The Big Parade* (1925) and *The Crowd* (1928), had to endure much frustration in subsequent years. Cukor was not experimental the way Vidor was, but he was elegant and tasteful, and Mayer and his assistant, Irving Thalberg, were more comfortable with that. Because Cukor relied on respected literary works that the undereducated Mayer held in high regard — and which were generally adapted into box office successes — the director thrived for decades. His characters tended to be "theatrical," either professionally, in real life, or both. Of course, the book on Cukor was that he was a great director of actors, most notably women. His early work with Tallulah Bankhead, Marie Dressler, Jean Harlow, and Constance Bennett was extraordinary, and he turned Katharine Hepburn into a star with *A Bill of Divorcement* (1932). The two would make ten films together over the course of nearly half a century. Later, Cukor would get career-defining performances from Judy Holliday, Judy Garland, and others.

Several of the great stars of silent films have not made an appearance in this book or been mentioned only in passing, including Douglas Fairbanks, Rudolph Valentino, Gloria Swanson, and Marion Davies. The most significant gap in this regard has been Greta Garbo, who was the greatest silent actress. (A title she shared with Lillian Gish.) At MGM, Garbo was mostly directed by journeymen studio directors such as Fred Niblo, Edmund Goulding, George Fitzmaurice, and her personal favorite, Clarence Brown. While her work in the late silent era and throughout the 1930s was terrific, I think few directors and projects fully challenged her transcendent talent. The notable exceptions are Rouben Mamoulian with *Queen Christina* (1933), Ernst Lubitsch with *Ninotchka* (1939), and Cukor with *Camille* (1937). (A recovered reel of Victor Sjöström's 1928 film *The Divine Woman* suggests that this might have been among them, but this potentially important work by Sweden's greatest director is essentially lost.)

Camille was already an overripe property in 1936 as the book and play by Alexandre Dumas *fils* was nearly a century old. Giuseppe Verdi's operatic adaption, *La Traviata*, was scarcely more current. The plot follows a well-known courtesan who dies tragically of consumption after being torn between the man she loves and the man to whom she is beholden. Dumas's story had previously been portrayed on film by talents as diverse as Sarah Bernhardt and Theda Bara. Garbo's Marguerite, however, somehow overcomes all obstacles to die in one of the most glorious scenes in the history of the movies — perhaps rivaled only by Gish's Mimi in Vidor's *La Boheme* (1926). In spite of its lavish period recreation, it is an easy film to fault for reasons raging from Robert Taylor's vacuity to Lionel Barrymore's typical scenery-chewing. At heart, though, Garbo gives an impeccable, incredibly moving performance under Cukor's direction, one that is indisputably among the greatest in cinema history.

Fritz Lang's You Only Live Once 1937

It would be hard to argue that Fritz Lang is a forgotten director. The conventional book on the Viennese auteur is that he was a great innovator in Germany who was forced to do hack work in Hollywood. However, through the efforts of Andrew Sarris, Peter Bogdanovich, David

Thomson, and others, his forty-year career is now viewed more holistically, with an appreciation of the continuity of his themes and style.

The overriding theme of Lang's work is fate, humanity having little control over its essentially tragic destiny. Stylistically, this is often expressed through glowering, menacingly dark, and almost otherworldly imagery. Lang is like the punch line of the joke about the paranoiac who really does have somebody out to get him. Howard Rodman's novel *Destiny Express* tells the story of how Joseph Goebbels offered Lang control of the German film industry in 1933, and how Lang took the next train to Paris. Although details may vary, the story seems essentially true. If he had stayed in Berlin, he might have made *Triumph of the Will* (1935) and not have endured the often humiliating treatment of Hollywood producers. Lang, however, whether out of fear, honor, politics, or whatever, left the Reich, filmed Ferenc Molnár's *Liliom* (1934) in France, and then sailed for America. His wife and scriptwriter, Thea von Harbou, stayed, became a good Nazi, and even directed a few films herself. Lang's politics are not clearly defined, and his reputation among his coworkers was that of a petty tyrant, if not a uniformed Nazi. (There was even one reported assassination attempt against him.) It would be difficult to make a case that in either his life or his work, Lang was a humanist like Jean Renoir or a committed romantic like Charlie Chaplin. Yet there are moments of genuine poignancy in his films (Peter Lorre's confession in *M* from 1931; much of *The Big Heat*, 1953; the protagonists in *You Only Live Once*) that betray Lang's having "normal" human feelings. His interviews show a cunning charm, though Ernst Lubitsch he is not.

You Only Live Once, his second American film, is one of his best. It is technically impeccable. (For decades, MoMA has circulated a reel depicting the filming of the bank robbery and the way the sequence was finally put together. This "textbook" lesson shows Lang as master craftsman.) The Bonnie and Clyde protagonists (Sylvia Sidney and Henry Fonda) fit perfectly with Lang's obsessions — people, i.e., organized society, are out to get them, and inevitably do. Speaking of having somebody out to get you, Sidney should have paid closer attention her choice of men. She was a fine actress, but after Phillips Holmes, who is convicted of murdering her in Josef von Sternberg's adaptation of Theodore Dreiser's *An American Tragedy* (1925), Cary Grant, who deserts her and drives her to suicide in a nonmusical adaptation of *Madame Butterfly* (1932), and Oscar Homolka, the wacko anarchist to whom she is married in Alfred

Hitchcock's 1936 film *Sabotage* (based on Joseph Conrad's *The Secret Agent*), three-time loser Henry Fonda should seem to be especially risky, even if they had appeared together without too much trouble in *The Trail of the Lonesome Pine* (1936). (Fonda would shortly become a respected American icon as a result of such John Ford films as *Young Mr. Lincoln* and *Drums Along the Mohawk*, both from 1939; and *The Grapes of Wrath*, 1940.) It is also interesting that Sidney's Hitchcock film was sandwiched between her two Langs, the other being *Fury* (1936). There were many instances of these two directors borrowing unashamedly from each other over the course of their careers. Lang went on to make a Brechtian comedy, *You and Me* from 1938 (also starring Sidney), several Westerns, and a number of first-rate anti-Nazi films. But as World War II wound down, he returned to his principal themes.

Frank Borzage's History Is Made at Night 1937

Frank Borzage was a great romantic who deserves to be better remembered. In the silent period, after a decade-long apprenticeship as a director and sometime actor, he made such visually striking, stylish, and deliriously romantic films as *Seventh Heaven* in 1927 (which won him the very first Oscar for directing), *Street Angel* (1928), *The River*, and *Lucky Star* (both 1929). All starred Charles Farrell and Janet Gaynor except for *The River*, which featured the forgettable Mary Duncan. Borzage's career took a few strange turns in the sound period, especially considering he was a former silver miner from Salt Lake City. He directed two films based on classics by the Hungarian novelist Ferenc Molnár: *Liliom* (1930, also starring Farrell) and *No Greater Glory* (1934, based on *The Boys of Paul Street*). In between, Borzage won his second Oscar for *Bad Girl* (1931), a fairly sappy soap opera. But then, 1931 was a particularly myopic year for the Academy Awards, as the Best Picture award went to the mediocre *Grand Hotel* while Charlie Chaplin's *City Lights*, Josef von Sternberg's *Shanghai Express*, and F. W. Murnau's posthumous *Tabu* were ignored.

Borzage was way ahead of his time — and Hollywood's — in anticipating the fascist menace. He directed two strong dramas about the Nazi threat while most of Hollywood was still cowering in fear of losing the German market. One was *Three Comrades* (1938), an

adaptation of Erich Maria Remarque's novel by F. Scott Fitzgerald (the writer's only screen credit, coming just two years before his death), starring the luscious Margaret Sullavan, probably Borzage's most accomplished actress. Sullavan also appeared in the *The Mortal Storm* (1940), which reunited her with James Stewart, her costar from Ernest Lubitsch's masterpiece of the same year, *The Shop Around the Corner*. Borzage's anti-Nazi films were works of great poignancy, credibility, and timeliness, and *The Mortal Storm* was released in June 1940, as MGM finally mustered the courage to acknowledge that the Nazis really didn't like the Jews.

So Borzage had a busy decade, but not too busy to periodically return to his romantic roots. Especially noteworthy were *A Farewell to Arms* (1932), *Man's Castle* (1933), *Desire* (1936), which reunited Marlene Dietrich and Gary Cooper from Sternberg's *Morocco* (1930), and *History Is Made at Night*. The latter film, declared by Andrew Sarris to be "the most romantic title in the history of the cinema," stars Charles Boyer, Colin Clive, and Jean Arthur.

In a decade immensely rich with actresses, Jean Arthur lacked the European exoticism of Greta Garbo and Dietrich and the ethereal ethos of Audrey Hepburn, Claudette Colbert, or Sullavan. She also seemed to lack the love-me-or-else dominance of Bette Davis, Joan Crawford, and Barbara Stanwyck. And, to make matters worse, she was never a raving beauty. What she had was a pure girl-next-door Americanism in an era when American values were being questioned as never before. Rivaled perhaps only by Irene Dunne and Carole Lombard, in the fleeting period between 1936 and 1939 Arthur put her stamp on a kind of zany but wily woman who perhaps never existed, but who you wished had, indeed, lived next door. Mostly in her roles for Frank Capra (*Mr. Deeds Goes to Town*, 1936; *You Can't Take It With You*, 1938; *Mr. Smith Goes to Washington*, 1939), but also in Mitchell Leisen's *Easy Living* (1937), Howard Hawks's *Only Angels Have Wings* (1939), and *History Is Made at Night*, Arthur's gift for allowing her femininity to show beneath a hard-boiled surface clearly anticipated a new kind of woman. In later decades her influence would be evident in women ranging from Marilyn Monroe to Hillary Clinton.

Charles Boyer had endured nearly two decades in European films (both silent and sound) before his big American breakthrough opposite Dietrich in *The Garden of Allah* (1936), made immediately prior to *History Is Made at Night*. He went on to a glorious career, appearing in films by Leo McCarey, George Cukor, Ernst Lubitsch, Alain Resnais, and the incomparable Max Ophüls.

He replaced Maurice Chevalier as Hollywood's all-purpose Frenchman, but frequently returned to both European film and live performance. Colin Clive had, of course, made his mark as Dr. Frankenstein, and his performance as the jealous husband in the love triangle at the center of *History Is Made at Night* verges on being comparably over the top.

Borzage's plot is improbable, but what matters are the romantic sparks generated by Arthur and Boyer. From *Seventh Heaven* on, the director was far more concerned with bringing his lovers together than with quibbling with reality. Borzage accepted that movies were fantasy. His 1915 adaptation of Joseph Conrad's novel *Chance* was his first popular success after decades of disappointment. Like *History Is Made at Night*, the novel reaches its denouement at sea. It is constructed on the premise that our lives are full of chance happenings that propel our destinies. Through his narrator, Conrad opines, "We are the creatures of our light literature [read here: movies] much more than is generally suspected in a world which prides itself on being scientific and practical, and in possession of incontrovertible theories." When Frank Borzage wanted to bring two lovers together to make romantic history, neither Colin Clive nor icebergs stood a chance.

Leo McCarey's Make Way for Tomorrow 1937

Leo McCarey reached his creative peak in 1937, the year of *The Awful Truth* and *Make Way for Tomorrow*. He had already written and directed countless Hal Roach shorts, discovered the wacky chemistry between Stan Laurel and Oliver Hardy, and handled the likes of Eddie Cantor, Mae West, and the Marx brothers. *Make Way for Tomorrow* is a film of devastating emotional impact and almost indescribable beauty. In it, financial circumstances arising from the Great Depression force a couple who have been married for half a century to separate at the prompting of their children. The great Japanese director Yasujirō Ozu gave McCarey credit for inspiring his own best film, *Tokyo Monogatari* (*Tokyo Story*), a masterpiece from 1953 about aging parents and insensitive families. McCarey, a director known for his comic genius, here faces his material uncompromisingly and dead-on. As the marvelous Beulah Bondi says in one of the film's most poignant moments, "when you're seventy... about all the

fun you have left is pretending there aren't any facts to face." There was no more solution for old age in 1937 than there is today, and McCarey showed rare courage in addressing that. (The film caused Paramount to fire him.) He knew that the only way out was in a box. However, because *Make Way for Tomorrow* was written by Vina Delmar, who also wrote the first genuinely great screwball comedy *The Awful Truth* (1937), much of the film mingles humor with sadness. As McCarey once told an interviewer, "I like people to laugh; I like them to cry."

When he wanted to, McCarey could certainly use the technical resources of cinema to achieve desired effects, but time and again, he fell back on — and was redeemed by — his direction of actors. Perhaps no other major figure save Charlie Chaplin depended so little on mise-en-scène and so much on the camera's ability to magically capture the *élan vital* of human beings, to preserve on celluloid the sublime spark of two souls rubbing together. At the end of this simple but not simple-minded film, we are left with the romantic and painfully spare image of an old lady standing beside a moving train, waving goodbye to her man of fifty years as it bears him away. On the soundtrack, unashamedly and perfectly, is "Let Me Call You Sweetheart," an instrumental reprise of the duet they had just sung together. As Leo McCarey makes us cry, we know as the couple does that they will be solo for all their tomorrows.

George Cukor's Holiday 1938

George Cukor was not stylistically flashy and his philosophical point of view was not rigidly defined by dogma. His talents were subtle, but nonetheless genuine. Cukor's *Holiday* was adapted from the Broadway success by Philip Barry, who went on to write *The Animal Kingdom* (1932) and *The Philadelphia Story* (1940). *Holiday* had been filmed previously as an early talkie by Edward H. Griffith — no relation to D. W. — with Ann Harding in the Katharine Hepburn role. (Harding had been a student at Byrn Mawr just before Hepburn was.) Robert Ames, a promising young actor who died shortly thereafter, took the Cary Grant role, and Edward Everett Horton was cast in the same part he would play in Cukor's version.

It seems to me that this 1938 movie could not be more relevant. The choice between being a successful Wall Street banker or following one's muse is, as they used to say in old movie trailers, "ripped from today's

headlines." Is greed — and its potential for corruption — good? Cary Grant makes it look appealing. But since there was only one Cary Grant (and few of us can do the backflips he performs in the film), it seems as if Cukor and Barry's deck is stacked against banking. As Dana Carvey's Church Lady said, "You be the judge."

There can be no dispute that much of the peculiar charm of *Holiday* comes from its actors and Cukor's exquisite timing with their banter. In spite of the cast's youthful hijinks, this is clearly a film made by adults for adults — the kind of film we seldom see today, at least in the American commercial cinema. Therein lies its appeal.

So much of Hollywood film production has degenerated into forgettable and time-wasting amusement for digi-addled teenagers. It may seem unfair, in a study focused on directors, to blame actors for this. However, ever since Charlie Chaplin, Mary Pickford, and Douglas Fairbanks (with D. W. Griffith) formed United Artists, provoking Sam Goldwyn to declare, "the inmates have taken over the asylum," it has been generally recognized that movie stars are the people with clout, and the ones who command big bucks. Since up until now we've focused on the first forty years of film history, I haven't had much opportunity to rattle the chains of people who aren't safely dead. Now, though, I would like to appeal to some of our leading actors, people whose talent I admire. By singling these guys out, I don't mean to let others off the hook, but Robert Downey, Jr., Denzel Washington, Leonardo Di Caprio, and Jake Gyllenhaal have all appeared in effects-burdened blockbusters that were derived from video games or comic strips or at least seemed as if they were. I urge these stars to consider doing something that might have a reasonable shot at being shown at a museum a few generations from now, and be seen by people and not robots — if any of the former survive the digital revolution. Of course, there are risks involved: *Holiday* probably contributed to Hepburn's famously being labeled box office poison. Her career was ironically salvaged by another Cukor/Barry/Grant collaboration, *The Philadelphia Story*.

In 2011, *The New York Times* ran a piece by Scott Turow, Paul Aiken, and James Shapiro comparing the threat the Internet posed to copyright to the collapse of the business model that enabled Elizabethan theater. "The experiment was over... and the greatest explosion of playwriting talent the modern world has ever seen ended. Just like that." For me, these collapses parallel the fall of the Hollywood studio system that made little gems like *Holiday* possible for several decades. There are

still some interesting plays being written, just as there are interesting films being made, but — and this is very hard for many of my curatorial colleagues to wrap their minds around — there may have been a golden age of cinema, similar to the Shakespearean era for theater, that ended in the 1960s or so — and is irreplaceably gone. (Mark Harris covered much of this ground in a 2011 *Esquire* piece called "The Day the Movies Died.")

When I first moved to New York and had nothing much to do, I discovered that Cary Grant lived at the Warwick Hotel just down the block from MoMA on 54th Street. I presumptuously dropped off a note at the hotel indicating my willingness to collaborate with him on an autobiography. A few days later I got a phone call, a male secretary asking if I would hold the line for Mr. Cary Grant. Would I? There was probably nothing I, or anybody I knew, wouldn't do for Mr. Cary Grant. He came on the line and explained that he wasn't yet ready to write such a book, even though he had retired from acting. He concluded, "I wish you good fortune." Throughout our brief conversation there was a pervasive graciousness. Grace! That was what George Cukor, Katharine Hepburn, Cary Grant, and *Holiday* had, and what has been overwhelmed far too often by a deluge of tedious consciousness-constricting digital effects.

Howard Hawks's Bringing Up Baby 1938

Howard Hawks directed several dozen more-or-less masterpieces at a half-dozen different studios and across even more genres. To illustrate his genius for the "screwball comedy," one might mention *Twentieth Century* (1934), *His Girl Friday* (1940), or *Ball of Fire* (1941), but I think *Bringing Up Baby* (1938) is the best, or as Andrew Sarris suggests, "the screwiest of screwball comedies." Or maybe I just like cats. The film's "plot" involves a naïve zoologist (Cary Grant), who, while in pursuit of a rare dinosaur bone, encounters a zany heiress (Katharine Hepburn) and her pet leopard, Baby. It also features George, a bone-burying dog. Despite making films like this, one gets the impression from his filmed interviews that Hawks was not a barrel-of-laughs kind of guy. He seemed somber and serious about his profession, and lacked the sardonic, self-disparaging attitude that passed for humor in his great rival and friend, John Ford. Hawks had suffered the tragedy of

losing two brothers in an airplane crash, and the rest of his personal life (which included three divorces) did not appear to offer fertile ground for comedy. (Dudley Nichols, who shared screenwriting credit on *Bringing Up Baby*, also displays a surprisingly light touch in the film. Nichols, Ford's writer of choice for most of the 1930s and 1940s, usually gravitated toward humorless films such as Ford's *The Informer*, 1935; and *The Fugitive*, 1933; and Fritz Lang's *Scarlet Street*, 1945. He also made his own with *Mourning Becomes Electra* in 1947.) Still, with the possible exception of Leo McCarey, Hawks seemed to have the richest natural gift for pure and sustained comedy of any Hollywood genre director, and not just in his comedies.

Hawks was a great advocate and practitioner of professional commitment and responsibility. He expected everyone — directors, writers, actors — to play their roles to the hilt. In his book on Hawks, *The Lure of Irresponsibility*, the late critic Robin Wood argues that the "problem" in *Bringing Up Baby* is that all of the characters are obsessively fulfilling their designated personas. Cary Grant's paleontologist is fixated on his dinosaur; Katharine Hepburn is a madcap heiress 24/7; Charlie Ruggles can't help but be a big game hunter, even in the wilds of suburban Connecticut; and George the dog and Baby the leopard can't get their minds past dinosaur bone and raw meat, respectively. Wood, ever the moralist, argues that this is a flaw in Hawks, missing much of what is hysterically funny about the film. I suggest that viewers set analysis aside and enjoy. Bet you'll leave the theater humming, "I can't give you anything but love…."

Marcel Carné's Port of Shadows 1938

Marcel Carné (1909–1996) shared the fate of René Clair — who he assisted on *Under the Roofs of Paris* (1930) — in that both peaked early in their careers and then spent several decades in evident decline. Clair came from the French surrealist movement of the 1920s, and his *Under the Roofs of Paris* and *Port of Shadows* are examples of the "poetic realism" popular at the time. Distinguished poet and songwriter Jacques Prévert also came from this milieu (his "Autumn Leaves" was made famous in French by Yves Montand and Edith Piaf, and in English by Johnny Mercer) and for more than half a century auteurists have squabbled over the role he played in

Carné's career. I believe a cogent argument can be made that Prévert wrote all of Carné's best films.

Long, long ago in a universe far, far away (the Hamptons), I was eyewitness to two successive incidents at intimate dinner parties of famous screenwriters lying in wait to ambush auteurist critic Andrew Sarris. These guys had years of pent-up resentment at Andy's apparently cavalier underestimation of their craft. It was not a pretty sight. What needs to be said, I think, is that a really good screenwriter should work in close collaboration with a really good director. Closeness and mutual respect allow the writer to anticipate and articulate what the director visualizes. I think of teams such as Jules Furthman and Josef von Sternberg; Furthman, again, and Howard Hawks; Frank Nugent and John Ford; and Samson Raphaelson and Ernst Lubitsch. There are also many examples of writers who are most comfortable directing their own scripts: Preston Sturges, Billy Wilder, Blake Edwards, to name a few. Then there are director/writers who are too idiosyncratically obsessed (Charlie Chaplin, Ingmar Bergman) to provide much guidance on where the boundary lies.

In the case of Prévert and Carné, there may be some clue to their relationship in the two films Prévert wrote for Jean Renoir in the mid-1930s before his stint with Carné: *The Crime of Monsieur Lange* and *A Day in the Country* (both from 1936). These are among Renoir's best films, both funny and romantic, and they are extremely unlike the great somber, atmospheric Carné/Prévert tragedies of the late 1930s, such as *Port of Shadows* and *Daybreak* (1939). Prévert gave each director what that director needed, and he was talented enough to allow his persona to be subsumed in deference to his craft. So, in a sense, we have an unresolvable chicken-or-egg conundrum. In 1945, Prévert and Carné collaborated on *Children of Paradise*. Although made under the German occupation, it is arguably the most French movie ever made, and its premiere just after the liberation of Paris seemed to trumpet a similar liberation for French cinema. Regrettably, the pair never regained their prewar magic.

I would be remiss in not giving credit to the great actor, Jean Gabin, who starred in *Port of Shadows*. He was like Humphrey Bogart, Spencer Tracy, and John Wayne rolled into one. Gabin had the face of the construction worker and auto mechanic he had been, and he projected a sexuality – just ask Marlene Dietrich – that anticipated the equally homely Jean-Paul Belmondo. He worked with nearly all the great French directors from Maurice Tourneur to Max Ophüls. Without Gabin, *Port of Shadows*

might have been just another potboiler. With him, it's an existential text evoking the cosmos – and a damn good movie, too.

Abel Gance's J'Accuse 1937

Abel Gance's second version of *J'Accuse* is hardly the director's best film. It begins near the end of World War I, after the male protagonists in the story's love triangle have reconciled. Gance's 1919 original, a peculiar but impassioned antiwar epic, was mostly taken up with the rivalry over the heroine, which is finally interrupted by the coming of war. So the 1937 film is only somewhat of a remake. Most of it is barely credible melodrama shot primarily through close-ups, and the only spectacular imagery is gleaned from nightmarish wartime newsreels. These choices speak to both Gance's budgetary restrictions and the limits of his imagination when dealing with subjects that don't lend themselves to grandiosity.

It has become commonplace to pair the second *J'Accuse* with Jean Renoir's *Grand Illusion*, both French films made the same year with the ostensible hope of convincing the world to avoid World War II. I suspect, however, that Renoir was much too canny to think that his humanistic masterpiece would have any lasting effect. Gance, on the other hand, with his somewhat delusional ambition, probably fancied that he could accomplish this with the overheated intensity of his vision.

Few, if any, filmmakers have had such a grandiose opinion of themselves or their powers. In *La Fin du Monde* (1931), Gance more or less destroyed the world, even though the film's ending isn't clear. At the end of *J'Accuse* it is similarly unclear whether Gance made an impact by summoning the dead of World War I other than in scaring the pants off some Verdun cemetery workers. It is probably not fair to question Gance's motives too closely, but it is hard to reconcile his pacifism with his veneration of the mass-murdering thug Napoleon, and the proto-fascist tendencies he expressed in other films. There is reason to question whether Gance ever had anything consistent or coherent to say, or whether, for him, the medium was truly the message.

Much of his sound career was given to remaking his silent successes and producing fairly conventional costume pictures such as *Lucrece Borgia* (1935) and his last two films, *Austerlitz* (1960) and *Cyrano and D'Artagan* (1964). (By happy accident, Gance had actors mouth

the exact dialogue when filming his silent film *Napoleon* in 1927, which enabled him to issue an abridged sound version, *Bonaparte and the Revolution*, in 1934, and to update it in 1971.) Gance's inventions, like Polyvision, his widescreen process that anticipated Cinerama and CinemaScope by decades, cannot be ignored, though they often were at the time. Although he managed to keep working, Gance suffered a similar fate to that of Erich von Stroheim and Orson Welles, frightening away financiers who worried he was out of control. Gance was also stymied by producers, who feared his costly visual innovations might catch on with the public. Explaining his films from the post-*Napoleon* period, Gance once said, "The films I made I describe as 'prostitution,' not to live but so as not to die... I did not have the problem of wondering whether I was guiding the characters or being led by them. I had to respect the established structures, outside which I could not stray."

The critic Bernard Eisenschitz wrote that Gance's vision posed a threat "in calmly affirming the existence of artistic techniques which render current practices obsolete and demand that they be rethought." Yet, as Tom Milne has suggested, "he was one of the greatest masters of the image in the history of the cinema, and that should count for something."

Jean Renoir's La Marseillaise

1938

Because of copyright issues, we were unable to include *Grand Illusion* (1937) in the exhibition upon which this book is based. I have also chosen not to include the film here since the recent publication of Nicholas Macdonald's *In Search of La Grande Illusion* provides more erudition on that great film than I could manage. Instead, I'm including a far less familiar Renoir movie, one that perhaps reveals some interesting things about the director, including his aspirations and limitations.

The most famous line from Renoir's *The Rules of the Game* (1939) suggests non-judgmentally that everyone has reasons for their behavior. In *La Marseillaise*, Renoir's subject is the French Revolution and the overthrow and regicide of Louis XVI. The king is sympathetically portrayed by Renoir's older brother, Pierre, who had previously appeared in Jean's films as Inspector Maigret in an adaptation of Simenon's *Night at the Crossroads* (1932) and Charles Bovary in an adaptation of Flaubert's *Madame Bovary* (1934). (Pierre's other great role was in

Marcel Carné's lovely *Children of Paradise*, which was made under the occupation in 1945. That was seven years before the actor's untimely death, and after Jean had fled to America.) Pierre's doddering, soft, well-intentioned persona seemed perfect for a king who was not overly bright or resourceful, and easily overwhelmed. The film's other aristocrats are not in-your-face evil either, as Jean allowed for complexity, individuality, and character development. As André Bazin said, "The primary goal of the film, the one which determines its entire style, is to go beyond the historical images to uncover the mundane, human reality." Bazin adds that Renoir "demythologizes history by restoring it to man."

I do not mean to suggest that Renoir was unsympathetic to the torturous realities that provoked the revolution in the first place. However, his innate need to understand his fellow man and his craving for authenticity led him far afield from the original intent of his financial backers, the French left-wing Popular Front. Abel Gance could glorify Napoleon; Sergei Eisenstein did the same for his Bolshevik masters; Leni Riefenstahl... (I think you get the point). Renoir was not apolitical, and politics kept pursuing him through two world wars, but his vision of reality was more transcendent and complicated than these other directors, or almost anybody else's.

Even though there is hardly any religious content in his films, Renoir can still be viewed as one of the most spiritual filmmakers. And though he showed minimal flesh and offered no memorable double entendres save perhaps in *Boudu Saved from Drowning* (1932), Renoir was also the most sensual of filmmakers. As I get older, it becomes harder to view humanity as something other than a failed experiment, harder to accept humanity — as Renoir does — on its own terms. Peter Bogdanovich sees him as some kind of secular saint.

Biographer Pierre Leprohon suggests that in *La Marseillaise* Renoir carried his "good intentions" and "gentleness" too far. I am reminded of a touching scene late in Renoir's splendid novel *The Notebooks of Captain Georges*. The title character, a devoted heterosexual — the whole book is about his affair with Agnes, a young prostitute — is travelling on a train with a Russian prince. Georges awakes from a nap to find the prince holding his hand while masturbating. The prince makes a perfunctory apology, telling Georges that he finds him attractive and thanks him for the service he has unwittingly rendered. Renoir writes, "He told me all this in that charming Russian accent which made even the most outrageous utterance acceptable. It was the only happening of its kind during the journey."

Jean Renoir's The Rules of the Game 1939

Saying something new and interesting about *The Rules*
of the Game is more than a challenge. Perhaps no film with
the possible exception of *Citizen Kane* from 1941 has been
so universally acclaimed by critics of all stripes and
persuasions. It is generally known that the film was almost
lost as a result of the outrage it caused when it was released
in France on the brink of World War II. Only painstaking
restoration efforts have enabled us to see it today.

 The film came at the end of Renoir's most
spectacular decade. He had already opened up film-
making to nature and reality with *Boudu Saved from
Drowning* (1932) and *A Day in the Country* (1936). He had
laid the groundwork for Neorealism with *Toni* (1935).
He had probed unexplored psychological depths with *La
Chienne* (1931), *Night at the Crossroads* (1932), *The Lower
Depths* (1936), and *The Human Beast* (1938). He had
humanized the French Revolution and World War I
with *La Marseillaise* (1938) and *Grand Illusion* (1937). That
Renoir was dissatisfied with the existing order should
have come as no surprise after *The Crime of Monsieur
Lange* (1936) and his flirtation with the French Left.
All the while, he was developing a unique and barely
visible style of long takes and deep focus that, as Andrew
Sarris suggests, makes life seem to overflow beyond
the frame. Even so, people were caught off guard by
the ferocity of *The Rules of the Game*, especially since it
came from the bourgeois son of a highly successful
painter. Released less than two months before the
German invasion of Poland, the French ruling class was
scandalized by Renoir's satirical portrait of its behavior
on the brink.

 After production started, Renoir was reportedly
distressed by Nora Gregor's performance as the female
lead. (Hers is a fascinating story – Gregor came from
Jewish ancestry, married an Austrian fascist, and was
exiled to South America, where she ultimately
committed suicide.) Renoir rewrote her part and made
himself an onscreen *metteur-en-scene*. He had acted in a
number of his earlier films, most notably, of course,
A Day in the Country, in which he comes across as the
jovial bear of a man whom my erstwhile colleague,
Eileen Bowser, recalled from a visit to the Museum.
It is apt that Renoir selected a bear outfit for the costume
party in that film. One can only assume that *The Rules of
the Game* captures something of what the director

was like in real life, a thinly veiled genius masquerading
as buffoon. I once wrote a piece comparing the
seemingly disparate visions of Renoir and Josef von
Sternberg, who were both born the same year. Although
Sternberg never appeared before the camera, he was
willing to cast an ironic eye on himself via the
performances of Adolphe Menjou in *Morocco* (1930)
and Lionel Atwill in *The Devil Is a Woman* (1935). In the
cases of both directors, there was a willingness to risk
fragile dignity in the service of art.

 There is something disconcerting about the
ruckus that *The Rules of the Game* caused among the
French. Renoir was, after all, the most tolerant and
humane of all artists, and his central message is one of
forgiveness – everyone has his or her own reasons for
their behavior, no matter how foolish or selfish. Although
he retained his love of France and returned there
frequently after the war to make films, he made his home
in Los Angeles where he and his wife, Dido, had found
refuge. The French New Wave directors who came of age
under the auteurist criticism of *Cahier du Cinema* turned
their backs on much of France's film heritage, but they
never abandoned Renoir. He went on to mentor the group
along with another Hollywood exile, Alfred Hitchcock.

Sergei Eisenstein's Alexander Nevsky 1938

Sergei Eisenstein was world-renowned by the age of
thirty for applying his theory of montage to his youthful
masterpieces *Strike, Battleship Potemkin* (both 1925), and
October (Ten Days That Shook the World) from 1928. These
films found heroism in collectives – among workers,
sailors, and in the case of his 1929 film *Old and New*,
farmers – and in the stick-figure commemoration of the
Bolshevik revolution. In 1930, Paramount Pictures invited
Eisenstein to come to Hollywood, and during his time
there he pursued several projects that would never be
completed. Among them was an attempted adaptation of
Theodore Dreiser's *An American Tragedy*, which would
ultimately be made by Josef von Sternberg in 1931. To
delay returning to Russia, in 1932 Eisenstein persuaded
Upton Sinclair and his wife to finance the intended
epic *Que Viva Mexico!*

 Eisenstein and his crew lingered in Mexico;
the director reputedly enjoyed the charms of local boys
and occasionally shot some film. Finally, the Sinclairs

ran out of patience and money, and Eisenstein had to return to Moscow. He and Stalin later attempted to get Sinclair to send him the footage so that it could be edited. The Soviet representative in these negotiations was a young man named Thomas J. Brandon. Brandon eventually became the entrepreneur behind Brandon Films, the most successful non-theatrical/16mm film distributor, and the owner of an enormous catalog of European, Japanese, and Russian classics. (As a "fellow traveler," he also distributed Soviet bloc items like *Apple Blossom Time in Poland*.) This all has a personal resonance because I was one of his last employees. In capitalist disguise, Brandon took a cue from the Wizard of Oz and sent illegible tirades each day to staff from his estate in Westchester, where a lucky few of us were occasionally invited for the privilege of raking his leaves. Rarely, he would descend upon the office, and usually arrive about 5:25 in the afternoon as if to defy anyone to leave. Anyway, TJB (as he fashioned himself) failed — it was only after Eisenstein and Stalin were long gone that MoMA managed to preserve the *Que Viva Mexico!* footage, much of which is exquisite. In 1972, duplicates were dutifully sent to Gosfilmofond, our Moscow-based colleague in the International Federation of Film Archives.

Upon his return to Moscow, Eisenstein found that he was out of favor. His second collectivist farm epic, *Bezhin Meadow* (1937) was destroyed by the Soviet government before it was completed. Fortunately for film historians, a single frame of each shot was saved. Jay Leyda — onetime Eisenstein assistant, briefly a member of the MoMA staff, and later a distinguished professor of cinema studies at NYU — assembled the surviving stills into a short. It was only after Stalin fired Boris Shumyatsky, czar of the Soviet film industry, that Eisenstein's career experienced a rebirth.

In the late 1930s, Stalin was increasingly anxious about Hitler's ascendance in Germany and his expansionist inclinations. *Alexander Nevsky* was made in part to remind the Germans that the butt-kicking they had received from Russia in the thirteenth century could be repeated seven hundred years later. Nevsky himself was the great hero who had saved Russia from Teutonic conquest and, unlike Eisenstein, been made a saint. A television poll a few years ago declared him the greatest of all Russians. (Scarily, Stalin placed third.) The amazing thing about Nevsky is that his victories came when he was twenty or twenty-one years old. But then, what else would one expect from the grandson of Vsevolod the Big Nest? The film's star, Nikolai Cherkassov, was nearly twice that age at the time of the film.

Cherkassov specialized in playing great men (Ivan the Terrible, Maxim Gorky, Modest Mussorgsky, Nikolai Rimsky-Korsakov, even Franklin Delano Roosevelt), and he is mythologically perfect for Eisenstein, who had little experience creating heroic leads, preferring instead collective heroes like rebellious sailors or strikers from the pre-revolutionary period. The film that resulted from their collaboration is one of the greatest historical epics in cinema.

Leo Tolstoy renounced much of his early work in later life. In some ways the same can be said of Eisenstein, although he never reached an advanced age. *Alexander Nevsky* is more sedate and slower paced than his silent films, and it saves much of its montage for the climactic "battle on the ice" scene, where the Germans do, indeed, get their butts kicked. That battle sequence is perhaps rivaled only by Orson Welles's Battle of Shrewsbury in *Chimes at Midnight (Falstaff)* (1966), yet *Nevsky* also paved the way for the splendors and spectacle of *Ivan the Terrible* nine years later.

Leo McCarey's Love Affair 1939

Leo McCarey was a key figure in 1930s Hollywood. For the exhibition that this book accompanies, we highlighted two of his Laurel and Hardy shorts; *Duck Soup* (1933), made with the Marx brothers; his innocent homage to America, *Ruggles of Red Gap* (1935); and his melancholy meditation on old age, *Make Way for Tomorrow* (1937). He made several other noteworthy films during his best decade, and although we did not include it, *The Awful Truth* (1937) is one of his finest screwball comedies.

The first half of *Love Affair* (1939) is probably as good as anything McCarey ever did. In it, Charles Boyer, Irene Dunne, and Maria Ouspenskaya cast a mature romantic spell worthy of Charlie Chaplin, Jean Renoir, or Max Ophüls. The actors inhabit a world of misty ship decks, sunlit Madeira gardens, and silent chapels where "it's a good place to sit and remember." Dunne and Boyer meet on a ship en route to New York, and during a stop at Madeira they briefly visit Ouspenskaya, cast as Boyer's sagacious grandmother. Ouspenskaya tells Dunne she is still young and offers up her grandson, telling her: "There is nothing wrong with Michel that a good woman could not make right." It is almost too beautiful.

In fulfilling the necessities of its contrived plot, however, *Love Affair* begins to fall apart. The lovers are

LOVE AFFAIR. DIRECTED BY LEO MCCAREY. 1939. USA. BLACK AND WHITE, 88 MINUTES.

separated for an interminable thirty minutes of screen time, and grandma dies. There is a foretaste of the heavy-handed religiosity that was to afflict much of McCarey's later work; Dunne confesses to a priest what a bad girl she had been and fawns over some orphanage brats who seem to be auditioning for McCarey's saccharine *The Bells of St. Mary's* (1945).

In the final scene of reconciliation and reunion, McCarey attempts to recoup the ground he has lost, predictably through relying on his stars' chemistry. It is a great testament to the director's faith in his actors that this scene − an entire reel of screen time − consists almost entirely of interaction and dialogue between Dunne and Boyer. The only "cinematic device" deployed is a painting of Dunne and Ouspenskaya that hangs on the wall of Dunne's New York apartment. Like the portrait of Janet Gaynor as the Madonna in Frank Borzage's *Street Angel* (1928), the painting serves as a reminder of an apparently lost future and rekindles the lovers' feelings for each other. Ultimately, we are convinced that the Boyer/Dunne romance is true, and that they will conquer the adversities imposed by the film's plot. The movie leaves us happy, for in the wonderfully romantic world of Leo McCarey circa 1939, as the orphans' song goes, "wishing will make it so."

The director's prominence, however, was fleeting, and it suffered as he struggled to maintain a tenuous equipoise between very genuine talent and growing Catholic sentimentality. The latter eventually burgeoned into quasi-fascist anti-intellectualism during the McCarthyite 1950s, and obliterated much of his art. For a brief period, McCarey remained prominent. His two Bing Crosby vehicles (*Going My Way*, 1944; and

The Bells of St. Mary's, 1945) were very popular in the mid-1940s, and he did a more or less successful *Love Affair* remake, *An Affair to Remember*, with Cary Grant and Deborah Kerr in 1957. In the last three decades of his life, McCarey only made five other films – and none possessed the élan of his 1930s work.

John Ford's Young Mr. Lincoln
1939

John Ford (1894-1973) was the greatest film director America has ever had – or ever will have – and remains quite possibly the country's greatest artist. His usual reaction to such views was that of a snarling, sarcastic sonofabitch. He was a man who could be quite cruel, even violently so, to people who loved him. Ford, like his predecessor, Walt Whitman, was a poet of genius and contradiction.

He was born John Martin Feeney on the southern coast of Maine in Cape Elizabeth, the youngest surviving son of an Irish saloonkeeper from Portland. As a high school football hero known as "Bull," young Jack showed an unusual affinity for theater and literature. (The school auditorium now bears his adopted name.) Many years after his much older brother Francis Ford first left home (some say he was run out of town) to become an actor and director in newly established Hollywood, Jack joined him and began what amounted to a quarter-century apprenticeship making movies, the majority of which were Westerns.

Although Ford won an Oscar for *The Informer* (1935) and made many fine films in the intervening years (including *The Iron Horse*, 1924; his Will Rogers trilogy; and *The Prisoner of Shark Island*, 1936), he did not fully hit his stride and become "John Ford" until 1939. Sandwiched between *Stagecoach* and *Drums Along the Mohawk* (both from 1939), *Young Mr. Lincoln* began Ford's exploration of American political culture. This would culminate a quarter-century later in another masterpiece, *The Man Who Shot Liberty Valance* (1962). One of Ford's many gifts was his capacity to simultaneously see the mythological qualities of his characters as well as their human frailty. No other director believed so much in the American myth, or saw so clearly its deficiencies.

In *Young Mr. Lincoln*, Henry Fonda is perfect as the young backcountry lawyer, just as Walter Huston had been as the older Lincoln in D. W. Griffith's *Abraham Lincoln* (1930). While Griffith had struggled with the demands of nascent talkies, Ford absorbs the free-flowing visuals of German Expressionism into his own personal and poetic style. When Fonda goes to the top of a hill at the end of the film to perhaps glimpse the future, it is a simple, almost trite, gesture. Yet in Ford's hands, it contains spectacular emotional resonance. There would be many such moments in later Ford films – Jane Darwell burning her memories in the form of photographs in *The Grapes of Wrath* (1940), Fonda's farewell to Darwell in that same film; virtually all of *How Green was My Valley* (1941), and a galaxy of examples in Ford's John Wayne Westerns. Through his command of the medium, Ford led viewers to care about his characters in an almost familial way. These moments, like Ford's films, are all inimitable.

Ernst Lubitsch's Ninotchka 1939

The first two decades of the American film industry grew out of a nativist culture given to various Victorian melodramatic flourishes. It was the WASP preserve of D. W. Griffith, Cecil B. De Mille, and Thomas Ince, though a certain level of Irish intrusion was eventually allowed in the figures of Raoul Walsh, Marshall Neilan, and Francis and John Ford. With the coming of World War I, however, the European continent and its values began to intrude deeply into the American consciousness. Erich von Stroheim, the all-purpose Hun, became a regular onscreen presence, and less than a year after the armistice, he became a prominent director with *Blind Husbands* (1919). Through Stroheim's films, most notably *Foolish Wives* (1922), European decadence began to ooze into our movies. In one sense he thrived on perversity, but Stroheim's perversity was increasingly dominated by a self-destructive element that eventually snuffed out his career as a director.

The antithesis to Stroheim's European decadence was Ernst Lubitsch, who had established himself as a major director in Germany before coming to America. Although Lubitsch's films were no less "European" than Stroheim's, they substituted sophistication for decadence, wit for turgid melodrama, and a smiling face for one that leered. Other European directors would be imported in Lubitsch's wake – including Victor Sjöström, Mauritz Stiller, Benjamin Christensen, and F. W. Murnau – but none achieved his long-standing

success. And none had as much influence on American-born directors such as Howard Hawks, Leo McCarey, Preston Sturges, George Cukor, and Blake Edwards.

The 1930s marked an era in American film in which works of grace, opulence, and continental elegance shared the podium with more homely movies. There was fiefdom royalty amongst cowboys; Parisian jewel thieves amidst Chicago gangsters; operetta next to Depression. Europe, in Lubitschland, was palaces, spectacular apartments, magnificent banquets — the best furnishings MGM and Paramount could buy — and Hans Dreier and Cedric Gibbons in a stylized shootout at the O. K. Corral. As the darkness of the war began to close in on the back lots of Hollywood, however, Lubitsch saw the end of his era of European grandeur. The whole point of *Ninotchka* is that although Lubitschean civilization may be doomed, it still sparkles and scintillates through William Daniels's imagery. Daniels, who was Stroheim's favorite cinematographer, also served in a similar capacity for Greta Garbo.

The film was intended to lend Garbo a human touch, but this proved futile in the face of her irredeemable regality. It is fitting that this Queen of MGM should reign over the closing chapter of a Europe that still existed in Lubitsch's mind but not on any map. She was no longer popular at the American box office, and the European market was disappearing under Nazi boots. The Sweden to which she had often threatened to return when Louis B. Mayer didn't pay her enough was now precariously neutral in the war that broke out just as the film was being prepared for release. Lubitsch had, over the years, engaged in his own personal tour of European actresses from Henny Porten to Pola Negri and Marlene Dietrich; it was inevitable that he would direct Garbo, and she gave one of her best performances — one of the most luminous ever committed to celluloid.

I scoff at those who cite 1939 as significant because of *Gone with the Wind* or *The Wizard of Oz*. There were many great films that year both in the U.S. and abroad, but two stand out as augurs, laments about the passage of worlds that will never return: Jean Renoir's *The Rules of the Game* and *Ninotchka*.

1940-1949

Walt Disney's Pinocchio

1940

Walt Disney lavished years of work on *Snow White and the Seven Dwarfs* (1937), and it took him another three to produce *Pinocchio*, a picaresque adventure of a youthful innocent who happened to be a wooden-headed marionette. More time has now passed since the release of Disney's film than between Carlo Collodi's 1882 children's book and the Disney adaptation, both of which are legitimately considered classics. I thought Disney's version was pretty scary for kids, but in comparison to the book the film almost seems tame.

I once took my nieces (who were then in the single digits) to see the movie, and as the climax approached, the middle one got more and more anxious. By the time Monstro the whale appeared she had climbed onto my lap in tears, and we had to do the unthinkable: wait for the others in the lobby. Collodi's book is rife with violence and gore – Pinocchio's feet burn off; four rabbit undertakers express their disappointment that Pinocchio is not dead – and there is copious self-mutilation. The charming Jiminy cricket (played by Cliff Edwards in the film) is squashed in an early chapter, though he returns several times as a ghost. Instead of Monstro the whale, the book features a mile-long shark. Jiminy, Honest John, and Stromboli, the most interesting and three-dimensional characters in the film, are essentially the creations of Disney and his minions. There is also nothing in Collodi to rival the film's delightful songs, which play as the puppet hero stumbles from one calamity to the next.

There must have been something in the air in 1939 and 1940 in America that led to the mindless optimism generated by conservative filmmakers. In Leo McCarey's *Love Affair* (1939), Irene Dunne sings "Wishing Will Make It So," while in *Pinocchio* Jiminy Cricket sings, "When You Wish Upon a Star Your Dreams Come True." Disney went on to corner the market with films like *Fantasia* (1940), *Dumbo* (1941), and *Bambi* (1942), while his rival, Max Fleischer, failed to keep pace. Uncle Walt's vision helped shape American feelings of "exceptionalism," and his films reflected his politics and sanguine view of the world. In any case, my niece, terrified by Monstro, grew up to be a Republican.

John Ford's The Grapes of Wrath 1940

Orson Welles once told Peter Bogdanovich, "John Ford knows what the earth is made of." Although Welles probably did not intend this to be a cryptic observation, it does lend itself to several interpretations. He could have meant it geologically, and perhaps been referring to the Paleocene epoch, when complex life began to form. He could have also been thinking of the even more complex development that came after – the appearance of those troublesome bipeds that we later evolved from. If this all this sounds a bit grandiose for a director who spent much of his early career making mostly mindless two-reel Westerns, so be it. But I believe both interpretations of Welles's remark are apt. Ford had a unique

perspective on man's place in the natural world, and he had a spirituality that could simultaneously encompass our glory and frailty. John Steinbeck also had both of these qualities. I would contend that although *The Grapes of Wrath* is by no means Ford's best or most personal film — though it did win him his second Oscar — Ford shares a kinship with Steinbeck that makes him the perfect director to bring the book to the screen. I would further argue that there is no other adaptation of a genuinely great novel that is as good or as fully realized as Ford's.

Although *The Grapes of Wrath* was, more than any other Ford film, a commentary on its own time and a strong statement of his commitment to liberal values, there is a wistfulness in place about the loss of a simpler past. This was a feeling he would embellish in films over subsequent decades. Increasingly, Ford and American society had to rely on memories of better times. The ways of life people had depended on for generations were becoming uncertain, and the future seemed ominous. This makes the scene in which Jane Darwell burns her photographs before the family moves to California one of the most transcendent moments in twentieth-century art. One thinks of Falstaff's reminiscences of his youth, or Lear's lament over his daughters' betrayal. This poignancy lends the film a timeless and universal quality, a sensibility not bound by the immediate realities of the Great Depression or the New Deal, hinting at an underlying chaos. It is naked, stark, raw.

I don't wish to dismiss, however, the film's success in other regards. For a film made in 1940 by a major Hollywood studio, it was genuinely courageous of Ford and Daryl F. Zanuck to suggest that capitalism had failed and that socialism offered a genuine alternative. Henry Fonda, moving from Lincoln to Tom Joad, carried with him an authenticity derived both from American populism and the power of Ford's cinematic tools. Although the film does temper Steinbeck's book a bit, as Morris Dickstein suggests in *Dancing in the Dark*: "Finally, however, the novel and film come together as an almost seamless composite of words and images, fictional characters and performances, an indelible testament to their times."

I do not fully buy into the common wisdom that Ford's leftward leanings were transitory and that he became much more conservative with the passage of time. Yes, he respected the traditions and rituals of the military, bolstered by his World War II combat experience at Midway and Normandy (of which he was enormously proud), his O.S.S. filmmaking responsibilities, and

his lasting commitment to the postwar retreat he established at Field Photo Farm for the men who served under him. Yes, his Cavalry Trilogy (*Fort Apache*, 1948; *She Wore a Yellow Ribbon*, 1949; *Rio Grande*, 1950) can be superficially read, as it is by my friend Garry Wills, as Cold War propaganda. And yes, he wound up his public life by conveying God's blessings to the disgraced Richard Nixon. But the military he venerated had fought the good war for the preservation of civility and decency. The Cavalry Trilogy is one of the American cinema's greatest achievements; a veritable visual poem on what it was like to live on the frontier in the nineteenth century. It is, in effect, the *Moby Dick* of the movies. At the same time as he was making these films, Ford challenged Cecil B. De Mille's rightwing putsch to take over the Director's Guild. And the Ford who praised Nixon was a cancer-riddled old man only months from his death, accepting from the President of the United States the two highest awards ever bestowed on a filmmaker.

In both his films and his life, Ford, the son of an immigrant Irish saloonkeeper, was an ardent supporter of the Irish Revolution. He shared the same sympathetic feelings he found in Steinbeck with the populist, mixed-race comedian and actor, Will Rogers, and the pair made three excellent films just before Rogers's death. Ford loved Jack Kennedy, who sprang from the same roots as he did, and he mourned the president's assassination. He felt compelled to make *Sergeant Rutledge* (1960) and *Cheyenne Autumn* (1965) to be certain that the future did not interpret his films as racist. In his declining years, disappointed in his own natural children, he became a genuinely close paternal figure to the black Woody Strode and the gay Brian Desmond Hurst. Ford never bought into — and snarled at — John Wayne's reactionary politics. If he were alive today, Ford would lock arms with Tom Joad in defense of the people against the banks, the corporations, and the shrill know-nothings among us. Like Walt Whitman, John Ford sometimes contradicted himself. But also like Whitman, he contained multitudes.

King Vidor's Northwest Passage 1940

While MGM focused its attention on *Gone with the Wind* in 1939, King Vidor was brought in to salvage *Northwest Passage*, which turned out to be a more

authentic epic than its competitor. Aside from a scene in *Gone with the Wind* in which William Cameron Menzies burns Atlanta, *Northwest Passage* was more creative in its use of color and was infinitely more personal. The latter film was made at the same time as *Drums Along the Mohawk*, John Ford's first color film, and it is far more interesting to compare the two, especially since *Drums* is curiously similar to *Northwest Passage*. Ford even used art director Richard Day and composer Alfred Newman, who both had been Vidor regulars throughout the decade. In 1939, the careers of these directors came closer together than they had at any time before or would at any point after.

In *Northwest Passage*, the character Spencer Tracy plays (a major in the French and Indian War who leads his men to open up new territory) is strikingly similar to Nathan Brittles, the character John Wayne would play in Ford's great *She Wore a Yellow Ribbon* nearly a decade later. The fact that Laurence Stallings contributed to both scripts makes this something more than a coincidence. Stallings also wrote Vidor's monumental silent, *The Big Parade* (1925), and Robert Young's character in *Northwest Passage* is highly reminiscent of John Gilbert, a young aristocrat who dabbles in war until it almost kills him. At the climax of *Northwest Passage*, Tracy must make a highly charged three-and-a-half-minute speech in a single take. Vidor forced a reluctant Tracy to cry in anguished disappointment, and the speech was delivered, as Tracy biographer James Curtis says, with "his character teetering on the brink of madness." Tracy's Major Rogers, both autocratic and idealistic, is a classic American hero.

Among the triumphs of the film is a sequence of carnage in an Indian village. It is one of the most incredible examples of location shooting in any film. Whatever its moral and racial implications, it is, like the whole of *Northwest Passage*, undeniably an extraordinary piece of filmmaking.

Charlie Chaplin's The Great Dictator 1940

The Great Dictator presents unique problems for the historian trying to reconcile Bosley Crowther's judgment in 1940 that Charlie Chaplin's movie was "perhaps the most significant film ever produced" with the film's occasionally flawed execution of Chaplin's grand

and noble conception. Because Chaplin was a universally recognized and beloved personality — whose famous moustache had been stolen by an equally well-known, but far less beloved, comedian cum tyrant — his film on Hitler was an event of worldwide consequence.

To deem the film a work of propaganda or to reduce it to a genre (scores of anti-Nazi movies emerged during the war) would be to demean it. *The Great Dictator* is the product of extraordinary synchronicity and an unprecedented convergence of historical and artistic forces. By happy accident, we find the century's most emblematic popular artist testing his gifts against the man who embodied the greatest threat to civilization, human freedom, and, in fact, art in recorded time. It is not an overstatement to refer to *The Great Dictator*, as Chaplin biographer David Robinson does, as "an epic incident in the history of mankind." In its confrontation with the cosmos — and its deeply felt intent to alter the state of human affairs though art — the film stands alone on a very special pedestal of aspiration.

Chaplin's audacity is even more remarkable for the fact that he was working in an essentially new medium for him: the sound film. Improvisation and experimentation yielded to a preplanned script, and as he had anticipated, something was lost in the subservience to dialogue. *The Great Dictator* does not flow as rhythmically as its predecessors. In part, this can be attributed to the need to cut back and forth between the two disparate plots: Adenoid Hynkel in his palace and the Jewish barber in the ghetto. Even so, Chaplin's verbal wit is too often outdistanced by his imagery, and there is an awkwardness in the pacing. The film is funny, but the dialogue is often obligatory and annoyingly superfluous.

Some of the cleverest sequences include no talking whatsoever. One senses Chaplin is most at ease when relying solely on the facility of his face and body. Chaplin can provide funny banter (Commander Schultz: "I always thought of you as an Aryan." / Barber: "I'm a vegetarian."), but it reduces the cosmic to the merely comic. To succumb to cliché, when dealing with the most visually expressive of performers, a picture is worth a thousand words.

Hitler, whose circumstances of birth were similar to Chaplin's (they were born only four days apart) was a source of primal fascination for the filmmaker. Both were endowed with unparalleled charisma and forceful personalities, yet their paths and purposes could not have been more divergent. They were the era's apostles of love and hate. Commercial considerations aside, Hynkel

is the only justification for *The Great Dictator* being a sound film, as radio was probably the primary factor in Hitler's astonishing sway over Germany. In a sense, then, the dictator was the creature of the technology that Chaplin had so long despised and resisted. There is a kind of poetic justice in the fact that Chaplin was so skillfully able to turn this unfamiliar weapon against his ranting nemesis. Chaplin calls attention to the reality that, as speechmaker, Hitler was nothing more than another actor, one whose excessive animation and gestures are reminiscent of the lesser talents of the silent screen. We are now in the era of sound, however, and subtlety has given way to noise, civility to barbarity. Like the barber awakening after twenty years of amnesia to a very changed and diminished world, Chaplin, after trying to ignore reality, resolves to confront it.

It is doubtful that Chaplin could have so brilliantly captured the zaniness inherent in Nazi-ness if he had foreseen the enormity of evil just around the corner. The easy laughs of 1940 cannot in hindsight escape the shadow of the crematoria. Chaplin understandably failed to appreciate the full significance of destroying the Nazis, but this does not diminish the poignancy of his efforts to try.

In one of the greatest of cinematic ironies, the Tramp-like barber is mistaken for the dictator and forced to make a speech announcing the annexation of Osterlich. It is a moment made infinitely more ironic by the fact that Chaplin, a man whose mistrust of words was legendary, steps out of character and delivers a daring personal appeal to a despairing humanity. Schultz tells him: "You must speak... it's our only hope," and who is to say that Chaplin did not believe that this speech, and *The Great Dictator* itself, was not humanity's last, best hope? And who is to say that this appeal, wrenched from "the little fellow's" gut, didn't help save the world by giving mankind a timely kick in the butt?

THE GREAT DICTATOR. DIRECTED BY CHARLIE CHAPLIN. 1940. USA. BLACK AND WHITE, 125 MINUTES.

Fritz Lang's Western Union 1940

In the interim between his bizarre Brechtian musical
experiment *You and Me* (1938) and his anti-Nazi classics
(*Man Hunt*, 1941; *Hangmen Also Die*, 1943; *Ministry of Fear*,
1944), Fritz Lang was assigned by Daryl F. Zanuck at
Twentieth Century-Fox to make two Technicolor
Westerns. Of the two, Lang preferred *Western Union* to
The Return of Frank James (1940), and there was no small
irony in the leading European director bragging about
the authenticity of his film by mentioning accolades from
the Flagstaff "old timers" club. Part of whatever credit is
due should surely go to his veteran associate producer
Harry Joe Brown, who started directing Westerns in the
1920s and went on to produce such fine Budd Boetticher/
Randolph Scott collaborative efforts as *Ride Lonesome*
(1959) and *Comanche Station* (1960) two decades after
Western Union.

For Lang, *Western Union* was relatively
impersonal, and the film carries with it many of the clichés
and conventions of other men's Westerns. It was made on
the heels of the successful *Stagecoach* (1939), and the
music and visual qualities seem to reflect the influence of
John Ford, but also to curiously anticipate his master-
pieces of the next decade, namely *Fort Apache* (1948),
She Wore a Yellow Ribbon (1949), and *Rio Grande* (1950).
(In *Western Union*, Francis Ford is glimpsed briefly as a
stagecoach driver.) *Western Union* seems particularly
virulent in its racism, especially when compared to the
complexity with which Ford treated the Indians. Even the
major characters, however, are more types than warm-
blooded people, often a flaw in Lang's otherwise brilliant
films. The romantic interest, played by Virginia Gilmore,
never seems fully integrated into the plot. Slim
Summerville largely recreates the role he played in *All
Quiet on the Western Front* (1930), and the comedy he
provides seems intrusive and heavy-handed when
compared with similar characters, such as Andy Devine in
Stagecoach or *The Man Who Shot Liberty Valance* (1962), or
Walter Brennan in *Red River* (1948) or *Rio Bravo* (1959).

Edward Cronjager had been the cinematogra-
pher on Victor Fleming's *The Virginian* (1929) and Wesley
Ruggles's *Cimarron* (1931), two of the major Westerns of
the early sound period. In *Western Union*, he and his
colleagues make beautiful use of Technicolor and its
capabilities, marred occasionally by badly matched
back projection. Films such as King Vidor's *Northwest
Passage* (1940), Ford's *Drums Along the Mohawk* and
Fleming's *Gone With the Wind* (both 1939) had already
demonstrated that the Technicolor epic could be
something more than just eye-filling spectacle.

Fritz Lang apparently did not have the freedom
in *Western Union* to make his presence and vision felt
in any depth. It is interesting, then, that he resurrected
and reworked some of the same scenes and situations a
decade later when he returned to genre with his very
personal *Rancho Notorious* (1952).

Preston Sturges's The Lady Eve
1941

Preston Sturges (1898–1959) was in that coterie of
Hollywood scriptwriters that included Billy Wilder, John
Huston, Joseph L. Mankiewicz, Blake Edwards, and Elaine
May, to name just a few, who ultimately weren't content
to let someone else direct their scripts. Sturges's own
transition from screenwriter to director took a long time.
He wrote part or all of seventeen films between 1930
and his directorial debut a decade later. In retrospect, it
seems pretty clear that Sturges was primarily responsible
for the success of such films as William Wyler's *The Good
Fairy* (1935) and Mitchell Leisen's *Easy Living* (1937).

Like many writers, Sturges had trouble
privileging the visual over the aural, but he was blessed
with superb instincts in choosing character actors who
could finesse any tendency to be over-literary or
pretentious. For me, Eugene Pallette (*Shanghai Express*,
1932; *The Ghost Goes West*, 1935; *The Adventures of Robin
Hood*, 1938; Mr. Pike in *The Lady Eve*) could never go
wrong, and he was in great company in *The Lady Eve* with
Charles Coburn, William Demarest, Eric Blore, Melville
Cooper, and a pack of Sturges-selected screwballs.
Andrew Sarris compared the way Sturges populated his
films with the gifted congestion of Breughel's paintings.
Although he lacked the visual flair of such masters
as Buster Keaton, Charlie Chaplin, or even his hero, Ernst
Lubitsch, through his films Sturges secured a place for
himself as one of the great comedic directors.

Sturges skewered everyone, but he seemed to
take great satisfaction in going after the rich, a class he
shared many experiences with. That is one of the
qualities that make *The Lady Eve* so appealing. Another is
the film's stars: although Henry Fonda was by this point
an established star, he had never done genuine comedy
before. I can't conceive of anyone other than Barbara
Stanwyck who could bring off the dual role Sturges wrote

THE LADY EVE. DIRECTED BY PRESTON STURGES. 1941. USA.
BLACK AND WHITE, 93 MINUTES.

for her, playing a card sharp con woman masquerading as British nobility on a transatlantic voyage. The rich but innocent Fonda is her unsuspecting target.

In a sense, Sturges was ahead of his time and perhaps overly restrained by the limitations of film. He resembled recent commentators like the late George Carlin at his best, or Bill Maher — "comedians" freed by cable television to talk about things as they saw them. In short, Sturges was what we would now call "a free spirit." There is some of this in middle-period Woody Allen and in Mel Brooks's more over-the-top moments. As was true of Lubitsch, sex is at the heart of Sturges's art, as exemplified by *The Palm Beach Story* (1942), *The Lady Eve*, *Hail the Conquering Hero* (1944), and *The Miracle at Morgan's Creek* (1944). While following Lubitsch's model of not being too blatant or explicit, Sturges's films were still

open about sexuality. World War II-era America was not quite ready for this, but Sturges managed to leave us with some scintillating films — and a never-to-be-gratified craving for more.

Orson Welles's Citizen Kane 1941

Orson Welles (1915–1985), from Kenosha, Wisconsin, was, like the other three greatest U.S.-born directors — D. W. Griffith from La Grange, Kentucky; John Ford from Portland, Maine; and Howard Hawks from Goshen, Indiana — a product of a rural America that began to disappear with the coming of the Industrial Age. In American literature and history, ambitious and talented young men have often left home for creative urban centers at a young age, and both Charles Foster Kane and Orson Welles conformed to this pattern with a vengeance. Whatever *Citizen Kane*'s script owes to

Herman J. Mankiewicz, the film can justly be seen as an autobiographical expression by Welles. What 25-year-old was ever so ambitious and innately talented? Certainly no one in cinema was before or has been since.

Citizen Kane may or may not be the greatest film ever made, but as a late friend of mine suggested, it is the most fun of all the great films. It oozes with gratification, coming in no small measure from Welles's almost orgasmic joy at playing with his new toy. It has been argued that the film is in some ways superficial — but then, how much depth is reasonable to expect from someone so young? — and that it takes full advantage of the cinematic accomplishments of Welles's predecessors, from Soviet montage to German Expressionism as filtered through John Ford. Does this make Welles, the great innovator, a poseur or fraud? He was not uncomfortable in that role, of course. His early exploits, like going to Ireland as teenager and masquerading as an older prominent American actor, or hoodwinking the country into thinking Martians were taking over, or settling comfortably into the role of a stage magician, all reflected a willingness to deceive. (One of his last completed films, F for Fake from 1975, helped reinforce this image.) But what, after all, is cinema but deception, an alternative reality that its masters can make us feel and believe in? The Church of Cinema offers its congregants a mythologized fantasy, but at less cost and with fewer demands than most religions.

Charles Foster Kane, America's most powerful newspaper publisher (modeled in part on William Randolph Hearst), aspires to be a profit-making prophet, and in this seems all too relevant to today's über-capitalist America. What has changed, however, is how we regard Welles's great theme of loss. In almost all of his films, the towering figures he chose to play wind up losing, failing, and often dying alone and unmourned: Kane, Franz Kindler in The Stranger (1946), Macbeth, Othello, Mr. Arkadin in Confidential Report (1955), Hank Quinlan in Touch of Evil (1958), Hastler in The Trial (1962), Falstaff, Mr. Clay in The Immortal Story (1968). All carry with them Welles's sense of having reached a height and then fallen from grace. Is there a cinematic poet today even remotely capable of conveying this kind of tragic loss? And have we lost all belief that the wicked and hubristic will be punished?

The airwaves and newspapers periodically seem to be awash in discussions of whether there is such a place as hell. As a nonbeliever, this seems to me to be frivolous and irrelevant. (I sort of think that the absence of hell would be a letdown; I'm looking forward, like Mark

Twain quipped, to shaking the devil by the tail.) It does, however, point to a contemporary level of despair, a feeling that today, anything goes. Marlene Dietrich, who was sawed in half by Welles in Follow the Boys (1944) and gave what she deemed to be her best performance in a cameo in Touch of Evil (1958), saw Welles as a kind of saint or deity: "When I have seen him and talked to him, I feel like a plant that has been watered." Unlike Kane, Welles, with all his foibles, was really not good hell material.

Simon Callow, at the conclusion of the first volume of his Welles biography, The Road to Xanadu, wrote, "His engagement with his own personality led to the complete abolition of the dividing wall between himself and his creations... Eventually, he found an extraordinary benevolence towards life, coming finally to smile on his younger self, that self preserved forever in Citizen Kane."

John Huston's The Maltese Falcon 1941

John Huston (1906-1987) has always been something of an enigma to me. The director of The Maltese Falcon, The Treasure of the Sierra Madre, Key Largo (both 1948), The Asphalt Jungle (1950), The Red Badge of Courage, The African Queen (both 1951) and late-career gems like The Man Who Would Be King (1975), Prizzi's Honor (1985), and The Dead (1987) is too formidable to be dismissed out of hand. Yet there are too many instances in Huston's career in which he fails to be engaged, or, during a two-decade-long middle period, seems blatantly frivolous. To the uninformed, Huston is frequently lumped with John Ford and Howard Hawks as "classic Hollywood directors." However, he lacks the former's visual gifts and the latter's comprehensive worldview. In short, he is a talent but not a genius.

Huston's early life followed the classic "born in a trunk" story. He traveled with his vaudevillian parents until they divorced when he was seven, and he subsequently pursued boxing, a career in the Mexican cavalry, and a stint as a journalist. By the time John had sort of settled down in Hollywood, his father, Walter, had become one of the leading stars of the early talkies. This led to writing assignments for the movies, but John soon took off again for Paris to become a painter. When he finally returned to California, he did become a full-time screenwriter (earning credits for Jezebel, 1938; High Sierra,

HOW GREEN WAS MY VALLEY. DIRECTED BY JOHN FORD. 1941. USA. BLACK AND WHITE, 118 MINUTES.

1941; and *Sergeant York*, 1941) and did intelligent and erudite work for major directors like William Wyler, Raoul Walsh, and Hawks. Finally, with *The Maltese Falcon*, he took the plunge and directed his own script.

Although he's not a director, let's pause for a moment to pay tribute to Jack Warner, the dominant figure at Warner Brothers, for assembling his extraordinary stable of actors. Where would the cinema of the 1930s have been without James Cagney, Edward G. Robinson, Bette Davis, Joan Blondell, and the character actors who make *The Maltese Falcon* so memorable: Sydney Greenstreet, Peter Lorre, and Elisha Cook, Jr? When she played opposite John Barrymore as a teenager in *Beau Brummel* (1924), Mary Astor had a luminous beauty, rivaling Greta Garbo and Lillian Gish. After an affair with Barrymore, four marriages, numerous

scandals, a suicide attempt, and alcoholism, she returned to the screen for an equally memorable role. Playing a cynical older woman (at 35) in *The Maltese Falcon* she remained beautiful, projecting an intelligence that was the perfect match for Humphrey Bogart.

Novelist Dashiell Hammet's Sam Spade character had appeared on the screen before Bogart, incarnated once by Ricardo Cortez and later by Warren William. Before Bogart took on the role of the iconic detective, he had spent most of the 1930s wandering in and out of films and perplexing directors who didn't know quite what to do with his lisping staccato. Raoul Walsh finally made him a star with *They Drive by Night* (1940) and *High Sierra*, but it was Huston's scripts and direction that solidified Bogart's status.

In 1950, James Agee, who would collaborate with Huston the following year on *The African Queen*, wrote of the director: "To put it conservatively, there is nobody under fifty at work in the movies, here or abroad, who can

excel Huston in talent, inventiveness, intransigence, achievement or promise... he stays at it because there is nothing else he enjoys so much." Agee, however, never lived to see *The Barbarian and the Geisha* (1958), *The List of Adrian Messenger* (1963), *The Bible* (1966), or *Annie* (1982), and one wonders whether enjoyment alone was enough. One also wonders how Agee could write off people like Max Ophüls, Luchino Visconti, Roberto Rossellini, and Otto Preminger — not to mention Orson Welles, who had already made three films better than anything Huston would ever direct.

John Ford's How Green Was My Valley 1941

By 1941, John Ford had reached the peak of the Hollywood studio system. Aside from a few of his later Westerns, *How Green Was My Valley* is unchallenged as his best film. It beat out *Citizen Kane* for the Oscar (partially due to industry antipathy toward Orson Welles), but it also stands head and shoulders above any other film that the Academy, in its collective wisdom, ever managed to grant its top award. This all was somewhat accidental, since the film was originally intended to be shot in color and directed in Britain by William Wyler. Instead it was made in black and white on the Fox backlot and remained faithful to Richard Llewellyn's fine novel. It is ineffably Fordian. Much credit must go to veteran screenwriter Philip Dunne, who later wound up writing speeches for President Kennedy. Surprisingly, his only other collaboration with Ford was on *Pinky* (1949), which Ford began but which was ultimately credited to an acolyte, Elia Kazan. One must also credit Arthur C. Miller, who was the cinematographer on several films for Ford, including *Young Mr. Lincoln* (1939).

Llewellyn's novel is a tale of memory, recounting a childhood among the poor coal miners of Wales. Ford's images are graphic and stunning, and he evokes splendid performances from his ensemble cast. *How Green Was My Valley* has the feeling of being a long and intensely moving poem, a profound elegy to lost youth and family love. A great warmth and lyricism runs through it, and its narrative is not fragmented — the antithesis of *Citizen Kane*. It is Ford's most explicit statement of devotion to the traditional values of home and family.

Like John Wayne's Ethan Edwards in *The Searchers* (1956), Ford apparently never had a satisfying family life as an adult. *How Green Was My Valley*, however, does seem to echo his childhood experience of growing up in a large family in a small Maine town. Roddy McDowall's long illness in the film also paralleled the director's early experience with diphtheria — Ford fell a year behind in school, but enriched himself with literature, "noble books" read to him by his widowed sister, who was represented in the film by the Anna Lee character. This phase likely transformed him into the closeted intellectual we know him to have been.

Though he never lived them, Ford believed in the conventional patterns of life. In *The Man Who Shot Liberty Valance* (1962), the ultimate self-sacrificing aim of Tom Doniphon (John Wayne, again) is to create an environment in the American West where the traditions of civilization and the values of home and family could take root. Although *How Green Was My Valley* is set in Wales, it is the best and most personal of his "Irish" films. McDowall's parents, Sara Allgood and Donald Crisp, are clearly modeled on Ford's parents, and the scenes in which a shy little boy copes with many older brothers feels as if it comes from memory. It is, as biographer Joseph McBride says, "a Feeney (the family's original name) family portrait."

Ford's depiction of families and particularly mothers began with such sentimentalized silents as *Mother Machree* and *Four Sons* (both 1928). He persisted in this vein with *Pilgrimage* (1933), but the mothers played by Jane Darwell in *The Grapes of Wrath* (1940) and Sara Allgood in *How Green Was My Valley* are much more complex and deeply felt, betraying Ford's dependency on and attachment to his own mother, who died while *Pilgrimage* was being shot. Such familial concern would occasionally surface in Ford's films, and oddly enough, did so perhaps most movingly in his cavalry Western, *Rio Grande* (1950), in which a young soldier, Claude Jarman, Jr. is torn between his estranged parents (Wayne and Maureen O'Hara).

How Green Was My Valley was O'Hara's first film with Ford, and she would go on to the glories of *Rio Grande* (1950), *The Quiet Man* (1952), *The Long Gray Line* (1955), and *The Wings of Eagles* (1957). O'Hara became the quintessential heroine for a director never entirely comfortable with women. This complex relationship is explored in O'Hara's fascinating autobiography, *'Tis Herself*. Love, hate, and a helluva lot of other stuff went on between them then and over the next third of a century, but by the time *How Green Was My Valley* was completed, O'Hara "thought John Ford was a walking god."

Leo Hurwitz and Paul Strand's
Native Land 1942

As with Merian C. Cooper and Ernest B. Schoedsack
(directors of *Grass*, 1925; and *King Kong*, 1933), the
presence of two directors on *Native Land* raises the
question of authorship, of a single primary creator. While
Cooper and Schoedsack were pretty much joined at the
hip during their directorial careers, Leo Hurwitz (1909–
1991) and Paul Strand (1890–1976) essentially only
collaborated as directors on this one film, although they
later came together as part of the progressive collective
Frontier Films. Beyond that, I also have general
reservations about documentaries. Only rarely, in my
judgment, does a documentary evoke the emotional
resonance that seems to me the essence of the highest
example of cinema. I would cite Alain Resnais's *Night
and Fog* (1955) as the exception that proves the rule.

The beating heart of *Native Land* is the offscreen
audio presence of the incomparable Paul Robeson.
If I may be permitted a slight digression, I consider
Robeson to be one of America's greatest heroes. At
Rutgers over a half-century ago, I made an effort to get the
university to write Robeson (All-American football player
and Phi Beta Kappa) back into its history. This raised
eyebrows and failed at the time. In subsequent decades,
however, he has been recognized and honored. The great
singer and social activist never had a chance to make the
kind of movies he wanted to make, but *Native Land*
literally gave him a voice. I cannot fully subscribe to the
epitaph that appears on his upstate New York tombstone
("The artist must fight for freedom or slavery") because
too many of the greatest film artists — Max Ophüls, F. W.
Murnau, Josef von Sternberg, Buster Keaton, to name a
few — seemed to have no politics at all, but I admire
Robeson's commitment. One of the reasons it was so
gratifying to organize MoMA's Charles Burnett
retrospective was because he seemed to be following
in Robeson's footsteps.

Native Land is important, too, as a counterweight
to films like Frank Capra's *Why We Fight* (1942–1945). Yes,
it's terrific we won the war, but America and the movies
have a lot to live down, from genocide, slavery, and
bigotry to the films that glorified and accepted them.

Both Strand and Hurwitz were dedicated men of
the left and, like Robeson, victims of the McCarthy era.
In collaboration with painter Charles Sheeler, Strand
made one of the first poetic documentaries, *Manhatta*

(1921), a film that influenced Robert Flaherty, Joris Ivens,
Alberto Cavalcanti, and Walter Ruttmann, and (likely)
Dziga Vertov. Strand, one of the premiere still
photographers of the twentieth century, also worked with
Fred Zinnemann on the beautiful *The Wave* (1936), with
Pare Lorentz on *The Plow That Broke the Plains* (1936),
with Herbert Kline on *Heart of Spain* (1937), and with Kline
and Henri Cartier-Bresson on *China Strikes Back* (1937)
and *Return to Life* (1938).

Hurwitz worked on several of the same projects,
but other than *Native Land* his most famous directorial
effort was 1948's *Strange Victory*, a feature-length
documentary calling attention to the fact that although
we whipped fascism abroad, it lingered forcefully in
America. (Several generations later, it still does.) Hurwitz
had also been a driving force behind the Film and Photo
League, which documented much of the Depression-era
struggle for a more just society. Some of the League's
footage was incorporated into *Native Land*. MoMA has
collected, exhibited, and circulated much of the output
of both directors.

Lacking the production values of a major studio,
Native Land came out just after Pearl Harbor — precisely
the wrong time to provoke a scathing questioning of
American values and history. It was suppressed for
twenty years, but its depiction of capitalism's war on the
common man makes it fresh and increasingly relevant.
As Woodrow Wilson was impressed by D. W. Griffith's
hateful *The Birth of a Nation* during a White House
screening in 1915, perhaps the time has come for Wilson's
successors to take a look at the inspiring *Native Land*.

Why We Fight
Frank Capra's WWII
Propaganda Films 1942–1945

Because everyone went to the movies during World
War II, the American government found the film industry
to be exceptionally helpful in spreading propaganda.
Americans were movie-mad and generally believed
whatever they saw at the local theater. As part of the war
effort, the Roosevelt administration enlisted the services
of numerous major film directors who had volunteered
for military service, and it is interesting to look at these
(mostly) documentaries from an auteurist standpoint. For
example, John Ford's *The Battle of Midway* (1942) strongly
reflected the director's personality in its sentiments,

visuals, and use of Henry Fonda and Jane Darwell, who were closely identified with Ford's great *The Grapes of Wrath* (1940). Ford was injured during that Japanese attack in the Pacific, but he continued filming the fighting with a 16mm camera. Directing doesn't get much more personal than that. Similarly, John Huston's *Report From the Aleutians* (1943) and *San Pietro* (1945) reflected the virile, simplistic style Huston had displayed in *The Maltese Falcon* and would display in many of his postwar films, perhaps most notably in his butchered Civil War epic, *The Red Badge of Courage* (1951).

Hollywood's most ambitious project during this period, however, was a series of seven films designated *Why We Fight*. Under the leadership of General George Marshall, the U.S. War Department chose Major (eventually Colonel) Frank Capra (1897–1991) to produce these films. Capra, a naturalized American from Sicily, had spent twenty years in Hollywood as a successful director whose credits included *It Happened One Night* (1934), *Mr. Deeds Goes to Town* (1936), *Lost Horizon* (1937), and *Mr. Smith Goes to Washington* (1939). He had never made a documentary, but nobody questioned his patriotism. From his fiction films, one could interpret his political views as ranging from proto-fascist to collectivist. (War and talent transcend consistency.) He had held many important positions in the Motion Picture Academy and Screen Directors Guild, and *Why We Fight* won him the Distinguished Service Medal. *Prelude to War* (1942), the first film in the series, received an Oscar.

The films themselves — "emotionalized history lessons" as film historian Erik Barnouw called them — remain extremely watchable. Capra had access to plenty of Hollywood's best talent, and cast Walter Huston as narrator of the series, who was then becoming Hollywood's favorite wise old man and who conveyed the kind of reliability and credibility that Walter Cronkite would later bring to the Vietnam television generation. Capra also borrowed techniques and footage liberally from Leni Riefenstahl's *Triumph of the Will* (1935). Like so many films of the period, *Why We Fight* presents a dogmatic portrait of Axis fanaticism, and with respect to Japan, is tinged with racism. Although some of Capra's wartime views may have seemed extreme at the time, subsequent revelations about the Holocaust, death marches, comfort women, and so on now suggest that his portrayals of Axis brutality might not have gone far enough.

In any case, Capra was not known for his subtleties. It may be hard for more cynical recent generations to fully grasp, but Americans had never been so united behind a cause and have not been since. Given the isolationist spirit of the 1930s, Capra and his colleagues deserve a lot of credit for making America the main cog in the machine that saved civilization. Of course, corners were cut in the films, and much was glossed over. Stalin emerges as some kind of hero, as does Chiang Kai-shek. The Allied alliance would unravel when the war ended, but movies themselves had never been used so effectively to bring people together for what was essentially a noble purpose. Capra had promised Marshall, "I'll make the best darn documentary films ever made." He came pretty darn close.

War Comes to America (1945) was the final film in the series, and to some extent it sums up the preceding six. Viewed from the comfort of many years' distance, it is tempting to condescend to the film. It manipulates us with its too easy stereotypes, its flashing shots of dead babies, its implication that the Japanese with their "toothy smiles" had planned the war for eighty years. From with the opening sequence of schoolkids saluting the American flag onward, Lincoln-esque Walter Huston assures us of how wonderful we are. His shorthand recounting of our history and his facile cataloging of our virtues leaves little room for the complexities of the American experience. Certain assumptions lie behind the film's attitudes, and they are largely the same assumptions implicit in Capra's fiction films. America is viewed as a populist democracy with room for diversity — but only diversity that falls within the confines of the filmmaker's own preconceptions.

As examples of propaganda that manipulated editing along with every other visual device available at the time, the *Why We Fight* films are brilliant. They reflect a meticulous use of the resources of several major film archives, including MoMA. *War Comes to America*, like its predecessors, proceeds at a hysterical pace, leaving the viewer little time to question the reasonableness of what he or she is seeing and hearing. Yet, amidst the clamor he creates, Capra pauses for the lyrical "Last Time I Saw Paris" sequence, in which the wistful song is accompanied by a romantic montage of the city. It is a mark of a major filmmaker that he is willing to take the time for a moment of painfully touching poetry.

Michael Curtiz's Casablanca 1942

In a recent online post, the Writers Guild of America chose *Casablanca* as the greatest screenplay of all time.

The list of 101 titles found only two foreign films — Renoir's *Grand Illusion* from 1937 and Fellini's *8½* from 1963 — worth including. I don't know how people find time for such insipid silliness, but they do. I admit that Michael Curtiz's film has an ingratiating charm even after several viewings, but it is no closer to being the best than its signature song "As Time Goes By" is to rivaling Mozart. *Casablanca* is not even the best American film of 1942.

It is hard to argue with Andrew Sarris's assessment that *Casablanca* is a happy accident, one that is difficult to account for in auteurist terms. Over his fifty-year career, the Hungarian-born Curtiz (1886–1962) worked in numerous European film industries before coming to Hollywood in 1926. About eighty percent of his silent films are lost, but *Sodom and Gomorrah* (1922) and *Moon of Israel* (1924) were sufficiently close to the spectacles of D. W. Griffith and Cecil B. De Mille to bring Curtiz (then Michael Kertesz) to the attention of Jack Warner. At Warner Brothers, Curtiz became involved in the studio's nascent sound experiments and continued his exploration of Biblical themes with *Noah's Ark* (1929). In Hollywood, he worked in all genres, but unlike Howard Hawks or Raoul Walsh, his films did not reveal a scintilla of personality. His work with Errol Flynn, James Cagney, and Joan Crawford was praiseworthy, but Curtiz's versatility and availability for all assignments mitigated attempts to elevate him above the level of being a very competent hack. In short, there's no "there" there. What can one say about a guy who could follow up *The Egyptian* with *White Christmas* (both 1954) or jump immediately from *Francis of Assisi* (1961) to a John Wayne Western?

Humphrey Bogart had worked with Curtiz on three films before *Casablanca*, and the director helped save us from many bad memories by insisting on Bogey over the announced first choice for the role of Rick, Ronald Reagan. The great Ingrid Bergman somehow won out over Ann Sheridan. Much of *Casablanca*'s continuing popularity must be attributed to its glowing ensemble cast. The script by the Epstein Brothers and Howard Koch *is* first-rate, and the film, shot by cinematographer Arthur Edeson (*All Quiet on the Western Front*, 1929; *Frankenstein*, 1931; *The Maltese Falcon*, 1941) does look good and authentic. Even composer Max Steiner, usually given to excess, is tolerable. No doubt, Curtiz was around for all this and may have given helpful suggestions, but his whole career argues that he didn't give a fig about the romantic issues facing Rick and Ilse or the cosmic issues facing the world in 1942. He was, no doubt, already looking ahead to his next assignment.

Howard Hawks's Air Force 1943

Howard Hawks's *Air Force* and John Ford's *They Were Expendable* (1945) are the cream of a very abundant crop of Hollywood World War II films. Predictably, Hawks, a former member of the Army Air Service, was fixated on airplanes (especially the B-17 Flying Fortress), while Ford, a Navy admiral in his spare time, had a love affair with boats (especially PTs). Hawks had already lost two brothers in a plane crash and made four airplane films, including *The Dawn Patrol* (1938), an early talkie masterpiece, and *Only Angels Have Wings* (1939). He was not to return to flight again, unless one includes his uncredited directorial contribution to *The Thing from Another World* (1951).

Hawks was a master of practically every film genre, so the quality of *Air Force* is not a surprise. Dudley Nichols, a Ford regular, wrote the screenplay — one of the three for which he was nominated for an Oscar — and this was pretty close to being his best work. As I have argued previously, a writer best serves a film by submitting to the needs of a director, especially, of course, if his name happens to be Hawks or Ford. Nichols had worked with Hawks on *Bringing Up Baby* (1938), and they would later collaborate on the Western *The Big Sky* (1952). In *Air Force*, Nichols is able to ground the film in believable and sympathetic characters — not always the case in Hawks's films.

In all his genre movies, Hawks would focus on a group and on the professionalism of its constituent members, including their willingness to sublimate their personalities to the task at hand. Because of this, his films depend on expert ensemble acting. Still, this did not prevent him from frequently using Hollywood's biggest stars — James Cagney, Paul Muni, Cary Grant, Gary Cooper, Humphrey Bogart, John Wayne — as group leaders. In *Air Force*, there are no stars, although John Garfield would become one and Harry Carey had been one. For this reason, the film is one of the purest Hawksian movies in the director's oeuvre. As the critic Robin Wood wrote, this is the film in which "group unity becomes the central theme... It proved to be one of his greatest works; in feeling perhaps the noblest... only Hawks could have made it."

In its own way, my erstwhile colleague Jenny He's exhibition at MoMA, "Crafting Genre: Kathryn Bigelow," was a kind of tribute to Howard Hawks. One could argue that the bomb-disarming unit in *The Hurt Locker* (2008) parallels the bomber crew in *Air Force* or

other small Hawksian units with a job to do (*The Dawn Patrol*, 1930; *Only Angels Have Wings*, 1939; *Red River*, 1948; *Rio Bravo*, 1959). It is also a measure of how far auteurist criticism has brought us that someone like Bigelow can no longer be dismissed out-of-hand for not wearing her art on her sleeve. It took decades of hard writing, mostly by French and American critics, to make serious people realize that directors like Howard Hawks were more than just entertainers. The collapse of the studio system and the recent penchant for expensive blockbusters aimed at teenagers make it all the harder to direct intelligent and personal films. So it is gratifying that someone like Bigelow, a strong Hawksian woman by all accounts, is carrying the torch.

Michael Powell and Emeric Pressburger's The Life and Death of Colonel Blimp 1943

The idiosyncratic and overlapping careers of Michael Powell (1905–1990) and Emeric Pressburger (1902–1988) are arguably the strongest challenge to the auteurist notion that a single artist, the director, is the primary creative force behind a film. What happens when there are two directors? Andrew Sarris, in his seminal *The American Cinema*, pretty much evades the question by not allowing Powell and Pressburger a spot in any of the eleven categories (including "miscellany") by which he groups directors worth mentioning. Yet it is hard to believe that Sarris found less to admire in Powell and Pressburger than he did in others deemed worthy of inclusion, such as Gordon Douglas or Arch Oboler. He did include several of the pair's films in his annual rankings: *The Life and Death of Colonel Blimp* earned them a mark of 25; *The Red Shoes* got them their highest rating, 19, in 1948. Personally, I would rate both of these – and several of their other films – somewhat higher.

By lumping together the roles of producer, director, and writer, Powell and Pressburger seemed to be contradicting the not-yet-articulated auteur theory. Before they assumed the name "the Archers" for *Colonel Blimp*, the two had worked together on four films between 1939 and 1942 in which they were credited more conventionally: Powell as director, Pressburger as writer. However, since Powell had also directed two dozen films on his own and would direct nine more after the collaboration ended, it seems likely that he was the

director of the fifteen Archers films, deferential though he may have been to his partner's scripts.

There is certainly enough material in Powell's mammoth two-volume autobiography to get a clear picture of his engaging and eccentric personality. The one time I had the privilege of meeting him in the 1980s, he was attired, as I recall, in a deerstalker cap and a Sherlockian cape. This would have been entirely appropriate to the Scottish moors, but we were in a loft on 29th Street with nary a Baskerville nor Moriarity in sight.

Powell had started in film as a teenager, lurking about the continent with the likes of Rex Ingram and a young Alfred Hitchcock, both off-center, unconventional, expressionistic talents. Before he linked up with Pressburger, Powell directed a host of low-budget British films, culminating in *The Edge of the World* (1937), in which attempted to do for the Shetlands what Robert Flaherty had done for the Aran Islands a few years before in *Man of Aran* (1934). Powell's subject matter, like his personality, often seemed a trifle odd, but of such oddities, quite often, art is made.

More than half of the Powell and Pressburger collaborations had some ostensible connection to World War II, and they brought a unique perspective to the realities of the conflagration. Winston Churchill's Minister of War tried to stop the production of *Colonel Blimp* and actually prevented Laurence Olivier (star of the pair's 1941 film *49th Parallel*) from playing the title role, leaving the actor free to star in his own film version of *Henry V* (1944). *Colonel Blimp*, like most Powell films, is highly idiosyncratic, using twentieth-century British military history as a canvas for expressing eccentric and charming views about human nature. Similarly, in *A Canterbury Tale* (1944) and *A Matter of Life and Death* (1946), Powell and Pressburger seem to use the war as a mere stepping stone into flights of fancy. It might be easy to dismiss the pair's eccentricity as glib flippancy, but there is something highly original and experimental by the standards of commercial filmmaking in how Powell and Pressburger create their fantasies. Their unique use of color is, in itself, one of the glories of British cinema.

Carl Theodor Dreyer's Day of Wrath 1943

Despite being one of the greatest film directors, Carl Theodor Dreyer, will probably always be considered an

acquired taste. His best films are much too austere and demanding for even many serious moviegoers. There is a religiosity about his concerns that, I think, can legitimate my occasional all-too-glib references to cinema as a religion. He also seems to require a belief in vampires, witches, and the Evil One. And, worst of all, there are no Michael Bay-like (or even Cecil B. De Mille-like) special effects to compensate the audience for their efforts. This is not to say that Dreyer is deficient technically — the composition, performances, and camera movement of his films are masterful — but he is totally focused on conveying his vision, even when a little pandering to the folks in the dark might help. Personally, as someone who is disinclined to take the supernatural seriously and who is looking for a bit of visual gratification in my movies, I have frequently struggled to fully appreciate Dreyer's devotion to his trance like Lutheranism. (I have similar problems with the great French director Robert Bresson, an ostensibly devout Roman Catholic.)

Day of Wrath, made during the Nazi occupation of Denmark in 1943, was only Dreyer's second talking feature, and his first in more than a decade since *Vampyr* (1932). In it, an old woman is accused of witchcraft and of laying a curse on her accuser. It is material that might be silly in lesser hands, but Dreyer tells his tale with great conviction. For a brilliant explication of the film, I refer you to the monograph by my erstwhile colleague Jytte Jensen, *Carl Th. Dreyer*. Jytte, as a woman and as a fellow Dane, has insights into *Day of Wrath* and other Dreyer films that I can't hope to match. Dreyer, she writes, expressed "an understanding of the psychology of the female character that was both amazingly compassionate and deeply passionate, and he imbued these with his intensely personal quest for discovery and artistic expression."

I feel a little less out-of-my-depth in sharing James Agee's assessment of *Day of Wrath* in *The Nation*, which came out five years after the film's original release in May 1948. He describes Dreyer's style as having "a severe, noble purity which very little else in movies or... in contemporary art can approach, or even tries to." Praising the director for not betraying a "single excess in word, or lighting or motion," and appearing "to know and to care more about faces than about anything else," Agee claims that although Dreyer "goes against most of the 'rules' that are laid down," he ultimately succeeds in the most important way: "There is only one rule for movies that I finally care about: that the film interest the eyes — Dreyer has never failed to do that."

Personally, I feel most at home with Dreyer's

exploration of romantic passion in his final film *Gertrud* (1964), in which obsessiveness is mostly uncontaminated by anything otherworldly or which smells of blood, burning bodies, or brimstone. Still, the cinema is richer for having saintly, quasi-religious figures like Dreyer and Bresson. In spite of the medium's carnival-like roots, let us not forget that several of the earliest "masterpieces" were versions of the Passion Play, and the first long film, in 1909, was *The Life of Moses*.

Otto Preminger's Laura 1944

When writing about *The Life and Death of Colonel Blimp* (1943), I mildly berated Andrew Sarris for mostly ignoring Michael Powell and Emeric Pressburger in his auteurist bible, *The American Cinema*. With *Laura*, by Otto Preminger (1905–1986), we have an example of just how influential Sarris was and remains. By 1971, the staid MoMA Department of Film accepted a major donation of Preminger's films and showed them in a month-long retrospective. For a filmmaker largely viewed as a studio hack in the 1940s, this represented a major change in fortunes, and it was thanks in large part to Sarris's intervention. In Sarris's words, *"Laura* is Preminger's *Citizen Kane."*

Preminger was always gregarious and outspoken, and in the late 1960s, I asked him on behalf of *Film Culture* magazine whether he shared Josef von Sternberg's view, as expressed in his autobiography *Fun in a Chinese Laundry*, on the absolute dependence of actors on directors. Preminger's response was typically pragmatic, referring to Sternberg "as my old friend," and describing his take as too dogmatic: "Although film is a director's medium, the director is not God — he can only bring out what is already within the actor. The finished product is a measure of the talents of both. Above all, the director must be decisive, for someone must exercise control."

Of course, Preminger became well known for his exercise of control, which often caused his actors to loathe him. Yet many of them still chose to work with him several times. (The combination of Otto's Austrian accent, his autocratic ways, and his Stroheim-esque dome made him the new "man you love to hate" in *Margin for Error* in 1943 and a decade later when he acted in Billy Wilder's *Stalag 17.*) In *Laura* alone, Preminger achieved four of the year's best performances from Gene Tierney, Clifton Webb, Dana Andrews, and Judith Anderson.

Even Vincent Price is credible as a "romantic" lead. The film, one of cinema's great romantic murder mysteries, is told in the shadowy film noir style that was popular at the time. Preminger was one of its most skillful practitioners. He would go on to become a dominant force behind film noir before leaving Twentieth Century-Fox less than a decade later to make his big-budget features.

Preminger's reputation and brashness did little to cushion him during fights with film industry censors in the 1950s. We are indebted to him for loosening the barriers to expression, but the pendulum has now swung so far toward anything-goes vulgarity that contemporary viewers might miss his innuendo, as they do that of Ernst Lubitsch or Preston Sturges. Preminger, like Powell and Pressburger, deserves high marks on ambition alone, and he was one of the most successful of the independents to emerge from the wreckage of the studio system. Sarris calls him a "director with the personality of a producer," who "displays a tendency to transform trash into art." The fact is if viewers are looking for high moral judgments or a fully formed philosophy of life, they won't find it in Preminger. Instead, his fluid camera movement and tendency to use two-shots to keep multiple actors in the same frame comment on the value of making complex judgments about people. Rather than suggesting one character is superior to the other, Preminger's "passive gaze," Sarris says, leads to "ambiguity and objectivity."

Vincente Minnelli's Meet Me in St. Louis 1944

Over the years, I have had three close friends who were so devoted to Vincente Minnelli (1903-1986) that they wrote about the director of *Meet Me in St. Louis* extensively. Out of respect for their judgment, I have worked hard to treat Minnelli with due deference, in spite of niggling doubts. Part of the problem is that I take my movies seriously, and it tends to bother me when a plot is abruptly halted, my emotional engagement temporarily interrupted. When characters in Minnelli's films go off into musical production numbers, though they may be spectacularly executed, I nonetheless find it intrusive. I have never been a big fan of opera or musical theater, but I am willing to accept their conventions as artifice, ones that are not to be confused with reality-based cinema.

My own musical and cinematic tastes tend to run toward Lubitschean operettas (*The Merry Widow*, 1934; Mamoulian's *Love Me Tonight*, 1932) and dramas about cabaret performers wherein the music is incidental to the plot (*The Blue Angel*, *Morocco*, both 1930; *La Vie En Rose*, 2007). One of my unfunny (but quasi-true) jokes is that my favorite musical is John Ford's 1950 cavalry Western, *Rio Grande*, which has a soundtrack dominated by the Sons of the Pioneers.

Anyway, my three Minnelli Musketeers have been Stephen Harvey, David Gerstner, and Mark Griffin. Stephen died tragically young of AIDS in 1993. His *Directed by Vincente Minnelli* was published by MoMA in 1989. Stephen highlighted the appeal of *Meet Me in St. Louis* to me, deeming it "Minnelli's least stylized musical." The film depicts a comfortable midwestern family at the time of the 1904 World's Fair in St. Louis, a period of great satisfaction and optimism as America was on the cusp of the Industrial Age. The musical numbers generally retain a naturalistic and believable quality, and if those numbers were removed, the film would still present an enduring and endearing chunk of Americana not totally foreign to a John Ford or D. W. Griffith historical recreation. There are, however, wonderful musical numbers, and I have never found Judy Garland more accessible – at least, until her vulnerability overflowed in George Cukor's *A Star Is Born* a decade later. Of an intense Margaret O'Brien scene in which a little girl decapitates her snowman in protest against a proposed move from St. Louis, Stephen wrote: "Once again, Minnelli has allowed the placid surface of the Metro musical to be shattered by naked emotion." That's my kind of movie.

David Gerstner is a professor at the College of Staten Island who has published extensively on Minnelli, emphasizing gender study and the director's somewhat ambiguous sexuality. David's collection of essays, *Manly Arts*, includes a piece on Minnelli wherein he quotes James Agee's review of *Meet Me in St. Louis*. There is kind of fairytale look and feel to the film even as Minnelli strives for realism, and so Agee describes it as "too sumptuously, calculatedly handsome to be quite mistakable for the truth." This is a view I also sympathize with.

Mark Griffin's *A Hundred or More Hidden Things: The Life and Films of Vincente Minnelli* is scrupulously scholarly, but he confesses his devotion to Minnelli on the first page, tracing it back to his first viewing of *On a Clear Day You Can See Forever* (1970) at the impressionable age of sixteen. Regarding *Meet Me in St.*

MEET ME IN ST. LOUIS. DIRECTED BY VINCENTE MINNELLI. 1944. USA. 113 MINUTES

Louis, Mark presents a reasonable appraisal of Garland: "Freed from Andy Hardy, Busby Berkeley, and her outmoded ugly duckling image, a new Judy Garland emerges… and she's a beauty." Mark also quotes Minnelli's own assessment of the film: "It's magical." So, I'll buy into that and hold my ambiguity and qualms in check at least for *Meet Me in St. Louis*, *The Pirate* (1948), *An American in Paris* (1951), *and The Band Wagon* (1953). Musicals are supposed to be magical.

Jean Renoir's The Southerner

1945

Jean Renoir made six films during his American exile. All were worthy projects, but consensus holds that *The Southerner* is the best. The making of *Swamp Water*

(1941) was so contentious that Renoir famously confronted Darryl F. Zanuck and wondered whether Twentieth Century-Fox wasn't taking credit in its name to being many centuries in advance of its actual abilities. With regard to Renoir's attempts to recreate France in Hollywood with *This Land Is Mine* (1943) and *Diary of a Chambermaid* (1946), whatever their virtues, both films suffer from an artificiality. *Salute to France* (1944) is a modest documentary, and his Joan Crawford film noir, *The Woman on the Beach* (1947), seems incongruous — until one recalls the director's work on *La Chienne* (1931), *Night at the Crossroads* (1932), and *The Human Beast* (1938).

In *The Southerner*, Renoir returns to the river motif that was so central to much of his earlier work.

Andrew Sarris has written: "Renoir's career is a river of personal expression. The waters may vary here and there in turbulence and depth, but the flow of personality is consistently directed to its final outlet in the sea of life." The potential for this metaphor had been present since the very beginning of his career. In *The Whirlpool of Fate* (1925), Catherine Hessling (Renoir's first wife) is borne by waters to her destiny. In *Boudu Saved from Drowning* (1932), Michel Simon is rescued from a suicide attempt in the Seine only to return to the river after he tires of the rigors of civilization. The last scene sees him floating downstream to the freedom of hobo life. In *A Day in the Country* (1936), illicit lovers find an alcove on the river in which to exercise their passion. Then, as they must part and return to dreary reality, nature cries for them in a torrential rain shot from a boat moving rapidly upriver. This would all culminate in 1950, with *The River*, Renoir's breathtakingly beautiful "Indian" movie, filmed in color. These films, which focus on man finding his place in nature, mark a phase in the director's career that is somewhat removed from the scathing societal examinations of his 1930s work. (Later, as we will see, a third phase would focus on the theater and artifice.)

In *The Southerner*, the river and nature turn murderous. Given the film's setting in the American South, it seems strangely linked to then-contemporary documentaries like Pare Lorentz's *The River* (1938), a film about the Tennessee Valley Authority that was in part intended to prevent the kind of flooding depicted in *The Southerner*; and *The Land* (1942), made by Renoir's American sponsor, Robert Flaherty. Fifteen years after *The Southerner*, Elia Kazan made *Wild River*, one of his best films, which addressed the New Deal's efforts to persuade the South of the efficacy of the TVA. That film stars Montgomery Clift and the marvelous Kazan discovery Lee Remick. Kazan worshipped Renoir like a god, and there definitely seem to be links between Renoir's film and Kazan's. Jo Van Fleet's intransigent grandmother in *Wild River* is close to an homage to Beulah Bondi in *The Southerner* — both actresses specialize in playing women decades older than they are. In any case, there is genuine irony in the fact that a Frenchman has trumped several American filmmakers in capturing a slice of rural America. Renoir was, in fact, nominated for an Oscar for *The Southerner*, and although he returned to Europe to make films, he lived the rest of his life in the California sunshine.

Laurence Olivier's Henry V 1945

I can't recall an image of an auteur in action that is as stirringly visceral, dynamic, and frankly, sexy, as Laurence Olivier (1907–1989) playing Prince Hal in tights, rousing his army at Agincourt. (Mom, I don't want to be cowboy or a policeman. I want to grow up to be an auteur!) Well, it didn't exactly come naturally to Olivier. It was with some reluctance that he was drawn into directing *Henry V*, and as a movie director he only once ventured beyond the safety net of Shakespeare and Chekhov. A glorious acting career, on stage and on screen, didn't offer much of a hook for hanging an auteurist hat.

I've also always found it painfully difficult to rate any director's contribution to a film adapted from Shakespeare, as I think works like *Henry V*, *Hamlet*, and *Richard III* are all quite beautiful on multiple levels. Since Olivier is readily recognized as a "man of the theater," it cannot be forgotten that he largely made his international reputation — and his money — through starring in films such as *Wuthering Heights* (1939), *Rebecca*, *Pride and Prejudice* (both 1940), and *That Hamilton Woman* (1941). Gradually, Oliver gave both theater and film their due by opening up the Globe stage to Shakespeare's imagination and his own with *Henry V*, and by incorporating some of the most spectacular battle scenes ever filmed.

There had been very little really well executed Shakespeare on film before Olivier took his turn — Orson Welles, Peter Brook, Roman Polanski, Franco Zeffirelli, and Kenneth Branagh all came later. The "golden opportunity" for Olivier arose from Britain's need for a patriotic epic that wartime audiences could rally round. Shakespeare's combination of ringing poetry and grand-scale spectacle had been committed to film a few times before, usually by Hungarian directors in places like the back lots of Warner Brothers. In 1945, however, Olivier, the middle-class son of a British preacher, seemed ideally suited to carry the sword for his sceptered isle.

Before I saw him perform live, I'd always had great personal respect for Olivier. When visiting London in 1972 friends secured me a ticket for the stage version of *Long Day's Journey into Night*, but unfortunately, the show took place the same day I stepped off the plane in Britain, so O'Neill's epic has become a bit hazy in retrospect. My host was Britain's leading auteurist film critic who, with his group of friends, had the unfortunate habit of dismissing Sir Laurence as "Bloody Olivier." I never did figure out why Olivier inspired all that rancor. My guess is

that Larry was just too good at what he did and made it look too easy. His film direction may have been made up of moments of flash rather than sustained vision, but given the British theater's condescension to film, Olivier was generous with the time he gave to both media.

Marcel Carné's Children of Paradise 1945

James Agee called *Children of Paradise* "the highest kind of slum-glamor romanticism, about theater people and criminals, done with strong poetic feeling, with rich theatricality." Indeed, it is hard to find a major film that so successfully conveys cinema's debts to its theatrical roots. For all the praise directors have received for their visual inventiveness since the beginning of cinema, one must remember that it was stage artists (Georges Méliès, D. W. Griffith, Charlie Chaplin) who first got the show on the road.

Marcel Carné's (1906–1996) film was made as World War II raged across France, before the triumph of the Allies and the collapse of the swastika. It is a film unlike Carné's superb pre-war "poetic realist" films with Jean Gabin (*Port of Shadows*; *Hotel du Nord*, both 1938; *Le Jour se Lève*, 1939), which are all rooted in a reality that seems to exist on a different planet from *Children of Paradise*. The film's running time is well over three hours, throughout which the viewer is immersed in one of the most skillful and immaculately created visions of the past ever seen in cinema. Dwight Macdonald wrote that *Children of Paradise* "revived my faith in the cinema," and is "without qualifications, a masterpiece."

Children of Paradise is an authentic portrait of the Parisian theater scene in the 1830s and 1840s. Based on real characters, the film depicts the world of Garance, played by Arletty, and the four men – played by Jean-Louis Barrault, Pierre Brasseur, Louis Salou, and Marcel Herrand – who drift in and out of her highly romantic life.

The gifted screenwriter, Jacques Prévert, was a graduate of the surrealist movement in his youth. Just before writing Jean Renoir's *The Crime of Monsieur Lange* and *A Day in the Country* (both 1936), Prévert began a long collaboration with Carné, producing seven films over the course of a decade. Most of his later work with other directors, most frequently with his brother Pierre Prévert, remains peripheral. However, as Philip Kemp suggests, "Few screenwriters have served their actors better; to

have furnished Gabin, Arletty, Barrault, and Jules Berry [in *The Crime of Monsieur Lange*] with their finest screen roles is a formidable achievement."

Arletty (born Leonie Bathiat) owed much to Carné and Prévert. Although her career in film was somewhat truncated by being convicted of collaboration after having an affair with a Nazi officer, she was forty-seven when *Children of Paradise* came out and was still quite alluring. Though Jean-Louis Barrault, who acknowledged Charlie Chaplin's influence in his performance as the mime, was primarily obsessed with theater, he did make films with G. W. Pabst, Sacha Guitry, Jean Grémillon, Max Ophüls, Jean Renoir, Ettore Scola, and Luigi Comencini to top off his earlier collaborations with Carné and Prévert. Both Arletty and Barrault later appeared in Daryl F. Zanuck's D-Day extravaganza *The Longest Day* (1962), with John Wayne and Red Buttons. (Despite its title, the film wasn't nearly as long as *Children of Paradise*.)

Pierre Brasseur's prolific half-century career in film, which began with Renoir's silent debut *Whirlpool of Fate* (1925), was somewhat overshadowed by his post-*Paradise* stage work. He was eventually reunited with Barrault (and Barrault's wife Madeleine Renaud) at the Theatre de France, of which he became head. Maria Casares, who had her debut in *Children of Paradise*, went on to star in Jean Cocteau's *Orpheus* (1950) and *Testament of Orpheus* (1960). So, one might suggest that these "children" had a pattern of intertwining their careers and private lives in a way that was redolent of Carné's film – romanticism gone mad, no ordinary show biz story for sure.

The romantic grandiosity with which *Children of Paradise* treats theater reminds me of Alexandre Volkoff's silent *Kean* (1924), based on Alexandre Dumas's portrait of the English actor. Edmund Kean was played by the great Ivan Mozzhukin for Albatros, the company of Russian refugees that settled in Paris in the 1920s. That film, too, was episodic, and traversed the fine line for theater artists between stage fantasy and real life. Amazingly, Carné and Prévert were also depicting real historical personalities in *Children of Paradise*, however grandiose.

The distinguished Yale professor Dudley Andrew singles out Barrault's performance, which "alone lifts *Children of Paradise* to the heights where masterpieces outlive the eras from which they come, taking on an otherworldly aura that keeps us at a respectful distance." François Truffaut, who as an angry young critic dragged Carné's "name through the mud," made a joint appearance years later with Carné and announced: "I've made twenty-three movies, and I'd give them all up to have done *Children of Paradise*."

Sergei Eisenstein's *Ivan the Terrible* 1945

Many volumes have been written about the contributions of Eisenstein and his Soviet colleagues V. I. Pudovkin, Alexander Dovzhenko, Lev Kuleshov, and Dziga Vertov to film theory and montage. Yet much of Eisenstein's thinking was derived from seeing the seminal films of D. W. Griffith, most famously *Intolerance* (1916). In an essay that appeared in his book *Film Form*, Eisenstein also pays tribute to Charles Dickens for his genius with storytelling. Early critics, either enamored with the politics that montage directors appeared to represent or not yet exposed to the subtleties of Max Ophüls, Ernst Lubitsch or Jean Renoir, credited Eisenstein with excesses of genius. The cult of Eisenstein paved the way for film textbooks riddled with praise for the Odessa steps sequence in *Battleship Potemkin* (1925), and other fleeting exercises in "cinematic" style.

Somewhat superficially juxtaposed against montage films were the Expressionist movies of the Weimar Republic, most prominently those of F. W. Murnau (*Nosferatu*, 1922; *The Last Laugh*, 1924; *Faust*, 1926). In contrast to the Russians, the Germans placed greater emphasis on lighting effects, unrealistic sets and angles, and the use of mobile cameras to produce flowing images rather than short, static shots. I have the sense that all later cinema derives from an amalgam of these two movements, and that they perhaps reach their most equitable balance in the films of John Ford, who studied Murnau's methodology when the German director made *Sunrise* (1927) at Fox. (I am tempted to add Alfred Hitchcock, as he had the same opportunity to closely observe Murnau filming *The Last Laugh*, but Ford's best films have a level of emotional resonance for me that Hitchcock never quite attains.)

None of this is intended to diminish Eisenstein's contributions. Nor is my belief that *Ivan the Terrible*, which seems to contradict the basic tenets of montage theory, may be Eisenstein's most fully achieved film. Its stately style, composed on exquisitely ornate sets, both eschews quick cutting and also avoids camera movement — one of the hallmarks of expressionism.

One might even suggest that the film is influenced by Hollywood spectacle. Eisenstein's depiction of Ivan seems to owe something to Josef von Sternberg's *The Scarlet Empress* (1934), an over-the-top portrayal of Catherine the Great starring Marlene Dietrich. (Eisenstein had spent some time in Hollywood hoping to film Theodore Dreiser's *An American Tragedy* for Paramount, a project Sternberg realized in 1931.) Both *Ivan* and *The Scarlet Empress* share an overriding strangeness, a quality Eisenstein had also achieved in his 1938 medieval epic *Alexander Nevsky*. Although it is announced at the beginning of *Ivan* that it will be the story of "a man not a legend," it shares a grandiosity with *Nevsky*, particularly since Nikolai Cherkasov — who played roles ranging from Don Quixote to Peter the Great to Franklin D. Roosevelt — starred in the title role in both films. Rodney Farnsworth actually calls *Ivan* "operatic — a film in which words, image, and music achieve a perfect dramatic union." The music, of course, was composed by Sergei Prokofiev, who also did the haunting score for *Nevsky*.

Over the years, much speculation has gone into whether Eisenstein's Ivan was intended as a cryptic critique of Josef Stalin, who had in many ways hobbled the director's career. From a perspective several decades removed from the Cold War, it is tempting to see parallels in a recent Russian leader's ravings about his "scheming western neighbors," but perhaps irredentist views just go with the territory — that particular territory, anyway.

Ivan was intended to be a three-part epic, but Eisenstein's early death prevented the conclusion of Part III. It is hard to tell from the existing twenty-seven minutes of color prints how Eisenstein might have handled the demands and possibilities of color. To his credit, he never ceased to experiment, and his death just a few weeks after his fiftieth birthday remains one of the cinema's great losses.

Roberto Rossellini's *Rome Open City* 1945

Although many serious film scholars attribute the dawn of Italian Neorealism to Luchino Visconti's 1942 adaptation of James M. Cain's *The Postman Always Rings Twice*, or go even farther back to Jean Renoir's 1934 film *Toni* (on which Visconti was an assistant), most people would probably identify it with Roberto Rossellini's *Rome Open City*. Perhaps the Visconti film is not gritty enough, or is insufficiently raw, or too American. Rossellini (1906–1977), who made several films while in the service of the Fascist regime, began *Rome Open City* only two months after a debilitated Rome had been liberated from the Nazis. As Stephen L. Hanson has written, the impoverish-

ment of the Italian film industry proved to be a virtue in terms of encouraging authenticity and realism. Since *Rome Open City* depicts the capital under Nazi rule, there are rich opportunities for plot development, although Hanson criticizes the film as overly melodramatic. Melodrama was somewhat typical of Rossellini, at least until his evolution into an educator in the 1960s. At that point, the director decided that his mission was to depict historical figures (Louis XIV, Socrates, Blaise Pascal, etc.) rather than characters drawn from his imagination.

At the heart of *Rome Open City* is half-Egyptian Anna Magnani. She had labored as an actress, sporadically and mostly in obscurity, since silent film days. Her sensuality and passion proved a unique combination, and her "emotional authenticity," as Robin Wood put it, probably derived from her background as a poverty-stricken, illegitimate child. Her son was also born out of wedlock and contracted polio, so real suffering was familiar to her. Rossellini captured this in *Rome Open City* and a few years later in *The Miracle* and *The Human Voice*, two short films released as *L'Amore* (1948). And no one so lacking in physical beauty could have ever been as compelling as Magnani was in Jean Renoir's *The Golden Coach* (1952).

Perhaps *Rome Open City* does suffer from being overly melodramatic, and from reducing characters to stick figures. But one must remember that its story is told by people who in real life had just survived harrowing experiences paralleled in the film. The film captures how in the wake of Mussolini Italian society was forced to temporarily bond together — communist resistance fighter to priest to prostitute — to save what remained of civilization. Arrayed against them are the Nazis, who Russolini portrays as homosexual beasts who practice methods the twenty-first century would come to think of as "enhanced interrogation."

The place of *Rome Open City* in film history is perhaps best summed up by Rossellini biographer Jose Luis Guarner: "Everything seems miraculously to have been seen for the first time, just as it did at the birth of the cinema."

Kenji Mizoguchi's Utamaro and His Five Women 1946

Kenji Mizoguchi (1898–1956) was arguably the greatest of all film directors. Although *Utamaro and His*

Five Women is not his best or most expansive film, it is important because of its exploration of art and artists, and the intrusion of the world into their sacred domain. As Akira Kurosawa said of the American occupation of Japan after World War II: "I recognized for the first time that freedom of creation could exist." Mizoguchi, however, did have to get special dispensation from the Americans, who considered his seventeenth century subject matter too "feudal" for the postwar Japanese. Part of his ploy was to argue that the film was about the emancipation of women — a key theme throughout his work — but ultimately it is about the artist, and the women's lives revolve about him and his needs. (Some of Mizoguchi's films tend to veer a little too close to soap opera.) I think it is fair to suggest that sexual dominance could never be fully separated in Mizoguchi's mind from his artistic endeavors.

It would be unfair, though, to try to pigeonhole Mizoguchi stylistically. He made the first of a few dozen silent films (mostly now lost) in 1922 and 1923, the same time as F. W. Murnau's *Nosferatu* and just before Sergei Eisenstein's *Battleship Potemkin* (1925). Mizoguchi's style may more closely resemble that of Murnau in its fluidity and pictorialism, as opposed to Eisenstein's quick cutting, but it is uniquely his own. There is a definite kinship between Mizoguchi and Utamaro's nature studies. A surviving print of *The Water Magician* (1933), for example, contains images resembling some of Utamaro's woodblock landscapes. Unfortunately, color, one of the great seventeenth-century innovations of which Utamaro was a master, was not available to Mizoguchi until virtually the end of his career. Andrew Sarris wrote: "To understand the full meaning of a Mizoguchi film is to understand the art of direction as a manner of looking at the world rather than as a means of changing it."

Even so, there remains considerable resistance to Mizoguchi's charms. Western audiences have problems with the slow pacing, preferring the sword-in-your-face style of Kurosawa, and many Japanese critics consider him old-fashioned. Donald Richie, the doyen of American critics of Japanese film, mostly offered what amounted to faint praise, and lacked the motivation to do a full-length study of the director, as he had done with Kurosawa and Yasujirō Ozu. Daisuke Miyao's brilliant and definitive *The Aesthetics of Shadow: Lighting and Japanese Cinema* barely mentions Mizoguchi.

In *Currents in Japanese Cinema*, the great Tadao Sato sees Mizoguchi's "old-fashioned" cinema and slow pacing as a way of harking back to the formalized aesthetics of Kabuki and Bunraku puppet theater, which

he sees as at odds with the Japanese desire for progress and modernism. Sato says, "The close relationship between Mizoguchi's style and the old performing arts is apparent, and only in this limited sense can his works be called premodern... Mizoguchi's art is an expression of endurance and continuing protest against relentless oppression."

Joan Mellen in *The Waves at Genji's Door* juxtaposes the heroism of an artist such as Utamaro against Kurosawa's samurai, asserting the supremacy of the former. She writes: "Mizoguchi believes that the truly dedicated person... offers his life as a sacrifice to his vocation. If the artist... is exceptional, his total devotion, commitment and concentration belong to his work." Mellen seems to be saying that the genuine artist takes himself seriously, and Kenji Mizoguchi certainly did that.

Alfred Hitchcock's Notorious
1946

With the possible exceptions of *Vertigo* (1958) and
North by Northwest (1959), *Notorious* is Alfred Hitchcock's greatest romance. The director made it during a moment of considerable anti-Nazi passion — he had just worked on a documentary shot at Auschwitz — and his deeply held belief in the righteousness of the Allied cause helped him transcend some of the plot improbabilities of *Notorious*. Prior to *Notorious*, Hitchcock had touched on WWII in such films as *Foreign Correspondent* (1940), *Saboteur* (1942), and *Lifeboat* (1944). Like many of his contemporaries, Hitchcock was not generally politically engaged, although some of his prewar British films (*Secret Agent*, *Sabotage*, both 1936; *The Lady Vanishes*, 1938) dealt with espionage and anarchy. Of all the great directors, I would suggest that only Charlie Chaplin, Jean Renoir, John Ford, Fritz Lang, and, by default, Sergei Eisenstein, showed much interest in the world events of their times.

Hitchcock had a highly sympathetic screenwriter in the committed Zionist Ben Hecht. Hecht had been a successful novelist and playwright before writing Josef von Sternberg's silent gangster hit *Underworld* (1927) two decades before *Notorious*. He followed this up with Howard Hawks's *Scarface* (1932), and Hecht hitched up with Hitchcock for *Spellbound* in 1945. As I indicated, I have some problems with the plot, not finding it entirely credible that Ingrid Bergman, despite whatever guilt she might feel over her father's treason, would be willing to marry someone at the behest of the American government — especially if she was already in love with Cary Grant. Furthermore, I don't find Claude Rains a particularly attractive alternative, even though he was the most sympathetic Nazi in movies. He was a fine actor, best known to American audiences for *The Invisible Man* (1933) and his supporting role in *Casablanca* (1942), but he was perhaps most charming opposite Vivien Leigh in the film adaptation of George Bernard Shaw's *Caesar and Cleopatra* (1945). (Louis Calhern, America's main man in the Rio de Janeiro of *Notorious*, also was to play Julius Caesar in Joseph L. Mankiewicz's Shakespearean adaptation.)

Andrew Sarris wrote: "*Notorious*, far from being a simple spy story, turns out to be an incredibly intricate exercise in irony and ambiguity, and one of the outstanding testaments of Hitchcock's expressive complexity as an artist." All of the major Hitchcockian ingredients are present: visual experimentation, skillfully contrived suspense, tortured but intensely moving performances by two of the greatest actors of the classical Hollywood cinema — Cary Grant and Ingrid Bergman. Cinematographer Ted Tetzlaff became a full-time director after *Notorious*, and the long vertical descent in the transfer of the keys sequence and the climactic staircase scene are masterful. The wine cellar sequence anticipates the Bates fruit cellar in *Psycho* (1960), but perhaps with a less shocking, if not less suspenseful, denouement.

François Truffaut published a book-length interview with Hitchcock in which he expressed admiration for the film. He told Hitchcock, "of all your pictures this is the one in which one feels the most perfect correlation between what you are aiming at and what appears on the screen... You have at once a maximum of stylization and a maximum of simplicity." To me, what Truffaut was getting at is unique to Hitchcock at his best. Although these films are always deeply rooted in a familiar reality, there is something off-center, slightly surreal about them — in Hitchcock's mind, there exists an alternative reality and a perilous bridge between it and our world; a bridge made even more perilous by the director's inclination to take risks.

Frank Capra's It's a Wonderful Life 1946

It is hard to overstate Frank Capra's role in the film industry in the years leading up to World War II. He won the Oscar for Best Director for *It Happened One Night* in 1934 (Claudette Colbert and Clark Gable won the best acting awards); he won Best Director for *Mr. Deeds Goes to Town* in 1936 (Gary Cooper was nominated for his acting); *Lost Horizon* was nominated for Best Picture in 1937; *You Can't Take It with You* won for both Best Director and Best Picture in 1938. Capra, his film, and James Stewart were all nominated in 1939 for *Mr. Smith Goes to Washington*, but the competition from *Gone with the Wind* was too strong. When the war did come, Capra's documentary series *Why We Fight* (1942–1945) made him a borderline war hero and reinforced his status as a household name.

After the war, his career experienced almost total collapse. *It's a Wonderful Life* was made for his newly formed Liberty Films, part of a short-lived partnership with George Stevens and William Wyler. The film is about a small-town banker, disappointed with his life, who comes to realize that he has made an enormous difference in the lives of those around him.

Capra's career experienced many ups and downs between 1922, when he started working as a director, and 1946, but it was America that changed dramatically. The country that emerged from the war was a different one. It was less traditionally conservative, less censorious, less prone to believe in the kind of "Capracorn" the director foisted on audiences. It was also less accepting of pixilation, Shangri-la longevity and guardian angels – in some respects, America had grown up.

Given the opportunity to look back on Capra's triumphs, including this film, I can't help but think how lucky the director was to have James Stewart in his service. Although I admire the surprising versatility of Gary Cooper, Stewart's work with Capra, Frank Borzage, Alfred Hitchcock, John Ford, Ernst Lubitsch, George Cukor, Anthony Mann, Robert Aldrich, and so many others makes him stand head-and-shoulders above all other American-born actors. No one could go from whimsicality to suicidal despair so fluidly and convincingly. And although the screenwriters Frances Goodrich and Albert Hackett (whom I had the privilege of meeting through their sister-in-law and my friend Blanche Sweet) are more frequently thought of in terms

of light fare like *The Thin Man* (1934) or musicals like *The Pirate* (1948) and *Seven Brides for Seven Brothers* (1954), it is worth noting that they had a darker side that comes to the fore in Capra's film. (They also wrote the play and film of *The Diary of Anne Frank*, 1959.)

As Andrew Sarris points out, there is Dickensian quality to *It's a Wonderful Life*. Certainly the villainous character of Lionel Barrymore (whose most heinous crime might be his flagrant overacting) could easily have fit into Scrooge's nightdress. It's puzzling to think about how Barrymore could have avoided taking this role in the course of making over three hundred films, but he did take some redeeming parts. I believe Orson Welles directed him in a radio production on Christmas Eve in 1939, and Barrymore did manage to appear in George Cukor's 1935 film of *David Copperfield*. However, the elements of fantasy and the plot contrivances in *It's a Wonderful Life* qualify it as fully Dickensian – a major postitive in my book.

King Vidor and David O. Selznick's Duel in the Sun 1946

Although the nominal director of *Duel in the Sun* was the near-great King Vidor, it is hard to view the film as anything other than a monument to the poster child of excess and second-guessing, that is, to its producer David O. Selznick. As biographer David Thomson says, "There never was a movie over which David felt such passion...." Selznick frequently cast aside moderation and subtlety for sensationalism, and directors who worked for him were accustomed to his often scathing memos. Even if one gets antsy watching *Gone with the Wind* (1939), we owe that and much more to Selznick. He brought us Katharine Hepburn's film debut in *A Bill of Divorcement* (1932) and many of George Cukor's other films, and was responsible for importing Alfred Hitchcock and Ingrid Bergman to America, as well as that ape on the top of the Empire State Building. Also, anybody who had Louis B. Mayer as a father-in-law deserves some kind of dispensation.

Vidor was also prone to some grandiosity of his own. *The Jackknife Man* (1920), *The Big Parade* (1925), *The Crowd* (1928), *Hallelujah* (1929), *Our Daily Bread* (1934), *Northwest Passage* (1940) – all masterpieces in their own ways – were eventually followed by eccentricities like *The Fountainhead*, *Beyond the Forest* (both 1949), and

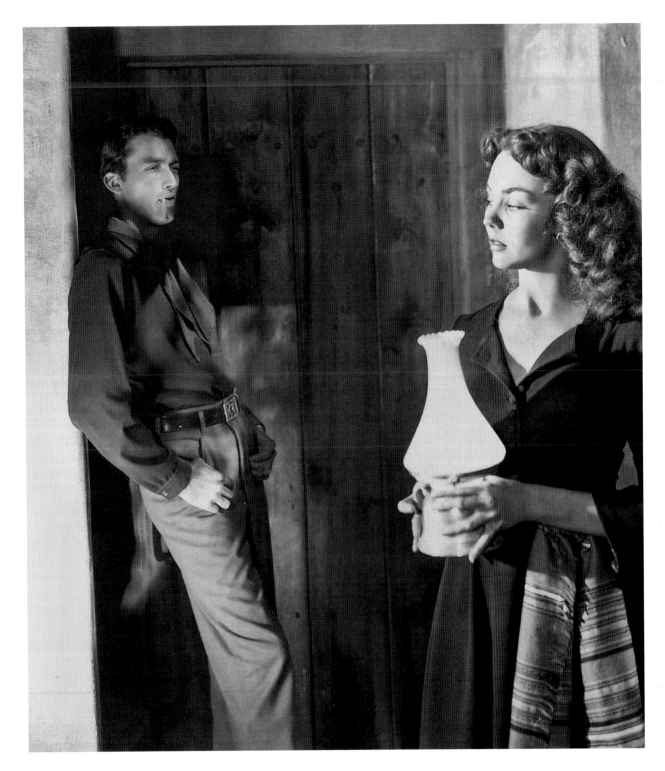

DUEL IN THE SUN. DIRECTED BY KING VIDOR. 1946. USA. 144 MINUTES.

Ruby Gentry (1952), which reunited him with Jennifer Jones in a trashy, oversexed melodrama. Vidor did manage, howver, to bring several personal touches to his direction of *Duel in the Sun*. A rocking chair blowing in the wind during a storm was a throwback to his silent *Wild Oranges* (1924), and it complements a scene in which the great Lillian Gish dies a very moving death, echoing a moment Vidor had originally captured two decades earlier in *La Bohème* (1926). When Jennifer Jones grabs Gregory Peck's legs to prevent him from leaving, we are reminded of Renée Adorée doing the same to John Gilbert in *The Big Parade*. Yet *Duel in the Sun*, for all its spectacle and lavish attempts at authenticity, ends in madness, contrary to the optimism of earlier great Vidors.

Dimitri Tiomkin was the perfect composer for this, matching Selznick/Vidor grandiosity with a score that included both a prelude and an overture. (The always-contentious Selznick chose to have a dispute with Tiomkin over what he called the "orgasm music.") Tiomkin, a favorite of Frank Capra, Howard Hawks, and Hitchcock, must have made Selznick's ear sparkle, as the composer always seemed to provide a certain European quality to his music. Selznick, a native of Pittsburg, perhaps felt provincial, but even so, he was unafraid of dealing with the sohisticated likes of Michael Powell and Alexander Korda.

I find some of the acting in *Duel in the Sun* problematic. Jennifer Jones's self-declared "trash" is barely credible; it is hard to be much moved by her performance or those of any of the principals. The film is more interesting around the fringes: there is Walter Huston's over-the-top preacher, channeling a similar role he played in *Rain* (1930), and one takes a certain pleasure in seeing Lionel Barrymore being dragged by his horse after being thrown — payback for our patience with his painful performances, perhaps. As I pointed out in my 1976 book on Westerns, the film does reunite Gish and Barrymore, who had worked together in the D. W. Griffith Western *Just Gold* (1913). I suggested that Griffith, who was frequently on set while *Duel in the Sun* was being shot, also seems to linger spiritually over the film. Several of his other actors are in it, and it is likely the kind of Western spectacle Griffith might have made had his career not been cut short.

I also think that Jones's Pearl Chavez started a trend in which rather strange, kinky women replaced men as the dominant force in 1950s Westerns. Fritz Lang's *Rancho Notorious* (1952), Nicholas Ray's *Johnny Guitar* (1954), and Samuel Fuller's *Forty Guns* (1957) are a few examples.

David Lean's Great Expectations 1946

I think *Great Expectations* is the most cinematic of Charles Dickens's novels, and so it is not surprising that it has been adapted several times to film. The 1946 version by David Lean (1908-1991) has the reputation of being the best of all Dickens films. Charles Dickens died a quarter-century before the birth of the movies, but his descriptive imagery almost betrays knowledge of what the future would bring. The author's depictions of the churchyard on the moors where Pip encounters Magwitch, Miss Havisham's "wedding" chamber, the attempted escape down the Thames — these and other moments qualify Dickens as a first-class location scout. David Lean captured all of them beautifully, and the film won Oscars for cinematography (Guy Green) and art direction (John Bryan).

As critic Robert Murphy has pointed out, Lean's tightened plot almost improves Dickens's somewhat rambling story, which is spread over many years with many characters, all of whom display their eccentricities. My major quibble with the film is that John Mills was pushing forty when he was cast to play Pip as a young man, and he was already fourteen years into an extraordinary sixty-five-year movie career. He had been in a slew of World War II military pictures, and *Scott of the Antarctic* was just two years off. Alec Guinness, who plays Pip's friend, was six years younger and though it was only his second film, he might have been a better choice. Possibly Lean agreed, since he cast Guinness as Fagin in his next film, *Oliver Twist* (1948). The lovely Jean Simmons plays Estella as a girl; ironically, she wound up playing Miss Havisham in a TV miniseries over four decades later. Martita Hunt makes a superb Miss Havisham, and she capped her career off playing a similarly strange character in Otto Preminger's *Bunny Lake Is Missing* nineteen years later. Preminger's film also featured Finlay Currie, Lean's Magwitch, who was gifted at being alternately terrifying and sympathetic. Francis L. Sullivan recreated his role as attorney Jaggers in the Stuart Walker's American version of *Great Expectations* in 1934. Any Dickens film meant a lot of character actors could eat, and Sullivan evidently ate early and often.

There's little point in going too deep into an analysis of Dickens. You either love him (as I do) or find reasons to complain about too much sentimentality, too

many coincidences, too much plot contrivance, and so on. Dickens was one of the greatest narrative artists in English, at least before the movies, and Lean serves him well. His legacy in film was acknowledged by D. W. Griffith and Sergei Eisenstein, and was obvious in Chaplin. Would there ever been a John Ford without a Charles Dickens? Dickens, of course, was a performer, acting out many of his characters as he read from his texts. In *Great Expectations*, again, he was anticipating the movie audiences that would come to see Griffith's *Cricket on the Hearth* (1909), John Bunny as Mr. Pickwick, countless versions of *A Christmas Carol*, and even Ralph Fiennes as Charles Dickens.

Largely because of his Dickens films, Lean developed a reputation as one of cinema's foremost adaptors of literature – to me, a minor virtue. He made spectacular and award-winning films of Pierre Boulle's *The Bridge Over the River Kwai* (1957), Boris Pasternak's *Dr. Zhivago* (1965), and finally E. M. Forster's *A Passage to India* (1984). Although these films have their virtues, by the time he was making them Lean had become too big to make relatively small, contained films like *Great Expectations*. Even more grandiose, was *Lawrence of Arabia* (1962), adapted from *The Seven Pillars of Wisdom*, the romantic memoir by World War I hero T. E. Lawrence.

Roberto Rossellini's
Paisan 1946

Roberto Rossellini followed *Rome Open City* (1945) with *Paisan*, his episodic trip up the Italian boot in the climactic years of World War II. Such a film is destined to be uneven, but it has many striking moments, and its broader, less-constricted canvas perhaps gives us more of the gritty flavor of what we now call Neorealism. Whether the film, as biographer Jose Luis Guarner suggests, "introduced a new standard of realism in films [and was] as revolutionary as *Citizen Kane*" is certainly debatable, but as Guarner points out, "The whole of *Paisan* witnesses the same pressing need to portray a complex reality directly." There aren't many (if any) examples in film history of a society being captured in a "fictional" work while still in the throes of a gut-wrenching, life-shattering experience. Perhaps some Depression-era American films come close, but even in those there seems to be some distancing from actual events.

As in most classic Neorealist films – *Rome Open City*, Vittorio De Sica's *Shoeshine* (1946) and *The Bicycle Thief* (1948) – children figure prominently. The ill-fated Sicilian girl in the first episode, the street kids, and the children living in caves all must be viewed as part of Rossellini's vision, however remote, for a better future. Conquering American soldiers oscillate between being depicted as clowns and heroes. The same black soldier whose boots are stolen (and who Rossellini can't avoid stereotyping) makes the salient point that he is fighting for democracy in Italy though he must eventually go home to an America that is undemocratic and unjust. Although emphasis is placed on how society must be bound together, there is ambivalence toward prostitutes. The priests in the monastery won't eat with the Protestant and Jewish clergymen from America.

Guarner says: "*Paisan* is presented above all as simple reporting, but it can easily be seen now to express as personal a viewpoint as a film by Hitchcock." James Agee countered this by disparaging Rossellini and *Paisan:* "I see no signs of originality in his work; a sickening lack of mental firmness, of fundamental moral aliveness, and of taste." There is no way to bridge such a gap in perception, but perhaps, if Agee had lived longer, he might have better understood Rossellini's concept of himself as a teacher, as a reporter, and as a somewhat gifted artist. The last very powerful section of *Paisan*, which depicts a brutal struggle between Italian partisans and Nazis in the Po valley, features images that Guarner correctly describes as "having such authenticity that they might simply be part of a newsreel."

For me, Rossellini seems uneasy in the standard role of the director – that is, in telling Anna Magnani or Ingrid Bergman what to do when responding to another actor in a fabricated situation. He seems more comfortable, if constrained, providing reportage – even of Louis XIV's bowel movements, as he did in *Rise of Louis XIV* (1966). In that and subsequent films, he seemed to revert back to his Neorealist quasi-documentary period, even at the risk of being called pedantic. Andrew Sarris cites the imagery of partisans being butchered in *Paisan* as being among several moments in early Rossellini that "possess a formal dignity unique in world cinema. However, like most mystics, Rossellini sacrifices fact for truth, and the ambiguities of the human condition often elude him." I share Sarris's mixed assessment of Rossellini, not ever being entirely comfortable with the director's ambiguous values.

Michael Powell and Emeric Pressburger's Black Narcissus 1947

Describing the filming of *Black Narcissus* in his mammoth multivolume autobiography, Michael Powell wrote, "I started out almost as a documentary director and ended up as a producer of opera... It was opera in the sense that music, emotion, image, and voices all blended together into a new and splendid whole." I think Powell was referring in part to the realization that, in order to maintain proper control of the production, he had to make the film mostly in England's Pinewood Studios rather than journey to India. The film revolves about the residents of a nunnery in India, and Powell and designer Alfred Junge were able to somewhat meticulously create the desired location and atmosphere without leaving the country. Yet novelist Rumer Godden, who had written the book the film was adapted from, was much more pleased with Jean Renoir's *The River* (1951), which was also based off one of her novels. Four years later the Archers — the name of the production company run by Powell and his partner Emeric Pressburger — would make one of the most beautiful opera films ever from Jacques Offenbach's *Tales of Hoffmann*.

The Powell production was lavish, and earned Alfred Junge the Oscar for art direction. Junge had worked with Paul Leni (*Waxworks*, 1924) and E. A. Dupont (*Moulin Rouge*, 1928; *Piccadilly*, 1929) in silents, had a brief stint with Alfred Hitchcock, and worked on several earlier Powells. One of the overwhelming characteristics of *Black Narcissus* is its use of color. Powell and Junge must share much of the credit for this with the great cinematographer Jack Cardiff, who took off most the 1960s to direct such fine films as *Sons and Lovers* (1960) and *Young Cassidy* (1965). Cardiff had photographed only two features before *Black Narcissus* — Gabriel Pascal's *Caesar and Cleopatra* (1945) and Powell and Pressburger's *The Life and Death of Colonel Blimp* (1943). He went on to a stunning career that included the Archers' most famous film, *The Red Shoes* (1948).

In 2014 I curated a MoMA exhibition based on Daisuke Miyao's excellent book, *The Aesthetics of Shadow: Lighting and Japanese Cinema*. Miyao's book and the exhibition dealt not just with Japanese cinema, but also with the interaction between films made in Europe and America. The exhibition was for various reasons restricted to black and white films, but if we had incorporated color, *Black Narcissus* would have been an early choice for inclusion. Few color films make such creative and haunting use of expressive lighting effects, what Kent Jones refers to "glorious artifice."

Powell called *Black Narcissus* "the most erotic film that I ever made." Indeed, American censors forced many cuts in a movie that was totally lacking in love scenes or anything overtly sexual. Part of what Powell was referring to was the intensity of the performances — actors were shot in stark close-up, often betraying tiny ticks of sexual repression. James Agee, who conceded that some of the film was "intelligent and powerful," also found it "as a whole tedious and vulgar." Agee believed celibacy "faintly obscene," and thought the film exploited it for the purposes of titillation. With *Peeping Tom* (1960), Powell would once again have to fend off charges of bad taste, the price he paid for his eccentricity.

Charlie Chaplin's Monsieur Verdoux 1947

Like Alan Turing's cracking the Nazi Enigma code or Marlene Dietrich's march on Paris with the U.S. Army, Charlie Chaplin was one of the undersung heroes of WWII for his demolition of Hitler in *The Great Dictator* (1940). The world, however, was such that it would not stay saved for long after WWII. With the revelations of the Holocaust and the A-Bomb in 1945, Chaplin's hopeful vision of "the glorious future" turned bleak. The combination of his private anger and public sense of responsibility produced his darkest and most complex film, *Monsieur Verdoux: A Comedy of Murders*.

Chaplin had come a long way from the days of sliding on banana peels and going to the guillotine spouting aphorisms and foreboding prophesies. For many who adored the Tramp, the evolution was unfathomable. For Chaplin, now approaching old age as a serious and self-conscious artist, it seemed perfectly natural to want to impart his wisdom to the world, whether the world wanted it or not. Chaplin had moved left as America had moved right. But before Cold War politics demoralized Western intellectuals by making the unthinkable not only thinkable but also mandatory, there was a brief postwar interlude in which rational people could imagine a different future for the world — one that wasn't based on an endless, futile arms race and a nuclear deterrent built on pillars of barbarism. Chaplin, alone

among major Hollywood artists, entered into this breach with a work of devastating Swiftian irony.

Like Josef von Sternberg's *Morocco* (1930), Alfred Hitchcock's *Vertigo* (1958), and Carl Theodor Dreyer's *Gertrud* (1964), *Monsieur Verdoux* is, in its own way, one of the great cinematic explorations of romantic obsession. Verdoux sacrifices everything – his honor, his sanity, and finally his life – in his attempt to shelter his invalid wife and his child from a world gone out of control. Even though he is capable of concern for a caterpillar and charity toward cats, all his relations with humans other than his family are utterly duplicitous.

In the course of defending Verdoux's position, Chaplin (the erstwhile silent Tramp) makes several long, sincere, and soulful speeches. Here, I am inclined to indulge him, as he was engaged in a quite fearless personal testament, which was essentially a new phenomenon in film at the time.

The clever device of having Verdoux narrate the film from his grave would be used a few years later in another masterly exercise in cynicism, Billy Wilder's *Sunset Boulevard* (1950). Music is used very effectively to convey emotions, and one detects the first bars of the *"Smile"* theme from *Modern Times* (1936), during the introduction of the invalid wife and her son. The theme is used again to accompany the vagrant Marilyn Nash after Verdoux decides he shares a bond of ruthless romanticism with her. The song thus becomes a kind of Chaplin signature and a signifier that those characters belong to a dead past, a world that had been safe for Tramps and other innocents.

Although Chaplin understood that Verdoux's fate had to be bleak, he seemed genuinely surprised that the response to his film was so vitriolic. Chaplin's fan base generally felt betrayed and confused, failing to appreciate the prophetic nature of his vision as a substitute for banana peels. In the final scenes, Verdoux, looking a bit like Chaplin's late friend Douglas Fairbanks, trudges off to his death. Over the years, the century's premiere rebel had been forced to give up little slivers of his soul. Having outlasted his moment, the only solace left was that of the guillotine.

Max Ophüls's Letter from an Unknown Woman 1948

Andrew Sarris considered Max Ophüls (originally Max Oppenheimer, 1902-1957) to be the greatest of all film

directors. Although he was born and died in Germany, Ophüls was probably the best traveled of all filmmakers of his era thanks to the Nazis. Something of a prodigy as a theater director, he began to direct films in 1930 and ultimately made his finest films in America and France. Ophüls had a few successes in Germany, most notably *Liebelei* (1933), before he went on to work in France, Italy, and Holland, and, after a visit, turned down the opportunity to direct in the Soviet Union. He made over a dozen quality films in the pre-war decade, displaying some of the purest romanticism in all of twentieth-century art.

Although Ophüls came to America in 1941, he did not direct here until after the war. He then made the lyrical historical romance *The Exile* (1947), which starred and was produced by Douglas Fairbanks, Jr., and followed this up with *Letter from an Unknown Woman* (1948). That film was adapted from a 1922 novella by Stefan Zweig, who, like another Ophüls favorite, Arthur Schnitzler, was a semi-apostate Viennese Jew and a seminal figure in twentieth-century romanticism. (Viennese-born director Josef von Sternberg was another.) Zweig, a friend of Schnitzler, Freud, and Richard Strauss, had also seen his life disrupted by Hitler and wound up committing suicide in Brazil in 1942. More than a half-century later, Wes Anderson gave screen credit to Zweig for inspiring his award-winning film *The Grand Budapest Hotel* (2014).

Ophüls's film was quite unlike any other coming out of Hollywood at the time. In a sense, it can be viewed as a throwback to the glory days of Erich von Stroheim in the 1920s or Sternberg in the 1930s, but there is a grace and resplendent charm at work in Ophüls at his best that is truly unique. Ophüls himself tried to describe the new opportunities cinema offered as facilitating the "tension of pictorial atmosphere and of shifting images." The director's primary means of expressing this lay in capturing the movement of the camera and of the subjects being photographed. To an extent, this was rooted in the darker vision of his German predecessor from the silent days, F. W. Murnau, but while Murnau eschewed montage in favor of continuous motion, Ophüls's films were more foreboding. His constantly moving camera offers vitality, but he also never lets viewers forget what awaits us all in the end. *Letter from an Unknown Woman* and other Ophüls films do not necessarily end happily, but they do present a world in which people love, laugh, and dance till time inevitably catches up with them.

In Hollywood, Ophüls had access to major talent. Joan Fontaine had already been a star for a decade, making notable films like *Rebecca* (1940), opposite

Laurence Olivier; *Suspicion* (1941), opposite Cary Grant; and *Jane Eyre* (1943), opposite Orson Welles. Writer Howard Koch had worked on William Wyler's *The Letter* (1940) and *The Best Years of Our Lives* (uncredited, 1946) and Michael Curtiz's *Casablanca* (1942). The cinematographer Franz Planer, also a refugee from the Nazis, had worked with Murnau and with Ophüls as early as *Liebelei*. The two were reunited for *The Exile* and *Letter from an Unknown Woman*. Some scholars credit Planer over Ophüls with *Letter*'s extraordinary use of tracking dialogue scenes, which became a trademark of Ophüls during his triumphant return to Europe in the 1950s.

Vittorio De Sica's The Bicycle Thief 1948

Vittorio De Sica (1902–1974) has the reputation, along with Luchino Visconti and Roberto Rossellini, of being a father of Neorealism. However, most of his film career was given over to acting rather than directing, and he built his reputation as a handsome leading man in highly commercial films during the 1930s. He directed a few films during World War II, but his Neorealist reputation lies primarily on the two films he made immediately after the war, *Shoeshine* (1946) and *The Bicycle Thief*. Although one could attribute the shift from De Sica's comfortably bourgeois background to his sudden concern with the downtrodden as a sign of versatility, there seems to me to be a disconnect there. In fact, what we think of as vintage De Sica could just as easily be attributed to screenwriter Cesare Zavattini, whose engagement with De Sica lasted from 1935 to 1972.

As was typical of the period, young people figure prominently in both *Shoeshine* and *The Bicycle Thief*. Children pass judgment on adults' failure to preserve and leave them with a viable social order. De Sica captures the spectacle of how poverty drives good people to desperate acts, and how society, beset by poverty, unemployment, and corruption, teeters on the brink. Rome, in *The Bicycle Thief*, has hardly looked less picturesque. This film is a small one depicting small lives. In this, it anticipates Ermanno Olmi's *Il Posto* (1961), but also recalls Charlie Chaplin's *The Kid* (1921), in which a father figure struggles to maintain his concept of masculinity in a menacing world.

Chaplin is a good point of reference because *The Bicycle Thief* has considerable humor and sentimentality, and De Sica relies heavily on Chaplinesque/Dickensian

coincidence. In one scene, a little boy gets to drink wine in a trattoria – but only after he's slugged by a priest for interrupting a confession. Joel E. Kanoff says the trattoria scene is among the "most subtly nuanced and believable expression of a father-son relationship in the history of cinema." Indeed, it does bear echoes of Chaplin's Tramp rescuing the "Kid" from the authorities. However, Andrew Sarris argues, "lacking an insight into the real world, De Sica relied instead on tricks of pathos that he had learned too well as an actor." By the time of *Miracle in Milan* (1950), De Sica and Zavattini were allowing a high level of whimsy to cast doubt on their seriousness, and the film won major prizes in Cannes and in New York.

Throughout the 1950s, De Sica still worked in a neo-Neorealist vein (*Umberto D.*, 1952; *The Roof*, 1956; *Two Women*, 1960) but began to transition towards the more commercial projects he would make in the 1960s. Perhaps his most important contributions after *The Bicycle Thief* were as an actor, most gloriously in Max Ophüls's *The Earrings of Madame de...* (1953) and later in Rossellini's *General Della Rovere* (1959). It leaves one to wonder how deeply committed De Sica was to socially concerned films like *The Bicycle Thief* – especially when more commercial projects beckoned.

Howard Hawks's Red River 1948 / Rio Bravo 1959 / El Dorado 1967

Howard Hawks was known as a master of all genres, but with regard to Westerns, he placed a strong second to John Ford. However, as I wrote in 1976, "Probably not until Howard Hawks's *Red River* (1948) did filmmakers succeed in matching the epic Western's landscapes and sweeping historical canvas with a narrative worthy of it." Although he had dabbled in the genre before, this was the first Western for which Hawks was able to take screen credit. Ironically, this account of the first post-Civil War cattle drive on the Chisholm Trail is the most Fordian of Hawks's Westerns, featuring some of the most visually stunning imagery in the genre. In *Rio Bravo* and *El Dorado*, Hawks would deny the audience's expectation of spectacle, much as Ford would do in *The Man Who Shot Liberty Valance* (1962).

Hawks depends more on relationships and complexity of character than most other directors. His films showcase the strong feelings within a mutually

THE BICYCLE THIEF. DIRECTED BY VITTORIA DE SICA. 1948. ITALY. BLACK AND WHITE, 89 MINUTES.

dependent group of men; a rich, warm blend of person-alities linked in adventure and facing adversity. The basic characters played by John Wayne, Montgomery Clift, and Walter Brennan in *Red River* would reappear in *Rio Bravo* and *El Dorado*. When a schism develops between Wayne and Clift, it erupts with great passion due to their closeness and codependency. Similarly, the alcoholism of Dean Martin in *Rio Bravo* and Robert Mitchum in *El Dorado* (an extraordinarily good yet melancholy remake of *Rio Bravo*) threatens the survival of the group.

At the heart and head of the group is Wayne. Although he appeared in B-grade Westerns throughout the 1930s before Ford's *Stagecoach* (1939) finally kickstarted him into getting cast as a leading man in quality films, *Red River* is the film that convinced almost everybody, including Ford, that Wayne was a major acting talent. Wayne, in quick succession, made Ford's

Cavalary Trilogy (*Ford Apache*; *She Wore a Yellow Ribbon*, both 1948; *Rio Grande*, 1950) as well as *The Quiet Man* (1952) and *The Searchers* (1956).

Throughout his career and across very different genres, Hawks was intent on emphasizing the need for professionalism and cooperation, which can be taken as a metaphor for the collaborative nature of filmmaking. Even so, a leader is almost always in charge in his films. There is Richard Barthelmess in *Dawn Patrol* (1938), Paul Muni in *Scarface* (1932), or Cary Grant in *Only Angels Have Wings* (1939) – without one, as happens in *Bringing Up Baby* (1938), chaos reigns.

Critics have repeatedly labeled *Red River* an epic, invoking Homer rather than Hollywood. Comparisons can be made with Ford's silent *The Iron Horse* (1924), James Cruze's *The Covered Wagon* (1923) or Raoul Walsh's early talkie *The Big Trail* (1930), which also starred Wayne but was financially unsuccessful because of its use of widescreen. However, technological developments made *Red River* more accessible than those films. Geoffrey O'Brien calls it "iconic," which it is, while pointing out that Hawks is normally "consciously averse to grandiosity...

Things just happen, as in most ancient narratives: abruptly, and sometimes with inexplicable gaps in between."

Jean Cocteau's Orpheus 1949

Because of its roots in nickelodeons and popular pleasure palaces — and due to the expenses involved in making films — cinema has always been under more pressure than other art forms to conform to some level of mass appeal. Many filmmakers are willing to ignore these pressures and risk laboring in relative obscurity. Others, such as Jean-Luc Godard, Andy Warhol, and Stan Brakhage, develop cult followings in which fans ostensibly understand and appreciate what they are creating. Then there are filmmakers such as Ingmar Bergman, who, while genuinely gifted, hover between seeking public acclaim and acting on the compulsion to find deeper meaning in life, which can often be distancing and tedious. One auteur who seems to push the envelope, to practice extreme auteurism while still being aware of a need to charm his audience, is Jean Cocteau (1889–1963). As Roy Armes puts it, "crucial to the lasting quality of Cocteau's work… is the combination of artistic seriousness and persistent… self-mockery."

In *Orpheus*, Cocteau played with film's capacity for visual trickery, a quality that Georges Méliès and Ferdinand Zecca used to capture audiences. He even reverted to superimpositions, one of the earliest cinematic innovations. Through his wizardry (and that is the appropriate word) Cocteau creates a world in which characters, some real and some mythic, move freely between reality and the supernatural or underworld. Occasionally, this gets a bit too precious, such as when dead people disappear as though they were being beamed up on *Star Trek*. In other cases it seems prescient, such as when Orpheus, anticipating Sarah Palin's "death panels," encounters a panel chaired by Death tasked with deciding who is allowed to survive and return to the surface. Although cleverly executed, it all seems to oscillate between the sublime and ridiculous.

At the same time, *Orpheus*'s reality could be evocative and sensual. Cocteau cast his ex-lover Jean Marais (the beast in *Beauty and the Beast* from 1946) alongside his current one, Edouard Dermithe, in leading roles, the latter's character inspired by another long dead but venerated lover. Maria Casares, who had debuted in Marcel Carné's *Children of Paradise* (1945), plays Death, a role she would reprise a decade later in Cocteau's

Testament of Orpheus (1959). As a poet making a movie, Cocteau was suddenly confronted with an infinity of choices that exceeded the capacities of language, and was able to be experimental in the best sense of the word. I would suggest that we are fortunate he did not make movies in the digital age, when every image is possible and most are phony and vacuous. In spite of his obsession with mythology and magic, Cocteau remained grounded in real creatures of flesh and blood and animal needs. Cocteau wrote rather cryptically of *Orpheus*: "A work is beautiful as a person is beautiful. The beauty I mean… causes an erection of the soul. An erection is unarguable. Few people are capable of having one."

Raoul Walsh's White Heat 1949

Raoul Walsh had been making "gangster" films since *Regeneration* in 1914, but he had only directed James Cagney in one previous one, *The Roaring Twenties* (1939). By the thirties, Cagney had essentially made the genre his own, and only Edward G. Robinson and Humphrey Bogart came close to rivaling him. Gangster films were then taking full advantage of the advent of sound, and the genre became Warner Brothers' bread and butter. Cagney typically worked with the studio's house directors, most notably William Wellman, with whom he collaborated on *Public Enemy* (1931). In that film, Cagney pushes half a grapefruit into Mae Clarke's face, and by the time of *White Heat* he had lost none of his charm.

Cagney's image had, however, softened by 1949 thanks to his delightful performances in lighter fare: Lloyd Bacon's *Footlight Parade* (1933), Walsh's *The Strawberry Blonde* (1941), Michael Curtiz's *Yankee Doodle Dandy* (1942), and his heroic roles for Howard Hawks. Consequently, in *White Heat* Cagney is able to credibly go from killing an erstwhile compatriot in cold blood to being a fifty-year-old mama's boy. Walsh, who shared a similar New York upbringing with Cagney, said "only he could play the snarling paranoid with a mother fixation. It was a natural for his brand of talent." Walsh described a prison hall sequence in which Cagney learns that his mother has been shot as "some of the greatest acting of all time."

Walsh belonged to a breed of Hollywood director that combined total professionalism with obsessiveness. (Allan Dwan, Tay Garnett, and Don Siegel are other examples.) Although these directors have recurring stylistic flourishes, themes, and quirks, they don't seem to

LATE SPRING. DIRECTED BY YASUJIRŌ OZU. 1949. JAPAN.
BLACK AND WHITE, 108 MINUTES.

hold the kinds of overarching worldviews that can
be found in the films of Jean Renoir, John Ford, Charlie
Chaplin, and Alfred Hitchcock. Directors such as Walsh
have at their core the need to entertain, regardless of genre
or budget. This can be viewed as primitive, or better yet,
fundamental. Movies evolved from man's primal need to
sit around a fire and tell stories — some amusing, some
scary, and some sacred. In a sense, Cody Jarrett, Cagney's
vicious and violent character in *White Heat*, is yet another
monster in a long line of unfathomable threats to
civilization. Given this, it seems appropriate that the final
image in *White Heat* — after an enraged Cagney screams to
his mother's ghost, "Ma, top of the world!" — is a mushroom
cloud emerging from a gas tank explosion.

Walsh's half-century directorial career went on
for another fifteen years after *White Heat*, and remained
eclectic as ever. Although his Westerns never attained

the status of those of Ford or Hawks, he made a lot of
them. His war films were often among the grittiest; he was
reunited with Cagney for *A Lion Is in the Streets* (1953);
and he made some striking films that recalled his days
sailing ships. (Before arriving in Hollywood to play John
Wilkes Booth in *The Birth of a Nation* in 1915, Walsh had
legendarily been a cowboy and had run away to sea.)
I still have vivid memories of first runs of *Captain Horatio
Hornblower* (1951) and *The World in His Arms* (1952),
Walsh's two 1950s seafaring epics with Gregory Peck.

Yasujirō Ozu's Late Spring 1949

Japan must remain eternally grateful to Yasujirō Ozu
for rescuing its cinema from the exoticism inherent in
the period dramas of Kenji Mizoguchi and Akira
Kurosawa. As beautiful as their films are, and as much as I
venerate them, their inherent anachronism — and really,

otherworldliness — stands in stark contrast to the bustling, industrious country that exists now. Of course, there is also an otherworldly quality to the Japan Ozu depicts, but I didn't run into any samurai during my visits to Japan, and the one evening I spent in a Japanese home was unfortunately not with Setsuko Hara, the gorgeous star of *Late Spring* (1949) and *Tokyo Story* (1953). I've always had a bit of trouble with Mizoguchi's contemporary dramas, though I find enough that is familiar in Kurosawa's pre-*Rashomon* depictions of the twentieth century.

One might argue that no director has been more consistent in subject matter or style than Ozu. In his case, the subject was the Japanese family and his style was to position a static camera up from the perspective of a person sitting on a tatami mat. This seemed laborious to Andrew Sarris, who believed that Ozu's "plots" sometimes seem to teeter on the edge of soap opera. I think they are redeemed by many factors, including superb performances by familiar actors like Hara and Chishu Ryu, the father in *Late Spring*. Ozu does feel the need to gratify the audience with transitional codas accompanied by music, and in the case of *Late Spring*, train travel through the countryside.

Certainly from the time of *I Was Born, but…* (1932) there is a thematic consistency to Ozu's work. Curiously, for someone who lived virtually his whole life with his mother and who didn't depict physical love in his movies, many of his films revolve around the need to be married and renew the family. Though Ozu's films contain sly humor and awareness of baseball and Western movies, once they were finally released in the West in the early sixties, they unintentionally served the purpose of introducing a traditional but new Japan to America — Noh and the tea ceremony, for example. Given how the "Nips" had been treated in American films since Pearl Harbor, this was a welcome antidote.

Ozu had a genuine gift for understatement. In *Late Spring*, Hara feels obliged to care for her widowed father Ryu, but he convinces her that she must find a husband and make a life for herself. Ozu captures Hara's depature through a poignant scene in which Ryu silently peels an apple. In the end, he is all alone.

Carol Reed's The Third Man 1949

I've always been troubled by how little credit the third-billed actor, Orson Welles, received for *The Third Man*. Nominally directed by Carol Reed (1906-1976), the film is so rich in shadowy Wellesian imagery and camera angles that Reed's achievement seems suspect. Welles himself even has a few scenes in the film. After he's been romanticized by other characters, we see him rising above Vienna in a ferris wheel, and later, as we come to understand his true character, descending to the depths of the sewers, a motif possibly borrowed from *Les Miserables*. Now that footage from Welles's *Too Much Johnson* has surfaced, the city chase scene in *The Third Man* can also be understood in terms of a similar one shot in New York a decade earlier.

Then again, Robert Krasker received the Oscar for cinematography and had already collaborated with Reed on another dark masterpiece, *Odd Man Out* (1947). (Although most of Krasker's later career was devoted to color, he did yeoman service in black and white for Joseph Losey, Peter Ustinov, and John Frankenheimer.) Scholar Leland Poague also cites the influences of British documentaries and Italian Neorealism on the film, with "rubble-strewn" postwar Vienna replacing devastated Rome.

Of course, we cannot forget scenarist Graham Greene, who was echoed onscreen in the popular novelist played by Cotton, a man who pursued the truth about Harry Lime (played by Welles), much as the reporter in *Citizen Kane* pursued the truth about Charles Foster Kane after he died. Fortunately for all, coproducer and American rights-holder David O. Selznick was six thousand miles away and could only minimally interfere in his notorious manner with the production. (Selznick did, however, devote a fair amount of time and memos to Anton Karas's zither score.) The actual producer, Alexander Korda, became a sort of father figure to Reed, and they ultimately collaborated on five films.

The location shooting in Vienna was spectacular. The city had long been romanticized in the films of Ernst Lubitsch, Josef von Sternberg, Erich von Stroheim, Max Ophüls, and many others. Now, it provided the perfect metaphor for a world divided against itself, a place in which old-world charm had been mostly snuffed out by the destructive power of twentieth-century technology.

Carol Reed had come to directing after chicken farming and acting, and he gained significant attention before World War II with his Hitchcockian thrillers, which came out just as Hitchcock was being brought to America by Selznick. Reed's WWII documentaries were acclaimed, and he became a major figure in the postwar decade. Yet his career took many turns: His multi-Oscar winning adaptation of the stage musical *Oliver!* in 1968 was a far cry from the gothic glory days of *The Third Man*.

Ida Lupino's Never Fear (The Young Lovers) 1949

Ida Lupino (1918–1995) played a unique role in the history of directing. Failing to heed Lillian Gish's warning that directing was no job for a lady, Lupino tested the waters in her early thirties. Compared to her substantial acting credits, which spanned nearly half a century, the six or seven movies and many television shows that Lupino directed might appear relatively inconsequential — until one appreciates that being "ladylike" was not her highest priority. For Lupino, professionalism outweighed other considerations. She committed to the theater early on, having written and performed in a school play at age seven.

The Lupino family had a distinguished history in British theater; her mother's family had been on the stage since the seventeenth century. Her uncle, Lupino Lane, appeared in numerous silent films in both Britain and America; his most familiar role was in Ernst Lubitsch's early musical *The Love Parade* (1929). In Ida's case ancestry was destiny, and her first significant role was as a teenager in *Her First Affaire* (1932), a British film made by American director Allan Dwan.

Although she would eventually work with many of the top directors in Hollywood, Lupino had a particularly fruitful relationship with Raoul Walsh, with whom she made four films including the Humphrey Bogart classics *They Drive by Night* (1940) and *High Sierra* (1941). Walsh was an icon of masculinity. When he visited MoMA he was in his eighties, blind but still immaculately attired as a cowboy — appropriate dress for the man who directed the first sound Western of consequence (*In Old Arizona*, 1928) and the first widescreen Western (*The Big Trail*, 1930). He had introduced the world to John Wayne, and made many other Westerns featuring Errol Flynn, Clark Gable, and even Troy Donahue. My colleague Anne Morra, whose essay on Lupino appears in *Modern Women: Women Artists at the Museum of Modern Art*, attributes the director's considerable involvement with Westerns and other macho subject matter to Walsh's influence.

The theatrical film, *The Hitch-Hiker* (1953), which Lupino directed and cowrote three years after *Never Fear*, has no female characters. It is a film about male bonding in which the two main characters, captured by a sadistic murderer, are explicitly punished for their devotion to each other. As director, Lupino becomes a kind of female voyeur gazing upon a violent drama enacted by men. It is a highly competent and compactly focused film noir that was made with practically no budget. It was photographed by the great Nicholas Musuraca, who shot several Val Lewton horror films and made noir classics for Robert Siodmak, Jacques Tourneur, and Fritz Lang. (Actually, Lupino was quite astute in choosing her cinematographers: she used Archie Stout, then in the midst of his John Ford collaborations, for *Never Fear* and two other films.) The location shooting in the Mexican desert must have entailed a good deal of what Miss Gish would have considered "unladylike."

Never Fear (The Young Lovers) reunited Sally Forrest and Keefe Brasselle, the stars of Lupino's first directorial effort, *Not Wanted* (1949), which she shot while filling in for an ailing Elmer Clifton. Forrest plays a dancer who contracts polio, and Brasselle is her partner. Forrest worked for or with Lupino several times during her brief career, and the highlight of Brasselle's oeuvre was an improbable portrayal of performer Eddie Cantor. (Hugh O'Brian, on the other hand, debuted in *Never Fear* and went on to enjoy a long film career and to reincarnate Wyatt Earp on television.) The film definitely brought out a distinctively feminine side to Lupino's direction. It's difficult to define precisely, but there is an unusual tactile quality to the way the film's characters relate to one another. Although it would be hard to argue that the film has a conventionally feminist sensibility, it would also be hard to imagine it having been directed by a man. *Never Fear* must have had a special resonance for Lupino (who cowrote it with then-husband Collier Young), since she, like her heroine, had experienced polio as an adolescent. The fact that due to an injury she had to direct the film from a wheelchair must have been a constant reminder of how close she came to a grim early fate. Instead she recovered and, as Morra has written, her work "remains singular, a vital contribution to the evolution of women in cinema and of American independent film production in general."

1950-1959

Akira Kurosawa's Rashomon

1950

It's hard to overstate the impact of the arrival in the West, and particularly in America, of *Rashomon*, which opened up a whole new cinematic world to moviegoers. We suddenly became aware of one of the most productive, vital, and creative cinemas in existence. (The Hollywood studio system, already in its death throes, was at that time contending with television and the European influx following World War II.) Of course, there were many important Japanese directors besides Kurosawa, most notably Kenji Mizoguchi, perhaps film's greatest visual stylist, and Yasujirō Ozu, creator of family dramas more poignant than anything Louis B. Mayer ever imagined. Both Mizoguchi and Ozu were avid followers of American movies and, especially in Ozu's case, of broader American culture. Kurosawa openly acknowledged his debts to Hollywood.

I can't think of a foreign-language film title that has entered the English lexicon as pervasively as *Rashomon*. (The title actually refers to the "castle gate" separating the two ancient capitals of Kyoto and Nara.) The film depicts participants and witnesses offering conflicting accounts of the ostensible rape of a Japanese noblewoman traveling through the forest with her husband. It is common now to refer to a situation as "Rashomon-like" when various witnesses to an event have different points of view on what actually transpired. This is, in effect, highly cinematic.

Kurosawa (1910–1998) had been directing for

nearly a decade before *Rashomon*, and a surprising number of his films up until that point dealt with contemporary social issues (alcoholism, gangsters, syphyllis) although the two parts of *Sanshiro Sugata* (1943) and *The Men Who Tread on the Tiger's Tail* (1945) provided a foretaste of the period samurai films to come. The American occupation authorities looked down upon those films as too feudal. In fact, many of the early films of Kurosawa and other key Japanese directors were not available to us until Donald Richie curated a massive retrospective at MoMA nearly twenty years after *Rashomon*.

For his *Drunken Angel* (1948), Kurosawa stumbled upon a barely experienced young actor named Toshiro Mifune, who was possessed, in the director's words, "remarkable sincerity and truth." That doesn't begin to describe the physicality, the uniquely raw energy, the magnetism — and here, the animality — that Mifune brought to his roles. Perhaps James Cagney or Jean Gabin might be considered rivals, but at times, as in *Rashomon* or *Yojimbo* (1961), he seems to be a species unto himself, perhaps from a less mundane world. *Rashomon* made Mifune an international star, and he was Kurosawa's muse in films as diverse as *Seven Samurai* (1954), *I Live in Fear* (1955), *Throne of Blood*, *The Lower Depths* (both 1957), *The Hidden Fortress* (1958), and *The Bad Sleep Well* (1960).

On at least a superficial level, *Rashomon* raises key questions about cinema's role in portraying reality and fostering memory, the latter concern being central to the director's hero, John Ford. Whether Kurosawa's film can be considered over-enthusiastic medievalism or contemporary misanthropy, there was a crucial distance between the Japanese director and his American mentor in that there is a benign humanism at the core of Ford's

films. Kurosawa, on the other hand, had what Andrew Sarris referred to as a "sentimental nihilism."

Kurosawa had already worked many times with Takashi Shimura (soon to be at the center of his *Ikiru*, 1942; and *Seven Samurai*). In *Rashoman*, he is the somewhat subdued antithesis of Mifune. The director had not worked previously with Kazuo Miyagawa, but he would be the cinematographer on several masterpieces Mizoguchi made before his untimely death in 1956. *Rashomon* overflows with cinematic flourishes: magnificent tracking shots; startling close-ups and camera angles; a ghost's voice that anticipates *The Exorcist* (1973); a *Bolero*-esque crescendoing music track; and more rain than Darren Aronofsky could ever imagine.

John Ford's Wagon Master 1950

In my 1976 book *The Western Film*, I suggest that the people who prefer *My Darling Clementine* (1946) and *Wagon Master* to John Ford's other Westerns generally have an antipathy to John Wayne, who stars in *Stagecoach* (1939), *Fort Apache*, *Three Godfathers* (both 1948), *She Wore A Yellow Ribbon* (1949), *Rio Grande* (1950), *The Searchers* (1956), *The Horse Soldiers* (1959), and *The Man Who Shot Liberty Valance* (1962). Almost all the Wayne vehicles are at least as good as *Clementine*, which starred Henry Fonda, and several seem more important than *Wagon Master*. I also suggested that at t he heart of Ford's greatest successes, Wayne represented a kind of larger-than-life figure. He played characters comparable to Henry V or Othello, men Ford could construct films around.

With regard to *Wagon Master*, by removing Wayne and his star persona, Ford accentuates community, which was central to the Mormon pioneer trek to Utah that the film depicts. Each person was dependent on everyone else, especially as the group encounters Native Americans, bandits, and a troupe of traveling snake oil salesmen. Although Wayne leads the trek on the Oregon Trail in Raoul Walsh's *The Big Trail* (1930) – which is perhaps the film closest in spirit and substance to *Wagon Master* – that is novice Wayne, and he is far less dominating than he would be in later years. As Walsh did in *The Big Trail*, Ford insists on the physical ordeal and the tragic uncertainty of the movement west. As Mormons, the trekkers are rejects from and rejecters of what passed for American civilization in 1849. Cinematographer Bert

Glennon's stunning long shots of the wagon train passing through the desolation of Monument Valley capture their solitude beautifully. This is complemented by a simple, folksy score by Richard Hageman, a pianist and orchestra conductor who had been working with Ford since *Stagecoach*, the score of which won him an Oscar.

In place of Wayne, Ford elevated two talented and appealing members of his stock company, Ben Johnson and Harry (Dobe) Carey, Jr. Johnson had been a cowboy and stuntman before Ford gave him his break. After four

RASHOMON. DIRECTED BY AKIRA KUROSAWA. 1950. JAPAN. BLACK AND WHITE, 88 MINUTES.

films, they had a falling out because of Johnson's unwillingness to accept Ford's reliance on personal abuse. Johnson went on to have a successful career, working with George Stevens, Sam Peckinpah, and Steven Spielberg, and winning an Oscar for Peter Bogdanovich's *The Last Picture Show* (1971). Carey was the son of Ford's first star and mentor, Harry Carey, who had teamed up with the director in silent films. Carey, Sr. had also had a falling out with Ford, but Ford dedicated *Three Godfathers* (starring Carey, Jr.) to his memory. Dobe's mother, Olive Carey, is the woman who stands in the doorway at the end of *The Searchers* when the excluded John Wayne, supposedly spontaneously, grabs his left elbow with his right hand – the gesture which Carey, Sr. was known for.

Even without John Wayne, *Wagon Master* is very much a Ford Western, which means it is one of the best in the genre. Ford was notoriously mean to his actors, and Dobe Carey was accustomed to suffering physical abuse at the hands of "Uncle Jack." He told Lindsay Anderson: "I think *Wagon Master* was the only picture I ever went through with Ford without getting my ass chewed out at least once a day… the happiest I've ever seen him on a film… a happy time for us all."

Max Ophüls's La Ronde 1950

La Ronde represented Max Ophüls's return to Europe and was the first of the four startling masterpieces (*Le Plaisir*; *The Earrings of Madame de…*, both 1953; *Lola Montès*, 1955) before his tragic death. Arthur Schnitzler's play, which was written in 1897 but not performed until 1920, seemed like the ideal vehicle for the director. The idea of constant movement, of relentless flow both in life and film, provided the perfect metaphor for Ophüls's thematic concerns and stylistic artifice – particularly his reliance on a tracking camera. Although *Letter from an Unknown Woman* (1948), Ophüls's most successful American film, carried more gravitas on account of its serious subject matter (it included a plague that caused multiple deaths), *La Ronde*'s erotic carousel just kept on turning. The film portrays multiple characters having sexual liaisons, with each character moving from one rendezvous to the next. In the process, it captures over-the-top Vienna during its fin-de-siècle glory days, flavored with Anton Walbrook's (and Ophüls's) romantic view of the past as restful and reliable.

Oscar Straus's music had previously been used in several films, including two by Ernst Lubitsch: *The*

Smiling Lieutenant (1931) and *One Hour with You* (1932). *Letter from an Unknown Woman* had also been set in Vienna, and ownership rights to the city remained an issue between Lubitsch (whose best musical, *The Merry Widow*, 1934, is set in Vienna) and Ophüls (who historian Philip Kemp once described as a "spiritual" native of the city). Since both were German interlopers, however, admirers of native Austrians like Erich von Stroheim and Josef von Sternberg may argue with this view.

La Ronde was photographed by cinematographer Christian Matras, who collaborated with many of the great French directors over a career that spanned 1926 to 1972. (He also worked on *The Earrings of Madame de…* and *Lola Montès*.) The production designer, Jean d'Eaubonne, worked on all four of the late Ophüls films, but his touch is perhaps most exquisite here, as stylization was so central to the director's intent. He did similar yeoman work on Jean Cocteau's *Blood of a Poet* (1932) and *Orpheus* (1950), and it was no doubt the latter that brought him to the attention of Ophüls, who had been exiled from France for over a decade.

The performances, from Walbrook on down, are superb, and the cast is a who's who of mid-century French cinema. Many of the actors would appear in subsequent Ophüls films, especially Danielle Darrieux, who starred in *Le Plaisir* and *The Earrings of Madame de…*. Though Max loved her, she wound up being a prime target in his son's documentary about French collaboration with Nazi occupiers, *The Sorrow and the Pity* (1969).

Ophüls had filmed Schnitzler's *Liebelei* in Germany in 1932 as a very young man, just before Hitler forced him on his odyssey. Andrew Sarris, who considered Ophüls the greatest of all filmmakers, defended the director against charges that he had softened Schnitzler's cynicism in this and *La Ronde*. Sarris suggests:

[Ophüls's] elegant characters lack nothing and lose everything. There is no escape from the trap of time. Not even the deepest and sincerest love can deter the now with its rendezvous with the then, and no amount of self-sacrifice can prevent desire from being embalmed in memory… This is the ultimate meaning of Ophülsian camera movement: time has no stop.

Philip Kemp also wrote "of the director's perennial theme: the gulf between the ideal of love and its imperfect, transient reality." Ophüls was very aware that time must ultimately stop for everyone, and the constant movement in his films reflects both the vitality and the pressure of finding pleasure before an impending and quite literal deadline.

Roberto Rossellini and God
The Miracle 1948 **and**
The Flowers of St. Francis 1950

Unlike Carl Theodor Dreyer, Robert Bresson, and Ingmar Bergman, issues of God and religion do not seem central to the cinema of Roberto Rossellini. Even so, he made at least two extremely moving and beautiful films that seem to me to be of great religious import. He also took on overtly religious issues late in his career with such educational ventures as *The Acts of the Apostles* (1969) and *Augustine of Hippo* (1972).

In the interest of openness, I must state that I am a nonbeliever. I'm what might be described as a lapsed Jew, although the lapsing came both before and after an involuntary crash course for my Bar Mitzvah, which I agreed to in order to please guilty parents. The cinema and occasionally sports arenas have always been my temples of choice. This not to say that I disrespect religiously oriented directors and their sincerity, but I do not fully understand their need for a higher power, and if I were to express personal spirituality, I would opt for something like pantheism and humanism, the latter tempered by what I see as an increasingly cynical headlong slide into global calamity.

Rossellini had several divorces and annulments, including an infamous affair with Ingrid Bergman, and it would be hard to describe him as a devout Catholic. (Rather, his spiritual sustenance seems, like mine, to have revolved around a lifelong fixation on the cinema, beginning at an early age.) I imagine it would be hard for a thoughtful man who grew up in the age of Mussolini, one in which the Pope was accused of collaboration with the Fascists, to retain a conventional faith in the Church of Rome. Although priests are depicted sympathetically, or at least humanely, in his Neorealist classics *Rome Open City* (1945) and *Paisan* (1946), the issues that preoccupy him seem to be more of this world than of the next. However, Robin Wood argues: "The achievement of holiness or sainthood: provided one doesn't interpret the terms too narrowly, that could be seen as the unifying concern of Rossellini's entire career."

Wood is scathing with regard to what he considers the phoniness of *The Miracle* (1948), Rossellini's short film in which a despised and demented peasant, Anna Magnani, is impregnated by shepherd Federico Fellini and acts out a parable paralleling the birth of Christ. (Fellini is credited with the script, one of several

he wrote for Rossellini before becoming a director.) Rossellini biographer Jose Luis Guarner describes the film as "carnal almost to the point of obscenity." As a bystanding nonbeliever, I found the film very well done, especially considering its limited resources.

By the time he made *The Flowers of St. Francis*, Rossellini was already in his Ingrid Bergman period. Although much larger in scale than *The Miracle*, *St. Francis* retains much of the simplicity and stark imagery of the earlier film, and I think it would be hard to question the director's sincerity in directly confronting its characters and subject matter, no matter how bizarre Francis's world may seem to us. Rossellini scrupulously recreates the medieval milieu of Francis and his followers, which relied on what contemporary viewers might see as primitive culture and unfamiliar behavior. As my late colleague and mentor Mary Lea Bandy wrote, "In the film's most lyrical scene… Francis prays to God to make him an instrument of peace, to teach the joy of loving rather than of being loved… he communes with the birds, expressing the hope that all may learn the secret of the Lord's peace as the little creatures know it. It is a deeply felt moment of love, and a yearning for God to emerge from hiding." Mary Lea, an art historian, made a point of comparing the film and its imagery to medieval painting. She wasn't alone: An early version of the film contained a prologue by an unknown director that showed Giotto frescoes depicting the life of Saint Francis.

Luis Buñuel's Los Olvidados
1950

The odyssey of Luis Buñuel closely paralleled that of Max Ophüls. Ophüls was forced out of Europe by Hitler, while Buñuel was exiled by Franco. Buñuel then experienced some homegrown fascism here in New York when the Roman Catholic archdiocese forced MoMA to fire him as Iris Barry's assistant. After a fruitless stop in Hollywood, he went to Mexico and resumed his directorial career. Ophüls sojourned in Hollywood, where he eventually made four films. Both directors later returned to Europe, where they enjoyed their greatest successes.

Los Olvidados was inspired by Vittorio De Sica's Neorealist classic *Shoeshine* (1946). Although Buñuel's film helped restart his career and is now revered

as a classic in its own right, it was initially enormously controversial in political circles for its honest and graphic depiction of third-world poverty. This changed quickly after the film won a prize at Cannes and poet Octavio Paz wrote an article praising it. For these and other reasons, *Los Olvidados* was Buñuel's favorite of his films.

On one level the film is a compendium of nonstop misery, cruelty, violence, and grotesqueries. Buñuel was unstinting in showing the hopelessness of the Mexican underclass. Ronald Bowers has suggested that *Los Olvidados* "was the first film of any reputation to present a realistic picture of what life was like in the third world." Buñuel made powerful claims for the authenticity of the film's well-researched horrors, stating "I loathe films that make the poor romantic and sweet." Yet Bowers believed that Buñuel's semi-documentary approach was undermined somewhat by the "studio-influenced" picturesqueness of Gabriel Figueroa's cinematography.

By the time he began work on *Los Olvidados*, Figueroa was already Mexico's top cinematographer. He collaborated regularly with both Emilio Fernández and Fernando De Fuentes, Mexico's two leading pre-Buñuel directors. He had also done John Ford's *The Fugitive* (1947) and would go on to shoot films for John Huston and Don Siegel, in addition to working with Buñuel on several more movies. Figueroa had been influenced by Sergei Eisenstein's beautifully shot but unfinished *Que Viva Mexico!* (1931), and had been an assistant to Gregg Toland, the cinematographer of *Citizen Kane* (1941) and *The Grapes of Wrath* (1940). He was also heavily influenced by David Alfaro Siquieros and other Mexican muralists.

Buñuel seemed to have adapted well to Mexico, but having once traveled in some of the most sophisticated circles in Paris and New York, he must have always felt a little like a European interloper. Then again, a good part of Buñuel's life's work was to undermine such circles through subversive art. The bleakness of *Los Olvidados* ran counter to the false optimism that blanketed Western societies, even Mexico, in the 1950s. Bosley Crowther, chief reviewer for *The New York Times*, found the film's truth-telling all too brutal: "Although made with meticulous realism and unquestioned fidelity to facts, its qualifications as dramatic entertainment — or even social reportage — are dim." Crowther, as on many occasions, was wrong. The film reestablished Bunuel's career, and when he eventually returned to Europe — and his surrealist roots — he triumphed.

Joseph L. Mankiewicz's
All About Eve 1950

Joseph L. Mankiewicz's film career started quite humbly with assisting his big brother Herman, the co-screenwriter of *Citizen Kane* (1941). Joe also wrote the intertitles for silent films during the transition to sound. These included a bunch of potboilers, but also somewhat prestigious films like Josef von Sternberg's *Thunderbolt*, Rowland V. Lee's *The Mysterious Dr. Fu Manchu*, and Victor Fleming's *The Virginian* (all 1929). When he turned twenty-one he graduated to writing dialogue for talkies, and worked on *Skippy* (1931), *Million Dollar Legs* (1932), *Diplomaniacs*, and *Alice in Wonderland* (both 1933). The idea of the loquacious Mankiewicz writing for silent pictures is a little jolting, and his promotion to putting words in the mouths of little Jackie Cooper, W. C. Fields, Robert Wheeler and Bert Woolsey, and the Mad Hatter seems even more incongruous for a man who eventually was accepted as a true Hollywood sophisticate.

Mankiewicz (1909-1993) became a producer of distinction at twenty-six for his work on *Fury* (Fritz Lang's first American film, from 1936), several Frank Borzage films including *Three Comrades* (Scott Fitzgerald's only screen credit, in 1938), George Cukor's *Philadelphia Story* (which revived Katharine Hepburn's career in 1940), George Stevens's 1942 film *Woman of the Year* (the first time Hepburn teamed up with Spencer Tracy), and a slew of Joan Crawford vehicles. Finally, with *Dragonwyck* in 1946, he got to direct.

By the time he made *All About Eve* in 1950, Mankiewicz was at the height of his powers and prestige. Both that film and *A Letter to Three Wives* (1949) won him Oscars for best director and best writer, and the year *Eve* came out he was made president of the Screen Directors Guild. (Not long after, John Ford thwarted Cecil B. De Mille's efforts to force a loyalty oath on "Mank" and the members of the guild.) Mankiewicz began his career at Paramount Pictures, spent a fruitful decade at MGM, but only become a director by moving to Twentieth Century-Fox. Perhaps an indication of his growing hubris was his decision to film *Julius Caesar* (1953) two pictures after *Eve*, and to cast Marlon Brando, James Mason, and John Gielgud. He had traveled some distance from Sax Rohmer to the Bard of Avon. Mankiewicz was erudite and well read, and thought of film as an extension of — or not-quite-legitimate offspring of — theater and literature.

In 1970, Mankiewicz assessed his life and career: "I am never quite sure whether I am one of the cinema's elder statesman, or just the oldest whore on the beat." In his *Pictures Will Talk* (a play on the title of Mankiewicz's 1951 film *People Will Talk*) "Mank" biographer Kenneth L. Geist gives a lively account of his own experiences with Mankiewicz, and the director's contrariness and ambiguity. Mankiewicz had a low opinion of the film industry, and as such, felt a need to elevate it. *All About Eve* reflects his aspirations and frustrations, his strengths and weaknesses. The director wanted film to reach the level of live theater, and he wanted screenwriters to take their craft as seriously as the best playwrights did. Who better than Bette Davis to assert the sophisticated seriousness of the stage, while combining it with a cynical awareness of how thin the veneer was? Who better than the world-weary George Sanders to voice Mankiewicz's own acerbic witticisms about seeing through it all and profiting from the spectacle?

But as Andrew Sarris points out, Mankiewicz lacked visual imagination, and the cinema was always a medium dominated by images rather than words. Even if sound did enhance movies, the great films of John Ford, Max Ophüls, Kenji Mizoguchi, Josef von Sternberg, Jean Renoir, and others still depended most of all on the camera's eye. Even at his most verbose in *Monsieur Verdoux* (1947) and *Limelight* (1952), Charlie Chaplin still relied on the expressive power of his face. Although Mankiewicz often got good performances from his actors, one senses that the need to visually satisfy the audience was something of a burden on him. The people in his movies were often erudite, but that wasn't enough to make Mank a major auteur.

Joseph Losey's The Lawless 1950

The 1950s may be cinema's most interesting decade. During that period many major Hollywood directors reached full maturity, a plethora of foreign films arrived in America, and giant studios began to dissolve and give way to television. Fresh filmmaking talent from France, Italy, Japan, Sweden, and several other countries flooded the international market. Tried-and-true geniuses like Jean Renoir, Carl Theodor Dreyer, Max Ophüls, Fritz Lang, and Luis Buñuel showed that they were by no means done. By the end of the decade, a New Wave flowed from France into other countries, suggesting an imminent rebirth of the movies.

Joseph Losey (1909–1984) represents a particularly interesting example of the turbulence and promise of the times. With his origins on the stage and in leftist politics, Losey was not destined to be an easy fit in a Hollywood struggling to survive. The McCarthy witchhunt was in full bloom, and Losey was soon to be blacklisted for his questionable loyalties. Fortuitously, after he was, London beckoned, and his career was reborn. Losey made five films in Hollywood, of which *The Lawless* was the second. How much America may have lost when its left-wing cinema was slaughtered during the HUAC/McCarthy period we will never be able to measure. The departure of Losey, a major talent, was obvious, and the great Charlie Chaplin was also stifled. Abraham Polonsky didn't get to direct another film for twenty years after *Force of Evil* (1948). How many projects were aborted out of fear or frustration?

The Lawless is a small and rather rough film, but it's quite relevant to today's racism and vigilantism. The low budget film was shot on location in a California border town, and it depicts conflicts and clashes between migrant Mexican fruit pickers and white residents. That Losey could transform himself into the elegant, suave, and underspoken director of *The Servant* (1963), *King and Country* (1964), and *Accident* (1967) remains a small miracle. For this film, he did have MacDonald Carey — who had lucked into a role in Hitchcock's *Shadow of a Doubt* (1943) early in his career — and the lovely but tragic Gail Russell.

I learned only recently of the great animator John Hubley's uncredited involvement on the film. Hubley also worked on *The Prowler* (1951) and Losey's remake of Fritz Lang's *M* (1951). (Full disclosure: John's daughter Emily is one of my best friends, as was her late mother Faith Hubley; I have been designated an honorary Hubley by the family.) Both Losey and Hubley came from similar backgrounds, both were from Wisconsin, and they had worked together on the 1947 stage production of Bertolt Brecht's *Galileo* with Charles Laughton. (Losey later directed a 1973 film of the play with Topol.) Losey apparently felt himself to be visually deficient, and Hubley was able to contribute to the look and movement of Losey's films. Hubley had not yet set up his own animation studio, and was still in his *Mr. Magoo/* UPA period. While working on *The Lawless*, Losey and Hubley studied photos of the riots that ensued after Paul Robeson's postwar concerts in upstate New York, and apparently took them as inspiration while designing similar scenes in the film. While working together, the two men established a pattern of pre-designing

sequences. Losey found this immensely helpful and later expressed his debt to Hubley in interviews, comparing their collaboration to a marriage. This relationship set the pattern for Losey's later work with Richard MacDonald, who went on to serve as his art director and production designer for more than two decades.

Jean Renoir's The River 1951

Why do Jean Renoir's films appear more frequently in this book than those of any other director? He did not specialize in the striking visual effects that characterize powerful sequences like the Odessa steps scene in Sergei Eisenstein's *Battleship Potemkin* (1925) or the shower murder in Alfred Hitchcock's *Psycho* (1960), moments so sensational they cannot be ignored in any text on filmmaking. True, Renoir's use of deep-focus photography in the 1930s did heavily influence *Citizen Kane* (1941), the great Hollywood noir films of the 1940s, and Italian Neorealism. Yes, *The River* did bring Renoir significantly closer towards his stated effort of emulating Henri Matisse in his use of color. To argue, however, that Renoir's greatness stems from his visual innovations is to greatly shortchange his work.

Let me again quote Andrew Sarris's assessment of *Boudu Saved from Drowning* (1932), and his observation that there is a thematic consistency to Renoir's films: "Renoir's career is a river of personal expression. The waters may vary here and there in turbulence and depth, but the flow of personality is consistently directed to its final outlet in the sea of life." This "river" metaphor is certainly front-and-center in works as diverse as *Boudu* (his 1931 satire involving a Parisian bum who finds bourgeois life too demanding and instead chooses to float leisurely down the Seine); *A Day in the Country* (his 1936 romantic evocation of Guy de Maupassant in which nineteenth-century lovers find fleeting erotic bliss in a tree-shaded alcove on a river); *The Southerner* (his 1945 incursion into the dark and dangerous waters of the American south); and, of course, *The River*, his exploration of an English family living in India. Yet not even this metaphor fully explains Renoir's attraction.

Few films are less assuming than *The River*. In fact, it may be considered an acquired taste. Nothing much happens, and there is some awkwardness stemming from Renoir's use of several nonprofessional actors. As André Bazin, the great French critic and godfather of the French New Wave points out, there are no panning or dolly shots. In this, Renoir recalls the great Japanese director, Yasujirō Ozu, whose films seem close to real life because they make few efforts to be "cinematic." For Bazin, *The River* is "one of the purest, richest, most touching works in the history of the cinema."

Perhaps the true measure of Renoir's greatness lies with his peers. To Elia Kazan he was a "god," and to Peter Bogdanovich he was a "saint." He was like a father to François Truffaut, and Orson Welles told Bogdanovich that he "loved" Renoir most of all directors, going so far as to title his *Los Angeles Times* obituary for Renoir "The Greatest of All Directors." John Ford wanted to remake *Grand Illusion* (1937); Fritz Lang remade *La Chienne* as *Scarlet Street* in 1945, and *The Human Beast* as *Human Desire* in 1954; and Luis Buñuel remade *Diary of a Chambermaid* in 1964. Erich von Stroheim repaid his early adoration of Renoir with an iconic performance in *Grand Illusion*, and echoes of Renoir appear in much of the post-war work of his prewar assistant, Luchino Visconti.

Out of respect for the greatness of their art, a heathen like me can pay obeisance to the religious films of Carl Theodor Dreyer or Robert Bresson without accepting the mystical tenets or dogma to which they subscribe. I confess to being more moved by, and feeling closer to, what Bazin describes as Jean Renoir's "universal spirituality." That quality, possessed by a handful of artists, writers, composers, and directors, offers a hint as to why I hold Jean Renoir in such high esteem.

Max Ophüls's Le Plaisir 1951

Le Plaisir, **like Charlie Chaplin's** *The Circus* **(1928), has** suffered neglect over the years because it happens to be sandwiched between two of its director's most famous films. *The Circus* came between *The Gold Rush* (1925) and *City Lights* (1931), and in the oeuvre of Max Ophüls, *Le Plaisir* comes between *La Ronde* (1950) and *The Earrings of Madame de...* (1953). This neglect is especially unfortunate, for both *The Circus* and *Le Plaisir* go a long way in expressing the personalities of their respective creators. In fact, *The Masque*, the brief opening episode of *Le Plaisir*, encapsulates most of what Ophüls was all about in just a few minutes. An old man trying to disguise the ravages of time offers a moment far more poignant than a viewer might expect from a character we have just met. The reason for this is simple: he exposes a universal tragedy that none of us can ignore. The sequence is shot in the dazzling style that is emblematic

of the director, and which captures all movement. Sometimes the camera moves with the actors and sometimes they dance in countermotion. The flow never stops until someone collapses in exhaustion.

Word has it that *Le Plaisir* was Stanley Kubrick's favorite film, and though one can certainly find parallels in their use of tracking shots, Ophüls's make much more sense because they are integral to his themes. Other shared propensities between the directors include period precision (Kubrick's *Barry Lyndon*, 1975) and decorousness (*Eyes Wide Shut*, 1999). When *Le Plaisir* was finally released in America in the mid-1950s, it was nominated for an Oscar for best art direction in a black and white film.

The three ostensibly unrelated stories that comprise the film are by Guy de Maupassant. *Le Plaisir* is essentially faithful to the texts, although the adaptation is less cynical and misogynistic. (Ophüls was an ardent feminist.) All the films Ophüls made during his great late period in France (1950-1955) are somewhat episodic, relying far more on parts that add up to more than a whole rather than a conventional narrative. Although *La Ronde* hangs together in its overall theme, it basically tells ten short stories linked by Anton Walbrook and his carousel. Even the great *The Earrings of Madame de...* and *Lola Montès* are episodic. Ophüls seems to close each incident by wrapping it up in a past that can no longer be retrieved — particularly in *Lola*, as the heroine is always riding off in her coach to new adventures and "loves." In effect, the director suggests that life is one long tracking shot with occasional pauses along the way.

In the American version of *Le Plaisir*, Peter Ustinov replaces Jean Servais as the narrator, and the second episode, *Le Modèle*, is bumped up to precede *La Maison Tellier*. Although this switch might leave the audience in a happier frame of mind, it does somewhat change Ophüls's intent. *Le Modèle* ends with its heroine in a wheelchair. Lola Montès tells us "life is movement." By losing her mobility, the model in *Le Modèle* more or less loses her life. In fact, since Lola speaks for Max, the notion that life is movement explains Ophüls's other films, shots, and his continual movement on to new episodes.

Since *La Maison Tellier* is, as Robin Wood has pointed out, a rare outdoor excursion for Ophüls, the fact that he chose a Maupassant story that so closely resembled the one Jean Renoir used for his brilliant Maupassant adaptation, *A Day in the Country* (1936), shows a certain kinship and respect between these two men. Both stories and films end in thwarted love affairs, and in *A Day in the Country* more than any other film,

Renoir expressed his own romantic sensibility. After all, "life is movement," and it must go on.

Samuel Fuller's The Steel Helmet 1951

After many years of ambivalence, I have decided to like Sam Fuller (1911-1997). Unlike directors who I find classical or classy, Fuller strikes me as having been painted with a coarser brush. Sometimes filmmakers come along who pass all the tests of being a genuine artist or auteur, but they still make me uncomfortable. Perhaps they seem too adolescent, too undisciplined, or even too crazy. Fuller is one of them. Still, behind the cigar chomping and the Bronze Star, Silver Star, and Purple Heart, beats the heart of an artist.

Fuller took time off from his career as a B-picture Hollywood writer and pulp novelist to almost singlehandedly win World War II. (See above.) He didn't get a chance to direct until he was almost forty, and *The Steel Helmet* — the first of his several war films and the first American film about the Korean War — was only his third effort. Like all his work, it reflects Andrew Sarris's cogent assessment of the director as an "authentic American primitive." In *The Steel Helmet*, Gene Evans seems to be the embodiment of Fullerian crudeness, lacking in common social grace. Although the actor was then still in his twenties, he seems world-weary and cynical way beyond his years. He was to appear in many other Fuller films before assuming a similar persona for Sam Peckinpah. Evans shares the awkwardness and timidity of Boris Karloff in James Whale's *Bride of Frankenstein* (1935) before the big oaf stops trying to get along with his human tormentors. Evans also reminds me of Louis Wolheim in Lewis Milestone's *All Quiet on the Western Front* (1930), a crude Caliban with a heart of gold.

The Steel Helmet is ostensibly an antiwar film, but one wonders whether Fuller's use of caricatures, his understanding of the genre's cinematic potential, and the sheer strangeness of his vision doesn't detract from his message. (One might also question whether his own heroic wartime trajectory might not have left him a little too in love with war to be fully committed to its abolition.) In any event, when one thinks of Fuller, one does not think of fully articulated and coherent ideas.

Fuller's soundtracks also more closely resemble the grunting of a Tarzan picture than the intensely cerebral

dialogue of an Éric Rohmer or Robert Bresson film. Yet, as Sarris has cautioned, Fuller's work must be judged as cinema, not highfalutin' literature. I think most of us discovered his movies as kids, looking for fun – something, indeed, along the lines of Tarzan – not while seeking an intellectual challenge. Tarzan worked because it brought us pleasure to see him swinging through the trees, conversing with the animals, and occasionally wrestling one or two of them to death. One hopes that although our horizons have expanded to include Rohmer and Bresson, it doesn't negate the childlike enjoyment available in a movie rich in diversion but poor in intellectual heft. I don't mean to dismiss Fuller's films as the equivalent to Tarzan movies; I only mean to make the point that cinema, as the most comprehensive of all the arts, has room for all kinds.

Charlie Chaplin's Limelight

1952

If Charlie Chaplin's *Modern Times* (1936) is a poignant and graceful valediction to silent cinema, *The Great Dictator* (1940) "an epic incident in the history of mankind," and *Monsieur Verdoux* (1947) a unique polemic prophesying the imminent end of history, then *Limelight* also has its own special niche in the annals of film. It is the first in a category of works that have come to be known as "old men's films," a very limited genre built on the subjective summations of the masters of the medium, the pioneers of cinema. A handful of the great cineastes provided us with at least one film that contained the distilled purity of their mature years, works that express their deepest feelings and comment with considerable intimacy on their lives, careers, and values. Among the most notable of these films are John Ford's *The Man Who Shot Liberty Valance* (1962), Carl Theodor Dreyer's *Gertrud* (1964), Howard Hawks's *El Dorado* (1966), and Luchino Visconti's *Death in Venice* (1971).

All of these works share certain characteristics: they are melancholic, nostalgic, and contemplative. They are austere in emotion, if not always in style; they are the assured works of mature artists; and they run the risk of being too personal, too intimate, too close to the bone. We should feel privileged that these men have chosen to confide in us, to offer up their memories, confessions, and vulnerabilities – and their realization and acceptance that, as the subtitle of *Limelight* suggests, "age must pass as youth enters." The most stirring images from *Limelight*

are the haunted close-ups of the elderly Calvero (Chaplin), peering through the camera's lens into an empty theater, seeking his lost audience. It is as though the public has mimicked the Tramp at the end of *The Circus* (1928) by turning away and leaving him as he left it, in mournful solitude.

Limelight, like *The Circus*, is an artfully tormented exercise in self-therapy, and it was seized upon by Chaplin's critics as self-pitying, even solipsistic. To reach this appraisal is to ignore the fact that Chaplin's whole oeuvre was an uninterrupted flow of self-expression, personal testament, and autobiography. He, unlike any other filmmaker, allowed his soul to stand naked before us. Calvero may be too sentimental for some, but the compensation is substantial – he gives us perhaps the most intensely felt performance in the history of the medium. *Limelight* is Chaplin devoid of frills and facades, and, as such, it is quintessentially beautiful and true, late-period Matisse for the movies.

Having made his mark as one of the greatest silent film artists, Chaplin seemed now to distrust the silence of those films, and he became ever more insistent on imparting his philosophical wisdom. At times, *Limelight* teeters on the brink of becoming an essay or a lecture. This discursive quality is shared with the other valedictory films mentioned earlier. Such reflective pauses do not diminish *Limelight* but rather enhance its value. As he did at the end of *The Great Dictator*, Chaplin steps out of character (or better still, beyond character) to offer us a Brechtian commentary on those who strut and fret on the celluloid stage. Embattled on all sides and envisioning his own death, Calvero declares: "Truth is all I have left." *Limelight* is the truth as Chaplin saw it. One assumes that he subscribed to Calvero's dictum that "time… always writes the perfect ending," but Chaplin also could see no harm in adding a few pungent aphorisms of his own to help time along.

Limelight is also not without conventional cinematic virtues. Although the film is only intermittently funny, the other performances are essentially the best in any of Chaplin's sound films. The movie, like Chaplin's life, is scattered with disappointments, but the ultimate thrust is toward romance and a joie de vivre. If *Limelight*, like the tribute to Calvero in the film, is not "the greatest event in theatrical history," it is, at least, a uniquely self-revelatory and touchingly brave event. As his father-in-law, Eugene O'Neill, had made peace with his family demons in *Long Day's Journey into Night*, so Charlie Chaplin made moving and haunted art of his own accumulated ghosts in *Limelight*.

Kenji Mizoguchi's The Life of Oharu 1952

In the last five years of his life Kenji Mizoguchi made nine films, nearly all of which are transcendent masterpieces. Even if he had not lived until 1956, Mizoguchi would have already earned a place as one of the cinema's greatest masters of mise-en-scène. By the time of *Utamaro and His Five Women* (1947), Mizoguchi had been directing for a quarter century. He made some four dozen silent films (almost all of which are lost), including adaptations of Eugene O'Neill and Guy de Maupassant, belying any suggestion that Japanese artists were uncontaminated by Western influences. (In fact, both Yasujirō Ozu and Akira Kurosawa were even more acutely conscious of what was going on in Hollywood.)

The Life of Oharu, the first of Mizoguchi's final nine films, is central to his reputation as a feminist. Poverty-stricken as a child, he witnessed his elder sister being sold into the life of a geisha. The siblings lived together after their mother died, and this closeness seems to have had a profound effect on Mizoguchi's sensitivity to the role of women in Japanese society — which, in his day, had not improved much from feudal times. In the film, Oharu is punished for being in love with a man below her station and is forced into prostitution. What some Western critics mistake for turgid melodrama is redeemed by the director's elegant style, which is characterized by long takes and graceful camera movement, and is enhanced by his exquisite recreation of period ambience through sets and costumes. Mizoguchi, who started as a painter, was a perfectionist and a stern taskmaster toward his crew. Perhaps as a result, his compositions are like no one else's in film history.

Donald Richie, the great scholar of Japanese cinema and a former MoMA curator, praised Mizoguchi's early work for contributing to the obsolescence of the *benshi* — the live, in-person narrator who would explain what was happening in Japanese silent films. He also celebrated Mizoguchi's "concern for the pictorial image" and "search for cinematic style." Richie compared Mizoguchi's work to that of F. W. Murnau, whose *The Last Laugh* (1924) dispensed completely with the need for written intertitles. According to Richie, "Mizoguchi excelled in the creation of atmosphere, that almost palpable feeling of reality which is the special quality of the well-made film." The director "wanted a world that was more realistic than life."

With regard to *Oharu*, Richie made note of Mizoguchi's ambivalence toward traditional Japanese institutions. On the one hand, the director shows respect for them while simultaneously making clear that these feudal institutions were fully responsible for the troubles of his ill-fated heroine. Mizoguchi's respect for the past, and his painterliness and literariness, made him seem somewhat old-fashioned to contemporaries. Yet his apparent quaintness now seems timeless. Kurosawa, the other great creator of Japanese period films (*jidaigeki*), admired Mizoguchi more than any other Japanese director, but thought him too stylistically austere to deal with samurai. In Kurosawa's view, quick-cutting rhythms and close-ups were more appropriate to such subject matter than long, overhead tracking shots. (See *Seven Samurai*, 1954; *Throne of Blood*, 1957; *Yojimbo*, 1961.) Richie, to whom we owe more than anybody our access to the richness of Japanese cinema, wrote books on Kurosawa and the curator's great hero, Ozu. While he obviously admires Mizoguchi, he finds something emotionally lacking in his films, which was perhaps his reticence and austerity, his tendency to keep a distance in his shots.

A brief note on Kinuyo Tanaka, who portrays Oharu and who appeared in *Utamaro*: She made fifteen films with Mizoguchi. Shortly after completing *Oharu* she became Japan's first female director — an appropriate role for the great feminist filmmaker's favorite muse.

Fred Zinnemann's High Noon 1952

Fred Zinnemann (1907-1997) can be comfortably grouped with such directors as Rouben Mamoulian, Lewis Milestone, John Huston, and William Wyler. Andrew Sarris, in *The American Cinema*, dismissed them as "Less Than Meets the Eye." All of these men were highly regarded by their peers, though I would prefer to recognize them for their legitimate accomplishments when matched with suitable projects. How genuinely can we recognize them as auteurs given the dearth of thematic consistency over the course of their careers? In Zinnemann's case, Sarris finds that films like *High Noon* "vividly reveal the superficiality of Zinnemann's personal commitment."

Zinnemann began his career as an assistant cinematographer in Weimar Germany before coming to America in 1930, and by the mid-1930s he had made a significant mark by directing (with the great photographer Paul Strand) the Mexican documentary *Redes* (1936). Heavily under the influence of Robert Flaherty, Zinnemann developed a reputation for realism. From 1938 to 1946, he directed a number of shorts and minor features in Hollywood. With *The Search* (1947), *The Men* (1950), and *Teresa* (1951), he attained a status as a serious but somewhat humorless director. Incidentally, he also introduced Montgomery Clift, Marlon Brando, and Rod Steiger. I would suggest that beginning with *High Noon*, Zinnemann's subsequent films became more diffuse, and that Elia Kazan picked up the realist baton. Kazan would shortly make major films with all three of Zinnemann's discoveries, and these films were more deeply felt than anything by Zinnemann.

High Noon was one in a string of antiromantic, antipopulist Westerns following William Wellman's *The Ox-Bow Incident* (1943) and Henry King's *The Gunfighter* (1950), films that used the form of the Western to present social messages in a cynical and heavy-handed manner. There was little regard in them for either the nobility of Western mythology or the cinematic potential of the American West. *High Noon* seems to explicitly contradict the work of John Ford (*Stagecoach*, 1939; *My Darling Clementine*, 1946; The Cavalry Trilogy; 1948–1950) and Howard Hawks (*Red River*, 1948). Hawks, in fact, was so unhappy with Zinnemann's film – and leftist screenwriter Carl Foreman's portrayal of a beleaguered sheriff trying to maintain law and order – that he "made *Rio Bravo* the exact opposite from *High Noon*." *High Noon*, however, camouflages its purposes by using traditional Western actors: Thomas Mitchell (*Stagecoach*, *The Outlaw*, 1943; *Silver River*, 1948) and Gary Cooper (*The Virginian*, 1929; *The Plainsman*, 1936; *The Westerner*, 1940; and many others). Cooper's Oscar-winning performance was a signature moment for him, as it was wrought from pain and exhaustion. Cooper had been unhappy that Westerns had not depicted the region more realistically, and *High Noon* contradicted the romantic Western image he had cultivated for a quarter-century. His last important Western, Anthony Mann's *Man of the West* (1958) is even bleaker in its outlook than *High Noon*.

A few words about Cooper are in order. Although other leading men of his era (James Stewart, Cary Grant, John Wayne, James Cagney, Humphrey Bogart, and Henry Fonda) were more idiosyncratic and better actors, I am impressed with Cooper's versatility. In addition to being John Wayne's main rival in Westerns, Cooper provided a love interest for Marlene Dietrich in *Morocco* (1930) and *Desire* (1936), a comic muse for Ernst Lubitsch and Howard Hawks, an everyman for Frank Capra and Sam Wood, a swashbuckling hero for Henry Hathaway, William Wellman, and Cecil B. De Mille, and a Randian superman for King Vidor. And this just skims the surface of a career that spanned silents to Cinemascope.

Jacques Becker's
Casque d'Or 1952

Jacques Becker (1906–1960), for those of you into Kismet or astrology, was born on Jean Renoir's twelfth birthday, and their lives and careers were intertwined. They met as children through family connections to Paul Cézanne, the Impressionist contemporary of Renoir's father. In addition to assisting Jean, Becker appeared in his silent *Le Bled* (1929) and played occasional roles in Renoir films throughout the director's great period in the 1930s. Becker was apparently meticulously slow during the early years of his career – too much so for the producer of *The Crime of Monsieur Lange* (1936), which was originally intended as a directorial vehicle for Becker but wound up being another Renoir masterpiece. Becker's big break didn't really come until the Occupation (and after he spent time as a German POW), following Renoir's departure for America.

Dudley Andrew, the noted scholar of French cinema, finds Becker and his films hard to define, lacking perhaps the thematic or stylistic consistency of a Renoir, Robert Bresson, François Truffaut, or Jean-Luc Godard. Becker wrote: "Only the characters, who become *my* characters, obsess me to the point where I can't stop thinking about them… This is my somewhat etymological side: whatever happens in France, I am French, I make films about French people, I look at French people, I am interested in French people." Renoir, of course, stayed in California, and after his work with Becker his films took on a kind of universality. The two men remained emotionally close until the end of Becker's abridged life, despite being a continent and an ocean apart.

Casque d'Or, from its opening shot, has echoes of Renoir's Becker-assisted film *A Day in the Country* (1936). Both films begin with pastoral river scenes and reveal a deep humanism in their treatment of relation-ships. The plot of *Casque d'Or* revolves around a romantic

triangle involving two former prisoners and it ends in tragedy. Its depiction of a criminal gang – replete with a climax on the guillotine – is the underside of Belle Epoque Renoir depicted in *French Cancan* (1954). (Andrew pegged Becker's version as "grim romanticism.") Becker, indeed, did focus on his characters – in this case, lovers played by Simone Signoret and Serge Reggiani – and what one critic called "a vivid gallery of... individually depicted" friends and associates. Signoret and Reggiani were already on their way to several decades of international stardom, though neither fit the stereotypical role of glamorous movie star.

Two years later, Becker modernized his portrait of gangsterdom with *Hands Off the Loot* starring Jean Gabin. Becker, who had worked with the actor on the Renoir classics of 1930s, adapted Gabin's role as a father figure in *French Cancan* to fit the young gangsters and prostitutes of his new film. Like Paul Muni in Howard Hawks's *Scarface* (1932), Gabin is always immaculately dressed, even when he's smacking people around or firing a machine gun. As a gangster leader, he draws on Claude Dauphin in *Casque d'Or*. As with that film, *Hands Off the Loot* was shot in shadowy black and white in the streets and bistros of Paris. It presages the French New Wave, and appropriately, stars an extremely young Jeanne Moreau, whom Renoir finally caught up with for his final film *The Little Theater of Jean Renoir* (1970). The long climactic shootout in *Loot*, filmed on deserted country roads, looks like it could be from Renoir's Simenon adaptation of a generation earlier, *Night at the Crossroads* (1932) – which Becker assisted on – although it can also be suggested that Gabin provided something of a role model for Jean-Paul Belmondo's morose, independent gangster in Godard's *Breathless* (1960).

Sadly, Becker never lived to see Godard's feature debut, dying early in 1960. His last years were marked by tragedy and disappointment. After *Loot*, he made mediocre adaptations of *Ali Baba and the Forty Thieves* (released in 1954 and starring the comedian Fernandel) and *The Adventures of Arsène Lupin* (1957). Then, following the tragic death of the great Max Ophüls, Becker took over and completed the master's *Montparnasse 19* (1958) about the life and early death of Modigliani. Gérard Philipe was cast as the painter, and he was not only the same age as Modigliani, thirty-six, but also dying of a comparable disease. Becker had barely finished his intense prison drama *The Night Watch* (1960) before he too died, abruptly ending an incomplete life and career.

Max Ophüls's The Earrings of Madame de... 1953 and Lola Montès 1955

A shot that does not call for tracks is agony for poor old Max,

Who, separated from his dolly is wrapped in deepest melancholy.

Once, when they took away his crane, I thought he'd never smile again.

This amusing doggerel was composed by James Mason, who acted in *Caught* and *The Reckless Moment* (both 1949), the last two films Max Ophüls made in America before his return to Europe. (These were the films that launched Mason's long and distinguished Hollywood career.) Mason's affectionate poem was a clever commentary on the director's dominant stylistic motif. As critic Myron Meisel put it, Ophüls's "peripatetic camera never pauses an instant, recording each inexorable, unalterable, painfully passing moment, and instilling every fabulously intricate tracking shot with breath-taking grace."

Andrew Sarris, who considered Ophüls the greatest of directors and *The Earrings of Madame de...* the greatest film ever made, famously wrote of his epic circus film *Lola Montès*:

This is the ultimate meaning of Ophülsian camera movement: time has no stop. Montage tends to suspend time in the limbo of abstract images, but the moving camera records inexorably the passage of time, moment by moment. As we follow the Ophülsian characters, step by step, up and down stairs, up and down streets, and round and round the ballroom, we realize their imprisonment in time. We know that they can never escape, but we know also that they will never lose their poise and grace for the sake of futile desperation. They will dance beautifully, they will walk purposively, they will love deeply, and they will die gallantly, and they will never whine or whimper or even discard their vanity.

Dave Kehr goes even further than Sarris, calling *The Earrings of Madame de...* "one of the most beautiful things ever created by human hands." Since I don't disagree with either Sarris or Kehr, this leaves me with very little to add. In terms of plot, the film echoes *La Ronde* (1950). An expensive pair of earrings keeps changing hands, going from Louise (Danielle Darrieux) to her husband (Charles Boyer) and her lover (Vittorio De Sica). They are pawned,

then sold, but keep coming back to her, ultimately resulting in a tragic duel. The story is almost embarrassingly simple, but executed with great elegance and feeling.

The great cinema romantics tended to be of European origin: Ophüls, Jean Renoir, Josef von Sternberg, F. W. Murnau, and Charlie Chaplin. (Maine-born John Ford was also a romantic, but American mythology was so dominant in his emotions and instincts that there was little room left for personal or erotic relationships.) Of these five, Ophüls was the only one to voluntarily move back to Europe and frankly, it is doubtful that he could have attained equal status as an artist if he continued to work in Hollywood. His work in California was excellent, and *Letter from an Unknown Woman* (1948) is a highly personal masterpiece, but Ophüls was unlikely to find much empathy among Hollywood moguls for his thinking about the Cold War era. He spent a glorious five years in Europe before tragically succumbing to heart disease in 1957.

Danielle Darrieux began making movies in 1931. She appeared in Ophüls's *La Ronde* and starred in both *Le Plaisir* (1952) and *The Earrings of Madame de....* Max's son, Marcel, considered her his father's favorite actress and lamented that his documentary, *The Sorrow and the Pity* (1971), made long after Max's death, had to call attention to her collaboration with the Nazi occupation. Ophüls's taste in heroines always struck me as unique. Renoir's most interesting heroine was probably Anna Magnani in *The Golden Coach* (1952), while Sternberg, of course, relied on Marlene Dietrich in seven of his greatest and most romantic films, beginning with *The Blue Angel* and *Morocco* (both 1930). Magnani and Dietrich seem to me to be mistresses of all situations, having resiliency and strong senses of irony. On the other hand, Darrieux, Joan Fontaine in *Letter from an Unknown Woman*, and Martine Carol in *Lola Montès* (Ophüls's last completed film) seem more passive, more accepting of the vicissitudes of life. All three directors are feminists, but Ophüls's women seem more prone to go with the flow.

Andrew Sarris concluded his summation of Ophüls's art with this: "It will all end in a circus with Lola Montès selling her presence to the multitudes, redeeming all men both as a woman and an artistic creation, expressing in one long receding shot, the cumulative explosion of the romantic ego for the past two centuries." While Max lay dying in Hamburg, the moneymen were mutilating *Lola Montès*. (There was a time during my not-brief-enough career in film distribution in the late 1960s when I thought I had the only surviving print of the Ophüls cut under my desk.) Actually, romanticism is romanticism, and reality is reality; it didn't end in a circus. For Max, it ended in a Hamburg hospital room and for the real-life Lola, a nondescript grave in Brooklyn's Greenwood Cemetery.

Federico Fellini's I Vitelloni 1953

For many Americans, Federico Fellini (1920–1993) is the very definition of foreign filmmaker. Several years ago, a critic with *The New York Times* stated unequivocally that cinema in the second half of the twentieth century had been dominated by three men: Ingmar Bergman, Akira Kurosawa, and Fellini. At a certain point, it seems, Fellini succumbed to self-idolatry, actually including his own name in the title of some of his later works. While his films can be very entertaining and include visually stunning moments, I suggest that he was overrated. Although early movies like *The White Sheik* (1952), *I Vitelloni*, *La Strada* (1954), and *Nights of Cabiria* (1957) have strong emotional cores, I find the films from *La Dolce Vita* (1960) on to be overinflated. With his confessional signature work *8½* (1963), the director essentially admitted that his inspiration, his muse, had deserted him.

Between 1939 and 1952 Fellini had been a writer on over two dozen films, including Roberto Rossellini's excellent *Rome Open City* (1945); *Paisan* (1946); *The Miracle* (1948), in which Fellini also acted; *Flowers of St. Francis* (1950); and *Europa '51* (1952). Perhaps he burned himself out? Like Bergman in the 1960s and 1970s, and Kurosawa in the 1990s, Fellini seemed to pull away from narrative. His fantasies, however, seemed less rooted in anything personal or autobiographical than theirs. Rather, they seem rooted in a desire to make the world seem more bizarre, populated by the weirdest-looking and most flamboyant people he could find. Was this experimentalism or self-indulgence? Occasionally, Donald Sutherland or Giulietta Masina or Marcello Mastroianni could drag him back to something approaching cine-reality, but the Oscars, grand prizes, and honorary degrees kept flowing from his legend.

I am aware that there is an apparent contradiction in criticizing Fellini for being too self-indulgent and praising someone such as his hero, Charlie Chaplin, for the autobiographical nature of his films. Both directors had practically unprecedented control of their work, and so the notion of discipline helps distinguish them. Chaplin took several years to make each of his features; he endlessly rehearsed and

discarded shots, scenes, and characters that didn't meet his standards. I don't get the sense that Fellini ever had doubts about his work – he was after all, Fellini. Perhaps a solution to the Fellini-as-auteur enigma was hinted at by Stephen Hanson, who wrote that each of Fellini's films is a "deliberately crafted building block in the construction of a larger-than-life Fellini legend which may eventually come to be regarded as the 'journey of a psyche.'"

Fellini, of course, insisted that he never betrayed his Neorealist roots. When we think of Neorealism, we tend to think of grainy images; shots that don't turn out perfectly but are not refilmed due to a scarcity of film stock; the gritty black-and-white quality we associate with *Rome Open City* and *Paisan*, and Vittorio De Sica's *Shoeshine* (1946) and *The Bicycle Thief* (1948). *I Vitelloni*, Fellini's vivid recreation of his youth in Rimini, holds essentially true to that model, as do *La Strada* and *Nights of Cabiria*. *I Vitelloni* impressed Eugene Archer (an early Andrew Sarris mentor) with Fellini's "understanding of his characters… and with the compassion of the director's approach." Archer called *I Vitelloni* "a model of progressive film technique… *Vitelloni* distinctly evokes the image, not of art, but of life." Up to a point, Fellini is correct when he insists on his fealty to Neorealism: "Telling the story of some people, I try to show some truth." The question remains as to whether we have always had too narrow a conception of Neorealism, or whether Fellini, in his solipsism, drifted from his roots.

Kenji Mizoguchi's Ugetsu Monogatari 1953

My uncle, Albert Green, was an internationally acclaimed ceramicist whose work is now mostly concentrated in the collection of the Morris Museum in New Jersey. Although he never visited Japan, he was heavily influenced by Japanese potters. Uncle Albert was a genuine artist, obsessed with his kiln and achieving the proper glaze for a particular piece. Genjuro, the potter who is the central character in Kenji Mizoguchi's haunting ghost story *Ugetsu Monogatari*, is less concerned with artistic perfection than with the sale of his pots, extolling the virtues of financial success like some sixteenth-century Mitt Romney. I find it hard to accept that Genjuro might be, as some have suggested, a stand-in for the obsessive Mizoguchi.

Ugetsu arrived in the West hard on the heels of Akira Kurosawa's highly popular *Rashomon* (1950). In addition to Mizoguchi's usual muse, Kinuyo Tanaka (*Life of Oharu*, 1952; *Sansho the Bailiff*, 1954), the film also stars two of the leads from *Rashomon*, Machiko Kyo and Masayuki Mori. (Kyo was to become, in the perception of the West, Japan's leading actress. She also starred in the beautiful color import, Teinosuke Kinugasa's *Gate of Hell*, 1953, and went on to play opposite Marlon Brando in *Teahouse of the August Moon*, 1956.) *Rashomon* and *Ugetsu* were both photographed by Kazuo Miyagawa, who later shot several more Mizoguchi films as well as Kurosawa's *Yojimbo*. The music for both films was composed by Fumio Hayasaka.

The contrast between *Rashomon* and *Ugetsu* was too much for some untutored Americans. *New York Times* reviewer Bosley Crowther was befuddled. His review of Mizoguchi's film – which had already won the top prize at Venice – warned that the movie might "vex" the audience with its "weird, exotic stew." Crowther shortly followed up with a more sympathetic piece, attributing his befuddlement to "the comparative obscurity of Japanese films." He is reassuring (if a tad racist) in telling his readers that they will never pose so great a threat to American films as mahjong.

Donald Richie, to whom we all owe a great debt for persevering in the face of Crowtherian attitudes, considered *Ugetsu* "the most perfect" of Mizoguchi's films. However, to be fair, the *Times* critic had a point. There was very little precedent in American or European cinema for this film's style. Perhaps Carl Theodor Dreyer's *Vampyr* (1932) most closely resembles it, but one might also credit F. W. Murnau's silent *Nosferatu* (1922). In light of the otherworldly and supernatural nature of his subject matter, Mizoguchi seeks to mystify the environment through misty traveling shots, obscure lighting, and eerie sounds and music. His film was based on several popular supernatural stories by eighteenth-century author Akanari Ueda, whose book *Ugetsu Monogatari* can be translated variously as *Tales of the Silvery Moonlight in the Rain* or *Tales of the Moon Obscured by Rainclouds*. By the time he began work on the film, Mizoguchi had already made the silents *Foggy Harbor* (1923), based on Eugene O'Neill's *Anna Christie*, and *White Threads of the Waterfall* (1933). Making things crystal clear and logical were not high on Mizoguchi's agenda. There is the usual dose of misanthropy one detects in his films (which also affected Kurosawa), and his male characters are typically responsible for female misery. In *Ugetsu*, the masculine sin is ambition, something that Mizoguchi would have clearly seen in himself.

Personally, I find many of the virtues of *Ugetsu* in the director's other films – *Utamaro and His Five Women* (1947), *The Life of Oharu* (1952), *Sansho the Bailiff*, *The Crucified Lovers* (both 1954), and so on – and I find it hard to digest the fantasy elements of the film. As Scott Tobias has suggested, "no clear line of demarcation separates the realms of the real and the supernatural… and every time the director pulls out the rug, it seems freshly devastating." *Ugetsu* is a beautiful object worthy of great respect, but I would disagree with those who consider it the greatest film ever made.

Alfred Hitchcock's I Confess 1953

Alfred Hitchcock has so far been represented in this book only by *Blackmail* (1929) and *Notorious* (1946). One of the subsidiary purposes of launching the auteur cinema screening series was to point to major gaps in MoMA's archival holdings in the hope of remedying them. I think both *Strangers on a Train* (1951) and *Rear Window* (1954) are more important and fuller expressions of Hitchcock's personality and genius than *I Confess* (1952), but neither film was available in the Museum's collection. Fortunately, though, Hitchcock's work is sufficiently rich that even his lesser films have a gravitas that few other directors can claim.

One of the first things one notes about *I Confess* is its total lack of humor and charm. (Hitchcock himself told François Truffaut he thought the film "heavy-handed.") In the film, shot on location in highly picturesque Québec, a priest hears a confession to a murder. He winds up being torn between his need to defend himself and his priestly duty to respect the privacy of the confessional. In their book-length study of Hitchcock, the *Cahiers du Cinéma*-critics-turned-New Wave-directors Éric Rohmer and Claude Chabrol comment that because Montgomery Clift's priest cannot speak of what he learned in the confessional, the film is dependent on various actors' glances and looks. "Only these looks give us access to the mysteries of his thought. They are the most worthy and faithful messengers of the soul." Apologizing for their "inflated" tone, Rohmer and Chabrol contend that the "majesty of this film invites as much, and leaves little room for humor."

Hitchcock, of course, was a Jesuit-educated Catholic, but one does not get the impression from his career or what we know of his life that he spent much time agonizing over religious issues. (Maurice Yacowar, who interprets the film through Christian myth, suggests

that the title "could be the Catholic Hitchcock facing his maker with appropriate penitence for having squandered his devotions upon the sensations and delights of the secular life.") In any event, since *I Confess* dealt quite directly with Catholicism, Hitchcok clearly chose to treat religion with an unrelieved seriousness, which was atypical in his career. (It has been reported that he was reluctant to make the film but was persuaded by his wife, Alma Reville.)

I Confess suffers from a certain awkwardness thanks to its rather improbable script, but this did not detract from excellent performances by Clift and Anne Baxter. Although he received an Oscar nomination for his next film, Fred Zinnemann's *From Here to Eternity* (1953), Clift as tortured priest seems much more in keeping with his strengths as an actor. And although Hitchcock was not especially sympathetic to method actors, Karl Malden tended to smooth over any friction with the director. (Malden never worked with Hitchcock again, but he did become good friends with Norman Lloyd, who fell from the Statue of Liberty in Hitch's *Saboteur*, 1942, and became indispensable to the director in the production of his television series). Also worthy of praise are O. E. Hasse and Dolly Haas. The latter was a beauty in pre-Hitler Germany who went on to play the Lillian Gish role in the British sound remake of D. W. Griffith's 1919 masterpiece, *Broken Blossoms*, and later married Al Hirschfeld.

I Confess, whatever its limitations, does take up certain key Hitchcock themes and obsessions, most notably the transference of guilt from one protagonist to another – in this case, from Hasse to Clift. Clift's inability or unwillingness to articulate what he is experiencing lends an ambiguity to the director's intention, and Hitchcock seems ambivalent, perhaps having been more troubled by Catholic issues than he would have cared to admit. Biographer Patrick Mc Gilligan says, "*I Confess* smolders without ever catching fire." He also, however, sees it as Hitchcock's most compassionate film.

Fritz Lang's The Big Heat 1953

After moving to the country in 1934, Fritz Lang found his American sea legs with *You Only Live Once* (1937). In successive years, he adapted the themes of violence and fate that dominated his German films to more prosaic milieus, leaving behing Richard Wagner, a futuristic metropolis, the moon, and a bizarre Berlin underworld.

During this transitional period, Lang actually made three Westerns — *The Return of Frank James* (1940), *Western Union* (1941), and the highly stylized *Rancho Notorious* (1952). He also enthusiastically met his obligations to his new nation with commendable anti-Nazi films like *Man Hunt* (1941), *Hangmen Also Die!* (1943), and *Ministry of Fear* (1944). As America emerged from the war, however, Lang was able to discover a fertile new landscape for his particular paranoias. The America of his imagination in *The Woman in the Window* (1944), *Scarlet Street* (1945), and *Clash by Night* (1952) was cheesy and corrupt, and his visions of violence and crime reached their fullest flowering in *The Big Heat*.

As critic Kim Newman has pointed out, the 1950s were a rich time for Hollywood movies about organized crime. This was the time of the televised Kefauver hearings. As Cagney, Robinson, and Muni had done with Warner Brothers films in the early 1930s, the films in this new cycle exploited public interest in contemporary headlines, and *The Big Heat* seems to have reached its own level of credibility. (As fanciful as Lang's three *Mabuse* films and *M*, 1931, may appear to us now, they seemed to have reflected a certain level of authenticity for German audiences of the time.) As film historian and director Gavin Lambert put it, "the basic material of *The Big Heat* resembles that of a score of American thrillers, but a personal imagination transforms it and relates it to the artist's own created world… rich in symbols of evil prescience."

In the years between *You Only Live Once* (1937) and *The Big Heat*, Lang's approach seems to have changed. The "criminals" in the earlier film, the Clyde-and-Bonnie-like Henry Fonda and Sylvia Sidney, were presented sympathetically, and organized society took the form of police pursuing them. Even Peter Lorre's child murderer in *M* was given moments of pathos. In *The Big Heat*, however, Glenn Ford's cop is the hero and the victim of the criminals. Lang acknowledges what critic Lotte Eisner refers to as "the spread of corruption throughout society on both sides of the law." Although he is motivated by revenge, Ford's character has the purity of Siegfried in *Die Nibelungen* (1924), and like Siegfried, he seems to be contending with overpowering and menacing forces. It is an open question whether the "big heat" (the police crackdown on crime) will be hot enough to contend with this menace.

In a sense, *The Big Heat* represents Lang at his most mature and persuasive. Thanks to a strong script by Sidney Boehm, there is a pervasive sense of normalcy, and the characters have more depth and detail than is typical of Lang's films. Lacking the visual nuance of his

German works, Lang's American efforts are more dependent on plausibility, and the director is immensely assisted in this regard in *The Big Heat* by his actors. Glenn Ford probably was never better, and Lee Marvin, a decade before switching to being a good guy, was about as bad as anyone could be. Despite winning an Oscar for *The Bad and the Beautiful* (1952), Gloria Grahame was one of the most underappreciated actresses of the 1950s.

William Wyler's Roman Holiday 1953

How one relates to William Wyler (1902–1981) goes a long way toward delineating how one relates to the auteur theory. To the Hollywood establishment, Wyler was one of its most honored and esteemed directors. He received three Oscars for films that in retrospect seem less than extraordinary: *Mrs. Miniver* (1942), *The Best Years of Our Lives* (1946), and *Ben Hur* (1959). If that wasn't enough, the Motion Picture Academy also gave him their humanitarian Thalberg award in 1965, and the American Film Institute presented him with their "Lifetime Achievement" award in 1976.

From humble cinematic beginnings — he directed over two dozen silent Western quickies at Universal — in sound's first decade Wyler graduated to directing major stars such as Walter Huston, Bette Davis, Laurence Olivier, and Gary Cooper. He would soon add Greer Garson, Olivia De Havilland, Charlton Heston, and Barbra Streisand to that list, among many others. It is hard to find an actor who didn't love him and speak of him in respectful and affectionate terms, even though Wyler was meticulous about what Charles Affron has called "his tireless search for the perfect shot." One can't imagine any of Wyler's actors describing him the way Henry Fonda described John Ford, who he called without prompting "a perverse Irish son-of-a-bitch genius." (Fonda worked with Wyler on *Jezebel*, 1938, and gave his greatest performances for Ford.) Wyler's own visual "genius," as heralded by the great French critic André Bazin, seems now more a product of a prescient collaboration with the superb cinematographer, Gregg Toland. (*Citizen Kane*, 1941; aside, Toland also did *his* best work with Ford.)

The production history of *How Green Was My Valley* (1941) at Twentieth Century-Fox tells us a great deal about the differences between Wyler, the intended

THE BIG HEAT. DIRECTED BY FRITZ LANG. 1953. USA. BLACK AND WHITE, 90 MINUTES.

director, and Ford, who ultimately made the film. For multiple reasons Wyler left the project and moved on to the Bette Davis/Lillian Hellman vehicle *The Little Foxes* (1941), taking Toland with him. Producer Darryl Zanuck loved Philip Dunne's script for *How Green Was My Valley*, but the Fox money people believed Wyler's reputation for slowness would prove too costly, and Ford was brought in to salvage the project. Dunne, who later wrote speeches for President Kennedy, felt Ford's film was too "corny," even though the film's emotional quality helped it at the box office. (Although Ford contributed little to the script, he wound up considering the film highly personal, almost autobiographical.) The "corniness" that Ford brought to the project calls attention to the main problem with Wyler, which is that he never seemed to care very much, suffering from what Andrew Sarris called "a lack of feeling." (Sarris's assessment of *Roman Holiday* was atypical, finding it "genuinely poignant [with] breath-taking gravity and insight.")

Traces of Wyler's indifference can be found in the diversity of his subject matter, but even he could not prevent the radiant new talent of Audrey Hepburn from winning an Oscar for *Roman Holiday*, her first significant role. Wyler, freed of studio comforts and constraints, seemed more trusting, more willing to risk imperfect shots so long as he could rely on the glories of Rome and Ms. Hepburn. (At this pre-Fellini point, Italian cinema was still largely defined by less-than-gorgeous Neorealism.) *Roman Holiday* did for the Eternal City what Alfred Hitchcock did for the Riviera in *To Catch a Thief* (1955). Wyler can be forgiven for many boring, overrated films in exchange for discovering the future Holly Golightly and Eliza Doolittle. Hepburn, with her fragile beauty and poignant vulnerability, was unlike anybody else since the

days of Lillian Gish. Billy Wilder, who cast Hepburn in *Sabrina* (1954) and *Love in the Afternoon* (1957) once commented glibly on her charms: "This girl… may make bosoms a thing of the past."

Vincente Minnelli's The Band Wagon 1953

The Hollywood backstage musical had been a mainstay since the birth of the talkies. At Warner Brothers, Lloyd Bacon and Busby Berkeley presided over both *Footlight Parade* and *42nd Street* in 1933 alone, directing the diverse talents of James Cagney, Joan Blondell, and Dick Powell. And who could ever forget Warner Baxter in the latter film telling Ruby Keeler, "You're going out a youngster, but you've got to come back a star"?

As detailed in Mark Griffin's wonderful book, *A Hundred or More Hidden Things: The Life and Films of Vincente Minnelli*, Vincente (formerly Lester) spent his childhood as part of a barnstorming Ohio theatrical troupe called the Minnelli Bros. Mighty Dramatic Company Under Canvas. Although the boy played children's roles, he was more passionate about being an artist than an actor, and his father and uncle began accepting his suggestions for set and costume designs at an early age. As Griffin says, though the Mighty Dramatic Company "wasn't the Ziegfeld Follies, it wasn't peddling snake oil either." (Minnelli partially directed MGM's *Ziegfeld Follies* seven years before *The Band Wagon*.) Minnelli spent several years working in the theater, both in Chicago and as the art director at Radio City in New York, before going to Hollywood. He had what my late colleague Stephen Harvey referred to as "sensitivity to the special, self-contained qualities of the theater." He was also known for visual extravagance and the graphic flamboyance of his stage productions.

Writing of *The Band Wagon*, Harvey refers to "the distilled theatricality" of the film. "Within Minnelli's mock proscenium, his cast gives the illusion of immediacy you get from live performance, enhanced by the proximity of the camera. It's a fusion of the best of both worlds." In Minnelli's films, one wonders how much of his personal phantasmagoria he sacrificed to conform to the cinematic pull toward naturalism – and to the commercial pressures not to get too far ahead of the audience or studio. Of course, cinema's capacity to do things not possible on the stage may have allowed him to

realize more of his personal fantasies. Before *The Band Wagon*, he perhaps went too far in the drive toward reality with his other Fred Astaire film, *Yolanda and the Thief* (1945). That wouldn't last. With its spectacular performances, superb Oscar-nominated Comden and Green script, and its Dietz and Schwartz score, *The Band Wagon* was a huge success.

Writing for CinemaTexas film society in 1977, Dave Rodowick and Ed Lowry confronted the dichotomy between Minnelli's commitment to both stage and screen: "Early in the film, it becomes apparent that The *Band Wagon* is a 'post-Minnelli-musical' as the development of the new show grows into a parody of the Minnelli style… *The Band Wagon* may be the first existential musical." After explicating this premise, the two authors conclude that there are two Vincente Minnellis in conflict over who is the auteur of the film. One Minnelli is committed to the "high art" of the theater (embodied by Jack Buchanan), the other to the "low art" of the movies (embodied by Fred Astaire). Within this construct, the director finally achieves a high/low synthesis, represented by Buchanan's declaration of the equality of rhythm between "Bill Shakespeare's immortal verse and Bill Robinson's immortal feet."

Lest we get carried away, Mark Griffin reminds us that *The Band Wagon* is "one of the most joyous and exuberant musicals in cinema history…. Minnelli's movie radiates with the soul of showbiz." So it seems plausible to consider this the director's most personal film, with Astaire and Buchanan his onscreen representatives. It also seems possible that both would subscribe to the words of Howard Dietz:

> *Everything that happens in life*
> *Can happen in a show*
> *You can make 'em laugh*
> *You can make 'em cry*
> *Anything – anything can go*
> *A show/that is really a show*
> *Sends you out/with a kind of a glow*
> *And you say/ as you go on your way*
> *That's entertainment.*

George Cukor's The Actress 1953

George Cukor, a graduate of New York City's DeWitt Clinton High School, was barely out of his teens when he began working on Broadway. Less than three years

younger than Ruth Gordon, Cukor must have shared some of the hopes and aspirations the actress expressed in her autobiographical play, *Years Ago*, which served as the premise for Cukor's film *The Actress*. (Gordon adapted the screenplay.) The film, set in the period before World War I, is about a small town New England girl (Jean Simmons) who aspires to be an actress, causing her conventional father (Spencer Tracy) some trepidation. The theater was in his Cukor's blood, and *The Actress* openly reveals its origins as a play.

In his first two years in the movies, Cukor directed *The Royal Family of Broadway* (a 1930 spoof on the Barrymores, some of whom he had directed on the stage), worked with Tallulah Bankhead, and discovered Katharine Hepburn. Many of the director's films were adapted from the proscenium (*Romeo and Juliet*, 1936; *Holiday*, 1938; *The Women*, 1939; *The Philadelphia Story*, 1940; *My Fair Lady*, 1964); many were about backstage life (*What Price Hollywood?*, 1932; *Zaza*, 1939; *A Double Life*, 1947; *A Star Is Born*, 1954; *Les Girls*, 1957); many were tales of lives that were intrinsically theatrical (*Sylvia Scarlett*, 1935; *Camille*, 1936; *Travels With My Aunt*, 1972). Cukor was not only a "man of the theater," but one of America's dozen or so greatest native-born directors – and arguably the greatest from New York.

Ruth Gordon's career never quite made it to the front burner. Although portrayed by the gorgeous Jean Simmons, the real Gordon was, sadly, more pedestrian. The critic Heywood Broun wrote of her first starring role, "anyone who looks like that and acts like that must get off the stage." After dabbling with the movies in Ft. Lee, Gordon finally attained a fair degree of acclaim as a stage actress in the 1920s and 1930s. She also had some film success in 1940, playing Mary Todd opposite Raymond Massey in *Abe Lincoln in Illinois*. Her acting opportunities remained sporadic, and today she is mostly remembered as a witch in Roman Polanski's *Rosemary's Baby* (1968) – a role that won her an Oscar – and the foil to an orangutan in two of Clint Eastwood's lesser efforts. Gordon's real contributions to cinema were in the screenplays she and her husband, Garson Kanin, wrote for Cukor, culminating in *The Actress*.

The Actress, unfortunately, came out at a time of great hoopla in Hollywood over widescreen and 3-D. Lacking in spectacle and gimmickry, this small black and white film lost a million dollars. Still, critics praised the performances. Spencer Tracy had already made four films with Cukor, and he was at the height of his long career. Tracy's biographer, James Curtis, rightly points out that in the actor's care his character "became an amalgam of all the fathers of the world who want something more for their children than what they had for themselves."

Cukor was known for his superb directing of actresses, guiding a number to Oscars including Ingrid Bergman (*Gaslight*, 1944), Judy Holliday (*Born Yesterday*, 1950), and Vivien Leigh (*Gone With the Wind*, 1939 – albeit credited to Victor Fleming). A partial list of other great performances under his direction include Greta Garbo (*Camille*), Judy Garland (*A Star Is Born*), Audrey Hepburn in Cukor's own Oscar winner (*My Fair Lady*), and a slew of Katharine Hepburn triumphs from *A Bill of Divorcement* (1932), *Little Women* (1933), and *Holiday* (1938) to *Love Among the Ruins* (1975) and *The Corn Is Green* (1979). Simmons and Teresa Wright in *The Actress* were not far behind. What Cukor lacked in visual style, he made up for in intensity of feeling and in the humanity he generated over a half-century career.

Roberto Rossellini's Journey to Italy 1954

We all love Italy, we cherish the place precisely because it attends to, is visible living proof of, the effort, the greatness, the power and the triumph of creativity in man.
– Guy de Maupassant, "Happiness"

In its heyday in the 1950s, *Cahiers du Cinéma* designated this film as one of the twelve greatest of all time. Founding editor André Bazin declared: "The art of Rossellini is linear and melodic. True, several of his films make one think of a sketch: more is implicit in the line than he actually depicts. But is one to attribute such sureness of line to poverty of invention or to laziness? One would have to say the same of Matisse."

The film depicts Ingrid Bergman and George Sanders trying to save their marriage by driving through Italy. From its seemingly lackluster beginning to its abrupt climax, it confronts the viewer with many problems. The director's lack of facility with English imposes an awkward quality on the dialogue, and George Sanders's discomfort with Rossellini's improvisatory methods is evident throughout. (Ingrid Bergman later revealed in an interview that the actor once broke down in tears during filming.) As with other Italian movies of the era, the dialogue was not recorded until after the film was shot, and the post-synchronization of the minor actors, most of whom mouthed something other than English, is atrocious.

Although the director captures the light and texture of his milieu with a beautiful visual style that anticipates the best of Michelangelo Antonioni, this is offset by heavy-handed symbolism of pregnant women and dead civilizations, and shamelessly nude Mediterranean art that offends prudish Anglo-Saxon sensibilities. Rossellini's obsession with history (in this case, Pompeii) is never as fully integrated into the drama as one might wish. It is almost as though his actors are posed against a kind of temporal back-projection. It is an idea that works much better in theory than on the screen.

Ingrid Bergman carries and sustains the film in a manner befitting one of cinema's great actresses. The autobiographical connotations of her relationship with Rossellini (or as one critic put it, the "nakedness" of her performance) are never very far from the surface. The strain on their real-life marriage at the time ("I brought Roberto failure… every film we made together, one after another, was received badly") comes through to a degree. Bergman said that "jokes in marriage are the cement," but there are no jokes in *Journey to Italy*.

Regarding Rossellini, the critic Robin Wood quoted André Bazin: "More than with any other director," he wrote, "the essential meaning has to be read behind and between the images, in the implications of the film's movement which rise to the surface only in rare privileged moments whose significance is never overtly explained and which draw their intensity as much from the accumulations of context as from anything present in the image."

Accepting this, one may consider *Journey to Italy* a poignant and essential work for anybody who has ever had to test their love with a trip to Italy, or simply to the more exotic regions of the soul.

Yasujirō Ozu's Tokyo Story 1953

The writings of the late Andrew Sarris are the inspiration for the series on which this book is based, and it is in part dedicated to him. No one in the English-speaking world has done more than Sarris to explain and celebrate the role of the director as artist. The case of Yasujirō Ozu, however, is probably the most glaring example of where Sarris and I part company. In writing about *Tokyo Story* back in 1972, Andy opined that the film was "as mired in malaise as anything concocted by our own professional pessimists. Ozu's rigid frames are the most rigorous expression I know of the trap of nondramatic daily existence, that vast void of time in which nothing much

ever happens." Sarris was responding to a number of factors that make up the content and austere style of Ozu's films, of which *Tokyo Story* is probably the most accomplished. The fact is that there is very little plot and the pacing is slow; the director's camera is essentially stationary and contemplative; he shoots from a low angle, simulating the point-of-view of somebody seated on a traditional Japanese tatami mat; occasionally, he offers transitional images — still lifes, also rigorously composed, that act as codas between scenes. Nevertheless, Ozu's films, and especially this one, are incredibly moving.

The story, such as it is, is simple. An older couple comes to Tokyo to visit their children and grandsons. They are treated by the family with passive abuse, except for their war-widow daughter-in-law, played beautifully by Setsuko Hara, the star of Ozu's *Late Spring* (1949), who also worked with Akira Kurosawa. After their disappointment, the couple returns home, where the grandmother dies. Hara offers to move in to take care of the old man (played by the brilliant Chishu Ryu), but he chooses to be alone and tells her to remarry.

The book on Ozu — before Donald Richie brought him to western attention and Dan Talbot at New Yorker Films released a slew of his films — was that he would never be understood outside of Japan. Of course, Ozu was quite familiar with what was going on in America and Europe. He readily acknowledged his debt to Leo McCarey's *Make Way for Tomorrow* (1937), which dealt with many of the same issues as *Tokyo Story*. Ozu had been a military officer in World War II (though one doubts he was very good at it) and had been exposed to Americans and Brits when they held him as a POW. In his last film, *An Autumn Afternoon* (1962), Ryu and some of his old army buddies tipsily wax nostalgic in a noodle bar about what it might have been like to win the war and occupy New York. As David Bordwell points out, one of the grandsons in *Tokyo Story* also whistles the theme from John Ford's *Stagecoach* (1939). In many of his films, Ozu's characters make reference to various American movie stars, and he shared with the Danish director Carl Theodor Dreyer a surprising fondness for Ernst Lubitsch. As different as his films seem from ours, Ozu knew America and its movies. And, as Bordwell indicates, the director finds a "poetic resonance" in the seemingly mundane acts and objects that disappointed Sarris. Hara sums up the film's ending by pointing out that "life is disappointing," and ultimately we are all left alone with our own reality.

Writers uniformly call *Tokyo Story* a masterpiece. The late Penelope Gilliatt labeled it "one of the manifest

miracles of cinema." Even Jonas Mekas, that staunch critic of narrative film said, "there is in it none of the stuff from which movies are made — images, movement, light, But, my God, what a movie!" Speaking of God, Ozu's strongest advocate, Donald Richie, acknowledged the spiritual or religious nature of the director's films, but paradoxically emphasized that Ozu's worldview is completely people-centered. I find it slightly ironic that the director, whose movies are all about family life, never married and spent most of his adulthood living with his mother. He died on his sixtieth birthday and is buried where he was born, in the city of Kamakura. The cemetery is next to the train station, just a short ride from Tokyo and modern reality. I spent a rainy day there once, trying to find him.

Arne Sucksdorff's The Great Adventure 1953

Film history is not always dogmatic. There is room for fun, for genres, for animation, for documentaries. In that latter category, it might seem as if the director has less control. He or she is theoretically bound to images of reality, not ones of their own creation. In truth, however, the history of documentary filmmaking is strewn with instances of directors fudging their commitment to reailty in order to meet the demands of narrative. Robert Flaherty staged much of *Nanook of the North* (1922), and actually reshot the whole film when the original got lost. Cooper and Schoedsack cleverly balanced their devotion to purity with their visual sense in *Grass* (1925). Much of the output of the great Soviet filmmakers of the 1920s and 1930s (Sergei Eisenstein, Dziga Vertov, V. I. Pudovkin, Alexander Dovzhenko) was propaganda masquerading as documentary. A good deal of the mad splendor of Leni Riefenstahl's *Triumph of the Will* (1935) was actually staged for her cameras, and at the other end of the political spectrum, Patricio Guzmán's *The Battle of Chile* took liberties with facts. Frank Capra borrowed from both the Soviets and Riefenstahl in his *Why We Fight* (1942-1945) series in admirable support of the Allied cause in World War II.

The "nature" documentary was nothing new by the 1950s, but Swede Arne Sucksdorff (1917–2001) did bring a personal vision to the genre that was unlike anything seen in the works of Flaherty or others. His films were lyrical, but he was willing to expose the cruelty of

the natural world. This candor reflected Sucksdorff's refusal to "rape reality." His films are intended for children as well as adults, but some of the imagery may be too graphic for younger viewers.

In his short films from the 1940s and in *The Great Adventure* (1953), the director developed a black and white photographic style that heavily influenced his slightly younger contemporary, Ingmar Bergman. Sucksdorff was a perfectionist, taking over two years to complete *The Great Adventure*. This patience is reflected in what Pauline Kael called the film's "dazzling compositions." It is structured very much like a Flaherty film in that it has an authentic yet fictional protagonist, comparable to the way *Louisiana Story* (1948) portrayed a young boy in the bayou. In *The Great Adventure*, Sucksdorff's son lives on a farm adjacent to a forest and observes and participates in the struggles of various creatures to survive. There are dangers imposed both by nature and man, but the director draws on his own childhood to illustrate his extraordinary kinship with wild animals and his appreciation of their struggles.

In his comprehensive survey, *Documentary: A History of the Nonfiction Film*, Erik Barnouw cites Sucksdorff as the first member of a group of documentarians he calls "poets." Sucksdorff was lyrical, Barnouw claims, yet he "saw cruelty as an essential ingredient in the world he was portraying" and "loathed sentimental depictions of nature." Nearly twenty years later, Sucksdorff shot brilliant but gruesome footage for *Mr. Forbush and the Penguins* (*Cry of the Penguins*) (1971), depicting avian atrocities that were as violent as those of our own species. Perhaps Sucksdorff was not that far removed from the profound pessimism of Fritz Lang or Alfred Hitchcock after all.

Jacques Tati's Monsieur Hulot's Holiday 1953

When a director acts in his own movie, it's almost like he's on third base in his bid to score as an auteur. The most obvious examples in America are Charlie Chaplin, Buster Keaton, Orson Welles, and Erich von Stroheim. Sacha Guitry is comparable in France, and even Jean Renoir acts in two of his most important films (*A Day in the Country*, 1936, and *The Rules of the Game*, 1939) and appears onscreen in his last, *The Little Theatre of Jean Renoir* (1970). Similarly, François Truffaut plays major

roles in *The Wild Child* (1970), *Day for Night* (1973), and *The Green Room* (1978). I expect Jacques Tati (1908–1982) never saw the base, and, if he had, he would have tripped over it or inadvertently picked it up as a souvenir, especially if a game was in progress. (Fittingly, before he went into film, Tati's stage act was built around parodying sports stars of the era.) Yet he played the lead in all five of his features.

Although I admire Tati, I'm at a loss to credit what seems to me André Bazin's extravagant praise for *M. Hulot's Holiday*. Tati's Hulot is obliviousness personified, stumbling awkwardly around other vacationers, and causing humorous consternation of which he is unaware and which wouldn't faze him if he were. The character is developed in subsequent films as a menace to modern life, although Hulot sees life itself as the menace, and regards himself as a mere passive observer. Tati is clever and inventive in creating visual and aural gags and awkward situations, but my feeling is that Chaplin and Keaton, in addition to being funny, are dealing with matters more cosmic than comic, and that Welles and Stroheim are also operating on a plane beyond entertainment. Perhaps Harold Lloyd is America's closest equivalent to Tati. Lloyd seldom gave an engrossing performance, and was mostly defined by his outfits and physical appearance. He lacked the grace of Chaplin and Keaton, although he didn't suffer from Tati's abnormal gawkiness.

Leslie Rodier makes the point that while Chaplin and Keaton invent their own special universes through their personalities, Tati inhabits our universe. As Rodier says, "Hulot, rather than creating the comedy in his films, adds a counterpoint to the other characters… to provide the audience with a new comic perspective on banal, commonplace events." To quote Pauline Kael, "it is Jacques Tati's peculiar comic triumph to have caught the ghastliness of a summer vacation at the beach… Tati is sparse, eccentric, quick. It is not until afterward — with the sweet, nostalgic music lingering — that these misadventures may take on a certain depth and poignancy." It is the front-and-center depth and poignancy of Chaplin and Keaton, however, that I think makes them a cut above Tati. While the cinema has turned Charlie and Buster into gods, we are amused by and see our reflection in M. Hulot. As Tati's said of Hulot: "He is just a fellow in the road… a little head-in-air, thinking about other things."

No one has written more admiringly of *M. Hulot's Holiday* than Dave Kehr, who says that Tati "is one of the handful of film artists — the others would include Griffith, Eisenstein, Murnau, Bresson — who can be said to have transformed the medium at its most basic level, to have found a new way of seeing." Kehr's view is that by rejecting plot, Tati "drove the first decisive wedge between cinema and classical narration." He traces the emergence of "modern cinema" to this film, and includes Jean-Luc Godard, Jean-Marie Straub, and Robert Bresson as among Tati's progeny. I would add Andy Warhol to this list (and probably question the inclusion of Bresson), but, by my personal boorish bourgeois standards, I confess to confusion as to whether this is reason to celebrate Tati or condemn him. Kehr suggests that Tati's innovation results in "sheer boredom," but he cites that as virtue. Perhaps I've sat through too many hours of self-indulgence by Godard and Warhol in the service of "purity" to not wish that somebody would, at least, trip over third base and perhaps even bleed a little. I like Tati, and I'm not sure he deserves all this intellectual baggage.

But as William Faulkner told us, the past is never dead or even past: A few years ago, Sylvain Chomet, director of the lovely animated feature *The Triplets of Belleville* (2003), dusted off Tati's unrealized script for *The Illusionist*. The resulting animated feature, which starred a Hulot-like character as an itinerant stage magician, was nominated for an Oscar in 2010.

Jean Renoir's The Golden Coach 1953

Critic J. Hoberman was on to something when he linked Jean Renoir's *The Golden Coach* with Vincente Minnelli's *The Band Wagon* (1953) and Max Ophüls's *Lola Montès* (1955). As Hoberman says, "*The Golden Coach* revels in showmanship. The screen is riotously textural — flaming velvets, lemony satins, blazing patterns of 'natural' light." Since Renoir is at the apex of the film pyramid, it is sometimes easy to forget that he was a man perhaps equally devoted to theater and its peculiar set of illusions and delusions. He wrote plays like *Orvet* and *Carola*; directed ones like *Julius Caesar* (his favorite stage work) and *The Big Knife* (by his friend Clifford Odets); and adapted works by Maxim Gorky (*The Lower Depths*) and Prosper Merimee (*The Golden Coach*) to film. Movies like *Nana* (1926), *French Cancan* (1954), and *The Golden Coach* are essentially backstage dramas, and the characters in *Grand Illusion* (1937) and *The Rules of the Game* (1939) put on shows. His final film was a television anthology, *The Little Theater of Jean Renoir* (1970), which literally brought a curtain down on his career.

With *The Golden Coach*, Renoir owed almost everything to Anna Magnani. The film is based on *commedia dell'arte*, known in its original incarnation as *commedia all'impriviso*, or comedy of improvication. As Renoir began to prepare with Magnani, he discovered that she was not very good at memorizing lines, and that her gift was, indeed, for improvisation. The problem was that the film was in English, a language totally foreign to the actress, and one in which he feared she could not improvise. His worries, despite occasional friction between them occasioned by the star's diva-like behavior, were unfounded. Magnani, after twenty years of filming and having been schooled by Roberto Rossellini (*Rome Open City*, 1945; *L'Amore*, 1948) and Luchino Visconti (*Bellissima*, 1952), was a true professional. Playing Camilla, an eighteenth-century stage star in South America, Magnani credibly yet theatrically goes from suitor to suitor in her breaks from performing.

"Authenticity" is the word Robin Wood uses to describe her, and he believes *The Golden Coach* contains her greatest performance: "Magnani... in the film's final paradox, retreats back into the theater as the only place where, by consciously acting roles, she can be herself. It is a film that calls into question the very concept of authenticity and asks whether we do not, everywhere and always, act." Or, as Renoir put it, "I tried to erase the borders... between the representation of reality and the reality itself. I tried to establish a kind of confusion between acting on a theatrical stage and acting in life."

At the climax of the film, one of Camilla's lovers addresses her: "You were not made for what is called life. Your place is among us, the actors, acrobats, mimes, clowns, jugglers. You will find your happiness only on stage each night for the two hours in which you ply your craft as an actress, that is, when you forget yourself. Through the characters that you will incarnate, you will perhaps find the real Camilla." François Truffaut pointed out that this speech represented Renoir's "artistic testament." Truffaut also reminds us that earlier in his career, Renoir acted in some of his own films, most notably as Octave in *The Rules of the Game*. In that film, which is structurally similar to *The Golden Coach*, Octave effectly serves as onscreen director of the action. The auteur stepped in front of the camera, set foot upon the stage, entered the screen like Buster Keaton in *Sherlock, Jr.* (1924). For a long time, Jean Renoir had wanted to reframe reality, erase the borders, establish a kind of confusion, and break the rules of the game. In *The Golden Coach* he succeeded brilliantly.

Documentary Drifts
Albert Lamorisse and Edmond Séchan 1952–1959

One might use the term "quasi-documentaries" to describe Albert Lamorisse's efforts to enhance the authenticity of the documentary milieu. Though some documentarians were sticking to reality – the 1950s and 1960s were the "golden era" of French documentary that produced Jacques-Yves Cousteau's mind-boggingly beautiful masterpieces *The Silent World* (1956) and *World Without Sun* (1964) – as we have seen with Robert Flaherty, Merrian C. Cooper and Ernest B. Schoedsack, and Arne Sucksdorff, documentary filmmakers habitually strayed from strict adherence to reality in the service of personal artistry. Lamorisse (1922-1970) was among them. He was an unashamed storyteller, and one with a gift for encapsulating and enhancing a certain vision of the world. His Camargue in *White Mane* (1952) and his Paris in *The Red Balloon* (1956) depict realities that are available to all of us, but are intensified by the director's rhythmic and poetic imagery. Lamorisse once told an interviewer he "makes films to bring to life his childhood dreams." So, there is something paradoxical about the dreamlike quality of his films and the grittiness of their locations – as if they were fairy tales tempered by real-world realities.

White Mane clearly seems to have been influenced by Flaherty's last film, *Louisiana Story* (1948), and it anticipates Carroll Ballard's lovely *The Black Stallion* (1979). It is essentially a romantic fantasy depicting the adventures of a young boy who discovers a white wild stallion in the marshes of the Camargue region in southern France. The script of the film was adapted by Denys Colomb de Daunant, whose estate in Camargue (visited by the likes of Pablo Picasso and Ernest Hemingway) provided Lamorisse with locations for shooting. Daunant was to go on to make his own film in 1960, *Dream of the Wild Horses*, a color documentary very much in the vein of Lamorisse. While *White Mane* is visually beautiful, how one responds to it will certainly be affected by feelings about the anthropomorphization of animals – this was, after all, the century that gave us Rudyard Kipling and Walt Disney.

In *The Red Balloon*, Lamorisse requires us to read into human behavior through a piece of inflated rubber. 1956 was a banner year for balloons, as David Niven's Philias Fogg traveled *Around the World in Eighty Days*.

Lamorisse's fantasy was not quite so ambitious, as his balloon only followed his son Pascal to the fringes of the Menilmontant neighborhood in Paris. The film was and remains highly esteemed. It won the Palme d'Or at Cannes and an Oscar for best screenplay, even though it has virtually no dialogue. René Clair said he would have traded his whole career to have made this one short film, and François Truffaut called it "one of the most beautiful color films ever made." It would not be going too far afield to notice echoes of Lamorisse's Paris in Truffaut's great debut *400 Blows* (made only three years later), *Small Change* (1976), and many of his other films.

Edmond Séchan (1919-2002) was a major cinematographer for decades, photographing films such as Jean-Paul Belmondo's *That Man from Rio* (1964). Two of the first five films he shot were *White Mane* and *The Red Balloon*, and the short he directed, *The Golden Fish* (1959), shows him to be an artist clearly aligned with Albert Lamorisse, right down to the use of a color in the title. (Séchan's fish film was produced, appropriately enough, by Captain Cousteau.) The film that is a cat-lover's dream, only slightly less believable than ones about horses that act like humans and brainy balloons.

Following *The Red Balloon*, Lamorisse seemed to have been inspired by Jules Verne, and began shooting films from Fogg-like balloons. In the final scene of *The Red Balloon*, Pascal ascended to the heavens in a pretty impressive special effect, and for Lamorisse, it was onward and upward from there. He developed a technique called Helivision that enabled him to photograph films from helicopters. (Also, prophetically, he invented the board game Risk in 1957.) The director once mused about the kind of films he would be making at eighty. He would never find out: In 1970, his helicopter crashed while he was making a film for the Shah of Iran. He died at forty-eight.

Elia Kazan's On the Waterfront

1954

In Elia Kazan's *On the Waterfront*, Marlon Brando gives one of the most superb tragicomic performances in the history of the cinema. In American films, there have been a handful of relationships between actors and directors (John Wayne/John Ford, Marlene Dietrich/Joseph Sternberg, James Stewart/Alfred Hitchcock, Lillian Gish/ D. W. Griffith, Cary Grant/Howard Hawks) that have

largely defined the art of movie acting. Brando and Kazan (1909–2003) also belong in this elite group, and *On the Waterfront* represents the apogee of their work together, which also includes *A Streetcar Named Desire* (1951) and *Viva Zapata!* (1952). Although Kazan offered him subsequent roles (*Baby Doll*, 1956; *A Face in the Crowd*, 1957; *The Arrangement*, 1969), Brando never worked with his mentor again and, in my opinion, never approached the level of his performance in this film.

It is a work of first-rate craftsmanship, from its staccato opening to its stumbling conclusion. The plot revolves around Terry Malloy (Brando), a dockworker on the Hoboken waterfront, who testifies to the corruption and mob ties of his union, even implicating his brother, played by Rod Steiger. The other actors are uniformly excellent (something one took for granted from Kazan), and Boris Kaufman's Oscar-winning cinematography captures the grittiness of New Jersey. Kazan said that shooting in the chill of a Hoboken winter forced him to take liberties with Budd Schulberg's script. Judging by *Waterfront*'s superiority to their other collaborative effort (*A Face in the Crowd*, 1957), one must assume this was all to the good. As Pauline Kael wrote, "Many weaknesses go back to the script... but Kazan, by trying to make assets out of liabilities, forces consideration of his responsibility." She concludes, "intermittently... the film is great."

This is genuinely a Kazan film: One can trace Terry Malloy's aspirations to "be somebody" back to the James Dunn character in *A Tree Grows in Brooklyn* (the director's first film from 1945) and to Arthur Kennedy's need "to get moving" in *Boomerang* (1947). In *On the Waterfront*, despite Schulberg's tendency to delineate the world in terms of good and evil, we have the first fully coherent expression of Kazanian moral ambiguity — which culminates in the inability or unwillingness to pass judgment. Thus, in spite of its heavy-handed symbolism, its too-facile resolution, and its hysteria, *On the Waterfront* contains substantial evidence of a major cinema artist and a fascinating man.

Of all the directors in the auteur series, I probably had more frequent contact with Kazan than any other. We were never buddies, and I never felt close enough to call him Gadg, but I interviewed him twice and we shared a few dinner parties. I remember one evening when, for some forgotten reason, Kazan, Joe Mankiewicz, and the great cinematographer Sven Nykvist (winner of two Oscars for Ingmar Bergman films) were hanging out in our offices. Kazan was apparently very pleased with the program notes I had written for MoMA's 1971

ON THE WATERFRONT. DIRECTED BY ELIA KAZAN. 1954. USA. BLACK AND WHITE, 108 MINUTES.

retrospective of his work (my first such endeavor), and I think he was touched that I had asked him to sign a copy of one of his novels to give to my mother. On that occasion, I had interrupted a meeting with Sam Spiegel, producer of *On the Waterfront, The Bridge on the River Kwai* (1957), and *Lawrence of Arabia* (1962) – all best picture Oscar winners – and, later, Kazan's *The Last Tycoon* (1976), which they were probably working on at the time. Kazan acted like a proud little kid when introducing me to Spiegel. In our interviews, he insisted on editing the transcripts to remove any four-letter words (there were many) that might offend his wife, Barbara Loden.

There has been much written over the years about *Waterfront* being an apologia for Kazan and Schulberg's cooperation in naming names before the House Un-American Activities Committee during its Hollywood witchhunt. (I also met Schulberg, who was far from charming.) Many careers and lives were ruined by HUAC – including that of actor John Garfield, who was killed by a stress-induced heart attack after being pressured into testifying. In his autobiography *A Life* (which critic John Lahr called "the best volume ever written about American show business"), Kazan discusses his testimony at length, trying to explain what he did without apologizing. He concluded, "I don't hold people's faults against them; I ask their tolerance for mine." In effect, he was echoing the sentiments Jean Renoir expressed in *The Rules of the Game* (1939)– that everyone has his reasons. I never discussed the matter with Kazan.

Alfred Hitchcock's To Catch a Thief 1955

By 1955, Alfred Hitchcock was enjoying a level of celebrity never attained before by a movie director, with the possible exception of Cecil B. De Mille when he was hosting *Lux Radio Theatre*. Hitchcock was making weekly appearances on television to introduce episodes of *Alfred Hitchcock Presents*, which he occasionally directed. His tiny cameos in his films, a practice he initiated in the silent era, made him instantly recognizable, as did his hand-drawn silhouette, which he used as a logo on TV and as a signature in his correspondence. (*Alfred Hitchcock's Mystery Magazine* was about to launch, though the director had no direct involvement with the publication other than selling it the use of his gold-standard name.) In France, he was interviewed separately for *Cahiers du Cinéma* by two young and little-known enthusiasts, Claude Chabrol and François Truffaut. He also met and was championed by their colleagues André Bazin, Jean-Luc Godard, and Éric Rohmer. (*Cahiers* released a "Hitchcock issue" in 1953, and was planning another for the summer of 1956.) Both interviews would eventually lead to book-length studies that would be reproduced worldwide in many languages. In New York, Andrew Sarris alerted American readers of *Film Culture* to "The Trouble with Hitchcock." He believed the chubby Cockney title-card designer had become the auteurist equivalent of "king of the world."

What did all this mean in terms of Hitchcock's artistry? Quite simply, it enabled him to be an auteur – to choose and develop films that expressed his rather perverse personality. First Paramount and later Universal found it lucrative to provide the director with the resources he required, and he made the most of their largesse. I am a firm believer in the thesis, set forth by Robin Wood in *Hitchcock's Films*, that Hitchcock's work in the 1950s surpassed that of any other period in his – or almost anybody else's – career. Wood views *To Catch a Thief* (1955) as something of a comedown from *Rear Window* (1954), the film that immediately preceded it. In the film, set on the French Riviera, a reformed cat burglar played by Cary Grant has a radiantly romantic affair with a gorgeous Grace Kelly, even as he comes under suspicion for new burglaries. Sarris initially viewed *To Catch a Thief* as self-parody, though he later changed his mind and regarded the film as "close to perfection as a romantic comedy." (Hitchcock biographer Patrick

McGilligan says it "begs comparison to the work of Ernst Lubitsch.") This gets to why, I think, Hitchcock made it: it was an antidote to the darkness of *Strangers on a Train* (1951) and *Rear Window*, both of which were reflections of what Wood calls "that chaos-world that underlies the superficial order." The theme of guilt transference is retained from major Hitchcock films of the period, and Cary Grant's performance as a fugitive foreshadows his final Hitchcock appearance in the more serious *North by Northwest* (1959) a few years later.

Why not take a breather? Why not, after all, film a romance, and bask in the beauty and light of the French Riviera with two of the era's most bankable and beautiful stars? *To Catch a Thief* is, as Sarris says, one of Hitchcock's "silkiest and most sheerly enjoyable" films. The script is almost too witty, and the director acknowledged that it was "a lightweight story." This is a film Hitchcock, at the peak of his powers, made for himself. In that, it resembles the indulgences of John Ford's *The Rising of the Moon* (1957) or Jean Renoir's *Picnic on the Grass* (1959). Hitchcock's predecessors included fellow Brits who sometimes ventured in shallower waters without betraying their gifts. Their names were William Shakespeare and Charles Dickens. The film did contain one betrayal, however: the lie that cinematic romance could overcome reality. As a result of the film, Grace Kelly met her prince, and, tragically, she died hurtling down some of the same roads that she had used to flee the police with Cary Grant.

Federico Fellini's La Strada 1954

After Federico Fellini finished *I Vitelloni*, he was still in the throes of Neorealism and hadn't yet been deified. His next project, *La Strada*, was a modest and rather moving film, one that achieves a poignancy that Fellini's talent and ego would frequently deny him in later years. By depicting the grotesque underbelly of Italian showbiz in the bleakest of landscapes, the director (like his mentor, Roberto Rossellini) was able to convey genuine human feelings. In most subsequent films, feeling – and coherent narrative – would be overwhelmed by his gift for visual imagery, which he put to the service of what my late colleague, Stephen Harvey, dubbed the "phantasmagoria" of Fellini-land.

A good deal of the sweet pathos in *La Strada* is due to Giulietta Masina, acting in the first of her four major roles for her husband. (The others are in *Nights of*

Cabiria, 1957; *Juliet of the Spirits*, 1965; and *Ginger and Fred*, 1986.) In the film, the gamine-like and possibly mentally handicapped Gelsomina (Masina) travels throughout rural Italy with her partner Zampanò (Anthony Quinn) as he struggles to make a living as a strongman. Masina's performance has been described as Chaplinesque, but in reality she more closely resembles Chaplin's early music hall colleague, Stan Laurel. Brutishly treated by Zampanò, as Stan was by Oliver Hardy, Gelsomina similarly responds with a goofy smile. Chaplin's Tramp, by contrast, was too wily to be disrespected for very long. Still, Fellini loved Chaplin, and Nino Rota's score is a clear homage to the master's films, notably *The Circus* (1928).

Anthony Quinn is a whole different story. He built his more than six-decade-long film career on being the screen's foremost exotic "other." He went from playing a Cheyenne for his father-in-law, Cecil B. De Mille, to characters that were Chinese, Spanish, Italian, Eskimo, French, and Arab. He played Attila the Hun, Greeks from Zeus to Ulysses to Zorba, and occasionally he was even cast as a Mexican, which he was by birth. (Appropriately, he won an Oscar playing Marlon Brando's brother in Elia Kazan's *Viva Zapata!*) He later inherited Brando's role of Stanley Kowalski in Kazan's stage production of *A Streetcar Named Desire* – an early exercise in Zampanò-like brutishness, with a New Orleans-Polish twist. Fortuitously, Quinn had been shooting several pictures in Rome when Fellini was casting *La Strada*, and Roberto Rossellini recommended the actor. He offered the younger director what one critic called the perfect "lust for overacting."

It would be grossly unfair to say that Fellini's career went into precipitous decline following *La Strada*, but I do have issues with his choices. Masina's next star turn in *Nights of Cabiria* was somewhat butchered before its release, but it earned Fellini a second Oscar and won back the audience he might have lost with the bitter *The Swindle* (1955). By the time the three-hour *La Dolce Vita* came out in 1960, things were becoming problematic. Metaphorically, this bloated work too closely resembles the dead sea-creature that washes up on the beach at the end of the film, which itself was reminiscent of Anthony Quinn's flotsam-like body on the beach at the close of *La Strada*. To me, Fellini is signaling somewhat prophetically that he is out of both ideas and hope.

Of course, there are intermittent pleasures and rewards in *8 ½* (1963), *Juliet of the Spirits*, and the dozen or so progressively more self-indulgent and repetitive films Fellini made over the next quarter century. His fame and fortune grew, but for all the personal revelations hinted at in the titles of his films – "Fellini-this" or "Fellini-that" – the director's real personality remained elusive. To quote Stephen L. Hanson, "whether any of the films are truly autobiographical in any traditional sense is open to debate. They definitely do not interlock to provide a history of a man...."

Robert Aldrich's Vera Cruz 1954

Robert Aldrich (1918–1983) brought an extraordinary pedigree to his directorial career. He had assisted two of the greatest cineastes on masterpieces, having worked with Jean Renoir on *The Southerner* (1945) and Charlie Chaplin on *Limelight* (1952). Aldrich's own films, however, were quite different. They more closely resembled the frenetic and gritty work of Robert Rossen (*Body and Soul*, 1947), Abraham Polonsky (*Force of Evil*, 1948), and Joseph Losey (*The Prowler* and *M*; both 1951), filmmakers he had also apprenticed for. Few directors have begun their careers with that kind of experience.

Vera Cruz was the second of Aldrich's six Westerns, three of which were made in collaboration with Burt Lancaster. (They also worked together on the nuclear-era thriller *Twilight's Last Gleaming* in 1977.) Set in Mexico in the 1860s, the film stars Lancaster and Gary Cooper as they conspire to steal treasure from Emperor Maximilian. It was photographed by Ernest Laszlo, who made six Aldrich films before finally winning an Oscar a decade later for Stanley Kramer's *Ship of Fools* (1965). Both Laszlo and Aldrich were master technicians. Aldrich actually ran afoul of Chaplin for too carefully composing his imagery – Néstor Almendros, the Oscar-winning cinematographer of Terrence Malick's *Days of Heaven* (1978), once told me that Chaplin was always perfect in his camera placement. In *Vera Cruz*, the location shooting in Mexico is quite spectacular and marked Aldrich as visually astute, an aptitude that would serve him well in masterpieces such as *Flight of the Phoenix* (1965), *The Dirty Dozen* (1967), and *Ulzana's Raid* (1972). Although Aldrich often found Lancaster unmanageable, there was mutual respect between them, and the experience on *Vera Cruz* prepared the director for subsequent problematic stars. Playwright and movie star Sam Shepard (*Days of Heaven*, 1978; *The Right Stuff*, 1983) attributed his own acting success to practicing Lancaster's sneer from *Vera Cruz* in front of a mirror as a teenager.

As Lancaster biographer Kate Buford points out, critics dismissed the film as a "violent, sordid mess." It was, however, defended by Sergio Leone and Louis Malle, who cast Brigitte Bardot and Jeanne Moreau in *Viva Maria!* (1965), a film modeled on it. By the mid-1950s, so-called "anti-Westerns" were beginning to come out, but classical directors still dominated the genre. John Ford had yet to make his great summations (*The Searchers*, 1956; *The Man Who Shot Liberty Valance*, 1962) or his semi-apologetic valedictories (*Sergeant Rutledge*, 1960; *Cheyenne Autumn*, 1964), and Howard Hawks had not yet made *Rio Bravo* (1959) and *El Dorado* (1966). Sergio Leone, Robert Altman, Sam Peckinpah, and Clint Eastwood were still on the horizon. In a sense, Aldrich's nihilism could be seen as both an omen and a catalyst. Buford quotes director and Ford scholar Lindsay Anderson (who I found to be a good friend, although his outlook was somewhat cynical) in characterizing Lancaster as "an odd mixture of violence and decency." I believe this description can also be applied to Aldrich. Over the next two years, the director made several films that can be seen as trailblazers for violence in movies — *Kiss Me Deadly* (1955), *The Big Knife* (1955), and *Attack!* (1956) — yet there was always something fundamentally humane in his work. Aldrich's decency was perhaps not in the same category as that of his first tutor, Jean Renoir, but as Ed Lowry has pointed out, it was motivated by a critical, ironic sense of American hypocrisy, and what Aldrich has called "his own personal anger at the compromises we all must make."

François Truffaut said of another Aldrich film, "with his lyricism, his modernity, his contempt for the slightest vulgarity, his desire to universalize and stylize the subjects he treats, Aldrich's effects remind us constantly of Jean Cocteau and Orson Welles." Together with Blake Edwards, Robert Altman, and Stanley Kubrick, Robert Aldrich was one of the most important American directors to show up on the scene in the 1950s.

Jean Renoir's French Cancan

1954

I feel a stronger emotional kinship with Jean Renoir than with any other filmmaker, except possibly Charlie Chaplin or John Ford. Unlike those two gentlemen, however, Renoir had a wider range, a greater ability to work brilliantly across diverse genres over a sustained period of time. If someone asked me to recommend two or three essential Chaplin or Ford films, I would be less hesitant than I would be with Renoir, whose thoughts and feelings seem universal, and whose films seem to encompass virtually all that is cinema — and life itself.

In the chapter of his autobiography that discusses *French Cancan*, Renoir writes: "I got nearer and nearer to the ideal method of directing, which consists in shooting a film as one writes a novel. The elements by which the author is surrounded inspire him. He absorbs them." (Elsewhere he wrote, "an artist only exists if he succeeds in inventing his own little world.") Among the worlds the director's soul and psyche were steeped in was the nineteenth-century Belle Époque, an era he lovingly commemorated in *Renoir, My Father*, his best-selling biography of Pierre-Auguste Renoir. The younger Renoir was also happy to be reunited on *French Cancan* with Jean Gabin, who had previously appeared in three of his 1930s masterpieces: *The Lower Depths* (1936), *Grand Illusion* (1937), and *The Human Beast* (1938). "I am grateful to the cinema for having given me this comradeship," Renoir writes. "I love Gabin and he loves me."

More than he had ever been before or would be after, Renoir was at the time immersed in theater. He had completed *The Golden Coach* with Anna Magnani two years earlier, which, like *French Cancan*, was a backstage drama. He had just staged *Julius Caesar* with Jean-Pierre Aumont and Paul Meurisse (who was then appearing in Henri-Georges Clouzot's *Diabolique*, 1955; and would soon star in Renoir's *Picnic on the Grass*, 1959) at the 15,000-seat arena in Arles. Renoir had also staged his own comedy, *Orvet*, in Paris with Meurisse and Leslie Caron. Finally, he was planning to direct a French stage version of his friend Clifford Odets's play *The Big Knife*, which was about to be released as a film by Robert Aldrich.

So, according to Jean Renoir's own theory, by the time he began working on *French Cancan* he had already absorbed all of this stimuli. After *The River* (1951) and *The Golden Coach* he was also deeply immersed in color, and it is hard to think of a film, even in the flamboyant Hollywood 1950s, that is quite as ravishing as *French Cancan*. One might suggestively call it garish, but that misses its aim to evoke the garishness of the era. At the same time, the sedately romantic yet bittersweet courtship scene between the prince and the laundress on the Montmartre hillside recalls the lovely intimacy of *A Day in the Country* (1936). The climactic scenes (during which we cannot be sure that the show will indeed go on) harken back to the hectic denouements of *Grand Illusion* (1937) and *The Rules of the Game* (1939). Throughout the

film, Jean Gabin − who critic Nick Pinkerton describes as having "conveyed an entire philosophy in his carriage, as essentially French as the Parisian shrug" − mostly lends a passive presence to the action. Ultimately, it is all Renoir, although from what we know of his devotion to family and friends, one doubts that he shared Danglard's (Gabin's) dictum that the only things that mattered to him were those he created.

French Cancan has so much energy, and its ending is so exhaustingly exuberant, that one cannot doubt that this film mattered a great deal to Renoir. "Broadly speaking," he wrote in his autobiography, French Cancan "is an act of homage to our calling, by which I mean show-business."

Carl Theodor Dreyer's
Ordet 1955

A writer once referred to the "ravishing austerity" of Carl Theodor Dreyer's Ordet (The Word). I can't think of another director who might merit such a seemingly paradoxical phrase, one that nevertheless sums up an almost-otherworldly artist working in a medium that can be so crassly commercial. Or, as Variety, the film industry's vulgar bible put it, "Here is that arty house paradox, a brilliant, almost monumental film, yet with a stigma of anti-[box office] on it because of its uncompromising, heavygoing style and a touchy religioso theme of faith and miracle involving a conflict between Catholic and Protestant views towards life and religion." As critic George Morris suggested, Dreyer's solution for all this was to transform Ordet into "a formal and aesthetic miracle itself."

Dreyer had not made a feature for nearly a decade prior. Kaj Munk's play Ordet, which revolves around the role of religion in the lives of two families in a rural hamlet in Denmark, had been previously adapted to film by Dreyer's Swedish contemporary Gustaf Molander. Molander had taught Greta Garbo at the Swedish National Theater, written screenplays for Mauritz Stiller and Victor Sjöström (who he cast in Ordet), and made a star of Ingrid Bergman with Intermezzo (1936). Molander's version of the Munk play was made in 1943, the same year as Dreyer's Day of Wrath. Molander's Ordet stuck much closer to the original text than Dreyer's did, but Dreyer criticized the earlier film for straying from Munk's spirit. A clergyman, Munk was murdered by the Nazis the

year after Molander's film came out, likely because of his involvement in the Danish resistance movement.

Dreyer was certainly shrewd enough to understand that his "touchy religioso theme of faith and miracle" was bucking a contemporary trend. He declared, "this is a theme that suits me − Faith's triumph in the skeptical twentieth century over Science and Rationalism." He even accepted the idea that "the best believers are the child and the deranged person, since their minds are not rational." Dreyer seemed to subscribe to John Wayne's dictum in John Ford's The Searchers (1956) that apology was "a form of weakness." Like the heroine in his next and last film, Gertrud (1964), Dreyer was not one to compromise. Hennig Bendtsen, the cinematographer on both Ordet and Gertrud, achieved for Dreyer a "realized mysticism" through hypnotic lighting within frames and progressively longer tracking shots. Although perhaps less ethereal, Bendtsen's later work included films for Gabriel Axel and Lars Von Trier. Von Trier inherited Dreyer's unrealized Medea script, which he filmed quite nicely in 1988, and also − via Bendtsen − the tuxedo Dreyer wore when he received the Golden Lion in Venice for Ordet.

As usual with Dreyer, I find myself scrupulously avoiding passing judgment on the substance of Ordet. Like with Renaissance religious paintings, I believe one can value them as works of artistic genius without being one of the faithful. Dreyer himself was worldly enough to appreciate the work of other filmmakers; he admired (surprisingly) Ernst Lubitsch and (unsurprisingly) Charlie Chaplin and Elia Kazan. The director felt that the human face is "a land which one can never tire of exploring." Chaplin's whole genius was built on the exploration of his own face, and by time Dreyer praised Kazan in 1959, the latter had extracted luminous performances from the likes of Vivien Leigh, Marlon Brando, and James Dean. Dreyer was an ardent advocate of auteurism: "The director must be the man who must and shall leave his hallmark on the artistic film."

The University of Kentucky Press has published a little book by Jan Wahl, Carl Theodor Dreyer and Ordet: My Summer with the Danish Filmmaker. As a young man, Wahl was invited by Dreyer to observe the director film on location. The Dreyer who emerges from Wahl's account is human, not the foreboding presence his films would suggest. (He used to send Christmas cards to my former colleague, Eileen Bowser, who organized the Museum's first Dreyer retrospective − I don't recall them having chipmunks or red-nosed reindeers depicted on them.) In Wahl's book, Dreyer explains Ordet this way:

"The end is to enrich one's fellow human beings by engrossing them in an emotional experience they would not otherwise encounter."

Orson Welles's Mr. Arkadin 1955

By the time *Mr. Arkadin* finally arrived in America in 1962, Orson Welles's career had undergone more highs and lows than a roller coaster across the Himalayas. *Citizen Kane* (1941) was a commercial failure, but everyone with eyes must have been aware that no director had ever made such a striking debut. (Even John Ford, the man Welles cited as his mentor, devoted two decades to apprenticeship before he began to realize his full potential.) Welles's second great masterpiece, *The Magnificent Ambersons* (1942), was yanked from him and slashed to ribbons by Robert Wise after Welles left early to make an omnibus film about Latin America. The latter project was never finished, but much of Welles's footage was feautred in the 1993 documentary in *It's All True*, thanks in part to the efforts of producer Myron Meisel. Welles made *The Stranger* largely to prove to Hollywood studios that he could be a loyal team player – not the maverick he was reputed to be – and was disappointed with the film. Even so, *The Stranger* remains one of the best pictures of 1946, a particularly fruitful year for Hollywood. Before finally moving to Europe, he made another underappreciated masterpiece, *The Lady from Shanghai* (1947), and a low-budget *Macbeth* (1948), the least accomplished of his forays into Shakespeare.

Throughout this period Welles supported himself by acting in films such as *Jane Eyre* (1943) and *The Third Man* (1949), and by working for other directors – sometimes quality filmmakers such as Sacha Guitry, but all too often for lesser Hollywood hacks. The money Welles earned enabled him to shoot sequences in Morocco and Venice for his brilliant *Othello*, which finally appeared in 1952. With the possible exception of his *Chimes at Midnight* (*Falstaff*) (1965), which was also made under budgetary pressure, *Othello* remains the greatest rendering of the Bard on celluloid. (This is not to minimalize the substantial contributions of Laurence Olivier, Peter Brook, Roman Polanski, Franco Zeffirelli, Julie Taymor, and others – I just have a hunch that Will and Welles shared a similar vision of the world.) In the quarter century after 1932, the year he turned seventeen, Welles managed to play almost every major Shakespearean character and several minor ones in stage productions.

Although *Arkadin* came out in Europe in 1955 as *Confidential Report*, it took seven years to reach our shores and was butchered and battered in the process. Meanwhile, Welles made a triumphant return to Hollywood in 1958 with *Touch of Evil* (thank you, Charlton Heston), plugged away at his never-really-completed *Don Quixote*, and admirably played various roles for John Huston, Richard Fleischer, and even, Abel Gance.

So, was *Mr. Arkadin* worth waiting for? Yes, I think so. It retains enough Wellesiana to fit nicely with his other work. Like *Citizen Kane*, it is about a very rich and powerful man's efforts to thwart an investigation into his past. (Welles would play a similar character, Mr. Clay, in his 1968 adaptation of Isak Dinesen's *The Immortal Story*, the last of his narrative films to be released.) Shot over an extended period of time in a half-dozen different European countries, *Arkadin* offers memorable performances by Michael Redgrave, Akim Tamiroff, Mischa Auer, and Katina Paxinou. It suffers from being sandwiched between masterpieces (*Othello* and *Touch of Evil*) but even so, *Arkadin* has elements that border on Shakespearean tragedy.

Ultimately, *Mr. Arkadin*, like every Welles tale except *The Maginificent Ambersons*, is about the actor and auteur himself. As Andrew Sarris wrote, each of the films "is designed around the massive presence of the artist as autobiographer... he is always at least partly himself, ironic, bombastic, pathetic, and, above all, presumptuous." Perhaps "presumptuous" is unfair, but consider the ordeals Welles underwent while making his films, conflicts reflected in the internal scuffles of Kane and his successors. As William Faulkner admonished, "An artist is a creature driven by demons. He doesn't know why they choose him and he's usually too busy to wonder why. He is completely amoral in that he will rob, borrow, beg, or steal from anybody and everybody to get the work done."

Satyajit Ray's Pather Panchali 1955

"Third World" cinema mostly did not exist for Western audiences until the 1950s. In 1951, with Akira Kurosawa's *Rashomon*, Japanese films began to appear on a very limited basis. Other depictions of Asia and Africa remained, as they had always been, the products of exploitative white imperialists, such as the Hungarian-turned-British Korda brothers (*Elephant Boy*, 1937; *The*

PATHER PANCHALI. DIRECTED BY SATYAJIT RAY. 1955. INDIA.
BLACK AND WHITE, 125 MINUTES.

Drum, 1938; *Four Feathers*, 1939), or of Hollywood studio exoticism (*Trader Horn*, 1931; Tarzan; "documentaries" by Martin and Osa Johnson, Clyde Beatty, and Frank Buck). Although Japan and India both had booming film industries, their films seemed only to be for home markets. The acceptance of subtitles in America spread with the popularity of postwar Italian and French films, and this led distributors to take a few more risks. Nontheatrical distribution companies like Brandon Films provided a market for these films after they completed their limited theatrical runs. With the advent of the less cumbersome 16mm format, film societies and classrooms could more easily manage the transport and projection of films, and in fact, MoMA joined the trend in the 1930s with its film circulation program.

MoMA played a significant role with regard to *Pather Panchali* — and ultimately with making Indian films slightly more available to American audiences. Satyajit Ray (1921-1992) was a Bengali filmmaker who had been born into an intellectual family in Calcutta. He worked mainly as a graphic designer but cofounded the Calcutta Film Society in 1947. This led him to seriously study independent film, and fortuitously, Jean Renoir showed up two years later in search of location advice for *The River* (1951), which critic André Bazin later said shared "the same spiritual tone" with *Pather Panchali*. Through Renoir, Ray was able to arrange a trip to London, where he saw a huge number of films that confirmed his determination to make movies. He was heavily influenced by Vittorio De Sica's *Bicycle Thief* (1948), prompting critic J. Hoberman to call *Pather Panchali* "the last masterpiece of Italian Neorealism."

After returning to India, Ray began filming an

adaptation of a 1928 Bengali novel, of which he had illustrated a children's edition a decade earlier. After three years, he was still struggling to find funds to complete the project, but finally, he obtained some money through government subsidies. Through Monroe Wheeler at MoMA, Ray arranged to hold the film's world premiere at the Museum in May 1955 in conjunction with an exhibition of "Textiles and Ornamental Arts of India." (A short film by Charles and Ray Eames was made about the exhibition, and it remains in the MoMA collection.) Wheeler also seems to have provided Ray with museum funds to help him purchase the print, and to access raw film stock that was not available in Calcutta.

Ray's reputation was established and his career as a director was launched after *Pather Panchali* was shown at the 1956 Cannes Film Festival, even though the film did not begin its record-breaking run at the Fifth Avenue Playhouse in New York until two years later. It had been an enormous critical and commercial success in India. In 1981, with Ray present and participating, MoMA embarked on a complete retrospective of his work as part of a massive "Film India" exhibition. Shortly before his death, Ray received a lifetime achievement Oscar.

Pather Panchali is the first in Ray's "Apu trilogy," and it was succeeded by *Aparajito* (1956) and *Apar Sansar* (1959). The trilogy follows the fortunes of a family of poor villagers as they move from the countryside to the city. Its vision is very much akin to Neorealism, but its black and white textures and lighting are of a higher, more painterly quality than most of the Italian films of the 1940s. Together they make up a peasant family saga full of astonishing realism and truth. A Bombay critic conscious of the revolution Ray was provoking wrote that: "It is banal to compare it with any other Indian picture... *Pather Panchali* is pure cinema. There is no trace of theater in it. It does away with plot, with grease and paint, with the slinky charmer and the sultry beauty, with the slapdash hero breaking into song on the slightest provocation or no provocation at all." It took fifteen more years for Indian cinema to follow Ray's example.

THE SEARCHERS. DIRECTED BY JOHN FORD. 1956. USA. 119 MINUTES.

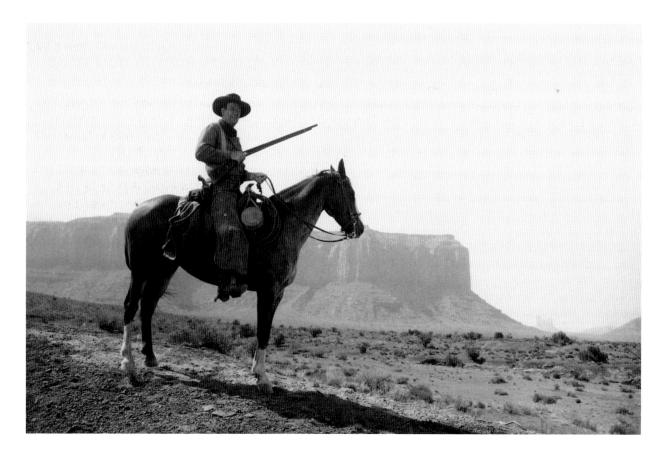

Elia Kazan's East of Eden 1955

From a technical standpoint, *East of Eden* marked a departure for Elia Kazan. It was the first time he used color and widescreen, and it was his most lavish Hollywood production. Kazan felt he had not fully used the resources of cinema until he made *Panic in the Streets* (1950) — even though three years earlier he had won multiple Oscars for *Gentleman's Agreement*. With *East of Eden*, a family drama about a troubled son loosely adapted from a John Steinbeck novel, Kazan was proud of his treatment of color, and the film now has the reputation of being one of the most innovative early pictures shot in CinemaScope. Occasionally this newly acquired technical virtuosity may seem obtrusive, but it also results in marvelously skillful moments, such as a scene in which Julie Harris follows James Dean into a garden after his father (Raymond Massey) rejects him. In this, Kazan seems to be anticipating Michelangelo Antonioni's *Blow-Up* (1966) by more than a decade.

As always with Kazan, the performances in *East of Eden* are superb. (He went on to cast Massey as the star of his 1958 Broadway production of Archibald MacLeish's *J.B.* alongside Christopher Plummer and Pat Hingle.) Yet good as they are, Harris, Lois Smith, and Jo Van Fleet, whom Kazan used again in his 1960 masterpiece *Wild River*, are ultimately little more than props to serve James Dean during his most haunting performance. Of the three major roles Dean was to play before he died (the others being *Rebel Without A Cause*, 1955; and *Giant*, 1956), this was his first and best. Here the Dean screen persona as we know it materializes, and surely, in the visualization of this magical, mystical, yet all-too-mortal creature there is more than a little legerdemain — Ala-Kazan!

Actually, as Kazan confided to me, he found Dean a very troubled young man. There seems to be ample evidence to support this. A doctor I once visited recounted the experience of finding the then-unknown actor asleep on a park bench across the street from his Fifth Avenue office. It's also hard to imagine another actor from the period who might have (allegedly) posed for a photo in which he was up a tree, naked, and fully erect. I'm sure other stories abound, but it is to Kazan's credit that he managed to mold something as moving and beautiful as Dean's performance from such volatile and potentially explosive material. As Kazan put it, "Jimmy Dean... had violence in him, he had hunger within him, and he was himself the boy that he played in the film." It should come as no surprise that the director who enabled the signature career achievements of such sexually ambivalent mega-talents as Marlon Brando (*A Streetcar Named Desire*, 1951; *On the Waterfront*, 1954) and Montgomery Clift (*Wild River*, 1960), and whose closest collaborator was Tennessee Williams, would have the sensitivity to find genius in Dean, even in an era when the actor's Oscar competition consisted of macho types such as Ernest Borgnine and James Cagney. In all fairness, Kazan gives plenty of credit to Julie Harris for drawing out Dean's performance, calling her "an angel on our set... she was goodness herself with Dean, kind and patient and everlastingly sympathetic."

Kazan's identification with the source material, and with Steinbeck's Cal Trask, also contributed to the film's success. In a sense, Kazan's early mentor was John Ford, his fellow director at Twentieth Century-Fox in the 1940s. Ford's adaptation of Steinbeck's *The Grapes of Wrath* (1940) was one of the greatest films ever made from a major novel. *East of Eden*, Kazan said, "is more personal to me; it is more my own story. One hates one's father; one rebels against him; finally one cares for him, one recovers oneself, one understands him, one forgives him... one has accepted him." In my judgment, this qualifies the film as an auteurist masterpiece.

John Ford's The Searchers 1956

The Searchers is one of John Ford's finest achievements, and is even considered by some to be the greatest film ever made. It has a richness, a resonance, and a virtuosity unrivaled by any other Western, except perhaps for a handful of Ford's own. More than any other character in an American film, John Wayne's Ethan Edwards has the eminence and stature of a folk hero. He is an ambulatory legend, both a myth and his own mythmaker. When others suggest he is limited, vulnerable, mortal, Wayne's disparaging response — "That'll be the day!" — convinces us that Edwards is limitless, invulnerable, and immortal. Ethan Edwards is the Great Man of the West. Like Walt Whitman's archetypal American ("Do I contradict myself? Very well then I contradict myself, I am large, I contain multitudes"), in *The Searchers*, John Wayne contains multitudes.

As with Ford's *Two Rode Together* (1961), *The Searchers* deals with white pioneers' most recurrent nightmare — abduction by Indians. When Edwards's niece is kidnapped by Comanches, his contradictory responses reflect the complexities of the problem. There is a racist

side to Wayne's character, and a fear that the child may be irrevocably tarnished by the "other." However, Edwards is also torn by his memory of Debbie as a little girl who might, under other circumstances, have been his own daughter. The difficulty of this issue, and the bloody and seemingly insoluble clash of civilizations, is explored in great detail by Glenn Frankel in *The Searchers: The Making of an American Legend*. Frankel examines not just the film, but also the novel by Alan Le May and the history on which it is based. As Scott Eyman, who has written definitive biographical studies of both Ford and Wayne, puts it in that book: "In so many ways, *The Searchers* is a summation for its director, for its star, and for the Western."

The film is a glorious collaboration between cinematographer Winton Hoch and Monument Valley, and between writer Frank Nugent and "Pappy" Ford. It is Ford's most symmetrical and consciously structured film – he even casts Mrs. Harry Carey as the mother of Harry Carey, Jr. More than four decades earlier, D. W. Griffith had made a short for Biograph, *Olaf – An Atom* (1913), which starred Harry Carey, Sr., who would later become Ford's collaborator on several dozen Cheyenne Harry Westerns. In *Olaf*, Carey plays a loner not unlike the saddle tramp Ethan Edwards. After Carey saves a man's life, the film climaxes with a scene of a family reunion shot outward through the open door of the family home. The reunited family enters, leaving Carey, who is responsible for their happiness, outside and alone. According to John Wayne, it was seeing Olive Carey standing in the doorway during the last shot of *The Searchers* that spontaneously inspired him to grab his elbow in the manner that was characteristic of her late husband. Then, the door closes on Ethan Edwards forever, and we are left with a dark screen... and a legend.

Robert Aldrich's Attack! 1956

Robert Aldrich absorbed a certain quantity of leftism through his early associations with Jean Renoir, Robert Rossen, Abraham Polonsky, Joseph Losey, Charlie Chaplin, and Jules Dassin, all of whom he served as an assistant. He also had experience with war films, having worked on William Wellman's *The Story of G. I. Joe* (1945), Lewis Milestone's *Arch of Triumph* (1948), and Fred Zinnemann's *Teresa* (1951). So, it was not altogether surprising that he wound up directing films like *Attack!*, *The Dirty Dozen* (1967), *Too Late the Hero* (1970), and *Twilight's Last Gleaming* (1977).

After a period of HUAC-induced exile from Hollywood, he returned and thrived unlike many of his left-wing associates, and eventually became president of the Directors Guild. Though Aldrich enjoyed a privileged upbringing as a relative of the Rockefellers, he was a dedicated union activist and his work contained a tendency towards rawness and grittiness. Women are conspicuously missing from much of his world, and when they show up – as Joan Crawford and Bette Davis do in *What Ever Happened to Baby Jane?* (1962), or Davis and Olivia De Havilland in *Hush... Hush, Sweet Charlotte* (1964), or the "ladies" in *The Killing of Sister George* (1968) – they are hardly finishing-school role models. What Aldrich lacks in grace, he makes up for in naked power, embodied in characters such as Mike Hammer in *Kiss Me Deadly* (1955) and Rod Steiger, who is full of chutzpah in *The Big Knife* (1955).

Writing about film carries with it an unstated assumption that I possess omniscience about all subjects that come before a camera. Obviously, that is not even remotely close to being true. For example, I have never been a tightrope walker, but it is my job in writing about Chaplin's performance in *The Circus* (1928) to describe his genius as a swarm of escaped monkeys climb all over him, bite his nose, and pull down his pants while he balances on a wire. I have never ridden a horse, but that doesn't humble me enough to prevent me from telling you why the Westerns of John Ford and Howard Hawks are better than those of anyone else. My entire military career consisted of a single day in a Rutgers ROTC uniform saluting all the wrong people before it was determined that a congenital hip problem made me unfit for service. The closest I ever came to a war zone was when I, with millions of my compatriots, was in proximity of the World Trade Center when it was destroyed. Still, I feel unconstrained in discussing the Civil War and *The Birth of a Nation* (1915), World War I and *The Big Parade* (1925), or my favorite World War II films (Ford and Hawks again), *They Were Expendable* (1945) and *Air Force* (1943). That's why it was so refreshing when my blog post on Sam Fuller's *The Steel Helmet* (1951) prompted a correspondence with William Gruendler.

In some ways, William and I share a similar background. He studied film at Northwestern and, like me, at Chicago's wonderful Clark Theater in the Loop (a shrine to cinema which brought the faithful a new double bill every day), and later in revival houses in Manhattan. He reads *The New Yorker* and loves the films of cinematographer Gregg Toland who worked on *The Grapes of Wrath*, *The Long Voyage Home* (both 1940), and

Citizen Kane (1941). However, William is also very different from me. He volunteered for the draft in 1970 and became a combat veteran in Vietnam. After an honorable discharge, he had nine children and became a born again Christian. In 1989, he joined the Tennessee National Guard and wound up seeing combat again in Operation Desert Storm. I tell you all this with William's approval and to demonstrate that he is obviously much more qualified than me to evaluate Robert Aldrich's *Attack!* So, here goes:

 The film "resonates... on a visceral level" for William, since "I have been in the shoes... of the hapless protagonist... portrayed to heart-wrenching perfection by (Jack) Palance... I would PAY to watch Jack Palance tie his shoes." He expresses his admiration for the Aldrich and Palance film *Ten Seconds to Hell* (1959) and Aldrich's *Too Late the Hero* (1970), "and didn't my buddies and I adore *The Dirty Dozen* while still in high school... sadism sanitized." William adds "that, for sheer stark power in moviemaking, the final scene in *Attack!* simply cannot be equaled: two men on gurneys destined to graves registration. In reality, the men's faces would be covered with a blanket, poncho, or the like... maybe I would have covered the faces in a brief, medium shot, tracking out to Aldrich's... But as in nature, where his battles play out like scenes from a Joe Kubert comic under a clear sky on a naked hill, so with Aldrich's characters: he can spare us no accoutrements."

 I think Aldrich would be pleased by William's authentication of his vision, to which I am happy to defer with gratitude and respect.

Midcentury Portraits of New York City 1952–1956

New York street scenes have been captured on film since the very beginning of the medium in the 1890s. In 1908, D. W. Griffith, cameraman Billy Bitzer, and Griffith's stock company of actors wandered outside of the Biograph Studio on 14th Street, just east of Union Square, and shot films that documented the city. In the early months of doing this, the director went to the Bowery for *Deceived Slumming Party* and the Lower East Side for *Romance of a Jewess* (both 1908). By the time of his seminal gangster film, *The Musketeers of Pig Alley* (1912), Griffith, like most others in the industry, had begun moving his operation westward, towards the California sunshine.

To this day, the city remains a rich source of imagery for both narrative films and documentaries. In the 1920s, Robert Flaherty made *Twenty-Four Dollar Island* (1927), and Paul Strand and Charles Sheeler made *Manhatta* (1921). Jay Leyda's *A Bronx Morning* (1931) — which won the young man an internship with Sergei Eisenstein — and Willard Van Dyke and Ralph Steiner's *The City* (1939) bookended the 1930s, and who can forget the climax of *King Kong* in 1933? Fifteen years later, the nitty-gritty street shooting of Griffith's era was echoed by Jules Dassin's *Naked City*. Despite the efforts of Francis Thompson (*N.Y., N.Y.,* 1957) and Shirley Clarke (*Bridges-Go-Round,* 1958) to add a dash of color to the palette in the 1950s, the city remained resolutely black and white.

 The documentary *In the Street* (1952) featured candid street scenes of the Upper East Side of Manhattan and was made by still photographers Helen Levitt, Janice Loeb, and James Agee. The latter, of course, also wrote now-classic film reviews for *The Nation* and *Time* magazines, as well as three novels (including the Pulitzer Prize-winning *A Death in the Family*, later filmed as *All the Way Home*, 1963), five screenplays (including John Huston's *The African Queen*, 1951 and later Charles Laughton's *The Night of the Hunter*, 1955), and he collaborated with Walker Evans on *Let Us Now Praise Famous Men*. Levitt, Loeb, and Agee had previously contributed as cinematographers to Sidney Meyers's documentary *The Quiet One* (1948), and Levitt had gained a few more movie credits, which she mostly disowned. Like Agee, she was also associated with Evans, and she was part of the Museum of Modern Art's first photography exhibition in the late 1930s. Both women lived more than twice as long as Agee, who died in 1955. *In the Street*, like *A Bronx Morning*, brought a candor and a degree of cinematic verité to its material long before anyone thought of coining the term.

 Rudy Burckhardt (1914-1999) was also a still photographer, and was deeply immersed in cinema. Many of his films were collaborations with the poet Edwin Denby, and later the artist Joseph Cornell. Jonas Mekas said that *Under the Brooklyn Bridge* (1953) has "sequences... which belong with the best footage of New York by anybody." There is something exquisitely, nostalgically lyrical about seeing boys innocently swimming under Roebling's great structure only a short time before the Dodgers left and broke their (and my) heart.

 Lionel Rogosin (1924-2000) was a total New Yorker. He was born here and he established his filmmaking career with *On the Bowery* (1956), filmed on the skid row streets a few blocks from his Greenwich

Village home. The film was nominated for an Oscar, and it won the documentary prize in Venice. Rogosin's portrait of alcoholism and despair was stark, but arthouse audiences had already been exposed to Neorealism with Roberto Rossellini's *Rome Open City* (1945) and Vittorio De Sica's *The Bicycle Thief* (1948) and *Shoeshine* (1946). The director was paving the way for Shirley Clarke's *The Cool World* (1963), John Cassavetes's *Shadows* (1959), and Peter Goldman's *Echoes of Silence* (1967), which would all come a few years later. In subsequent films, Rogosin went on to direct his outrage at racism, colonialism, and war. I had the opportunity to meet him in 1968 at the Bleecker Street Cinema, which he had purchased in 1960 to show his and other quality films. I was looking for a career, and Rogosin, like the ever-stalwart Dan Talbot of New Yorker Films, was encouraging and supportive. Rogosin's films may not have always been subtle, but they left no doubt that he was on the right side of history.

Hollywood Animation 1944–1959

The Disney and Fleischer studios were the dominant forces in American animation in the 1920s and into the 1930s, when Warner Brothers entered the market. Although the Fleischers were located in New York and briefly in Miami, their distribution deal with Paramount Pictures effectively made them part of Hollywood. When their efforts to enter the feature-length film market failed, the Fleischer operation collapsed, leaving much of the field to Disney, which was by then producing features on a regular basis (*Snow White*, 1937; *Pinocchio*, and *Fantasia*, both 1940; *Dumbo*, 1941; *Bambi*, 1942) in addition to occasionally releasing shorts. Other major Hollywood studios had also joined the fray. In 1941, a strike at Disney led to defections and caused number of producers to start working independently.

The most notable contributions to animation, however, probably came from Warner Brothers. Bugs Bunny, Daffy Duck, Porky Pig, and Elmer Fudd had the star power to rival Disney's Mickey Mouse and Donald Duck and Fleischer's Betty Boop, Popeye, and (later) Superman. Unfortunately, calling out the individual Warner Brothers artists who worked on various cartoon characters is beyond my scope here. *Bugs Bunny Nips the Nips* displays a racism that was all too common among World War II filmmakers. Its director, Friz Freleng (1906-1995) — who had once been Disney's neighbor in Kansas City — spent thirty years at Warner Brothers before launching his

successful *Pink Panther* series in the 1960s.

The director most closely associated with Bugs was Charles M. "Chuck" Jones (1912-2002). As with Freleng, proximity to the famous wabbit and his cohorts seemed to promote longevity in the company. Jones was also at Warner for three decades, where he worked with all the "stars" (Bugs, Daffy, Porky, Elmer). He did take a brief sojourn to MGM in the mid-1960s to work on *Tom and Jerry*. Jones was adept at developing the strong "personalities" of his performers: He was personally responsible for the *Roadrunner* series and Wile E. Coyote.

Robert Clampett (1913-1984) actually preceded Jones at the studio and established himself as the Porky Pig guy in the 1930s. Before he moved to television and produced the *Beany and Cecil* series (1962-1969) he made *The Great Piggy Bank Robbery* (1946), one of his last films at Warner Brothers. Robert McKimson started out working as a teenager for Disney on his *Oswald the Rabbit* series. He also spent three decades at Warner Brothers, working mostly on Bugs and Daffy. Frederick Bean "Tex" Avery left Warner Brothers for MGM in 1942. *Little Rural Red Riding Hood* was a partial remake of his *Swing Shift Cinderella* (1945), but like the others, he underwent a Porky/Daffy/Bugs period. Historian Win Sharples considered Avery to be an inferior draftsman compared with his studiomates (he was blind in one eye), but valued him as a superior artist, saying that missing *Red Riding Hood* will be regretted "to your dying day."

William Hanna (1910-2001) and Joseph Barbera (1911-2006) began their collaboration in 1940 at MGM, where they produced animated sequences for Gene Kelly and Esther Williams films, and worked on the *Tom and Jerry* series. Much later, they dominated the fields of television and feature-length theatrical animation, creating *The Flintstones*, Yogi Bear, *The Jetsons*, Johnny Quest, and Scooby-Doo. Their later work seemed to suffer from a less-sophisticated style, probably due to inferior TV budgets and working conditions.

Ward Kimball (1914-2002) was someone special. He was one of scholar John Canemaker's designated "nine old men" at Disney. Though he was most closely associated with Jiminy Cricket — the heart, soul, and conscience of *Pinocchio* — he also worked on *Fantasia*, *Dumbo*, and many other features of the 1940s and 1950s. Towards the end of the latter decade, he contributed to *Eyes on Outer Space* (1959), a series of space films developed as part of Disney's expansion into television. The series, which Kimball called "the creative high point of my career," eventually led to the creation of futuristic amusement parks like Epcot.

Independent Animation 1947–1960

The departure of many animation artists from Disney as a result of labor troubles and the desire for freer expression led to a diffusion in the field of animation. Different talents and styles began appearing. At the same time, more highly independent and solitary individuals began working in animation and experimental filmmaking.

Douglass Crockwell (1904–1968), creator of the ultra-experimental four-minute short *The Long Bodies* (1947), spent his career somewhat isolated in upstate New York, where he worked as a Norman Rockwell-esque illustrator for magazines including *The Saturday Evening Post*. His avocation, however, was far removed from his magazine work. Crockwell experimented with abstract film imagery by using various substances (glass, clay, wax) to create shifting forms. His abstractions, as well as those of Len Lye (1901–1980) and Robert Breer (1926–2011), creator of *Jamestown Baloos* (1957), coincided with the burgeoning concerns of "modern art" and of museums like MoMA, which may have been resistant to narrative in film. (However, it must be said that Iris Barry, founder of what became MoMA's Department of Film, was from the first a great admirer of Walt Disney and nonabstract characters like Mickey Mouse.)

Lye, a transplanted New Zealander, had been a major force in Britain in the 1930s in the General Post Office Film Unit, a government-sponsored production unit run by John Grierson before he moved to Canada to head the National Film Board. Lye's revolutionary approach consisted of inscribing images on celluloid film – a practice that Stan Brakhage would perfect in his painterly films a half-century later. *Color Cry* (1953) was made during Lye's time in America, where he invented a technique he called "shadowcast film stencils." Eventually, Lye gave up film for painting and sculpture. Breer continued making films into the twenty-first century and also worked in other media. His highly experimental work made him one of America's foremost avant-garde animators.

At the center of the postwar independent animation movement was United Productions of America (UPA), a studio that grew out of the 1941 Disney strike. UPA's major innovation was to make animated figures more limited and less naturalistic. This was a significant move creatively, as it enabled audiences to feel liberated from the Disney universe and enjoy more adult fare, but in later years it became more of a cost-cutting concept than an aesthetic one.

The heart and soul of UPA was John Hubley (1914–1977), who had worked on all Disney features from *Snow White* (1937) to *Bambi* (1942). Hubley contributed to the Mr. Magoo film *Fuddy Duddy Buddy* (1951), but the signature Magoo director was Pete Burness, who made *When Magoo Flew* (1954). Robert Cannon, formerly one of the major Porky Pig guys at Warner Brothers, directed the first UPA film, *Brotherhood of Man* (1945), followed by the highly original *Gerald McBoing Boing* (1951). Ted Parmelee made an extraordinary adaptation of Poe's *The Tell-Tale Heart* as part of the brief 1953 craze for 3-D. The business end of the studio was handled by Stephen Bosustow, who, with Burness, eventually took over Magoo's TV career. The pair also produced programs like *Rocky and Bullwinkle*.

John Hubley eventually left to form his own studio, taking Cannon with him as a collaborator, and UPA never fully recovered. Hubley was later blacklisted for refusing to cooperate with the House Committee on Un-American Affairs witchhunt. With his wife Faith Elliott Hubley, he formed Storyboard Studios, which became the Hubley Studio. (In addition to collaborating with John until his death, Faith made a film of her own each year, and their daughter, Emily, is now a distinguished independent director of both animation and live-action films.) *The Tender Game* (1958) and *Moonbird* (1959) are representative of Hubley's early award-winning style, which built on UPA's productions. According to legend, John had been heavily influenced as early as 1939 by a stylized Soviet animated film from 1934 (Ivan Ivanov-Vano's *The Tale of the Czar Durandai*) that had been brought to the attention of Disney animators by Frank Lloyd Wright.

Ernest Pintoff was at UPA before he moved into live-action directing. *The Violinist* (1959) and *The Critic* (1963), his last cartoon, are hysterically funny and now considered classics. Stan Vanderbeek (1927–1984) was a major figure in the American Surrealist movement who collaborated with Buckminster Fuller, John Cage, Merce Cunningham, and Yvonne Rainer. *Science Friction* (1959) is an early example of his collage work. Lou Bunin (1904–1994), a puppeteer who apprenticed with Diego Rivera and Tina Modotti in Mexico, worked with 3-D puppet animation at the 1939 New York World's Fair and made a feature-length version of *Alice in Wonderland*, which was suppressed by Walt Disney to promote his own version. Like Hubley, a victim of right-wing political hysteria, Bunin devoted the rest of his career to television puppet animation, of which *Dingo Dog and the Kangaroo* (1960) is representative.

Animation Abroad 1946–1959

In 1941, Scottish-born Norman McLaren (1914-1987)
was asked by John Grierson to head the animation unit at
the National Film Board of Canada. McLaren accepted,
and went on to direct over seventy films, creating a body
of work that was incredibly diverse and experimental.
When his budget was limited by wartime scarcity,
he tried out different styles and anticipated acclaimed
directors like Stan Brakhage by decades. McLaren's films
ranged in tone from the humorous *Fiddle-de-dee* (1947)
and his Oscar-winning *Neighbors* (1952) to the somber
mysticism of *A Little Phantasy on a Nineteenth Century
Painting* (1946).

"John Halas" was a married couple consisting of
the Hungarian Janos Halasz (1912-1995) and Joy
Batchelor (1914-1991). The pair was remarkably prolific,
and in 1954 they made the feature-length *Animal Farm*
based on the novel by George Orwell. (They also
worked with McLaren during this period.) Their informa-
tional series, which dealt with various contemporary
social issues and featured a character named Charley,
grew out of their wartime propaganda work for the British
government.

Jiří Trnka (1912-1969) was a contemporary of
Karel Zeman in Czechoslovakia, and in terms of
cinematic puppetry, he was a predecessor of Jan
Švankmajer, who in turn influenced the Quay Brothers.
By his mid-thirties, Trnka had rejected conventional
animation and turned to puppetry. At that point, stop-
motion films had been established by Ladislas Starevitch
in Russia (and later in France), Willis O'Brien in
Hollywood (*The Lost World*, 1925; *King Kong*, 1933), and
George Pal in Hungary and Hollywood. One of Trnka's
earliest puppet films, *The Song of the Prairie* (1949), wittily
played off tradition and included a cowboy singing
"Home on the Range" and "Red River Valley." Many of
Trnka's works were adaptations of literary classics, and
spanned Boccaccio to Andersen, Chekhov to
Shakespeare. He even made a feature-length version of
Midsummer Night's Dream (1959).

Lotte Reiniger (1899-1981) had been a pioneer
animator in the silent period, and was responsible for the
first feature-length animated film, *The Adventures of
Prince Achmed*, in 1926. Her sixty-year career was
devoted to silhouette animation, first in Germany and
later in Britain. She worked closely with her husband, Carl
Koch, who collaborated with Jean Renoir on *Grand
Illusion* (1937), *The Rules of the Game* (1939), and many
other projects. In the Weimar period she worked with
Fritz Lang and G. W. Pabst, and contributed a sequence to
Renoir's *La Marseillaise* (1938). Much of her 1950s work,
including *Thumbelina* (1954), was for American television.

The Montenegron/Croatian Dušan Vukotić
(1927-1998) cofounded the Zagreb Film Studio in 1953. His
parodies tended towards surrealism flavored with
Yugoslav cynicism. *Concerto for Sub-Machine Gun* (1958)
came relatively early in his career, as part of a series
that satirized American genre films. *Ersatz*, made three
years later, received an Oscar, becoming the first non-
American animated work to do so.

The Polish-born Walerian Borowczyk (1923-2006)
worked mainly in France, and a number of his early
films were collaborations with Jan Lenica, another Polish
expatriate. Their films occasionally reflect a certain
bitterness and irony. "Between them," writes historian
Ralph Stephenson, "Lenica and Borowczyk have done
more than any other cartoonists, not only in Poland but
anywhere, to raise the status of the cartoon to a serious
art...." In his monograph on the Quay Brothers, my
colleague Ron Magliozzi notes that Borowczyk and Lenica's
shorts, "which the Quays describe as 'animation at its
most intense, mysterious and metaphoric,' most explicitly
point the way to the films they will make themselves."

John Frankenheimer's
The Young Stranger 1957

John Frankenheimer's *The Young Stranger* is very much
a product of the 1950s. That was when Americans
were united against the "Red Menace," and there was
good reason to worry about Joe McCarthy coming after
you. It was before the unpleasant realities of Vietnam and
before it became clear that African-Americans, women,
and gays were not thrilled to be permanently relegated
to the back of the bus. James Dean epitomized rebellious
young people onscreen, and James MacArthur seemed
like the nice boy next door. (Of course, if Dean happened
to live next door, you would want to make sure the
shades were down and the doors locked.)

We are now told the 1950s were the "Golden Age
of Television" (ignoring the current splendors of "reality
shows," over-orchestrated talent spectacles, and cable
channels for every taste or lack thereof) and
Frankenheimer spent much of the decade making live
television at CBS. Dramatic shows done live without

retakes were at the heart of television during this era. There were, indeed, occasional treasures like Lillian Gish's performance in Horton Foote's *The Trip to Bountiful* (which has been fortunately saved by MoMA), but not everything was golden. I remember a live adaptation of Mary Shelley's *Frankenstein* in which the creature, venturing from one part of the soundstage to another under the never-ceasing vigilance of the camera, made the wrong move. The director was forced to shout out, "Close the goddamn door!" Commercials were also done live, and I recall one instance in which an unfortunate young woman playing a nurse forgot the sales pitch for whatever snake-oil she was selling and fainted – my kingdom for a teleprompter!

Television was a mixed blessing for the movies. In my opinion, the audience's decision to stay at home was the death knell of the studio system, the moment when cinema went into irrevocable decline. TV did, however, infuse new talent into the medium. Robert Altman, Sidney Lumet, and John Frankenheimer (1930-2002) all started in cinema around the same time from television backgrounds, and the latter two had parallel careers. Both directed their first theatrical feature in 1957 – Lumet's was *Twelve Angry Men* and Frankenheimer's was *The Young Stranger*. Both wound up directing definitive film versions of Eugene O'Neill's masterpieces: Lumet adapted *Long Day's Journey into Night* in 1962, and Frankenheimer did *The Iceman Cometh* in 1973; and each reached a career peak in the 1960s. That was when Lumet made *The Fugitive Kind* (1960), *Fail Safe*, *The Pawnbroker* (both 1964), *The Hill* (1965), *The Group* (1966), and when Frankenheimer made *Birdman of Alcatraz*, *The Manchurian Candidate* (both 1962), *The Train* (1964), and *Seconds* (1966). As is apparent in these films, Frankenheimer and Lumet shared a social conscience – even though it's hard to describe Frankenheimer as anything other than "vaguely liberal" – and both had a certain visual dazzle that wasn't common for graduates of television.

The Young Stranger started out as a television play, and it is very Eisenhower-era. There are a surplus of Cadillacs and martinis, and characters are in the habit of walking into theaters during the middle of a movie. There were lots of films about delinquent rebels being made at that time, but it's not at all clear what star James MacArthur (son of Helen Hayes and playwright Charles MacArthur) was rebelling against. The boy gets in trouble with the police, but it seems that his affluent parents are largely responsible for his unhappiness. At that time, delinquency in the movies was mostly a middle-class phenomenon.

Andrew Sarris exiled Frankenheimer to his "strained seriousness" category, saying the director "betrays his television origins by pumping synthetic technique into penultimate scenes as if he had to grab the audience before the commercial break." Frankenheimer does pull off some visually stunning moments in films such as *The Manchurian Candidate*, *The Train*, and *Seconds*, but Sarris dismisses him as "a director of parts at the expense of the whole." Critic John Baxter, citing the same early films of which Sarris is critical, takes a contrary view, writing that Frankenheimer was "a perfect bridge between television and Hollywood drama, between the old and the new visual technologies...." However, Baxter indicates that the director's choices eventually became "erratic." Even though he was fortunate enough to work with Burt Lancaster in five films during the actor's prime, much of Frankenheimer's later career is sadly forgettable. He wound up back in television.

Phil Karlson's The Brothers Rico 1957

Phil Karlson (1908-1985) struggled against what Andrew Sarris called "cosmopolitan genre prejudices." Even for those of us who defiantly affirm that movies are an art form, it can be difficult to acclaim what Wikipedia labels "tough, gritty, realistic, and violent crime thrillers." And even for a museum that enshrines a nightmarish portrait of a man screaming and extolled the proletarian virtues of a garage sale, Karlson's frequently unpleasant and flatly naturalistic view of reality is not an easy sell. Other noir directors – Orson Welles, Fritz Lang, William Aldrich, Robert Siodmak, Jacques Tourneur, Don Siegel – all strived toward a visual universe that was their own. With some exceptions, this was not true of Karlson, who seemed more content to focus on storytelling over obtrusive artistry. Critic Jake Hinkson, however, gives him credit for possibly being "the toughest director in film noir" and winning the competition "to see who could inject the most head-thumping into an 80-minute potboiler."

The case for Karlson as a highbrow artist is not helped by his humble creative beginnings. High art does not readily come to mind when one thinks of Charlie Chan, the Shadow, the Bowery Boys or other denizens of "Poverty Row" studios. (We dare not even think of some of the schlock he worked on as an assistant or second

unit director, from Abbott and Costello on down.)
It took Karlson six years after his directorial debut in 1946
to make such creditable films as *Scandal Sheet* and
Kansas City Confidential (both 1952), the latter of which
was based on a novel by none other than Sam Fuller.
Karlson's stature grew in the mid-1950s with *99 River
Street* (1953) and *The Phenix City Story* (1955), and several
other films and lots of television work was sandwiched
between them. In short, Karlson was a modest and
effective filmmaker without being an in-your-face auteur.

Then he made *The Brothers Rico*, which Sarris
considers the director's best film. It transposes Georges
Simenon's characters to the American Mafia, and follows
Eddie Rico (Richard Conte) as he tries to protect his
real family from the Mob. The film is less bleak than
Georges Simenon's novella, in spite of the contributions
of the blacklisted renegade writer Dalton Trumbo. In
some ways the film suffers from a kind of visual flatness
that was endemic to the Eisenhower era, when many

directors found a haven in the lesser ambitions of
television and many Americans regarded the law, as
Dennis Schwartz puts it, "as above suspicion." Crime was
increasingly recognized as a bland white-collar
enterprise, and even Italian gangsters aspired to
bourgeois respectability — a development that culmi-
nated in Francis Ford Coppola's *Godfather* saga. One critic
saw Eddie Rico as "the quintessential Eisenhower-era
hero: the informant a hard-working business man, a
family man."

Long gone were the days when actors like
Edward G. Robinson in *Little Caesar* (1931) and Paul Muni
in *Scarface* (1932) could transcend their Eastern European
origins and play out-and-out "greaseballs." (For better
or worse, this early-1930s worldview is echoed in the TV
show *Boardwalk Empire* in its tireless search for blood,

WITNESS FOR THE PROSECUTION. DIRECTED BY BILLY WILDER. 1957.
USA. BLACK AND WHITE, 116 MINUTES.

guts, and graphic sex – all preferably in the same scene – and in its unwillingness to spare any ethnic groups, even WASPS, from disdain and stereotyping. I must say I found the show fun and engrossing, but maybe you have to have grown up in New Jersey, had distant relatives involved in bootlegging, and taken periodic visits to Atlantic City to fully appreciate it.) The flatness of *The Brothers Rico* is a little surprising though since cinematographer Burnett Guffey was renowned for his noir work for Nicholas Ray, Fritz Lang, and Max Ophüls; one of his last films was Arthur Penn's *Bonnie and Clyde* (1967). Martin Scorsese later opined that the style reflected "a sense of unease evident in the zeitgeist of the late '50s in America – things are not as they appear. Legit has a rotten underbelly, and hoods look legit."

Though he was able to claim large budgets later on in his career, Karlson seemed to lose some of his edge. For example, his *Hell to Eternity* (1960) oscillates between being a strikingly beautiful widescreen war film, a social drama with a plea for tolerance, a psychological study, and a tasteless sexual sequence that, in early 1960s convention, is all tease. These sections seem unduly isolated from each other. The film stars Jeffrey Hunter after he played John Wayne's "half-breed" cohort in John Ford's *The Searchers* (1956) and before he starred as Jesus in Nicholas Ray's *King of Kings* (1961). It also features the great Sessue Hayakawa during his post-*The Bridge on the River Kwai* victory lap. Though he had a late-career comeback with *Walking Tall* (1975), Karlson would soon stoop to directing Elvis Presley and Dean Martin in more frivolous projects. The director is almost a case study in the complications of remaining a genuine artist if one achieves a certain level of commercial success in the movie business.

Billy Wilder's Witness for the Prosecution 1957

Samuel (Billy) Wilder once expressed the wish to spend his hundredth birthday at the Museum of Modern Art, but he didn't quite make it. Born in Austria, Wilder (1906-2002) worked in Weimar Berlin and Paris before becoming a U.S. citizen in 1934. He spent his first eight years in Hollywood as a writer, and his most important films during that time were *Bluebeard's Eighth Wife* (1938) and *Ninotchka* (1939) for Ernst Lubitsch; *Midnight* (1939) for Mitchell Leisen; and *Ball of Fire* (1941) for Howard

Hawks. Wilder first made a serious directorial impression with a string of film noir classics: *Double Indemnity* (1944), *The Lost Weekend* (1945), *Sunset Boulevard* (1950), and *Ace in the Hole* (1951), with the middle two winning Oscars. Over time, the perversely comic side of his personality began to dominate, and it comes out in *Stalag 17* (1953), *The Seven Year Itch* (1955), *Some Like It Hot* (1959), and *The Apartment* (1960), which also won an Oscar. The latter two films initiated a collaboration with the great Jack Lemmon that lasted for seven films and more than two decades.

Witness for the Prosecution owes much to *The Paradine Case* (1947) and other Alfred Hitchcock films, including the 1950 Marlene Dietrich vehicle, *Stage Fright*. All three begin as murder mysteries and end as static courtroom dramas. Hitchcock clearly seemed more comfortable with this kind of material, but in *Witness*, Wilder still winds up doing justice to both Dietrich (in one of her best postwar performances) and Agatha Christie, who wrote the original play. *Witness* seems to echo *Stage Fright* in other ways, too. Dietrich engaged in similar relationships with her male counterparts in both films: first Richard Todd, and then Tyrone Power in his last completed role. Dietrich had worked sympathetically with Wilder a decade before on *A Foreign Affair* (1948), and Wilder enlivens what is otherwise a somewhat inactive film with a flashback that evokes that collaboration. That moment is set in a German cabaret where Marlene first meets Power and loses half her pants in the process. It's also a nod to Deitrich's own history: Nearly three decades earlier, she had risen to international stardom with her roles as a cabaret performer in Josef von Sternberg's monumental masterpieces, *The Blue Angel* and *Morocco* (both 1930).

Wilder relies heavily on splendid performances from Charles Laughton (who somewhat channels his role in *The Paradine Case* and also anticipates Otto Preminger's *Advise and Consent*, 1962), Elsa Lanchester, Hitchcock stalwart John Williams, and Power. Yet despite all this talent, Wilder doesn't manage to invigorate the style-stifling courtroom drama, or fully display the cynical humor that was to dominate his films immediately following *Witness*.

In my 1974 monograph on Dietrich, I suggested that by 1957, "it became increasingly difficult to determine where the role playing left off and the real Dietrich began." Interestingly, after reading my book, she didn't question this in her response, but rather focused her objections on "the untruths" in my listing the seventeen films she was in prior to *The Blue Angel*. (Though already

a movie star by the time *The Blue Angel* came out, she claimed to have been an inexperienced theater student in Berlin and denied making the films.) Years later, she turned down Wilder's offer to play the wacky Norma Desmond in *Sunset Boulevard*, leaving the opportunity open to Gloria Swanson. Dietrich might have brought off a similar part in Wilder's failed 1978 film *Fedora*, but approaching eighty, she returned the script to Wilder with an angry scrawl: "How could you possibly think!" I got off easier than Billy.

Wilder was somewhat redeemed in auteurist circles thanks to a late-career reassessment by Andrew Sarris. Although the director's films lacked visual sparkle and glitter, since he looked at the dark side of America, his style was deemed appropriately bleak. This bleakness, however, isn't all there is to him — Wilder's movies are full of moments of spectacular humor that capture his infectious love of moviemaking.

Ingmar Bergman's Wild Strawberries 1957

Once upon a time, our most distinguished newspaper published an article that has stuck in my craw for decades. Writing of Ingmar Bergman (1918–2007), one of their critics definitively declared: "His position in the great triumvirate of directors dominating the second half of this century (with Federico Fellini and Akira Kurosawa) is unquestioned." I consider this utter nonsense.

To begin with, the writer completely ignores the fact that many of the greatest directors in film history were still turning out masterpieces, a number of which equaled or surpassed anything the "triumvirate" ever managed. This includes Luis Buñuel, Charlie Chaplin, George Cukor, Carl Theodor Dreyer, John Ford, Howard Hawks, Alfred Hitchcock, Fritz Lang, Kenji Mizoguchi, Max Ophüls, Yasujirō Ozu, Jean Renoir, Roberto Rossellini, Luchino Visconti, and Orson Welles. Then there are an even greater number of more recent filmmakers whose rivalry made the dominance of the "triumvirate" way less than "unquestioned." A partial list would include Woody Allen, Robert Altman, Michelangelo Antonioni, Bernardo Bertolucci, Robert Bresson, Claude Chabrol, Miloš Forman, Jean-Luc Godard, Elia Kazan, Stanley Kubrick, Joseph Losey, Louis Malle, Roman Polanski, Alain Resnais, Satyajit Ray, Martin Scorsese, François Truffaut, Agnes Varda, and Andrzej

Wajda. Finally, the critic refuses to recognize other important figures who came along later in the century.

I don't blame Bergman for the overinflation of his reputation, although such critical adulation did inevitably lead to pretentiousness in his work. I believe Bergman's most successful and lasting works are his more accessible, less cerebral films: lyrical movies such as *Smiles of a Summer Night* (1955), *Wild Strawberries* (1957), *The Virgin Spring* (1960), *The Magic Flute* (1975), *Fanny and Alexander* (1982), and more naturalistic ones such as *Scenes From a Marriage* (1982). In the tortured films in which we are invited to agonize along with Ingmar — *Winter Light* (1963), *Shame, Hour of the Wolf* (both 1968), *The Rite* (1969) — Bergman's excessive introspection winds up alienating anyone who doesn't equate "going to the movies" with slumming. Bergman's most committed devotees tend to be elitists.

My inclination is to agree with critic Jonathan Rosenbaum's obituary for Bergman, "Scenes from an Overrated Career," which posits that the director was often too self-absorbed to remain relevant. In *Bergman Island* (2004), a documentary made on Faro Island, the director's isolated home of many years, filmmaker Marie Nyreröd examines Bergman's "cruelty and vanity" toward his many wives and other women. He was also constantly tormented by his own peculiar concerns about the existence of God. Ultimately, Bergman's obsessions undermined his ability to communicate with his audience and became like a tumor on his work — auteurism metastasized. In a sense, like Ford with *Young Mr. Lincoln* (1939), *How Green Was My Valley* (1941), and *The Man Who Shot Liberty Valance* (1962), Bergman was at his best when he was celebrating cinema's capacity to evoke poignant memories and feelings, and to make the past come alive. *Wild Strawberries* is an excellent example of this.

Victor Sjöström, the star of *Wild Strawberries*, returned to Sweden after a childhood in Brooklyn and became Europe's leading director for much of the silent period before then returning to America to work at MGM. There, as Victor Seastrom, he directed Lillian Gish in her two best films after leaving D. W. Griffith, *The Scarlet Letter* and *The Wind* (both 1926), and Greta Garbo in the mostly lost *The Divine Woman* (1928). Sjöström also acted in many of his own films (*A Man There Was*, 1917; *The Outlaw and His Wife*, 1918; *The Phantom Carriage*, 1921), and after returning to Sweden again in the 1930s, he resumed his acting career. In *Bergman Island*, Bergman relates how the older man took over Svensk Filmindustri and disciplined him on how to make films without

alienating his coworkers. He seemed to have taken the lesson to heart when it came to directing Sjöström. The older man acted in Bergman's 1950 film, *To Joy*, which Sjöström also wrote; and in *Wild Strawberries*, Bergman manages to extract a superb final performance from a reluctant and tired Sjöström. The actor, approaching death both in the film and in real life, had little stamina or patience, but like a true professional with forty years of filmmaking behind him, he gave Bergman a stunning portrait of old age. Bergman did the same with Bibi Andersson and Ingrid Thulin. If there were a triumvirate of great directors of actresses, I would certainly include him along with George Cukor and Elia Kazan.

Ingmar Bergman was a very complex man. One could write him off as a cold fish were it not for films such as *Wild Strawberries*, which brought out what Roger Manvell called the director's "compassionate understanding and need for warmth and humanity." Every year on his birthday (Bastille Day), Bergman screened Chaplin's melancholy masterpiece, *The Circus* (1928), for family and friends. So the guy wasn't all existential angst. Sometimes, he could enjoy an inept tightrope walker with his pants falling down being attacked by a barrel of monkeys. But then, was this funny, or a metaphor for life?

Michelangelo Antonioni's
Il Grido 1957

Il Grido catches Michelangelo Antonioni (1912–2007) transitioning from his Neorealist roots to a more personal despairing vision. Although his earlier directorial efforts were not notably Neorealist, he had written screenplays for Roberto Rossellini, Giuseppe De Santis, and Federico Fellini. By the late 1950s, pretty much all of the prominent figures to come out of Italian Neorealism had broken away from the constraints of the movement. Fellini was drifting toward solipsism; and Rossellini, getting over his infatuation with Ingrid Bergman, seemed to be moving in the opposite direction, sublimating his obsessions in favor of using cinema as an educational tool. Luchino Visconti was giving full credence to his operatic vision of the world, and Vittorio De Sica, who had never been fully committed to Neorealism, continued to oscillate between making serious films, commercial works, and acting. He gave brilliant

performances in Max Ophüls's *The Earrings of Madame de...* (1953) and Rossellini's *Generale Della Rovere* (1959), and his penultimate film appearance was in Paul Morrissey's *Andy Warhol's Dracula* (1975). The world Antonioni depicted in his next film, and first international success, *L'Avventura* (1960), was, indeed, something new. For a few years in the early 1960s, the director seemed a perfect match for a reality that included a rebuilt but seemingly aimless Europe, a nearly apocalyptic missile crisis, and a general, but perhaps long overdue, crumbling of the old order.

In a sense, *Il Grido* wasn't too far removed from Fellini's *La Strada* of the previous year. Both featured barren Italian landscapes, which were unrelieved in their ugliness. (The gifted Gianni de Venanzo became Antonioni's regular cinematographer, and before his early death, he worked with Francesco Rosi and Fellini.) As Fellini had used Anthony Quinn and Richard Basehart in *La Strada*, Antonioni used Americans Steve Cochran and Betsy Blair. Most of the film features a despairing Cochran wandering through the Po Valley until he meets a tragic end. Cochran's career was a bit strange, but it may be noteworthy that he appeared with James Cagney in Raoul Walsh's masterpiece, *White Heat* (1949), which climaxes on a tower similar to the one at the end of *Il Grido*. While costar Alida Valli was Italian, she had become something of an international name through her roles in Alfred Hitchcock's *The Paradine Case* (1947) and Carol Reed's *The Third Man* (1949).

Although *Il Grido* might pass for picaresque as Cochran wanders in isolation and disillusionment, Antonioni's long takes and panning camera movement paradoxically seem to render him stationary and alone. Like Monica Vitti in *L'Avventura* and *The Red Desert* (1964), Cochran's Aldo almost seems to share the audience's desire for an end to his suffering through some sensible plot resolution. (Though Antonioni set *L'Avventura* on a bleak island, *Il Grido* and *The Red Desert* allowed the director to return to the region where he grew up.) One critic has drawn parallels between Antonioni's film and *Ossessione*, Visconti's 1942 version of James M. Cain's *The Postman Always Rings Twice*. Visconti's film, also shot in the Po Valley, is generally considered the beginning of Neorealism. In some sense, *Il Grido* echoes the past and anticipates the future. Despair was to become Antonioni's touchstone, and *Il Grido's* scene of lovemaking in a muddy field foreshadows the Death Valley lovemaking that the director would capture over a decade later in *Zabriskie Point* (1970).

Douglas Sirk's The Tarnished Angels 1958

I've always considered Douglas Sirk (1900–1987) a bit problematic. Born Hans Detlef Sierck to Danish parents, he lived and worked in Hitler's Germany longer than I would have felt comfortable. He directed his first film at UFA in Berlin in 1935, more than two years after the Nazis came to power. He did atone somewhat with his first American film, *Hitler's Madman* (1943) which was based on a script by a Yiddish playwright and which starred an over-the-top John Carradine as Reinhard Heydrich, the butcher of Czechoslovakia.

My reservations, however, don't end with politics. Andrew Sarris wrote: "Even in most dubious projects, Sirk never shrinks away from the ridiculous, but by a full-bodied formal development, his art transcends the ridiculous, as form comments on content." Sirk, in other words, meets the absurdity of soap opera head-on. This formulation also strikes me as true of Josef von Sternberg, but I think Sirk's films tend to be more talky and improbable. *The Tarnished Angels* revolves around a romantic triangle (or rather quadrangle) set in the fatalistic world of ex-WWI pilots. *The Tarnished Angels* isn't helped by the fact that it is adapted from William Faulkner's *Pylon*, a novel which I find almost unreadable and which a critic called "a seething melodrama about a family of daredevil pilots." Though the subject matter might seem preposterous, Faulkner at least had a long history with planes: he had been in the Royal Air Force in World War I, and claimed he had been involved in a crash landing a few days after the armistice. In 1933 he bought his own plane, and his brother, Dean, had been a barnstorming pilot. So Faulkner's rare departure from Yoknapatawpha County was understandable.

Michael Zeitlin, a Canadian historian, links the sensationalism of bloody plane crashes to "Faulkner's stunningly overdetermined figure for modernity: the phallic pylons, the revolving airplanes, the inevitable smashing of machines, the burning of the pilot's corpse, the crowd's rapt fascination, the front-page, bold face publicity." He then compares this to the rise of fascism. I do not mean to suggest that either Sirk or Faulkner were fascists, but their work was very much a product of their time, and this was a time that had peculiar effects on human relationships.

Perhaps I can make myself clearer by comparing *The Tarnished Angels* with the film Sirk made almost simultaneously, *Written on the Wind* (1956), a kind of companion piece. Both films star Robert Stack, Rock Hudson, and Dorothy Malone, who plays it more promiscuous in *Written on the Wind* and was rewarded with an Oscar for her performance. The film is set in the 1950s, when a Hollywoodized woman would express her (hyper) sexuality by driving a red convertible and doing provocative dances. The plot revolves around Robert Stack's recklessness, Malone's nymphomania, and Rock Hudson and Lauren Bacall trying to remain afloat in a highly charged sexual maelstrom. It was as "modern" as the disintegrating Production Code permitted a film to be in 1958 — the Four Aces sang over the credits — and it sealed Sirk's reputation as one of the first prominent directors in America to take on themes such as overt sexuality and miscegenation. Hollywood's newfound maturity, however, was not yet very mature, despite the Hitchcock films of the era and the release of John Ford's *The Searchers* in 1956. Otto Preminger had yet to repeatedly challenge the taboos surrounding sex.

Sirk's films are movie melodrama in which everything seems to hit the fan at once. In *Written on the Wind*, phallic pylons are replaced by gigantic Texas oil pumps that rhythmically erect and descend. Malone even gives a final "hand massage" to a model oil well when it becomes clear that she will never have Rock Hudson. The film tiptoes around the language of how to express Stack's possible infertility (his "weakness") and Hudson's possible violation of his marriage to Lauren Bacall, just as *The Tarnished Angels* strains to deal with the fact that nobody quite knows who sired Malone's young son. In *Written on the Wind*, Hudson is a mere reporter, not the potential culprit — that privilege goes to Jack Carson of all people, an actor known for playing "numbskull buffoons and backslapping pests."

In a sense, Sirk cannot be faulted for his reasonably accurate depictions of the American values of his era. It was a time when oil millionaires were unquestioned good guys; when someone declaring, "your daughter is a tramp" constituted grounds to kill (even though everyone knew she was); and when childbearing was a question of morality. From the perspective of more than a half-century later, America looked like a pretty sick society. If, as George Orwell says, "all art is propaganda," Sirk strikes me as too prone to accept the status quo and the falseness of his age's values. He was content to be a passive reporter like Rock Hudson in *The Tarnished Angels*, and to non-judgmentally gloss over reality with stylization. Having already watched the Nazis rise, Sirk once again proved himself to be a pretty

good observer. Whether he was also a significant artist is, I think, open to question.

Experimental French Documentaries 1947–1958

The postwar period produced several stunning short French films of a hybrid nature, works that are suspended somewhere between documentaries and experimental poetic exercises.

Jean Epstein (1897-1953) was born in Warsaw but emigrated to France as a youth, where he got a degree in medicine. (Appropriately, his first film, made after meeting the pioneering Auguste Lumière, was a documentary about Louis Pasteur.) Epstein was never a "commercial" director; his most famous film was probably his Edgar Allan Poe adaptation *The Fall of the House of Usher* (1928). He was also briefly a member of Films Albatros, Alexandre Kamenka's collective of Russian émigrés who worked in Paris during the 1920s. The words that come to my mind when viewing *Le Tempestaire* (1947), a short fable about a huge storm at sea off the coast of Brittany in which the supernatural comes into play, are "elemental" or "primal." In some ways, Epstein anticipates Captain Jacques-Yves Cousteau's abstract visions of the sea, *The Silent World* (1956), *World Without Sun* (1964), and echoes Slavko Vorkapich's *Moods of the Sea* (1941). The film does, indeed, teeter between fantasy and being an exquisite documentary of the sea.

There seems to be some dispute over proper accreditation of *Les desastres de la guerre* (1951) and *Le charmes de l'existence* (1949). Both Jean Grémillon (1901-1959) and Pierre Kast (1920-1984) are in the mix, but sources differ on who was responsible for what. In terms of film history, Grémillon was the much more important of the two. His career dated back to the early 1920s, and he was a prominent filmmaker during the Nazi occupation, perhaps second only to Marcel Carné. Like Carné, however, most of his postwar films were disappointments. Kast's career, on the other hand, never got off the ground. He made over two dozen films, but about half of these were shorts. Of his features, few if any are known outside France. However, these two men were able to collaborate on two extremely beautiful and unusual documentaries.

Grémillon and Kast's *Les desastres de la guerre* explores Francisco Goya's great and terrible series with

images that are perhaps too horrific for art. The film anticipates the work of American documentarian Ken Burns in that the pair's camera prowls over painted images the way Burns's later would with archival photographs. Other related films, such as Robert Flaherty's silent take on Pablo Picasso's *Guernica* or shorts by Carl Theodor Dreyer on Danish sculptor Bertel Thorvaldsen, pale in comparison to Goya as filtered through the filmmakers' camera, which slinks up and down and about. If they weren't so intrinsically beautiful, the nightmarish images could be mistaken for moments from the SyFy Channel or the TV show *The Walking Dead*. By contrast, *Les charmes de l'existence* offers the beaux-arts splendor of fin-de-siècle France, an age when sensuality and spectacle seemed to rule, and cinema was just beginning.

Georges Franju (1912-1987) only made eight theatrical features, but is still considered a major figure. Part of his importance was that until 1949 he was — horror of horrors — a film archivist, having cofounded the Cinémathèque Française with Henri Langlois. Over a ten-year period beginning in 1949, he made thirteen short films, and would go on to do television work in the 1970s. His 1958 short *La première nuit* is a lovely, eerie evocation of the Paris Metro that is very much in keeping with the New Wave aesthetic of shooting on the "streets" of Paris. (A quarter-century earlier, a very young Franju had made another short called *Le Metro*, now presumably lost.) Franju's composer, Georges Delerue, would later work with Alain Resnais, Louis Malle, and François Truffaut. But before he went roaming in the Parisian underground, Franju looked at the city's streets and slaughterhouses. *Blood of the Beasts* (1949) is perhaps the director's most famous film, and for those of us who are animal lovers, it is as much an evocation of hell as anything Goya ever did. Could Goya have even imagined men who sing while they slaughter?

Louis Malle's The Lovers 1958

Louis Malle (1932-1995) is generally included in the remarkable group of French New Wave directors who came along at the end of the 1950s. In some ways, however, his inclusion is a kind of an anomaly: His films tend to lack the emotional wallop of François Truffaut, or the stylistic iconoclasm of Jean-Luc Godard, or the Hitchcockian sardonicism of Claude Chabrol. Rather than joining the filmmakers and writers who were

reshaping film criticism at *Cahiers du Cinéma*, Malle apprenticed with the great documentarian and oceanographer Jacques-Yves Cousteau, and worked for Robert Bresson and Jacques Tati. Though Malle shared the *Cahiers* crowd's veneration for classical Hollywood cinema, he aspired to break away from the confines of France and make films in America. Ultimately, he married the actress Candice Bergen – daughter of ventriloquist Edgar Bergen, and flesh-and-blood sibling of the Oscar-winning wooden dummy, Charlie McCarthy, whose short films came out during Malle's diaper days. Malle eventually died in Beverly Hills, having never won an Oscar himself.

The radiant Jeanne Moreau had already made more than twenty films before she appeared in Malle's first film, *Elevator to the Gallows* (1958). That film, along with *The Lovers*, launched her ascent to international stardom. Before long she was working with all the New Wave directors, as well as Orson Welles, Joseph Losey, Luis Buñuel, and Michelangelo Antonioni. A censorship case brought in the U.S. against *The Lovers* for its precedent-shattering close-up of Moreau's face during orgasm gave rise to Justice Potter Stewart's famous dictum about knowing what pornography is "when I see it." Malle's film was exonerated, which opened the floodgates to greater freedom in the movies. In an ironic way, this may have been Malle's greatest gift to Hollywood.

While *Elevator to the Gallows*, aka *Frantic*, was shot mostly on the streets of Paris, *The Lovers* was more in keeping with Malle's background as a descendant of French nobility. The film depicts an upscale romance in French high society, a milieu with which Malle was presumably familiar, and moves back and forth between Paris and a mansion in Dijon. Similarly, his extraordinary *The Fire Within*, made five years later with Moreau, deals with the alcoholism of a rich young man. It was only in later years that Malle took up the problems and social issues of the have-nots.

Critic John Baxter has written of Malle, "Of the New Wave survivors, he was the most old-fashioned, the most erotic, and, arguably, the most widely successful." With regard to eroticism, Baxter stresses not only *The Lovers* but also the implied fellatio in *Viva Maria!* (1965), the incest in *Murmur of the Heart* (1971), the child prostitution in *Pretty Baby* (1978), and the sadomaso-chism in *Lacombe, Lucien* (1974). Godard prides himself on his sophistication, and Truffaut would argue that he never lost his childlike sense of wonder. Yet Malle brings a kind of maturity that Baxter sees as more sustainable than the sensibilities of his "flashier" competitors. Malle

seemed unwilling to risk the playfulness that was common among his contemporaries, perhaps fearing he would be accused of not approaching his subjects with sufficient seriousness.

Although Malle more than paid his dues to French history and culture with lovely mid-career works such as *Murmur of the Heart*, *Lacombe, Lucien* and later, *Au Revoir les Enfants* (1987), the director's efforts in America, where he spent most of his last two decades, produced decidedly mixed results. He seemed to have been somewhat uncomfortable with American locations and environments. I think the one great exception to this is *Atlantic City* (1980), his nostalgic look at a decaying New Jersey resort, which was then in the process of being renewed.

Susan Sarandon and 67-year-old Burt Lancaster are terrific in *Atlantic City*, and Lancaster sums up the aging process with his off-hand remark, "the Atlantic Ocean was really something in those days," a line presumably written by the playwright John Guare. I had the opportunity of meeting Malle and Guare briefly at MoMA years later. They were working on a biographical film about Marlene Dietrich that would have starred Uma Thurman. The film was, unfortunately, never made, but I can report that Malle was, indeed, highly professional and not at all "flashy."

Andrzej Wajda's Ashes and Diamonds 1958

Eastern Europe and its Cold War regimes contributed a great deal to film, and this is in part thanks to Andrzej Wajda. We are very much in Wajda's debt, not just for his own substantial body of work, but also for his protégées, including Roman Polanski and Agnieszka Holland.

Wajda's personal history was heroic. He fought the Nazis on behalf of the Polish government in exile, and repeatedly riled the Soviets during the Russian occupation. (His 2007 masterpiece, *Katyń*, about a Soviet massacre of Polish military officers and intelligentsia that had been blamed on the Nazis, was a story Poles long wanted told.) I know little about Polish cultural history, but I would venture to guess that Wajda is perhaps the most prominent Pole to stride the global artistic stage since the transplanted Englishman Joseph Conrad.

Ashes and Diamonds was Wajda's seventh film. By then, he had already achieved some international

Alain Resnais's masterful documentary *Night and Fog* (1955) and Gillo Pontecorvo's *Kapo* (1960). All of this history played into Wajda's style, which is starkly realistic and heavily dependent on symbolism.

For the lead in *Ashes and Diamonds*, Wajda chose Zbigniew Cybulski, who was known as the Polish James Dean for his performances and rebellious offscreen persona, and later for his tragically premature accidental death. Unlike Dean, he was able to make three dozen films during his life, and was posthumously chosen by *Film* magazine as "Best Polish Film Actor of All Time." In an interview, Wajda claimed that he and Cybulski had consciously patterned the actor's performance after Dean. An even clearer influence on *Ashes and Diamonds* was Laszlo Benedek's *The Wild One* (1953) starring the young Marlon Brando in a role that was as dominating and ruthless as Cybulski's. (Benedek, a Hungarian Jew who was brought to Hollywood by Louis B. Mayer, curiously came within one day of sharing Wajda's birthday). Wajda never came to Hollywood, but he still continues to make movies and administer his acclaimed film school in Krakow.

Stanley Kramer's The Defiant Ones 1958

I don't think Stanley Kramer (1913–2001) would get too indignant about being called more of a producer than a director. Although he directed twenty films and had a talent for getting really good and dependable actors to accept roles in them, it's hard to make a case for him having a truly artistic bent. Rather, Kramer's contributions seem to lie more in being a conscience for America during a time of considerable anxiety and turmoil. Many great directors (F. W. Murnau, Josef von Sternberg, Max Ophüls, Carl Theodor Dreyer, and Buster Keaton, to name a few) had little interest in politics, and even less in saving the world. Others, such as Charlie Chaplin, John Ford, Alfred Hitchcock, and Fritz Lang, did deal with contemporary issues, but personality and style tended to prevail over politics. Kramer, however, took strong stands against the Holocaust, racial prejudice, bigotry, and nuclear war, and his artistry was almost incidental. In the process, he managed to have a successful career.

The Defiant Ones, only his third film as a director, was made a full decade after he became a producer. The film, set in the South, is about two prisoners of

THE DEFIANT ONES. DIRECTED BY STANLEY KRAMER. 1958. USA. BLACK AND WHITE, 96 MINUTES.

recognition with *A Generation* in 1955 (featuring a young Polanski) and *Kanal* (1957). Because of Poland's tragic history in the twentieth century, Wajda's films could not escape the burden of politics. *Ashes and Diamonds* is about Polish resistance to the Nazis towards the end of World War II, and it focuses on the extraordinary complexities that had developed within Polish society as the result of centuries of outside domination. There was little room in totalitarian Poland for screwball comedies or frothy musicals. To Wajda's credit and to Poland's, there was a major effort after the war to confront the legacy of Polish anti-Semitism and the country's role in the Holocaust. One of the most extraordinary examples of this is Wanda Jakubowska's film on concentration camps, *The Last Stop* (1948), which came out long before

different races (Tony Curtis and Sidney Poitier), who are shackled together when they escape from jail. The film's statement of racial equality was fairly shocking for Hollywood at the height of the Civil Rights movement, and it must have entailed some degree of chutzpah and courage on Kramer's part. *The Defiant Ones* represents a significant milestone in Hollywood's painfully slow efforts to transcend the legacy of D. W. Griffith's *The Birth of a Nation* (1915). Before that, Sidney Poitier and his great buddy Harry Belafonte had opened up new opportunities for African American actors in films like *Blackboard Jungle* (1955), *Edge of the City*, and *Something of Value* (both 1957) – opportunities that had been denied to great performers like Bill Robinson and Paul Robeson. (Interestingly, Poitier made his uncredited film debut in 1947, the year Jackie Robinson was Rookie of the Year for the Dodgers.) *A Raisin the Sun* (1961), *In the Heat of the Night* (1967), *Guess Who's Coming to Dinner* (1967), and dozens more films lay ahead for Poitier, and one wishes he had won his Oscar for something other than the precious *Lilies of the Field* (1963). Poitier's success also helped open the door for future auteurs like Melvin Van Peebles, Spike Lee, and Charles Burnett.

A word of praise, too, for Tony Curtis – then making his transition from prettyboy to serious actor – who no doubt took a risk by accepting the role that Marlon Brando had turned down. As Poitier said later, *The Defiant Ones* "disturbed a lot of people… and informed them." Curtis was nominated for an Oscar, and the role clearly did not have a negative effect on his career. My impression of Curtis is that he was never one to toot his own horn. When he graciously volunteered to come to New York for our Alexander Mackendrick retrospective, Tony was less interested in serious subjects than in telling stories, like the one about how the costumer on *Some Like It Hot* (1959) had pinched both his backside and Marilyn Monroe's and pronounced Curtis's superior.

HIROSHIMA, MON AMOUR. DIRECTED BY ALAIN RESNAIS. 1959. FRANCE. BLACK AND WHITE, 90 MINUTES.

Stanley Kramer was aware that he had probably defined himself too rigidly as a proponent of "the message film." As he said, "I would like to express myself a little more simply and, if you will, artistically." Still, all the Oscars he won for *The Defiant Ones* are hard to argue with, and *It's a Mad, Mad, Mad, Mad World* (1963) proved that Kramer was no Mack Sennett. When it came to ending the world, though, as Kramer demonstrated in his nuclear apocalypse in *On the Beach* (1959), nobody did it better.

Karel Zeman's The Fabulous World of Jules Verne 1958

To quote Seth MacFarlane, creator of television cartoon shows *Family Guy*, *American Dad*, and *The Cleveland Show*, "There's a prejudice against the medium of animation." He was referring to a historic tendency to write off the field as insignificant or lacking in seriousness. It is, indeed, hard to compare the fantasy-world nuttiness of animation with the classical gravitas of directors such as Jean Renoir or Max Ophüls. Nonetheless, animation cannot and should not be ignored. Feature-length animation was once a great rarity, but in the computer era, what it might lack in quality it makes up for in diversity.

The Czech Karel Zeman (1910–1989) is hard to categorize. Zeman had experience as a graphic designer, and some of his imagery seems to anticipate the Quay brothers, particularly in his use of live action, miniatures, and puppetry. Since he worked entirely in Czechoslovakia, he shared the Eastern European roots that so influenced the Quays, and also shares their bent toward eccentricity. Zeman was a contemporary of another great puppeteer, Jiří Trnka, and both men were named National Artist of Czechoslovakia.

Dozens of films were adapted from the works of Jules Verne beginning with Georges Méliès's *A Trip to the Moon* (1902). *The Fabulous World of Jules Verne* (1957) came on the heels of a Verne and science-fiction revival fueled by Mike Todd's *Around the World in Eighty Days* (1956) and the launch of Sputnik, which set off the real live race to the moon. Verne, of course, seemed to have a gift for seeing into the future. *Facing the Flag* was one of his more obscure novels, but in it he seemed to have anticipated the era of nuclear weapons.

Zeman's film combined live action, animated drawings, and lithographs, all packaged under the description of "mystimation," a meaningless term coined by Joseph E. Levine. The overall look of the film was intended to replicate the illustrations in the original edition of the 1896 novel, and it is also an homage to Méliès. Like Méliès, Zeman uses two-dimensional backdrop sets, and although the plot aspires to science (it includes a search for heavy water and pure matter), there is an undeniably poetic fairy-tale dimension to it (camels on roller skates, underwater bicycles, and so on). In a sense, the scientific focus is on the field's evil underbelly, particularly with Hiroshima in hindsight. The influences of Fritz Lang's *Metropolis* (1927) are evident, as are those of less familiar films such as Stuart Paton's *20,000 Leagues Under the Sea* (1916), which featured the services of an expensive giant octopus and the pioneering underwater cinematography of George M. Williamson and his brother J. Ernest. Zeman's film, however, was a bubbling over of unprecedented imagination.

Zeman followed up in a similar style with an adaptation of *Baron Munchausen* (1962), Gottfried Burger's fantasy collection that provided fodder for a number of films, including a Nazi-era color spectacle that Goebbels produced to mark the twenty-fifth anniversary of the UFA studio, and in 1989, Terry Gilliam's *Adventures of Baron Munchausen*. Zeman also made a number of other Verne adaptations and a series of films on Sinbad the sailor. In making those, he put himself in direct competition with Ray Harryhausen, the inventor of the stop-motion technique Dynamation, whose innovations had a direct effect on George Lucas.

Alain Resnais's Night and Fog 1955 and Hiroshima, Mon Amour 1959

If one includes the 8mm films Alain Resnais made as an adolescent, he had one of the longest careers of any director in film history, working for roughly eighty years. (The Potuguese director Manoel de Oliveira, however, still outlasted him.) For the decade or so beginning with *Night and Fog*, Resnais was front and center on the cinematic stage. Though generally considered to be part of the French New Wave, he did not share the *Cahiers du Cinéma* lineage of Claude Chabrol, François Truffaut, Jean-Luc Godard, and Éric Rohmer. His instincts were more literary — he collaborated with Marguerite Duras, Alain Robbe-Grillet, and Jorge Semprún — and he was

less inclined to be influenced by Hollywood movies than by surrealists like André Breton. In the two dozen shorts he made in the 1940s and 1950s, his subject matter was heavily influenced by then-contemporary French cultural and artistic movements. He made films on Vincent Van Gogh, Max Ernst, Paul Gauguin, and Pablo Picasso, and forged working relationships with Agnès Varda and Chris Marker.

Night and Fog brought him to international attention in 1955 with its matter-of-fact approach to the horrors of the Holocaust. The script was written by novelist Jean Cayrol (who later wrote Resnais's 1963 film *Muriel*) and read by Michel Bouquet, the star of several Truffaut films and, more recently, *Renoir* (2012). The film remains one of the most powerful statements on the twentieth century. It raises a question that bears on all cinema and would become central to Resnais's work: the role of memory. By juxtaposing color images of Auschwitz in the present with black and white footage of the past, Resnais reminds us that there are some things we can't, and shouldn't, escape. The film reinforces Renoir's dictum that the only things that matter are the things we remember.

In *Hiroshima, Mon Amour*, and also in subsequent work, the director returned to this theme. The film, set in Hiroshima, revolves around an affair between a French woman and a Japanese man after the bombing of the city. There is much talk and little action in Marguerite Duras's script (this would become a pattern in Resnais's films), and this becomes a barrier to audience engagement. In this, his first effort at a narrative feature, Resnais deprives his audience of the conventional pleasures of a love story, and opts instead to elaborate on didactic intellectual points. Later, he leaned more towards the emotional side of storytelling.

Emmanuelle Riva made her credited film debut in *Hiroshima, Mon Amour*, beginning a distinguished career that culminated in her Oscar nomination for Michael Haneke's *Amour* (2013). Her costar Eiji Okada worked primarily in Japan, and went on to star in Hiroshi Teshigahara's 1964 film *Woman in the Dunes*. Unfortunately, Resnais's aims, methodology, and style do not facilitate an emotional bond between the couple. Andrew Sarris was an admirer of Resnais, but like me, he found the director's "abstract formalism" distancing and problematic. Sarris wrote that Resnais's films were "longer on reflection than on action." He believed that "the director is at his worst when any kind of action is required dramatically. His characters always talk about the past, but Resnais lacks Hollywood's gumption when it come

to reliving it." As a result, "there can be no development… of emotion."

Resnais began to address this problem in the 1960s, and in *The War is Over* (1966), he permitted Yves Montand, Ingrid Thulin, and Genevieve Bujold greater latitude in character development than in any of his previous films. His 2012 follow-up of sorts, *You Ain't Seen Nothin' Yet* is a film about actors, some playing themselves, who had appeared in *The War is Over* nearly a half-century earlier. In his *New York Times* review, A. O. Scott speaks of Resnais "exploring the slippery line between truth and illusion." In his early work, the director blazed a trail that did not always appeal to cinemagoers whose tastes were more attuned to feelings than ideas. Because of this, in the final analysis, Resnais was probably the most provocative and "new" of the New Wave filmmakers.

Joseph L. Mankiewicz's
Suddenly, Last Summer 1959

***Suddenly, Last Summer* is a case study in how many** cooks with different recipes can muck up a soup. The project appears to have started with Sam Spiegel, who was then on a roll: he had recently won Best Picture Oscars for both Elia Kazan's *On the Waterfront* (1954) and David Lean's *The Bridge on the River Kwai* (1957) and would soon be handed a third for Lean's *Lawrence of Arabia* (1962). Spiegel wanted to build *Suddenly, Last Summer* around Elizabeth Taylor, who was Hollywood's biggest box office draw at the time. Newly freed from her MGM contract, Taylor was also on a roll, having acted in *Giant* (1956), *Raintree County* (1957), and *Cat on a Hot Tin Roof* (1958). To boot, she was on the verge of winning two Oscars of her own own, and would soon be reunited with Joseph L. Mankiewicz by starring in *Cleopatra* (1963).

Enter Joe Mankiewicz, kid brother of Herman J. Mankiewicz, who had won an Oscar for the *Citizen Kane* screenplay along with Orson Welles. Joe's roots were humble: he contributed English intertitles to silent UFA films in Weimar Berlin, wrote *Million Dollar Legs* (1932) for W. C. Fields, and scripted *Diplomaniacs* (1933) for Bert Wheeler and Robert Woolsey. By 1959, however, his career had taken off. He had written major films for Fritz Lang, Frank Borzage, and George Cukor, and had won directing and writing Oscars for *A Letter to Three Wives* (1949) and *All About Eve* (1950).

SUDDENLY, LAST SUMMER. DIRECTED BY JOSEPH L. MANKIEWICZ. 1959. USA. BLACK AND WHITE, 114 MINUTES.

Then even more Hollywood royalty was added to the mix: Katharine Hepburn (Mankiewicz had written a comeback role for her in *The Philadelphia Story* nineteen years earlier), and Taylor's fraternal soulmate, Montgomery Clift, who was then uncertainly recovering from a traumatic automobile accident and dealing with what one critic has called his "conflict of unsettled sexuality." Whatever limited credibility Clift brings to the role of a brain surgeon in *Suddenly, Last Summer*, I think he's magnificent in his next film, Elia Kazan's brilliant *Wild River* (1960), in which he stars opposite the luminous Lee Remick.

Now we come to Tennessee Williams, who wrote the one-act play that was the genesis of the film. Williams had had conflicting experiences with Hollywood: an adaptation of *A Streetcar Named Desire* was censored but honored, and the films adapted from his later plays (like the plays themselves) were a mixed bag. After *Suddenly Last Summer*, Williams and Taylor were reunited for Joseph Losey's *Boom!* (1968), and I had occasion to be at the Kennedy Center for the 1980 opening of *Clothes for a Summer Hotel*, Williams's riff on the Fitzgeralds. I don't remember much about the play, which I suppose means it was forgettable, but I do remember it was attended by a still striking Taylor and her then-husband, Senator John Warner, and also by the playwright, who was laughing loudly — and without accompaniment — at his own jokes.

The one-act play on which *Suddenly, Last Summer* was based was certainly personal to Williams, as his sister Rose underwent the devastating operation that is at the center of the drama. Taylor, playing Hepburn's niece, is supposedly mad, and Clift is brought in to assess her condition. (Like America's other greatest playwright, Eugene O'Neill, Williams used personal family tragedy in

his work.) Whatever good qualities Mankiewicz had as a writer, his films tends toward loquacity – one is called *People Will Talk* (1951) – yet I was still caught off-guard to discover that Williams's original play had only a single act. To remedy this, Gore Vidal was brought in.

I consider Vidal to have been one of the most trenchant commentators on contemporary events, a sort of George Carlin/Bill Maher/Maureen Dowd all rolled into one. His plays, screenplays, and novels are fine, but he was also a man of exquisite judgment and a master of the nonfiction essay. Spiegel persuaded Williams to share credit for the screenplay by essentially telling the playwright that he could win an Oscar by letting Vidal do the heavy lifting. This didn't happen, and at least two-thirds of the film is attributable to Vidal.

The actual production was apparently unpleasant. Hepburn, another Clift protector, was appalled by Mankiewicz's brutal treatment of the fragile actor and immediately after shooting she allegedly spit in the director's face. Needless to say, they didn't work together again. In her progressive madness and increasingly bizarre behavior, Hepburn's character at times seems to be channeling Gloria Swanson from Billy Wilder's *Sunset Boulevard*, made nine years earlier.

Although we don't learn about it until a tacked-on monologue at the end of the film, Taylor's pyschological condition was caused by the death of her cousin, Hepburn's beloved son. He was gay, and was murdered and eaten on a beach in Spain by a bunch of angry (and apparently hungry) boys who wanted to have sex with his mother. So, the film had to find a way to deal with the triple-whammy of homosexuality, incest, and cannibalism without violating the production code. It cheats a bit, but in a split-screen monologue Taylor manages to tell the audience enough about the boy's proclivities without incurring the wrath of the guardians of morality. As the Legion of Decency concluded, "Since the film illustrates the horrors of such a lifestyle, it can be considered moral in theme even though it deals with sexual perversion." In the 1995 documentary *The Celluloid Closet*, Vito Russo put it this way: "Hollywood achieved the impossible; it put an invisible homosexual on the screen." Vidal, who had succeeded that year in keeping Charlton Heston ignorant of the gay subtext of *Ben Hur*, complained less about Williams taking credit for his screenplay than about Mankiewicz's ending, and "those overweight ushers from the Roxy Theater on Fire Island pretending to be small ravenous boys."

Claude Chabrol's The Cousins
1959

When Andrew Sarris published *Interviews with Film Directors* in 1967, he was already able to write that Claude Chabrol (1930–2010) had "quickly become one of the forgotten figures of the nouvelle vague." Of the most prominent New Wave directors, Chabrol had been the first to complete a feature film (*Le Beau Serge* in 1958), which was financed with an inheritance from his then-wife. The film was shot in Chabrol's home village of Sardent, where his grandfather and father had been pharmacists, and where Chabrol had established a film society as a young teen during World War II. *Le Beau Serge* inaugurated a pattern for Chabrol of setting his films in the French provinces, and, indeed, *The Cousins* is largely concerned with the perennial tension between Paris and the rest of the country. The plot hinges on a rivalry between two male cousins (one from the city and one from the provinces) for the same woman, and it contains what Robin Wood and Michael Walker describe as an "almost [Fritz] Lang-like sense of doom." For the film, Chabrol brought back the two leads from his first film, Gérard Blain and Jean-Claude Brialy, who both went on to successful careers as actors and directors. The former was briefly compared to James Dean and broke into the English-language market with the Howard Hawks film *Hatari!* in 1962.

Chabrol had been one of the critics at *Cahiers du Cinéma* with François Truffaut, Jean-Luc Godard, Jacques Rivette, and Éric Rohmer, and was mentored by André Bazin. With Rohmer, Chabrol had written a book on Alfred Hitchcock, and the themes and obsessions that preoccupied Hitchcock, including an ambivalent attitude toward Catholicism, recur throughout Chabrol's work. Chabrol quickly became known as the French counterpart of the "master of suspense," yet while he was enormously prolific, I would argue that none of his films approach the complexities of Hitchcock's *Notorious* (1946), *Strangers on a Train* (1951), *Rear Window* (1954), *Vertigo* (1958), or *Psycho* (1960). Still, between 1960 and 1978, Chabrol produced a number of films with his second wife, Stéphane Audran, that can be compared to D. W. Griffith's collaborative films with Lillian Gish or Josef von Sternberg's with Marlene Dietrich. The couple divorced in 1980, and although Chabrol was still directing at eighty, much of his later work was in television and was only intermittently successful.

The Cousins received generally bad press in America, which wasn't unusual for early New Wave films. Bosley Crowther of *The New York Times* said it had "the most dismal and defeatist solution for the problem it presents... of any picture we have ever seen." The "dean" of critics wrote that Chabrol's "attitude is ridden with a sense of defeat and ruin." This review and and other similar ones prompted Pauline Kael to make an extensive effort to extol the film's virtues, praising the way it

"glitters" and referring to its "glossy stylishness." Kael wrote: "*The Cousins*, more than any other film I can think of, deserves to be called *The Lost Generation*, with all the glamour and romance, the easy sophistication and quick desperation that the title suggests." Kael, probably more than she realized, was on to something.

The New Wave, of which *Les Cousins* was a major harbinger, was indeed something new, and cinema would never be the same again. The comfortable verities and virtues of Hollywood (so admired by the *Cahiers* crowd) and the classical, linear stodginess of European production (mostly reviled by the same group) were about to give. The American studio system, staggered by television, would soon reap the benefits of Robert Altman, Martin Scorsese, Arthur Penn, Woody Allen, Blake Edwards, and Stanley Kubrick. In Britain, realists like Karel Reisz, Lindsay Anderson, and Tony Richardson had arrived; in Italy and Sweden, bleak visionaries like Michelangelo Antonioni and Ingmar Bergman would soon dominate; and in France, the New Wave was submerging the past. But what about filmmakers like Jean Renoir and John Ford and Charlie Chaplin? In the parlance of the day, where had all the flowers gone?

THE 400 BLOWS. DIRECTED BY FRANÇOIS TRUFFAUT. 1959. FRANCE. BLACK AND WHITE, 99 MINUTES.

François Truffaut's The 400 Blows 1959

In the interest of full disclosure, let me make it clear that of all the directors who came along after Orson Welles made *Citizen Kane* in 1941, I feel the strongest spiritual kinship with François Truffaut (1932–1984). His body of work, which includes *The 400 Blows*, *Shoot the Piano Player* (1960), *Jules and Jim* (1962), *Fahrenheit 451* (1966), *Stolen Kisses* (1968), *The Wild Child* (1970), *Two English Girls* (1971), *Day For Night* (1973), *The Story of Adele H.* (1975), and *The Last Metro* (1980) seems to me unrivaled. That Truffaut chose as his mentors Jean Renoir and Alfred Hitchcock reinforces his importance. Steven Spielberg was on to something when, in 1977, he cast Truffaut as humanity's representative in its "close encounter" with Renoir-lookalike aliens. Insofar as humanity could be seen positively in the twentieth century, François Truffaut was its near-perfect representative. As another sometime Spielberg actor, Harrison Ford, said at a White House event, "the language of film is emotion." François Truffaut was one of our greatest linguists.

SHADOWS. DIRECTED BY JOHN CASSAVETES. 1959. USA.
BLACK AND WHITE, 82 MINUTES.

Truffaut's humanism was not always front and center. His career as a critic for *Cahiers du Cinéma* under the tutelage of editor and surrogate father André Bazin (to whom *The 400 Blows* is dedicated) was often marked by the "incendiary" writing, as Truffaut himself later described it, of an angry young man. Having survived a troubled childhood, incarceration in debtor's prison, and an army desertion — all of which was autobiographical grist for the mill of his first feature, which won the Best Director award at Cannes — Truffaut was rescued by Bazin from a bleak future in a manner similar to that of Jean Genet, who was saved and steered toward greatness by Jean Cocteau.

The 400 Blows grew out of Truffaut's frustration with the brief running time of his short film *Les Mistons* (1957). Although the former is undeniably autobiographical, it is clearly indebted to the director's movie addiction. Jean-Pierre Leaud plays Antoine Doinel, the director's charming teenage alter ego, who runs afoul of almost every imaginable societal convention, and would go on to appear in later Truffaut films. Any serious analysis of *The 400 Blows* will reveal an extended list of references, but some of the more obvious are to Josef von Sternberg's *The Blue Angel* (1930), Jean Vigo's *Zero for Conduct* (1933), and Albert Lamorisse's *The Red Balloon* (1956), all of which are masterpieces. Like most New Wave works of the period, *The 400 Blows* contains in-jokes, for example, a scene in which Antoine Doinel and his parents attend and later analyze Jacque Rivette's *Paris Belongs to Us* (1961). (Rivette was a close associate of Truffaut at *Cahiers*.) Truffaut provides us with lots of what he called "privileged moments." His lingering over kids

at a puppet show, for instance, is an early foreshadowing of his love for children, a theme that would dominate *Small Change* (1976) nearly two decades later. *The 400 Blows* is clearly subversive, but in a much less rude and nihilistic way than the works of Jean-Luc Godard, Truffaut's early friend and later rival. Truffaut's message is that when life becomes especially tough, it's a good idea to go to the movies.

One of Truffaut's singular achievements was his book-length interview with Hitchcock, a unique tribute for one major director to pay to another. One of the now well-known stories Hitchcock told Truffaut was of his father taking him to the police and arranging an incarceration – an event that resulted in something of a lifelong trauma for Hitchcock. A similar incident was depicted in *The 400 Blows*. As far as other paternal dynamics go, Truffaut was estranged from his actual family, but he did maintain an ongoing relationship with Jean Renoir for years, even after Renoir became a permanent resident of California.

Although I saw Truffaut from a distance a few times, I never had occasion to actually talk to him. (I did attempt a conversation once in the plaza at Lincoln Center with Jean-Pierre Leaud, but my French was even more limited than his English.) My only direct contact with the director was visiting his grave in Paris several years after his tragically early death.

John Cassavetes's Shadows

1959

John Cassavetes (1929–1989) was a unique figure in the history of the American cinema. He moved comfortably in Hollywood, but was also a seminal director in what we now think of as independent film. *Shadows* is a central work in this movement, and Cassavetes inspired a number of other filmmakers.

In the 1950s, Cassavetes acted in a number of parts on television, and had prominent roles in such films as Andrew L. Stone's *The Night Holds Terror* (1955), Don Siegel's *Crime in the Streets* (1956), (he reunited with Siegel for *The Killers* in 1964), and *Edge of the City* (1957), Martin Ritt's debut film, which costarred Sidney Poitier. The latter established Cassavetes as an important player in the Civil Rights struggle, and paved the way for certain brave and trailblazing elements in *Shadows*, such as the depiction of relationships across racial lines. Throughout his all-too-brief life, Cassavetes remained a stalwart supporter of integration, equality, and African-American culture, especially jazz.

In 1957, emulating the Italian Neorealists of the previous decade, he directed an extremely low budget version of *Shadows*, which was thought to be lost until its discovery a decade ago by biographer Ray Carney. (The version possessed by MoMA was shot in 1959 and won the Critics Award at the 1960 Venice Film Festival.) Jonas Mekas, who became a kind of doyen of the independent film movement and helped establish Cassavetes's reputation as a director, promoted the original version of the film in *The Village Voice* and considered the 1959 version "bastardized." Cassavetes, however, apparently preferred it. Shot in 16mm, *Shadows* uses authentic New York locations (including MoMA) as a backdrop to its melancholy interracial romance. Though Cassavetes shared New York roots with pioneering directors such as Raoul Walsh and George Cukor, his family had taken him to live in Greece for seven years as a child, making English, in effect, his second language.

Whereas *Shadows* is brief and compact, many of the director's later films are much longer and arguably overindulge his performers. In the immediate aftermath of the release and acclaim of *Shadows*, Cassavetes directed two sensitive but fairly conventional films with Hollywood stars: *Too Late Blues* (1961), with Bobby Darin and Stella Stevens, and *A Child Is Waiting* (1963), with Burt Lancaster and Judy Garland. It was only with his later films, I think, that Cassavetes – actor, graduate of the American Academy of Dramatic Art, Stanislavski disciple – emerged as a full-blown auteur. Although *Shadows* had been improvised, the ones following it are scripted. Cassavetes's stylistic contribution was that he allowed his actors to be creative in their performances and in the development of their characters within the constraints of a script. This increasingly led to longer and longer films, such as *A Woman Under the Influence* (1974), in which the director allowed intimates – such as his wife, Gena Rowlands, and his friends Ben Gazarra and Peter Falk – to do their thing. No one could argue with the fact that they had talent, but the films seemed to take on an obsessive quality that wasn't to everyone's liking.

Some have compared Cassavetes to Orson Welles, as he used his acting skills and personal charisma to earn money to support his directorial career. Cassavetes was never a conventional leading man, but he seemed at home in Robert Aldrich's *The Dirty Dozen* (1967), Brian De Palma's *The Fury* (1978), and most notably Roman Polanski's *Rosemary's Baby* (1968). Cassavetes, however, saw the cinema differently from Welles. Welles had been a

man of the theater, but he recognized that movies were primarily a visual medium. Welles's films are full of deeply felt, superb performances – a partial list would include those of Joseph Cotten, Agnes Moorehead, Akim Tamiroff, Marlene Dietrich, Jeanne Moreau, and Welles himself – but he never lost sight of the importance of the imagery, even when filming Shakespeare. Cassavetes, on the other hand, explicitly rejected this: "People who are making films today are too concerned with mechanics – technical things instead of feeling." You pays your money, and you takes your choice.

Robert Bresson's Pickpocket
1959

In an update of a Parisian problem left over from the eighteenth century, guards at the Louvre recently went on strike to protest pickpockets who targeted visitors and even the guards themselves. I don't know whether anyone in the French press thought to blame Robert Bresson (1907-1999) for this, but I suspect that only in America do movies get blamed for criminal acts and society gone astray. Bresson's *Pickpocket*, loosely inspired by Dostoyevsky's *Crime and Punishment* (Bresson's *Four Nights of a Dreamer*, 1971, is based on that author's *White Nights*), was the director's fifth feature, preceded in the same decade by his perhaps more accessible works, *Diary of a Country Priest* (1951) and *A Man Escaped* (1956). The style of *Pickpocket*, and most of Bresson's subsequent films, seem to me more austere, although there is perhaps some reluctant reversion to humanistic sentiment in *Au hasard Balthazar* (1966) (though this came via a donkey) and *Mouchette* (1967).

Bresson's approach to filmmaking was unique and not necessarily captivating for a mass audience. His films often include an intrusive voiceover or narration, and don't allow the free-flowing storytelling of conventional films. (Paul Schrader says Bresson "has an antipathy toward plot.") His editing is somewhat oblique, and he prefers non-actors, shying away from professional performers who might threaten to impose their vision of a character over his own. The audience is forced to pay careful attention to nuance, and many people don't go to the movies for such hard work. In *Pickpocket*, Bresson's austere approach keeps the audience at a distance, preventing any emotional identification with his protagonist, a young boy who becomes a professional thief.

As Paul Schrader points out in *Transcendental Style in Film*, "In a medium which has been primarily intuitive, individualized and humanistic, Bresson's work is anachronistically nonintuitive, impersonal, and iconographic." Both Schrader and historian P. Adams Sitney use the word "transcendent" in describing Bresson, and there is, indeed, something mystical in his work. One could argue that this quality is inherent in cinema, but aside from its crude beginnings in Méliès and the otherworldliness of F. W. Murnau and Carl Theodor Dreyer, few filmmakers fully explored and captured it. While Schrader seems to subscribe to the accepted view that Bresson's mysticism is emblematic of Catholicism, making an elaborately detailed case for his films being "religious art," Sitney points out that three of the director's later protagonists commit suicide, in violation of Catholic teachings. As one might gather – since my cinematic preferences run toward John Wayne on a cavalry horse rather than Calvary – I find Bresson not to be exactly my cup of tea. But, to paraphrase Walt Whitman, the movies contain multitudes, and Bresson deserves a significant place in film history.

California Dreaming
The American Avant-Garde
1942–1958

Although the U.S. never produced anything comparable to the French Surrealist films of the 1920s, over the years the occasional maverick production would appear on the periphery of Hollywood. A notable example was *The Life and Death of 9413, a Hollywood Extra* (1928), a collaboration between Robert Florey (a mostly journeyman director who assisted Charlie Chaplin in 1947 on *Monsieur Verdoux*), Gregg Toland (the great cinematographer of *The Grapes of Wrath*, 1940, and *Citizen Kane*, 1941), and Slavko Vorkapich. "Vorky" (1895-1976), as his disciples called him, emigrated from Yugoslavia after World War I and provided montage sequences for many of the classic films of George Cukor, Frank Borzage, and Frank Capra. He eventually became an educator and lecturer, heading the film department at USC and eventually moving back to Belgrade to teach. In his 1941 short *Moods of the Sea*, Vorkapich poetically unites the rhythms of Mendelssohn with the movies.

The real American avant-garde or underground filmmaking scene can be traced to Maya Deren (1917–

1961), who emigrated to New York from Kiev as a little girl. Deren is rightly considered the mother of the American avant-garde, and *Meshes of the Afternoon* (1943) is the first of the nine films she directed. After getting degrees from NYU and Smith, Deren moved to Los Angeles where she met her second husband, Alexander Hammid (Hackenschmied), with whom she collaborated on *Meshes*. (Hammid had founded the Czech avant-garde film movement and went on to prominence as a documentarian in the U.S.) Deren, a still photographer enamored with California, was obviously well versed in German Expressionist films and in directors such as Josef von Sternberg, and her films seem to embody Orson Welles's dictum that "cinema is a ribbon of dreams." Scholar P. Adams Sitney referred to *Meshes* as a "trance film," and the dreamlike work is rich in striking images and symbolism. Deren went on to explore her obsessions with dance (she had worked for dancer and choreographer Katherine Dunham) and voodoo (her last project was a documentary on Haiti). She did not linger long in California, becoming a relentless critic of Hollywood. A New York exhibition of her films in 1946 — the year she won the first Guggenheim ever awarded to a filmmaker — inspired Amos Vogel to form his film society, Cinema 16. In the words of my colleague, Sally Berger, "Deren was a pioneer… influencing future generations of filmmakers and artists and changing the direction of moving-image mediums in the twentieth and twenty-first centuries."

Sidney Peterson (1905–2000) died at ninety-four, but his working life in film lasted less than a decade. (In his youth, he had been a painter and sculptor in Paris.) *The Potted Psalm* (1946) was his first film, made in collaboration with fellow novice James Broughton (1913-1999). The pair was heavily influenced by the Surrealists, notably Luis Buñuel and Salvador Dali, and their work led to the beginning of the filmmaking program at the California School of Fine Arts, now the San Francisco Art Institute. This film and Peterson's output during the following decade became part of what was later known as the San Francisco Renaissance. There is a haunting quality to *The Potted Psalm*, and Maya Deren's influence shows up in part in the film's conscious critique of Hollywood. It also contains more than a hint of perversity and kinkiness, embodied in, among other things, an out-of-focus nude drag queen and a scene in a cemetery. Peterson worked briefly at MoMA in the mid-1950s as the Director of Educational Television Production. He also had a stint in Hollywood working for Walt Disney on an abortive *Fantasia II* project.

Broughton revelead his lighter side with his 1951 Chaplin parody, *Loony Tom*, in which an imitator of the Tramp frolics and flirts in California. He remained an active filmmaker for decades and led the West Coast contingent of independent filmmakers.

In 1947, at the age of twenty, Kenneth Anger came flaming out of the closet with *Fireworks*, an extraordinarily graphic film that anticipated Jean Genet's *Chant d'amour* by three years, and featured an in-your-face sexuality never seen before. Anger had actually been making films since he was fourteen, and by the time *Fireworks* came out he had made at least five, though some place that number as high as nine or ten. His "dream of a dream" led to a celebrated California Supreme Court case that contributed to the societal acceptance of film as an art form. Nothing so homoerotic had been shown before, and it's hard to gauge the impact of *Fireworks* — as well as his later films, which cross Surrealism and S&M — on the gay rights movement.

When he was very young, Anger became friends with Curtis Harrington (1926–2007). Harrington, who was mentored by Deren, also had a strange career: Like Anger, he made shorts at an early age, and in 1949 he made *On the Edge*, which follows the dreamlike California landscape pattern established by Deren and Peterson. Then, after his first feature, *Night Tide* (1961), he became a more-or-less mainstream feature director with *Games* (1967) and made several somewhat skillful and stylish films cut from the underbelly of the horror genre, featuring top-notch actors such as Simone Signoret, Shelley Winters, and Ralph Richardson. (Harrington was an avid admirer of 1940s horror film maven Val Lewton.) He ultimately became a prolific television director, contributing to series as varied as *Dynasty* and *The Twilight Zone* for two decades.

Bruce Conner (1933–2008) was a man of many media. By the time his first movie, *A MOVIE*, appeared in 1958, he was already recognized as an artist for his work in painting and assemblages. The fragmented film was made using found footage, and its concept paralleled his plastic works. Though the bulk of his fifty-year film career was built around collage, he was not thrilled to be deemed a progenitor of music videos and MTV. In his eyes, his films had a spiritual quality and offered cogent commentary on politics and the media.

Non-California Dreaming
The New York Avant-Garde
1948–1960

After Maya Deren and Alexander Hammid moved back east and Amos Vogel founded Cinema 16, New York started to rival California as the center of the independent film movement. Other artists were already at work in the city. Painter Mary Ellen Bute had been making short abstract films – some of which played in the newly built Radio City Music Hall – since the mid-1930s. Jim Davis was a painter whose mobiles appear in the experimental *Light Reflections* (1948). I'm not sure how much of a role MoMA played in the development of filmmakers of the period, but Iris Barry's propensity for collecting and showing experimental films could not have gone unnoticed. In 1957, Davis spoke at the Museum and propounded an optimistic and comprehensive theory of "prospects for the film": "New inventions which utilize light are revolutionizing the visual arts. Today many of the most powerful stimuli for visual experiences are provided by new tools that depend upon light as the principal means of producing forms of color. The camera – the film, television – electric signs and artificial illumination of all kinds now influence everyone, everywhere."

Ian Hugo (1898-1985), born Hugh Parker Guiler, was a successful banker and engraver who Hammid encouraged to take up film. *Bells of Atlantis* (1952), the second film Hugo made over a thirty-year period, was written by and stars Hugo's wife, the poet Anaïs Nin, and was based on Nin's novella *House of Incest.* The combination of Nin's poetic language and Hugo's lyrical imagery prompted the great French director Abel Gance to compare it to Rimbaud, calling it the first cinematic poem. Stan Brakhage also expressed appreciation for Hugo's influence on him. One point that needs to made, I think, is that although the members of what came to be known as "the New American Cinema" knew each other and interacted, each developed his or her own style and vision.

Shirley Clarke (1919-1997) studied dance with Martha Graham and Doris Humphrey, but after failing to succeed as a choreographer she turned to cinema. *Dance in the Sun* (1953) was her first film, and she returned to dance for *Bullfight* (1955) and *A Moment in Love* (1957), all of which showcase her revolutionary technique of "cinedance." Clarke was a tried-and-true New Yorker, and much of her work was devoted to the city she loved. (She lived at the Chelsea Hotel on 23rd Street, which has plaques on its façade commemorating her residency and those of other luminaries.) Both *Skyscraper* (1960) and *Bridges-Go-Round* (1958) are early shorts that pay homage to the city, and her later features like *The Cool World* (1963) and *Portrait of Jason* (1967) expose some of its seedier aspects. Together with Deren, the French director Agnes Varda, and later the animator Faith Hubley, Clarke became something of a feminist role model. She won an Oscar for her 1963 documentary *Robert Frost: A Lover's Quarrel with the World.*

In 1950, Jonas Mekas, a Lithuanian refugee still in his twenties, arrived in New York and became the hub of the avant-garde film scene. He began the magazine *Film Culture* in 1954 and in 1958 started writing his "Movie Journal" column for *The Village Voice.* (Mekas was instrumental in bringing Andrew Sarris to the *Voice* two years later.) After many years of gypsying around the city – including being busted under pornography laws for screening a Jack Smith/Jean Genet double bill – Mekas finally found a permanent venue at the Anthology Film Archives in 1970. He remains a tireless champion and godfather for independent filmmakers, none of whom owe him more, I think, than Stan Brakhage.

Brakhage (1933-2003) was probably the most prolific filmmaker since Allan Dwan. On the Internet Movie Database, Brakhage is listed as the director of 373 films. The eighth on that list, *The Wonder Ring* (1955), reflects in its vision and title Brakhage's sense of his art as magic. The film was financed by the artist Joseph Cornell in an effort to preserve the memory of New York's Third Avenue El train, which was about to be torn down. Cornell was disappointed in Brakhage's film, and responded with *Rednow Gnir* (1955), which spells "wonder ring" backward and shows the original film upside-down. Brakhage made *The Dead*, a meditation on Paris, five years and fourteen films later, and it reflects his growing sophistication and ambition. There was definitely a sense that Brakhage was a child of the independent movement (he briefly lived in Maya Deren's apartment), and over the course of a half-century career he documented his own unique vision of the world while opening up all kinds of possibilities for future filmmakers to explore. MoMA has over three hundred Brakhage titles in its collection, putting him behind only D. W. Griffith and Andy Warhol.

Francis Thompson (1908-2003) made only a few films, including the "distorted documentary" *N.Y., N.Y.* (1957). The film captures New York through surreal images shot with special kaleidoscopic lenses. It won a prize at Cannes, and Thompson's next film, *To Be Alive!*

(1964), involved three screens, anticipated IMAX and won an Oscar. Thompson's films are genuinely experimental, and they highlight how mainstream filmmakers in Hollywood would often incorporate the concepts of independent directors into their work.

Jean Genet's A Song of Love 1950 and Jean Cocteau's Testament of Orpheus 1960

Jean Genet's association with cinema was peripheral. One of the leading French writers of the second half of the twentieth century – he wrote the plays *The Balcony*, *The Blacks*, and *The Maid*, and the novels *Querelle*, *The Thief's Journal*, and *Our Lady of the Flowers* – he essentially made only one short film, *A Song of Love*. A number of his literary works were, however, adapted for films – most famously Rainer Werner Fassbinder's *Querelle* in 1982 – and just before his death he played himself in a short German documentary for television, *Am Anfang war der Dieb*, for which he was credited as codirector. For a novice, *A Song of Love* proves that Genet (1910-1986) was quite confident in his use of striking imagery, in this case, to tell a story of erotic interaction in a prison. In spite of its provocative subject matter, the film is rather chaste and innocent. Genet, of course, had a famously rough life: his prostitute mother gave him up to foster parents; he cross-dressed and also worked as a prostitute; he spent his early years in a series of psychiatric institutes and penal facilities; and he was kicked out of the Foreign Legion for homosexual acts. Eventually, he was rescued by Jean Cocteau, who saved Genet from a life sentence in prison and got his first novel published. While not everyone's cup of tea, Genet became one of France's leading writers of the period. By middle age, having achieved a fair degree of literary success, Genet's outlaw status was more of a conceit than a reality.

Jean Cocteau (1889-1963) is unique in that he had concurrent careers as a poet, playwright, novelist, actor, librettist, painter, sculptor, choreographer, and graphic artist. His main occupation, however, seemed to be playing Jean Cocteau. Although he only directed about a half-dozen films, he wrote or appeared in roughly thirty others. I once asked my late colleague, Gary Carey, who he thought was cinema's greatest artist, and he chose Cocteau. Gary was an aesthete in the best sense of the

word, but I can't accept Cocteau's apparent dilettantism when it came to movies. His *Beauty and the Beast* (1946) and *Orpheus* (1950) hold their own as anonymous works of cinema – despite certain signature Cocteau flourishes, like the liquid mirrors in *Orpheus* – but most of the director's output is too self-absorbed and introspective for me. Perhaps I contradict myself in congratulating other filmmakers for making personal works while criticizing Cocteau and Ingmar Bergman for films that strike me as overly self-indulgent. To this I would like make two points: First, movies originated as a popular medium aimed to appeal to a general audience, not a select cult of academics or religionists who happen to share the filmmaker's esoteric proclivities. Second, I believe the ultimate measure of a film's success is its ability to move the viewer emotionally, something that becomes increasingly unlikely the more obscure the filmmaker's concerns.

Cocteau had great imagination, intermittent playfulness, and a willingness to use cinematic camera tricks. *Testament of Orpheus* was intended as his final film, a journey through the classical world. In it, a dying poet essentially playing Cocteau looks back nostalgically on his life's work. The film teeters on the brink of self-indulgence and also gets bogged down in lengthy sequences in which Cocteau shows off his erudition. Cocteau referred to his first film, *The Blood of a Poet* (1930), as "a realistic documentary of unreal events," and critic Roy Armes has suggested that this description can be applied to his other major works. Armes also points out that before we can dismiss Cocteau's work as too precious or pretentious, it's important to remember that *Testament of Orpheus* was produced by François Truffaut at the same time he was directing fundamentally proletarian, nitty-gritty works such as *The 400 Blows* (1959) and *Shoot the Piano Player* (1960).

There is a certain irony in the fact that Cocteau was something of an inspiration to the French New Wave. Truffaut, Jean-Luc Godard, Claude Chabrol, and others were ostensibly rebelling against the stuffiness of the recent French cinema, the so-called "tradition of quality," represented by directors such as Marcel Carné, Jean Delannoy, Claude Autant-Lara, André Cayatte, and Yves Allegret. Somehow these filmmakers were regarded as too literary, especially when contrasted with Hollywood "primitives" such as Howard Hawks, Raoul Walsh, and Sam Fuller. Despite being apparently closer to the former, Cocteau, the ultimate Renaissance man of culture, escaped the wrath of the rebels.

1960-1969

Jules Dassin's Never on Sunday 1960

Jules Dassin (1911–2008) had a circuitous journey in life. He went from the Bronx to Broadway to Hollywood — where he apprenticed for Alfred Hitchcock — and later was exiled from both the U.S. and Greece for allegedly wanting to overthrow their governments. Dassin had already made seven films before he scored his first big success with *Brute Force*, a 1947 prison film starring Burt Lancaster. (It is noteworthy, I think, that Lancaster was so central to the early careers of such hard-bitten directors as Dassin, Robert Aldrich, and John Frankenheimer.) In 1948, on the heels of Henry Hathaway's anti-Nazi thriller *The House on 92nd Street* (1945), Dassin made *The Naked City* and reestablished the genre of the crime film shot on the mean streets of New York. For that film, he used over one hundred different shooting locations and paved the way for directors like Don Siegel (*Coogan's Bluff*, 1968), Martin Scorsese (*Mean Streets*, 1973), and Sidney Lumet (*Prince of the City*, 1981), as well as television series like *Cagney and Lacy*. As critic Rob Edelman has pointed out, Dassin's style at the time had roots in Italian Neorealism. Sadly, just as Dassin brought the Mediterranean to America, after the forties, he would be forced by politics to travel in the opposite direction.

Dassin's life would make a fascinating movie. While an aspiring actor in Yiddish theater, Dassin briefly belonged to the Communist Party, though he resigned in 1939 following the Nazi-Soviet pact. This came to light in 1948, during the House Committee on Un-American

Activities witchhunt. Like Joseph Losey and Robert Aldrich, Dassin was forced to go to Europe, but unlike them, he never fully regained his standing after things blew over. (I would suggest that ultimately Dassin lacked the talent of Losey and Aldrich.) His 1955 French film, *Rififi*, provided a kind of model for heist movies, just as *The Naked City* did for New York film noir. With Melina Mercouri, whom he married in 1966, he made *Never on Sunday* (1960), *Phaedra* (1962), the award-winning *Topkapi* (1964), and three lesser films. The fascist coup in Greece caused the couple to move to New York in 1967, but they eventually returned to Athens where Mercouri became a member of parliament and, in 1981, the country's first female Minister of Culture.

Essentially, *Never on Sunday* is an undemanding and charming fable about a contemporary Athenian prostitute, replete with an Oscar-winning title song. How authentic is this vision of modern Greece? Could a Jewish boy who grew up in the Bronx do justice to it? To answer these questions, one should look no further than the acclaimed *Zorba the Greek*, made four years later by the most famous Greek-born director, Michael Cacoyannis, and adapted from the classic Greek novel by Nicholas Kazantzakis. In it, Zorba was played by Anthony Quinn — who was Mexican-American. Moreover, even though one can't get more Greek than Mercouri, it's obvious that Dassin loves her and has come to love the laissez-faire attitude toward Greek culture that her character embodies. In the past, movies were often burdened with austere visions of the ancient world. The Rome of MGM, however, gave way to *Fellini Satyricon* (1969) and to television series like *I, Claudius* and *Rome*, which, while showing the otherness of the past, also links it to contemporary

decadence. While some still envision Greece as full of old guys in sheets wandering the Acropolis spouting wisdom until somebody pours hemlock in their ears, my guess is that for a reasonable price, these old guys might shut up and allow Mercouri's Ilya to do her work.

Jules Dassin's career took some odd turns for a political dissident who started out as one of the fathers of film noir. It would have been impossible to guess that he would end up making a sexy comedy with an Oscar-winning song. As Andrew Sarris put it, Dassin's career "verged on the grotesque."

Otto Preminger's Exodus 1960

Otto Preminger (1905–1986), like Josef von Sternberg, Erich von Stroheim, Billy Wilder, Fred Zinnemann, and Edgar G. Ulmer, was a Viennese Jew. (Fritz Lang was also Viennese, though his Jewish mother converted to Catholicism.) Preminger's Judaism was mostly secular, and *Exodus* is his only film in which his religion and ethnicity seem of much relevance. He had actually used his accent and demeanor to play a convincing Nazi in several films, including his own *Margin for Error* in 1943 and Billy Wilder's *Stalag 17* a decade later.

Israel was still a fledgling country when *Exodus* was made, and the events of 1948 were fresh in the minds of millions. As the Jewish state has aged, a patina of nostalgia and considerable anxiety have comingled. For Preminger, whose career was more or less balanced between studio-contained film noir and expansive spectacles, this film, a sprawling epic recounting various incidents in Israel's war for independence, seems to represent an unusual level of personal emotional investment. For what it's worth, the only two Preminger movies films that Andrew Sarris ranked significantly higher than *Exodus* in his annual listings are *Laura* (1944) and *Bunny Lake Is Missing* (1965), both of which Sarris designated as the best picture of their respective years. *Laura* and *Bunny Lake* both depict psychopaths who, as Cullen Gallagher suggests, "are preoccupied with illusory truths and shifting facades." Although Preminger, a director Jonathan Rosenbaum called "the least apparently autobiographical of all 'personal' Hollywood stylists," left Austria before *Anschluss* and found citizenship in the United States, he seemed to have had strong feelings for European Jewry and for the Israeli survivors depicted in *Exodus*, who had their own real life encounters with psychopaths.

Much has been written about Preminger's preference for group shots as a means of suggesting impartiality. Gallagher attributes this in part of the director's training as a lawyer, which he claims led to a "judicial sensibility" in which "no truth... is to be taken for granted." This is especially explicit in courtroom dramas like *Anatomy of a Murder* (1959) and depictions of the legislative process such as *Advise and Consent* (1962). *Exodus* contains its own entanglements with international law and politics. By hiring the blacklisted Dalton Trumbo to write his screenplay, Preminger was commenting on political developments and reactionary trends in America. Trumbo was working off the novel by Leon Uris, which in 1958 became the biggest bestseller since *Gone With the Wind*. The director had originally engaged Uris to adapt the screenplay, but fired him because, significantly, he felt the author was too partisan. Preminger said that Urbis's book "has a pox against all enemies of the Jews." He then added, "I don't believe that there are any real villains. If somebody is a villain, I try to find out why. I don't necessarily excuse him, but I try to understand him."

Ingmar Bergman's The Virgin Spring 1960

Ingmar Bergman had turned forty and already directed twenty films (including international hits such as *Smiles of a Summer Night*, 1955; *The Seventh Seal* and *Wild Strawberries*, both 1957) when he made his Oscar-winning *The Virgin Spring*, a film set in the Middle Ages about a father's response to his daughter's rape and murder. Although Bergman (1918–2007) was by then an established director, there is for me a sense of break-through in *The Virgin Spring*. Bergman had worked with the great cinematographer Sven Nykvist before on the excellent *Sawdust and Tinsel* (1953), but with *The Virgin Spring* they began a collaboration that would last for a quarter-century and have few rivals in film history.

As Robin Wood points out in his book-length study of Bergman, one of the great virtues of *The Virgin Spring* is the credible recreation of medieval life, which is largely devoid of the mysticism and magic that dominates so much of Bergman's work. The film makes him more accessible, and much of the credit for this must go to Nykvist's ability to capture the textures of the natural world. For once, it feels as if Bergman is not manipulating his characters into presenting larger metaphysical

truths or channeling the director's obsession about his personal relationship with God. I don't pretend to be an authority on religion, but it seems that over time Bergman despaired of faith in a way the great Danish director Carl Theodor Dreyer did not — even though Dreyer made religious films such as *Passion of Joan of Arc* (1928) and *Ordet* (1955). Ultimately, Bergman seemed to retreat to a realistic, autobiographical, non-cosmic milieu with works such as *Scenes from a Marriage* (1973) and *Fanny and Alexander* (1982).

Actors Max von Sydow and Gunnel Lindblom illustrate another important aspect of Bergman's career. Historically, great directors such as D. W. Griffith, Charlie Chaplin, and Jean Renoir had relied on their personal stock companies of actors. Von Sydow and Lindblom were there for Bergman well before *The Virgin Spring*, most notably in *The Seventh Seal* and *Wild Strawberries*, and they remained with him for decades. In *Virgin Spring*, von Sydow plays the father of the murdered girl, and Lindblom her servant. The former, of course, parlayed his Bergman connection into a highly successful international career that earned him two Oscar nominations and roles as varied as Jesus, the exorcist in *The Exorcist* (1973), and Ming the Merciless.

Bergman's reputation in America has undergone a degree of revision recently. At the time of *The Virgin Spring*, he was considered, as Daniel Humphrey puts it in his book *Queer Bergman*, "arguably *the* paradigmatic figure in the history of mid-twentieth-century art cinema." In big cities and college towns, it was impossible to ignore the pervasiveness of his influence: Everyone had an opinion on Bergman. Back then, it would have been impossible to predict a time in which young people wouldn't recognize his name, or in which a screening of *Wild Strawberries* or *The Virgin Spring* would be met with surprise. I must confess to certain ambivalent respect for Bergman's work. His serious films are perhaps too serious; his comedies perhaps too unfunny; I feel strangely more comfortable with his operatic adaptation of *The Magic Flute* (1975) or the soap opera-ish *Scenes from a Marriage*; and, frankly, this may result more from my failings than Ingmar's.

Gavin Lambert's Another Sky
1960

It may seem a little peculiar to include Gavin Lambert (1924-2005) in this series, but he was an important figure

in film history and scholarship, and his sole directorial effort, *Another Sky*, is an interesting example of an independent film made with passion and dedication outside the mainstream. Lambert had befriended Lindsay Anderson and Karel Reisz at Oxford, and as a critic, he was part of their circle at *Sequence* magazine.

Another Sky was shot in the mid-1950s, and to the extent it was released at all it only came out in 1960. It was filmed in Morocco, and I must confess to a certain fondness for that country, based on a 2001 visit where I delivered a paper on Josef von Sternberg's *Morocco* (1930), which is close to being my favorite film. Although I never got to Marrakesh or the Atlas Mountains, Lambert seems to have captured the flavor of a slowly changing country nearly half a century before my visit. The plot of *Another Sky* revolves around a young British woman who visits Morocco in search of romance and adventure. She finds it in the person of a young native musician, and, like Marlene Dietrich following Gary Cooper in Sternberg's *Morocco*, she begins a somewhat mad journey into the desert. It's evident that Lambert had seen Sternberg's film, which was shot in Hollywood. Lambert was also influenced by gay expatriate author Paul Bowles (with whom he later became friendly), whose novel *The Sheltering Sky* was filmed on location in 1999 by Bernardo Bertolucci. Making *Another Sky*, Lambert was blessed to be able to shoot inexpensively in the streets, mountain villages, and in the desert, which he did with an unfailing and highly professional sense of composition. The film was photographed by Walter Lassally, who went on to a distinguished international career working for Michael Cacoyannis, Tony Richardson, Pier Paolo Pasolini, and James Ivory, among many others.

Although Lambert's shy English heroine is a long way from Marlene Dietrich's nightclub diva in *Morocco*, Lambert borrows Sternberg's ultra-romantic ending, having the girl pursue her man (a young, indigenous musician, not a bit like Gary Cooper's Legionnaire) into the desert with passionate abandon. In his extremely useful book-length interview with George Cukor, Lambert tries to draw the director into discussing the parallels between his approach and Sternberg's, whose work with Dietrich was somewhat comparable to Cukor's own with Greta Garbo and Katharine Hepburn.

Shortly after *Another Sky*, Lambert moved to Hollywood and wrote biographies of Norma Shearer, Alla Nazimova, and Natalie Wood, in addition to a memoir about Lindsay Anderson. He wrote seven novels, including *Inside Daisy Clover*, which Robert Mulligan filmed, casting Wood in the starring role. Lambert is

remembered mostly for his screenplays, especially *Bitter Victory* (1957), *Sons and Lovers* (1960), and *The Roman Spring of Mrs. Stone* (1961). *Bitter Victory* was directed by Nicholas Ray, who may also have been Lambert's lover. In Vito Russo's *The Celluloid Closet*, Lambert recounted his difficulties in portraying a gay character in the film adaptation of *Inside Daisy Clover* (1965). He lamented, "The important thing to remember about 'gay influence' in movies is that it was obviously never direct. It was all subliminal." I think we may also lament that he never directed films after *Another Sky*.

Jacques Rivette's Paris Belongs to Us 1961

Jacques Rivette strikes me as one of the most uneven and least prolific of the major figures to come out of the French New Wave. Both he and Éric Rohmer started earlier than the rest of the *Cahiers du Cinéma* crowd, making several shorts beginning in the late 1940s. *Paris Belongs to Us*, a look at bohemian Parisian life in the late 1950s through a group of actors, was Rivette's first feature. Like some of his later films, it can be accused of being too long, one of a number of reasons Rivette is often viewed as an acquired taste: *Celine and Julie Go Boating* (1974) was well over three hours, *L'Amour Fou* (1969) was over four, and *Out 1: Spectre* was cut to a similar length from its original thirteen hours for its release in 1971. Rivette's second feature and most commercial project, *The Nun* (1966), an adaptation of Diderot's novel with Anna Karina, ran a mere 135 minutes.

Rivette replaced André Bazin as the editor of *Cahiers* for a few years following Bazin's death (Rohmer had been the immediate successor, but he left for political differences) and it is probably fair to say that Rivette's films remained mostly loyal to Bazin's original radical vision of what movies should be. (Robert Bresson said Bazin "had a curious way of taking off from what was false to arrive ultimately at what was true.") This was something of a departure from Rivette's early admiration for Alfred Hitchcock, Otto Preminger, Robert Aldrich, and Fritz Lang, whose *Metropolis* (1927) was the source of a sequence Rivette used in *Paris Belongs to Us*. François Truffaut, who mostly shed his radicalism for commercial respectability — albeit with more than a touch of genius — wrote to his and Rivette's mentor Jean Renoir in 1960: "All of us at *Cahiers*... are so shocked by the gap between

our ideas as cinephiles and our discoveries as film-makers that we don't dare write anything any more."

Like Claude Chabrol, Rivette came from a family of provincial pharmacists, and like many of his New Wave colleagues, he moved to Paris and became a protégée of Henri Langois at the Cinémathèque Française. He worked for Renoir on *French Cancan* (1954), and twelve years later made a lengthy television documentary about the master. *Paris Belongs to Us* was originally intended as a script for Roberto Rossellini, and it took Rivette four years to direct it himself and get it released. He finished it with help from Chabrol and Truffaut, who in 1959 won the Best Director award at Cannes for *The 400 Blows*. Upon viewing the film, one will certainly appreciate some of the complexities in getting it made — and of the director's mind.

In spite of intermittent raves from prominent critics, Rivette's films did not have much international success outside of occasional breakthroughs on the festival circuit. This tended to blight his ability to finance his films: Rivette was only able to make five features in the 1980s, seven in the 1990s, and four in the last fifteen years.

In a sense, Rivette's cinematic choices some-times seem perverse. *Paris Belongs to Us*, for example, is about an unsuccessful attempt to stage Shakespeare's *Pericles* without financial backing. The play was hardly the Bard's biggest box-office draw, and this presaged Rivette's future struggles to realize his own projects, however visionary and unique they might be. Yet Rivette did have his supporters. Comparing *Paris Belongs to Us* to the first works of Chabrol, Truffaut, and Godard, distinguished critic Jonathan Rosenbaum calls the film "intellectually and philosophically mature, and one of [Rivette's] most beautiful."

Jean-Luc Godard's Breathless 1960

To give Jean-Luc Godard's *Breathless* its proper place in film history would require a great deal more space than is available here, and indeed, volumes have already been written on the subject. Roy Armes put it succinctly: "All the rules of conventional filmmaking are scorned." Over more than the intervening half-century, Godard has become, if not our greatest living director, then certainly our most written about. Richard Roud, a Godard admirer, wrote "For many, he is the most important film-maker of his generation; for others, he is, if not the worst, then the

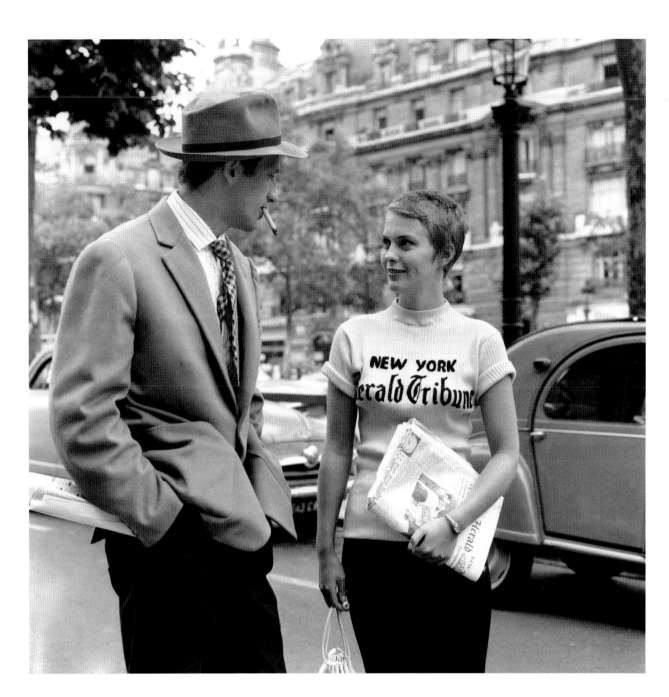

most unbearable… he is admired and detested for the very same reasons."

 A rich kid from Geneva, Godard made several shorts in Paris in the 1950s. He became part of the *Cahiers du Cinéma* crowd of contrarian critics, and like his colleagues, Godard was heavily influenced by Hollywood genre films. (*Breathless* is dedicated to Monogram Pictures, producers of such classics as *Port of Missing Girls*, 1938; *Black Market Babies*, 1945; *The Ghost Creeps*, 1940; and *Bomba, the Jungle Boy*; 1949.) In *Breathless*,

BREATHLESS. DIRECTED BY JEAN-LUC GODARD. 1960. FRANCE. BLACK AND WHITE, 90 MINUTES.

Jean-Paul Belmondo plays Michel, an amoral French gangster living in Paris with Jean Seberg (Patricia), a young American. When Michel and Patricia go to the movies to hide from the cops, they see Budd Boetticher's *Westbound* (1959). Paris, especially at night, has never looked more scintillating. Much of the credit for this

must go to cinematographer Raoul Coutard, who photographed almost all of Godard's and François Truffaut's films in the New Wave glory days of the 1960s.

Although *Breathless* remains one of Godard's most accessible films, it's nevertheless hard to escape the impression that Godard represents auteur theory gone manic. The in-your-face rulebreaking and fragmentation that the film introduced is now so influential that it's almost impossible to recall how it was experienced at the time of release. I must confess to impatience with the seemingly endless bedroom banter between Michel and Patricia. To me, much of the film's freshness is as vanished as Patricia's employer, *The New York Herald Tribune*. The outrageousness and impropriety of its sexuality has become outdated. One can hardly blame Godard for changes in cinema and in the real world, but one can also never recapture the film's initial appeal.

On a Turner Classic Movies telecast, Drew Barrymore, who grew up being E.T.'s playmate and went on to become Little Edie in *Grey Gardens* (2009), described the Seberg and Belmondo characters as "the coolest people you've ever seen." Of course, in Godard's hands Belmondo is a psychopathic murderer, thief, and liar, and Seberg is not much better, whimsically selling him out to the police because she decides she doesn't really love him. In Anthony Trollope's mammoth *The Way We Live Now*, an 1875 novel about British cynicism and corruption written in the wake of a trip to idyllic America, the novelist says this of one of his protagonists:

"But it cannot be said of him that he had ever loved any one to the extent of denying himself a moment's gratification on that loved one's behalf. His heart was a stone. But he was beautiful to look at, ready-witted, and intelligent."

Has solipsism become the new "cool"? Perhaps Ms. Barrymore is not too far off the mark. Godard, over the course of more than half a century, has made much of his humanism and concern over social issues, often buying into ultra-leftist arguments. But what if the selfish, ruthlessly "cool" characters of *Breathless* are really self-portraits of the director himself?

Satyajit Ray's Two Daughters
1961

In the six years following his debut with *Pather Panchali*, Satyatjit Ray made a habit of winning awards all over

the world and established himself as a major film director. Ray had been a pupil of the great writer Rabindranath Tagore at the university Tagore founded, so it was not surprising that after Ray completed his Apu trilogy, he turned to his former mentor's stories for inspiration. *Two Daughters* (*Teen Kanya*) was an adaptation of some of Tagore's rural Indian tales that was later abridged for international release. I have never seen the additional hour that was cut from prints shown outside of India (though it's now available on DVD), and I'm not sure whether it was in any way inferior to the rest, or whether the third daughter made the film too long and slow for prospective Western audiences. *Lawrence of Arabia*, which was released the following year, was almost twice as long as *Two Daughters*, and *Cleopatra*, released the year after, was well over twice as long. All three films were set against what might be called exotic backdrops, but Ray's film lacked the glossy touch of David Lean or the Hollywood star power of Liz Taylor, Richard Burton, and Sir Rex Harrison. (Years later, in 1984, Lean's *A Passage to India* approached three hours in length.)

Ray had great authenticity, and his films were rooted in Neorealism. Although this movement was most closely associated with 1940s Italian directors such as Luchino Visconti, Roberto Rossellini, and Vittorio De Sica, it really began in the mid–1930s with films like Jean Renoir's *Toni* (1935), on which Visconti was an assistant. Renoir, of course, had been Ray's earliest mentor, relying on Ray for help in filming his Indian masterpiece, *The River* (1951). The young woman on the swing in the second story of *Two Daughters* seems to me a clear homage to Sylvia Bataille in Renoir's *A Day in the Country* (1936).

Ray, a sophisticated and cosmopolitan guy, was by this point very assured in his artistry. In a way, he reflects the dilemma of India, a country whose great culture is precariously balanced between modernity and mud, malaria, and madmen-infested villages. *Two Daughters*, however, is a film of considerable humor — take, for example, a young lawyer's admiration of Napoleon in the second story: two circumstances and prospects of the two men could not been more different. There is also a very innocent and gentle quality to the film. The little orphaned girl in the first story reminds me of the Natalie Wood character in Allan Dwan's *Driftwood* (1947). Thanks to Soumendu Roy, black and white cinematography has seldom looked better, and Roy became Ray's main collaborator later in his career. After using sitar virtuoso Ravi Shankar in the Apu trilogy, in *Two Daughters* Ray began writing his own music. (Coincidentally, the hero of the second story is, I think,

almost a dead ringer for another Shankar collaborator, the soon-to-be world-famous John Lennon.) This also contributes to the emotional resonance of his films.

Ray reveals himself to be a committed feminist, critical of a society that, then and now, treats women unequally and often abusively. However, Ray rejects emotionalism by changing Tagore's ending to *Postmaster* (the first story) to something less sentimental, in his words, less "Victorian." Ray makes his ending more subtle, less confrontational, and perhaps more modern. (I have heard this scene described as "one of the most heart-wrenching moments ever seen in cinema.") It may be simplistic to suggest, but I think the tension between the traditional and contemporary sums up the dilemma Ray wrestled with throughout his career, and which many "Third World" intellectuals contend with. The pressures of modernity, the long shadow of the West, are forever in conflict with the traditional ways and values of the past, mostly rooted in the East. This is hardly a new phenomenon. In his stirring novelization of the life of the Roman Emperor Julian, Gore Vidal recounts how, almost two thousand years ago, Julian attempted to roll back the forces of the West (Christianity) and reinstate the ancient gods. Cinema, because of its peculiar ability to recreate the past, has often provided fertile ground for directors who seemed as if they would rather inhabit another time. Perhaps Satyajit Ray was torn in this way, but he was in the good company of people like John Ford, Jean Renoir, Max Ophüls, D. W. Griffith, and many others.

Billy Wilder's The Apartment

1960

The Apartment won Billy Wilder three Oscars for producing, directing, and screenwriting. It is hard to recall a film that is so honored and so cynical — even in spite of its over-the-top romantic ending — or, for that matter, so lacking in visual elegance. These are all common criticisms of Wilder's work. The Motion Picture Academy could have recognized the genius of Alfred Hitchcock's *Psycho* that year, or even sprawling epics like Otto Preminger's *Exodus* or Elia Kazan's *Wild River*, but *The Apartment* seemed to have touched a contemporary, and possibly raw, nerve.

Like the New Wave directors in France at the time, Wilder allows himself a few in-jokes: he evokes his Oscar-winning *Lost Weekend* (1945), and mocks television's

destruction of classic movies such as *Grand Hotel* (1932) and *Stagecoach* (1939) with its crappy reception and endless commercials. He also pokes fun at Marilyn Monroe, who had starred in his films *Seven Year Itch* (1955) and *Some Like It Hot* (1959) — and whom he had come to dislike — by casting a look-alike, Joyce Jameson. As always, Wilder presents everything with a subversive edginess.

Bertrand Tavernier, the director of *The Clockmaker* (1974) and *'Round Midnight* (1986), succeeded the Godard/Truffaut/Chabrol/Rivette/Rohmer generation at *Cahiers du Cinéma*. He said recently: "The auteur theory is still working, but it has been caricatured. It was saying that within the best films of a director... you have an author [who] really had a chance of expressing his ideas. But the notion then came that the people working round him are less important. This is a mistake! This is a mistake!" Wilder is a particularly good example of Tavernier's point. Romanian-born I.A.L. Diamond began cowriting with Wilder on *Love in the Afternoon* (1957), and from that point on they never stopped collaborating until the end of their respective careers, with the lone exception of *Witness for the Prosecution* (1957). Diamond, almost a generation younger than Wilder, shared the director's cynical subversiveness, and it is hard to find a director/writer duo as compatible in Hollywood history, except possibly Josef von Sternberg and Jules Furthman — or Charlie Chaplin and himself.

The plot of *The Apartment* revolves around a low-level insurance salesman (Jack Lemmon) who curries favor with his superiors by loaning them the keys to his apartment for after-hours trysts. This works well — until he falls for the boss's girlfriend. Fred MacMurray plays the unsympathetic head of the gigantic company. Paul Douglas, who was originally cast in the role, had died, and it's hard to resist the idea that Wilder thought of MacMurray because he had played a shady insurance man in the director's excellent noir melodrama *Double Indemnity* (1944). Shirley MacLaine, who also starred in the film, would appear again in Wilder's *Irma La Douce* (1963). Lemmon, of course, was a Wilder regular. It can be argued that with *The Apartment*, Lemmon began to progress from his lightweight comedic persona into the serious actor of *Days of Wine and Roses* (1962), *Save the Tiger* (1973), which won him an Oscar, and *That's Life!* (1986). Of course, even after this turn Lemmon could still be hysterically funny, as he was in Blake Edwards's *The Great Race* (1965), Gene Saks's *The Odd Couple* (1968), and Wilder's *The Fortune Cookie* (1966) and *Avanti!* (1972).

Some years ago, I contemplated doing a book on directors born, like Wilder, in or near Vienna, of which

THE APARTMENT. DIRECTED BY BILLY WILDER. 1960. USA. BLACK AND WHITE, 125 MINUTES.

there were a disproportionate number. Most of them were Jewish, and they brought both genius and a questioning of conventional Anglo-Saxon values and sexual mores to American cinema. In the silent era, the films of Erich von Stroheim (who would later star in Wilder's *Five Graves to Cairo*, 1943, and *Sunset Boulevard*, 1950) not-so-subtly hinted at a kinkiness that contemporary conservative politicians might call "anti-American." In the 1930s, the Viennese-born Sternberg and Marlene Dietrich minced no images. In my monograph on Dietrich, I point out a scene in *The Scarlet Empress* (1934) in which the actress, as Catherine the Great, is en route to a tryst with John Lodge. The road is overlaid with a shadow cast by a statue of Satan — the director's ironic comment on what must be going through the audience's minds. At another moment, Sternberg focuses his camera and Marlene's gaze on Gavin Gordon's groin as Dietrich informs him that she's heard a lot about him "from the ladies." (For this observation I was reprimanded for having a dirty mind by the late Sternberg biographer Herman G. Weinberg — a charge several critics also leveled at Wilder after *The Apartment*.) In 1953, Viennese lawyer Otto Preminger opened the floodgates to debauchery in Hollywood by using the word "pregnant" in *The Moon Is Blue*, the same year he appeared in *Stalag 17* as the Nazi commander of Wilder's laugh-producing POW camp.

Wilder himself, trained as he was at Berliner Ernst Lubitsch's knee, had raised eyebrows and hackles before *The Apartment* — most notably in *Sunset Boulevard* through Gloria Swanson's romantic *mishegoss* with William Holden; Stroheim, doing triple duty as her ex-director, ex-husband, and live-in butler; and possibly even her deceased chimp. Wilder followed with the cross-dressing and sexual ambiguity of *Some Like It Hot*.

The Apartment, coming at the end of the supposedly sedate and wholesome Eisenhower era, was the next logical step. Lemmon turns his home into what his landlady calls a "honky-tonky," a free-for-all where extramarital sex was the norm. The conservative Hollywood ship had sailed, and Billy Wilder was at the dock to see it off. Even the White House became something of a honky-tonk under Kennedy — according to my late friend, the distinguished Dietrich biographer Steven Bach, when Marlene paid a visit, she was treated to a before-lunch quickie.

Blake Edwards's Breakfast at Tiffany's 1961

With the possible exception of Robert Aldrich, Blake Edwards (1922–2010) is I think the most important director to emerge from the shambles of the Hollywood studio system. (He was also the greatest Oklahoman since statehood.) While Aldrich was the embodiment of noir, Edwards had a more diverse talent. Though he displayed a darker side in *Experiment in Terror*, *The Days of Wine and Roses* (both 1962), and *Gunn* (a 1967 movie derived from his innovative TV series), no director in the sound era maintained a higher standard of physical comedy, whimsical characterization, and outright slapstick. Edwards's best films are reminiscent of the great silents of Charlie Chaplin, Buster Keaton, and Harold Lloyd. *The Great Race* (1965) is dedicated to Laurel and Hardy, and Edwards's Peter Sellers films, such as *The Party* (1968) and *A Shot in the Dark* (1964) — along with the rest of the Pink Panther series — are without parallel. His work with Julie Andrews, his wife for over forty years, preserves on celluloid one of cinema's greatest and most enduring love stories between an auteur and a performer. They made such masterpieces as *Darling Lili* (1970), *S.O.B.* (1981), *Victor Victoria* (1982), and *That's Life* (1986). A self-styled "spunky, smart-assed kid" from Tulsa, Edwards was the step-grandson of silent film director J. Gordon Edwards (mentor of Theda Bara and William Farnum), and the stepson of Jack McEdwards, another significant movie industry figure. Edwards, in other words, seemed destined for directing.

After stints acting and writing, Edwards directed his first film in 1955, but his great success came four years later with Cary Grant and Tony Curtis in *Operation Petticoat*. He starting making *Breakfast of Tiffany's* two

years later, and this history is recounted in Sam Wasson's wonderful little book, *Fifth Avenue, 5 A.M.: Audrey Hepburn, Breakfast at Tiffany's, and the Dawn of the Modern Woman*. (I've lived down the block from Tiffany's since I moved to New York in 1968, but I've never ventured there at five in the morning.) Wasson provides a broad context for the film, and makes us understand the extent to which movies interacted with American society in a way that may now largely be lost. The film is about Holly Golightly, an eccentric but highly successful female escort and prostitute who finally finds true love. Reading about the renewed struggle for women's rights or watching news about it on TV, one can't help but think of Holly Golightly (personified by the glorious Audrey Hepburn and thankfully not Truman Capote's preferred Marilyn Monroe) and her "huckleberry friend." The critic Molly Haskell styled Holly "a true modern original."

The film, of course, is based on the novella by Capote, but homage should also be paid to screenplay writer George Axelrod, who collaborated with Billy Wilder on *The Seven Year Itch* (1955). (That film, along with Wilder's *Sunset Boulevard*, 1950, and *The Apartment*, 1960, resembles *Breakfast at Tiffany's* in plot and sensibility.) In spite of the many talented collaborators, however, the film is dominated by Edwards, then discovering his inner romantic, which would burgeon during his Andrews period. Wilder would have been too cynical to have brought *Breakfast at Tiffany's* off alone, and one can't imagine him having a film culminate with the loving embrace of a cat. In the final analysis, the film is a modern fairy tale, with Holly as a self-imprisoned and ultimately liberated Snow White or Rapunzel. Unlike Snow White, however, she finds her Prince Charming living in her own Greenwich Village apartment building.

François Truffaut's Shoot the Piano Player 1960

After the international success of François Truffaut's *The 400 Blows* (1959), the director turned to adapting the noir-ish novel *Down There* by David Goodis, an American author who was considerably better known in France than he is here. (The director asserted that one of the reasons he made *Shoot the Piano Player* was because he thought his first film too French, and he wanted to establish links with the American cinema and B-movies.) In it, a piano

player working in a Paris gin joint goes on the lam to avoid gangsters. Truffaut compared this film to the 1932 adaptation of Georges Simenon's *Night at the Crossroads* by Truffaut's mentor and father figure, Jean Renoir. Both films are marked by headlight-lit automobile journeys down country roads. During this, Renoir's darkest period, he made works like *La Chienne* (1931), which closely resemble the films of Truffaut's other hero, Alfred Hitchcock.

In *Shoot the Piano Player*, many scenes are shot from inside the car, with the widescreen standing in for the windshield. The director defended his use of widescreen by comparing it to an aquarium in which actors were able to move freely within the frame. There is lots of camera movement and many scenes of characters running, suggesting that Truffaut himself was in a hurry, perhaps sensing that he might die at a tragically young age. The character of the piano player's comical kid brother Fido, played by Richard Kanayan, underlines the director's fascination with children.

At the heart of *Shoot the Piano Player* is Edouard Saroyan, aka Charlie Kohler, the concert pianist turned piano player played by Charles Aznavour, who was named "Entertainer of the Century" in a 1998 CNN poll. Although he appeared in over five dozen films ranging from *Rat Trap* (1953) to *The Yiddish Connection* (1986), his cinematic career would likely have been forgotten or ignored were it not for this this role. Born in Paris to Armenian parents who had survived the 1915 genocide, Aznavour became a protégé of Edith Piaf as a teenager in the wake of World War II. His concerts and records made him world famous. (I saw him at New York's City Center a few years ago on one of his "farewell tours," and his voice and energy level were those of a man half his age.) Based in Geneva, he has served as Armenia's ambassador to Switzerland and as a delegate to the United Nations. Although he went on to innumerable honors and a multifaceted career, it is as hard to imagine a New Wave without Aznavour as it is without Jean-Pierre Léaud, Jean-Paul Belmondo, or Jeanne Moreau.

Although Truffaut and Aznavour kept up a regular correspondence, Truffaut turned down the opportunity to direct an autobiographical film treatment written by the actor in 1963, urging him to direct it himself. In a letter written in 1980, Truffaut told Aznavour that in their work together, "it gave me a marvelous sense of security to have you on the set in front of me... attentive and open-minded, meticulous and flexible... nervous and poetic. You're a marvelous actor and, should the occasion arise, we'll work together again one of these days." Sadly, they never did.

Jean-Luc Godard's *A Woman Is a Woman* 1961

As *Breathless* (1960) deconstructs the Hollywood gangster film, Jean-Luc Godard's *A Woman Is a Woman* attempts to do the same thing with the Technicolor Hollywood musical. While his model for *Breathless* had been the B-movies of Monogram Pictures, Godard was now in the realm of Vincente Minnelli's MGM musicals such as *The Band Wagon* (1953) and *Gigi* (1958). For this he summoned Jean-Paul Belmondo, already the reigning star of the New Wave. Jean Seberg was replaced by Danish-born Anna Karina (soon to be Mrs. Godard), and Jean-Claude Brialy, who would rival Belmondo throughout the 1960s, became the third member of the plot's *ménage à trois*.

Godard's direction effectively establishes rule breaking as the new rule. His films disrupt standard filmmaking, which presumes a clear narrative with a steady flow of images and plot. In *A Woman Is a Woman*, Karina wants a baby, and she's not very particular about who fathers it. Godard approaches this premise with clever and cute touches that many would consider too clever and too cute. Even the great iconoclast Orson Welles respected audience expectations, and the brilliance of his imagery compensates for the disorientating effect of his films. Godard's narrative fragmentation can also bring on something approaching pain or punishment, but in his early work, he compensates for this with the charm of his performers. Karina, whom I once had the pleasure of meeting, could not have been more charming. She won the Best Actress award at the Berlin Film Festival for *A Woman Is a Woman*, and went on to appear in several of Godard's best films, including *My Life to Live* (1962), *Band of Outsiders* (1964), *Pierrot le Fou* (1965), and *Alphaville* (1965). Following her starring role in Jacques Rivette's excellent *The Nun* (1966), Karina remained an active film star for the next quarter century, performing for Luchino Visconti, Volker Schlöndorff, George Cukor, and R. W. Fassbinder. While still an actor, she also became a major chanteuse, a novelist, and a film director in her own right.

In this early period Godard was enthralled with Hollywood glitz and glamour, and in *A Woman is a Woman* he references Burt Lancaster, Gene Kelly, Cyd Charisse, and Ernst Lubitsch. There is a comedy and an absurdity that parodies and echoes the silliness of many Hollywood musicals. Godard playfully refers to *Breathless*

and has Belmondo ask an uncredited Jeanne Moreau how François Truffaut's *Jules and Jim* (1962) is progressing. This part of Godard's rule breaking has a pleasant, almost endearing, self-referential quality. Yet for me, the director seems unable to fully give himself over to the spectacle and alluring magic of the musical form. At this point in his career, Godard did not have the resources of Jean Renoir, who could produce *French Cancan* (1954), a ravishing Gallic variation on the showbiz drama. While Renoir re-created the Moulin Rouge, Godard is bound to the strip joint in which Karina works.

Before he started making movies, Godard referred in one of his critical essays to "the innate sense of comedy possessed by the great filmmakers." Try as he might, this seemed to be something Godard could not attain. There is humor in *A Woman Is a Woman* and his other films, but it seems labored, almost as if the director is apologetic for diverting the audience from the serious business of watching a movie. Godard references the 1933 talkie, René Clair's *14 Juillet*, in *A Woman is a Woman*, but Clair's 1930s musicals, like Lubitsch's, had a lightness of touch to them that Godard would probably consider beneath him.

It would not be long before his tendency toward heaviness tinged with 1960s politics began to dominate his youthful exuberance. A scion of a well-to-do Geneva family, Godard declared himself a fervent Marxist. He was torn between admiration for John Wayne's tear-inducing performance in John Ford's *The Searchers* (1956) – the ending of which he compared to the climax of *The Odyssey* – and his passionate hatred of Wayne's politics. Whatever one's feelings toward him are, Godard's contradictions and complexities, and his long journey of self-exploration, make him an undeniably important auteur.

Michelangelo Antonioni's
L'Avventura 1960

After the success of *Il Grido*, Michelangelo Antonioni embarked on a series of films (*L'Avventura*, *La Notte*, 1961; *L'Eclisse*, 1962; *Red Desert*, 1964) that cemented his role as the most prominent figure in the Italian equivalent of the French New Wave. Yet he wasn't known for making gripping films, and even after his success, Antonioni was a polarizing figure. Andrew Sarris wrote that the director's films expressed "Antoniennui," and a friend of mine once described them as "boring in a new way." That was unfair. At their best, Antonioni's films projected a stylized view

of modernity that still seems shockingly contemporary more than half a century later. *L'Avventura* was also booed during its debut screening at the Cannes Film Festival, anticipating a similar reception for the great Carl Theodor Dreyer's *Gertrud* four years later.

After an opening sequence shot in a bleak landscape that seems left over from *Il Grido*, Antonioni's vision in *L'Avventura* ranges from the gorgeous desolation of the Aeolian Isles to the madness of Palermo to the unique beauty of a rural and bucolic Sicily. His characters wander through these locations apparently looking for something they, and we, can't quite fathom. The film mostly lacks what we would consider a plot: A woman mysteriously disappears, and her boyfriend becomes entangled with her friend. Ultimately, the protagonists become estranged without much explication. It might all be dismissed as picturesque, but the director has a luminous and meaningful sense of visual geometry and composition. Although *La Notte* and *L'Eclisse* are essentially urban, Antonioni would return to the "wasteland" motif of *L'Avventura* in *Red Desert* and *Zabriskie Point* (1970) – and to quote noted film critic Carly Simon, "Nobody does it better."

At the heart of *L'Avventura* is, of course, Monica Vitti, his muse throughout this period. (He returned to her decades later in *The Mystery of Oberwald*, 1981.) Vitti has an extraordinary haunting quality that perfectly expresses the detachment of Antonioni's universe. At times, one could compare her to Greta Garbo at the end of *Queen Christina* (1933) or Marlene Dietrich in the climax of *The Scarlet Empress* (1934) – all are triumphant in their respective quests, but they leave us uncertain of their opaque inner feelings. At the end of *L'Avventura*, Vitti seems to accept Gabriele Ferzetti (a handsome enough rival to Marcello Mastroianni). Ferzetti appears to presage some of our current oversexed and clueless politicians in that he's charming but seemingly humorless.

The underlying theme of Antonioni's films is alienation and the inability to communicate, and it's hard not to feel that the director often overburdens women with this failure. Still, many would make the case for the director as a feminist because so much of *L'Avventura* (and his other Vitti films) is told from the actress's point-of-view. Ferzetti's character was close to being dismissed at the start of the film by his fiancée, the girl who later disappears on the island. Only a burst of eroticism (which Antonioni considers a modern plague) enables the boat journey to the island and the "plot" to, more or less, unfold. Ultimately, the characters seem prepared for lives full of material comfort and pointless misery.

During this period in film history, we see Shirley MacLaine saved by Jack Lemmon in Billy Wilder's *The Apartment* (1960) and Audrey Hepburn rescued by George Peppard in Blake Edwards's *Breakfast at Tiffany's* (1961). Hollywood, in spite of its cynicism, still could contrive happy endings. Europe — not so much.

Francesco Rosi's Salvatore Giuliano 1962

Francesco Rosi's birth in Naples came only a few weeks after Mussolini's train ride in 1922, famously heralded as the dictator's "March on Rome." Rosi was also born a day before Sicilian bandit-turned-separatist-leader Salvatore Giuliano, who was shot dead in 1950. I'm not sure that Rosi even knew this, but it strikes me as an amazing coincidence. Much of Giuliano's life and death is shrouded in mystery, and Rosi's eponymous biopic sheds little light on the intimate details of its protagonist.

Giuliano is rarely on screen and barely says anything, though the film is constructed in such a way that his presence dominates.

After a brief stint in Il Duce's army, young Rosi worked in radio, theater, and film before finally getting a chance at directing in his mid-thirties. *Salvatore Giuliano* was his third and most famous picture. He had assisted Luchino Visconti on *La Terra Trema* (1948), one of the great classics of Neorealism, and Rosi retained a strong sense of the actuality that went with that territory. Much of his work depended on nonprofessional actors, and he was also influenced by the great Bolshevik spectacles of the 1920s and 1930s. The scene in *Giuliano* depicting the aftermath of the May Day massacre, for example, is reminiscent of a scene in Sergei Eisenstein's *Alexander Nevsky* (1938) in which the camera prowls a battlefield littered with bodies. Much of the stark beauty of *Giuliano*, photographed with great precision in

YOJIMBO. DIRECTED BY AKIRA KUROSAWA. 1961. JAPAN. BLACK AND WHITE, 110 MINUTES.

glorious black and white, can be attributed to the superb cinematographer Gianni Di Venanzo, who also worked for Visconti and shot several of Michelangelo Antonioni and Federico Fellini's major films – in addition to a number of other Rosi pictures – before his untimely death at forty-five.

Salvatore Giuliano is structured in flashbacks, beginning, like Orson Welles's Citizen Kane (1941), with the death of its central figure. Like Rosi's The Mattei Affair (1972) and Welles's Mr. Arkadin (1955), the movie takes the form of an elliptical investigation into the circumstances surrounding the death of its protagonist. Since Giuliano is hardly given an opportunity to make an impression or generate sympathy from the audience, it is left to those on the periphery – the Sicilian separatists, the peasants who view him as a latter-day Robin Hood, and his hysterically grieving mother – to convince us that he matters.

I have never found courtroom dramas very cinematic, not even Alfred Hitchcock's The Paradine Case (1947), or Stage Fright (1950), and the second half of Rosi's film gets bogged down enough that one begins to pine for Di Venanza's barren Sicilian hills. Michael Cimino's 1987 adaptation of Mario Puzo's novel The Sicilian (deemed "militantly lugubrious" by Leonard Maltin) covered much of the same territory.

Early in his career, Rosi tended to be political and socially conscious, yet his depiction of Sicily in Salvatore Giuliano is almost medieval. The director observes that mainlanders (represented by the military and paparazzi) are condescending to southerners, but he may not be entirely free of fault in that regard, as he occasionally betrays a certain sense of superiority due to his presumed sophistication. Rosi's proletarian instincts are also tempered by a fascination with crime figures and the Mafia. In 1973 he made Lucky Luciano with Gian-Maria Volonte, who played Clint Eastwood's rival in Sergio Leone's seminal "spaghetti Western" A Fistful of Dollars (1964).

As scholar Ann Harris has pointed out, Rosi's main departure from his Neorealist roots lies in his lack of emphasis on character development, which sets his work apart from films like Roberto Rossellini's Rome Open City (1945) and Vittorio De Sica's The Bicycle Thief (1948). Instead, his focus is on primitive Sicilian society and its landscape. Perhaps accounting for this, Rosi has said, "I believe that through an engaged cinema that attempts as much as possible to rub shoulders with the truth... one can succeed in conveying the urgency of respecting human dignity."

Akira Kurosawa's Yojimbo 1961

Akira Kurosawa's genius for visual rhythms, camera movement, composition, and editing often prevented a single character from dominating a film. The notable exceptions are Takashi Shimura in Ikiru (1952) and several Toshiro Mifune performances – especially Yojimbo. The film was inspired, according to the director, by Dashiell Hammett's The Glass Key, a novel that was filmed very differently in Hollywood adaptations starring George Raft and Brian Donlevy. (It was, of course, later turned into Sergio Leone's 1964 A Fistful of Dollars with Clint Eastwood.) Yojimbo was beautifully photographed by Kazuo Miyagawa, who had worked on Rashomon (1950) and several of Mizoguchi's late masterpieces. As far as I'm concerned, though, the seminal influence on the film was a hard-drinking Irishman from Maine named John Ford, who made Westerns.

In Waiting on the Weather: Making Movies with Akira Kurosawa, Kurosawa's devoted longtime assistant Teryuo Nogami describes two encounters between the directors, both of which were limited by a seemingly insurmountable language barrier. At the end of World War II, Ford visited Kurosawa on set while he was filming The Men Who Tread on the Tiger's Tail (1945) at the Toho studio in Tokyo. Years later, in 1957, they met for a second time in London, where Ford was making Gideon's Day (Gideon of Scotland Yard). Kurosawa visited the set, and he was greeted by Ford's crew with much applause. (For both directors, these films were atypically bound to studios. It can be argued that Ford and Kurosawa used landscapes and pastoral settings more successfully than any other major directors.)

Kurosawa admired and tried to emulate Ford Westerns from Stagecoach (1939) to The Man Who Shot Liberty Valance (1962), and especially those made with his homegrown "samurai," John Wayne. In his MoMA exhibition, Tokyo 1955–1970: A New Avant-Garde, my erstwhile colleague Doryun Chong featured a 1965 painting showing Yojimbo surveying a stylized recreation of Monument Valley, the location of several Ford/Wayne epics, including The Searchers (1956), Fort Apache (1948), and She Wore a Yellow Ribbon (1949). One of my favorite guilty pleasures occurs in a 1953 film called Spring Breeze, directed by Kurosawa friend Senkichi Taniguchi. (Kurosawa colloaborated with him on the screenplay.) Mifune plays a yellow taxicab driver, and in tribute to his cab and to Ford, he repeatedly sings a variation of the title song from She Wore a Yellow Ribbon.

At one point, Kurosawa told Nogami: "John Ford is really great... When I'm old, that's the kind of director I want to be." In many respects, he came damn close. *Ran* (1985), his riff on *King Lear*, is a strong candidate for the best film of the last half-century. When Ford died, Nogami and her associates "couldn't bring [themselves] to tell Kurosawa the sad news."

Ermanno Olmi's Il Posto 1961

Ermanno Olmi made around three-dozen short documentaries — many for the electric company in Milan — before his first narrative feature, *Il Posto*. This might account for the assured, polished quality of that film, in spite of its episodic structure. Most of his films are set in Milan and the surrounding Lombardy area, and Olmi's satirical depiction of a modern city and the dehumanizing effects of its bureaucracy is deeply rooted in personal experience. Milan is the city that produced Silvio Berlusconi just a few years after Olmi was born there in 1931, and its vision of modernity is far removed from the classical tradition and historical focus of Rome, Venice, or Florence. Milan is a business and industrial city, perhaps looking more to the future than its more antiquated predecessors, and Olmi's films are a product of his personal history, perhaps more so than most filmmakers.

The director's films have clear roots in Neorealism, but he breaks with Luchino Visconti, Roberto Rossellini, and Vittorio De Sica by using nonprofessional actors and never working with box-office stars like Burt Lancaster, Ingrid Bergman, and Sophia Loren. In his private life, Olmi had ample experience with working class troubles, which are reflected in the protagonist's frustrations in *Il Posto*. The film is about a boy struggling to find a lifetime position that will be banal and unfulfilling, perhaps echoing Olmi's time working for the electric company. The young woman who plays Antonietta in *Il Posto* wound up becoming Mrs. Olmi (the couple lived a somewhat hermetic existence away from the city), and Domenico, the film's hero, is clearly autobiographical. Whereas Federico Fellini turned his youth in Rimini into a thing of charm and poetry in *I Vitelloni*, Olmi's alter ego works in an unadorned office amidst backstabbing colleagues in dead-end jobs. His one potential night of joy, the annual office party, turns out to be a long and frustrating ordeal.

Olmi enjoyed a brief vogue on the international scene with *Il Posto* and *The Fiances* (1963). He was somewhat comparable to the British realist directors of the period (Karel Reisz, Tony Richardson, Lindsay Anderson), but they would soon go off in other, more commercial directions. Olmi continued to make films, several for television, until in 1978, he returned to prominence with *The Tree of Wooden Clogs*, his epic depiction of the life of northern Italian peasants. Much of Olmi's output in recent decades has been documentaries for television. An audience that proved somewhat receptive to simple but meaningful black-and-white films in the 1960s has given way to one seeking glitzy, digital, and generally mind-numbing pyrotechnics.

Yasujirō Ozu's An Autumn Afternoon 1962

Yasujirō Ozu died in 1963 on his sixtieth birthday. *An Autumn Afternoon* was his last film, and he cowrote it with Kogo Noda and cast Chishu Ryu to star, both of whom had been his collaborators since the silent era. Although Ozu was apparently unaware of his terminal cancer during production, the death of his mother no doubt shaded and made the film's central concept even more somber: that ultimately we are all alone. The film has the aura of summing up and consolidating his themes, values, and style. There is, of course, great continuity throughout Ozu's career. Donald Richie, his champion and biographer, points to the similarity in the director's titles (*Late Spring*, 1949; *Early Summer*, 1951; *Early Spring*, 1956; *Late Autumn*, 1960; *An Autumn Afternoon*, 1962) and suggests that this reflected Ozu's fixation, from slightly different perspectives, on his singular subject, the Japanese family. Or as Ozu put it himself, "I am strictly a tofu-dealer."

Because of his obsession with the family, the director's focus was on character, and he confessed boredom with plot. Thus in contrast to Kenji Mizoguchi's visual spectacles and Akira Kurosawa's samurai epics, it was only with some trepidation that Ozu's films were released in the West. Indeed, some audiences do find the films too mundane. Richie has described Ozu's methodology as "heightened realism," and Ozu's films did perhaps anticipate Italian Neorealism and the British social realists. Although Japan and Ozu himself had long been drawn to American culture, Japanese audiences clearly responded to his films in ways that American masses conditioned to cowboys and Hollywood glitz never would.

There is so much gentility in Ozu's movies that I cannot quite wrap my mind around the fact that he was imprisoned by the British for being an Imperial Army officer in China and later in Singapore. Nonetheless, Ozu makes light of that history in *An Autumn Afternoon* by having a naval veteran sing a tribute to his old "floating fortress," and reminisce with fellow veterans in a bar about their disappointed plans to win the war and conquer New York. Echoing his great *Late Spring* and *Tokyo Story* (1953), the film finds Chishu Ryu marrying off the last of his children and being alone.

Humor is crucial to Ozu's films. He lightens serious scenes of characters discussing their problems – the camera always tilting up from the tatami mats on which they are ususally stoically seated – with comic interludes on scatology and farting, and beautifully composed still-life codas on bottles, smokestacks, and elements of modern detritus, all accompanied by upbeat music. Ultimately, as critic David Bordwell has suggested, there is something about Ozu's best films, including *An Autumn Afternoon*, that reflect "a melancholy resignation... a recognition of a cycle of nature that society can never control." The world is ever changing, children leave their parents, and even good people die.

Ozu's death, tragic as it was, seemed almost appropriate in its timing. The "Golden Age" of Japanese cinema was coming to an end, a moment nearly simultaneous with the death-knell of the Hollywood studio system. Mizoguchi died in 1956, and although Kurosawa worked for decades, he increasingly struggled and even attempted suicide. As one critic put it, *An Autumn Afternoon* "seems the perfect final film for Ozu." The director's diary entry after he returned from his mother's funeral reads: "Like torn rags, the cherry blossoms display a forlorn expression – sake tastes bitter as gall."

A few words about Donald Richie, who died in Tokyo in February 2013: Donald was a friend and all-too-briefly a colleague. No one had previously done anything comparable to what he did in opening up the richness of Japanese cinema to American audiences. His many film books, including his definitive monographs on Akira Kurosawa and Ozu, were only surface manifestations of his exploration of Japanese culture. Dive into *The Inland Sea* and *The Donald Richie Reader*. For those of us who were fortunate enough to visit Donald in what became his natural habitat, he was a gracious host and guide, a candid yet worshipful critic of Japanese society.

When I first came to MoMA, Donald was attempting to survive in New York and was a curator in the Department of Film; he was, in effect, my boss. With some trepidation, I called to Donald's attention an unfavorable review I had recently published of his short monograph on director George Stevens for the Museum. He graciously explained to me that it was something he really hadn't wanted to write, but that he had done so out of necessity. From then on, we remained on respectful terms, although I never felt really close to him. I doubt that many people did. But then, I was no Chishu Ryu or Toshiro Mifune.

Pietro Germi's Divorce, Italian Style 1961

Italian cinema has historically been undervalued in comparison to the films of the United States, several other European countries, and post-World War II Japan. Yet in the silent days, directors like Giovanni Pastrone, Enrico Guazzoni, and Carmine Gallone paved the way for D. W. Griffith and Cecil B. De Mille, and in the 1930s, Mario Camerini and Alessandro Blassetti blossomed. The Neorealist giants (Luchino Visconti, Roberto Rossellini, Vittorio De Sica) and the succeeding generation (Federico Fellini, Michelangelo Antonioni) finally established that Italy was a major player in the forties and fifties. The next generation (Pier Paolo Pasolini, Bernardo Bertolucci, Mario Bellocchio) overlapped and rivaled the French New Wave, and Italy turned out to have an incredibly "deep bench": Mario Monicelli, Francesco Rosi, Ermanno Olmi, Sergio Leone, the Taviani brothers, Ettore Scola, Elio Petri, Valerio Zurlini, Franco Zeffirelli, and several more on the roster. Pietro Germi (1914–1974) was also in this mix.

Germi, like many of his colleagues, studied at the Centro Sperimentale di Cinematografica in Rome. He began writing screenplays before World War II and became a director shortly after its conclusion. *Divorce, Italian Style* was his first international success, and won an Oscar for its screenplay. Germi was fortunate to get Marcello Mastroianni fresh off his worldwide acclaim for Fellini's *La Dolce Vita* in 1960 (which the Sicilian villagers attend in Germi's film) and Antonioni's *La Notte* (1961). The actor brought a special ironic twinkle to the long-standing movie convention of the "Latin lover," and was nominated for an Oscar for this role, though he never won one.

Though Germi was from Genoa, many of his films were set in Sicily, which offered filmmakers fertile visual and social ground. The region had changed

DIVORCE ITALIAN STYLE. DIRECTED BY PIETRO GERMI. 1961. ITALY. BLACK AND WHITE, 105 MINUTES.

Luchino Visconti's
The Leopard 1963

Count Luchino Visconti (1906–1976), like his fellow Milanese Pietro Germi, had a fascination with Sicily and several of his most important films (*La Terra Trema*, 1948; *Rocco and His Brothers*, 1960; *The Leopard*) were shot there. Visconti is generally considered the "father" of the Neorealist movement, and it has been suggested that his work assisting Jean Renoir in the 1930s helped push him in that direction. Like Renoir in later decades, Visconti's canvas gradually became more expansive and theatrical. According to Renoir's autobiography, Renoir and Visconti were great buddies who were separated by the outbreak of World War II.

At first glance, the two would seem to be very different: Visconti was a nobleman turned committed leftist, his politics complicated by his homosexuality; Renoir was a Popular Front leftist turned essentially non-political humanist — he spent his final years basking in Beverly Hills — and something of a ladies' man. (Renoir wasn't close-minded about sexuality, however — his great novel, *The Notebooks of Captain Georges*, includes a very sympathetic gay character.) As Gilles Bourdos's film *Renoir* (2012) suggests, young Jean was something of a prince, living on his father's estate surrounded by the attractive models in his father's paintings, including the one he married and made into a movie star. Visconti's *The Leopard*, scrupulously adapted down to its episodic structure from the only novel by Prince Giuseppe di Lampedusa, provided the perfect material for the director to think through his own conflicted feelings about his noble heritage and progressive instincts. The hero of *The Leopard*, Fabrizio, is a family patriarch who is self-aware enough to realize that his world is irrevocably changing. As Garibaldi moves to include a reluctant Sicily in unified Italy, Fabrizio is more an observer than participant.

Lavishly photographed by Giuseppe Rotunno, who began his career as a cameraman on Visconti's *risorgimento* epic *Senso* (1954), the camera seems to float through sunlit landscapes and palatial estates. The climactic forty-seven-minute ballroom sequence provides some of the most beautiful moments in all of cinema, with meaningful dance arrangements accompanied by a third Giuseppe — Verdi. These moments and movements are perhaps only rivaled in cinema by Max Ophüls's *The Earrings of Madame De...* (1953). Lampedusa, whose novel

somewhat in the century separating Visconti's nine-teenth century *The Leopard* and Germi's film, which was actually made two years before Visconti's epic, and which features Mastroianni scheming and dreaming of ways to kill his wife. Perhaps, however, Sicily didn't change that much — the extremities of family honor were still fair game for satire, and in this regard Germi had a subtle gift. In Visconti's film, based on the novel by Giuseppe di Lampedusa, Burt Lancaster has to restrain his attraction to his nephew's fiancée for generational reasons, and is forced to maintain his princely dignity amidst the tedium of family life. The modern desperation of Mastroianni's Ferdinando, on the other hand, means that he is free to fantasize about various hilarious ways of liberating himself from married life, which eventually culminate in murder. It's a film that would never have passed the Hollywood Production Code. (Germi's *Seduced and Abandoned*, made three years later, is even more outrageous.) Germi, who began as a Neorealist disciple of Roberto Rossellini, wound up very cleverly questioning the traditional values of rigid Italian society — which made his death at sixty all the more untimely.

was initially rejected as unpublishable, was aware of the movies, as evidenced by his reference to Sergei Eisenstein's *The Battleship Potemkin* (1925). One senses the author would have approved of the languid pacing and ornamental detail of Visconti's film if he had survived to see it.

Lampedusa and Visconti present Italy as a country enslaved since the beginning of the Roman Empire, and their vision of Sicily is one of a region dealing with absorption into the Italian mainland and the arrival of an uncertain modernity. Fabrizio tells the household priest, "We're not blind, my dear Father, we're just human. We live in a changing reality to which we try to adapt ourselves like seaweed bending under the pressure of water." The instrument of change is a fourth Giuseppe – Garibaldi. The general was treated more sympathetically in Alessandro Blasetti's 1934 film *1860*, though Visconti does allow him one of the most spectacular battle scenes in all of cinema. Ultimately, though, the struggle matters little to Fabrizio. He opines: "We were the leopards, the lions; those who'll take our place will be jackals, hyenas, and the whole lot of us, leopards, jackals, and sheep, we'll all go on thinking ourselves the salt of the earth." How comfortable Visconti was with this, his progressivism potentially in conflict with his aristocratic roots, provides the film with an intriguing tension.

Visconti had a habit of using English-speaking actors in his films: Farley Granger in *Senso*, Dirk Bogarde in *The Damned* (1969) and *Death in Venice* (1971), Trevor Howard in *Ludwig* (1972). All Italian films were dubbed,

THE LEOPARD. DIRECTED BY LUCHINO VISCONTI. 1963. ITALY. 185 MINUTES.

and in the case of *The Leopard*, a badly abridged English version was released in this country. In that version, Andrew Sarris believed Burt Lancaster's performance lost much of its authority. I essentially agree with this, although I think some of Lancaster's best moments are actually silent. The choice of the actor was somewhat forced on Visconti, and there was considerable bad blood between the star and his director. At one point, Lancaster confronted Visconti about how he was being treated, and according to a witness, as recounted in an excellent biography of the actor by Kate Buford, the two emerged with "real, deep affection, esteem, respect, solidarity." They were reunited for *Conversation Piece* (1974) two years before Visconti's death.

Karel Reisz's Saturday Night and Sunday Morning 1960

Karel Reisz (1926-2002) was a Czech Jew who was rescued from the Nazis as a child before World War II. His parents died in Auschwitz, and although he spoke no English when he was brought to Britain, Reisz wound up serving in the Royal Air Force. Along with Tony Richardson, Lindsay Anderson, and Gavin Lambert, he became a film critic and a director; the products of their labor included *Sequence* magazine and the Free Cinema movement. There was a kinship between their early work and the "kitchen sink" stage dramas of John Osborne, Arnold Wesker, Shelagh Delaney, and Keith Waterhouse, whose plays these directors adapted to film. These works

reflected a dark realism appropriate to England at the time. The country had lost its empire and was struggling to recover from a depression sandwiched between two devastating world wars, and it was also in the midst of slowly restructuring of its ancient class system. Before *Saturday Night and Sunday Morning*, Reisz directed three documentaries: *Momma Don't Allow* (1955), which he codirected with Richardson, *We Are the Lambeth Boys* (1958), and *March to Aldermaston* (1959). His later work, including *Night Must Fall* (1937), *Morgan!* (1966), *Isadora* (1968), and *The French Lieutenant's Woman* (1981), was more diverse and provided major roles for superstars like Vanessa Redgrave and Meryl Streep, both of whom attended a memorial that MoMA held for Reisz following his death.

Reisz's films during the sixties had a bleak visual quality to them, the black and white reflecting the starkness of the period. *Saturday Night and Sunday Morning* retains a documentary quality, but Reisz was extraordinarily fortunate to cast Albert Finney in his first major role, one that came just before his signature performance in Richardson's Oscar-winning *Tom Jones* (1963). Prior to that, Finney had played a small part in Richardson's *The Entertainer* (1963), which was written by Osborne and starred Laurence Olivier. In some sense, Finney wound up replacing Olivier as the most durable British actor of his time. In *Saturday Night and Sunday Morning*, Finney brings an earthiness and naturalness to his role. In spite of his Shakespearean training, he retained enough provincial simplicity and rustic charm from his boyhood days in Manchester to make him credible as the angry young man of Alan Sillitoe's script. (*Saturday Night and Sunday Morning* was partly responsible for kickstarting the "angry young man" phenomenon in Britain.) The other performances in the film are uniformly good for a first-time director, especially those of Shirley Anne Field and Rachel Roberts, who would soon appear in Lindsay Anderson's debut feature, *This Sporting Life* (1963).

Starting with *Saturday Night and Sunday Morning*, the British realist school of the early 1960s to some degree paralleled the New Wave in France. Both movements were led by young critics-turned-filmmakers trying to be different. Although Jean-Luc Godard was ostensibly critical of bourgeois politics, he, like his compatriots, seemed more concerned with disowning French cinematic traditions, venerating Hollywood, and shattering the rules of filmmaking. The Brits seemed to take a more academic approach, one that was calculated to depict a troubled society in rather drab black and

white actuality. The movement was relatively brief, and by the mid-1960s its practitioners were mostly replaced by upbeat and inventive directors estranged from their native America, including Joseph Losey, Stanley Kubrick, and Richard Lester. Reisz, like most of his colleagues, eventually became more Hollywoodized with romantic star vehicles like *Isadora* and *The French Lieutenant's Woman*.

Andrew Sarris, who classified Reisz's style as "strained seriousness," once commented, "Karel Reisz's academically metaphorical montage tends to detach him from any emotional involvement with his characters whom he exploits more than he expands." There is indeed a sense in his films that, individually good as they may be, Reisz has no compelling reason to make them, no great theme or intrinsic style. Perhaps that has something to do with why he only made two films in the last twenty years of his life.

Tony Richardson's A Taste of Honey 1961

Tony Richardson (1928–1991), like Karel Reisz and Lindsay Anderson, came from the British realist school of directors. Following the great commercial success of *Tom Jones* in 1963, however, he moved on to a varied, multinational career. He also did a great deal of work in the theater, both in London and in the U.S., and Andrew Sarris suggests that Richardson's stage direction is superior to his movies. I think it hard to make a case for Richardson's films being either stylistically or thematically consistent.

In spite of the acclaim for *Tom Jones*, I believe that Richardson had already reached his peak with *A Taste of Honey* (1961) and *The Loneliness of the Long Distance Runner* (1962). Richardson had an inclination, if not a gift, for adapting literary works. He turned not only to novels, including ones by Henry Fielding, Evelyn Waugh, Jean Genet, Marguerite Dumas, and Vladimir Nabokov, but also to plays that ranged from Shakespeare to Richardson's contemporaries. *A Taste of Honey*, an adaptation of a play by Shelagh Delaney, is both very funny and poignant, although I could do without the recurring infestation of a singing chorus of neighborhood children.

Though Richardson had originally directed *A Taste of Honey* for the stage, there is some sense in the

film that he is aware of cinema's potential for spectable. In all three of the previously mentioned films, Richardson was aided by the superb cinematographer Walter Lassally, who went on to win an Oscar for *Zorba the Greek* (1964). Like other British realist works of the period, *A Taste of Honey* captures a contemporary grunginess that wouldn't be dispelled til Richard Lester's *A Hard Day's Night* (1964). Britain was still recovering from the privation of World War II, and the loss of empire had a negative effect on the collective psyche. The stage was dominated by "kitchen sink dramas," and the most prominent films seemed to be black and white tales of unhappiness. In *A Taste of Honey*, Rita Tushingham is a not very attractive or socially aware young woman who is impregnated by a black sailor who leaves her, and Murray Melvin is a shy young gay man who resolves to take care of her and the baby. The flickering sparkler at the climax of the film in some ways foreshadows the career of Tushingham, who won a British Academy Award for this, her debut role. (Both Tushingham and Melvin also won awards at Cannes.) Despite going on to work with Lester and David Lean, this early success was not a harbinger of great things to come. Similarly, over the course of his long career Murray has never quite had a role as good as the one he played in *A Taste of Honey*. Richardson was bisexual and died of AIDS, and one can only speculate as to how this affected his extremely sympathetic treatment of Melvin's gay character, an approach which at the time was very rare. Throughout the film Richardson and Delaney seem to poke gentle fun at sexism, racism, and stereotypes.

There seems to me a taste of Truffaut in *A Taste of Honey*, which was not untypical of British films of the period. The Brits were conscious of the international success of the French New Wave, and particularly the low-budget black and white films that were shot on location with unknown young actors. There is some parallel, I think, between Tushingham's dilemma and that of Jean-Pierre Leaud in *The 400 Blows* (1959), as both were estranged from the authority and values of parental figures. Although the slightly younger Leaud did not struggle with issues of race and gender, he was deemed antisocial and was determined to live as such. Both France and Britain were struggling to adjust to the postwar, post-colonial world, and cinema held up a mirror to their societies. The youthful rebellion that came out of this would emerge a few years later via the Beatles in *A Hard Day's Night* (1964).

Bryan Forbes's Whistle Down the Wind 1961

The 1960s were an important period in the history of English cinema, yet the decade is also hard to label or define. The classical directors were either gone or struggling to stay afloat: the Korda brothers (Alexander and Zoltan) were dead; Michael Powell remained active but had become less interesting; David Lean was working on three colossal international coproductions, but the impetus and money for these projects came mostly from Hollywood. Laurence Olivier was busy acting. Much of the quality output came from American émigrés such as Joseph Losey, Stanley Kubrick, Richard Lester, and Cy Enfield. The British social realists had flourished briefly, but they then drifted off towards less personal and more lucrative pursuits. Then there are the talented but somewhat amorphous directors like Clive Donner, John Schlesinger, and Bryan Forbes (1926–2013), who might not be considered authentic auteurs.

Whistle Down the Wind was Forbes's first directorial effort, although he had been acting since World War II. In it, an escaped murderer (Alan Bates) hiding in a barn is discovered by children who think he is Jesus Christ. The film's premise is so fragile that Bates's strong performance is all that holds it together. In the sixties Forbes caused a brief stir with this film, *The L-Shaped Room* (1962), *Séance on a Wet Afternoon* (1964), and a few other ones later in the decade. His adaptation of *The Stepford Wives* (1975) became a minor classic, developing a cult following and spinning off several sequels. Forbes was a frequently published author of novels and memoirs, and there is a certain literary quality to the best and earliest of his films, which he generally wrote himself. Though he had a flair for directing actors, as one critic suggests of *The Whisperers* (1966), the direction in many of his films is "too restrained to be really absorbing." This gets at the heart of Andrew Sarris's rather harsh dismissal of Forbes: "always nibbling at nuances, always straining for subtlety… perpetually pursues the anti-cliche only to arrive at anticlimax." In addition to *Whistle Down the Wind*, he directed another dozen films over the course of his career before retreating to television for his three final decades.

By the time of *Whistle Down the Wind*, Hayley Mills was already a child star thanks to Walt Disney. She was the daughter of John Mills, who would star opposite Ralph Richardson and Peter Sellers in Forbes's madcap *The Wrong Box* (1966), a nineteenth-century black comedy ostensibly based on a Robert Louis Stevenson

story. Her mother, Mary Haley Bell, wrote the novel that *Whistle Down the Wind* was based on. Like many child stars, Mills had a certain girlish charm that did not carry over into adulthood. Although Mills continued working after *Whistle Down the Wind* – she appeared in Ronald Neame's *The Chalk Garden* (1964), Ida Lupino's *The Trouble with Angels* (1966) and *The Moon-Spinners* (1964), a film that created the unlikely pairing of Eli Wallach and Pola Negri – her career failed to blossom after the 1960s.

Alan Bates, on the other hand, remained a prominent figure for decades after his breakout role in *Whistle Down the Wind*. He went on to appear in films directed by Losey, Donner, Lester, Schlesinger, Michael Cacoyannis, Franco Zeffirelli, Ken Russell, Paul Mazursky, Lindsay Anderson, Philippe de Broca, Robert Altman, and even Harold Pinter. The history of British film in the 1960s and 1970s is unimaginable without Bates. Yet while Forbes and Mills were nominated for BAFTAs, Bates was not. Like Burt Lancaster and Paul Newman in America, he remained mostly underrated, perhaps as punishment for his good looks.

Lindsay Anderson's This Sporting Life 1963

Lindsay Anderson (1923-1994) directed more than a dozen short films between 1948 and 1959, of which *O Dreamland* (1953), the Oscar-winning *Thursday's Children* (1954), and *Every Day Except Christmas* (1957) are considered classics. During this early period, Anderson also created *Sequence* magazine along with Gavin Lambert, Karel Reisz, and others. Albert Finney, the star of Reisz's *Saturday Night and Sunday Morning* (1960), worked on the stage with Anderson, and he likely introduced the director to Reisz. Along with Tony Richardson, this "Free Cinema" group nudged British film in a new, less classical and class-bound direction that is generally referred to as social realism. Up to a point, this paralleled the proletarian instincts of the French New Wave, which was surging around the same time. The main impetus of *Sequence* was to react against the tradition of quality English films (for example, those of Michael Powell, David Lean, and Alexander Korda), much as the young critics at *Cahiers du Cinéma* (François Truffaut, Jean-Luc Godard, Claude Chabrol, Jacques Rivette) were rebelling against postwar French films. Both groups expressed a strong preference for American films, and in Anderson's case, for

John Ford. Anderson summed up his personal aesthetic as such: "I think the most important challenge is to get beyond pure naturalism into poetry."

Anderson was an army brat of mostly Scottish descent born in India, and Reisz was a Czech refugee. Although they both had traditional upper-middle-class British educations (Anderson went to Oxford and Reisz went to Cambridge), they both shared a sense of being outsiders. Following in the footsteps of his father and grandfather, who both served the Empire, Anderson volunteered for the army during World War II. (One of his favorite Ford films was the 1945 PT-boat epic, *They Were Expendable*.) When I had the privilege of spending time with Anderson around 1980, he was a charming curmudgeon, and I suspect military discipline was not his cup of tea. During this period, Lindsay was at MoMA's Film Study Center researching the book he was writing on Ford, which would ultimately be dedicated to his friend and biographer Gavin Lambert, among others.

The book is erudite yet cantankerous. Unlike nearly all Fordians, Lindsay (for whom "style is the essence") had a low opinion of the director's 1956 masterpiece, *The Searchers*, preferring the unpoetic and marginal *Tobacco Road* (1941). In the interest of full disclosure I'll say I was touched that Lindsay quoted at some length my comparison of Ford's early *Just Pals* (1920) with D. W. Griffith's rural romances, agreeing with my assertion that *Just Pals* "exhibits some of the same brilliance at being simultaneously naturalistic and poetic." I'm also quoted elsewhere, but I'll spare you that. In any event, Anderson remained devoted to Ford and his circle, even using Harry Carey, Jr. in one of his last and best films. *The Whales of August* (1987) was shot on an island in Maine, and in addition to Carey, Anderson cast the two great but feuding stars, Lillian Gish and Bette Davis, as two feuding sisters.

In *This Sporting Life*, Richard Harris plays a rough-and-tumble former coalminer who becomes a professional rugby player and makes the lives of those around him more difficult. Although he had already appeared in seven films, *This Sporting Life* enabled Richard Harris to make his mark. His performance was nominated for an Oscar and won a prize at Cannes, and he went on to act in films as desolate as Michelangelo Antonioni's *Red Desert* (1964) and Clint Eastwood's *Unforgiven* (1992) to ones as regal as Joshua Logan's *Camelot* (1967) and Ridley Scott's *Gladiator* (2000), in which he played the respective parts of King Arthur and Marcus Aurelius. David Storey (who would work with Anderson on *In Celebration* in 1975) based the screenplay of *This Sporting Life* on his own novel, and Harris's Frank Machin is a rugby player as

rough off the field as on it. (Harris and Storey were rugby players in real life.) Both Joseph Losey and Reisz had passed on directing the picture – Reisz wound up producing it – and the team of Storey and Harris created a sense of verisimilitude that the nonathletic and mild-mannered Anderson could not have mustered on his own. Anderson did bring his passion for his documentaries to the film, and there is an authenticity to his scenes of northern England and of the playing field. Anderson went perhaps farther than his contemporaries in capturing the rawness of British life at the period. One does, indeed, get the sense that Harris is playing a character close to his real persona. In his diary, Anderson confessed to having had a crush on his star, which, in his mind, endangered his ability to properly detach.

John Schlesinger's Billy Liar

1963

John Schlesinger (1926–2003) represents something of an anomaly in postwar British film history. Neither a classicist like David Lean or Carol Reed nor a rebellious leftist like Karel Reisz, Tony Richardson, or Lindsay Anderson, much of Schlesinger's success came from his forays into Hollywood, which included the Oscar-winning *Midnight Cowboy* (1969), *The Day of the Locust* (1975), and *Marathon Man* (1976). (Appropriately, having gone Yankee, he died in Palm Springs.)

At his core, Schlesinger remained solidly British. After acting in films like Michael Powell's *Oh… Rosalinda!!!* (1955), his first feature was *A Kind of Loving* (1962), a film about a lower-middle-class couple forced to marry by an unintended pregnancy. This was the closest he would come to the kitchen sink realism that prevailed in British cinema at the time. Following *Billy Liar*, he directed *Darling* (1965), a "romance" set among London's unreliable mod mob, which made Julie Christie one of the brightest of stars of the era and won her an Oscar. In his attempt to deal with the "mod" scene, the openly gay Schlesinger was fortunate to collaborate with Frederic Raphael, who two years later would write the exquisite *Two for the Road* for Stanley Donen, which starred Audrey Hepburn and Albert Finney. Raphael also penned the script for Schlesinger's backward glance at England, a highly credible adaptation of Thomas Hardy's *Far From the Madding Crowd* (1967), which cast Christie and Peter Finch, who after thirty years in movies was finally

coming into his own. Finch would go on to star in the director's gay-themed (and, once more, "mod") *Sunday Bloody Sunday* (1971) and, of course, Sidney Lumet's *Network*, which won the actor a posthumous Oscar.

Billy Liar (Tom Courtenay) is a conventional young man leading a conventionally boring life – except when he escapes into graphic fantasies, which Schlesinger illustrates. (Writer Keith Waterhouse, who worked on Schlesinger's 1962 film *A Kind of Loving* and later adapted his novel about Billy for a television series, got his start in film with Brian Forbes's *Whistle Down the Wind*.) *Billy Liar* was rather savagely attacked by Andrew Sarris upon its release. In *The American Cinema*, Sarris sums up his feelings by saying Schlesinger "lacks the directorial coherence to tie together his intermittent inspirations." However, the dean of auteurist critics somewhat mitigates his review with two rather prophetic observations: that "Schlesinger is obviously a man to watch for future awards," and that the director deserves enormous credit as the discoverer of "a poetic apparition professionally known as Julie Christie." Sarris would later wax ecstatic on "the most beautiful actress on the screen today" in reviews of films like *Darling* and David Lean's *Dr. Zhivago* (1965), which also features her *Billy Liar* costar Tom Courtenay.

Personally, I like *Billy Liar*. Christie and Courtenay – then coming off his startling debut in Richardson's *The Loneliness of the Long Distance Runner* (1962) and about to make Joseph Losey's masterpiece, *King and Country* (1964) – remind us that whatever Schlesinger's flaws and inconsistencies are, he was a superb director of actors. The fantasy moments stand in clear contrast to the social realism that prevailed at the time, even in Schlesinger's own *A Kind of Loving* (1962). There are lyrical passages very similar to the intermittent street scenes of the early French New Wave. Schlesinger seems to be saying that escape into fantasy is a viable way of dealing with the drabness of contemporary British life. Maybe he was on to something. What, after all, was the swinging scene, with its miniskirts, Beatles, and Stones, if not fantasy? Or, maybe I just like the film because I have cat named Billy, who has a rich fantasy life but never, ever lies.

Peter Brook's Lord of the Flies 1963

Peter Brook is generally thought of as one of the most innovative theater directors of the past century, and he

has been directing for the stage for the majority of that century, over seventy years. His contributions to film are usually minimized, however, and in fact, he all but abandoned the medium in 1990. Before that, he made a dozen or so films, often adaptations of stage work. His collaboration with Paul Scofield on *King Lear* was superb, and I had the good fortune to see both his Tony Award-winning stage production and his film version of Peter Weiss's truly mesmerizing and revolutionary *Marat/Sade.* This being said, *Lord of the Flies* strikes me as especially cinematic. Brook seemed to thrive on being in a real environment with juvenile nonactors improvising dialogue; the resulting film is almost semi-documentary. Brook is faithful to the spirit of William Golding's novel, but one also senses the presence of imaginative producer Lewis M. Allen, who would go on to produce films like François Truffaut's *Fahrenheit 451* (1966) and Carroll Ballard's *Never Cry Wolf* (1983), as well as a 1990 remake of *Lord of the Flies.*

 Lord of the Flies was William Golding's first novel, and its lineage clearly comes from Shakespeare's *The Tempest.* The novel's "Beast," the mysterious creature that terrorizes the schoolboys stranded on an island after a plane crash, is an obvious descendant of Caliban. (Julie Taymor's film of the play is shot on a craggy island resembling Brook's.) Brook, like Golding, is somewhat obsessed with history and mythology. In 1964, a year after *Lord of the Flies*, he presided over the Royal Shakespeare Company's "Theatre of Cruelty Season," which was rich with the ideas of Antonin Artaud and featured *Marat/ Sade*, Brook's take on Sade's famous recreation of the anarchic French Revolution during his incarceration in the lunatic asylum of Charenton. (The Brook production, which incorporates some very memorable music, also owes much to another of his predecessors, Bertolt Brecht.)

 Lord of the Flies, of course, is about anarchy and how that thin veneer we refer to as "civilization" can be threatened by the clarion call of bestiality and hatred. In some sense, Golding and Brook seem to invoke H. G. Wells's novel *The Island of Dr. Moreau*, and specifically Erle C. Kenton's 1933 film version of the book, *Island of Lost Souls.* In that movie, Charles Laughton's mad experiments physically transform his victims into half-beasts, prompting Bela Lugosi to plead, "Are we not men?" In *Lord of the Flies*, no surgery is necessary. The lack of immediate adult supervision and the presence of primeval fear are enough to bring out adolescent fascism in nearly all the boys.

 Frankly, rereading the book and re-watching the film, I couldn't help thinking of the parallel events transpiring in Congress during the Obama administration, where there seemed to be no adult authority. In the movie, there was a gradual tendency among the boys toward nudity. Fortunately for all of us, we have been spared this in Congress… so far. The next step, however, might be following the boys towards their embrace of war paint. As Golding says, Ralph's regressing band of "civilized" boys "understood only too well the liberation into savagery that the concealing paint brought." Ralph tells Jack, his fascistic rival, "You aren't playing the game." The game, ultimately, is majority rule and fair play, and Golding's book and Brook's film — as well as the actions of Congress — remind us how dangerous and tenuous that can be.

Robert Rossen's The Hustler 1961

Robert Rossen was a victim of the blacklisting witchhunt of the 1950s, an experience that apparently contributed to his early death at fifty-seven. Rossen became a Communist Party member when he moved to Hollywood while still in his twenties. Like Elia Kazan, Rossen wound up naming other Party members, but unlike Kazan, neither his career nor his health fully recovered. He hit a peak with his 1949 adaptation of Robert Penn Warren's Pulitzer Prize-winning novel *All the King's Men*, which won the Oscar that year for best picture. *The Hustler*, with nine Oscar nominations, was a major comeback after a decade-long interruption.

 Rossen started out at Warner Brothers, and made an enemy of Jack Warner through his work with the writers' union. He scripted antihero roles for actors such as John Garfield, James Cagney, and Humphrey Bogart. Paul Newman's hustler, Fast Eddie, is a poolshark who challenges the legendary Minnesota Fats, played by Jackie Gleason. In a sense, the Newman character is a successor to Rossen's 1930s antiheros. Newman reflects the contemporary American malaise, but with a bit of the twinkle that was then reflected in brand-new president John F. Kennedy. Newman is close to perfect in the role, although he had to wait a quarter-century until he would win an Oscar for the role — and that was in Martin Scorsese's *The Color of Money* (1986). It has been argued that *The Hustler* is partly an autobiographical confession by Rossen, an act of penance for something that perhaps resembled Fast Eddie's betrayal of a woman who had helped him.

 The Hustler often seems slow-paced, allowing the audience to savor the performances. It's also beautifully photographed and more visually striking than

most of Rossen's work — one of the two Oscars the film won was for Eugene Schuftan's cinematography. (Schuftan, as Eugen Schüfftan, had been a central figure in Weimar German and pre-World War II French film.) In terms of the actors, this was Gleason's first theatrical film. Of course, he generally did not play serious parts, and my view is that of all the television comedians of the period, he came closest to the quality of Charlie Chaplin and Buster Keaton. *The Hustler* provided Piper Laurie with the opportunity to prove she could move beyond roles opposite swashbuckling Tony Curtis or Francis the Talking Mule. She received an Oscar nomination and then retired for fifteen years before coming back to earn another nomination for her role in Brian De Palma's *Carrie* (1976). George C. Scott had already established himself in Otto Preminger's *Anatomy of a Murder* (1959), and only made one more film prior to that. He would soon help destroy the world as General Ripper in Stanley Kubrick's *Dr. Strangelove* (1964), and would later repopulate it as Abraham in John Huston's *The Bible* (1966).

By 1961, Rossen had proven himself to be a formidable director of actors. He had previously directed Dick Powell in *Johnny O'Clock*, Garfield in *Body and Soul* (both 1947), Broderick Crawford in *All the King's Men*, Anthony Quinn in *The Brave Bulls* (1951), Richard Burton in *Alexander the Great* (1956), and Harry Belafonte in *Island in the Sun* (1957), with its courageous acceptance of miscegenation. Although he also had success with actresses — he worked productively with Mercedes McCambridge in *All the King's Men*, Joan Fontaine in *Island in the Sun*, and Laurie in *The Hustler—* he had problems with Jean Seberg on his last film, the somewhat underrated *Lilith* (1964), which he made while in declining health.

Considering that he was only fifty-three when he made *The Hustler*, we were denied many films by Rossen's early demise. All in all, his career is admirable for its seriousness and intermittent successes, but sadly and hardly uniquely, it was blighted by running afoul of politics.

Elia Kazan's America, America

1963

I first wrote about Elia Kazan's *America, America* in 1971 for MoMA's Kazan retrospective; in 1977, I did a program note on it for our "Films from the Archives" series. During that decade I also had the opportunity to interview Kazan

twice, and thirty years later I introduced his work at a memorial screening of *America, America* at the Gramercy Theater. My opinion of this film as his most personal work, and possibly his best, hasn't changed much in all that time.

The book *America, America* was the first in a series of popular and generally acclaimed novels that Kazan wrote later in life as filmmaking and fundraising became more demanding. It is based on the real experiences of his uncle, whose adventurous trip to America eventually transported Elia and the rest of his family from Anatolia to the Statue of Liberty. Kazan had filmed his friend John Steinbeck's novel *East of Eden* with James Dean in 1955, and I think one point of reference for Kazan's adaptation of *America, America* was John Ford's take on Steinbeck's *The Grapes of Wrath* (1940). The cinematographer on that film was Gregg Toland, who had worked on *Citizen Kane* (1941) and *The Long Voyage Home* (1940).

Ford was Kazan's hero and colleague at Twentieth Century-Fox in the forties, and I find many parallels between *America, America*, which was photographed by Haskell Wexler of *Medium Cool* (1969) and *Bound for Glory* (1976), and Ford's *The Grapes of Wrath*. The films share starkly spectacular black-and-white photography, a picaresque structure, an emphasis on the fundamental human value of family, and a quasi-religious belief in the enduring myth of America. Ultimately, through the character of Stavros (played by Stathis Giallellis and based on the director's uncle), Kazan also acknowledges his roots in classical Greek culture.

Like his "god," Jean Renoir, Kazan is a masterful portrayer of human frailty. Stavros, ambivalent and sometimes amoral, is "washed clean" only by his arrival in America. The director's gentler side comes out in scenes with Stavros's friend, Hohanness, in which the boys exchange acts of kindness and sacrifice. The ultimate achievement of *America, America* does not lie in its extraordinary narrative or its eloquent imagery, but in the emotional resonance of Stavros's experience. Kazan tells us: "He saved himself." This is the story of tens of millions of relatives who saved themselves, and by extension, us. My paternal grandfather deserted the Czar's army to reach Ellis Island in 1904. He never learned to read or write English, but his descendants all benefited from his journey. Our ongoing headlines about "undocumented aliens" tell us that the story of *America, America* has not ended. Even now, as is repeated at the end of the film, there are "people waiting."

Regarding Kazan, I'd like to quote from my introduction to the first interview I conducted with him in 1972, which he ended somewhat unceremoniously:

"Come on, go. You've got enough for a fucking interview."

He is perhaps the archetypal New York intellectual of his generation. He has succeeded in a fistful of art forms. He has dabbled in politics, and he has gotten its angry fist smashed in his mouth. He has never made and never will make a deathless masterpiece of the stature of **The Rules of the Game***, which he so admires. Kazan's films have too much of the frenzied smell of crotch and armpit about them to attain the sublimity of vintage Renoir. Yet, the two men are not so far apart as it might seem. Renoir may put it lovingly, while Kazan ejaculates, but both men know that in the end, we are little more than tender lumps of protoplasm, vulnerable — almost pitiable — but able, in off-moments of drunken gaiety or melancholic sobriety, to experience that most godlike of human feelings, able to be touched by another shivery soul.*

Emile de Antonio's Point of Order 1964

In the 1960s, there were two new developments that impacted documentary film production. One was the growing influence of television, with its increasingly widespread access to a large audience, its relative inexpensiveness, and its changing technology, which made it easier for filmmakers to shoot in far-flung locations. Although newsreels and documentaries had been part of movie history from the beginning, they were often the products of establishment producers like The March of Time, Office of War Information propaganda films, or were produced by studios like Fox or Disney.

The other new tendency was the opportunity for independent polemicists, largely leftists, to use film to educate and try to persuade the public. Building on the European propaganda films of the 1930s (Leni Riefenstahl's Nazi *Triumph of the Will*, 1935; Joris Ivens's Communist *The Spanish Earth*, 1937; and others) the U.S. government produced films like Pare Lorentz's *The River* (1938), in support of the Tennessee Valley Authority, and Frank Capra's *Why We Fight* series (1942-1945) in support of America's war effort. Leo Hurwitz and Paul Strand had made *Native Land* (1942) and *Strange Victory* (1948), but Emile de Antonio's *Point of Order* began something new.

De Antonio (1919-1989) had a checkered history that ranged from time at Harvard to stints as a dock worker and a river barge captain. His entry into film was somewhat accidental. At a time when French directors

were making a case for cinema verité, De Antonio was unabashed about his progressive tendencies, and had no pretense of objectivity. (In this, he prepared a path for Michael Moore, among others.) In his eyes, "objectivity simply doesn't exist." He would argue that directing the camera, making cuts in the editing room and so on all reflect individual choices. In this, De Antonio is more aligned with auteurists than with documentary purists who think they are capturing unadulterated "truth" in their work, a notion he referred to as a "lie" and a "joke."

The idea for *Point of Order* apparently came from Dan Talbot, the exhibitor and film distributor who was a kind of patron saint of New York movie-lovers. The "Army-McCarthy" hearings a decade earlier had an enormous impact on television viewers unused to a close-up view of their government's (dis)function. My friend Richard Barsam, in his book *Nonfiction Film: A Critical History*, suggests that De Antonio's skilful editing and structuring of the raw material is critical of both Senator McCarthy and the U. S. Army, which the Senator said was riddled with Communists. Ultimately, as Barsam points out, the film "provides a vivid portrait of what happens when power is fueled by paranoia." The Senate turned on McCarthy when the fraudulence of his claims and the recklessness of his behavior became apparent. There is no question that De Antonio manipulated the material to reflect his viewpoint, but the film was more a celebration of McCarthy's downfall than the cause of it. America's perception of reality eventually coincided with the director's.

If De Antonio had gone to central casting he could not have come up with a worthier group of performers. Roy Cohn, McCarthy's legal assistant who was accused of trying to get special favors from the Army for his wealthy friend G. David Schine, was less sympathetic than a hungry zombie on *The Walking Dead*. Barely seen is Cohn's associate, the youthful Robert F. Kennedy, then still heavily influenced by his father's right-wing politics. Army counsel Robert Welch is like a good guy out of a Frank Capra movie — think Harry Carey in *Mr. Smith Goes to Washington* (1939) — and ultimately shames McCarthy for his recklessness: "Have you no sense of decency, sir? At long last, sir, no sense of decency?" (The HUAC/McCarthy witchhunt has been blamed for numerous suicides, including, apparently, the father of New York Mayor Bill de Blasio.)

As for tail-gunner Joe, he remains thuggish but somewhat inscrutable. Was he simply out to elevate himself, or did he have even a tiny modicum of delusion that there was a genuine "red menace" in the Army and

other American institutions? I doubt we shall ever know, and we are left with something akin to A. N. Wilson's assessment in *The Victorians* that "politics… does not attract deep minds." Yet McCarthy was, in some circles, something of what we might today label a rock star.

Frederick Wiseman's Titicut Follies 1967

There were many significant developments in the field of documentary filmmaking in the decades following World War II. The nature documentary pioneered by Robert Flaherty was followed shortly after his death by the color masterpieces of Captain Jacques-Yves Cousteau, *The Silent World* (1956) and *World Without Sun* (1964). The political polemics of Emile de Antonio and social concerns of Lionel Rogosin provided a new perspective on filmic truth. As a counterweight to this was the cinema verité movement, the offshoot of Soviet documentarian Dziga Vertov. In France there was Chris Marker and Jean Rouch. In America, we had Richard Leacock (formerly an assistant to Flaherty), D. A. Pennebaker, Robert Drew, and the Maysles brothers.

Several years ago, Joe Nocera wrote a column in the *New York Times* commemorating "the grand old man of documentary filmmaking." He was referring to Frederick Wiseman, and the occasion was the director's latest film, the four-hour *At Berkeley*. *Titicut Follies*, his first film, runs only 84 minutes. If one had to categorize Wiseman, he probably belongs with the verité directors, but there is a special flavor to much of his work. No other filmmaker seems to totally immerse himself in whatever subject he is dealing with, whether it's theater, dancing, boxing, animals, schools, or small towns. His cinematic world seems to encompass all of our world. Wiseman goes into great detail in examining his subject matter, often lingering over things that add to the milieu but can seem excessive. At times, I have half-jokingly suggested that Wiseman perhaps goes too far, is too inclusive. Part of me longs for a stronger editorial voice, somebody who provides a more personal touch like the great auteurs of narrative film: Jean Renoir, Charlie Chaplin, John Ford, and so on. Still, Wiseman's output is unique and to future scholars of our time will serve as a treasure trove of documentary images on "how we live now."

Titicut Follies grew out of Wiseman's visits while a law student to Bridgewater State Hospital in Massachusetts, a facility for the criminally insane. The director had already produced Shirley Clarke's *The Cool World* (1963), shot on the mean streets of New York, so he was not a complete novice at filmmaking. The denizens of Bridgewater, of course, provided rich and charismatic subject matter — too rich for contemporary tastes, it turns out. Audiences of the time were not ready for such raw images of reality. Lengthy court battles ensued in which the state of Massachusetts prevented the film from general release until 1991. Wiseman had secured permission from the inmates at the time of filming, but their nudity and brutal treatment were deemed unacceptable in certain political and judicial circles. (These practices — as well as others, like force-feeding — have apparently become standard since 9/11.) In any case, Wiseman's style of "direct cinema" documents what happens in front of the camera without any narrative commentary. In the case of *Titicut Follies*, nothing needs to be said. Wiseman has explicitly attacked cinema verité, which claims to be showing the undistorted truth, as a "pompous French term." Direct cinema, by contrast, acknowledges the manipulative influence of the filmmaker in shaping the material.

Lest Wiseman be accused of simply letting his camera roll (as Andy Warhol, who Wiseman has criticized, sometimes seems to do), it's worth noting that he is highly selective about what he releases in the final versions of his films. For example, he shot more than two dozen times the footage needed for his four-hour film *Belfast, Maine* (1999). Wiseman also argues that although he has a point of view and will unavoidably manipulate things during the editing process, his distillation is "fair" to his subjects. *New Yorker* critic David Denby echoes this view: "Wiseman… is free of the usual vanities and delusions. His clarity is temperamental and pragmatic; he's sure that he can't afford to be stupid. Yet this toughness is not accompanied by the usual cynicism and derision expressed by people who pride themselves on never being taken in. Hope lies in the underbrush of his movies too." Personally, I am glad we have a Fred Wiseman, but I must confess that I might pause before committing to watch a four-hour film on a subject I find less than fascinating.

Martin Ritt's Hud 1963

The Hollywood and television blacklist in the HUAC/ McCarthy era of the 1940s and 1950s had many victims. Perhaps the most talented of those directors affected was

Joseph Losey, whose exile to England resulted in a blossoming that might not have occurred if he had been able to continue his career in America. Losey was also atypical in other ways. Many of the men who had been implicated as communists were New York Jews. We tend to forget that leftism was widespread and up until the end of World War II was more or less acceptable in a country reeling from the Depression. For a time, Stalin portrayed himself as anti-Nazi, and great artists like the black superstar Paul Robeson and, to a lesser degree, the Jewish Edward G. Robinson and John Garfield were identified with left-wing causes. Among the major directors on this side of the political spectrum were Abraham Polonsky, who was banned from directing because of 1947's *Force of Evil* (starring Garfield) and did not release any films until 1968's *Tell Them Willie Boy Is Here*; and Robert Rossen, who was banned for four years after his Oscar-winning *All the King's Men* (1949), but allowed to resume his career after "naming names."

Martin Ritt (1902–1990) had been an associate of Elia Kazan at the New York Group Theater, and wound up as a television director. He arrived in Hollywood at the age of fifty-five after having been blacklisted from TV for six years. His first film was *Edge of the City* (1957), a somewhat politically charged successor to Kazan's *On the Waterfront* (1954). Before *Hud*, Ritt had already made three films with Paul Newman, one of the most marketable stars of the period, and they would be united twice more.

In a *New Yorker* article, John Le Carré, whose *The Spy Who Came in from the Cold* was adapted by Ritt for to the screen, described his colleague as "an accomplished director of great heart and daunting life experience." Ritt always maintained his quasi-Marxist pursuit of justice and fairness, and in later works — *The Great White Hope* (1970), *Sounder* (1972), *The Front* (1976), and *Norma Rae* (1979), among others — this became explicit. *Hud*, a film devoid of much overt political content, is more of a character study, set far from the urban environments where Ritt seemed most comfortable. With its beautiful widescreen cinematography shot by the great James Wong Howe in Texas's open spaces (Howe won his second Oscar for the film) *Hud* anticipates Peter Bogdanovich's adaptation of Larry McMurtry's *The Last Picture Show* (1971), which also depicts a declining way of life in a changing America.

Hud is an actor's film in that it displays the director's genuine gift for extracting superb performances. One presumes that the character closest to Ritt's heart was that played by Melvyn Douglas, the now-elderly erstwhile leading man of Marlene Dietrich and Greta Garbo. Douglas won the first of his two Oscars for his performance as the

principled owner of a cattle ranch. (He, too, had been a longtime advocate of liberal causes and was married to actress-turned-Congresswoman Helen Gehagan, one of the favorite targets of Richard Nixon during his rise to power.) By the end of the film, Homer Bannon (Douglas) is as ruined as his visage, but he maintains a stoic dignity, determined to do the right thing by his fellow man. Paul Newman, his renegade son, is his antithesis, and Ritt exploits the actor's cynical twinkle. Patricia Neal also won an Oscar, and she exudes a restrained eroticism that made her one of the best actresses of the period, however underappreciated she may have been for too much of her career. Elia Kazan was a great director of actors, and *Hud* marks Martin Ritt as one of his most gifted disciples.

The New Social Documentary and Television 1960–1962

Documentary films existed from the very beginning of cinema. Even before it occurred to filmmakers to manipulate their own images, still photography had provided a model for capturing the real world. It didn't take long for these "artists" to realize that reality could be shaped by where they placed a camera, how a shot was lit, and whether the frame might be moved or intercut with other shots. Ostensible actuality and authenticity were conditioned by personal points of view — this was nascent auteurism, if you will.

Gradually, this artistry outgrew the brevity and primitiveness of the Lumière brothers' films and became a genre unto itself, developing alongside the fictional narratives of pioneers like Georges Méliès, Edwin S. Porter, and D. W. Griffith. Filmmakers could take their cameras to the equator or the poles and bring back the wonders of the world. They could also juxtapose the images they shot into a narrative that was superficially truthful but argued for a particular set of principles, and the resulting propaganda could (arguably) pass for truth. With the development of television, a whole new market became available for these kinds of films, and in recent decades it has been vastly augmented by the growth of cable.

In the 1960s these filmmakers made little pretension to art, and their films are less memorable than more ambitious documentary works, including Emile de Antonio's polemics, Chris Marker's "verité," and Frederick Wiseman's immersive cinema. Filmmakers were constrained by cumbersome equipment, and also by the

restraints of funders, which prevented them from going too far in offending or provoking. Occasionally, documentarians did arouse controversy, but non-mainstream points of view were still held in check. These films did, however, point in a direction that is still with us. In 2014, PBS's *Frontline* ran an exposé of life in North Korea, containing mostly jumpy footage that was secretly filmed at great risk. Two of the best documentaries of 2013 were *Blackfish* and *Roman Polanski: Odd Man Out* (a sequel to the earlier *Roman Polanski: Wanted and Desired*). *Blackfish* chronicled the alleged mistreatment of orcas at Sea World, and after a theatrical run, it was shown repeatedly on CNN. Similarly, the Polanski documentaries, which argued that the director was badly treated by both the American and European legal systems, were shown on cable. These films skillfully interweave existing footage and commentary to present their cases.

Essentially the same techniques were used in two Willard Van Dyke television documentaries, *Ireland: The Tear and the Smile* (1961) and *So That Men Are Free* (1963). In 1965, Willard became the head of the Department of Film at MoMA, where he hired me. Although he had been making films for three decades, as he entered his seventh decade he seemed content with a desk job and the pursuit of still photography. (Van Dyke had been a protégé and close friend of Edward Weston.) In two films made for CBS's *The Twentieth Century*, he used the iconic Walter Cronkite as a talking head. Although it's hard to argue that Van Dyke was an auteur, his films over the years do reflect a progressive and humanistic bent. Though he later made films for big businesses, he had been an ardent New Dealer and worked with Pare Lorentz, with whom he later had a falling out. As historian Erik Barnouw has pointed out, Willard had been part of the left-wing Film and Photo League in the early years of the Depression, but *Ireland*, thirty years later, was exemplary of a "play it safe trend" at the broadcast networks.

George Stoney, on the other hand, seemed relatively consistent in his liberalism, and *You Are on Indian Land* (1969) is a clear example of using cinema as an instrument for social change. The handheld camera, however "inartistic," lends a sense of immediacy. The film was made for the National Film Board of Canada, and it openly showed disputes between Native people and police over territory. Of course, by the end of the 1960s, the Civil Rights movement and the Vietnam protests had opened up film and television to less "tasteful" portrayals of political realities. American rebellion had crossed the border into Canada, and Stoney and his Native compatriots were there to film it. As Richard Barsam has

written, "Stoney's work is marked by a concern for the disadvantaged, especially blacks and native Americans."

I would not argue that Van Dyke or Stoney were major auteurs, nor were they even singular figures, but they both helped expand the medium by pushing the documentary movement into provocative new territory.

Roman Polanski's Knife in the Water 1962

Roman Polanski's life has been so complex that it often obscures the fact that he is one of the most successful and idiosyncratic filmmakers of the last half century. He accomplished all that he did in spite of living under extreme circumstances: He spent his childhood as a fugitive hiding from the Nazis in the streets of Krakow and later in the Polish countryside; his mother died in a concentration camp; he was creatively suppressed for many years while living in Communist Poland; his wife, Sharon Tate, was murdered by the Manson gang; and he has been stuck in legal limbo for more than four decades after sexually abusing a minor. (The latter period was documented in Marina Zemovich's two films, *Roman Polanski: Wanted and Desired*, 2008; and *Roman Polanski: Odd Man Out*, 2012). Polanski has said movies "are my life's blood." As I wrote at the time of MoMA's Polanski retrospective in 2011: "Many of his films are infused with a mysterious, difficult-to-define sense of dread, which is understandable given much of his early life experience." His 1984 autobiography begins: "For as far back as I can remember, the line between fantasy and reality has been hopelessly blurred." I suggest that the director uses the fantastical elements of cinema to make sense of the extraordinary realities he has experienced.

There is a strangeness in the early shorts, and *Knife in the Water* exhibits the kind of menace that pervades almost all his films. That work, his thesis at the famous Łódź film school, was selected for the first New York Film Festival, nominated for an Oscar, and is probably the best student film ever made. In it, tensions arise when a young man accepts a couple's offer to join them for a sail in their small boat. Like Alfred Hitchcock, who is in some sense Polanski's stylistic mentor, the threat of chaos is always overlaid with wryly absurdist dark humor, and also like Hitchcock, Polanski is able to create something highly cinematic in a very constrained space using only a few characters. Both the

KNIFE IN THE WATER. DIRECTED BY ROMAN POLANSKI. 1962. POLAND.
BLACK AND WHITE, 94 MINUTES.

woman and the young man in *Knife in the Water* were
essentially neophyte actors. Although Polanski later
expanded his vision onto broad canvases in films like
Rosemary's Baby (1968), *Chinatown* (1974), and his Oscar-
winning and deeply moving Holocaust drama, *The Pianist*
(2002), the limitations placed on the director in *Knife in the
Water* bring about a virtual explosion of sexual tension.

Zygmunt Malanowicz, the film's somewhat
electrifying young boy, went on to have a long career,
working for distinguished directors like Jerzy Skolimowski
(who cowrote the screenplay for *Knife)* and Andrzej Wajda
(who helped Polanski get his start), but he never attained
the cult-like following of Zbigniew Cybulski, Wajda's James
Dean-like muse, who died tragically in 1967. Leon
Niemczyk, who played the role of the husband, was a
veteran of the Warsaw uprising against the Nazis, the U.S.

Army's occupation of Germany, and of struggles against
Poland's Soviet occupiers. Despite all this he had an
extremely long career. Jolanta Umecka, who plays the
female love interest, made only a few more films.

In recent years, Polanski has tried to raise funds
to make *D*, a thriller based on the Dreyfus affair, which
deals with anti-Semitism and witchhunts — subjects on
which he is well-versed.

Carl Theodor Dreyer's
Gertrud 1964

Carl Theodor Dreyer, like Orson Welles, is generally
considered one of the greatest filmmakers in spite of his
relatively small output over half a century. *Gertrud*, his
final and perhaps most personal film, is unlike most of his
earlier work.

Much of the director's career was devoted to religious and supernatural subject matter. His silent work culminated in *The Passion of Joan of Arc* (1928), arguably the greatest film made before the advent of sound. As in many of Dreyer's best works, the main protagonist in it is a woman. For the next quarter century, Dreyer's films were intermittent explorations of the occult: vampirism, witchcraft, coming back from the dead. Although directors like James Whale and Tod Browning sometimes dealt with similar material, the former tended to be whimsical and the latter mostly sought to entertain. Dreyer confronted these subjects head-on and with little humor. He only made five talking features (one of which he disowned) and a number of short documentaries, and it took him a whole decade to get support to make *Gertrud*, which he finally did at the age of seventy-five. (The great dream project of his career, a film about Jesus, was never realized.) *Gertrud*, like so many of his films, did not achieve a popular following. In fact, it was hooted at when shown at Cannes. Its solitary protagonist, Gertrud, is as uncompromising as Dreyer in maintaining her standards — she is unwilling to accept any of the men she has encountered in life because they have disappointed her.

One thing that differentiates *Gertrud* from Dreyer's other films is its emphasis on emotions that are unrelated to questions of faith and God. Gertrud is essentially unapologetic for her life, even when she disappoints others. (As Edith Piaf sings, "No Regrets.") Yet Dreyer himself led a life of some struggle. He was "illegitimate" and spent his early years in an orphanage. Although he was eventually adopted, it appears he was raised by an especially unloving couple, which portended a life of struggle. I don't know much about his married life, but as it became increasingly difficult for him to raise the funds necessary to make his films, he supported himself and his wife by managing a movie

GERTRUD. DIRECTED BY CARL THEODOR DREYER. 1964. DENMARK. BLACK AND WHITE, 119 MINUTES.

theater in Copenhagen. One suspects that although *Gertrud* is based on a play, the lead character expresses many of the director's own frustrations and satisfactions.

My colleague Jytte Jensen wrote of Gertrud, "She is concerned only with arranging to live out her life according to her strict adherence to her unique — and in Dreyer's world feminine — ideal. Love is all. The supremacy of emotions over power and fame finds its ultimate personification in *Gertrud*...." In his erudite monograph on the film, James Schamus argues that it is "a kind of remake of *The Passion of Joan of Arc*," Dreyer's other great depiction of an uncompromising woman resigned to her fate.

Stylistically, *Gertrud* is austere, containing only eighty-nine shots and few close-ups. However, as the great Danish scholar Ib Monty points out, the old director seems perfectly in synch with other younger major filmmakers of the 1960s. In fact, one could argue that *Gertrud* takes a leaf from Alfred Hitchcock's book. Filmmaking had historically been a contest between, on the one hand, montage directors like Sergei Eisenstein and the other Soviets reigning in the 1920s, and the long-take/moving-camera directors led by F. W. Murnau. Dreyer embraced both approaches. While *Joan of Arc* is famous for its spectacular close-ups of Renee Jeanne Falconetti, in *Gertrud* the frame is more inclusive, and the camera lingers, seemingly to capture the emotional resonance of what just transpired.

Dreyer is certainly not to everybody's taste, but it is hard to forgive the hostile disrespect the great director experienced at Cannes and occasionally faced elsewhere. I once saw *Gertrud* at an old "secret cinema" which had three-sided and roofed enclosures for each spectator. The only other person present was an older film scholar of considerable reputation. I was very disturbed that he spent the whole screening snickering. Clearly, Gertrud's conception of reality was not his, but as Dreyer said, "*Gertrud* is a film that I made with my heart."

Alfred Hitchcock's The Birds

1963

In his seminal study of Alfred Hitchcock, critic Robin Wood focuses on the director's career-long apprehension that civilization rests precariously on a very thin layer of what we accept as reality, which covers an underlying chaos. Although this theme is present in many of the director's films, it reaches its fullest fruition in *The Birds*. Hitchcock once suggested that the film was about the Day of Judgment, and in *The Birds*, Wood interprets this to mean "the value of life itself is on trial," and "that life is a matter of beating off the birds."

In the film, Melanie Daniels (Tippi Hedren) winds up in an isolated California coastal town where Mitch (Rod Taylor) lives with his mother (Jessica Tandy) and sister. Before long, the local bird population, for no apparent recent, turns murderous. In his *The Wrong House: The Architecture of Alfred Hitchcock*, a fascinating study of the location settings in Hitchcock's films, Steven Jacobs writes about the house Mitch and his mother live in under the chapter title "Life in a Cage." This nod at incarcerated birds implicates the deceased family patriarch, whose portrait dominates the living room and who still governs the lives of the Brenner family. In a sense, although Mitch rescues Melanie from the birds, the relationship between them rescues Mitch from his family.

There are, of course, parallels between Hedren's ascent on the staircase to the roof, where we know the birds await her en masse, and Martin Balsam's fatal climb to meet Mrs. Bates in *Psycho* (1960). Hitchcock, the self-styled "Master of Suspense," loved teasing the audience with expectations of what horrors he had lurking. This sardonic playfulness — which he encouraged with his personal appearances — did, however, mask the underlying seriousness of his mature films. In *The Birds*, nothing is fully resolved, and we are left dangling, not knowing whether the feathered ones will let the protagonists (and us) escape, or whether Armageddon is at hand.

Hitchcock was probably the most experimental of all the major auteurs, and he was assisted in making his ornithological masterpiece by Ub Iwerks and Albert J. Whitlock. The former was a major Disney animator who worked on the *Alice* series, and *Steamboat Willie* (1928). He briefly created some very clever cartoons on his own in the early 1930s, and won two Oscars for his special effects. Whitlock, who gave a great lecture at MoMA several decades ago on his use of matte painting, began a long career at Universal with the *The Birds*, later working on such films as *High Anxiety* (1977), *Earthquake* (1974), and *The Hindenburg* (1975). He collaborated with Hitchcock on four later films.

Two movies have been made about the strange relationships Hitchcock had with his leading ladies during shooting, and one dealt specifically with his infatuation with Hedren. I don't know (or much care) about this, but it is worth noting that they worked together again on

THE BIRDS. DIRECTED BY ALFRED HITCHCOCK. 1963. USA. 119 MINUTES.

Marnie (1964), and that much of the rest of her career was forgettable. Her birdlike performance is not. Similarly, Tandy never quite made it as a major figure in Hollywood, but his Sean O'Casey in Jack Cardiff's *Young Cassidy* (1965) — a film started by John Ford — is noteworthy. Tandy was mostly a stage actress — the original Blanche du Bois in *A Streetcar Named Desire* — though she later won an Oscar for *Driving Miss Daisy* (1989).

Daphne du Maurier's first two novels, *Jamaica Inn* and *Rebecca*, had been filmed by Hitchcock, and though Du Maurier was pleased by *Rebecca*, she was less happy with what he did with her short story, "The Birds." Hitchcock opened "The Birds" up and transposed the story from Cornwall to California. Of course, *Psycho* had been revolutionary in many ways, and the director was confronted with the task of meeting near-impossible audience expectations. *The Birds* came closer than any of his post-*Psycho* films in meeting the high standards he set for himself.

Ingmar Bergman's Persona 1966

I have long championed and preferred Ingmar Bergman's more narrative and linear films such as *Wild Strawberries* (1957) and *The Virgin Spring* (1960) over what I view as his more pretentious and solipsistic works. In some ways, however, *Persona* is uniquely able to bridge the gap between Bergman's world and ours by virtue of its dazzling expertise. As Andrew Sarris said, the film "seems to bewitch audiences even when it bewilders them. The perennial puzzle of What It All Means is quite properly subordinated to the beauty and intensity with which faces, beings, personae confront each other on the screen."

On one level, *Persona* seems to be a confession by Bergman about the ruthlessness of artists in using the suffering of real people as material for their work. An actress (Liv Ullmann) is sent to an isolated beach house with her nurse (Bibi Andersson) after she has a break-down and stops speaking. In a long monologue, the nurse reveals previous indiscreet behavior, and over the course of the film the women start to merge. Andersson graduated from the same theater school in Stockholm as Greta Garbo, and her many appearances in Bergman's films, beginning with *Smiles of a Summer Night* (1955), made her a star. By 1966, he doubtless knew all her secrets.

Norwegian by way of Japan, Canada, and New York, after *Persona* Ullmann made many more films with Bergman, with whom she lived for five years and had a daughter. So he knew Liv's secrets, too. (The 2012 documentary *Liv and Ingmar: Painfully Connected* chronicles their relationship. Narrated by Ullmann, the clips of Bergman's films are, in the words of reviewer Stephen Holden, "skillfully used to illustrate the shadowy line between art and autobiography.") After their breakup, Ullmann continued to work with Bergman, and had a reasonably successful career in films, directing, and stage acting. (I was privileged to see Ullmann in *Anna Christie* on Broadway with the star of the 1923 silent film version, Blanche Sweet, whose performance had been highly praised by Eugene O'Neill.) In her autobiography, *Changing*, Ullmann describes the living arrangement on Bergman's island, Faro. That was where *Persona* was shot, and according to her, the director's real-life setup strongly resembled the one in the film. In his own book, *Images*, Bergman wrote that in *Persona*, "I touched wordless secrets that only cinema can discover."

There are some suggestions of a homosexual attraction between the Andersson and Ullmann characters, especially in a scene where the two women

BLACK GIRL. DIRECTED BY OUSMANE SEMBÈNE. 1966. SENEGAL. BLACK AND WHITE, 65 MINUTES.

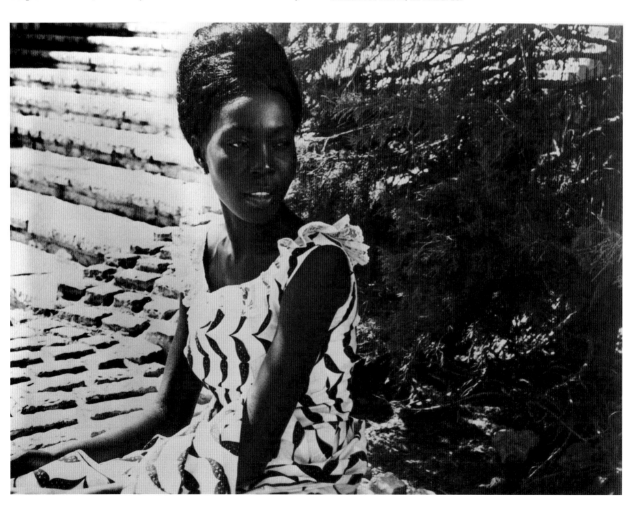

are peeling mushrooms. Daniel Humphrey, in his book *Queer Bergman*, points out that the director referred to himself in his journal as a "lesbian man," and that many of his films contain a degree of sexual ambiguity. Of course, he was married five times — not counting Ullmann — and fathered eight children. As with the many interpretations of *Persona*, you pays your money and you takes your choice. Directors as varied as Stanley Kubrick, Woody Allen, Robert Altman, and David Lynch have all paid homage to the film in their own work. Susan Sontag considered *Persona* the greatest film ever made.

Aside from the immaculate performances of the two stars in *Persona*, Sven Nykvist's documentary-style cinematography on Faro evokes Michelangelo Antonioni's island in *L'Avventura* (1960), with its foreboding sense of isolation and menace. In many ways, Bergman is questioning film itself, the medium to which he devoted his life. How much truth or reality can the camera show? How much can an artist reveal? And the question always with Bergman: how much "universal pain," as Robin Wood puts it, can the audience stand and understand?

Ousmane Sembène's The Wagoner 1963 and Black Girl 1965

Ousmane Sembène (1923–2007) of Senegal is considered "the father of African film." By the time he started making films at age forty, he had spent time deeply immersed in belief systems ranging from tribal religion to communism, had served in the military, and had worked as a long-shoreman in Marseille, among other things. He was also a prominent novelist in Senegal, but decided to study filmmaking at the Gorki Studios in Moscow thinking that, in a country where literacy was far from universal, he could reach a larger audience through cinema than books.

The Wagoner, a short film with a documentary quality, established Sembène as a director not afraid to pull punches, romanticize reality, or criticize his society. This twenty-minute film provides a slice of street life in Dakar; it's an actuality with no real plot. The deformed beggars who would play a crucial role in *Xala* a dozen years later are already here. Sembène does not shy away from depicting African problems out of fear that images of "backwardness" might play into the hands of racists. He is matter-of-fact about wealth disparity and the tragic waste of human life in Senegal's postcolonial

society. *Xala*, a 1975 film drawn from his novel, is very direct in its treatment of the lingering effects of tribal superstition and political corruption. Like Satyajit Ray in India, Sembène has a clear-eyed vision of a "backward" country struggling with modernity and Western values. In this later film, depictions of a polygamous wedding ceremony, witch doctors curing impotence, and an expectorating protagonist being humiliated are highly unflattering, but Sembène confronts them head on. Oscar Micheaux, the first black American director of note, was also willing to risk racial ridicule, as he did in 1925 when he cast Paul Robeson as a duplicitous holy-rolling preacher in *Body and Soul*.

Black Girl was Sembène's first feature. It, too, has a kind of documentary quality that is reinforced by its use of voiceovers, and could have easily been drawn from a contemporary account of a domestic worker leaving a developing country for a more affluent one. In it, Diouana, a young woman from Dakar, is hired by an affluent French couple to be a maid in Antibes. At times, perhaps, it is overdrawn, such as when the French housewife blatantly refers to the black girl as an animal. (One can't help thinking, however, of the naked hostility shown toward blacks a half century later in Steve McQueen's 2013 Oscar-winning *Twelve Years a Slave*.) Sembène also uses the soundtrack to let us hear characters' unspoken thoughts, as Eugene O'Neill did in *Strange Interlude* (filmed rather strangely thirty-three years earlier by MGM). Strikingly, Sembène directly addresses Diouana's suicide, which is depicted in flashbacks and takes place after she is forced to choose between her life in France and a return to poverty-stricken Senegal.

If the fundamental tenet of "auteurism" is the artistic expression of a director's innermost thoughts and passionate feelings, Sembène, albeit somewhat out of material necessity, counts as a thoroughly genuine auteur.

Roman Polanski's Repulsion
1965

Although his first feature, *Knife in the Water* (1962), was something of an international success, Roman Polanski's career plans remained uncertain after its release. He did not want to return to Communist Poland, and in spite of the fact that he had been born in Paris, he did not consider himself to be especially French. After three years of frustration, he made his first trip to

England. In James Greenberg's superb book, *Roman Polanski: A Retrospective,* the director says: "*Repulsion* was my discovery of London… I was suddenly overwhelmed by the Anglo-Saxon world: language, objects, sets, people. It was new to me and I was tremendously inspired."

Of course, the London Polanski depicts is not exactly a tourist's. The film is set mostly in an apartment where various grotesqueries occur as Catherine Deneuve has a breakdown, and city beyond it is compressed into quick sights and sounds. In some ways *Repulsion* is more claustrophobic than *Knife,* which centers on three people isolated in a boat. Even the scenes outside the apartment Deneuve shares with her sister — in a pub, in the beauty salon/torture chamber where she works — seem isolated, far from the swinging London of the time. Polanski bemoaned the limited resources at his disposal for this film, but these constraints may have contributed positively to the surreal effects of his imagery. (There is more than a touch of Polanski's film-school education in his nods to Luis Buñuel and Jean Cocteau.) Alfred Hitchcock made *Psycho* (1960) far more cheaply than some of his other films, but sometimes less is more. Deneuve's startling and primitive hallucinations might have been spoiled by a bigger budget.

My colleague, Dave Kehr, writes that the director "uses slow camera movements, a soundtrack carefully composed of distracting, repetitive noises… explicitly expressionist effects… to depict a plausible schizophrenic episode." Andrew Sarris argues that by "forcing the audience to share the girl's demented point of view, Polanski manages to implicate them in the irrational uncertainty of the plot." He continues, "What Polanski counts on is the fact… that we will somehow identify with the most perverted privacy rather than blow the whistle for the authorities." Although few of us might fantasize about wanting to kill Janet Leigh in the shower, Polanski's skills can make us hunger for Deneuve to murder at least one victim, just as we savor knowing what awaits Martin Balsam as he ascends the stairs in his search for Mrs. Bates. Perhaps seeing *Repulsion* now calls into question whether our attitudes toward sexual repression have changed during the intervening half-century — and the idea that perhaps they haven't.

Cinematic studies of madness have always been problematic, though even many of Shakespeare's greatest works fit more-or-less comfortably into this genre. What film does offer as a medium, though, are substantial tools to enhance the subject matter. From *The Cabinet of Dr. Caligari* (1920) through various incarnations of Dr. Jekyll and Dr. Frankenstein to Sam Jaffe in Josef von Sternberg's *Scarlet Empress* (1934) and Polanski's own much underrated *Macbeth* (1971), off-kilter psychopaths have always had a place in film. Even before *Psycho* (1960), Hitchcock depicted appealing and sympathetic mental cases in such classics as *The Lodger* (1927), *Shadow of a Doubt* (1943), and *Strangers on a Train* (1951).

Roman Polanski has had his share of troubles, but he is a strong candidate, in my opinion, for the greatest living filmmaker. His recent *The Pianist* (2002) is arguably the best film of the still young twenty-first century.

Hiroshi Teshigahara's Woman in the Dunes 1964

Hiroshi Teshigahara (1927–2001) was a latecomer to the movement known as the Japanese New Wave. Like his French counterparts, he began as a film critic, and was preceded in filmmaking by Susumu Hani, Nagisa Oshima, and Shohei Imamura. When the movement began in 1956, Kenji Mizoguchi was dying, but Yasujirō Ozu, Akira Kurosawa, and Kon Ichikawa were at their peaks. Teshigahara's breakthrough film was *Pitfall* (1962), which was written by Kōbō Abe. The two would collaborate again two years later on *Woman in the Dunes.* Abe was a member of an avant-garde that admired Dostoyevsky, Kafka, Nietzsche and Poe, and he was nominated several times for the Nobel Prize for Literature. He was also, like the male protagonist of *Woman in the Dunes,* an insect collector, and the film makes use of insect metaphors much as John Steinbeck did in *The Grapes of Wrath.*

Teshigahara was a multi-talented member of the avant-garde arts community, a painter and sculptor as well as a filmmaker, and he was also skilled in Japanese flower arrangement, an activity in which his father had been a grand master. Over the course of his career, he also made documentaries on artists such as Antoni Gaudí and Jean Tinguely.

Woman in the Dunes was nominated for an Oscar — making Teshighara was the first Japanese director ever nominated — and is generally considered his masterpiece. It stars Eiji Okada, who had come to international attention in Alain Resnais's *Hiroshima, Mon Amour* (1959). Kyoko Kishida, who plays the female protagonist, went on to a long and successful career. Teshighara used her again several times, and she appeared in Ozu's last film, *An Autumn Afternoon* (1962). Here, she plays a hermit

living in a remote dune who captures and imprisons a scientist visiting the area on holiday.

Although *Woman in the Dunes* can easily be read as misogynistic, the ending can also be read as romantic. (I don't want to give away too much of the plot, but let's just say this predated the phenomenon known as "Stockholm syndrome.") With its desolate, ominous landscape abetted by Toru Takemitsu's experimental and modern score, the film is a haunting, enchanting, and otherworldly fantasy. It shares a nightmarish quality with Polanski's *Repulsion* (1965) – especially in a scene in which masked locals gleefully celebrate an incarceration – and suggests a strange medievalism. (It reminded me of the Salé pirates who captured and imprisoned Robinson Crusoe. On the day before 9/11, I naively wandered alone around Salé, Morocco, unfamiliar with the details of Defoe's plot. There were no pirates, just some kids on bikes who wanted to know my opinion of George W. Bush.) In an interview in *Voices from the Japanese Cinema*, Teshigahara comments on a voyeuristic scene in which villagers force a couple to have public sex, seeing this as a "universal" human instinct. He recalls, laughing, an incident that took place during World War II when he observed "an old country fellow peeking at two lovers through the hole in a *shoji* screen."

The film's eroticism and nudity were very different from the mainstream Japanese cinema of the period – even though MoMA's own former curator, Donald Richie, was already shocking some Tokyo sensibilities by screening what amounted to "X-rated" underground films. In a way, Teshigahara helped make Japanese cinema more realistic and opened up new avenues for directors such as Nagisa Oshima, whose scandalously erotic *In the Realm of the Senses* (1976) proved too hot even for U.S. Customs over a decade later. But *Woman in the Dunes* was not simply shocking. As critic Gudrun Howarth wrote, "When the woman washing the man reacts to the touch of his skin and to the patterns of soap lather on his flesh, the sensual, almost tactile, participation of Teshigahara's camera creates one of the most erotic love scenes ever photographed."

Bo Widerberg's Raven's End 1963

In the early 1960s Bo Widerberg (1930–1997) was confronted with the dilemma of having to carve out his own niche in Swedish cinema as the anti-Ingmar Bergman. Bergman had been forced to compete with the legends of Swedish silent directors Victor Sjöström and

Mauritz Stiller, both of whom had gone to Hollywood in the 1920s, to mixed results. Bergman was worshipful of his predecessors, even trying to emulate them with his own attempt to break into the English language market, and he ultimately incorporated Sjöström into his oeuvre by casting him as the star of *Wild Strawberries* (1957). Widerberg, on the other hand, treated Bergman with respect, but from a distance. "Neither I nor my friends saw very much in him," he said of Bergman. "We didn't find the issue of God's existence that damned important." (As critic Peter Cowie points out, "Religion is entirely absent from Widerberg's films.") Widerberg's attack on Bergman in his book *Visions of Swedish Cinema* helped him launch a career that soon led to *Raven's End*.

Like so many early works by auteurs, the film is probably very close to the filmmaker's true perspective, which would be diluted in subsequent films. It is a work of social conscience and rebellion, and in some respects the complete antithesis of the sumptuous Technicolor romance he made only four years later, *Elvira Madigan*. In *Raven's End*, a young writer and factory worker struggles to get away from the slum he grew up in. Unhappy with his country's social conditions and his father's alcoholism, Anders ultimately escapes, but in doing so abandons a girlfriend he impregnated. Political engagement was a major theme in Widerberg's work, and it comes out most strongly in *Adalen 31* (1969), *The Man on the Roof* (1976), and *Joe Hill* (1971).

Although the film takes place in 1936, the year of the Berlin Olympics, it has been suggested that *Raven's End* is something of a self-portrait of Widerberg as a struggling writer. The film is set in a relentlessly grim ensemble milieu, a neighborhood struggling to survive – or maybe even escape – poverty and misery. (The actual location in Widerberg's hometown of Malmö was torn down shortly thereafter.) It reminds me a bit of King Vidor's adaptation of Elmer Rice's play *Street Scene* (1931) or Akira Kuosawa's depiction of postwar Tokyo, *Drunken Angel* (1947). The protagonist, played by Thommy Berggren, is essentially a good person who bends his moral sense in order to survive, much as Stathis Giallelis does in Elia Kazan's depiction of his uncle's epic journey to escape European oppression for salvation in *America, America,* also made in 1963. There is also a kinship with Arthur Miller's *Death of a Salesman* and Eugene O'Neill's *Long Day's Journey into Night*, in which failing alcoholic fathers, betrayed by their dreams, visit low key and ongoing hells on their famiies.

One should be mindful, too, of the British social realist films of the period, the works of Lindsay Anderson,

Tony Richardson, Karel Reisz, and so on. Berggren is not much like Richard Harrris, Tom Courtenay, or Albert Finney, but his background was quite similar to the role he played in Widerberg's film. His impoverished parents were both socialists, and his father an alcoholic. Berggren became so prominent in film and theater that a documentary called *The Bricklayer* was made about him in 2002 that recounts his commitment to political and social causes. Over many years, he was Widerberg's most reliable leading man, in spite of occasional work with Bergman.

Bergman, by the way, outlived Widerberg by more than a decade.

Joseph Losey's The Servant 1963

Joseph Losey was the most interesting director to come out of the American left except possibly for Turkish-born Elia Kazan. Like Orson Welles and Nicholas Ray, Losey was a product of that then-hotbed of progressivism, Wisconsin. Neither of the other two incorporated a strong political bent in their work (although Welles flirted with running for Senate as a New Dealer), and neither paid the price Losey did in the repressive 1950s. After a successful career in Hollywood (*The Boy with Green Hair*, 1948; *The Lawless*, 1950; *The Prowler*, 1951; a remake of Lang's *M*, *The Big Night*, 1951), he was blacklisted and forced to go abroad to work. He made ten films in Europe before *The Servant*, which marked his return to international prominence.

The plot of *The Servant* deals with the shifting social roles between the aristocratic Tony (James Fox), and his butler, Barrett (played by Dirk Bogarde). Tony's girlfriend Susan (Sarah Miles) never trusts Barrett, and gradually, insidiously, the servant assumes control over his employer. It has become conventional wisdom to say that the film Losey and Harold Pinter fashioned from Robin Maugham's novella is intended primarily as a Brechtian commentary on the decay and decline of Britain. I tend to agree with *The New Yorker*'s David Denby, however, that this is too broad a reading. As reviewers of the novella have pointed out, it seems to share traits with Poe's nineteenth-century portraits of evil and Wilde's *The Picture of Dorian Gray*. Maugham never makes any socially explicit argument, and his novella is narrated by a friend of Tony's who shares his friend's comfortable class values and laments his Faustian weaknesses. Of course, sixteen years separated the book and film, and English values were very much in flux by the time Losey's film came out.

Overtly political or not, there is a kinship between *The Servant* and the Peter Brook adaptation of William Golding's *Lord of the Flies*, made the same year. Before England burst forth with the Beatles and *A Hard Day's Night* (1964), a film made by another expatriate American, Richard Lester, the early 1960s were a period for questioning where had all the greatness gone, and what happens when the barriers of class and manners are broken. Even Losey would get caught up in this burgeoning trend with the strangely comic book-like *Modesty Blaise* in 1966. The year after that film, Losey was reunited with Pinter for the complexly rewarding *Accident* (1967).

In all these works, Losey cast the ambiguously brilliant Bogarde, the perfect embodiment of sixties uncertainty. Though the actor had been in film since 1947, he had only worked with Losey once before, and the pair had been jointly trying to raise money for *The Servant* for a decade. Bogarde won a British Academy Award for *The Servant*, and went on to become one of the key onscreen figures of the 1960s and 1970s. Bogarde's ability to convey ambiguity extended to sexuality, and this raised all kinds of unanswered and probably unanswerable questions about the film. Although Robin Maugham was self-styled as "defiantly homosexual," Bogarde was gay, and Losey was apparently bisexual, there is nothing in either the novella or the film that is overtly homosexual. The book portrays Barrett simply as loathsome: "His long thin body was green and horrible in the moonlight." Yet because of Bogarde's performance, one finds this not entirely satisfying. Maugham had previously described Tony in the bath in rather glowing detail, and on the page and on celluloid, there exists a clear rivalry between Barrett and Susan for Tony. Perhaps David Denby again has the answer: "Only the British could make sex seem so dirty."

François Truffaut's Fahrenheit 451 1966

By the mid-1960s, I had already made up my mind that François Truffaut was my favorite of the French New Wave directors who had transcended their roots as film critics. (Jean-Luc Godard seemed to me increasingly cerebral and self-involved, and Claude Chabrol never quite elevated his genre-based films to a higher level.) I think I've already gone on record appraising Truffaut as the most important filmmaker since Orson Welles debuted in the world in 1915. When it came to genre, I grew up on a diet of science

fiction and fantasy literature and films, and Ray Bradbury was a hero on that front. So it was with great expectation in November 1966 that I awaited the arrival of *Fahrenheit 451*. I was already under the sway of Andrew Sarris in the *Village Voice*, and I remember reading Truffaut's journal entries about making the film in England (this would be his only English-language production) earlier that year in the short-lived English version of *Cahiers du Cinéma*, which Sarris edited. On the whole, my expectations for the film were not disappointed.

Although the U.S. has so far managed to avoid Nazi-inspired book-burnings, Truffaut's film seems prescient in other ways. The movie portrays a society full of narcissism and loneliness, a dystopian future in which firemen burn books (including copies of *Fahrenheit 451* and *Cahiers*), which tend to make people think and become unhappy. As fireman Guy Montag (Oskar Werner) becomes increasingly disaffected, his wife Linda (Julie Christie) exhibits self-absorbed behavior on the monorail, retreats from reality, and ultimately develops an addiction to pills that proves suicidal. Linda's real relationships are not with her husband or reality, but with her "cousin" announcers on the wall-screen, who tell her she's "absolutely fantastic" for giving rehearsed answers to imbecilic questions. (Of course, today she might run the risk of ostracism by being "unfriended," or, even worse, receiving a negative response to an insipid tweet.) Given this situation, her husband begins reading and falls back on a defensive position: "These books are my family."

The film opens cleverly with credits that are audible rather than written, and Bernard Herrmann's music is spectacularly effective. Herrmann was the composer for some of of Alfred Hitchcock's greatest masterpieces (*Vertigo*, 1958; *Psycho*, 1960; *The Birds*, 1963), and along with Jean Renoir, he was one of Truffaut's mentors. The pair collaborated again two years after *Farenheit 451* on *The Bride Wore Black*. Werner had previously worked with Truffaut on *Jules and Jim* (1963), but the director's journals and correspondence with Hitchcock indicate that they had a less cordial relationship on *Farenheit 451*. (Truffaut's first choice for Guy Montag was Charles Aznavour, star of his 1960 crime caper *Shoot the Piano Player*.) Werner outlived Truffaut by only two days.

Like Antoine Doinel, Truffaut's young alter ego in *The 400 Blows* (1959), Montag is ultimately forced to run away. The final scenes have him seeking the refuge of the Book People at the end of the train track — a plot device borrowed by the cable TV series, *The Walking Dead*, when non-zombies escape their cannibalistic pursuers to find like-minded folks.

The film ends brilliantly in a scene shot in the snow. In Truffaut's several autobiographical films, including this one, he infused his characters with elements of his own personality. This is what Charles Dickens did with *David Copperfield*, and when Montag begins his "coming out" as a social deviant, he does so by reading *Copperfield* to Linda's horrified friends. When Montag decides to join the Book People, he memorizes Edgar Allan Poe's *Tales of Mystery and Imagination*. It's a kind of homage to Bradbury, who in some ways is Poe's twentieth-century equivalent.

Michael Roemer's Nothing But a Man 1964

The Motion Picture Academy awarded its Best Picture Oscar in 2013 to *Twelve Years a Slave*, making Steve McQueen the first black director ever to be honored in such a way by the Academy. This recognition had been denied to Charles Burnett, Spike Lee, and many others, including cinema pioneer Oscar Micheaux. That same year, a black man was inaugurated for a second term as president, it was the fiftieth anniversary of Dr. King's "I have a dream" speech, and other significant films by and about blacks (*42*, *Fruitvale Station*, *The Butler*) were produced but largely ignored by the Academy. In other words, it was a mixed bag.

Nothing But a Man, now in the National Film Registry of the Library of Congress, was made at the height of the Civil Rights movement and released the same year as Dr. King's speech. It was set in Birmingham, one of the key sites of Dr. King's struggles, and it offers an unpretentious look at racial prejudice in the South through the story and struggles of a young black couple. The year before, an attack on a church in Birmingham killed four children — a tragedy Spike Lee chronicled in *4 Little Girls* (1997). To me, *Nothing But a Man* has an authenticity, a naturalism, that I found deeply moving when I first saw it fifty years ago, and that has not diminished with time. This may be presumptuous of me to write as a white person, but then, the two men who made the film were also white.

Michael Roemer was born in 1928 in Berlin and had escaped the Nazis during his childhood. This undoubtedly led to a rare sensitivity toward the events depicted in the film. *Nothing But a Man* was enormously successful, especially in non-theatrical venues in the

1960s, and it's heartening that its recent restoration by the Library of Congress may allow it to assume its proper place in film history. (When I worked for distributor Brandon Films, we had several dozen 16mm prints that were in constant circulation to schools and churches.)

Roemer made his own Southern odyssey when planning the film, and as a liberal Jew in the South a year before three Civil Rights volunteers were murdered during the Mississippi Summer, he experienced some of the hatred of the period. *Nothing But a Man* stars Ivan Dixon (*Porgy and Bess*, 1959; *A Raisin in the Sun*, 1961; *A Patch of Blue*, 1965; *Car Wash*, 1976), a superb actor who worked mostly in television and tirelessly asserted the cause of black actors. Dixon won numerous awards from the NAACP and other groups, and among them was the Paul Robeson Award, a tribute to one of the century's most underappreciated artists. His costar, Abbey Lincoln (*For Love of Ivy*, 1968; *Mo' Better Blues*, 1990) made her film debut in *Nothing But A Man*, and most of her acting was also done on television. She was much better known as a jazz singer and songwriter, and as the wife of the great drummer Max Roach. Although Sidney Poitier and Harry Belafonte were getting juicy roles in the 1950s and 1960s, Hollywood, like America itself, was still resistant to giving opportunities to black folks. In this sense, *Nothing But A Man* was an independent anomaly rather than a trailblazing sign of changing times. Maybe, maybe, *Twelve Years a Slave* will help change that.

Peter Emanuel Goldman's
Echoes of Silence 1967

As Peter Emanuel Goldman graciously informed me when he showed up one day at MoMA, channelling Mark Twain, accounts of his death had been greatly exaggerated. Once I got over some of my embarrassment for thinking him deceased, I began fantasizing about paraphrasing General Douglas MacArthur and responding with something along the lines of "young auteurs never die, they just morph into international celebrities whose activities range from playing for the French national baseball team to advising presidents." All of which Goldman did. Born in 1939 in New York, he has also written two novels: *Last Metro to Bleecker Street* and *Echoes of a Crying Floor*, and is working on a sequel to *Echoes of Silence*.

Even before I saw *Echoes of Silence*, I was intrigued by Goldman's early break from the established film underground in New York and its high priest, Jonas Mekas. Mekas, then the film editor for the *Village Voice* and the future creator of the Anthology Film Archives, wrote a column on the burgeoning avant-garde and brought Andrew Sarris to the alt weekly to write about those pesky commercial films. Then as now, Mekas was a champion of Andy Warhol. Although Goldman claimed to like Warhol, in a letter to the *Voice*, Goldman described Mekas's defense of Warhol's *Eat* (1963) as an exercise in rationalizing "boring" movies, not the "pure cinema" that Mekas claimed the film was. At the risk of sacrilege, I must confess that I share many of Goldman's sentiments, but I'm sure I can be written off as an addict of those pesky narratives. Of course, it is ultimately Mekas's fault for putting Sarris in a place where he could be read by a long-time (but young and impressionable) moviegoer seeking distraction from the academe.

Echoes of Silence (which is now available on DVD with Goldman's 1969 film *Wheel of Ashes*) was called by critic Henri Chapier "the most poignant film ever made about the profound despair of the young." In *Echoes*, the director offers up brief portraits of the then-denizens of the New York underground, leaving it ambiguous as to how much was preplanned and how much was actuality. The film prompted Susan Sontag to designate Goldman as "the most exciting filmmaker in recent years." *Echoes* shares some of Warhol's traits, but I think there's a planned sensibility at work here, whereas many of Warhol's works seem to reflect a "director" who turned a switch on the camera and allowed his "actors" to offer whatever mindless chatter popped into their heads.

Goldman's film is without dialogue, but his images, some of them stills, capture 1960s New York scenes that remain indelible and hauntingly moving. They range from pickups at art museums or Greenwich Village coffee houses, to pre-Stonewall gay encounters, to pre-Disneyfied 42nd Street. There is a ghostliness that recalls F. W. Murnau's sublime silents *Faust* (1926) and *Sunrise* (1927). Given that these images were filmed during the decade of assassinations, Vietnam, and the Six Day War, one can't help but recall the Bogart quote in *Casablanca* about the problems of individuals under certain circumstances not "amounting to a hill of beans."

The reference to the Six Day War is pointed, since Goldman has spent much of his life and career championing the cause of Israel, and to becoming, in his words, "Torah-observant." He has traveled a long road since diverging from the denizens of the night depicted in *Echoes of Silence*. What might have been a long and illustrious career in film gave way to another calling. It is,

however, important to remember and salute the unique films that Goldman did make and to mourn (just a little) those that might have been. In some sense, Peter Goldman created a Sallinger-esque gap in our medium.

Arthur Penn's Bonnie and Clyde 1967

In some ways Bonnie and Clyde was a startling revelation that might be considered the beginning of modern American cinema. Its graphic violence and candor about sex created an immediate sensation, but the film also led to a cinema that fundamentally questions basic conservative American values and capitalism itself. Its influences, of course, include John Ford's brilliant 1940 adaptation of John Steinbeck's *The Grapes of Wrath*. In one of that film's more memorable moments, Okie farmer John Qualen has just been told that his land was seized by a bank. In his frustration at learning that there are no options open to him, he blurts out, "Then who do I shoot!?" The scene is played by Ford for its poignancy, but Arthur Penn's *Bonnie and Clyde*, also set during the Depression and in a similar locale, essentially advocates this kind of anarchy. Ford, whose directorial career ended two years before *Bonnie and Clyde* was made, tempered his ending by having an FDR-lookalike provide a reassuring presence at the California camp where Qualen and the other displaced people land. Penn's protagonists, of course, are killed, bloody victims of a government ambush. It's probably pointless to try to read Penn's politics into this ending — Bonnie and Clyde basically deserve what they get. Penn was a New York liberal, and Ford — though a father figure to the archly conservative John Wayne — was a committed New Deal Democrat.

Penn (1922–2010), a product of television and Broadway, made four films before *Bonnie and Clyde*. He had worked with Paul Newman and Marlon Brando, and this was his second film with Warren Beatty, then still in his twenties. Beatty's role as Clyde Barrow established him as one of the most ascendant stars in Hollywood, and he would go on to make *McCabe and Mrs. Miller* (1971), *The Parallax View* (1974), and *Shampoo* (1975). Faye Dunaway was not quite a neophyte, but her role as Bonnie Parker established her career and led to *Chinatown* (1974), *Network* (1976), and, of course, *Mommie Dearest* (1981). Screenwriters David Newman and Robert Benton had

hoped to interest François Truffaut in *Bonnie and Clyde*, but he was just coming off *Fahrenheit 451*, and it is probably fortunate that he did not take on a story so fundamentally American. Even though one critic felt that "few directors are more utterly American" than Penn, Andrew Sarris still thought the film too "Europeanized," believing that the final film stuck too closely to the original conception, which had been designed to appeal to Truffaut. *Bonnie and Clyde* owes much to its supporting cast, as well as to cinematographer Burnett Guffey (whose career dated back to the mid-1940s and included many classic film noir works), and editor Dede Allen, who became Penn's regular editor, and cut the Beatty-directed *Reds* (1981).

Critic Pauline Kael became famous largely through a long and prescient piece she wrote on *Bonnie and Clyde* for *The New Yorker*. Kael recognized the revolutionary nature of Penn's film and contrasted it with the Warner Brother gangster films of the 1930s and earlier adaptations of the Barrow/Parker story by Fritz Lang and Nicholas Ray. She emphasized the contemporaneity, the feeling of modernity in Penn's film, concluding that it was "an entertaining movie that has some feeling in it, upsets people." "By making us care about the robber lovers," she proposed that *Bonnie and Clyde* "put the sting back into death."

Arthur Penn went on to make several important films that critically appraise America. My favorite was his revolutionary *Alice's Restaurant* (1969), a work based on Arlo Guthrie's song that captured the antiwar/antiauthority zeitgeist of the Woodstock period. Penn's movie, the title song, and Arlo's life and subsequent career can all be viewed as indirect tributes to Arlo's father, Woody — the 1930s troubadour/poet whose life is lovingly captured in Hal Ashby's *Bound For Glory* (1976). Although Penn was never able to fully transcend his TV and stage origins, he did offer intermittent visual rewards in later films like *Little Big Man* (1970), *Night Moves* (1975), and *The Missouri Breaks* (1976).

John Boorman's Point Blank 1967

John Boorman's directorial career has lasted for over half a century. He got his start with several documentaries, followed by *Having a Wild Weekend* (1965), which attempted to do for the Dave Clark 5 what Richard

Lester did for the Beatles with *A Hard Day's Night* (1964). Because of his background, there is a sense that *Point Blank*, a fairly big-budget Hollywood film starring noteworthy actors, came out of nowhere. Although at the time it was mostly dismissed as just another genre film, Boorman's spectacular adaptation of Richard Stark's early novel *The Hunter* has now attained the status of a classic. Contemporary crime films had been defined for more than two decades by black and white noir works such as Jacques Tourneur's excellent *Out of the Past* (1947), but directors like Boorman, Blake Edwards, Don Siegel, and Clint Eastwood were beginning to widen the screen and the focus, essentially creating a new genre. As Andrew Sarris put it, these films "cannot be appreciated by movie reviewers afflicted with genre prejudices and an

POINT BLANK. DIRECTED BY JOHN BOORMAN. 1967. USA. 92 MINUTES.

inability to adjust to the age of the color film."

Boorman's film came out a few weeks after Arthur Penn's highly publicized *Bonnie and Clyde* and might have made a bigger splash if Penn's film hadn't preceded it. Like *Bonnie and Clyde*, *Point Blank* was part of a non-orchestrated, spontaneous movement in Hollywood filmmaking that aligned with the decade's questioning of American values. It was also extremely (and often inexplicably) violent. In the film, a thief played by Lee Marvin seeks revenge after his mob accomplices betray him. The mobsters are essentially successful businessmen, oligarchs of capitalism, while Walker, the thief, is a morally tainted hero who anticipates the likes of Richard Nixon and Spiro Agnew. The film is structured elliptically, in keeping with the geometric Los Angeles architecture photographed spectacularly by Philip H. Lathrop, Blake Edwards's favorite cinematographer. *Point Blank*'s reckless — but hardly wreckless — mad car

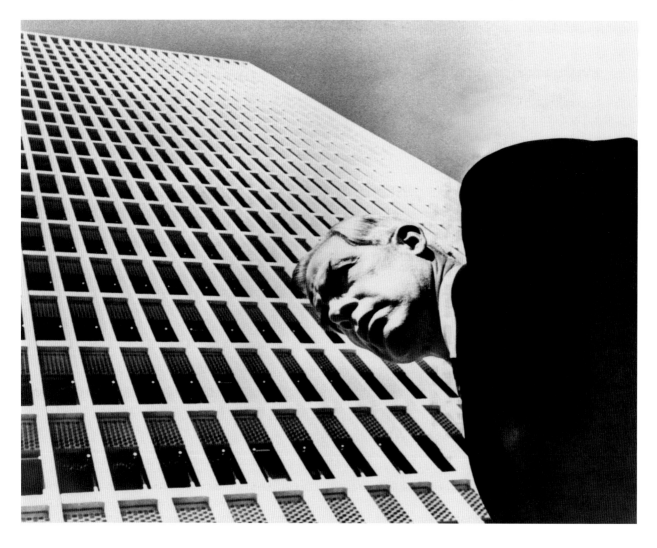

chase sequence helped pave the way for *Bullitt* (1968) and *The French Connection* (1971). Walker's relations with women have a masochistic tinge, and it can also be said that the film contributed to the growing trend toward kinkiness in modern American cinema.

Both violence and kinkiness seem to flow naturally from Lee Marvin, who worked again with Boorman on *Hell in the Pacific* (1968). He starred opposite Toshiro Mifune, another actor capable of personifying a kind of charming bestiality. (Thirty years later, Boorman made a documentary about Marvin, who had given him his big break.) Angie Dickinson, who played Marvin's wife in *Point Blank*, rivaled Julie Christie as queen of sixties sensuality, and John Vernon's role as Walker's psychopathic friend paved the way for a slew of similar parts for Siegel, Eastwood, and others.

Boorman's subsequent career has been basically honorable, if episodic. After the overpraised *Deliverance* (1972), films like *Zardoz* (1974) and *Excalibur* (1981) stand out as highly imaginative examples of spectacular fantasies made before the epidemic of computerized "can-you-top-this" movies. *The Emerald Forest* (1985) and *Beyond Rangoon* (1995) demonstrate a major gift for exotic location shooting. Yet the real treasure of Boorman's career is the autobiographical *Hope and Glory* (1987), a nostalgic look back at his childhood during the London blitz. As Sarris wrote in 1967, he is "a director to watch."

Luis Buñuel's Belle de Jour 1967

Luis Buñuel (1900–1983) led one of the most interesting lives of any director I can think of, and consequently the flow of his career often changed directions. Thematically, however, his films adhere to an idiosyncratic and highly unusual view of reality. With a Jesuit upbringing and a university education under his belt, Luis left Spain in the mid–1920s to assume a role in the Surrealist movement in Paris. His two films with Salvador Dalí, *Un Chien Andalou* (1929) and *L'Âge d'Or* (1930) were followed by his short documentary on Spain, *Land without Bread* (1933), but he mostly dabbled in film work throughout the 1930s.

After Buñuel fought for the Spanish republic against Franco, he escaped to America where he worked in the MoMA Film Library for three years under the department's founder, Iris Barry. Barry's secretary at the time, Margareta Akermark, a rather grand Swedish woman with a raucous sense of humor, told a tale of Luis

sneaking up on her during a screening of *Un Chien Andalou*, and, as the heroine's eyeball was sliced with a razor, somewhat creepily consoling her that it was only a cow's eyeball. Those were the good old days. Buñuel left MoMA in 1942 due to political pressure, but he did make a private return appearance in the early 1970s. I was sitting at my desk in the Film Study Center when suddenly this unique and instantly recognizable face was looming over me. He wanted to know, thirty years after leaving, which of his films we had acquired. We had what was known in film archive parlance at the time as a "hot print" of *L'Âge d'Or*, but we didn't have any rights to it. Quick-witted as always, I informed our then-curator, Donald Richie, of our surprise visitor, and Donald immediately got Buñuel to sign over permission for us to show his film.

After a brief sojourn in Hollywood, where he was unable to find meaningful work, Buñuel moved to Mexico, where he made over a dozen narrative features including *Los Olvidados* (1950). His reputation grew, and in the early 1960s, as he entered his seventh decade, he began making larger-budget films in Europe. Much of his reputation as a master filmmaker rests in the six color films he made in France, beginning with *Belle de Jour*.

I'm afraid I'm too literal-minded to ever fully accept Buñuel's strange, often fantastical universe. I do however appreciate his imagination and feel he was true to his Surrealist vision of the world in both his Mexican low-budget commercial potboilers and in his highly personal French successes. In *Belle de Jour* he has the twenty-four-year-old beauty Catherine Deneuve think thoughts and engage in behavior totally at odds with the image viewers had of her from Jacques Demy's romantic musicals (*The Umbrellas of Cherbourg*, 1964; and *The Young Girls of Rochefort*, 1967*)*. In *Belle*, Deneuve is a newlywed who secretly works in a high-end brothel, and the film deals with her erotic adventures and fantasies. It's not clear what might have prompted Buñuel to cast Deneuve in this role, although Buñuel biographer John Baxter has suggested that Deneuve was foisted on him by the producers and through the influence of her then-lover, François Truffaut. (Also, Roman Polanki's *Repulsion*, released three years earlier, had shown that kinkiness and depravity were within Deneuve's range.) In any case, the film allowed Buñuel to enter the final and most illustrious phase of his career, and he and Deneuve worked together again three years later on *Tristana*. When asked to comment at one point on his final decade of filmmaking, Buñuel said enigmatically that he saw his work as "the search for truth, as well as the necessity of abandoning it as soon as you've found it."

Miloš Forman's The Firemen's Ball 1967

Miloš Forman's career in some ways parallels Roman Polanski's. Forman was a major force in the Czech New Wave in the 1960s, and Polanski, a product of the Łódź Film School in Poland, won international acclaim for his first feature, *Knife in the Water* (1962). Both became fed up with Soviet domination and decided to build their lives and careers in the west. Their family histories were also tragically similar, as Forman's parents and Polanski's mother all died in Nazi concentration camps. Their films are marked by very dark humor.

The Firemen's Ball sprang out of an actual experience Forman had with cowriters Ivan Passer (a close friend and major director who wound up in Hollywood) and Jaroslav Papousek. The three were in a small Bohemian town working on a new film, and fortuitously, they decided to attend a firemen's ball that Forman later described as "such a nightmare that we couldn't stop talking about it." The film is a satirical recreation of the absurdity of that ball, capturing the ineptitude and corruption of Czech officialdom. There is no discernible plot or characterization, it's just an interminable and brilliant portrait suggesting a society in chaos. Although Forman contends he had no ulterior motives, the film's devastating portrait of Czech society hugely offended the Firemen's Union and the Communist regime, neither of which were favorably inclined towards the director. (Although a certain amount of humor was permitted in Soviet-bloc films, Forman crossed the line by critizing authority.) Because Carlo Ponti pulled funding in response to the controversy, Forman faced possible imprisonment for defaulting on loans. He journeyed to Paris where François Truffaut and Jean-Luc Godard helped bail him out. Truffaut had recently made *Fahrenheit 451*, a more serious critique of firemen and their potential to harm, but there had not been comparable outrage in the west. While Forman was in Paris the Soviets invaded Czechoslovakia, and he wisely decided not to return to Prague. He emigrated to New York in 1968 (his first American film, *Taking Off*, came out three years later) and *Firemen's Ball* was nominated for an Oscar the following year when it was released in the U.S.

Forman's career peaked in the mid-1980s and tapered off after that. His *One Flew Over the Cuckoo's Nest* (1975) won multiple Oscars, and bears some similarity to *The Firemen's Ball* and *Taking Off* in its dependence on ensemble performances and in the careful creation of particular milieus. Both *Hair* (1979) and *Amadeus* (a 1984 film that required Forman to return to Prague) are spectacular adaptations of highly successful stage productions. *Ragtime* (1981) and *The People vs. Larry Flynt* (1996) allowed Forman to turn his discerning critical eye on an America he revealed to be as grotesque as the Czechoslovakian reality depicted in *The Firemen's Ball*. Finally, *Valmont* (1989) and *Goya's Ghosts* (2006) demonstrated Forman's comfort with the past's own absurdities. All in all, the director's output has been sporadic and quirky with flashes of brilliance – again, not entirely dissimilar to Polanski's.

Éric Rohmer's My Night at Maud's 1969

Éric Rohmer (1920–2010) adopted his first name as a tribute to actor/director Erich von Stroheim and his second from pulp author Sax Rohmer, both of whom had also embellished or changed their names. Despite these campy origins, it's hard to think of a filmmaker more serious than Rohmer this side of Carl Theodor Dreyer, Robert Bresson, and Ingmar Bergman. *My Night at Maud's* even deprives the audience of the visual rewards available in that trio's most studied films, although there is an austere beauty to the black-and-white cinematography of the gifted Néstor Almendros. (Almendros worked with Truffaut and Luis Buñuel, among others, before coming to America to shoot Terence Malick's stunning 1978 color masterpiece, *Days of Heaven*.) Nor is Rohmer willing to provide the dashes of sentimental romanticism that his comrades occasionally do.

None of this is meant to denigrate Rohmer. When he died, I suggested that he may have been the world's foremost living director, owing in part to *My Night at Maud's*. In it, Rohmer offers what is essentially an exploration of Catholicism and the writings of Blaise Pascal disguised as a movie. Although Rohmer had been an important part of the French New Wave as a critic, his arrival as a director on the international scene came after Jean-Luc Godard, François Truffaut, and Claude Chabrol were already household names among cinephiles. Rohmer shared his comrades' admiration for American films, but he was always something of an odd man out. Godard eventually drifted off into left-wing politics and over-contemplation of his navel. Truffaut, while not overtly political, produced socially rebellious heroes like

Antoine Doinel, Charlie the piano player, and Montag the renegade fireman. Chabrol's subversiveness was closer to that of his idol, Alfred Hitchcock, who Rohmer also highly regarded. (The two young Frenchmen eventually wrote a book on the director.) Even though Rohmer was more politically conservative than his colleagues he did manage to serve as editor of *Cahiers* for seven years. Sadly, beyond an Oscar nomination for *Maud* and recognition in the art cinema scene, America did little to reciprocate Rohmer's admiration.

Without going into a detailed discussion of Rohmer's work – approximately thirty features and twenty shorts – his films do, indeed, have a special quality that does not appeal to all intellects. *My Night at Maud's* mostly features polite, articulate twentieth-century folks sitting around discussing the contemporary relevance of a seventeenth-century philosopher and attending a provincial Mozart concert.

While still a critic, Rohmer was a major contributor to the development of the auteur theory at *Cahiers*. He argued against the idea that aging directors became less cogent and creative with the passing of years. This became especially relevant in his own case, as his films were still winning prizes when he was approaching eighty, and he remained an active director almost up until his death at eighty-nine.

George A. Romero's Night of the Living Dead 1968

The Wikipedia entry for *Night of the Living Dead* cites 126 references, including an extensive bibliography and dozens of external links. This is not bad for a film that reputedly cost little more than $100,000 to make and came out of nowhere – or rather, Pittsburgh. (I love the line in Preston Sturges's *Sullivan's Travels* from 1941, where a studio official tells Joel McCrea, playing a film director named Sullivan, "they know what they like in Pittsburgh." Sullivan responds, "If they knew what they liked, they wouldn't live in Pittsburgh.") Of course, most of Romero's characters are zombies, and this may not be a fair representation of the local populace. It is also extraordinary that this little independent film would two generations later be a major and acknowledged influence on the popular cable television series, *The Walking Dead*.

In the film, for no discernible reason, the rural Pennsylvania countryside is besieged by a mob of flesh-eating zombies. A small group of "normal" people hide out in a farmhouse, led by a resourceful black man. In the nearly fifty years since it came out, Romero's film has not lost its frightening and creepy quality. Although *The Walking Dead* (which I, of course, only watch for research purposes) jazzes up Romero's vision with color and excessively graphic images of cannibalism, Romero's film seems still quite contemporary. Part of this is attributable, I think, to the fine performance of lead actor Duane Jones, who reminds me a bit of President Obama. Making an assertive, rational, matter-of-fact black man the guardian of civilization and order reflects an indisputable prescience for a horror film made in 1968. Jones, a former college professor (also like Obama), once acknowledged that he thought his race gave "a different historic element to the film."

Unlike vampires, which had Dracula to draw upon, zombies did not have a respectable lineage in American films. True, Bela Lugosi had crossed over in Victor Halperin's *White Zombie* (1932), and Jacques Tourneur's *I Walked with a Zombie* (1943) later brought forth later comparisons to Kenji Mizoguchi, but there was something distinctly low rent and socially unacceptable about the flesh-eating undead. Generally, they were relegated to B-movies like Steve Sekely's anti-Nazi *Revenge of the Zombies* (1943) in which the racially stereotyped Mantan Moreland quaked in his boots. The associations between zombies, cannibalism, and voodoo are somewhat outside the scope of this essay, but the thought of being chased by one Romero's zombies across a rural Pennsylvania cemetery is scary enough without contemplating also being breakfast.

Whether Romero's enormous success in his twenties might have stunted his development in later films is open to question. One hardly associates him with romantic comedies and musicals, yet he has cited Michael Powell's 1951 adaptation of Offenbach's *Tales of Hoffmann* as a major influence. (Curiously, the only other favorite he listed that might qualify as a horror film was Roman Polansksi's *Repulsion*, made three years before *Night of the Living Dead*. One can imagine that, given a few more scenes, Catherine Deneuve might have snacked on one of her victims in that film, zombie or not.) Although he dismisses Romero's other films, the distinguished critic Robin Wood sees the "Living Dead" trilogy (which includes *Dawn of the Dead* from 1978 and *Day of the Dead* from 1985) as "one of the major achievements of American cinema, an extraordinary feat of imagination and audacity carried through with exemplary courage and conviction."

1970-1980

Rainer Werner Fassbinder's
The Merchant of Four Seasons 1971

Tragically, Rainer Werner Fassbinder (1945-1982) died just days after his thirty-seventh birthday. Somehow, he crammed forty-four directorial credits and forty-three acting credits into his all-too-brief life, and he managed to become Germany's most noteworthy filmmaker since the golden age of Expressionism, that mostly Weimar era marked by F. W. Murnau, Fritz Lang, and G. W. Pabst. Fassbinder's sensibility was unique in spite of his being heavily influenced by somewhat overwrought Hollywood directors like Douglas Sirk and Samuel Fuller, as well by more contemporary directors like Jean-Luc Godard and Andy Warhol. (Comparing him to the latter, Andrew Sarris commented, "the least of Fassbinder's films is infinitely more serious than the best of Warhol's.") Fassbinder did have a certain cynicism, which Sarris called a "a bleak view of the world." For example, the director once expressed the opinion that "love is the best, most insidious, most effective instrument of social repression." This could easily be considered the prevailing theme of *The Merchant of Four Seasons*.

Fassbinder had already directed a dozen films in Germany — including his monumental 1982 television mini-series *Berlin Alexanderplatz* — before he came to the attention of American audiences with *The Merchant of Four Seasons*. The director was clearly indebted to the great German playwright-turned-Hollywood-writer Bertolt Brecht, who returned after World War II to manage the Berliner Ensemble in Communist East Germany. Brecht was known for what was called the "alienation effect," a technique that forced the audience to focus on larger themes in a drama by preventing them from becoming too emotionally involved with characters. In *Merchant,* Fassbinder's protagonist is a fruitseller whose life is a series of disappointments. The film follows, with some poignancy, the man's gradual disintegration, perhaps prefiguring the director's own suicide a decade later. By putting an unsympathetic and essentially pathetic protagonist at the center of the film, Fassbinder challenges the viewer to think about issues beyond the film's superficial soap opera narrative. This methodology, and the director's relentless depiction of misery, has not endeared his work to everyone. Sarris observed that Fassbinder's "taste for fragmentation and alienation has never been my own cup of tea," but he concedes that it "appeals to the unregenerate pessimist in me."

Although Fassbinder had roots in what I would call post-classical Hollywood — the period between the fifties and sixties — his work was extremely modern in that it was mostly devoid of sentimentality. This was a moment of considerable transition in the movies. While directors like François Truffaut and Peter Bogdanovich upheld the cinema's traditional romantic values, directors like Fassbinder, Robert Altman, and Jean-Luc Godard were pushing the medium in a new direction. What emerged in the ensuing decade were directors schooled in the old cinema who struck out in new, more personal directions, having been somewhat liberated from censorship, convention, and audience precon-ceptions. This includes figures like Steven Spielberg and Woody Allen, but also more manic directors like Werner

Herzog, Terrence Malick, Francis Ford Coppola, and Martin Scorsese. All were very aware of auteur theory, and felt comfortable enacting it in their work.

Robert Altman's McCabe & Mrs. Miller 1971

Robert Altman (1925–2006) strikes me as being, on balance, the most interesting American director to come along after Orson Welles. He was obstreperous, inconsistent (one critic described his career as "rather weird"), sometimes difficult to work with (you don't argue with a former bomber pilot), and provocatively idiosyncratic. As with Welles, because he never ceased experimenting, Altman was full of surprises. Although his career can be viewed as a critique of Hollywood moviemaking — in effect, playing off existing genres to create new variations of his own — much of his success was the result of compromising with commercialism, convention, and the star system. If Gilbert and Sullivan's Major General Stanley was the model for a modern major general, Altman seems the perfect model for a latter-day auteur.

Altman had been making films for nearly two decades before he finally made his mark with *M*A*S*H* and *Brewster McCloud* (both 1970). *McCabe and Mrs. Miller* brought together two of the era's brightest and most modern stars: Warren Beatty and Julie Christie, who was nominated for an Oscar for this role. Their careers seemed to be running on parallel tracks, and the two would later be reunited for *Shampoo* (1975) and *Heaven Can Wait* (1978). In addition to his skill at directing actors, Altman was also one of the cinema's great wranglers of acting ensembles, which is evident in *McCabe*, as well as in films like *Nashville* (1975) and *The Player* (1992). He eventually followed in the footsteps of D. W. Griffith, John Ford, and Welles — not to mention international directors like Jean Renoir, Ingmar Bergman, and Akira Kurosawa — and developed his own stock company.

The film stars Beatty as John McCabe, a scummy, ambitious, none-too-bright entrepreneur who establishes a brothel in the northwestern town of Presbyterian Church in 1902 and falls in love with one of his three prostitutes, Constance (Julie Christie). Everything goes well until some gun-slinging gamblers try to move in on his turf. Ostensibly an anti-Western that eschewed the romanticism of Ford, Altman is indebted to Howard Hawks for the film's subdued, atmospheric lighting, which

is reminiscent of the kerosene-lit sets of *El Dorado* (1966). Altman also owes something to Hawks in his experimental use of multi-layered soundtracks, and to Ford in his use of songs, in this case those of Leonard Cohen. *McCabe* was photographed by Vilmos Zsigmond, who went on to shoot Michael Cimino's *The Deer Hunter* (1978) and *Heaven's Gate* (1980), and Steven Spielberg's *Close Encounters of the Third Kind* (1977). The film's overall style contrasts markedly with its long climax, shot in broad daylight in the snowy streets of Presbyterian Church. As I wrote in my 1976 book on Westerns, *McCabe* is photographed "as though it were underwater... Its consistent use of subdued colors is ultimately rather lovely in its ugliness. Altman insists on the smells, dirt, and grossness of the frontier." I went on to say that the death of Beatty's "seedy entrepreneur... argues persuasively that not only is there no room left for a Western hero, but there isn't even room for an anti-hero." In a sense, Beatty's McCabe is the perfect surrogate for Altman, who was possessed — sometimes blindly — by indefatigable ambition.

Five years later, in *Buffalo Bill and the Indians*, which starred Paul Newman as William F. Cody, Altman grudgingly romanticized the West though a loving recreation of Cody's Wild West Show. At the expense of portraying historical reality, the director drew parallels between the West and show business itself. *McCabe* is packed with gratuitous violence and ends anarchically. In its haunting visuals, it perhaps anticipates America's future even more than it captures its past.

Don Siegel's Dirty Harry 1971

Don Siegel (1912–1991) was a director whose career had, in the words of biographer Judith M. Kass, "a historical uniqueness in terms of the Hollywood studio film." Judy, a friend, emphasizes that Siegel made "films that reflect himself," which is ultimately what auteurism is all about. While she, like Siegel, is not entirely fond of *Dirty Harry* or its protagonist, it was the director's most widely seen film and it has made an impact on the culture and language that far outdistances its antecedents in the genre. In it, Clint Eastwood plays Harry Callahan, a San Francisco cop who refuses to follow rules and niceties in trying to catch a psychotic killer.

Siegel first made his mark creating montage sequences for Warner Brothers, including the now-classic opening of *Casablanca* (1942). After World War II, he began

DIRTY HARRY. DIRECTED BY DON SIEGEL. 1971. USA. 102 MINUTES.

film noir by specializing in black-and-white crime films, and also made color films with heartthrobs like Audie Murphy, John Derek, and later on, Elvis Presley.

In retrospect, perhaps Siegel's most memorable early work is the original version of *Invasion of the Body Snatchers* (1956), which was made at the peak of the Cold War/sci-fi craze, but eschewed much of the sensationalism attached to the genre. He did *Body Snatchers* in order to work in CinemaScope and eventually became Eastwood's mentor, directing him in *Coogan's Bluff* (1968), *Two Mules for Sister Sara* (1970), and *The Beguiled* (1971). Under Siegel's tutelage, Eastwood became a major director in his own right with *Play Misty for Me*, which was made the same year as *Dirty Harry* and featured a cameo with Siegel. (Siegel returned the favor by having Eastwood's film appear on the marquee of a theater during one Harry's shootouts.) Siegel was also influential in the careers of other aspiring directors, including Sam Peckinpah.

The Fink brothers, who wrote *Dirty Harry*, began a long association with Eastwood after that film. Similarly, cinematographer Bruce Surtees, who shot *The Beguiled* and *Misty*, would go on to work with both Siegel and Eastwood on many more films, including Siegel's *The Shootist* (John Wayne's masterful last film from 1976) and *Escape from Alcatraz* (1979). By the time he made *Dirty Harry*, Siegel was fully in command of widescreen, from the credit sequence on. For someone who began shooting small black-and-white films, his location shooting proved to be peerless. Siegel was also not above borrowing from other films (including Alfred Hitchcock's *Rear Window* from 1954). At this point, television and revival theaters had increased access to older films and made many of his contemporaries amateur film historians, in the same way that VHS and DVD would do with the next generation of directors. (I vaguely remember a visit by Siegel to MoMA's Film Study Center, but I believe his primary interest was in reading about what we had on him.)

Because it shows so little regard for civil liberties, *Dirty Harry* remains as controversial now as it was when it was released. For a signature role, it is ironic that the first choices to play Harry were Wayne, Frank Sinatra, Burt Lancaster, and Robert Mitchum. (Whether the film might have been substantially different with any of them would make for an interesting debate.) Because of the film, Siegel was accused of betraying his liberal bent, and Eastwood had already proven himself to be a less-than-cuddly personality in Sergio Leone's "Spaghetti Westerns" — a reputation that culminated in his role as

to direct what were essentially B-pictures, but ones that featured actors who would soon be elevated to the A-list — Robert Mitchum, Broderick Crawford, Steve Cochran — thanks in part to their work with Siegel. He also directed Hollywood veterans like Sidney Greenstreet, Peter Lorre, Ida Lupino, and, yes, Ronald Reagan. Although his output later became more diverse, he became a key figure in

THE LAST PICTURE SHOW. DIRECTED BY PETER BOGDANOVICH. 1971. USA. 118 MINUTES.

cold-eyed killer in Leone's masterpiece, *Unforgiven*, made just after Siegel's death in 1992. It is hard to argue that *Dirty Harry* (like Harry himself) is not racist, homophobic, and devoid of genuine respect for what most of us consider constitutional liberties. We sort of know where Harry Callahan might stand on of the Bill of Rights, but where exactly would he stand on the Second Amendment? And how much of a defense is it that the film was made in the wake of the 1960s? It was a moment of assassinations, of "unpatriotic" rebellion against a murderous and unnecessary war, and of changing values in San Francisco. The movies were becoming more violent. It can certainly be argued that *Dirty Harry* was very much in step with its times.

Peter Bogdanovich's The Last Picture Show 1971

For cinephiles of my generation, there is a sense that Peter Bogdanovich is our Walter Mitty, the man who lives out our fantasies. Bogdanovich became a successful and scholarly critic, curated film exhibitions at MoMA and elsewhere, hobnobbed with the greats (the first time I met Peter he was with Orson Welles, the second time he was escorting Jean Renoir's widow), became a highly praised movie director in his own right, and had intimate relations with some of his stars. I remember, shortly after the release of *The Last Picture Show*, taking the elevator with another aspiring director of our generation who was thoroughly ticked off by the film's acclaim and apparently jealous of Bogdanovich, who he viewed

as a rival. Personally, I never gave much serious thought to making movies, even though my father left me his 8mm camera. (I once toyed with the idea of shooting my model Titanic sinking in the bathtub, and I did shoot some actuality footage of President Kennedy a year before the assassination from far closer than I should have been permitted.) I don't think I ever felt threatened by or jealous of Bogdanovich; he was one of us, one of the good guys.

A *Vanity Fair* piece by John Heilpern referred to Bogdanovich as "the seventies wunderkind" and pointed out the parallels between his career and that of Orson Welles, to whom he had for years played the role of Boswell. Some argue that *Citizen Kane* loomed over Welles's subsequent work in a way that resembles how *The Last Picture Show* looms over Bogdanovich's later efforts. Although films like *What's Up, Doc?* (1972), *Paper Moon* (1973), and *Daisy Miller* (1974) were pretty good, he wound up making only six additional films in the two decades separating *Picture Show* from its sequel, *Texasville* (1990). In the quarter century after that, he has made another dozen or so, mostly for TV. I think this "decline" has less to do with a lack or decline of talent than it has to do with the changing nature of American moviemaking. The directors he most admired, such as John Ford and Howard Hawks, were entrenched in the studio system, and often able to work with a personal stock company of actors and technicians who became friends or acolytes. Bogdanovich, on the other hand, had to put together each new film as a package, and to raise funds for them. In a way, Welles suffered a similar fate as Bogdanovich, though the former's was by choice – he rebelled against the studios and consequently lost his moorings.

The Last Picture Show, a coming-of-age set in a small 1950s Texas town, was in some sense a happy accident. In it, the demise of the local movie theater captures how changing times are sounding the death knell for a particular way of life. For cineastes like Bogdanovich (and myself) the closing is symbolic, since in a rural town much of the world is only available through picture shows. Martin Ritt's 1963 adaptation of Larry McMurtry's novel *Hud* mined some of the same dust-strewn Texas turf. There is in these works the feeling of a lost America that one also gets from Ford, who was, appropriately, the subject of Bogdanovich's documentary *Directed by John Ford* (1971). In *Stagecoach* (1939), *The Man Who Shot Liberty Valance* (1962), and *The Grapes of Wrath* (1940), for example, Ford laments the passing of simpler eras. By the time of *Picture Show*, the lament is for

the movie theater itself, where Ford and Hawks had enraptured a generation with fantasies of alternate and passing realities. In *The Last Picture Show*, pool hall owner Sam "the Lion" (Ben Johnson) hovers over the action like Hamlet's Ghost, a refugee from *Wagon Master* (1950) and cavalry Westerns.

The Last Picture Show was a very personal film for Bogdanovich, something he has not been quite able to replicate since. Some of us, I think, have a visceral and quasi-religious feeling for certain movies. Such is the case here. Between McMurtry's and the actors' extraordinary contributions and Bogdanovich's talent, *The Last Picture Show* is certainly the director's masterpiece.

Luchino Visconti's Death in Venice 1971

It's generally acknowledged now that F. W. Murnau, Sergei Eisenstein, Marcel Carné, George Cukor, Vincente Minnelli, James Whale, and Edmund Goulding were gay. Stories abound about many other directors, but only a few such as Lindsay Anderson, Tony Richardson, and Derek Jarman came out (more-or-less) during their lifetimes. Then there was Luchino Visconti (1906–1976). Visconti was an immensely complex man, a Marxist nobleman whose exit from the closet via *Death in Venice* – a film shot in color, in widescreen, and set in what is perhaps civilization's most spectacular location – was unprecedented. The culmination of a career that included lavish films like *Senso* (1954) and *The Leopard* (1963), Visconti let it all hang out in the service of a tale about a man's search for beauty. In the novella on which the film is based, Thomas Mann wrote, "desire projected itself visually," and Visconti essentially personified that in an adolescent blonde Polish boy in a skin-tight bathing suit. This was a moderately brazen thing to put in a big budget Hollywood studio film in 1971, but it was probably too brazen for the ratings board to get the point, since they gave it a PG rating. (Warner Brothers also initially tried to avoid releasing it.)

The film stars Dirk Bogarde as Gustav von Aschenbach, a composer made up to look like Gustav Mahler, whose music dominates the soundtrack. Fifty-nine years earlier, Mann's novella had ostensibly "outed" Mahler. Both Mahler and Mann were major cultural icons, and although they were both married with children, they apparently struggled with sexual

ambiguity. It has been speculated that Mahler was a repressed homosexual, and in the case of Mann, there is conclusive evidence that he was attracted to men throughout his life. *Death in Venice* was written just after the author's stay at a hotel in Venice where he became enraptured with Wladyslaw Moes, a young Polish nobleman he described as "the expression of pure and godlike serenity" — and a dead-ringer for the story's Tadzio. According to Mann's diaries, the boy's many young successors over the years often turned up as heroes in the writer's novels. (In the novella, Mann has a critic sum up Aschenbach's heroes as possessing "an intellectual and virginal manliness.") The distinguished critic Eric Bentley has argued that Mann's attraction to boys was not really carnal, but I think that in Visconti's interpretation, it was only the legal and social restraints of the time that kept Aschenbach from crossing from admiration into something less chaste.

Sexual obsession is a common and quite acceptable theme in the works of many great directors. One thinks of Alfred Hitchcock's *Vertigo* (1958), and a number of films by Charlie Chaplin, Josef Sternberg, Max Ophüls, Frank Borzage, François Truffaut, Roberto Rossellini, and so on. It did take Visconti, at sixty-five and more than thirty years into his career, a certain amount of courage to make *Death in Venice*, though as a film it does not differ much stylistically from his other work. As in *La Terra Trema* (1948), *Rocco and His Brothers* (1960), and *The Leopard*, Visconti takes his time and is more concerned with milieu than with plot. In *Death in Venice* as in *The Leopard,* Visconti's camera seems to float and prowl over the widescreen, giddily at times, reflecting Bogarde's uncertainty about his circumstances and his voyeurism. Does Tadzio know what he's thinking? After Aschenbach spends many frustrated hours hungrily watching Tadzio on the beach, Mann says "he felt exhausted, he felt broken — conscience reproached him, as it were after a debauch." Visconti sticks pretty close to Mann's text, but in making use of the visuals that only cinema can offer, the vibrant flesh one sees and imagines, he ultimately goes beyond the written word.

Werner Herzog's Aguirre, the Wrath of God 1972

I would argue that no director in film history has moved so successfully back and forth between actuality and

AGUIRRE, THE WRATH OF GOD. DIRECTED BY WERNER HERZOG. 1972. WEST GERMANY. 93 MINUTES.

narrative as Werner Herzog. Herzog's skill in both genres is best displayed in *Aguirre, the Wrath of God*. Although *Aguirre* is ostensibly a work of fiction, it presents itself as a document if not a documentary, and it has enough elements of historical reality to place it somewhere in between. The film centers on Aguirre, a madly ambitious subordinate who breaks away from Pizarro's expedition. The historical Lope de Aguirre (affectionately nicknamed El Loco) actually did command an Amazonian Peruvian expedition in 1561 in search of El Dorado. In his misperceiving madness, he declared himself prince, but

rebellious followers wound up killing and dismembering him, and sending his parts to different locations. These latter events, while not depicted in the movie, set the tone for the film.

Aguirre has an otherworldly and outright weird quality. The Internet Movie Database, for example, informs us that a flute-player was actually "a beggar with mental retardation." How many other films might feature a voice actor to portray a "conqueror being beheaded"? How many directors would "steal" several hundred monkeys for his film's finale? Just two years earlier, Herzog had made *Even Dwarfs Started Small,* and physical eccentricity was a regular part of his repertoire. As one critic put it, "Herzog's vision renders the ugly and horrible sublime." This strangeness and grandiosity is, in part, attributable to his devotion to opera: He has directed more than twenty stage operas, ranging from Wagner in Bayreuth to Mozart in Baltimore. Klaus Kinski in the role of El Loco is a throwback to the great performing monsters of Weimar cinema, such as Conrad Veidt and Max Schreck. In fact, Herzog went on to cast Kinski in Schreck's title role in his 1979 remake of F. W. Murnau's *Nosferatu.*

There is a thin line between cinematic illusion and the kind of delusion at the heart of *Aguirre*, and the first facilitates the second. Herzog belatedly confessed to embellishing El Loco's myth for his film, sometimes at the price of subjecting himself to the wrath of Kinski, who had filmmaking ideas of his own. (This was the first of ten collaborations, so the pair's eccentricities, which were almost always constructive, must have sometimes been congruent.) After Kinski died, Herzog made the documentary *My Best Fiend – Klaus Kinski* (1999), which illustrated how the madness of the actor interacted with his own acknowledged madness.

Kinski in *Aguirre* reminds me of Laurence Olivier's physically and mentally off-balance hunchback in *Richard III* (1955), which was originally written by Shakespeare about thirty years after Aguirre's venture. I think a shared medievalism runs through Shakespeare's portrayal of his antihero and Herzog's film. Francis Ford Coppola also acknowledged that *Aguirre* exerted considerable influence on *Apocalypse Now* (1979), his film about a river journey into a contemporary heart of darkness, replete with savages and an unknown other.

Herzog has subsequently roamed the natural world in search of what is probably best described as the unnatural. One might wish that contemporary technology were able to take him to the moon, Mars, and beyond, for he has so thoroughly mined what's available

to him here on Earth. In the early days of cinema, before airplanes and the spread of what John Wayne in *Stagecoach* (1939) called "the blessings of civilization," filmmakers like the Lumière brothers recorded and brought back largely unadulterated sights of immense wonder and mystery. Later, directors like D. W. Griffith and Martin and Osa Johnson explored and exploited "primitive" lands in the American West and Africa. In a sense, Werner Herzog is a throwback to early and instinctive cinematic curiosity, the idea that an artist should be able to take us deeply into the depths.

Ingmar Bergman's The Magic Flute 1974

Let me say up front that I know almost nothing about opera. As I recall, I've been to the Met three times to see *Der Rosenkavalier*, some Leos Janacek, and William Kentridge's Gogol-esque grotesquery. Once, in the pavilion on the boardwalk in Asbury Park, New Jersey, only a few yards from where the Morro Castle had run aground, I saw a low-rent production of *Tosca*. My only enduring memory was when the lead singer's girth got him caught in a doorway that almost pulled the whole cardboard set down. So, I'm in no position to judge whether Ingmar Bergman's film *The Magic Flute* does justice to Mozart. It is, though, a very entertaining movie, a picture a lot lighter than most of the director's work. Bergman, of course, oscillated back and forth between stage and screen, and although *The Magic Flute* lacks some of his more startling imagery, he manages to bring in some cinematic touches. (In spite of being more or less bound to the stage, the film does not lack for beautiful imagery. The snow scenes and ones set in a fiery cavern are homages of sorts to early D. W. Griffith and Cecil B. De Mille.)

In the film, Bergman invents a kind of locket for the princess to view her prince, has three spirits ride in a Jules Verne flying machine that could be in a Karel Zeman film, includes a "follow the bouncing ball" sing-along, and features a king's council that resemble the Stonecutters on *The Simpsons.* All of this comes as somewhat of a relief to those of us not well versed in "high culture." There are lots of close-ups, but that is typical of Bergman and other great Scandinavian directors. Like the master, Carl Theodor Dreyer, Bergman is not averse to bending the rules of what "cinema" should

be. By adding a good deal of humor, Bergman also bends the rules of what a Bergman film should be. In one sense, *The Magic Flute* is an example of how movies have been redefined in our more relaxed recent decades.

"Opera" films have been a cinematic staple since before the advent of sound. F. W. Murnau's great 1926 adaptaption of *Faust* (as much Goethe as Gounod) reached many who never stepped inside an opera house, and King Vidor's *La Boheme* (1926) probably portrayed Mimi's silent death, embodied by Lillian Gish, more movingly than any singer could manage. Before that there were lots of *Carmen*s. The talkies brought Ernst Lubitsch and his imitators, Michael Powell's *The Tales of Hoffmann* (1951), and Joseph Losey's *Don Giovanni* (1979). Even so, an uneasy relationship has always existed between the static, intense focus on a singer or two and the movies' primal urge toward kineticism. This sheds an interesting light on visual stylists like Bergman, Luchino Visconti, and Werner Herzog, who are drawn to staging opera because it highlights the tension between stasis and the quasi-orgasmic explosiveness that characterizes their work.

Stanley Kubrick's Barry Lyndon 1975

Stanley Kubrick (1928-1999) has long posed problems for auteur critics. It's hard to claim that the director lacked a unique personal vision, but his was fragmentary and misanthropic. Andrew Sarris, for example, wrote in 1963: "He may wind up as the director of the best coming attractions in the industry, but time is running out on his projected evolution into a major artist... *Lolita* is his most irritating failure to date. With such splendid material, he emphasized the problem without the passion, the badness without the beauty, the agony without the ecstacy." By 1968, after the critical and popular successes of *Dr. Strangelove* (1964) and *2001* (1968), Sarris remained somewhat hostile, but he did offer an apology of sorts. With *Barry Lyndon*, he came around enough to be able to appreciate the director's depth of feeling, writing "every frame is a fresco of sadness."

Most of Kubrick's films are either rooted in past violence and warfare (*Fear and Desire,* 1953; *Spartacus,* 1960; *Paths of Glory,* 1957; *Full Metal Jacket,* 1987) or an apocalyptic, or at least worrisome, future (*Dr. Strangelove; 2001; A Clockwork Orange,* 1971; and *A.I Artificial Intelligence,* which was prepared by Kubrick and finished by Steven Spielberg in 2001 after Kubrick's death). Others offered considerable menace (*The Shining,* 1980; *Eyes Wide Shut,* 1999). What was singular about *Barry Lyndon,* and what I think Sarris appreciated, was its pastoral, melancholy beauty, its retreat into a simpler past — still intermittently cruel and violent, but on a human and planetary scale. Adapted from William Thackeray's novel *The Luck of Barry Lyndon,* the film is set during the Seven Years War and it recounts the adventures of an ambitious young Irishman in his quest for status. (It is apparently Martin Scorsese's favorite Kubrick film, and one can find visual and thematic parallels in Scosese's *The Age of Innocence* from 1993.) Though this might seem like a departure, as my Jesuit friend Gene D. Phillips points out, the film echoes a major Kubrick theme: "through human error the best-laid plans often go awry." The emphasis here is on the human, not mad militarists acting on behalf of governments, or out-of-control machines. Barry's problems are mostly of his own making.

Barry is not much of a hero, but in the hands of Ryan O'Neal, he garners a certain level of sympathy and surpasses the histrionic Kubrick performances of Kirk Douglas (*Spartacus, Paths of Glory*), the blandness of Matthew Modine (*Full Metal Jacket*) and Tom Cruise (*Eyes Wide Shut*), and surely Malcolm McDowell (*A Clockwork Orange*) and Jack Nicholson (*The Shining*). As for James Mason (*Lolita*) and Peter Sellers (*Strangelove*), one's reaction is inevitably dependent on your level of patience for their peculiar pathologies.

With *Barry Lyndon,* Kubrick was somewhat constrained by the leisurely pacing of Thackeray's novel, and the film's spectacle of color warfare probably owes something to the splendor of John Ford's landscapes in *She Wore a Yellow Ribbon* (1949) and David Lean's in *Lawrence of Arabia* (1962). There are many parallels between the Seven Years War and WWI — both had surprisingly high death rates, and ultimately were pointless and inconclusive, given historical circumstances. Kubrick's portrait of the period, abetted by zooms and his trademark tracking shots, seems authentic. It's all about hegemony, money, and class, themes that are mocked in the narrator's final judgment: "It was in the reign of George III that the aforesaid personages lived and quarreled; good or bad, handsome or ugly, rich or poor, they are all equal now." As distinguished British critic Penelope Houston has pointed out, "Kubrick does not think much of the human race."

The glory of the film seems to me to exist mostly around the edges — it won Oscars for cinematography (John Alcott), design (Ken Adam), and musical adaptation

(Leonard Rosenman). It can be argued that *Barry Lyndon* is in some ways a betrayal of auteur theory, since it is so unlike a typical Kubrick film, yet this isn't quite fair. All the choices made were by Kubrick, and his attraction to what might be the first antihero of a major English novel is characteristic of the director. Although Thackeray's book leans toward the humorous, Kubrick's film is full of the biting but ultimately tragic satire that was typical of his worldview.

Steven Spielberg's Jaws 1975

Back in March 30, 1974, when I was introduced to the young director of *Sugarland Express*, I had no idea I would play a miniscule role in of one of the greatest revolutions in film history. *Sugarland Express* was being shown in our New Directors/New Films program, and this unknown kid (as I recall, his name was Steven Spielberg) asked me if I could recommend any movies involving sharks. Although fish are not my favorite cinematic protagonists, I did suggest Howard Hawks's *Tiger Shark* (1932). In this film, an unusually sympathetic Edward G. Robinson plays a three-limbed Ahab-like character who has lost an arm as a result of an encounter with a hungry shark. At the end of the movie, he dies from another shark attack. (It would be something of a stretch to find in him the genesis of the Robert Shaw character in *Jaws*, and I haven't read the Peter Benchley novel on which it is based, but the Robinson character does share some of Shaw's irascible saltiness.) *Tiger Shark*, which was shot in Monterey, is a not-bad adventure picture with a touch of romance, certainly far removed from the profundity of *Moby Dick*.

I don't know for sure whether Spielberg ever saw the Hawks film, and I don't claim any credit for *Jaws*. (In fact, as a card-carrying member of the Ocean Conservancy and the Cousteau Society, I was mostly rooting for the shark.) As with the release of George Lucas's *Star Wars* two years later, I think sufficient time has elapsed to provide a context for these two blockbusters which set a pattern of Hollywood filmmaking that we are reminded of every Friday. *Jaws*, in spite of its cost and schedule overruns, made more money than any previous film. The film famously recounts a series shark attacks on beachgoers, ultimately culminating in a mission to hunt the great white. Although the movie has some qualities that we can see as groundbreaking and unique, Spielberg was also standing on the shoulders of giants who preceded him.

From the very beginning, when we hear John Williams's foreboding, menacing score, we are transported to the reality (and surreality) of F. W. Murnau, Fritz Lang, and Alfred Hitchcock. I don't think Spielberg, an acknowledged student of cinema history, would object to the suggestion that he is indebted to his predecessors. In such works as *Close Encounters of the Third Kind* (1977), *E. T. The Extraterrestrial* (1982), the Indiana Jones cycle (1981–2008), *Jurassic Park* (1993), *The War of the Worlds* (2005), and *A.I.* (2001), the director carries forward earlier filmmakers' explorations of the eerie and otherworldly, albeit with his own personal touches. Even his more "serious" projects (*Empire of the Sun,* 1987; *Schindler's List,* 1993; *Lincoln,* 2012) have roots in the three directors named above, as well as John Ford. This isn't meant to denigrate Spielberg's achievement in any way – in post-studio-system Hollywood, his consistent level of achievement in balancing box office revenue and artistry is peerless.

What *Jaws* introduced, aside from the concept of the summer blockbuster, was Spielberg's gift for making movie "reality" intrude on mundane, everyday reality. Much of this can be attributed to the director's talent with actors. He singled out Richard Dreyfuss as his "alter ego" – a kind of nebbishy novice on a swift learning curve – and this role anticipated his being cast as the star of Spielberg's next picture, *Close Encounters*. Roy Scheider, my fellow New Jerseyan and Rutgers man, more-or-less graduated from *Jaws* to stardom. Robert Shaw, a man of varied talents, led a troubled life and committed suicide three years later. An argument can be made that the real star of the film was composer John Williams, who won Oscars for *Jaws* and Lucas's *Star Wars,* with Hitchcock's last film, *Family Plot* (1976), sandwiched between them. Spielberg has gone on to an extra-ordinarily successful and mostly serious career, but *Jaws* revealed a bit of naughty-little-boy quality that I think he retains.

Martin Scorsese's Taxi Driver
1976

No director has ever been so closely identified with New York in all its manifestations, terrors, and glories as Flushing-born Martin Scorsese. (Even Woody Allen became more or less a jetsetter, preferring European jaunts to the streets of his hometown.) Born in 1942,

Scorsese gave us fascinating portraits of New York's past through the grotesqueries of *Gangs of New York* (2002) and the patrician beauties of *The Age of Innocence* (1993). Before that, he mined his own experience of the city's more contemporary hazards in *Mean Streets* (1973) and *Taxi Driver* (1976), the latter of which has been described by critic Robin Wood as a work of "rich and fascinating incoherence."

The film revolves around daffy taxi driver Travis Bickle trying to cope with the sinister side of New York at night. Wood perceives *Taxi Driver* as a fusion of film noir, horror, and Westerns. He sees these elements expressed in the film's nightmarish vision of New York City, the psychopathic nature ("I got some bad ideas in my head") of Robert DeNiro's Travis Bickle, and Scorsese and writer Paul Schrader's acknowledgment that Bickle owes much to John Wayne's Ethan Edwards in John Ford's 1956 epic *The Searchers*. I suspect, too, that Peter Emanuel Goldman's *Echoes of Silence* (1967) was an influence on the denizens of the city, particularly around 42nd Street. (Scorsese had just graduated from NYU Film School and was making shorts when Goldman's film came out to much acclaim.) Schrader's dense and scholarly book *Transcendental Style: Ozu, Bresson, Dreyer* was published in 1972, and one might easily label *Taxi Driver* as Bressonian, in the tradition of *Pickpocket* (1959), in its austerity and distancing effect. (Many of Schrader's own films as a director, beginning with *Blue Collar*, which came out two years after *Taxi Driver,* were somewhat of a piece with his early Scorsese collaboration.) The two were reunited in 1980 for *Raging Bull.*

Robert DeNiro had already made eight films before Scorsese cast him in *Mean Streets.* That role, plus Francis Ford Coppola's *The Godfather, Part II* (1974) and *Taxi Driver*, established him as arguably the greatest actor of his generation. It's ironic that he replaced Marlon Brando in that designation, since he had played the young Brando's Vito Corleone role in Coppola's prequel. (And like Brando, De Niro has struggled in middle and older age to find roles truly worthy of his talents.) Unlike other major directors of his generation, Scorsese has shown himself adept at directing actresses in his testosterone-dominated world. He found something special in the adolescent Jodie Foster – who he had directed previously in *Alice Doesn't Live Here Anymore* (1974) – and besides her discoverer, Peter Bogdanovich, Cybill Shepherd had never worked with another male director. Their fine work in *Taxi Driver* foreshadowed the masterful performances Scorsese would later draw from Cathy Moriarity in *Ragng Bull* and Michelle Pfeiffer in

The Age of Innocence. Taxi Driver is also helped immensely by Bernard Herrmann's final score – the film is dedicated to the composer.

Scorsese's cinematic world is frequently one of violence. The soundtrack for *Taxi Driver* identifies each track with phrases that seem to be borrowed from a National Rifle Association commercial: "The .44 Magnum is a Monster," "Target Practice," "Assassination Attempt/After the Carnage." The director was forced to discolor the blood in order to get an R-rating. Five years after the film came out, John Hinckley Jr. notoriously shot President Reagan to impress Jodie Foster. (The film was shown at Hinckley's trial.)

Yet in person Scorsese seems mild-mannered and gentle, and he radiates a highly articulate intelligence. (Remember, he was also the director of *The Last Temptation of Christ,* 1988, and *Kundun,* 1997.) Like Walt Whitman said, a great artist can contain multitudes. I was once distressed and depressed by an African-American student who took away from *The Searchers* that John Ford was a racist. He seemed to not understand that John Wayne's Ethan Edwards (one of the central models for De Niro's Travis Bickle) could change and accept Natalie Wood (whom he had foresworn to kill) and her "half-breed" brother, Jeffrey Hunter, who Wayne had repeatedly abused. This interpretation precluded the possibility of redemption, while Travis is redeemed. One of the hazards of auteurism is that it can pigeonhole, limit, and too narrowly define a director. Scorsese has made many violent, frightening films, but he has also made fairytales.

Woody Allen's Annie Hall 1976

Woody Allen has directed over fifty films. *Annie Hall* was his eighth and, some suggest, his best. My own feeling is that with this film Allen graduated from being a standup comedian who used supportive imagery to becoming a genuinely serious artist. To compare him with one of our shared gods, it was the equivalent (on a lower level, to be sure) of Charlie Chaplin transforming from an actor of slapstick shorts into one of the greatest cultural icons of the twentieth century. *Annie Hall* marked the point where feeling and intelligence transcended an "anything for a laugh" attitude, and Woody was rewarded for his efforts with an Oscar.

Perhaps I'm focusing too much on the film's emotional resonance because his later ones seem to lack

it. *Annie Hall* is relatively free of the misanthropy that Stuart Klawans speaks of in his review of Allen's 2013 film, *Blue Jasmine* — "Allen is not overtly optimistic about anyone's morality." The following year, David Denby called his 2014 film *Magic in the Moonlight* "an accomplished, stately movie — unimpassioned but pleasing." This is not the case with *Annie Hall*. His characters are all wacky yet appealing in their own ways; there is a sense of autobiography (which Allen strenuously denies) and urgency in their respective compulsions. The throwaway humor of the early films is mostly gone, but *Annie Hall* is still very funny.

Part of this is attributable to Woody's under-appreciated gift as an actor. The film is a highly romanticized view of life in New York that can best be described as sui generis, and Allen's acting makes it authentic. *To Rome with Love* (2012) only comes alive for me during Woody's few onscreen scenes as a failed musical impresario. Of all his best films (and there are several), the only one in which he does not appear is *Radio Days* (1987), which he narrates offscreen. Again, comparisons with Chaplin can be carried only so far, but just as *A Woman of Paris* (1923) and *A Countess from Hong Kong* (1967) suffer from Chaplin's absence, the same can be said of Allen. There is always something charming about Allen delivering lines he has written for himself, no matter how familiar we have become with his personality.

I tend to agree with Mark W. Estrin that the character Allen develops in *Annie Hall* and its many subsequent variations — that is, "obsessive... perpetually and hilariously taking the mental temperature of everyone around him... [a] comic victim and witty victimizer, a moral voice in an amoral age who repeatedly discovers that the only true gods in a godless universe are cultural and artistic" — is "indelible." Frankly, this is a role model one can aspire to — though perhaps with slightly less nebbishness.

A well-known and highly esteemed actress once complained to me that Allen had given her no proper direction on set. Diane Keaton, who plays Annie and stars in several of Allen's most memorable films, seems so naturally neurotic onscreen (I've met her, and she's really not) that her Oscar-winning performance seems to have come much more easily than Cate Blanchett's channeling of Blanche DuBois in *Blue Jasmine*, which also won her an Oscar. (Incidentally, one of the discarded titles for *Annie Hall* was *Rollercoaster Named Desire*.) In their work together, Keaton's neuroses seem perfectly in synch with Woody's. A large part of direction seems to be in his

basic casting choices, rather than in moment-by-moment intensity on set. Again, to stretch things just a little, there are parallels here with Cary Grant and Irene Dunne's splendid performances in *The Awful Truth* (1937), Grant and Katharine Hepburn in *Bringing up Baby* (1938), and Hepburn and Spencer Tracy — all romantic comedy royalty.

Terrence Malick's Days of Heaven 1978

Terrence Malick was still in his twenties when his first feature, *Badlands*, debuted at the 1973 New York Film Festival. *Days of Heaven*, released five years later, was not followed by another film for two decades. It is hard to think of another significant filmmaker with that kind of gap in his output. Although many (but not all) critics acclaimed *Days of Heaven* and it won several awards, Malick apparently turned down many projects during his period of inactivity.

By 1978, Hollywood films had undergone a revolution. Studios and censors now exerted little control, and in films like *McCabe and Mrs. Miller* (1971) and *Bonnie and Clyde* (1967), directors such as Robert Altman and Arthur Penn rejected conventional narrative. *Days of Heaven* challenges the viewer to work a bit harder than "traditional" movies, but it is in some ways a throwback to the glory days of half a century earlier when silent films attained a level of visual elegance (much of it due to the use of natural lighting) that was later lost or understated in much of the sound era. The plot, for what little importance it has, involves a love triangle set on a wheat farm in the West during harvest. Malick depends on imagery and imagination more than dialogue and actors. The film was photographed by the great Néstor Almendros, who was rewarded with an Oscar for his achievement. Almendros, a Spaniard by way of Cuba, was the cinematographer of choice for French New Wave giants François Truffaut and Éric Rohmer, and the American Robert Benton. Although Almendros's films with other directors are very accomplished, it appears that Malick gave him an especially high degree of freedom to experiment. Describing his approach, Almendros commented, "Period movies should have less light... the light should come from the windows because that is how people lived." In pursuit of this ideal, Malick and Almendros alienated much of their technical crew.

The production was also plagued by other problems related to the script, the actors, and a lengthy and arduous editing process. Still, what emerged on screen was a portrait of America quite unlike anything that had preceded it. Dave Kehr wrote at the time of its release that the film "hovers just beyond our grasp – mysterious, beautiful, and, very possibly, a masterpiece." This elusive, ethereal, and poetic quality also recalls the silent days, when directors like D. W. Griffith, Carl Theodor Dreyer, F. W. Murnau, or King Vidor could deliver an alternate vision of reality unencumbered by dialogue and explicitness.

In *Days of Heaven,* Malick uses arch voiceover narration by young Linda Manz to hold together what there is of a narrative. The tactic was commonplace by this time: voiceovers had appeared in everything from the great films of John Ford and Orson Welles to B-pictures such as the "Whistler" noir series. More recently, directors such as Woody Allen have used voiceovers regularly, and Michael Hordern's narration for Stanley Kubrick's *Barry Lyndon* contributes greatly to the tone of the film. Manz, with her disconcerting New York accent in the midst of what is supposed to be the Oklahoma panhandle (but is really Canada), was apparently working unscripted, commenting at will on what was happening to her and the other characters, with Malick later selecting choice bits. This strikes me as very effective in highlighting the glories of nature – and balancing them against a depiction of how America was built on greed, duplicity, and despoliation.

Francis Ford Coppola's
Apocalypse Now 1979

Thanks to his first two *Godfather* films, Francis Ford Coppola had by the time of *Apocalypse Now* become the American director most able to garner both critical acclaim and box-office success. I would be loath to accuse Coppola of hubris, but the heights of his achievement were certainly matched by his ambition. *Apocalypse Now* (which stuck closely to a script by John Milius) took five years to make, but despite "its moments of cinematic grandeur," as Douglas Gomery calls them, there is something disjointed and disturbing about the film. It tells the story of a river journey during the Vietnam War in search of Kurz (Marlon Brando), a legendary former soldier who has formed a kingdom of his own. As Martin

Sheen and his colleagues go upriver, they encounter extraordinary circumstances, shot in a highly stylized way. In Coppola's defense, I'm not at all sure that one can make a fully coherent film on war, since it is a topic so akin to madness. Yet *Dementia 13* (1963), one of Coppola's first films, did provide him with some unanticipated preparation. One can easily imagine the crazed Robert Duvall ("I love the smell of napalm in the morning") and Marlon Brando characters from *Apocalypse Now* popping up in the earlier film.

There is something admirable about a major Hollywood director lavishing money (much of it his own) on exposing the venality and corruption of a government-sanctioned misadventure such as the Vietnam War so soon after it. Films expressing misgivings about the Great War were only made after an interval had passed, and with some exceptions, they depicted pacificism in Germans and Frenchmen rather than in patriotic Americans. John Ford did make *They Were Expendable* (1945), a downbeat World War II film on the early American defeat in the Pacific, but it was still patriotic and wasn't released until after Hiroshima and Nagasaki had been flattened by the "good guys."

For all its good intentions, there is an over-the-top quality to *Apocalypse Now* – perhaps it offers too much of a good thing. Several years ago, my erstwhile colleague Stuart Klawans, now the film critic for *The Nation*, wrote a book called *Film Follies: The Cinema Out of Order* in which he looked at various films that could be deemed extravagant. His classic example was D. W. Griffith's 1916 multi-epic *Intolerance*, a "film fugue" that was linked together through four intercut stories of intolerance throughout the ages. Stuart also cited Coppola's film as another prime example. With both films, audiences rebelled against being overwhelmed with spectacle, even if much of the craftsmanship and imagery was unprecedentedly innovative.

Apocalypse Now, is, of course, loosely based on Joseph Conrad's novella, *Heart of Darkness*. In the film, Coppola tells "the story of the dissolution of a man and of the system he stands for... the system of shameless exploitation," to quote Edward A. Weeks's introduction to the novel. In the case of the book, Conrad was exposing the rape of the Congo by Belgium. In Coppola's version, it was the French and later, American interventions in Southeast Asia. Both the novel and film are centered on a river journey (as Conrad says) "deeper and deeper into the heart of darkness... like travelling back into the beginnings of the world... on an earth that wore the aspect of an unknown planet." Coppola is adept at

capturing what Conrad calls this "unreal" milieu, and it is pretty evident that he had seen Werner Herzog's *Aguirre, the Wrath of God* (1972). Even so, and in spite of a solid performance by Martin Sheen (whose character has reality issues of his own), there is little to latch on to. In a sense, Coppola proves so successful at creating a graphic alternative reality that some of his political and social messaging is cast adrift.

The Museum now holds the print to *Apocalypse Now Redux*, Coppola and expert editor Walter Murch's 2001 re-editing of the original release. This version runs forty-nine minutes longer, and includes entirely new scenes. Griffith also habitually tinkered with his films, and as an auteurist, it would be hard for me to deny Coppola the privilege of choosing the version he wanted to leave as part of his legacy.

Martin Scorsese's Raging Bull

1980

I attribute my lifetime fascination with boxing to my maternal grandfather, Louie Greenberg. Chewy Louie (as he was affectionately known due to his steadfast support of the Wrigley franchise) lived upstairs from us in a house he had built. He was an expert plumber, and his skills were celebrated both by nearby nuns for his work on their cloister as well as by the bootleggers whose stills in the New Jersey woodlands he had repaired during Prohibition. From the time I was a little kid, I always had a standing date on Fridays to climb the stairs for Gillette Friday Night Fights. (To look sharp, to feel sharp.) Grandpa was the gentlest and most even-tempered man I have ever met, even when being henpecked by Grandma. Though there surely must have been times when he might have felt like paraphrasing Ralph Kramden's "One of these days, Bella... Pow! Right in the kisser!" he seemed to sublimate all his aggression and keep it in reserve for Friday nights. Then, leaning forward on the edge of his reclining chair (the arms of which sometimes contained remnants of last week's chewing gum), Louie would fight along with the guys on TV. His arms would flail, his head would duck — he could have been a contender.

Boxing in those days was dominated by two groups of fighters. There were the black champions such as Sugar Ray Robinson (who figures prominently in *Raging Bull*), Archie Moore, Kid Gavilán, Floyd Patterson, and many others. The other group included Italian Americans such as Rocky Marciano, Willie Pep, Carmen Basilio, and, at the tail end of his career, Jake LaMotta. Utterly devoid of prejudice, Louie loved them all. Whatever verbal venom he possessed was reserved for Republicans: "They stink!"

The film is a biography of the eccentric Jake LaMotta, former middleweight champion of the world, taking in both his boxing career and his later exploits with the mob and show business. For *Raging Bull*, Martin Scorsese was reunited with Michael Chapman, who had been the cinematographer on *Taxi Driver* (1976). Together with the great editor Thelma Schoonmaker they helped the director forge a searing document on what was the most popular blood sport in America for more than a century. Still, the sadism and brutality in the film go well beyond anything I remember witnessing on black-and-white television. Though the bloodlust of boxing crowds doubtless remain intact — and I must confess that I still look for knockouts in preference to "ring generalship" — today any self-respecting referee would quickly step in to stop the kind of beatings that *Raging Bull* repeatedly depicts. Boxing these days seems dominated by Fancy Dans like Floyd Mayweather and stoic, barely mobile heavyweights such as Wladimir Klitschko and his brother Vitali, who was improbably elected mayor of Kiev.

However, there's certainly method in Scorsese's "madness." To do justice to a larger-than-life figure like LaMotta requires an enhanced reality, and this is what Scorsese has done, filming key scenes in an over-the-top manner. As James Harvey says in his excellent book *Seeing Them Be,* Robert DeNiro's LaMotta displays "more than ordinary perversity, even ordinary craziness — it's epic." The actor gained an enormous amount of weight to portray the post-ring Jake, and Scorsese's commitment to his vision is equally mesmerizing. LaMotta himself is credited as a consultant on the film, and Scorsese and screenwriter Paul Schrader could not have made up his life. Adding to this remarkable tale is the fact that Jake married his seventh wife when he was in his nineties.

I'm not sure whether I fully agree with my esteemed colleague Jason Persse, who recently chose *Raging Bull* as the finest American film since 1975. It is, however, a powerful and unique experience. In terms of DeNiro's career, the selection of Marlon Brando's taxi cab speech in *On the Waterfront* (1954) — "I could have been a contender... I could have been somebody" — for LaMotta's recitation in his 1964 nightclub act is near perfection. Contrasting the two actors, film historian James Harvey noted, "Brando... plugs right into your feelings — where DeNiro leaves you to deal with them,

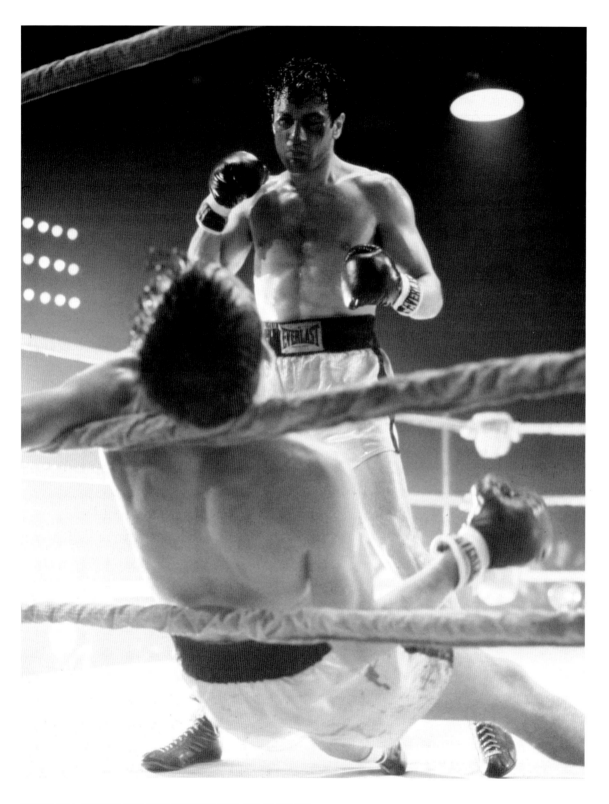

RAGING BULL. DIRECTED BY MARTIN SCORSESE. 1980. USA. BLACK AND WHITE, 129 MINUTES.

and good luck." The moment marked a passing of the torch. Bobby, as *On the Waterfront* director Elia Kazan called him, had become the new Brando, and as LaMotta, DeNiro imitated his predecessor before a dressing room mirror. Many years later, everything came full circle when Scorsese and DeNiro presented Kazan with an honorary Oscar.

Woody Allen's Manhattan 1979

For me, having lived in New York for almost half a century, Woody Allen is as vital to the city as Hendrik Hudson was. Between the two of them, there has been a long string of greats, extraordinarily accomplished men and women who have walked our streets. This includes George Washington and Abraham Lincoln, who passed through on their way to immortality; Herman Melville, who prowled the waterfront and Customs House; Walt Whitman, who just prowled; Frederick Law Olmsted, who designed a park that some consider the greatest work of art of the nineteenth century; Teddy Roosevelt, who wished that being police commissioner was an equestrian position; D. W. Griffith, who invented a new art form on 14th Street; Eugene O'Neill, who hobnobbed with Reds and drank himself silly in the Village; Babe Ruth and Jackie Robinson, who hit them out of the park and stole home; Elia Kazan, who talked dirty in his tiny office at the old Astor-Victoria theater; Charlie Chaplin and Orson Welles, who navigated the hallways at the Plaza Hotel; Greta Garbo, Lillian Gish, and Audrey Hepburn, who exchanged neighborly visits on the east side; Cary Grant, who hung out at the Warwick; and Andrew Sarris, who gave us auteur theory.

Manhattan is Allen's ultimate love letter to New York and its beauty. It almost makes you feel like Gershwin music is playing in our daily lives, transpiring in the signature image of Sutton Place Park and the bridge. Woody shot a key scene in *Manhattan* at the Museum of Modern Art. Thanks to the assistance of George Gershwin's *Rhapsody in Blue* and the work of super-cinematographer and native New Yorker Gordon Willis, *Manhattan* must have made many envious of those of us who live here. I remember seeing an Allen film in some forsaken venue (probably in Florida) and was surprised to discover that the crowd appreciated his humor, despite it being very "New York." There is a kind of universal romanticism to Woody's best work, which often sacrifices likeness for emotion. As his character says in *Manhattan*, "the brain is the most overrated organ." For all the Godardian theorizing and the varieties of verité, the movies are ultimately about feelings. Griffith had it right over a century ago when he offered up films such as *True Heart Susie* and *A Romance of Happy Valley* (both 1919) with a straight face.

Woody's New York City, of course, is no more real than any of Griffith's pastoral paradises. J. Hoberman has even suggested that Allen's vision of the city is derived less from reality than from the director's memories of the old movies of his youth. Still, his New York is the New York most of us came here seeking — and would like to think we've found.

Ultimately, Woody is a comedian, and perhaps the most successful actor and director in the sound era. It seems all the more appropriate, then, that the final scene of what may be his best film pays homage to the best film of his predecessor in the silent era, Charlie Chaplin's *City Lights*. That scene is the one that James Agee famously called "the highest moment in movies."

Index

Photograph Credits

In reproducing the images contained in this publication, The Museum of Modern Art has obtained the permission of the rights holders whenever possible. In those instances where the Museum could not locate the rights holders, notwithstanding good-faith efforts, it requests that any information concerning such rights holders be forwarded, so that they may be contacted for future editions.

Aguirre, The Wrath of God. Courtesy of Werner Herzog Film.

Amarilly of Clothes-Line Alley. Courtesy of Mary Pickford Productions.

The Apartment. © 1960 Metro-Goldwyn Mayer Studios Inc. All rights reserved.

The Bicycle Thief. Courtesy of Corinth Films.

The Big Parade. Courtesy of Warner Bros. Entertainment Inc. All rights reserved.

The Big Heat. © 1953, renewed 1981 Columbia Pictures Industries, Inc. All rights reserved. Courtesy of Columbia Pictures.

The Birds. Courtesy of Universal Studios Licensing LLC.

Black Girl. Courtesy of New Yorker Films.

Breathless. Courtesy of Janus Films.

The Cheat. Courtesy of Paramount Pictures.

The Defiant Ones. © 1958 Metro-Goldwyn Mayer Studios Inc. All rights reserved.

The Devil is a Woman. Courtesy of Universal Studios Licensing LLC.

Dirty Harry. Courtesy of Warner Bros. Entertainment Inc. All rights reserved.

Divorce, Italian Style. Courtesy of Janus Films.

Duel in the Sun. © ABC, Inc. All rights reserved.

Entr'acte. © 1924 René Clair.

The Great Dictator. © Roy Export S.A.S. Scan. Courtesy of Cineteca di Bologna.

The General. Courtesy of Buster Keaton Productions.

Gertrud. Courtesy of Palladium Film.

Hallelujah. Courtesy of Warner Bros. Entertainment Inc. All rights reserved.

Hiroshima, Mon Amour. © 1959 Argos Films – Como Films – Pathé.

How Green Was My Valley. © 1941 Twentieth Century Fox. All rights reserved.

King Kong. Courtesy of Warner Bros. Entertainment Inc. All rights reserved.

Knife in the Water. Courtesy of Janus Films.

The Lady Eve. Courtesy of Universal Studios Licensing LLC.

The Last Picture Show. © 1971, renewed 1999 Columbia Pictures Industries, Inc. All rights reserved. Courtesy of Columbia Pictures.

Late Spring. © 1949, renewed 2015 Shochiku Co., Ltd.

The Leopard. © 1963 Twentieth Century Fox. All rights reserved.

Love Affair. Courtesy of RKO Pictures.

Man with a Movie Camera. Courtesy of Kino Lorber.

Meet Me in Saint Louis. Courtesy of Warner Bros. Entertainment Inc. All rights reserved.

Modern Times. © Roy Export S.A.S. Scan. Courtesy of Cineteca di Bologna.

On the Waterfront. © 1954, renewed 1982 Columbia Pictures Industries, Inc. All rights reserved. Courtesy of Columbia Pictures.

Pather Panchali. Courtesy of Janus Films.

Point Blank. Courtesy of Warner Bros. Entertainment Inc. All rights Reserved.

Raging Bull. © 1980 Metro-Goldwyn Mayer Studios Inc. All rights reserved.

Rashomon. Courtesy of Janus Films.

The Searchers. Courtesy of Warner Bros. Entertainment Inc. All rights reserved.

Shadows. Courtesy of Janus Films.

Sherlock Jr. Courtesy of Buster Keaton Productions.

Scarface. The Shame of a Nation. Courtesy of Universal Studios Licensing LLC.

Suddenly, Last Summer. © 1960, renewed 1988 Horizon Pictures (G.B.) Ltd. All rights reserved. Courtesy of Columbia Pictures.

Witness for the Prosecution. © Metro-Goldwyn Mayer Studios Inc. All rights reserved.

Yojimbo. Courtesy of Janus Films.

The 400 Blows. Courtesy of Janus Films.